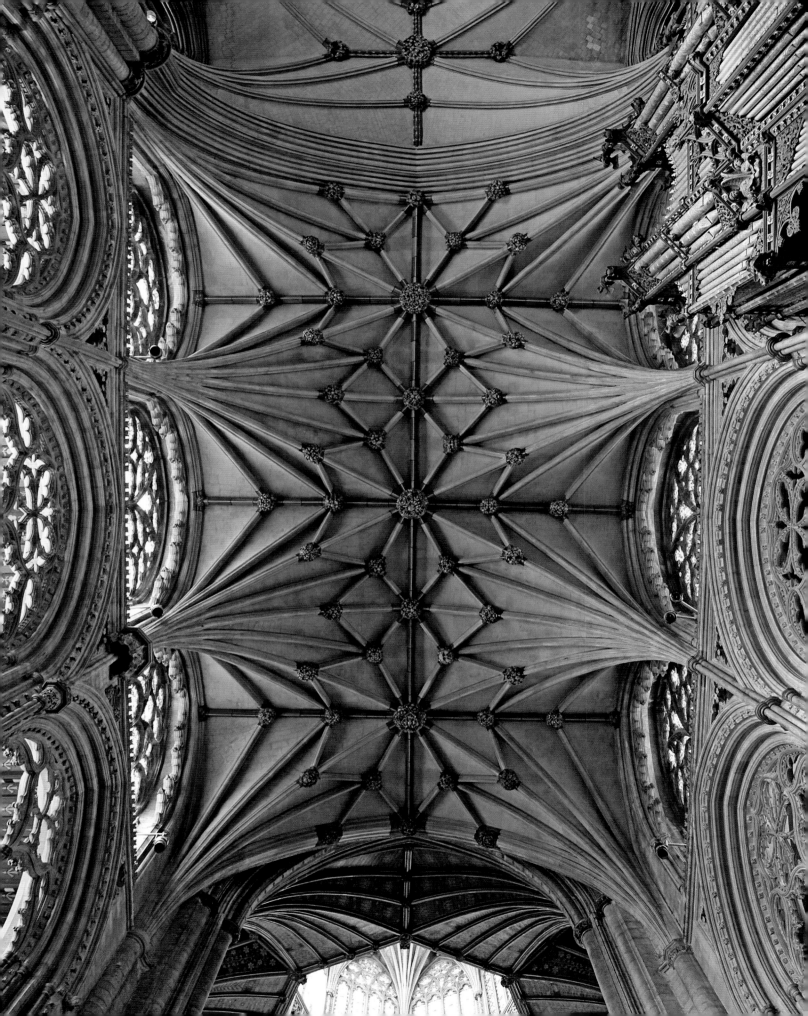

GOTHIC WONDER

ART, ARTIFICE AND THE DECORATED STYLE

1290–1350

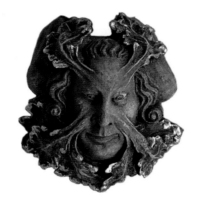

PAUL BINSKI

PUBLISHED FOR THE PAUL MELLON CENTRE FOR STUDIES IN BRITISH ART BY
YALE UNIVERSITY PRESS · NEW HAVEN AND LONDON

Designed by Emily Lees
Printed in China

Library of Congress Cataloging-in-Publication Data

Binski, Paul.
Gothic wonder : art, artifice and the decorated style 1290–1350 / Paul Binski.
pages cm
Includes bibliographical references and index.
ISBN 978–0–300–20400–1 (cl : alk. paper)
1. Art, Gothic – England. 2. Art, English – 14th century. 3. Architecture, Gothic –
Decorated style – England. 4. Creation (Literary, artistic, etc.) I. Title.
N6763.B56 2014
709.42'09022 – dc23
2014012249

A catalogue record for this book is available from the British Library

Frontispiece Ely Cathedral, vault of presbytery, completed 1337 (detail of pl. 156)
Image on p. iii Norwich Cathedral, cloister east walk, north end, boss of green man (see pl. 66)

CONTENTS

Preface vii

Introduction I

Part I MODE, INVENTION AND MEANS II

 I The Heroic Horizons of Pre-Decorated Art 13

 2 Gothic Invention 49

 3 Money and Motive 81

Part II THE AESTHETICS OF THE DECORATED STYLE II9

 4 Invention Energized: Scale and Allegory I2I

 5 Artifice and Allure I6I

 6 Solomon's House: Wonder at Ely 187

 7 The English Abroad 231

Part III ARTIFICE, AUTHORITY AND FIGURATION 281

 8 The Pleasures of Unruling 283

 9 The True Vine 307

 IO Contagion 339

Notes 365

Bibliography 391

Photograph Credits 434

Index 435

PREFACE

I think it was J. L. Austin who said that one has to be a special kind of fool to rush in where so many angels have trodden already. So immediately I must plead guilty: talents greater than mine have thoroughly traversed this field. But I feel that one more book might be acceptable, partly because books can best convey the ambition of a topic, partly because this text is (to an extent) a development of my own previous work published in book form.

I deliberately ended my study *Becket's Crown: Art and Imagination in Gothic England,* 1170–1300 (2004) with the possibility of a further analysis of the arts of the fourteenth century and what is generally known as the Decorated Style. In those pages I tried to make a practical, source-based case for thinking that appearances, however we may disagree about them, mattered then as now. Though almost all its subject matter was religious, that book was less about religion than about the possibility of a Gothic decorum: that ethics and aesthetics, virtue and beauty are both lived and teachable – an idea as familiar to ancient rhetoricians as to Hegelian *Bildung,* so to speak the rational education of desire. Form, stance, attitude, posture, look, expression – embodied form as a carrier of felt life – seemed to me one way of exploring Gothic art as a rhetorical art.

It is a fair, if not devastating, criticism of *Becket's Crown* that it placed greater stress on religion, ethics and ideas than on art and agency, human agency especially. So in the present study I have tended, I hope without undue perversity, to continue the discussion by reversing the order of priorities: here I enlarge the amount said about agency, art and aesthetics – the agency of people and things and the role of sensation and knowledge. My source-driven, inferential approach is concerned with trying to understand why aesthetic decisions were made in the light of beliefs about how and to what ends art creates experience. This approach to the close reading of the materials to hand has obliged me to steer a course between two very general and well-established outlooks, to both of which I am to an extent indebted. The first is the British school of empirical enquiry, which has without doubt done much to advance our practical understanding of medieval art. The second, put crudely, constitutes the various modes of ideological and moral interpretation. What I mean by these two designations will become clearer in the book. My point is that neither is entirely suited to the task attempted in the pages that follow. The empiricist school is inattentive, the schools of ideology and morality excessively attentive, to values. Neither has been especially interested in experience; and in both, the apprehension of outward appearances, the beauty of surfaces that makes things powerful, is dulled. Both tend, in consequence, to be non- or anti-aesthetic in

their interests. Each is useful (and at some stages fundamental); but neither gives a complete or satisfying account of the powers of things. I am sceptical about doctrinal certainties; reality is more complex.

Religion is, of course, an issue. This book's interest in great as well as small things, in the aesthetics of captivation and what is increasingly nowadays called 'wonder', is in part a measure of the weakness of my own capacity for religious faith. Perhaps all writers feel that what they study is extraordinary; yet it cannot be doubted that there is at present growing academic interest more generally in what Paul Fisher called the 'aesthetics of rare experiences', in the extraordinary, miraculous, charismatic and sublime. This book shares that interest. A keyword to be borne in mind, however, is 'rare'. In thinking about the sphere of the aesthetic as the sphere of what T. E. Hulme, referring to Romanticism, once called 'spilt religion', it is as well to be reminded that art and experience cannot be governed constantly by astonished or astonishing psychological states, any more than we can be daily driven by lust or rage: our capacity for humour and irony stands guard against such inner tyranny. This ordinary insight is itself an instance of complexity: that which is magnificent or splendid seems separable from that which is minificent, absorbing, alluring or funny, but nevertheless stands in a *relation* to it. Crucial to this, I shall argue, is the factor of *rationality* that separates most productive aesthetic activity and experience from states of rapture or transcendence, 'sublimation' of the self into something beyond feeling and reason. Most aesthetic engagement has an ordinary or everyday, firmly non-transcendental and sense-based, character; and for this reason I stress the rational artifice of the Decorated Style, not its basis in post-medieval notions of fantasy. 'Wondering' has exactly this rational basis: it is the start of the pursuit of knowledge, and so 'wonder' and 'artifice' form part of my title.

One of my concerns is that form of persuasion called 'soft' power, the power of allurement, not coercion. Positioning this sort of thing historically is tricky. Yet I find a certain delight, liberation even, in seeing that, while the reader and I can sometimes agree about the objective features of artworks, we will not agree all the time about their outcome. For all the talk about the agency of people and works of art, we forget the fugitive agency of situations. We have virtually no evidence for response, elite or non-elite. Again, social outcomes matter, and in these pages I discuss money, motivation and the aims of patronage. But an objection to the schools of ideology and morality is that they corral sensibility by trapping responses in the zone of that

which is deemed to be morally unanswerable. This is now so habitual to much academic practice that it seems almost heretical (i.e., 'irresponsible') to question it. But question it we must: in thinking about the marginal, for instance, I explore the consequences of over-seriousness with such doubts in mind.

The powers of art derive especially from the way things are wrought. The issue of the artisanal, of crafting that which may be soft or sublime, is important to what follows, as the title of this work indicates. This is not the product of some sort of anti-intellectual nervous tick. The idea that the artisanal is not simply 'handy' or mechanical, but also has an intellectual or liberal aspect, has been recovered in recent years from within the study of rhetoric in a way that has begun significantly to re-orientate and re-energize the study of medieval aesthetics. It has allowed us to think anew about technique, about exquisite calculation of effect, and about the training, experience and mastery needed to transform materials in order to produce outcomes apparent to the senses. In thinking about it we inevitably encounter virtues, such as patience or practical wisdom. It has cast doubt on the intellectualized, abstracted aesthetics of mid-twentieth-century medieval art history, which, I think, were the products of one sort of modernism (I am a modernist, but a sceptical one, as the following pages show). It throws into doubt familiar but unhelpful dualities – hand and mind, idea and action, rational and irrational, serious and playful. It emphasizes instead the pleasurable and fruitful difficulty in overcoming the resistance inherent in materials, and favours artful complexity, ambiguity, tension, irresolution, the ludic. It is not hard to see why the artisanal has been so long set aside. We have become suspicious of mastery. The tendency, social and intellectual, to downplay craft has been apparent in academic thinking since the thirteenth century, when the agency of artists as mindful authors was separated from the merely handy by the remorseless dissective power of the Aristotelian logic of causes. It survives today in the senseless and thoroughly self-interested professional *agon* between the academic and the vocational. It is a matter for our times.

I want to say something briefly about some of my imagined interlocutors and those to whom I owe some debts. We all have them, those minds, ears and voices, presences loved or unloved, squatting on our left or right shoulder egging us on, holding us back, scoffing, admiring us as we effortlessly answer questions we ourselves have posed, reminding us, as Oscar Wilde quipped, of our own immortality. The present book is not a conventional history of

style, and it does not engage in any debate about the value of the term 'Decorated', which is nineteenth century in origin: no term is perfect and in the present context debate about taxonomy would not be rewarding. So 'Decorated' our subject remains, *faut de mieux*. The work of Jean Bony, whose study *The English Decorated Style: Gothic Architecture Transformed,* 1250–1350 appeared in 1979, is my starting point. I did not know Bony, my one contact with him being a five-minute telephone conversation in which he enquired about the activities of one of my abler students. But I encountered the intellectual tradition to which he belonged in my days teaching at Yale, where the figure of Henri Focillon, Bony's mentor, was still mentioned with reverence. Focillon had taught at Yale and had encouraged the tremendous expansiveness of outlook on medieval art for which that university has become so celebrated. Some of the things I disagree with in Bony's writing have their origin in Focillon and his other followers, for instance, faith in the autonomy of style, and a form of orientalism. Bony's particular and intellectually 'French' form of rationalism I both assent to and dissent from: assent to, because it provides a superb and I think historically valid account of many aspects of French architecture in particular; dissent from, because it denies, or tends to deny, rationalism to English art and underestimates the ludic aspects of the French Rayonnant tradition to which Decorated architecture, in Bony's model, is seen as a reaction. Bony is too given to dualities. The points mightily in Bony's favour, however, are that he looks hard, writes clearly, teaches us to see, and is possessed of an ability to understand how art forms interrelate in a way consistent with medieval aesthetic practice, if less congenial to Renaissance hierarchism and Modernist absolutism. This book is as much a celebration as a critique of Bony, but it pays Bony the compliment of taking his ideas and wisdom seriously by interrogating them vigorously. The same might be said of the other pres-ence, that of Michael Camille. Michael I knew very well as a fellow student and sparring partner at Cambridge in the late 1970s and early 1980s. With him I shared many memorably ludic moments. I think it important to say here that little that is said in this book (Chapter Eight especially) was not said to him directly by me in one form or another while he was alive. It is a matter of sorrow that he is not here to argue back, but argue he would have done, and very interestingly.

In writing this book I must acknowledge the tremendous support of the Leverhulme Trust in awarding me a Major Research Fellowship in the years 2011–14, and Cambridge University and Caius College for granting me leave for that period. With the support of the Paul Mellon Centre in London, Yale University Press and Gillian Malpass and Emily Lees have allowed me to write the book I thought necessary to write and illustrate. Some of the material in it, especially in Chapters One, Two, Four, Eight and Nine was rehearsed in different form in the Slade Lectures that I gave at Oxford University in 2007. I wish to acknowledge those who helped specifically with the preparation of the present book, none of whom is responsible for its faults. I owe a particular and obvious debt to Mary Carruthers for informing and reading the entire text and keeping me on my toes, as she does, with characteristic insight, vigour and warmth. I am also obliged to Gabriel Byng, Tom Nickson and Noel Sugimura for reading parts or all of the text. Philip Dixon I thank for his generous help with Ely and providing artwork, and also John Maddison. John Crook assisted liberally with photography, as did Øystein Ekroll. Others who have offered artwork or academic help include Andrew Budge, Paul Crossley, Painton Cowen, Jennifer Fellows, Julian Gardner, Emily Guerry, Hugh Harrison, James Hillson, Stephen Jaeger, Justin Kroesen, Karin Kyburz, Richard Lithgow, Julian Luxford, Stephen Murray, Michalis Olympios and Conrad Rudolph.

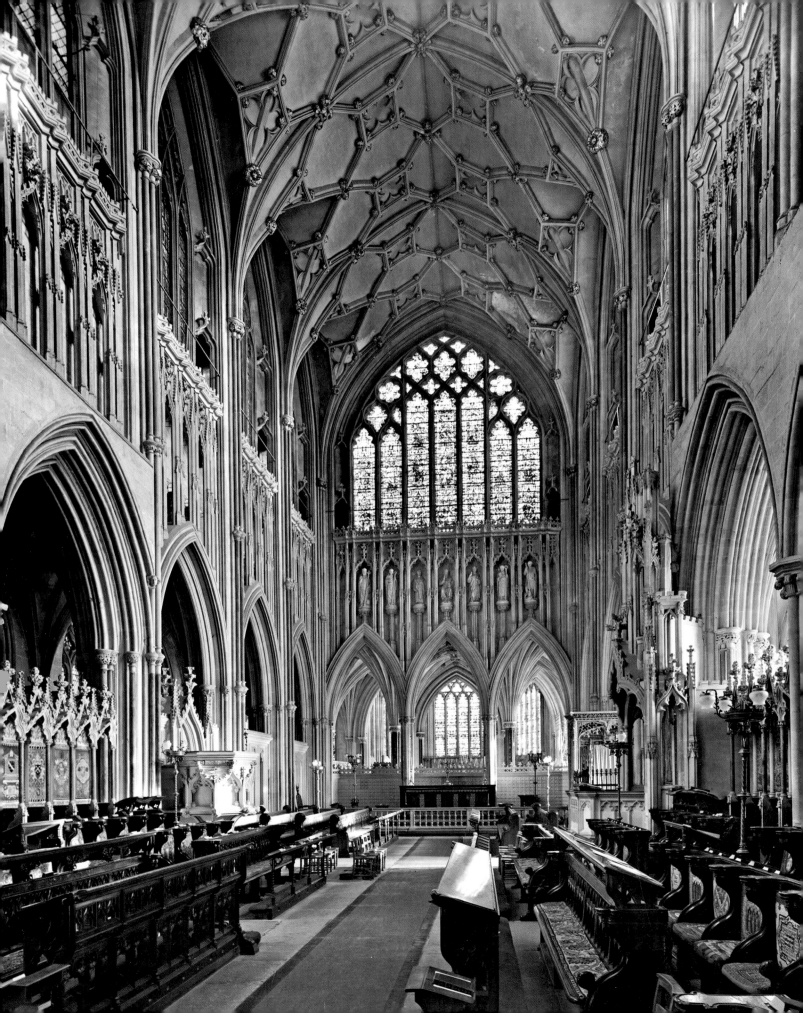

INTRODUCTION

...the architecture of England between 1250 and 1350 was, although the English do not know it,
the most forward, the most important, and the most inspired in Europe

Nikolaus Pevsner, *An Outline of European Architecture* (1943)

Fear of Fame

My subject – or a major part of it, since this is a book about the visual arts as a whole – celebrates an unusual episode in the history of British culture. In it, according to some commentators, English architecture shaped the destiny of continental European Late Gothic. The episode in question lasted no more than a half century or so, from some point in the later thirteenth century to around the time of the Black Death in 1348–9 – the period covered by the present book. Its focus was what has become known as the Decorated Style. Generally, the narrative of English art is one of receptivity to Europe as the source of all great things: so, naturally, the European importance of the Decorated Style is disputed. The power to influence is not the sole criterion of the importance of an artistic achievement, though it is a significant one. Indeed, when first pinned to a board as part of a scientific taxonomy of the English Gothic style by Thomas Rickman, in 1817, as the 'Decorated English', the possibility of its European-wide impact was not remotely contemplated. 'Decorated English' was simply the 'the perfection of the English mode' of Gothic.[1] The fate of the style in the hands of interpreters in the nineteenth century was variable: the sheer complexity of its

architectural and decorative components, already acknowledged by Rickman, made it vulnerable to the moral charge of sophistication, as were the freer elements of English 'marginal' art. Yet as an idiom actually revived by nineteenth-century church architects, the Decorated Style in fact flourished to an extent greater than its strait-laced younger sister, Perpendicular. Then, in the twentieth century, a remarkable bifurcation took place: the interpretation and rehabilitation of English Perpendicular became the task of English romantic nationalism, while the Decorated Style became a subject of international interest to professional practitioners of the new science of art history, and it was as a result of the latter that the accomplishments of the style became more generally known.[2]

This is neither the time nor the place for a full account of the moral and intellectual trajectory of modern responses to this important period of English art. *Kunstgeschichte*, as practised by the émigré Nikolaus Pevsner (1902–1983), was the first to celebrate fully this idiom because German art-historical tradition saw something in the Decorated Style in which it recognized itself. A complex game was afoot in which Pevsner, a German-trained art historian, journalist and broadcaster pronouncing on English mores and temperament, simultaneously offered back to the English 'their

most self-approving myths' while seeing in English formal invention something precocious to a degree matched only, if at all, by France: the Decorated Style shaped not just English, but also continental European, late medieval Gothic.[3] No other period of English art (with the possible exception of the nineteenth century) has been swept along by the enthusiasms of Internationalism in this way, and the case remains strong if not conclusive. Timing was all: Internationalism as a more general outlook was boosted by two World Wars that moved people around and so opened out the horizons of scholars, whether they liked it or not; and it was accompanied by a powerful set of intellectual formulations that connected art, society, morality and national temperament to the development of art style. For Pevsner, the Decorated Style was a formal manifestation of the English national tendency to irrationalism, or at least anti-rationalism; sceptical and empirical, the style stood against the dominant current of French 'rationality': the system – and 'system' is not too strong a word – of Rayonnant Gothic developed in Paris under Louis IX (1226–70). The Decorated Style, unlike the highest manifestations of architecture in France, was precisely not a system, because systems were disallowed to the English by their nature. Yet, as elsewhere in Pevsner's work, the English acted as forerunners, as prophets, of something more fully realized on the European stage more widely. In his influential *Pioneers of Modern Design*, Pevsner had traced to English social and moral reformers such as John Ruskin and William Morris the roots of a socially responsible craft-based modernism brought to fruition by the Bauhaus: 'Morris laid the foundation of the modern style; with Gropius its character was ultimately determined.'[4] In this formulation can already be seen the basic model of Pevsner's collectivist conception of Britain's medieval role in Europe: free, liberal, sceptical, innovative, inclined to irrationality – but never conclusive. It was to be repeated in his studies of the Decorated Style.

The other great interpreter of the Decorated Style in print, Pevsner's near-contemporary, the French architectural historian Jean Bony (1908–1995), belonged to this same war-riven generation, as his language of 'resistance' in the movement of the Gothic style internationally suggests.[5] Bony too used the polarity of English empiricism and French rationalism to explain the inner formal working of the Decorated Style, and thought too in terms of the 'freer' context of English artistic practice, unlike deadening French systematization. He saw in the Decorated Style a renewal of what he called the Gothic 'movement' (a word to be noted) – Gothic itself being the work of an 'avant garde'

inspired by a spirit of modernity, creating a 'new world of forms'.[6] Movements usually have leaders, so it was legitimate for Bony to think that in the late thirteenth century 'leadership' of the Gothic movement might be transferred from France to England. Indeed, both he and Pevsner established the Decorated Style as a modernist, progressive phenomenon, looking forward, not back, and that characterization has stuck. Along with Erwin Panofsky (1892–1968), both pointed to the idea of the triumph of the 'margins' in the European fourteenth century at the expense of the notional 'centre', France itself.[7] The Decorated Style was connected to a loss of classical equilibrium in a previously French-led Gothic culture. Bony, like Pevsner, was a formalist, and it would be hard to say which of the two was the most persuasive in the study of medieval English architecture. Both were shaped directly or indirectly by the German formalist tradition and tendency to cultural and temperamental generalization; in contrast, the British empirical strain of nationalist history was essentially biographical.[8] It is striking that until the 1990s the main book-length published studies with full scholarly apparatus devoted to the Decorated Style were produced by German or French scholars, including Pevsner's follower Henning Bock, whose intervention in the field has been underrated in Britain because it was published in German.[9] It might seem quixotic to take issue with what now look like 'period pieces' locked within a modernist mindset: but the influence of these works has been considerable, and the intellectual baton must be grasped from someone.

The notion that foreigners were better able to appreciate artistic virtues than the English was not a construct of modernity. Its roots were medieval. The origins of English diffidence lie in the very period in which the Decorated Style itself appeared, if not earlier. It is too easy to imagine that, because knowledge was not as extensively or as thoroughly textualized in the Middle Ages as it is now, one cannot speak with any confidence about fourteenth-century attitudes. In regard to their visual culture, articulate English commentators of the fourteenth century lived in a difficult time. Some laboured under the conviction that greatness in matters cultural, and especially literary, lay elsewhere, that is to say in continental Europe. Geoffrey Chaucer (*circa* 1343–1400), whose literary understanding of himself and the English was undoubtedly haunted by the sense of a huge heritage of letters either bygone or somewhere else, as it were the 'dwarf-giant' complex, is a case in point. Chaucer and his contemporaries matter here because they commented poetically, and in highly revealing

ways, on architecture; men of letters who were also connected to the visual arts were rare – Chaucer served briefly as a Clerk of the King's Works. In his sophisticated text on literary greatness, *The House of Fame*, of the 1370s, Chaucer summons up a hall of mighty pillars sustaining men of fame, the cultural heroes of antiquity (for a discussion, see p. 345).[10] In comparison to these eminences we are, as it were, dwarfish. His concept of great Latin and vernacular literature, of an actual canon, was dominated by ancient, Italian and French writing – not least Virgil, Ovid, Homer, Lucan, Statius, Petrarch, Boccaccio, Dante, Guillaume de Lorris and Machaut, some of whom stand aloft like idols in *The House of Fame*. According to Eustache Deschamps, Chaucer was above all the 'grant translateur' of the work of other Europeans.[11] Given this trepidation in the face of the greatness of European letters, it might be asking too much of the English to have valued their own visual culture at the moment of its greatest fertility and apparent influence.

But in addition to this latent or actual sense of inferiority, of the 'rude speche' of the English, there were, in addition, more insidious long-term issues that shaped the prevailing mode in which anyone approached architecture with serious literary intent before 1400.[12] The first of these was the durable Christian pastoral mode, which carried with it a form of default puritanism. The legacy in England of Bernard of Clairvaux's and later mendicant moral indignation about pride, superfluity and excess – and, of course, aesthetic pleasure – in art or architecture was already uncongenial to the expression of actual pride in artistic attainment. When the authors of fourteenth-century texts such as *Pierce the Ploughman's Crede* pounced upon *curiositas, error* and *superfluitas* in their architectural reveries (see pp. 348–51), the lofty gold of St Bernard's early twelfth-century rhetoric was transformed into the base and earthy disdain of vernacular estates satire.[13] Then, as earlier, much of the most powerful writing about art or architecture was not about idolatry, but about hypocrisy, money and Pride.

The second issue was the way that wider historical developments constricted the occasions for the praise of great patronage. Before the thirteenth century, writers in England were just as capable as their Continental neighbours of the high mode of praise, of *laudatio*: the heroic mode was sustained by conquest and by the literature of great patronage and sanctity, by the acts of great men. The literary form of praise or encomium, the 'auxetic' mode of the superlative and magnifying manner of epideictic rhetoric, was Graeco-Latin in origin, in Homer, Pindar, Horace; and its subject was human greatness.[14] Buildings in the Romanesque and Gothic styles were unashamedly regarded by contemporaries as products of ethical and spiritual magnanimity. Yet, unless it is to be 'empty', rhetoric of this sort requires a context in which it can operate and take effect. By the fourteenth century most of the practical occasions for praise of men and buildings had apparently passed. The great age of literature about conquest, charismatic saints and relics, which had occasioned some of the greatest emotions about buildings as well as people, was dead.[15] I do not think it is a coincidence that the greatest account of an English Gothic church in the twelfth and thirteenth centuries (see pl. 14) remains the Metrical Life of St Hugh of Lincoln, composed in epic dactyls in connection with that saint's canonization around 1220: this opens by citing the *Aeneid* – 'Arma virumque cano' – in heroic aristocratic-episcopal mode.[16] Chaucer's *The House of Fame* (ll. 143–8) also cites the same phrase but to very different literary purpose, since Chaucer's theme is the instability of fame, not the solid metaphysical glory of a cathedral shrine. Throughout the fourteenth century there undoubtedly remained a tradition of 'spiritual' and allegorical writing about architecture, though it lacked the specificity and bite of the satirists and was not directed to anything beyond literary and spiritual figuration.[17] But the English tradition of monastic historiography and instruction, which had produced texts such as Gervase of Canterbury's writings on Canterbury and the *Gesta abbatum* of St Albans, was dwindling significantly by the fourteenth century, nigh to the point of antiquarianism.[18] Later medieval remarks on actual buildings are fragmentary, and of nugatory interest. Indeed, the fourteenth and fifteenth centuries produced not a single account of an actual building in the Decorated Style that might point up its importance or give any useful information about it – with the possible exception of a document I shall call the 'Walsingham memorandum' concerning the octagon at Ely (p. 224), which is at heart an appreciation less of a building than of ingenious human action. The occasions had simply disappeared.

The third issue was the growing importance of satire in English letters. English clerical culture of the twelfth century already had within it a strong streak of educated satire, typically directed at the excesses of public power.[19] Alongside it, indeed with it, flourished the grand allegorical mode, the *lectio*, of theologians and moralists, as well as the epic treatment of the saints, the charismatically great of the day: these were two sides of the same coin. John Burrow has demonstrated the popularity of the poetry of praise in English vernacular literature.[20] In it, *laudatio* and *vituperatio*, or that

subtle mix of praise and blame *laudis simulatione detrahere*, was reserved not so much for things as for people, or ideals: of this Chaucer is our witness, despite some modern 'ironic' commentaries.[21] *Laus* and *vituperatio*, or 'Clere Laude' and 'Sklaunder', are the two trumpets of Aeolus, god of the winds, in *The House of Fame*.[22] Chaucer was quite capable of 'Clere Laude' or open generous praise. Yet literary interests – if I may be forgiven a generalization – were more preoccupied with the decay of society in the wake of crisis than some idealized noble high style.[23] Institutions were thought to be waning not waxing, and it was the purpose of any edificatory text to address this decline. It is striking, and bad luck for English architecture, that some of the nation's most well-known and influential medieval literature, Chaucer's *The House of Fame* and *Pierce the Ploughman's Crede*, featured uniquely long, vivid and articulate accounts of architecture as a symptom of ambivalence or actual moral depravity. At the very moment when an English art of stupendous elaboration and inventive prowess appeared, the circumambient English literary discourse of 'decay within' was positioned perfectly to understand it unfavourably. To understand why only Europeans could see the wider value of the Decorated Style is to ask first why the English themselves provided better ways for disliking than liking it.

The English moralizing tradition has had a significant impact on modern understanding too. This introduction began with the Victorians and the International Modernists because the origins of the attitudes of the people that rehabilitated the Decorated Style possess a clear affinity with the English tradition of moralizing, of satire and social 'realism': morality and architecture, so to speak, did not start with Pugin or Ruskin, or Morris or indeed Pevsner, himself in many ways a moralist, but with the medieval stoics, the clerks and the satirists.[24] This was a sustained, eloquent and hostile tradition. I will maintain eventually that this very same tradition has continued to colour interpretation of the visual arts in the English Gothic period to the present day, because it was secreted deep within the 'scientific' neutrality of the formalist practices of art history, and I think colours even postmodern moralism.

To sharpen this perception, and to see also that this was not simply a generalized medieval failure but a specific cultural trait, it will help to place the English tradition of *vituperatio* and moral deflation in the context of the two undoubted sources of universal cultural influence in the western European sphere, France and Italy: France because of the impact of its architecture, Italy for its painting, and both, as Chaucer recognized, because of their literature. Not

that French vernacular culture was free of irony, a potent force in the century of the *Roman de Fauvel* and the *ballades* of Deschamps. Yet consider two eminent Europeans writing during the height of the Decorated Style, Jean de Jandun and Petrarch. The scholastic Jean de Jandun is chosen here for his sublime optimism, his sense of present triumph and of French cultural hegemony. Jean is celebrated for his Latin *éloges* of Paris, a city laudation of a type originally developed for Rome or Milan, completed in November 1323. This well-known text provides a panorama of Paris, a new paradise, starting with its principal trade, its university, and moving on immediately to its great Gothic buildings, on which it says an exceptional amount for a medieval text: Notre-Dame and the Sainte-Chapelle (see pls 18, 24), upon the *magnificentia* and *varietas* of which he expatiates fully.[25] Jandun's encomium of these buildings is certainly the greatest of its type, and it ends at the Sainte-Chapelle with a flight upwards from the aesthetic complexity of its art, toward heaven, in a kind of revelatory mode.[26] But this flight into rapture goes with a social appreciation of intellect. Jean's connection of the intellectual trades of theology, law and medicine – the classroom struggle of minds – to the activity of building Gothic is notable.[27] In fact, it is an aspect of French intellectual pride. Jean's most striking claim is not about architecture but about the position of the French as 'world thinkers', a position he derived from Aristotle's *Politics* (VII.7). The *douceur* or temperateness of the French climate was the ideal context for the unfolding of the mind; the French had become the new Greeks – as Alexander Murray said, 'Greek self-confidence was at home in Paris'.[28] So the monarchy of France is owed universal acclamation.

Jandun's argument is about the connection of intellectual, political and cultural hegemony. The city and specifically its great buildings become a sign of what it is to govern well in the public domain. 'Where else?', *ubi queso*, Jandun asks in an anaphoric rhetorical flourish, would one find such fine details as those of Notre-Dame.[29] The answer (though Jandun may not have known it) was almost everywhere in northern Europe, since the Parisian style of its transepts and chapels attained a general currency unlike any other style, its rose windows being copied in London (Westminster Abbey, Old St Paul's, see pls 22, 44) and Uppsala. The year 1323 was a good one for the appreciation of Paris. In that year two Irish Franciscan friars making their way to the Holy Land stopped en route, admiring Paris, which, like London, was 'wonderfully furnished with lofty steeples and belltowers and other beauties of church architecture', a city

that was the 'home and nurse' of theological science, the mother of the liberal arts, with its great river, the church of Notre-Dame with its mighty sculpted west façade, and the famous chapel adorned with stories from the Bible in which was kept the Crown of Thorns – the Sainte-Chapelle.[30] London (see pl. 8) had once been the topic of such a laudation, by William fitz Stephen (*fl.* 1162–74), touching on its trades, its low life (p. 21). But now the palm was held by Paris. The English never developed the sense of architecture as an expression of a political consciousness as did the Aristotelian-minded French intelligentsia.

Jandun's vigorous chauvinism, untouched by satire and untroubled by doubt, may be said to have set the tone for French architectural 'nationalism' in the late Middle Ages, even when voiced by a pro-French Italian such as the poet Antonio Astesano (d. 1463). Astesano's *Heroic Epistles* (III) of 1451 presented to Jean, count of Angoulême, a brother of Charles d'Orléans, include an encomium of Notre-Dame in Paris, unweathered by age, and of important French cathedral cities such as Orléans, Tours, Noyon, Senlis, Laon, Soissons and above all Amiens (see pl. 28), the cathedral of which is so grand, so beautiful, so lofty, so bright, that there is nothing greater in France (though some prefer Chartres).[31] Indeed, he goes on tellingly: 'Some, coming from Italy, have seen this city [of Amiens] and think likewise, and though the cathedral they are building in the midst of Milan may be perfect in all respects, they hesitate to say which might be the more beautiful of the two.' Astesano is identifying a canon of great Gothic buildings (do you prefer Amiens, Chartres or Milan?), which connoisseurs might ponder as if weighing up the respective merits of Giotto or Simone Martini. Less subtly, the mid-fifteenth-century *Débat des hérauts d'armes de France et d'Angleterre* contrasts violently the meanness of English universities, relics, castles and churches with their magnificent French counterparts: 'Do you have churches of such decoration and magnificence as Notre-Dame of Paris, Chartres, Rouen, Amiens, Reims, Bourges?'[32] That such canons existed as practical guides or yardsticks is proved by documents of 1455–6 concerning the construction of the west towers of Troyes Cathedral, in which the master mason Bleuet advises the authorities at Troyes that it would be well to visit several churches including Reims, Amiens and Notre-Dame to get ideas: this he did with his companions, and made drawings of their towers and portals.[33] Doubtless by the fifteenth century it was recognized that very few truly great churches had enjoyed the resources to complete promptly their sculpted west façades and towers, let alone their naves. But

the point, again, is that England never developed so established a canon, nor so self-assured a sense of its architectural prestige: to imagine encomia of Westminster Abbey or York Minster in these terms is unlikely, yet this fact tells us nothing at all about the actual qualities of the buildings in question or their influence upon other architects.

Petrarch got to the bottom of this *Gallia superbia*, this French pride, with characteristic astuteness, for he too thought in terms of hegemony, universality, though (as an honorary Roman) from the perspective of pessimism, the loss of Rome's greatness. His *Invective* against a detractor of Italy composed in 1373 presses on with an attack on French scholastics and the complacency and levity of the French belief in their own superiority.[34] But, Petrarch replies, the university of Paris had been made great by non-Frenchmen: by Peter Lombard, Aquinas, Giles of Rome. Its claims to Greek confidence were open to attack – 'our little Gaul loves Greek titles' – but Aristotle was not manifestly superior to the Romans Cicero, Seneca and so on, for while the French Greeks had precision and reason, the Romans had persuasive power.[35] Petrarch himself possessed great literary authority, though his conceptions were not exactly aesthetic. On more than one evening in 1337 this great champion of Rome clambered to the top of 'the vaulted roof of that once magnificent building', the mighty Baths of Diocletian, with his companion Giovanni Colonna, and, as the sun set and the warm haze of a Roman evening enveloped them, mused on the fate of Rome spread out below.[36] They were dwarfs sitting on the shoulders of a gigantic heritage: Petrarch's was a great idea, a concept, an imagining – of the greatness of a past – but also of the possibility of reclaiming Rome and the papacy.

There might be an excuse for thinking Jandun too optimistic, Petrarch too pessimistic, and each too grand by half. But the point is to place the *sublimitas* of the two greatest cultures of western Europe in contrasting relation to the English tradition of allegory and satire. For France and Italy, culture was an aspect of a wider hegemony, a set of claims relatively free of *vituperatio*, in a way alien to the literary classes of England. Though it would be a mistake to disregard the 'political' dimension of Edward I's castle-building in Wales, his Eleanor Crosses (see pls 101–2) and approach to town planning, Edward III's works at Windsor Castle or Richard II's re-fabrication of the Norman great hall at Westminster (see pl. 189) – here action spoke louder than words – the English in their commentaries seem never explicitly to have tied great cultural achievements to political claims, even in the midst of persistent war with France.

It is as if they had a different conception, or possibly little or no conception, of the public domain. Recall, for instance, the elegant way that Joinville, the biographer of St Louis, wrote about the king's 'beautiful' abbeys illuminating the landscape of France as if it were a manuscript, or the idea that the new cathedral at Narbonne begun in 1268 (see pl. 19) had imitated the 'noble and magnificently worked churches which are being erected in the kingdom of France'.[37] Nothing of the sort was ever said about Henry III or Edward I, each a substantial and influential patron of the arts. R. W. Southern pinpointed one aspect of the problem, again in the context of national attitude: 'In France the Crown became the chief symbol of French national sentiment. In England national sentiment developed in opposition to the policies of the Crown.'[38] Of the English kings of the period, Edward I was most openly the subject of *laudatio* in the so-called *Commendatio lamentabilis* probably written at Westminster in 1307, and was the only medieval English king to have had his life painted on the grand scale (at Lichfield and Westminster).[39] The French political tradition was far more highly organized in terms of history writing both in propaganda (the *Grandes chroniques*) and in action, as the extraordinary promotion of the Capetians under Philippe IV of France shows.[40] The disastrous reign of Edward II coincided with the height of the development of the Decorated Style; paradoxically, the relatively high degree of cultural centralization of England – higher, in fact, than in France – as witnessed, for instance, by the influence of the architectural workshops of the court in London, had relatively little impact on the political outcome of art. As war with France intensified in the 1330s, the court in fact opted for a sophisticated redaction of Parisian Rayonnant, which Rickman called Perpendicular (see pls 43, 306–7).

Of the two modes of prospective confidence and retrospective regret, the English, having a strongly institutionalized tradition of historical writing, had tended to the latter. The Anglo-Saxon tradition, as represented by the poem *The Ruin* – 'Wondrously ornate is the stone of this wall, shattered by fate' – shows that higher forms of poetry had been connected with transience.[41] The Petrarchan theme of Rome as *urbs fracta* and as signifier of both decay and greatness is already beautifully developed in Hildebert of Lavardin's *Par tibi, Roma* of the 1120s, a poem cited fully by William of Malmesbury in the *Gesta regum anglorum* and by the mysterious clerk Gregorius.[42] Rather than engage in lofty rhetoric, however, the English, or at least writers in England, preferred the mode of the travelling inventory. The itinerant cleric Giraldus Cambrensis, not English at all but

Welsh, stands at the head of a tradition represented later by William of Worcestre (d. *circa* 1482) and the humanist John Leland (d. 1552). Take the accumulated lumber in William of Worcestre's *Itineraries* compiled in the 1470s: his obsessive measurement of buildings by pacing them out belongs ultimately to a tradition of appreciating greatness by quantifying it, but here scale is never tied to poetic exaltation. Measurement becomes an end in itself, the husk of magnificence. In this sense, William is an 'antiquary' who shows that English or Anglo-Norman came into their own as the practical languages of masons when describing the rolls, fillets, chamfers, bowtells, casements and ogees (*resaunts*) of ornate Perpendicular church doors in Bristol.[43] It is hard to find any brighter flash of aesthetic interest. Of the traceried windows at Tintern Abbey he remarks that they have the same *proporcio* (by which he seems to mean arrangement), but not scale, as those of Westminster Abbey; he admires the most beautiful vault of Exeter Cathedral (see pl. 11); he thinks of the cavern (*aula*) at Wookey Hole as being as large as Westminster Hall (*largus sicut Westminsterh-alle*) (see pl. 189), as if this were a figure of speech.[44] It would have been more interesting if he had likened Westminster Hall to Wookey Hole, though to find one of the greatest works of medieval English carpentry associated with a wonderful natural phenomenon seems appropriate to modern ears. Yet for Worcestre there is no greatness beyond measure, for everything has its compass. What impresses about the later version of this 'antiquarian' wandering tradition is its general lack of aesthetic and rhetorical content. It is not driven by some grand idea or sensibility.

John Leland is perhaps an exception. On the whole Leland did not allow himself the leisure, or the pleasure, of rhetorical amplification, though he was capable of it. His purposes were not 'aesthetic'. Yet, in contrast, he did allow at least a flash of Petrarchan sentiment of loss, of mourning a deplorable present, of nostalgia. In his account of Benedict Biscop in *De viris illustribus*, Leland wrote of the ruins of Jarrow-Monkwearmouth: 'now vast ruins stand as clear indications of the once mighty buildings, and I have lately contemplated these, not without awe, greatly regretting the vicissitudes of such human endeavours'.[45] In his *Itineraries*, Leland often passes judgement on Gothic buildings great and small, using words such as 'fine', 'fair', 'uniform'. Thus St Mary in Nottingham 'is excellent [newe] and uniforme yn work, an so [many] fair wyndowes yn it that [no] artificer can imagine to set mo[re] there'; Beverley Minster is also 'of a fair uniforme making'.[46] Perhaps Leland's setting at a premium the virtue of uniformity embodied the value

system of Perpendicular architecture. His language of 'fair uniformity' implies values very different from Chaucerian quaintness, curiosity and reverie. Leland's tone is generally clerical, inventorial and brisk, noting the general size of a building, the number of its windows, whether or not it employed marble and so on. Some great buildings such as Wells Cathedral are missed altogether (libraries apart), though there are matter-of-fact accounts of such thirteenth-century masterpieces as Salisbury and Lincoln as great enmarbled churches.[47] In fairness, however, his panegyric of the abbey of Bury St Edmunds belongs to the tradition of city laudation noted earlier.[48] What really galvanized this sense of loss were the Reformation and the Dissolution of the Monasteries. As Margaret Aston observed, 'The very process of casting off the past generated nostalgia for its loss.'[49]

These texts are not, of course, high literature, but compilations in readiness for something else. But they are all there is to go on. In them there is scarce mention of any of the striking cultural achievements of the English fourteenth century, despite the fact that Worcestre's travels took him *inter alia* to Norwich, Wells and Bristol, great centres of the Decorated Style. Worcestre and Leland were more often struck by the contemporary decencies of buildings of their own time. Buildings in what would now be called the Decorated Style, in short, made no impact on the longer-term literary landscape, and it is up to us to see if this indicates some deeper workings of sensibility.

The Diminutive Middle Ages and the Place of the Aesthetic

The obstacles to understanding the rise and fall of the language of magnification in the period from the Conquest in 1066 to the end of the fourteenth century also lie in part in the general direction of modern academic culture. Praise, great sentiments, the heroic mode, have for a generation or more all been looked down on from the vantage point of a *mésalliance* between two very dissimilar forces. The first has been the rise, principally within literary studies and then art history, of countercultural criticism given to the ironic, moralistic and demystificatory modes, preoccupied with what Paul Ricoeur called the 'hermeneutics of suspicion'. This mode of criticism has rendered the auxetic mode (of praise) ideologically unfashionable.[50] The second, from the opposing camp as it were, has been the persistence of a form of empiricist thought that has never grown out of the suspicion of rhetoric with which architectural history

as a discipline was first cursed by Victorian positivists. To such, the language of *laudatio* is either ideologically repellent or just language, mere words: ideas are just 'flapdoodle', in comparison with which architecture is somehow 'real'.[51] The great and the lesser can be separated at will. Neither school is much inclined to take things, surfaces, effects, at face value: this, to my mind, is both a human and a philosophical mistake. It also runs quite against the idea, preponderant in this book, that aesthetic attention and experience are fundamental to the function and effect of artworks. The British empiricist school, admirable as it is in so many ways, is suspicious of the affective: but in being so, it misses the point of much of the art that it claims to understand. In separating the analysis of style from the way style actually works, it too is open to the charge that it shows insufficient interest in what aesthetic power is.

One other consequence of this complex and unhealthy syndrome, which it is partly the aim of this book to identify and interrogate, has been brilliantly characterized by C. Stephen Jaeger:

> An overarching conception of medieval culture has fallen into place since the late 19th century, which I will call the diminutive Middle Ages. DMA [the diminutive Middle Ages] is the . . . scholarly consensus of a generation of titanic post-Romantic and anti-Romantic medieval scholars in which the Middle Ages is a period of small, quaint things and people, of miniatures, humble, little, overshadowed by its big neighbours, antiquity and the Renaissance . . . The emotional life of medieval people is grotesquely reduced by the DMA, now humble, now strident . . . their feelings those of children or dwarves, their anger that of Rumplestiltskin, not Achilles.[52]

My role in the present study is not, in fact, to foist a compulsory grand manner on all readings of English Gothic invention, of the Decorated Style: that was the task of those who newly envisaged the sublime vastness of England's medieval buildings in the seventeenth century, such as Hollar's image of an apparently interminable Old St Paul's (see pl. 1). But it is to focus much greater attention than has been usual recently on magnificence, minificence and mixture – on those special, complex and remarkable effects that belong within the domain of the aesthetic, and which could (but did not necessarily) produce corresponding experiences. By looking at art and language as primary documents, I want to argue that when people praised people or things they often meant it, even if they were capable of ironic reflection; that modern ideological mor-

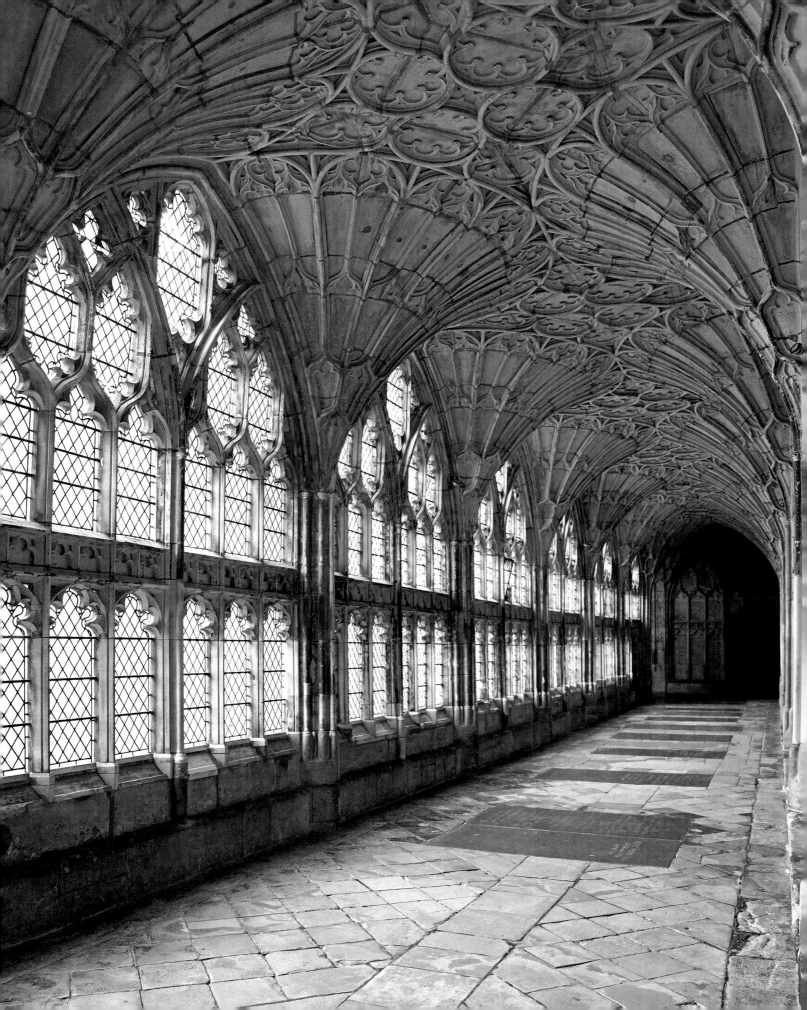

alization and emphasis on 'low' style may seriously obscure important truths about the medieval aesthetic domain (for instance, the interdependence of high and low style); and that much is to be gained by looking for aesthetic activity whose ends were (loosely speaking) the alluring, heroic and beautiful – the sublime, the painful, the abject have all been privileged critically since the 1980s in a way detrimental to the understanding of beauty as a crafted thing of artifice.[53] In all this, praise and blame, great and small, were not separable, but were mixed, endlessly in tension, a tension that energized the processes of creation and understanding of artworks. To understand this issue of mixture, of productive impurity, of dialectical ambiguity, is to understand much that is essential to the practical criticism of the art of this period: to see, for instance, why conventional architectural history has tended to proscribe connections between small and great things that are actually fundamental to a full aesthetic understanding of those things deemed 'great' by those who believe in the purity (and unfortunately also a hierarchy) of the media. Simply imagining a 'great' or a 'small' Middle Ages is to miss the point: the powers of art lay at both levels.

To understand this is also to articulate a critique, too long postponed, of stances towards the Middle Ages that may have closed off much that is interesting, even fundamental, in the visual arts. My argument is aimed at forms of automatic thinking that to my mind have (often inadvertently) narrowed the interpretative options, rather than enriching them. The domain of the aesthetic, as described by ancient and medieval thinkers as sense-based knowledge, is what fleshes out – renders human and apparent to our experience – that which is sensed and that which is known: that which mediates between appearance and concept.[54] In this dialectic lies pleasure: the pleasure that is grasped through the senses and through the imaginative regard towards that which is apparent to the senses. This pleasure, being affectively engaged with the world, disinterested but not dispassionate, is more than a simple gratification: it is the response of passion that drives the beholder towards understanding or intelligibility, as well as towards sympathy.[55] Because this sympathy or benevolence is subject to aesthetic persuasion, virtue, charity and the aesthetic are at least sometimes con-

nected, even if they are not necessarily so. The aesthetic regime of the Decorated Style was not totally disconnected from the function of artworks serving the Christian sacraments and the doctrine of suffrages: the beauty of the style had persuasive power, the power, as Elaine Scarry puts it, to 'bring things into relation', even if (to my mind) it did not possess truth.[56] The point to get across is that, whatever our view about beauty and truth, moral and functionalist arguments themselves come at a price. For this reason I also subject the lately fashionable ideological critique of the marginal, crucial territory in this debate, to vigorous questioning: ideology has tried to persuade us to suppress pleasure, humour and the domain of the affective as forms of betrayal of ideological principle. I argue instead that to remove the substantive issue of sense-based knowledge and hence pleasure in all its perversities from the equation is to fail to see how ideology works at all.

It will be obvious, then, that the purposes of this book move quickly beyond any anxieties as to the appropriateness of the names for styles. Its practical critique begins elsewhere, with what was deemed important, valuable and powerful, both in architecture and in other media. In the chapters that follow, it will be seen that English Gothic art formed part of a larger but changing regime of thinking and practice subject to circumstances, but not determined entirely by them: context is not all, though neither can it be set aside. The magnifying mode was, after all, appropriate to great things only if they could actually be afforded. In the long run the economic environment mattered. That such a mode had once existed in England cannot be doubted. It will be given full attention here for the simple reason that patrons, architects and artists in the thirteenth and fourteenth centuries had to live with its extraordinary, provocative and perhaps burdensome legacy, not least when they turned their attention to that which was smaller but beautifully formed. The heroic mode was eventually recast as a mode of protean complexity and inventive resource, the impact of which was felt as far away as the Mediterranean where so many art myths about greatness had themselves begun. The narrative of how this happened does not begin in 1174 or 1245, but in 1066 – and it is then, and perhaps even earlier, that this work must begin too.

Gloucester Cathedral (formerly Abbey), cloister (detail of pl. 307)

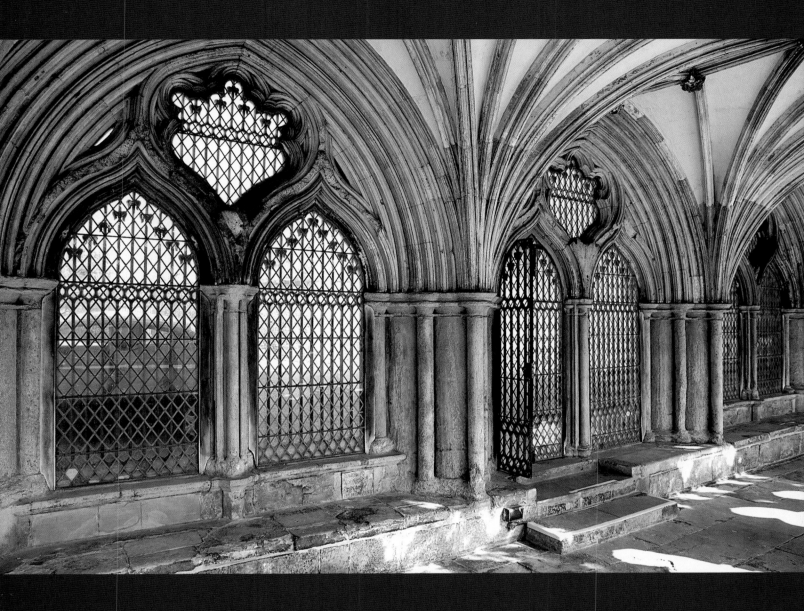

PART I

MODE, INVENTION AND MEANS

Norwich Cathedral, cloister east walk (detail of pl. 67)

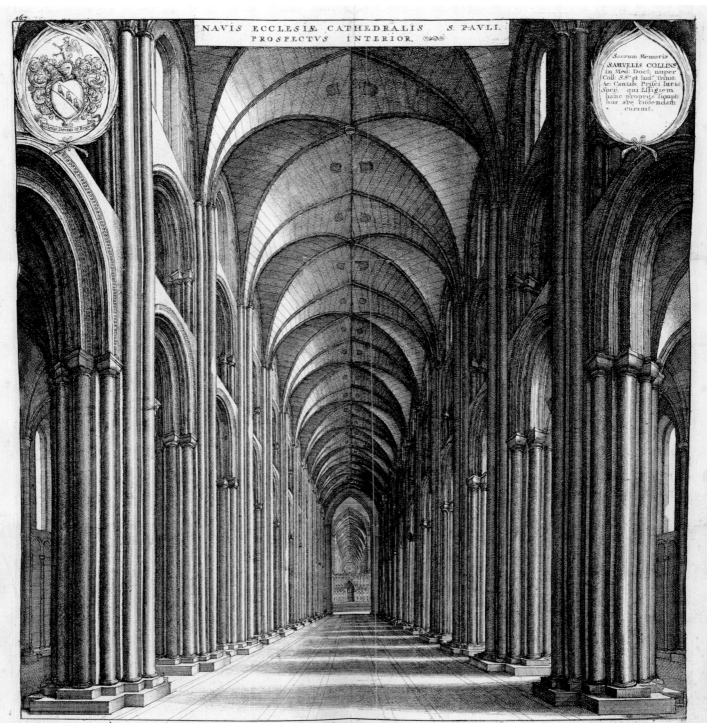

1 London, St Paul's Cathedral, the interior in its vast entirety, by Wenceslaus Hollar, 1658

I

THE HEROIC HORIZONS
OF PRE-DECORATED ART

Emulation is superiority contested; imitation is inferiority confessed

Edward Young, *Conjectures on Original Composition* (1759)

Magnitude

In 1314 the Gothic 'new work' of St Paul's Cathedral in London, a huge twelve-bay eastern limb begun in 1258 and extending the choir of the old church by about one-third, was consecrated.[1] The cathedral (pl. 1) was then measured and the results inscribed on a board.[2] Its total length was found to be 690 feet and its breadth 130 feet; the height of the western nave vault was 102 feet, and of the new choir, 88 feet; the tower and spire exceeded 500 feet in height. There was a more general connection between consecration and measurement. Following the example of the measuring of the Temple in Revelation 11 (see pl. 128), the renewed cathedral was to be compassed. As in the rite of the consecration of churches, this was a place of awe – *terribilis est locus iste*, 'Awesome is this place', to cite the solemn response in the ancient and dignified rite for the dedication of churches. This giant church surpassed all around it, dominating the London skyline: *fundata est domus Domini supra verticem montium et exaltata est super omnes colles* – the Lord's house is founded upon lofty mountains and is exalted above the hills, as a response in the consecration rite says, follow-

ing the prophet Micah 4:1. The connection of measurement and sublimity was perpetuated liturgically; it was a symbolic reflex, a way of fleshing out significance.

By the early 1300s the dimensions of St Paul's Cathedral were not wholly those of the fourteenth century: they were a product of the general eleventh-century re-foundation of the Church in England, and their surpassing standards were those of conquest. The epic mode of great building, both religious and secular, had been introduced by continental European invaders, and its momentum lasted up to the development of the Decorated Style, but not really beyond it. This development was important, and it needs to be examined further.

The reason for this is that there is a case for suggesting that medieval aesthetics placed practical emphasis in particular on two qualities of a building or its furnishings, *magnitudo* and *varietas*. Magnitude, the first concern here, was established by measurement; measurement, and hence number, was the demonstration of the symbolic and so exegetical depth of a structure, particularly a religious one; and it was also the yardstick of power. When, in 1942, Richard Krautheimer set out the most durable account of the importance

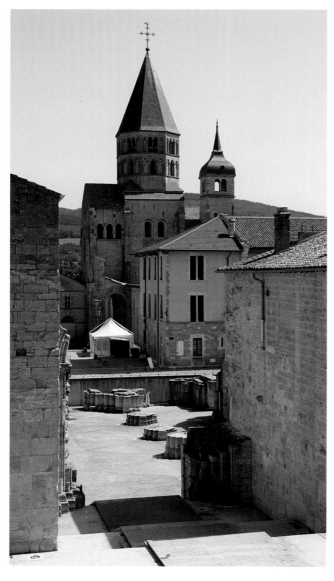

2 Cluny Abbey, begun 1088, nave portal looking through to south transept

these universal features aesthetic issues, the actual 'look' or 'style' of a building, were secondary: what one would now think of as style was accidental to the more important underlying typology. The difficulties with this polarity should not obscure the value of its basic insight: measurements, especially archetypal measurements, mattered. One reason for this, not in fact stressed by Krautheimer, was that church design especially could be imparted divinely in a revelatory way: invention could be a matter of recording faithfully a miraculous 'script' revealed supernaturally, in which the measurements of buildings were fundamental. Examples of divinely imparted building dimensions include Noah's Ark and the third abbey church at Cluny (Cluny III), begun in 1088 (pl. 2).[4] But the use of archetypes, whether or not for their dimensions, did not always need supernatural motivation. A few buildings demonstrably possessed continuing and undoubted authority, their vicissitudes and changes notwithstanding: the Holy Sepulchre in Jerusalem, St Peter's in Rome, Hagia Sophia in Constantinople (pl. 3) and the Carolingian palace chapel at Aachen are all cited by Krautheimer as the basis for copying *ad instar* ('on the model of'), *secundam formam* ('following the form of') or *ad similitudinem* ('according to the likeness of') at such places as Saint Germigny-des-Prés, Hereford (bishop's chapel), Santa Sofia at Benevento and Paderborn (Bishop Meinwerk's church) and Prague (church of Sts Peter and Paul).[5] To these might be added the example of the Pantheon in Rome (pl. 4), cited as a formal analogy for early medieval religious buildings such as the Mausoleum of Theodoric at Ravenna of 1057.[6] The church built by the bishop of Paderborn in 1036 was to be based on the 'similitude' of the Holy Sepulchre, as rebuilt after 1009, specifically requiring its measurements to be recorded for the purpose.[7] To invoke such buildings was in no sense 'historicism', but the recognition of an ever-present and still-vital authority, which might or might not correspond to antiquity.

The theory of similitude in such cases was basically Augustinian: the source buildings are images for thinking with, useful not because of their literal appearance or content, but because they provide an *animus*, an essence, that acts not as a literal object of mimesis but as a cognitive fiction stimulating further thought.[8] That such essential inspiration should flow from dream-visions, building miracles, is not surprising, since the material circumstances of the production of such buildings were no more central to their significance than their literal appearance. The heroic mode was a form of wondrous heightening, which might (but did not necessarily) include the supernatural. Building

of measurement in generating architectural invention and signification, he observed a distinction between the symbolic and the aesthetic: as the Middle Ages wore on, he suggested, 'copies, depictions and descriptions strive more and more towards giving a reproduction of the original in its visible aspects' to the point where, from the fifteenth century, 'a gradual process of draining the edifice of its "content" seems to begin'.[3] Initially, then, medieval signification is based upon a form of essentialism, in which certain weighty, prestigious and symbolically dense buildings offered universal types for copying and emulation by others. To

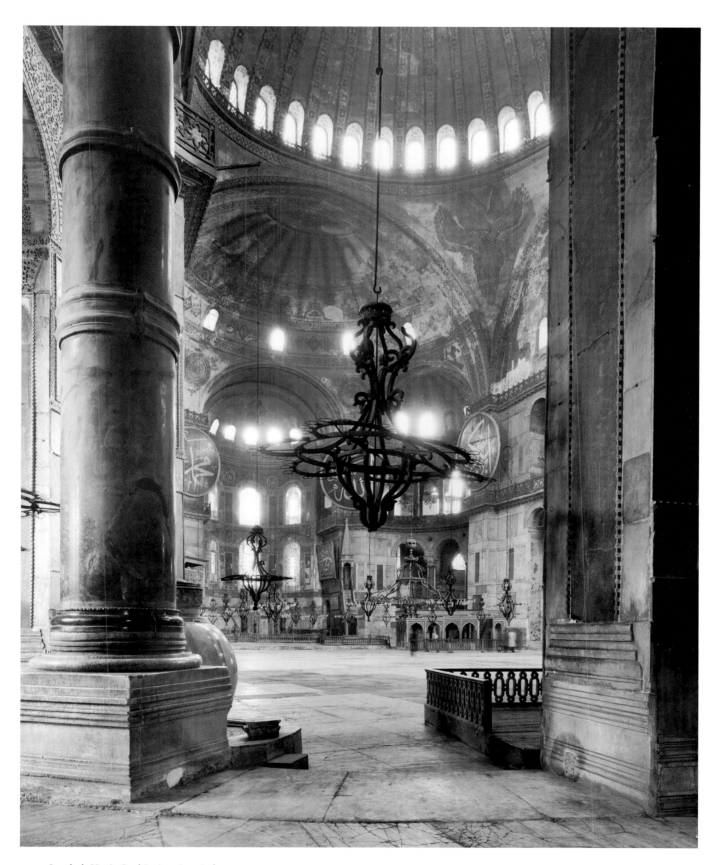

3 Istanbul, Hagia Sophia, interior, sixth century

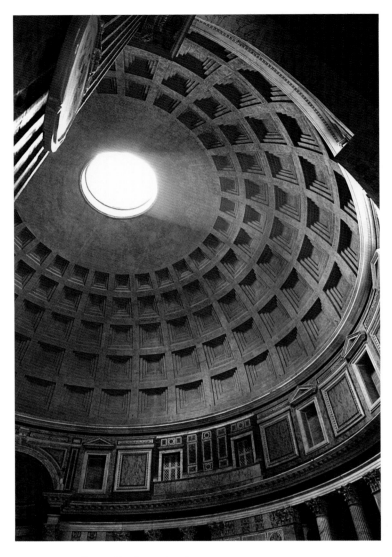

4 Rome, Pantheon, interior

miracles of this type tailed off after the thirteenth century, but it is not surprising to learn of them in connection with the most extraordinary individuals of the age. The English reception of Hagia Sophia in chronicles compiled around 1200 includes Ralph Diceto's account of the dictation of the general form of the giant church by an angel to its architect in a vision.[9] Hagia Sophia was, according to another English source, Ralph Niger, to be 'such a temple as had never been built from the time of Adam to the present day': when its patron, Justinian, at last entered the building he exclaimed: 'I have surpassed you, Solomon!'[10] The miracles of St Thomas of Canterbury include a vision of the martyr and St Thomas the Apostle together pacing

out a chapel to be built in their honour at Devizes; confusingly, they used different units of measurement.[11] Of such miracles the most clearly apostolic is the vision of Gunzo of Cluny, a sick monk to whom St Peter and St Paul appeared in order to instruct him in the form of the new abbey church of Cluny begun in 1088.[12] St Peter himself drew out a rope with which to measure the length and breadth of the edifice, showing in what manner it was to be built. The Life of Gilo, in which this miracle of invention appears, thinks biblically: Gunzo is struck down like the prophet Ezekiel before his vision, and takes careful note of the dimensions and 'schemas' imparted to him, following the account in Exodus 26 of the building by Moses of the Ark. Thus Cluny III, then the largest building of its type in northern Europe, invoking the five-aisled magnificence of the greatest basilicas of Rome, had direct apostolic and supernatural authority. Although this style of 'invention' was dying out, within the idea of typological association lay something of much more durable importance, which persisted into the late Middle Ages.

The Conquest: France and England from 1066

GREAT CHURCHES

'I greatly disdain piddling little buildings (*plerumque indignor pusillis edificiis*)', remarked the Flemish monastic hagiographer Goscelin of Saint-Bertin, in Book Four of the *Liber confortatorius* of *circa* 1080, 'and although poor, I plan great things (*magna propono*)'. In fact, he said, 'I wouldn't allow any buildings, however much they were valued, to stand, unless they were, in my view, glorious, magnificent, tall (*precelsa*), vast (*perampla*), filled with light (*perlucida*), and thoroughly beautiful (*perpulchra*).'[13] Goscelin was drawing an analogy between spiritual robustness and worthiness, and architectural splendour: his language is unembarrassed by the Christian discourse against Pride. It fits England perfectly well. In his Life of St Edith, Goscelin explicitly compares Edith's buildings to the heights of Babylon and Rome and to the magnificence of Solomon: the interest in measurement – Edith's tower at Wilton exceeding the ancient wonders – is striking.[14] It would in fact have graced many ecclesiastical patrons in northern Europe at the time. In Burgundy, Cluny was about to be set out as a five-aisled basilica modelled on the Constantinian exemplars in Rome, as imparted miraculously to Gunzo. Cluny was not only exceptionally long but also very broad and tall (approx.

30 m), rising to within about two metres of Gothic Notre-Dame in Paris (see pl. 18). Cluny's five-aisled plan was not common in France, but it was one of a series of buildings outside Italy, including Ripoll, Ghent and Orléans, and eventually St Sernin at Toulouse, Souvigny, La Charité-sur-Loire and St Martin at Tours, in which the naves were tremendously expanded laterally.[15] No English building of the post-Conquest era opted for this form of spaciousness, and only a few approached the height of Cluny (for example, Old St Paul's); scale was measured longitudinally, and latitudinally in so far as it included England's complex transept systems. In fact, the Constantinian or Early Christian model of spatially broad, thin-walled columnar churches with wooden roofs was not transplanted to England, and this was to have important long-term aesthetic consequences. But Goscelin is one among many sources that show that magnitude mattered.

The spread of the gigantic mode to England from continental Europe was a matter not of supernatural power, but of something more base: the quasi-imperial ambition of the Normans. To be sure, very large stone churches were now distributed in various regions of north-western Europe, including the Empire; and the impetus from Germany and elsewhere should not be overlooked. But the Conquest was decisive in actually imposing colossal and formally inventive stone churches that established the framework for great building in England for the next three centuries. In 1066 England had only one great church that measured up to Norman standards, Westminster Abbey, whose design must have reflected the part-Norman ancestry and outlook of Edward the Confessor (d. 1066). Within two generations of the Conquest the picture had changed remarkably, and is delineated in the following table:[16]

Total length of buildings

	metres (approx.)	feet (approx.)
Cluny III	172	564
Winchester Cathedral	157	515
London, St Paul's Cathedral	155	507
Bury St Edmunds Abbey	149	489
Rome, St Peter's Basilica	133	436
Canterbury Cathedral (1096)	133	436
Norwich Cathedral	132	433
Speyer Cathedral	129	423
Rome, San Paolo fuori le Mura	128	420
Ely Cathedral	118	387
Durham Cathedral	117	384
St Albans Abbey	114	374
Canterbury, St Augustine's Abbey	102	335
Westminster Abbey	100	328
Caen, St Etienne	84	276

Two things jump out: first, that the Norman ducal church of St Etienne at Caen, founded by William the Conqueror in 1066, is drawn out on a much smaller scale than many of the English buildings in the list; second, that some of the cynosures of great scale, such as the Roman basilicas, were easily surpassed by the Norman ecclesiastical foundations in England, notably the 'capital' foundations in Winchester and London.

This is not the place for a full review of the architectural consequences of the Conquest. In terms of the technologies of stonecutting and setting alone, to say nothing of 'rationalism' in the preconception of architectural forms of a complexity apparent in the 'spiral' pillars of Durham Cathedral (pl. 5), the situation after 1066 or so is clear and well understood.[17] These technologies mattered because they energized the extraordinary inventive power of English stonecutting for the next few centuries. Here, it is necessary simply to draw attention to a few features of longer-term importance for this discussion. These concern the language of laudation, attitudes to Rome and emulation.

A mere glance at the cities of Durham, Lincoln and Norwich indicates the capacity of Norman patrons, typically Norman churchmen, as well as builders to site and design building complexes involving castles and cathedrals in an eloquent relation to their urban context. Durham and Lincoln are spectacles, Norwich being an instance of ruthless urban redevelopment in which the new cathedral priory (1096) and castle were positioned deliberately to check the city's existing Anglo-Scandinavian market place and highways. Such thinking, worthy of the Romans, is the product of an epic mindset. It is exemplified in the work of one the ablest, shrewdest and most cosmopolitan commentators of the period, William of Malmesbury. Here is William writing *circa* 1120 about Maurice, bishop of London (d. 1107), who began the rebuilding of St Paul's Cathedral (see pl. 1) after 1087:

The mark of Bishop Maurice's great-mindedness (*magnanimitas*) is the basilica of St Paul which he began in London. Such is the magnificence of its beauty (*tanta est*

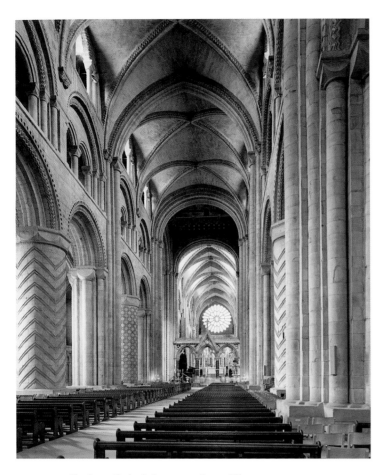

5 Durham Cathedral, nave, early twelfth century

decoris magnificentia) that it deservedly may be numbered among famous buildings (*praeclara edifitia*). So great is the breadth of the crypt and so great the capacity of the upper building that it may seem able to suffice for a multitude however dense. Because Maurice was thus a man of unrestrained mind (*mentis immodicus*), he transmitted to his successors the expense of a burdensome work . . .[18]

The passage is not without reproach of Maurice's financial 'over-reach', but its topics of personal magnanimity, fame and excelling beauty belong comfortably to the high language of *laudatio*, a language that, in ancient fashion, saw an inseparable ethical affinity between character and action, patron (or client) and artwork.

That this language was derived from laudation in the ancient world is of fundamental importance, not least because it emphasizes the tremendous shift in sensibility that was to take place between the post-Conquest period

and its 'epic' mode, and the literature of crisis of later centuries mentioned earlier. The links between French secular epic and the presentation of the Conquest in the Bayeux Tapestry are familiar.[19] Nicholas Vincent provides two illustrations of a specifically classically derived Norman outlook. One is the account in the Life of William by William of Poitiers, which in its account of the Conqueror's channel crossing to England consciously echoes the words of Julius Caesar and Virgil in likening it respectively to Caesar's expedition to conquer Britain and to Aeneas's flight to Rome from Troy. The other is the possibility that William, in offering his daughter as a nun to La Trinité at Caen in June 1066, was following the sacrifice by Agamemnon of his daughter Iphigenia as a supplication to the Greeks to ensure eventual success at Troy: if so, William 'trumped even Virgil in his appeal to classical mythology'.[20]

Christian Rome projected old imperial values deep into the Middle Ages, especially via such 'apostolic' centres of conversion as Canterbury. An alphabetic Latin word list of *circa* 800, possibly compiled at St Augustine's, Canterbury (Cambridge, Corpus Christi College MS 144, fol. 3), sets the word *Roma* parallel with *virtus* and *Romani* with *sublimes*.[21] The 'classicism' of Canterbury itself between the seventh century and the twelfth has been explored elsewhere; Eadmer, the biographer of St Anselm of Canterbury, noted that Canterbury Cathedral had first been built in the 'Roman manner' (*ex more Romanorum facta*), indeed 'in some measure in imitation of the church of St Peter, prince of the Apostles' (*ex quadam parte ad imitationem ecclesiae beati apostolorum principis Petri*).[22] Anselm himself seems to have taken this as an agenda, since the massive expansion of the east end of the cathedral begun by him in 1096, the 500th anniversary of Pope Gregory the Great's letter of instruction to the first English mission, outshone and in effect doubled the length of Archbishop Lanfranc's post-Conquest church to a total of around 133 metres, the length of St Peter's in Rome.[23] Anselm must either have had St Peter's measured, or had access to accurate information about it, and it looks very much as if his eponymous Italian nephew did the same at Bury St Edmunds when he became abbot there in 1121.[24] Lanfranc's circle was probably helpful for the elder Anselm. English knowledge, direct or indirect, of the dimensions of great Roman monuments is indicated by the remarkable coincidence between the three major arches of the west façade of Lincoln Cathedral built by Bishop Remigius – and specifically their dimensions (pl. 6) – and the width (approx. 25 m) of the Arch of Constantine erected in AD 315 (pl. 7): Remigius (d. 1092) had been to Rome with Lanfranc in

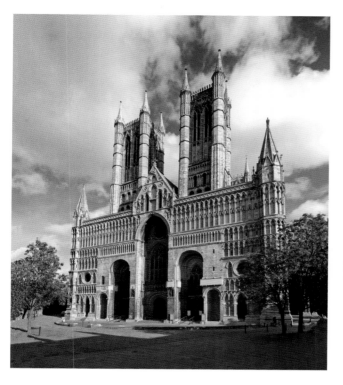

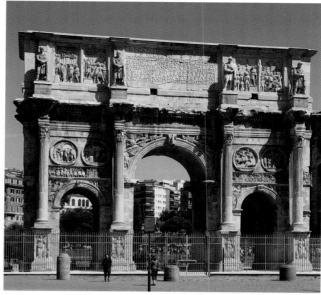

6 *(left)* Lincoln Cathedral, west front

7 *(above)* Rome, Arch of Constantine, AD 315

1071 and 1076.[25] This suggests some sort of direct access to the arch, since it is hard to see why, as a rule, church-wrights would include such a recherché object in their normal repertory of working measurements. Another text underwrites this style of admiration: the hagiographer Osbert of Clare wondered at the marble adornments of the Arch of Titus in Rome, unblemished by age, and wished that a similar monument might be raised to St Edmund at Bury.[26] The prologue of John of Salisbury's *Policraticus* explicitly likens its dedicatee, Thomas Becket, to a Roman triumphal arch.[27] In his (early thirteenth-century?) compilation of material on Rome, the *Speculum ecclesie* (Cap. 10), Giraldus Cambrensis includes measurements by paces of St Peter's and San Paolo fuori le Mura, and notes the similarity of scale of the Lateran in celebrating the *sublimitas* of patronage there.[28] The so-called Master Gregorius claims that he paced out the width of the Pantheon (i.e., Santa Maria Rotunda).[29] Gregorius, if he in fact ever visited Rome, is most unlikely to have been the first to try this sort of thing, given that dimensions conveyed the *animus* of a great structure to the inventively minded. As Anthony Quiney concludes in his study of the Lincoln façade, '*Romanitas* and *Christianitas* were indivisible'.[30] It seems quite likely that medieval Romans themselves compiled conventional lists of statistics and made them available to anyone seeking to learn them.

The essence of emulation as 'superiority contested' is that it invariably provokes a sort of chain reaction, one of the most primitive, and hence one of the most reliable, aspects of the history of commissioning. One such reaction undoubtedly happened in the case of the ever-increasing interior heights of the thirteenth-century Gothic cathedrals. In England, once eleventh-century clerks had notched up the general dimensions of the great Roman basilicas, the way forward was clear: the length of a building, not its height, was the main criterion of its standing. The authoritative studies of English Romanesque architecture by Eric Fernie and Richard Gem have exposed this extraordinary catena of competition.[31] The cathedral of Winchester, then capital of England, begun in 1079 and dedicated to St Peter, was very probably planned at the outset 'to be one of the largest, if not the single largest Romanesque church in Europe', surpassing buildings such as Speyer and Santiago, which 'themselves constituted some of the largest erected in western Europe since classical Antiquity'.[32] Of these, the most likely model at Winchester was St Peter's in Rome, itself planned on such a scale as to rival the Basilica of Trajan. The most probable motive, however, was emulation of Westminster Abbey, newly promoted and rebuilt by Edward the Confessor: William of Malmesbury expressly uses the term *aemuluntur* in describing the way other

churches were built at vast expense in response to the abbey, the first building of its type in England.[33] Scale was arrived at in a sort of 'battle of the capitals' of England.[34] In London's, St Paul's Cathedral (1087) was, in turn, a response to both the abbey and Winchester.[35] Eric Fernie has traced a similar pattern of interaction in the case of the regional giants of Ely (1080s), Bury St Edmunds (1080s) and Norwich (1090s), again ultimately informed in their planning by the scale of the largest Roman basilicas and the 'heroic' age of Constantine.[36] Again, specific links explain the sort of accommodation to apostolic Roman standards encountered at Norwich Cathedral. Its founder, Herbert de Losinga, probably dictated the plan after returning from Rome in 1094, having gone there to seek absolution for simony: the church's sloping site echoes that of St Peter's; its length matches that of the basilica; it has a sunken cloister with Early Christian precursors also closely matching the size of St Peter's atrium, and spiral columns in the nave echoing those in the Constantinian basilica.[37]

The issue of general scale and tone overshadowed the associative dimensions of 'Roman' forms, notably the use of a giant order in the main elevations of Tewkesbury Abbey (1080s) and the later foundations at Romsey, Jedburgh and Oxford, which may either have been explicitly Vitruvian or generated via connections to Normandy or the Holy Roman empire of the sort that had connected the bishop's chapel at Hereford to Aachen.[38] Most of the post-Conquest buildings were either overwritten in later centuries or have been destroyed, so generalizing about their formal potential, which must have been considerable, is impossible. In the long run, the politics of scale vied with the niceties of invention in establishing a long-term pattern of great church building.

City and Presidium

The study of the figurative arts in England from the mid-twelfth century onwards or so, its surviving painting and illuminating especially, emphasizes the extent to which the Norman and Angevin empires opened the gates of international cultural traffic in such a way as to expose England to the aesthetic traditions of the eastern Mediterranean and Rome. The aesthetic language and outlook of north-western Europe throughout this period were profoundly shaped and coloured by traditions and mythologies whose homelands were to the east of Rome. To these, Norman and Angevin England responded because it saw in this legacy something that answered to its own imperial ambitions. Such ambitions were, in turn, accommodated by new, or greatly redeveloped, power centres, specifically Winchester and London: government was obtaining and developing a sense of place. Cities, palaces and castles were as significant aesthetically as great churches.

The reception of the gigantic palace hall at Westminster (see pl. 189), first undertaken by William Rufus in 1097–9, is an example.[39] It was easy to cite the hall, the largest of its type in northern Europe (measuring approximately 73 × 21 m) and a building clearly intended for displaying the major rituals as well as the general standing of monarchy, to William's discredit. Henry of Huntingdon does so in his *Historia anglorum*: on first entering the hall in 1099, some in the king's presence said that 'it was a good size, and others that it was too large. The king said that it was only half large enough. This saying was that of a great king, but it was little to his credit.'[40] The high level of exactions made in order to build the hall is noted in the *Anglo-Saxon Chronicle*.[41] But William of Malmesbury, who tended to take a larger view of things, regarded the new hall as an index of William's regal liberality. He placed it in the context of an ethical assessment of William as king, not all of it positive; yet having apportioned blame, he lavished praise. The king, he said, 'provided some examples of real greatness of spirit (*magnanimitas*)'. For instance, in relating an episode in which the king showed courage, the author said:

> Some people, as they read their Lucan, might perhaps wrongly suppose that William borrowed the inspiration for these actions from Julius Caesar . . . rather, it was his innate fire of mind, and conscious valour . . . so did the soul of Julius Caesar pass into King William. He began and completed one building, and that on the grand scale (*permaximum*), his palace in London, sparing no expense to secure an effect of open-handed splendour (*non parcens expensis dum modo liberalitatis suae magnificentiam exhiberet*).[42]

William's use of classical analogy and his equally classically derived exploration of great-minded liberality (from Aristotle or Cicero) are important. William of Poitiers compared the Conqueror's actions to those of Julius Caesar; Rufus is now his very incarnation. William of Malmesbury had said that the mark of Bishop Maurice's great-mindedness was St Paul's Cathedral. These ideas were to find a new and exceptionally energized context in the persistent delineation of English episcopal sainthood in the late twelfth and thirteenth centuries as embodying aristocratic virtue –

8 Seal of Barons of London, *circa* 1219, obverse showing St Paul holding standard with leopards of England, with city at his feet, cathedral at centre, Tower of London to right

liberality, magnanimity and temperance. From Becket onwards, episcopal great halls such as that to be founded at Canterbury in imitation of the hall at Westminster 'were allied both in theory and practice to magnificent conduct and to its natural corollary, charitable largesse, the key political virtue of great men'.[43] In such accounts one almost encounters actual doctrines or prescriptions.

The way in which many of these contemporary texts are presented in classical or biblical Latin serves to underline the tone of authority they needed to strike. It must have been with this view in mind that, in the twelfth-century Life of William of Norwich, the sheriff, seated in the castle at Norwich, to whom the Jews turn in the midst of the story, is called a *presidium*: this consciously echoes the Vulgate in the account of Christ before Pilate in Matthew 27:3.[44] Entire cities could be drawn into this learned web of authority and textual magnification. London was the first English city to attract a true city laudation, of a sort associated previously with Milan, Verona or Rome (for example, Hildebert of Lavardin, *Par tibi, Roma* and the *Mirabilia urbis Romae*) and later found in Jean de Jandun, though in a very different context.[45] Earlier, it was observed that by the fourteenth century the literature of praise that had lauded saints and relics, and which had conveyed important ideas and sentiments about buildings and people, was declining. One

exact instance of this concerned a very important and charismatic man indeed: St Thomas of Canterbury. It is the *Descriptio nobilissimae civitatis Londoniae* by William fitz Stephen, citizen of London, that opens his Life of the martyr of *circa* 1173.[46] Becket, himself a Londoner, enjoyed a huge following there. He figures on the reverse of the extraordinary seal of the barons of London made before 1219 (pl. 8), which on its obverse depicts a panorama of the city dominated by the colossal figure of St Paul, dwarfing even the spire of his cathedral rising in front of him.[47] Citing classical authority, William sought to 'place' the Life of the martyr in the context of what is now acknowledged to be the seat of the English monarchy (*regni Anglorum sedes*). Great in religion, productive of noble men, cheerful in its ways and worthy of a metropolitan church, London's fame is widespread.[48] William moves almost immediately to St Paul's Cathedral, about which he says little in contrast to the mighty fortress of the Tower of London, its walls joined by cement tempered with the blood of animals, and the glories of the palace at Westminster, *aedificium incomparabile*.[49] In the twelfth century the White Tower appears to have provoked an extraordinary series of foundation myths, its origins being traced to Belinus, Brutus, Julius Caesar or Arthurian legend; William's use of the term *arx palatina* in describing it may well be a reference to the Palatine in Rome itself.[50]

William goes on to describe London's suburbs, its people, its schools (a priority in Jandun) and its trades, citing Virgil's *Aeneid* and *Georgics*. In fact, the high notes are accompanied by a strong *bass ostinato* of demotic and low style: public games, cockfights, tilting and winter sports. It might be expected that such high and low subject matter would be coupled, as indeed they are in Jandun's *éloges*. But William's purpose in doing so was political: it was to set the scene for the notion of *vox populi, vox Dei* developed in St Thomas's hagiography: the martyr was in a special sense the saint of the ordinary folk, the *vulgus*.[51] The *descriptio* could not be out-and-out 'high' laudation for precisely this reason. On the other hand, the text necessarily paid complement to St Thomas precisely in virtue of his greatness of spirit, his nobility. Its mixture is richly informed by classical ideas and rhetoric, ending, as Scattergood suggests, 'with an all-encompassing imperialist embrace, "*omnibus bonis totis orbis Latini*"' – 'to all good men of the Latin world' – 'the articulation by a proud Angevin intellectual of what he thought could be claimed for his culture'.[52]

As with great churches, it matters that such accounts involved great people, great actions and great things central to the present task of defining the heroic mode, a mode

9 Jerusalem, Church of the Holy Sepulchre, Tomb Chamber with post-medieval marble cladding

mixed comfortably and pleasurably with the 'low'. That these texts involved often highly learned people is a secondary issue, except in so far as men such as St Anselm were patrons with the intellect and means to bring these mighty visions into being. St Anselm's rebuilding and refurbishing of Canterbury Cathedral was an event of international significance; and those parts of the church rebuilt after 1174 to house the relics of his martyred successor Thomas Becket (d. 1170) (see pl. 27) quite consciously brought this building even closer to resemble the apostolic churches in Rome, which, in their size, 'classicism' and beautiful variety of forms and materials in turn embodied the highest aesthetic standards of the day.[53]

Varietas

When, sometime after 325, the Emperor Constantine issued instructions for the decoration of the newly discovered tomb of Christ in Jerusalem (pl. 9) in what was to become the church of the Holy Sepulchre, he affirmed an aesthetic

outlook that lasted for well over a thousand years. In the third book of his Life of Constantine, Eusebius relates that he intended the new sepulchre to be 'rich and of imperial magnificence'; he instructed that it should be a 'building out of the ordinary, huge, and rich' (note the order of priorities), 'superior to those in all other places'. There was to be a competent supply of columns and marble. The church was accordingly 'decorated with superb columns and full ornamentation, brightening the solemn cave with all kinds of artwork'; its walls were 'raised to an immense height and very extensive in length and breadth; its interior was covered with slabs of varied marble, and the external aspects of the walls, gleaming with hewn stone fitted closely together at each joint, produced a supreme object of beauty'. Of these untold beauties it was impossible to say enough about 'their size, number and variety'.[54] For this there was a model in the Old Testament figure of the Church, Solomon's Temple, a model of what it was to build and furnish richly, and also of what it was to behave like a patron in the fullest sense of the term.[55] It is sometimes suggested that there were no practical aesthetic doctrines in the Middle Ages, but in the face of such examples, doctrine seems unnecessary. The standing of subject, author and building in such a case was sufficient. Practice was doctrine.

Machismo was central to medieval patronage. But if magnitude was the quantitative aspect of the heroic arts, that aspect shaping 'hard' power, complexity, mixture and the resulting experiences were the qualitative, by means of which 'soft' power was eventually exerted. In England, the Conquest effected a new tradition of stonework in great churches that favoured complexity. If, in 1066, England had been conquered by the Mediterranean Normans or by the sort of Romans who built churches in the manner of the early twelfth-century Rome of Pope Callixtus II, the likelihood is that its practices of church building would have been dominated by an Early Christian basilican type of structure (pl. 10), with antique or quasi-antique columnar supports sustaining thin but plain upper walls and wooden roofs. Instead, the Conquest introduced from Normandy and elsewhere a paramilitary, in essence Roman imperial, mode of super-thick walling, massive round or rectangular piers, round arches and stone vaults characteristic as much of castle as of church building, in effect a form of Roman civic engineering whose ends were coercive (see pl. 5). The post-Conquest introduction of the vaulted thick-wall type of structure had profound and long-lasting aesthetic consequences in England.[56] By its nature and sheer expense it obviated very tall structures. It positively encouraged a dis-

10 Rome, San Crisogono, nave and pavements, ?early twelfth century

tinctive approach to wall surfaces and the aesthetic possibilities of the thickened wall. Arches could be provided with superlatively elaborate multi-order templates; supporting piers could be enriched and variegated at will;[57] walls and vaults could be covered with decorative patterns and networks; and the walls themselves could be gouged out, scooped into and hollowed in order to secrete sculpture and make subtle play with light and shade. All these rich and dynamic plastic effects could be enhanced by surface painted polychromy. By about 1200, in the nave and especially on the west façade of Wells Cathedral (see pl. 165), these many effects of surface gained an almost poetic quality to which church designers at (for instance) Lincoln (see pl. 14), Beverley Minster and Ely (see pl. 35) were also fully alert.

English Gothic in its first and most enduringly complex forms was fundamentally preoccupied with the aesthetics of surface, of skin and flesh, of *venustas* and *pulchritudo*. Exeter Cathedral (pls 11, 12), the earliest and most complete in conception of the new wave of large buildings in the Decorated Style, designed in many important essentials by 1280 or so, is a *locus classicus* of this traditional position: its multi-ribbed, highly articulated and patterned thick-wall surfaces provided sustenance for architects in the West Country for the next generation; its elevation may have been directed by a French Rayonnant model; and the building uses coloured marble.[58] Its window tracery possesses a marvellous and persistent variety of geometric forms.[59] Yet in the face of this brilliant eclecticism, as Peter Kidson justly said, 'Exeter remains a brilliant piece of masonry in which there happen to be windows'.[60] The English encounter with the

11 *(above)* Exeter Cathedral, nave, 1310s–*circa* 1350

12 *(below)* Exeter Cathedral, longitudinal section by John Carter (Society of Antiquaries, Blue portfolio, Exeter Cathedral)

dazzling French Rayonnant techniques of tracery – window tracery especially – did not, at least at first, displace this quite fundamental allegiance to traditions of building apparent at such influential shrine churches as Canterbury Cathedral and Westminster Abbey (see pls 21, 27), churches that, not coincidentally, preserved the cults of charismatic humans, in the case of Becket a wonder-worker on a heroic scale.

England's first entry into Europe in 1066 had no less far-reaching and deep consequences for the fourteenth century than the English encounter with Rayonnant from the mid-thirteenth. It located England within a more widespread and long-standing European tradition of aesthetics. According to this, splendour, radiance, sparkle, richness, complexity and colour were all noble features that resided in the way things were made by handiwork, *opus*, and in what they were actually made of, *materia*. It is entirely consistent with this portrayal of English Gothic within much longer and deeper traditions of prestige and beauty that the English, to an extent greater than any other northern European nation, continued their allegiance to the ultimately Mediterranean aesthetic of coloured marble. From the mid-twelfth century onwards the use of dark or variegated marbles for church decoration, Purbeck 'marble' especially, became a norm that persisted far into the first half of the fourteenth century and the elaboration of the Decorated Style, as at Ely (see pl. 169), Exeter (see pl. 11) and Beverley, and in tombs and church furnishings. By the 1330s the English revelled in the mixture of freestones, marble and alabaster in combination (the tomb of Edward II at Gloucester [see pl. 219], the cloister of St Paul's Cathedral).

The connection between *magnificentia* and tremendous materials, especially marbles, is fundamental.[61] As Krautheimer noted, the Holy Sepulchre was one of the more important models for medieval church building. Those who measured it for the sake of a copy at Paderborn may have noted the marble sheathing of the tomb aedicule itself, which may have consisted of many-hued marbles in creamy white and pink-red (see pl. 9).[62] An English pilgrim to the sepulchre in 1345 explicitly noted that the tomb shelf, the bench upon which Christ's body purportedly lay before the Resurrection, was of porphyry.[63] Porphyry was a stone that mixed political (imperial) and religious significations.[64] Pilgrims to Canterbury Cathedral as rebuilt from 1174 with white and pink quasi-Corinthian columns and reddish variegated marble floors around the shrine of St Thomas (pl. 13) may not have known about the Holy Sepulchre marbles or the form of Christ's tomb, with three little 'portholes' beneath its bench, which probably suggested the form of

13 Canterbury Cathedral, Trinity Chapel and marbles, completed *circa* 1184, looking north-west

the tomb of St Thomas in the cathedral crypt with its little round apertures.[65] Nor may they have known about the sophisticated exegesis of the text *candidus et rubicundus* in the Song of Songs, invoked locally in the narratives of Becket's bloody martyrdom.[66] The white–red imagery of Canterbury belongs to a distinct tradition of exegesis of red or purple as the 'bright' colours of martyrdom and *imperium*, starting with Cyprian and Bede (*De tabernaculo*).[67] Bede's *Historia ecclesiastica* would have been especially important in launch-

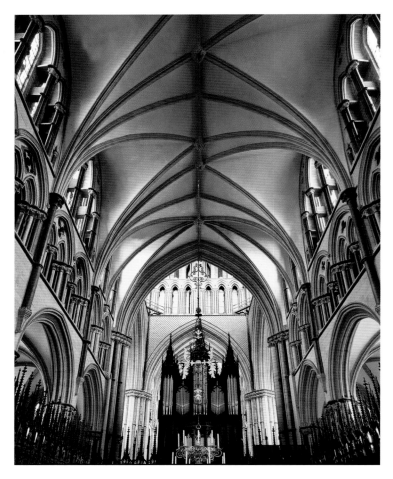

14 Lincoln Cathedral, choir and vault, begun 1190s, looking west

people. But when we 'read' in the marbles of St Thomas's shrine church at Canterbury, or in the account of the mixed yet united stones and marbles of the choir at Lincoln built by St Hugh (pl. 14) in the Metrical Life of that saint composed *circa* 1220, a sort of transfer of talismanic aura between extraordinary human and material seems evident.[70] The Metrical Life, which contains the richest such account of a Gothic church known, describes a building whose aesthetic character would have been of interest to English artists and architects of the late thirteenth and fourteenth centuries, and, if Pevsner and other authorities are right about its remarkable triradial vaults, to late medieval German architects too.[71] The use or language of marble persisted in major buildings in England long after ceasing in France, well into the fourteenth century in fact. The handiwork at Lincoln – the lop-sided or 'crazy' vaults, the 'syncopated' wall arcading, the profusion of complex templates and marble shafts, all conceived at some point before or around 1193–4 – is not discussed as such by the Life's author, and nor would it be, since architectural history interested or informed such writers not one iota. This is why the dismissal of such texts as conventional (i.e., 'empty') rhetoric, useless to modern empiricist enquiry, is such a mistake.

It is possible, in fact, to make good use of the poem's images, not because they elucidate the question of style or intention, but because they point to what it was that was thought to lend imaginative energy to the building's aesthetic. Setting aside its emphasis on lofty vaults, the imagery of bird's wings and other motifs of transport or transcendence, the writing on bright marble in the Metrical Life is particularly notable for its time. At Lincoln, marble, generally of dark tone but mixed with white freestone, is subject to several dynamics of understanding. The first is that the poetic reading of such materials was shaped by ideas of *effort* and *competition* lodged firmly in the portfolio of the Latin and Greek language of praise. So according to the Metrical Life, the old church was grubby, low and vile, while the new one brings everything together by arduous labour (*labor arduus*). Improvement comes at a price; difficulty is part of the game. The explicit language of emulation has already been picked up in William of Malmesbury or Ralph Glaber, or Constantine's edict for Jerusalem. The Metrical Life plays with this idea in another way, again in keeping with Roman art writing and especially the genre of the pastoral: competition is not a matter of scale but of the triumph of art – the handiwork and the materials pit art against nature in competition, and art wins. On the one hand, echoing Ovid, costly material is well matched by

ing exegesis of the mingling of red and white, since it explicitly describes the tomb of Christ as being of 'mingled red and white'.[68] The smaller class of clients and clerks responsible for commissioning such complex buildings would certainly have pondered these resonances, and would have done so for generations, since, in fact, the start of the European 'building boom' of the eleventh century to the thirteenth. So, Ralph Glaber, writing in his mid-eleventh-century histories, reflected on the new wave of church construction in France that began just after the millennium, one church community aiming to 'surpass' another, cladding themselves in a 'white mantle of churches'.[69] Glaber's extraordinary image of white marble as a kind of spiritual integument is explicitly exegetical, echoing the account of the Transfiguration. But the underlying structure of ideas, the discourse of improvement, is older still.

It is at least questionable to think of things having the quality of charisma, normally an attribute of exceptional

zealous craft (*Materiae pretio studium bene competit artis*), and the whole is fused into one entity as if a work not of art but of nature (*non esse videtur ab arte/ Quin a natura*) – an expression that echoes something like Eusebius's observation on the Holy Sepulchre that, gleaming with hewn stone, 'it fitted closely together at each joint' and so 'produced a supreme object of beauty'. On the other hand, the marbles are so fine, nature having painted there so many varied forms, that painted art would struggle to keep up (*Nam tot ibi pinxit varias natura figuras/ Ut si picturam similem simulare laboret*). So, indeed, might poets. Variety is obvious and valued, and can produce an ultimate organic harmony, worthy of a natural thing but better.

The art–nature nexus and the language of labour, struggle and difficulty are so dependent upon ancient (often poetic) thinking (Aristotle, Horace, Virgil, Ovid, Cicero), and so deeply embedded in late antique, Early Christian and medieval writings, that they need no further comment here, except as a reminder of the durable and apparently largely Benedictine monastic, literary tradition of writing about the movement, difficult, costly and dangerous – in effect an 'Odyssey' – of great marble stones and columns from Rome or Byzantium to adorn north-western European churches. Suetonius's observation that Augustus found Rome a city of brick and left it a city of marble anticipated the work of Christian commissioners such as Desiderius of Montecassino, Suger of Saint-Denis and Gauzelin of Fleury.[72] The Christian discourse of improvement therefore had imperial roots, and its later manifestations were in part royal. This idea of transporting stones from Rome encapsulates an important wider truth: that the aesthetic value systems implicit or explicit in medieval art were themselves imported from Rome and the eastern Mediterranean, along with high-grade materials. North-west Europe, in effect, borrowed the 'heroic mode' when it concerned itself with scale and magnificence, quantity and quality. At no point are actual formal solutions, 'style', central to this tradition; hence, perhaps, its neglect by formalistically minded art historians. What mattered at least as much was the consonance of art with conduct and thought. True to form, the last English instances of this mode occurred in Benedictine contexts: in an epitaph for one of the abbots of Westminster in the 1280s (see p. 228), and at Ely in the Walsingham memorandum (p. 224). The value of high-grade, long-lived and heroically wrought materials was articulated richly by the most influential poets – Ovid, writing about the House of Fame; Statius, about the House of Mars – in whose writing later medieval English writers found so much to admire, reflect on and use.[73]

Apart from, but related to, the main dynamic of magnificent effort and sheer quality is the issue of beauty. The sparkle inherent in marble, its brightness, was crucial to its aura: the word comes from the Greek *marmàiro*, 'to shine'.[74] Colour language of the period stressed brightness or value before hue: purple was thus a bright colour. Good writers on marble caught the sense of its veined complexity, its fascinating mixed-ness, in which 'marbling' they might dwell on mentally, rather than slather over it as a hungry man might drool at a well-veined steak. In the Metrical Life, Purbeck marble flashes and glints, and when examined closely it holds the viewer's mind in suspense as to whether it is jasper or marble – if marble, an aristocrat of marbles – *si marmor, nobile marmor*.[75] The marble shafts, 'more shiny than a fingernail', present a 'starry brilliance to the dazzled sight'. The connection of shining complexity and sparkle to nobility is striking and is repeated in another well-known source, Albertus Magnus's book of miracles, in which fractured marble is described as glittering, which is one of the reasons why marbles are more 'noble' than other stones.[76] The aura of marble was not unrelated to ancient notions of noble class; it was *classicus*, connoting enduring superiority, authority and perfection. In regard to empire, monarchy or sainthood, it auratically 'framed' charismatic power.

But its beauty, as well its status, lay as much in its polychromy, its variegation, as in its brightness. As Mary Carruthers has shown, Latin 'beauty' terms such as *venustas* and *pulchritudo* occurred frequently in relation to skin and mottled or dappled surfaces, and so variegated colour, polychromy (Greek *polychroia*).[77] Red or bloody hues seem to have been important in this word complex. One thinks of marble, especially some white marbles, as having 'veins'. This sense of beauty as something having the 'blush' of blood within it – 'good-lookingness, from one's veins, i.e. from blood' – as Isidore of Seville puts it (*Etymologies* x.v.277). At Canterbury, the image of white mingling with red, of Becket's brains suffused with blood, is an image of mixture in which exegetical depth was found (see pl. 13). The analogy between marble and paint was a commonplace encountered in the competition of art and nature in the Metrical Life. It was not uncommon to move from marble to paint in the language of praise: Procopius does it in his sixth-century account of Hagia Sophia (see pl. 3), in which he compares the marble decoration of the church to a meadow in full bloom with flowers: 'For [the viewer] would surely marvel at the purple of some [of the marbles], the green tint of others, and at those on which the crimson glows and those from which the white flashes, and again at

those which Nature, like some painter, varies with the most contrasting colours.' He was followed in this use of similes to marble in flowers and painting by Paulus Silentarius in his hymn of praise to Hagia Sophia, and later by the homilist Philagathos writing about the Cappella Palatina in Norman Palermo, and by Leo of Ostia on Montecassino.[78] Once these ultimately Greek concepts had passed into the Norman Mediterranean and especially the Benedictine sphere, their passage to England was, if not inevitable, at least greatly eased. The echo, in the Lincoln Metrical Life's passage on glinting marbles, of Paulus Silentarius's image of the shiny fingernail, is striking.[79] William of Malmesbury, echoing the biblical books of Chronicles and Revelation as well as some marble-minded curriculum poet like Statius, records the 'gleaming' marble pavements, splendid glass windows, many-coloured paintings and great ceiling in the dazzling choir of Anselm at Canterbury.[80] William's schedule in turn has much of Isidore's definition of decoration – *De venustate* – in his *Etymologies* (XIX.xi): 'beauty, *venustas*, is anything added to buildings for the sake of ornament and embellishment, such as ceiling panels set off in gold and revetments of rich marbles and colourful paintings'.[81]

It is misleading to speak of medieval practical aesthetics as if they had fixed codes, principles or doctrines; yet in the language – of experience as much as of making – of magnitude and mixture are encountered recurrent patterns and linguistic affinities that were deep, durable and widespread, and which, more importantly, often make sense of the art and architecture to hand. When Cassiodorus, in his *Institutiones* (I.iv), said of the Psalms that they 'are like a beautiful peacock which is adorned with round eyes and a rich and lovely variety of colours', his thoughtful language of pleasure also possessed dignity.[82] The image of the peacock is striking, because it exemplifies the combination of colours, *colores*, in rhetoric: the Psalms possess an engaging poetic diversity. That pleasure lies in the internally mixed character of sensations and things, for colour produces the variation necessary for pleasure.[83] The philosophical basis for this was clear. Though classical rhetoric might disapprove of unduly mixed styles, Aristotelian, Thomist and Avicennan thought on physics proposed that not only are things, starting with the elements themselves, inherently mixed, but so too is sense-based perception, or knowledge of things. There is every reason to regard this perception as an important basis for understanding the regimes of medieval art, not least the origin of delight and wonder in that which is mixed, which has complexion rather than fusion.[84]

A corollary of mixture was *varietas* itself, a virtue that, in classical rhetoric at least, flourished only within the constraints of decorum, whether in literary or artistic invention.[85] So, in the *Ad Herennium* (IV.xii.18), variety is linked to dignity.[86] This was certainly the Renaissance position, to cite George of Trebizond in 1429: 'variety is exceedingly useful and pleasant not just in painters or poets or play-actors, but in everything – so long, that is, as it is fitting' – sentiments true also of Alberti and Fazio.[87] *Varietas* is relevant to some of the most central responses to medieval art in two ways. The first is that it was an antidote to boredom, a point picked up by medieval 'behavioural psychologists' like Peter the Chanter, whose writings on prayer and prayer postures are, in this sense, classically rhetorical – to say nothing of St Bernard, who understood the monastic psychology and its perils well.[88] The second is that the pleasurable or carnal experience of *varietas* or *diversitas* was linked to the metaphysical transport of self in some celebrated accounts, typically of the Christian Neoplatonic tradition. Three texts stand out in this regard: the account of Hagia Sophia in Procopius' sixth-century *Buildings*, in which the viewer is transported after an encounter with the church's astonishing scale, complexity and variegation of colour and finish; Abbot Suger's *De administratione* of *circa* 1145, in which transport arises through meditation on the many-coloured gems of Saint-Denis; and Jean de Jandun's *éloges* of Paris of 1323, in which, again, the viewer is transported as if to heaven (*quasi raptus ad celum*) by the hyperbolic but various beauties of the Sainte-Chapelle (see pl. 24), of its select colours, its many flashing gems and its blushing or (take note) 'glowing red' stained-glass windows (*vitrearum rutilantium*).[89] Such accounts were, however, rare.

In regard to medieval art and architecture there was, to repeat, no consciously formulated doctrine or principle that prescribed or regulated *varietas* in a commission: as Eusebius's account of the variety of Constantine's patronage of the Holy Sepulchre showed, there was simply eloquent practical and authoritative testimony to the existence of such a virtue, true also for Procopius, Leo of Ostia, Andrew of Fleury and, for that matter, Abbot Suger of Saint-Denis. Indeed, strictly speaking, *varietas* was not a term applied to architecture *as architecture*: its object domain was typically that of smaller-scale things: jewellery, goldsmiths' work, textiles, marble fittings. This characteristic, when coupled to the standard medieval emphasis on liturgical priorities, explains the tendency in much of early and high medieval writing about ecclesiastical art to expatiate on the glittering multi-coloured furnishings of churches, their reli-

quaries, windows and revetments, rather than their actual architecture.[90] Yet, as Suger himself reminds us in *De administratione*, columns and arches could be understood within the discourse of *varietas*.[91] Beat Brenk has shown how the material and formal eclecticism of the Constantinian era, in the use of classical pagan *spolia* in Christian churches, may even have promoted an aesthetic of discontinuity, in which harmony arose, as it were, despite a certain discord of style and ideology.[92] A case, based on Auerbach's literary theory about the breakdown of classical rules of style in the Early Christian and medieval period, has been made for seeing rule-bound classical *varietas* mutate into a much more consciously extreme *diversitas*, suiting the newly complex linguistic, cultural and ethnic climate of early Christianity.[93]

What matters in this is the impurity of mixture, and with that impurity the ambivalence characteristic of many of the deepest aesthetic experiences. The recognition that an out-and-out excess of *varietas* (the excess or superfluous complexity that provoked not admiration or transport, but fascination, and even aesthetic and moral disgust) also held dangers is almost traditional in art history. *Varietas* seems often to encompass extremes of experience. That this was (and is) firmly founded in experience is undeniable: as Cicero remarked (*De oratore*, III.97–100), 'the greatest pleasure borders on disgust'. Much the most eloquent medieval exponent of this idea was St Bernard, who seems himself to have done much to promote the circulation of the concept of *curiositas*, the vice of the eye, into which an excess of *varietas* could easily tip.[94] Bernard's 'line' on most things was rather more complex than modern critical agendas allow. It matters because his profound understanding of the aesthetic was embodied in no less aesthetically remarkable language, which was eventually to have consequences for English medieval writing on related themes. The famous passage in Bernard's *Apologia* (*circa* 1125) about 'ridiculous monstrosity' and 'deformed beauty' in the art of the cloister is, after all, a text explicitly about the temptations of 'reading in marbles' (*legere in marmoribus*), an activity that is not solely textual but aesthetic.[95] Bernard's sermons on the Song of Songs are positively lusty on the spiritual significance of blood-warmth, as in this passage in which he dilates, paradoxically, on the Bride's cheeks:

> You must not cede a fleshly significance to this colouring of corruptible flesh, to this gathering of blood-red liquid that spreads evenly beneath the surface of her pearly skin, quietly mingling with it to enhance her physical beauty

by the pink and white loveliness in her cheeks. For the substance of the soul is incorporeal and invisible . . .[96]

The similarity of Bernard's quasi-amatory writing to classically derived and fairly common ideas of living marble (note particularly the white–red shift) is made evident by comparison with the doubtless tongue-in-cheek passage in Master Gregorius's *Narracio de mirabilibus urbis Romae*, in which the author encounters in the Roman Forum a statue of Venus made from Parian (i.e., white) marble to which he is repeatedly drawn because of its 'persuasive sorcery': 'she seems to blush in her nakedness, a reddish tinge colouring her face, and it appears to those who take a close look that blood flows in her snowy complexion.'[97] Mixture might be seen as entailing a form of corruption. What such writing also indicates is that materials such as marble possessed actual 'warmth' in their aesthetic variegation: marble was not simply a 'cool' material but also conveyed heat and brightness.

The blushing warmth of Bernard's language and imagery, and his alertness to the mixed nature of things, guides to a quality of real importance in the search for the foundations of later Gothic aesthetics: harmonious (and inharmonious) complexity, both in the making and the apprehension of art and architecture at its very core. This complexity is central to any notion of allure, of vitality, of persuasiveness, of heightened awareness and 'being'. No one sense can communicate it, certainly not just sight. St Augustine in his *Confessions* had lent authority to the idea that Christian transcendence was gained through all the senses; Bernard considers the sense of taste (and with it, kissing) as important a way of spiritual knowing as any other.[98] In the Metrical Life of St Hugh, such ideas are brought directly to the understanding of a Gothic church: St Hugh's work 'sweetened' the harshness of the old building (*acrem dulcorat*), the new one being like wax on the outside, but like honey within (*sed intus est [quasi] favus*), as if it had to be 'cracked' open to know or suck out its significance – an idea echoing Deuteronomy 32:13 and with one basis in medieval exegesis of the Song of Songs.[99]

Attention to the mixed character of things or faculties implies thought about the (modern) separation of art forms. The kinds of aesthetic apprehension documented here, and throughout the Middle Ages, paid little or no heed to the objects of such apprehension in regard to difference of *medium*: architecture, mosaic, sculpture, glass, marble and paint are part of a regime of art that viewed and relished multiple aesthetic effect, *varietas*, without analysing it into

component parts defined by the nature of handiwork, *opus*. The tendency, rather, was to draw such things together in an experience of harmony, not unity.

The aesthetic of the fourteenth century in England, its (generally acknowledged) stress on variety to the point of curiosity, its seemingly endless playful inventiveness at the level of the humorous and the grotesque as well as the great and beautiful, its persistence with practices of lavish detailed decoration with sculpture and marble, its love of mixed coloured, patterned and modelled surfaces, of polychromy, is fully comprehensible in terms of the most long-standing traditions of medieval art, themselves ultimately classical in inspiration. Northern French versions of Gothic emerging *circa* 1150 had set a slightly different agenda, one based on a kind of structural exhibitionism, a clean, cerebral 'visionary engineering' in Jean Bony's apt phrase, whose ends were an entirely new form of wonderful building, 'wonderful' not least in the sense that the way such extraordinary buildings come into being is not readily comprehensible.[100] The *parti*, the overall mode, of this new style of building (see pl. 17) forced radical changes of priority: *spolia* in the form of surviving columns or other artefacts could match neither the scale nor the single-mindedness of the new French aesthetic as it developed. England was quickly drawn into this agenda, not least because it had had a role in developing it in the first place as part of the Anglo-Norman domain. But for the reasons set out here, the relation of English art to the new trends was already bound to be complex. And that brings us to the Gothic style itself.

Pre-Gothic Wonders

Magnitude and mixture were aesthetic qualities shaping artistic practices, which also in turn shaped experience. The quantitative and qualitative dimensions of aesthetic practices were things enacted rather than set down; and if they were set down, it was as matters of 'legislation' in negative terms, 'don'ts' rather than 'do's', particularly when they concerned extremes of scale or quality judged by austere norms. But the moralist position should be placed in its due perspective. Practical continuities of magnificent building as a whole seem clear enough, considered so far in post-Conquest England in terms framed ultimately by Rome, Byzantium and the Christian 'Odyssey' of marble.

There are, however, objections to this particular geographical perspective. As if by default, such reference points lead into thought about classically inspired *renovatio*, stimulated by art practices traditional to the Roman and Christian Mediterranean milieux. But it is not clear that the imaginative horizons of medieval architects were circumscribed by what is now thought of as a 'Christian' classical aesthetic, however variegated and dependent upon 'pagan' accomplishment. There were two other spheres of reference that enlarged the whole issue: great buildings in territories largely under Islamic control; and great buildings, or things, preserved in mythologies beloved of all technocrats concerning the Wonders of the World.

From the eleventh century western Europe was starting to produce true architectural prodigies; but in the period between the construction of Hagia Sophia in Byzantium in the sixth century and of the imperial cathedral of Speyer and Cluny III in the eleventh, architectural *magnitudo* and enmarbled *varietas* were to a much lesser extent Christian objectives: 'to the usual art-historical axis of Europe–Byzantium we should add Europe–Islam and Islam–Byzantium'.[101] Architectural precedence over the Mediterranean in these years was established firmly by Muslim building in Kairouan, Damascus and Córdoba, not only in terms of their sheer scale and expansiveness of planning, but also of their continuation of the culture of marble adornment. This placed elaborate buildings in the West 'in competition not only with each other but also with prestige structures of their trading and warring partners in Byzantium and Islam'.[102] Such competition continued well into the thirteenth century and the advent of French Gothic: at the time of the conversion of the Great Mosque of Córdoba in 1236 (pl. 15), it was noted by Archbishop Rodrigo Ximénez that it 'surpassed all other Arab mosques in decoration and scale' (*que cunctas mezquitas Arabum ornatu et magnitudine superabat*); work such as Córdoba soon affected subtle aspects of Spanish cathedral Gothic.[103] It is misleading to characterize the aesthetics of *sublimitas* and *diversitas* and *magnitudo* as essentially or solely Christian: they were bound up with cross-cultural discourses of prestige. Nor, if this more expansive analysis is correct, were they inextricably connected to ideas of *renovatio* and hence western 'historicist' imagination: monuments in the non-Christian world were not necessarily appropriate objects of historicist attention, in so far as such a form of attention could have existed in the Middle Ages at all.

This was not a short-term issue, solely for the early Middle Ages. It is quite possible that structurally innovative twelfth-century columnar churches in northern Europe, such as Saint-Denis near Paris, were built in the knowledge of the geometry of complex polygons in turn derived from

15 Córdoba, Great Mosque, al-Mansur's addition, late tenth century

gling church 1,000 *braccia* long, 500 wide and 200 high; the church of Santo Stefano is 600 *braccia* long and 300 wide; the Lateran ('Sion') possesses 1,200 marble columns each 50 *braccia* high, 1,200 gilded bronze doors, 1,000 rows of colonnaded aisles each 428 *braccia* long and 40 braccia wide, a presbytery with 1,400 columns 60 *braccia* high, and so on. This is not the language of practical aesthetics or topography, but of out-and-out megalomania, to which the Christian world could respond principally in its own reports of Wonders such as Hagia Sophia: in London around 1200 Ralph Diceto described the Byzantine church as having a design imparted miraculously, precious materials throughout, but also 365 gates, one for each day of the year, some of bronze or ivory, as well as 1,000 priests.[107] Even in distant Tynmouth Abbey, sources known by the fourteenth century provided knowledge of the 173 columns supporting the crypt of Hagia Sophia, 245 columns surrounding the choir, 752 doors and windows without number, the building being served by 700 priests.[108] The other form of response lay in the thoroughly unbuildable religious literary imaginings of the Gothic period (for example, the late thirteenth-century fantasy Grail-temple in the German poem *Titurel*). From both 'eastern' and 'western' perspectives (relative to Rome and Byzantium), *mirabilia* were, in the first instance, distant things beyond easy verification that stretched human capacities for action and thought to the limits. They were, in other words, an aspect of the imagination of the transcendent, notably the medieval capacity to wonder: *miror*.

It is characteristic of wonder as a rare experience seldom repeated that it pertains to the sense of sight: wonder is in the first instance 'a relation to the visible world'.[109] So the second sphere here is that of myth, or near-myth, in medieval wondering, as represented specifically by the Wonders of the World themselves, literally 'marvels' or 'sights', *miracula* or *spectacula*, in Greek θαύματα.[110] The (usually) Seven Wonders constitute the first, and certainly the most widely known, canon of extraordinary human rather than natural creations-to-be-seen, and it was in the rehearsal of this canon from the second century BC onwards that one learns much about regard for giant scale and difficulty. More than one author presents their huge physical dimensions, and the impression created by the early literature on them is that beauty was less fundamental than the value of sheer technical prowess: the Wonders were triumphs of human, not supernatural, ingenuity on a colossal scale, rivalling the great works of nature. What they actually looked like is secondary to the fact that they were great things made by men: as man-made miracles they enjoyed a special status.

ancient mathematical knowledge in the nexus Constantinople–Córdoba.[104] The keynote here is reciprocity. In both the Christian and Muslim spheres, so to speak, prestige was measured in the same way, by scale, by cunning and knowledge, and by reference to extraordinary things a long way away. For instance, in sources as early as Gregory of Tours (sixth century) the phenomenon of column counting in churches is encountered as a way of measuring and circumscribing their essence. The Arab world did the same, in a kind of mirror image to the western sense of the extraordinary. Consider the text on Rome, explicitly as a Wonder of the World, by Yāqūt (d. 1229) following the writing of Ibn-al-Faqīh (d. 903).[105] It is useful to encounter an Arabic source echoing the view of Cassiodorus that Rome was, indeed, one of the Wonders; there were also Arab traditions about the Colossus of Rhodes.[106] Yāqūt purportedly records the words of a monk who visited and lived in Rome, but whose descriptions of it are manifestly hyperbole: the basilicas of St Peter and St Paul are rolled into one mind-bog-

The Latin literature on the Wonders is of interest here because it developed and put to practical use a verbal association between the verb *miror* and the noun *magnitudo* that carried over from the ancient world into medieval aesthetic language. As Deliyannis has shown, in classical texts the phrase *mirae magnitudinis*, denoting a thing 'of wonderful size', was associated first with enormous monsters, natural things, monstrosities; but by the sixth century it had transferred to the man-made Wonders.[111] So in his *Etymologies* (xv.xi.3) Isidore of Seville, like St Jerome, uses the expression in connection with the tomb of King Mausolus at Halicarnassus.[112] Usage of this period sometimes introduces the noun *pulchritudo* into the complex *miror-magnitudo* in order to denote a great thing that, being specifically man-made, also possesses beauty or 'art' rather than just monstrous size: tombs, temples, columns, doors and so on.[113] Subsequently, authors such as Cassiodorus and Gregory of Tours developed a Christian canon of Wonders including Rome itself (Cassiodorus, the Pseudo-Bede, Niketas), Noah's Ark, Solomon's Temple (Gregory of Tours) and, later, Hagia Sophia, the only church ever accorded such distinction.[114] This type of canon tended to blur the distinction between things made by man and things designed by God.

Two things deserve emphasis here in relation to the overall theme of this book. The first is that this canon came only very late to acknowledge giant structures in the Christian world; Hagia Sophia was undoubtedly admired, and for western observers was the loftiest enclosed space known (rising to more than 55 m), exceeding even the 48-metre-high Green Dome over the palace in Baghdad built by Al-Mansur, which collapsed in 941.[115] Such gigantic heights (and spans) proved to be beyond the economic and technical means of Gothic architects, though it is possible that the Visconti, patrons of Milan Cathedral, considered exceeding them. One building that was undoubtedly measured for its width and presumably height (approx. 43 m), and which is likely to have been a reference point for internally lofty dimensions, is the Pantheon (see pl. 4); yet the Roman monuments seem to have been treated collectively in the wonder literature. The second point is that the language of *miror-magnitudo* became naturalized in the Christian language of experience of the extraordinary by its occurrence in the *Liber pontificalis*, the record of the patronage of the popes in Rome.[116] Its occurrence in English medieval texts, whether referring to buildings or precious artefacts, is normal.[117] Master Gregorius in his *Narracio de mirabilibus urbis Romae* refers to the many and wonderfully tall columns in the portico of the Pantheon (*multis et mire altitudinis*

columpnis).[118] Henry of Huntingdon, already seen as alert to the great size of Westminster Hall, uses it in his *Historia anglorum* in reference to the remarkable portal-like blocks of Stonehenge, which literary tradition considered to be the work of giants; like many commentators on the Wonders, such as Pliny the Elder writing about the pyramids of Egypt, his main question was simply 'how was it done?' What effect such architecture had was less important than the question of its coming into being.

And there is a further point, which goes to the heart of the heroic mode at its height before the thirteenth century, and seemingly on the wane after 1300. The introduction into the naves of such Gothic great churches as Chartres, Reims and Amiens (see pl. 28) of *dedales* or labyrinths implied that for some clerical agents, certainly in the period before 1300, Gothic itself represented a generalized form of heroic engineered outcome, the product of extraordinary human action and thought.[119] The typology of Daedalus and the Christian architect is a reminder that the wonder response was central to the Christian imagination. It was right that, in its own eyes, a triumphant Church should by action surpass and actually displace such ancient archetypes as the Pantheon, the labyrinth or the ancient Wonders. Such great churches were Promethean feats of technical prowess, triumphs of human ingenuity. Here indeed was 'superiority contested'; here too, that sense of the grandeur of a charismatic, heroic, bygone world. This is why it is helpful to stress the way that 'ancient' heroic values and models sustained and promoted Christian objectives. By 1200 the Church was deploying massive heavy technologies – in architecture, those of high vault construction and buttressing; in the pictorial arts, expansive window glazing; in music, the construction of increasingly large bell towers and organs sustained by developing metallurgical industries – all of which produced big effects whose sublime booming totality drove home by dint of sheer scale and power to all the senses the pastoral messages of Christianity.[120] The term 'astonish' derives from the Latin *attonire*, 'to thunder at'. In this regard the capacity to shock or astound was not an issue of sight alone. The enlarged claims of building miracles such as that of Gunzo at Cluny – that the essence of a building could be conveyed supernaturally – were again more typical of the period before the thirteenth century than later. The monastic tradition of the haulage of great marbles from Rome to northern Europe for the sake of the Church, which repeatedly plays on the idea of difficult, has already been commented on. Somatic metaphors of lifting and hauling are surprisingly common in this period. They

16 Wrestlers, portfolio of Villard de Honnecourt, *circa* 1230 (Paris, BnF MS fr. 19093, fol. 14v)

typify the cult of carts and oxen miracles passed down to us from Guibert de Nogent from Laon Cathedral.[121] In his celebrated portfolio of *circa* 1230, Villard de Honnecourt used the image of the wrestler as a figure or schema (rhetorical in origin) signifying the serious play of the gymnasium of ideas (pl. 16), as the place of trial and struggle in invention more generally: *omnia secundum litem fieri*, 'everything is fashioned in strife', as Petrarch was later to remark.[122] It took the wit of Chaucer to see in the fiercest image of all, that of the labyrinth, the Latin *labor-intus*, a metaphor for the labour, struggle and serious play, in acts of creation and interpretation.[123] By 1250 or 1300 this heroic world was in retreat; yet its final and most physically astonishing expression was just dawning.

Megagothic

To *miror, magnitudo* and *pulchritudo* was added a fourth term, already used by Eusebius of the high walls of Constantine's Holy Sepulchre: *altitudo*.[124] In 1323 the two Irish Franciscans travelling via England and France to the Holy Land noted in their itinerary that, in Amiens, there was a cathedral of wonderful size, height and beauty (*ecclesia mirae magnitudinis, altitudinis et pulcritudinis*) honouring the Virgin Mary.[125] A similar formula had been used at Beauvais in 1272 to mark the first liturgical activity in its stupendous new choir of astonishing height and size, *in choro recens extructo mirae altitudinis et amplitudinis* (pl. 17).[126] These very slow gear changes in Latin vocabulary show that while, in general, Latin aesthetic language was by no means exact in its many usages,

it did evolve to take account of new priorities; and one of these was the new importance in French building accorded to absolute and relative internal heights: buildings that were actually tall, but also that were designed in such a way as to appear even more so to observers, so as subjectively to heighten experience of the wonderful.

That a number of major Gothic churches are not only tall, but look tall, is an art-historical truism.[127] But from what has already been said about the aesthetics of *varietas* and their relation to self-transcendence, it will have become apparent to the reader that sheer volume was not the only factor in establishing a medieval aesthetic of the wonderful. Clearly, from the late eleventh century something was driving architects in the central and northern areas of France to erect buildings of almost unprecedented loftiness whose new priorities – stone rib vaults, tall, wide windows and lean supporting structures – required the most radical re-engineering of the Roman concept of the basilica since the fourth century. The history of this culturally peculiar, yet dazzling shift in priorities towards buildings that could be both very wide and very tall is beyond this study. Astonishingly tall structures measuring more than 40 metres or so in interior height were not a norm but an exception. Jean Bony even cast doubt on the idea that the tall, as opposed to the broad and spacious, Gothic buildings were the real seats of innovation – sheer scale and inventive power were not necessarily related.[128] The English tradition of seemingly endless architectural invention but not loftiness supports this. Yet some brief comments on Gothic as a set of practices that were driven by the setting of stupendous problems of 'aesthetic engineering' are inevitable in order to understand the Decorated Style, since, according to one model, it was born in the wake of a northern European height race that produced new and admirable structures.

The tall thin 'look' of French churches began with eleventh-century Romanesque thick-wall structures whose main vessels were stretched towards a height to width ratio approaching 3:1, as at Santiago, Conques, Saint-Savin-sur-Gartempe, St Sernin in Toulouse, Jumièges, St Lucien in Beauvais and Cluny III (the last rising to approx. 30 m).[129] The list may have included the old Westminster Abbey begun before 1066, a relative of the Jumièges type, and the nave of St Paul's in London (see pl. 1), at around 31 metres. By the 1080s, then, great churches could rise to approximately 30–31 metres, including the imperial cathedral of Speyer (approx. 31 m). It was at this exceptionally early point that the English template of internal proportions was set: of the loftiest churches of the Romanesque and Gothic

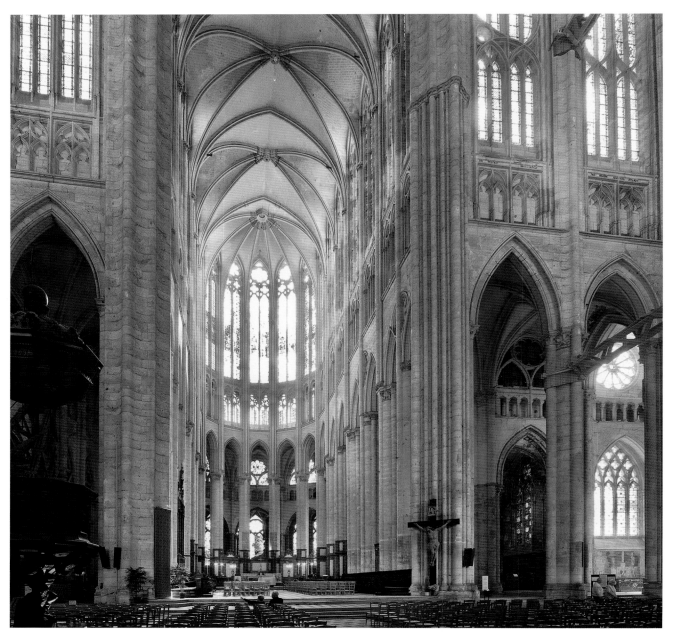

17 Beauvais Cathedral, choir and transepts

era in England, only St Paul's and Westminster Abbey (see pl. 21) in London, and the nave of York Minster begun by 1291 (see pl. 245), reached the 30 metre mark in their main elevations, York's planning and attention to French models presumably following Westminster's lead.[130]

The radical step had long before been taken by Notre-Dame in Paris (pl. 18), begun under Bishop Maurice de Sully in about 1163. The general plan in Paris was to create a high-vaulted, five-aisle basilica somewhat on the lines of Cluny III, but in size and thinness of structure reverting consciously to the ultimate 'Constantinian' model, Old St Peter's in Rome. St Peter's has always been celebrated as a very long and wide building, as its English imitators acknowledged. But it was also extremely tall, its roof being set approximately 32 metres (105 ft) above the pavement. The basilica's main elevation consisted of very large colum-

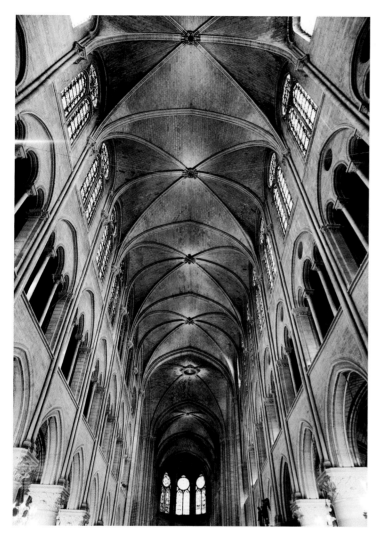

18 Paris, Notre-Dame, nave

nar supports sustaining exceptionally tall, thin walls, creating a tremendous impression of the load-bearing power of such columns. In Notre-Dame the walls are also thin and very sheer, and the columns appear to have the same load-bearing importance relative to the tall elevation, which, when vaulted, rose to approximately 32.5 metres (108 ft), just surpassing St Peter's and so by 1180 rendering the church the tallest of all Latin Christian buildings.[131] What motivated this new form of building is beyond this enquiry, though it is unlikely to be coincidental that Notre-Dame belongs to a family of giant five-aisle basilicas, including Cluny III and the cathedral begun at Bourges in the 1190s, whose form may have expressed the ambition of the Sully family, which held high office at all three institutions in the late twelfth century. But, once again, generalized emulation is almost certainly demonstrated by the passing remark of the chronicler of Robert de Thorigny under the year 1177 that the chevet (*caput*) of Notre-Dame was finished in that year minus its vaulting (or roof), a work that when perfected 'will have nothing on this side of the Alps with which it might be compared'.[132] This comment could allude to St Peter's in Rome or to yet more distant Wonders, and so cannot straightforwardly be recruited to the idea of a 'historicist' impetus in early Gothic building. But it was in the face of such aspiration that around 1190 Notre-Dame's neo-Stoic canon Peter the Chanter launched his celebrated 'Bernardine' attack on the proud *caputs* of French churches as affronts to Christian humility.[133] Something, or someone, in the Cluny–Paris sphere seems regularly to have goaded contemporary moralists, and vulgar personal ambition may be high on the list of suspects.

The subsequent narrative of *excelsior* is one of the most celebrated in the history of art, and it is expressed succinctly here by means of another table, of approximate maximum internal heights of the main vessels, planned or actual:

	feet (approx.)	metres (approx.)
Milan Cathedral (Parler projection)	187	57
Hagia Sophia, Constantinople	184	56
Green Dome, Baghdad (to 941)	157	48
Beauvais Cathedral	153	47
Cologne Cathedral	151	46
Milan Cathedral (actual)	148	45
San Petronio, Bologna	148	45
Palma Cathedral (Majorca)	144	44
Florence Cathedral	141	43
Ely Cathedral, octagon	141	43
Rome, Pantheon	141	43
Amiens Cathedral	139	42
Metz Cathedral	135	41
Narbonne Cathedral	135	41
Lübeck, Marienkirche	128	39
Reims Cathedral	125	38
Bourges Cathedral	125	38
Tournai Cathedral	118	35
Chartres Cathedral	118	35

Girona Cathedral	118	35
Le Mans Cathedral	118	35
Saint-Quentin, collegiate church	118	35
Paris, Notre-Dame	108	33
Soissons Cathedral	108	33
Prague Cathedral	108	33
Arras Cathedral	104	32
Cambrai Cathedral	104	32
Barcelona, Santa Maria del Mar	104	32
Rome, Old St Peter's	104	32
Speyer Cathedral	102	31
Westminster Abbey	102	31
London, St Paul's Cathedral (nave)	102	31
York Minster (nave)	102	31
Cluny III	98	30

Some points are particularly noteworthy in this table of buildings in Romanesque, High Gothic, Rayonnant and other styles. The first is that there are quite marked concentrations of buildings at certain height thresholds, which correspond closely to major models for emulation. One, including Florence and Amiens, falls in the 43 metre range, close to the Pantheon, which, though not formally recognized as a 'Wonder', was a well-observed and measured building and the loftiest enclosed space in western Europe, and so a straightforward challenge to any Gothic mason demonstrating the prowess of the new architecture. The inclusion of Ely's octagon at this point – exceptional in the sense that it was a crossing tower not a main elevation – will be discussed in Chapter Six, but it is observable that no other fourteenth-century English building appears on the list. Another point has already been noted: the group of buildings approaching or just exceeding 32 metres, the height of St Peter's, including Cluny III and Notre-Dame. Three also exceed or come close to the Roman basilica in length: Cluny III, St Paul's in London and Speyer.

Second, there are apparent cause-and-effect relations that are most probably explicable by inter-diocesan competition, such as the broadly chronological sequence Chartres–Bourges–Reims (1190s–1211): adjustments made during construction to the high vault profile at Reims, increasing it by nearly 2 metres, strongly imply a desire by the archdiocesan church not to be caught out by commitments recently made at Chartres and Bourges. Third,

excluding the two structures from the ancient world, four of the six loftiest Gothic churches are in the Mediterranean sphere. Fourth, two buildings confidently outstrip the Pantheon, the choirs of the archdiocesan cathedral at Cologne (begun 1248) and of the cathedral at Beauvais, begun after 1225 and consecrated in 1272. Of these two, it has been suggested that the module driving the height of the main elevation of Beauvais designed *ad quadratum* was derived from a translation of the 144 cubits measuring out the Heavenly Jerusalem in Revelation 21 into the corresponding number of French royal feet, yielding a height of 153 in modern feet.[134] The 'apocalyptic' figure 144 clearly also held significance for Giotto, whose shaft for the Campanile of Florence Cathedral (see pl. 184) begun *circa* 1334 was measured out at 144 Florentine *braccia*, its half measure 72 *braccia* yielding the height of Arnolfo di Cambio's cathedral nave, and corresponding happily to 'one Pantheon' (see p. 221).[135] By translating the 144 cubits of Revelation into modern units, Christian architects could not only arrive at a symbolically satisfying number but also automatically surpass the Pantheon, the one building that, since 609 or 610, historically and liturgically embodied a specifically Christian, and very well-known, vision of triumph and transformation embodied in the rite for the consecration of churches performed there by Boniface IV when it became Santa Maria ad Martyres, and later Santa Maria Rotunda.[136]

Beauvais, of course, went disastrously wrong in 1284 when its choir vaults collapsed. Yet this nemesis seems not to have deterred the Visconti project eventually to elevate Milan Cathedral into the greatest church of all time; its most implausible unbuilt scheme was that proposed in 1392 by Heinrich Parler for an internal elevation measuring 96 Milanese *braccia* in height, approximately 57 metres or 187 feet, exceeding the great dome of Hagia Sophia (56 m) by such a close margin that conscious surpassing may be guessed at: Milan was to be the first European building to outstrip a (late) addition to the canon of Wonders of the World.[137] But, as with so many façades, towers and spires of the period, this was nothing more than a paper ambition, lurking in the cathedral archive of Milan: by 1400 – and indeed in many parts of Europe by 1300 – it must have been clear that the drive to loftiness was proving economically unsustainable.[138] Milan was eventually engineered 'downwards'. In contrast to late medieval civic and parish projects, cathedral funding in northern Europe at least proved more erratic. The challenge of Hagia Sophia was ultimately met not by Christians, but by the fifteenth-

and sixteenth-century Ottoman determination, explicitly acknowledged in chronicles such as that of Tursun Beg and realized in the Suleymaniye mosque in Istanbul (1556), to take the great church as an exemplar.[139]

Superiority Contested: France and its Neighbours

No one was more alert than Pliny the Elder to the possibility that extraordinary human things could be done for less than noble reasons. In his account of the pyramids in Egypt, he opens by saying that 'they rank as a superfluous and foolish display of wealth (*pecuniae otiosa ac stulta ostentatio*) on the part of the kings'.[140] The emulative urge to build high, and with ancient Wonders in mind, reorientated upwards the zealous pursuit of *longitudo*. With the emulative urge came watchfulness, and with watchfulness came a willingness to adapt work in hand in order not to be outdone. The rapid reconfiguration of the high vaults of Reims noted just above may indicate attention to Chartres and particularly the archdiocesan cathedral at Bourges. At Beauvais (see pl. 17), within the archdiocese of Reims, Robert Branner noted a similar adaptive process in distinguishing between the first campaign on the great choir begun shortly after 1225 under Bishop Miles de Nanteuil and completed to triforium level, and a second campaign from the 1250s by a more adventurous, but possibly less scrupulous, architect who hubristically raised and attenuated the proportions of the choir, magnified to the point of vastness the clearstory windows, and fatally compromised the buttressing system, doubtless bringing about the collapse in 1284.[141] Not all aspects of Branner's account are accepted, but evidence backing the idea of a boost in the vertical scale of the building by a factor of 5 metres or so during the episcopate of Bishop William de Grez (1249–67) is provided by Stephen Murray.[142] This can be explained by aspiration – a desire to match the dimensions of the Heavenly Jerusalem – or by emulation, possibly of the Pantheon or of Amiens Cathedral (see pl. 28), begun in 1220, to which the height of the planned elevation at Beauvais seems first to have corresponded: by the 1240s the nave vault of Amiens was installed and its height self-evident in a way not true in 1225.[143]

Some kind of archdiocesan chauvinism of the more political sort may surely be suspected from the extraordinary preponderance of great churches with interior heights rising more than 32 metres within the archdiocese of Reims (Cambrai, Arras, Soissons, Saint-Quentin, Tournai, Reims,

Amiens and Beauvais) forming a vertiginous phalanx along the archdiocesan frontier with Cologne–Trier – the greatest concentration of such churches in western Europe. Reims' sense of its own standing as the focus of heroic architectural ambition and attainment was established even before its completion when huge images – actual architectural portraits – of its suffragan churches including Beauvais, Amiens and Soissons were installed in the hemicycle glazing in the 1230s and 1240s (see p. 128).[144] Some reaction from Reims' neighbours was inevitable. The choir of the metropolitan cathedral of Cologne, the archdiocese adjoining Reims, was begun in 1248 and eventually rose to within a metre or so of Beauvais. The extraordinary height of Cologne, and the equally obvious stylistic orientation towards High Gothic or early Rayonnant great churches in the royal domain of France, may be explicable by recognition of the situation in the archdiocese of Reims and especially by the ambition of its archbishop, Konrad von Hochstaden (1238–61), 'kingmaker' to Germany at a time when imperial authority was draining away during the so-called Interregnum. An attempt to outdo the French accomplishment seems clear.[145] Three other great churches emerged directly in the wake of the consecration of the choir of Reims in 1241. The first, the Gothic choir of Tournai Cathedral (begun 1243), reflects the city's submission to the French crown late in the previous century.[146] The impact of Reims is also apparent on the proudly idiosyncratic nave of Metz Cathedral in the archdiocese of Trier, also begun, it is now suggested, around 1243 by Bishop Jacques de Lorraine (1239–60) as part of a programme of city church construction, and in height exceeding Reims by a clear 4 metres or so.[147] The third was Westminster Abbey, rebuilt from 1245.

By the early 1240s in the archdioceses of Cologne, Trier and Canterbury, something like a near-total reorientation of interest had (apparently) occurred for the first time in the medieval period: the great buildings, the great ideas, the necessary 'look' of the great church, were now determined by models north, not south, of the Alps and geographically restricted to a relatively small, but prosperous and intellectually fertile area of northern France, at the heart of which lay the archdioceses of Sens and Reims, and King Louis IX (d. 1270) himself.

According to one source, this new agenda may even have been true of one region of France, its southernmost, which had fallen powerfully under the sway of Romanizing ideas well into the twelfth century. In 1268 the former archbishop of Narbonne, Guy Foulques, now Pope Clement IV, founded

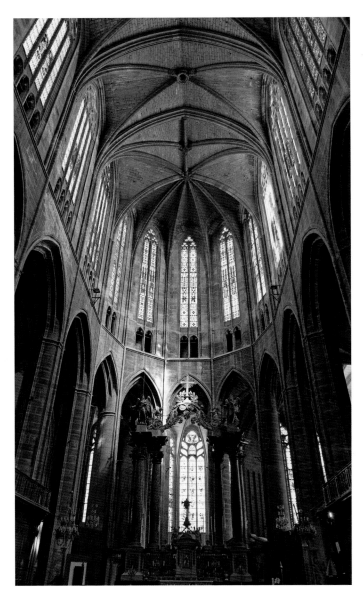

19 Narbonne Cathedral, choir, begun 1268

sleek but severe choir at Narbonne (pl. 19) does not, in fact, look quite like Rayonnant Saint-Denis or Notre-Dame. But technologically it is a Gothic church of the northern French type, being noble in its height but also splendidly 'worked'. Perhaps the same emphasis on production values, rather than exact visual outcome, is also suggested in the most famous document of French supremacy of the period, the text of *circa* 1280 by the chronicler Burchard von Hall describing the new Gothic church built in the French manner (*opere Francigeno*) at Wimpfen im Thal, which possessed windows and columns modelled on low-relief work (*ad instar anaglifi*), provoking much wonder among the people – language also redolent of the biblical account of Solomon's Temple.[149] As a pure statement of 'royalist' ideology, an anti-localist *grand projet*, Narbonne subsequently proved controversial. Clement IV was a councillor of Louis IX, and Languedoc had been annexed to the French crown in 1229; and the new cathedral was erected on the basis of a regional building boom funded in part by the seized assets of heretics. But this opportunity was short-lived: the diocese was subsequently divided and the cathedral corporation eventually fell into one of the many disputes with local communal authority that characterized the fourteenth century in Europe more generally, leaving the choir at Narbonne as a splendid towering stump, its transepts and nave only half raised and visible as such for miles around (pl. 20). The real era of royal power in the Languedoc concerned another form of 'impossible engineering', that of the canals in the Midi, in the age of Colbert.[150]

Narbonne falls into a pattern of extremely steep Gothic choirs begun in the thirteenth century that did not evolve into complete church reconstructions. Only a minority of northern Gothic cathedral churches exceeding 30 metres in height were built in their entirety in the thirteenth century – principally Paris, Chartres, Bourges, Soissons, Reims and Amiens – and it was only those begun by 1220 that also acquired fully developed sculpted portals and some at least of their projected towers, as the somewhat limited itinerary for study recommended by Bleuet of Troyes in 1455 implies (above, p. 5). The multi-towered profile of Romanesque and Gothic cathedrals in the north was to become a thing of the past: the future lay with the giant single tower or steeple. Beauvais' days of affluence were over by 1300; Tournai's economy was being exhausted; the nave of Metz was still under construction around 1380 as the economy of Lorraine faltered; and Cologne Cathedral too remained incomplete at the transepts, with the west front scarcely begun.[151] Projects not started or substantially incomplete around 1240

a new cathedral in that city which was to be 'wonderfully sumptuous, most beautiful and becoming' (*mira sumptuosa pulcherrima et decora*) and which in building was 'to imitate the noble and magnificently worked churches which are being erected in the kingdom of France, or have been completed' (*in faciendo imitare ecclesias nobiles et magnifice operatas et opera ecclesiarum que in regno Francie construuntur et sunt in preterito jam constructe*). Since the text recording these opinions survives only in a redaction of 1349, its authenticity as a statement of papal aesthetic intent in the 1260s is open to question.[148] As built over the ensuing decades, the

Westminster Abbey and Palace

England's economy did not move *pari passu* with France's, rather the contrary (see Chapter Three). But one building that acknowledged the revelatory qualities of French Gothic as things stood around 1240, and which also remained incomplete as a Gothic church for many generations despite extraordinary resourcing possibilities, was the English coronation church, Westminster Abbey, the new east end of which (pl. 21) was begun in 1245 by Henry III (1216–72).[153] Henry's express intentions for the church were never explicitly recorded, but they can, to an extent, be inferred from the building itself. Pope Innocent IV in 1245 and again in 1250 called it a work of the 'greatest costliness' (*opus plurimum sumptuosus*) and of 'wonderful beauty' (*mire pulchritudinis*), conventional aesthetic language very like that of Clement IV's purported remarks about Narbonne.[154] Costliness was a virtue to be catered for, not excoriated, and

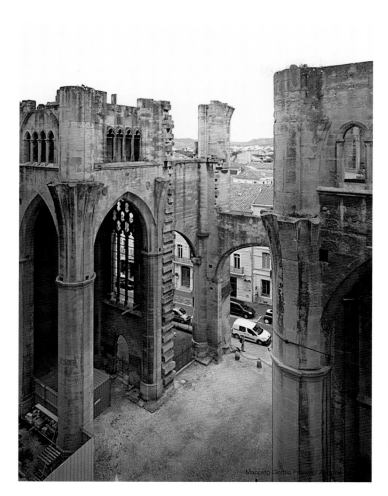

20 Narbonne Cathedral, crossing and nave looking south-west

were likely to experience difficulties unless they were in some way the beneficiary of exceptional revenue streams, or were in the region of Paris broadly construed. According to one type of analysis, the glory days of the Continental cathedral 'building boom' were over. After 1290 or so, the successful projects in the lofty mode were to be found to the south, in Catalonia (Barcelona, Santa Maria del Mar, from 1329), in the Balearic kingdom of Majorca (Palma Cathedral, from 1306, greatly enlarged from the 1360s), in Tuscany (Florence Cathedral, from the 1290s) and Lombardy (San Petronio in Bologna and Milan Cathedral, 1390s). The tendency to gigantism flourished in the mendicant churches, as at Toulouse, Norwich, Venice and Perugia.[152] Elsewhere (Bordeaux Cathedral, Toulouse Cathedral), the signs of exhaustion are apparent in the retention of wide twelfth- or early thirteenth-century naves accompanying Rayonnant choirs and transepts.

21 London, Westminster Abbey, presbytery, begun 1245

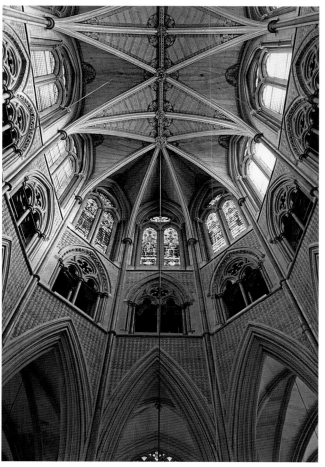

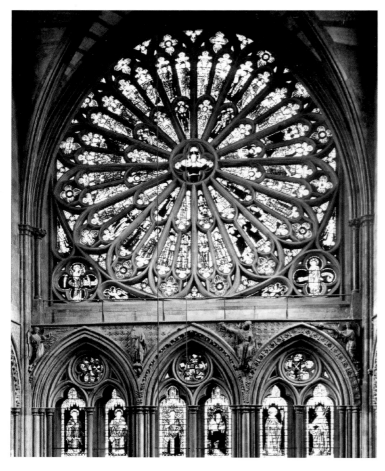

22　London, Westminster Abbey, south transept, rose window

charge, Henry of Reyns, adopted wholesale the design of the giant north transept rose window of Notre-Dame designed in the 1240s (or something very like it, perhaps in the Sainte-Chapelle) for the transepts of Westminster (pl. 22), just as did the Swedish coronation cathedral at Uppsala, begun in 1287 by a Parisian-linked architect, Etienne de Bonneuil.[156] Its fenestration generally indicates the newly acquired semiotic power of French Gothic tracery as developed in Reims and Paris. Incidentally, much the same might be said about the chapter of St Paul's in London, which opted in the late 1250s to borrow the design of Notre-Dame's south transept rose for the east end of its new work on the choir, eventually dedicated and measured in 1314 (see pl. 44). This was to be the single most well-known Gothic motif in England.[157] But, in a practice fundamentally objectionable to the rationalist mind of modernists, yet completely in keeping with the nature of great and eclectically well-informed patronage of the sort that Henry III obviously and repeatedly exerted, Westminster's architects rejected the Rayonnant 'system' as a whole, so dismissing themselves (in later eyes at least) as muddled and unsystematic empiricist opportunists out for a big effect.[158]

If one thing is clear from a study of Westminster, it is that formalist discussions of the rationalist type are by nature uncomfortable with, or heedless to, the brute, even vulgar, realities of virtually all high art commissioning – that such patronage did not wish to accord with 'systems' or the international movement of 'styles', and was prompted less by reasons than by entirely human motives of questionable delicacy, some of which (in Westminster's case at least) are acknowledged to have been blatantly political. It is for this reason that Bony's notion that a stately building such as Westminster Abbey can be seen simply as 'a rather objective and unbiased summary' of northern French Gothic at that time is so manifestly open to question.[159] Whatever the success of the eventual outcome at Westminster judged by the rather demanding norms of French rationality, the abbey remains a central example of the inseparable relation of form and content. This aspect of its architecture as a sort of seedbed for the later development of the Decorated Style was completely bypassed by Jean Bony, whose lack of interest in human context is striking. Westminster's general aesthetic of enmarbled opulence was quite as much recognition of the quasi-apostolic grandeur of Canterbury (see pl. 13) – and so of the aura of St Thomas – as of the more cerebral French models consulted in its making. In regard to magnificence and mixture it matters greatly to any understanding of the importance of the abbey's furnishings in Roman

Henry III had deep pockets, establishing a special exchequer for this most lavish building, completed to the first bays of the nave in the years 1245–69, quick even by the standards of the best-funded French *grands projets*. All this should be seen in the context of the Plantagenet–Capetian rivalry that was expressing itself at this time in the cults of relics of Christ's Passion at the courts of Henry and of his brother-in-law Louis IX.

This narrative of the heroic mode culminates with Westminster because, formally speaking, the abbey has been positioned at the very head of the process that triggered the Decorated Style, a style in turn denoting, in Jean Bony's words, 'everything that developed in direct response to the introduction into England of Rayonnant forms'.[155] Without being a Rayonnant church, so much as a relatively thick-walled High Gothic one with some Rayonnant tracery, Westminster's response to the most widely admired features of the very latest Parisian style is obvious: the master in

23 London, Westminster Abbey, Cosmati pavement before high altar, dated 1268 (compare pl. 10)

from which it borrowed much formally: the cathedrals of Reims and Amiens. What directed its dimensions were those of the previous church on the site and the desire to express parity with St Paul's Cathedral in London, as well as to outstrip all other English shrine churches in loftiness. Its general correspondence in height to Notre-Dame in Paris, also a 'royal' church, probably also mattered to Henry. Resources were directed by Henry III especially into a prodigious use, English-fashion, of Purbeck marble, remarkably complex templates, a waffle-like interior surface finish worthy of a Mosan shrine, and a technically prodigious display of brilliant, confident French-style window tracery. Henry's masons must have taken account of the progress of the Sainte-Chapelle in Paris, started around 1239–40 by Louis IX, and consecrated in 1248 (pl. 24). By 1250 Henry ordered that the corresponding chapel in the palace of Westminster, St Stephen's, should have added within it images of

24 Paris, Sainte-Chapelle, 1239–48, interior; for the reliquary platform, see pl. 87

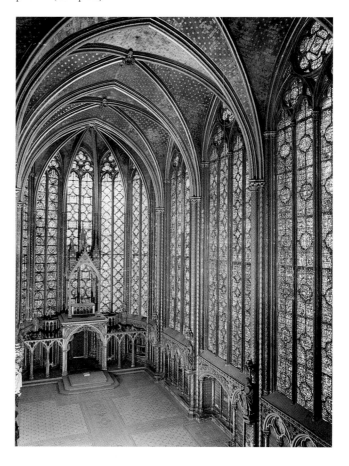

Cosmati mosaic – the sanctuary pavement, the shrine of St Edward (pl. 23 and see pl. 30) and the tomb of Henry III – that the first of these to be executed, the sanctuary pavement in 1267–8, was almost certainly facilitated by Clement IV in the wake of the recently ended civil war, and not something attributable in the first instance to the agency of Henry III, who together with the abbey seems to have borne the removal expenses of the mosaics.[160] Yet Bony states of such mosaics that 'It was the King and his Court who had taken the initiative of opening England to the new trends of Continental art. Henry III had a wide curiosity of taste and was attracted not only by French but also by Italian fashion.'[161] The use of Roman Cosmati mosaics at the liturgical heart of the abbey rendered it the most thoroughgoing statement of courtly *varietas* in contemporary Europe: but this cannot simply be ascribed to the king or his agents.

On the other hand, Henry's interference in the general concept of the abbey's architecture is probable, and his sanction certain. The abbey is, by English standards, a tall and fairly slim building, but well within the height range of 31 metres or so established as an absolute maximum in the Conquest era. It was easily outstripped by two tall buildings

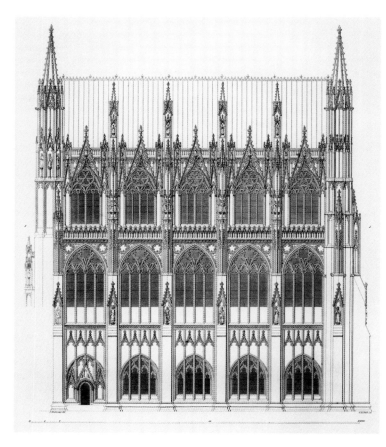

25 London, St Stephen's Chapel, Westminster, begun 1292, exterior south elevation, by F. Mackenzie, published 1844. The detailing of everything above the principal cornice of the upper chapel, including the clearstory and exterior statuary, is hypothetical. For the interior elevations, see pls 42, 63 and 85

the Twelve Apostles around the 'circuit' of its walls, together with a *Last Judgement* at its west end, features that must fix the date of the corresponding features of the source for this idea, the Sainte-Chapelle itself.[162] Though Cologne Cathedral did not use Paris-style rose windows, it too adopted the same circuit of Apostles around its choir interior.

Such wholesale filching and recombining of separate elements drawn directly from the Paris court milieu is very evident at Westminster between the 1240s and 1260s and is already well understood; this building undoubtedly set a precedent for the calculated mixture of ideas so apparent later in the Decorated Style itself. Cruder emulative motives remained at work at court. Just as Philippe IV of France (1285–1314) was casting an eye on the unmatched scale of Westminster Hall when replanning his own palace of the Cité in Paris and its new double-aisled Grande Salle, Edward

I was revamping the chapels and chambers at Westminster itself.[163] England had no tradition of what were later in France to be known as Saintes chapelles, but it did have palatine chapels. As rebuilt totally from 1292 by order of Edward I, St Stephen's Chapel (pl. 25) in the Palace of Westminster became a prodigy of invention in the Decorated Style in regard to its composition of elevations, vaulting, window tracery and micro-architecture. Like the Sainte-Chapelle to which it is often (and not always helpfully) compared, it was a two-storeyed palatine building. The Parisian building has a lower chapel 6.6 metres (22 ft) in height, and an upper chapel interior 20.5 metres (67 ft) high, 10.7 metres (35 ft) wide and 30.5 metres (100 ft) long. In 1292 St Stephen's was drawn out on a slightly smaller scale, its lower stone-vaulted chapel being 5 metres (17 ft) tall, its upper chapel 10.7 metres (35 ft) wide wall to wall, but 27.7 metres (91 ft) long. Its upper chapel was not at first conceived with a vault but with a wooden roof planned to rise immediately over an embattled cornice 12.8 metres or nearly 42 feet above the pavement, the internal ridge presumably rising to around 16.5 metres (54 ft).[164] So while its footprint was similar, its original intended interior height was about 4 metres below that of the Sainte-Chapelle. But this was to change. The construction of St Stephen's was a dilatory and complex process stretching over three reigns, but at some point between the full resumption of work in 1319–22 and 1333, the decision had been taken to revise the elevation of the upper chapel by the addition of a substantial clearstory in stone and wood, set above the range of already very large tracery-filled windows and the strong embattled cornice over them, planned in 1292 (see also pl. 85 for the interior elevation); this work was completed in the 1340s, and on it may have been employed the court carpenter William Hurley, who was in the process of raising the stylistically related wooden octagon and lantern at Ely (see pl. 152).[165] It had two presumed consequences: it hugely increased the level of natural illumination in the chapel, so allowing the lower parts of the main windows eventually to be blocked and painted; and it raised the total interior height by a factor that is uncertain (the clearstory was removed in the 1690s by Christopher Wren), but which could have been in the region of 7–8 metres, so approaching or even surpassing that of the Sainte-Chapelle at 20.5 metres.[166] Such things are part of the history of human political motivation, as well as of invention: the kings of England still performed homage to France as late as 1331. But a crucial moment in any re-evaluation of the royal chapel at Westminster might have been Edward II's state

visit to Paris in June 1313, when it is known that his father-in-law Philippe IV showed him the Sainte-Chapelle itself, since Edward made an offering there on 7 June.[167] That such competition took place is a matter of inference, but in support of the idea a postscript may be added in the form of the documents datable to around 1448 in which King Henry VI set out the specification of the college of his new foundation at Eton; one of these specifies the dimensions of the chapel, the choir of which 'schall be lenger than the qwere of the Newe College at Oxford bi. xlvij. fote brodder bi. viij. fote. and the walles heyer be. xx ti. fote. *And also heyer than the walles of seynt Stephenes Chapell at Westmonstre*' (my italics).[168] The chain reaction of greatness continued into the later years of Gothic. It is of course obvious that an interest in the height of such buildings alone cannot give a full account of their artistic character. But it conveys something about status and emulation. While the heroic mode in the conception of great churches was now increasingly unaffordable, its most primitive instincts had persisted into an age geared to inventive brilliance on the smaller scale.

The Decorated Style after Modernism

My introductory overview ends with Westminster Abbey, because this is where Jean Bony's influential study of the Decorated Style actually began, in 1245, with the reception in England of the large traceried Rayonnant window, which Bony saw as the major motor of change in English Gothic. Bony was of course profoundly well versed in the character of English building before 1245. Yet his narrative of the Decorated Style was not one about the longer continuum, but rather about a much narrower reception of comparatively recent formal trends in French architecture, and about an extraordinarily rapid and inventive transformation in the decades following 1245, which eventually re-energized the whole Gothic 'movement'. Bony's case speaks for itself: it is founded on the language of revolutions, not evolutions, seeing the Decorated Style as the outcome of shorter-term, essentially tactical, reactions. To suggest, in countering this approach to the Decorated Style, that what is required instead is a sense of the *longue durée* and of the wider panorama of European aesthetic activity is manifestly to challenge this paradigm of thinking. To begin to do this has entailed taking the reader through a bewildering range of materials and ideas at the outset in order to take a fresh look not only at the Decorated Style but also at the framing

of medieval aesthetic activity of which it formed so distinguished a part. My interest is less in the specific movement of forms, important (and well understood) as this is, but in the regime of the arts that governed that movement, gave it power and put it to effect.

To understand this regime is to take account of the persuasive domain of large-scale aesthetic activity expressed in magnitude, and of mixture or complexity discussed here under the virtue of *varietas*. In the course of the late thirteenth and fourteenth centuries artful complexity tended to flourish at the expense of magnitude. Few of the centres of innovation in the Decorated Style appear in the lists above of buildings that were either very extensive or very tall: this idiom was one that adapted well to the fact of an established, even saturated, building stock and a stable but not booming economy. To Bony, the dialectic of 'northern' complex linear networks (*varietas*) and the 'southern' feeling for vast space (*magnitudo*) actually drove the dialectic of late medieval European Gothic as a whole. Scale and innovation, as Bony suggested, were not necessary bedfellows. Yet each was fundamental to the persuasive (including religious) objectives that complex styles such as the Decorated at least in part served. Understanding these means and ends has not been a concern of the sort of formalist criticism that has dominated the field in the period of modernity.[169]

Consider at the outset certain presuppositions of authorities such as Bony and Robert Branner whose intellectual roots lie in modernism itself. One is the category of the 'rational'. Bony considered northern French Gothic to be premised upon rationalistic thinking of which thirteenth-century Rayonnant was eventually a product: Rayonnant reached 'an extreme of logicality' as a miracle of 'insubstantiality, not of irrationality or of fantasy'.[170] In turn, the Decorated Style was a 'direct response to the introduction into England of Rayonnant forms' whose context of system the English rejected, 'in a very English reaction'.[171] This sort of argument has corollaries that are potentially damaging to a full understanding of the arts of the period. One is a tendency to imagine that, because artistic outcomes in England and France differed, the English were by implication irrational in their outlook. This notion – an aspect of the European intellectual's view of the English as a romantic, literary and liberal nation – deserves its own history. Its most brilliant instance is a paper entitled 'The ideological antecedents of the Rolls-Royce radiator' delivered by Erwin Panofsky in 1962, a text half-wedded to racial theory (the English are irrational partly because of their 'Celtic' legacy), and fully committed to the notion of a medieval English

romantic and sublime imaginary.[172] Panofsky's essay entered Pevsner's territory of formalist and collective cultural analysis without once – strikingly – mentioning Pevsner himself: it is as if Panofsky was intent on formulating *The Englishness of English Art* without noting that it had, in fact, already been done. Pevsner's writing embodied no less this sort of thinking in emphasizing the expressionistic and perverse tendencies of the Decorated Style.[173]

The interest of this generation of European scholars in the English imaginary – marginalia are invariably mentioned along with 'curvilinearity' – is frequently coloured by the sort of dualistic thought also implicit in the language of marginality. It is useful to spot the way that an emphasis on English irrationality underwrites the major narrative of Gothic around 1300: that of a shift of creative initiative from (central) France to (marginal) England. When, in *Gothic Architecture and Scholasticism* (1951), Erwin Panofsky used the image of centre and periphery to explain what was happening at the start of the fourteenth century, he tied the decline or sublimation of the rational scholastic system in France to a rise in 'anti-rational mysticism' and subjectivism.[174] But there was a deeper-seated premise to this argument about decline and fragmentation: an acceptance of the crucial role of France and French art in the aesthetic evolution of modernity itself. *Ipso facto*, France had to be the premier site of innovation from which ideas were eventually diffused throughout Europe.[175] This diffusion necessarily carried with it the implication that the rationalistic, even academic, character of French Rayonnant contained within itself the seeds of its own destruction. Vitality would come to be assumed by the unorthodox, polymorphous margins. This position of course underestimates the innovative character of fourteenth-century continental European Rayonnant, the energies of which are now being recaptured by scholars.[176] For the present purpose, the important point is that an entire but questionable narrative has developed from the modernist edifice of rationality and irrationality, centre and margin – a narrative that has also spread, for different reasons, to the study of the illuminated manuscript. The notional 'freedom' of the margin is quite as apparent in the thought of modernists discussing architecture, as of postmodernists interrogating marginalia.

In this, play matters. Bony's use of words such as 'playful' ('ever since the arrival of Gothic . . . a general tone of playfulness – often with a touch of pure fantasy – had constantly been present in English architecture') is a distraction from the universal importance of the ludic in all medieval invention: according to his usage, play is not for the rational, let alone for the adult.[177] As regards rationality, the stonework argues against it: the astonishing sophistication of ashlar cutting and rib vaulting developed in the service of this idiom in the Anglo-Norman domain before 1100 should be a caution against supposing that rationality in planning, quarrying and cutting did not pre-date the thirteenth century.[178] Almost all types of vaulted Gothic buildings were based upon it, and the English participated fully in this practice. Every important aesthetic decision discussed in this book was, on the contrary, the product of exquisite calculation of the relation between conception, making, apprehension and understanding. Such calculation has nothing to do with fantasy or irrationality: it is best seen as the product of fully self-conscious intentional activity on the part of rationally minded artist-authors with personal styles. It is characteristic of some criticism that it sets medieval authorial agency aside almost entirely. In order to understand what rational calculation means, it is necessary, then, to turn first to authorship and invention, and it is there that I begin to delve (Chapter Two).

Little or nothing in the evidence (I believe) truly entitles one to press any further forward older structures of thinking without taking great care to examine the possibility that any thinking that overlooks the crucial notion of mixture and ambivalence governed by conscious agency is in some way misleading. My argument runs firmly against the cultural positioning of marginalia in only one possible way. But herein lies a more general issue of aesthetic consequence. The main point is that I favour an impure or mixed *centre*, seldom or never severed from that which is both serious and delightful or on the edge. What lends power to this paradigm (presently split across a centre–margin divide) is the aesthetic force and character of the representations themselves: it is this force that lends representation pleasure and power. For that reason, in Chapter Eight I set out an account of 'borders' consistent with this more general line of argument. To strip out the domain of sense-based knowledge from consideration of artworks is to block any consideration of how they actually function, a point I enlarge in my discussion of the aesthetics of the Decorated Style in Chapters Four and Five, in which I reflect on allure, vitality, persuasiveness, and heightened awareness.

These words, like 'pleasure' and 'power', are not lacking in psychological purchase, and they lead back to scale and complexity in the arts at large. In the fourteenth century the Decorated Style emerged as a style in intelligent dialogue with the accomplishments of the existing building stock of great churches (p. 68). The scale of these older monuments

was now beyond imitation – for reasons examined in Chapter Three, on money – but not their inventive prowess. It is for this reason that this chapter has considered the fate of the heroic mode as a prelude to a subsequent age of invention within more obvious constraints, economic and practical. Measurable scale, whether supernatural, biblical or human in origin, may have supplied the essence of a building but above all was the starting point for inventive thought. The example focused on especially in regard to the persistence of important mensural types as cognitive starting points is the major building complex at Ely Cathedral, in hand by the 1320s, discussed in Chapter Six. Depth of typological thinking enabled the creation of artworks of stupendous surface complexity (the Lady Chapel at Ely, see pl. 154) or great scale and universal form (the Ely octagon, see pl. 152).

The Decorated Style provides exceptional material for consideration of the aesthetics of the wondrous, often rooted in complexity as much as scale. *Varietas* is not, to repeat, a classic architectural virtue. It operated in a way similar to giant scale, in stressing exceptional human accomplishment; but *varietas* is typically a virtue of worked surfaces. Despite that it was not 'superficial'. To suppose so is to fall headlong into the trap of imagining style, and particularly decoration, to be the pretty skin, superfluous to the 'underlying' content of a work, that plagues Romantic criticism, and for that matter modernist moralizing about style and superfluity. *Varietas* helped to import significance while also troubling the very category 'architecture', so raising the entire question of what an architectural virtue might be. To that question, the Decorated Style was to volunteer one particular set of replies: that, as with certain forms of postmodernism, its architecture consists in the relationship to what is not itself.

Because *varietas* is complex and impure in character and may involve more than one medium, it seems antagonistic to the modernist emphasis on pure, even absolute form, the stylistically self-referential and the tendency to separate media from one another. W. J. T. Mitchell illuminates the point very well: 'the purification of the media in modernist aesthetics, the attempt to grasp the unitary, homogeneous essences of painting, photography, sculpture, poetry, etc., is the real aberration . . . [for] the heterogeneous character of media was well understood in premodern cultures'.[179] The important aesthetic category of *varietas* is to be understood not least within artistic training systems that linked, rather than separated, the acquisition of skills, as witnessed by the treatise by Theophilus, the arrangement of workshops at Cluny and the record that under Desiderius of Monte-

cassino monks were trained in all the arts, not some.[180] To grasp the nature and importance of artisanal mixture is to get behind the agenda of Romantic and modernist aesthetics of separating and reifying media as 'absolute' art forms. Modernist aesthetics have tended to be categorical, selective, hieratic and profoundly self-referential. With few exceptions they have led art historians to absolutize such media as architecture, sculpture and painting, and in doing so to create a hierarchy of invention and media that did not exist before the Renaissance: no concept of the *artes minores* was known in the Middle Ages.[181] What energized medieval creativity and created delight was precisely the dynamic shift between that which (later) would be regarded as small and great. Throughout the book that follows, these hieratic assumptions will be set aside in favour of a holistic reading that accords much better with the evidence of medieval and pre-medieval attitudes to that which was pleasurably persuasive.[182] This of course necessarily entails thought about the senses working together as a whole. Modernity has tended to develop a strong epistemological bias towards the sense of sight, and towards a division and hierarchy of the senses: 'visuality' has been a keynote of a substantial number of recent studies of medieval art.[183] The term 'holistic', which might for the sceptical bring to mind the tenets of alternative medicine, should instead be a reminder that, in Mary Carruthers's words, 'there is an enduring core of [medieval] medical writing . . . about the therapeutic effects of all sensory experience – sounds, and colours, and smells'.[184] Holism keeps open for us those dynamic possibilities of invention that arise from productive tension, as well as alerting us to the psychological content of arts in a way less favoured by the secularizing and univalent or categorical tendencies of modernist formalism.

Transhistorical concepts of modernism create a final, and significant, difficulty to which I will be returning throughout this study in considering the issue of authority (Chapters Two and Nine). They actually obscure the dynamic relation that some of the leading art forms of the period had to artefacts from the chronological past. Krautheimer shows why. His great insight was that the study or appropriation of archetypes, whether buildings or other artworks, occurred regardless of the actual antiquity of those archetypes: it was motivated not by their age, but by their present, enduring authority. There is remarkably little evidence in England in this period that clients or architects knew or cared about the exact chronological origin of things that caught their eye because, to them, they were old, impressive and possessed authority. The pre-Renaissance relation of

26 Chartres Cathedral, south transept south wall, stained glass, Daniel holding up St Mark, early thirteenth century

the nature of 'dynamic tradition': the *moderni* were as dwarfs mounted on the shoulders of giants, the *antiqui*, dependent upon them, yet seeing further.[185] This image, colossal and invigorating, was eventually chosen for some of the most prominent stained-glass windows of the transepts of Chartres Cathedral (pl. 26): it has been passed down to us in John of Salisbury's *Metalogicon* and its origins are complex.[186] For us it perfectly embodies in its physicality, action and sense of exaltation the 'heroic mode'. But it also captures, in fact lends substance to, the central typological idea, so well understood by Krautheimer, of the foundation of the Old underwriting the insights of the New, both in biblical terms and in those of the ancient world: that the relation of old and new authority is vital and mutually enhancing. This idea is far stronger than some weak notion of tradition. Modernism's central claim, on the contrary, is that the 'past' is in some way exhausted and should be dispensed with as a matter of principle.

Though their means differed from those of any previous way of building, the architects of the Gothic cathedrals persuade us, as they presumably persuaded their contemporaries, that, to quote Walter Cahn, 'mastery in the most accomplished sense has a kind of self-evident, autonomous claim to our admiration'.[187] In this regard they belonged to a much deeper, much more persistent, tradition of doing great things by means of stupendous technologies, their 'style' regardless: and it is against this that their 'modernism' must be measured. The French succeeded in producing one form of wondrous architecture informed by an idea of the superhuman, derived precisely from past authority. The English produced yet another, no less regardful of that which already possessed authority. The drive to superhuman technical accomplishment was not a modernist creation at all, but an aspect of the human *longue durée*. It is very important to stress that the wonder occasioned by *magnitudo* is wonder at a certain form of human achievement – and for this reason I have stressed the rational, technological basis of 'wonders' such as megagothic structures. In their presence, we, as humans, are enlarged, not diminished: no one, to my mind, fell victim to the terrors of a Romantic sublime in the Middle Ages.

The dynamic interdependence of ancient and modern helps one to understand the character of medieval invention as a form of renewable discovery, not least in a country, England, where 'traditional' medieval aesthetic values proved remarkably persistent. Post-Renaissance or modern concepts of self-conscious, even ironic, detachment from the past in 'historicism' – meaning, in this case, an acquiescence

ancient and modern was not simply a struggle, but a relation of productive interdependence between continuing old yet 'present' authority and new insight. In the twelfth century Bernard of Chartres and Peter of Blois found for it a perfect visual metaphor that brilliantly energized understanding of

to old styles regardless of their social relevance – precisely misunderstand this dynamic relation. It will be suggested later that the approach of English medieval artists and architects to art and architecture already before their eyes – whether Insular book art, 'Roman' remains, Romanesque architecture or the most dazzling accomplishments of the latest French building – was not that of a self-conscious detached and revivalist historicism, but of an active mode of reflection, deliberation and engagement that accorded more with the way that medieval glossators pondered existing textual authorities and then developed new arguments.

The 'old' works were deemed to have a continuing present authority. Not that England was obsessed with things past. The keynote was not revolutionary innovation or radical departure. Older, authoritative, artistic achievements stood precisely as *guarantors* for later, and in their way more brilliant, artworks. Mixture needed strong foundations.

But there are still important steps missing from the argument: next, it is necessary to consider more deeply the position of the agents who created art through the process of invention as a rational act, and indeed the nature of invention itself.

2

GOTHIC INVENTION

Decorated is perverse, capricious, wilful, illogical, and unpredictable.
It is unreasonable, where Perpendicular is reasonable

Nikolaus Pevsner, *The Englishness of English Art* (1956)

...poetry, even that of the loftiest, and, seemingly, that of the wildest odes, had a logic of its own,
as severe as that of science; and more difficult, because more subtle, more complex, and dependent on
more, and more fugitive causes

Samuel Taylor Coleridge, *Biographia literaria* (1817)

Dreaming and Thinking: The Rise of Rationality?

The idea that the phlegmatic English were not altogether rational is a construct not of modernity, but rather, if Pierre de Celle (bishop of Chartres, 1181–3) is to be believed, of medieval humoural theory. Pierre fell into a debate with an English monastic correspondent about the merits of the doctrine of the Immaculate Conception, which the English, who according to Pierre were prone to visions and imaginings, favoured. He saw the English capacity to dream as a form of *levitas*, light-heartedness, as opposed to French *maturitas. Levitas* was brought on, in Hippocratic fashion, by water, the pervasive insular element:

I now come to deal with your imaginings (*phantasmata*), seductive in their beauty but shaky for lack of a solid foundation ... Let English levity not be offended if Gallic maturity proves to be the more solid ... In my experi-

ence the English are greater dreamers than the French, and the reason is that a more humid brain is much more quickly affected by the vapours of the stomach and develops all kinds of images within itself ... and these are formed below the level where truth is judged and are called phantasms or dreams. But Gaul is not so cavernous and watery a place; it has mountains of stone ... it does not so easily deviate from sound judgement.[1]

Pierre drew no conclusion about the consequences of this temperament for English artistic invention, though wateriness tended to be linked to slow-wittedness. Mere imagining was not enough: true artistic invention required reasoned reflection or cogitation, weighty judgement of truth or *maturitas*, those qualities that were much later to connect earthy melancholy to the science of geometry.[2]

Pierre's views were, of course, stereotypical nonsense, though for the purposes of the present book they are useful

nonsense.[3] Something of the distinction between *levitas* and *maturitas*, fantasy and experienced judgement, survives in Jean Bony's views that, though English architecture could have 'high imaginative quality', it also showed that 'ever since the arrival of Gothic little more than a century earlier, a general tone of playfulness – often with a touch of pure fantasy – had constantly been present in English architecture. Gothic was never quite taken seriously.'[4] In assessing the importance of the ogee arch, Bony wrote that 'a new dream had seized the imagination of a most imaginative race'.[5] The yardstick of 'seriousness' is presumably French. It is the kind of rationality attributed by authorities such as Bony (himself working within a 'rationalist' understanding of architecture stemming, via E. E. Viollet-le-Duc, from deep within the French classical tradition) to the Gothic architecture of France.[6] According to Bony, echoing Erwin Panofsky's famous account of Gothic architecture and scholasticism, French thirteenth-century Gothic reached 'an extreme of logicality in the mental processes involved' and was 'the most logical of dreams'.[7] In England, wrote Bony, architecture did not hold the 'position of intangible pre-eminence' that it did in other countries, and as a result was more 'receptive to transfers from other techniques and to a wide range of influences' than the more closed European traditions.[8]

Quite suddenly, then, in the late thirteenth century the English imagination and free market in forms and ideas conferred on its architecture a liberty no longer available in the great French tradition, which correspondingly fell into a lofty academic routine. This analysis offers an intriguing description, but a problematical explanation, of the course of architecture around the year 1300. Throughout, this book will explore the many freedoms – freedoms of reference included – that English artistic practices indeed enjoyed at this time in architecture and the figurative arts, though it will look a little harder at why this liberty was sought. Evidence will also be encountered that the French did in fact develop high doctrines, not just of architecture in relation to other professions and bodies of thought, but also of human artistic authorship itself. Yet the contrasts of seriousness and levity, rationality and pragmatism, have a way of polarizing discussion in ways that conceal, for instance, the rational basis, the fully intentional and conscious powers, of English artistic 'irrationality'. The notion of the ludic was an important one in medieval thinking more generally; but it is not exactly this idea that Bony and others had in mind. To stress the 'playfulness', 'unreasonableness' or 'irrationality' of the Decorated Style is to underes-

timate the seriousness of intent of the playful, its capacity to draw on orthodox sources in the service of unorthodox outcomes, and its fully rational ability to ambiguate accepted aesthetic solutions.[9]

This point about rationality is of some importance. In the previous chapter, I suggested that English aesthetic values in architecture were to a significant extent continuous with those set out in western European practice and experience in previous centuries. I also noted in passing that the Conquest introduced new and remarkable techniques of design, stonecutting and setting that connected English architecture thereafter to the radical thinking about masonry that was, even then, leading to Gothic. These techniques were discussed by Jean Bony with particular regard to the pre-planning and execution of the extraordinary spiral piers of Durham Cathedral (see pl. 5), exemplifying in his view a 'virtuoso performance in rationalised stonework'.[10] Such performances inevitably required rationality, a logic involving first principles and internal consistency.[11] 'Instrumental rationality' is involved in the making of any complex artefact that requires solving a problem by means of 'the calculation of practical and logical consequences'.[12] A building by definition has to be conceived and executed in such a way that it not only looks good but also stands up – and stays that way. Such rationality is a human universal: the rationality implicit in the Roman architectural theorist Vitruvius is no different from that of the master masons of Amiens Cathedral, or architects of the modern age, for in all such cases aesthetic activity is not accidentally, but inherently, rational. Complex aesthetic activity also exhibits a natural tendency to 'sort itself out', to crystallize in time, in such a way that in retrospect may look purposeful to the teleologically inclined historian. This ordering process arises in any major activity in part from considerations of durability (i.e., risk), manufacturing efficiency and economy, as at Amiens Cathedral, the building that has prompted the most provocative literature on this topic.

Many critics agree that some (if not all) Romanesque and especially Gothic architecture was not only rational in its thinking and execution, but was also positively intended to *look* rational. French or early English Gothic great church elevations of the sort at, say, Notre-Dame in Paris, Noyon, Soissons, Laon, Ripon and Canterbury (pl. 27) convey this sense not merely of being rational, but also of using shafts, arches and walls to display a rational outlook in subtly different ways, to the point where one cannot just speak of an 'underlying' rationality, but of something more consciously evident in actual appearances. It is not wrong to

see this tendency intensified in the Rayonnant period. But because erecting a building *necessarily* entails instrumental rationality, a difficulty arises when Gothic architecture as it developed by the thirteenth century, as a distinct idiom as well as a procedure, is described as emanating from a new 'spirit' or 'rise' of rationality. In this aspect of Gothic can be seen the operation not of instrumental rationality but of 'value rationality'.[13] Gothic buildings of this type, to a degree not encountered in earlier systems, seem to exhibit a *stance* or *conviction* about appearances, namely that the reasoning that produced them should also be advertent or ostensive. Such a stance might be characteristic of the value rationality of a particular culture as a whole, such as that of twelfth- or thirteenth-century France. The new 'rational' procedures of Gothic operated in a context of values that positively favoured the display of that rationality (see Chapter Eight). This is what Panofsky meant by his formulation that scholasticism and Gothic architecture each observed the 'postulate of clarification for clarification's sake' or *manifestatio*; it is also what Marvin Trachtenberg means by the 'hyperrationalist yet structurally exhibitionistic properties of contemporary French [Gothic] modernism'.[14] It was not rationality per se that had arisen, but a particular set of values that promoted, amongst other things, a rational 'look'. This 'look' was not the sole end of Gothic buildings in France or elsewhere, because such buildings served a variety of ends. But that it was central to their aesthetic, so to speak their 'technological aesthetic', and so to the priorities of invention that produced them, is at least arguable.

Consilium: *Gothic Logistics*

An idea long common to writers, artists and composers is that the general form of a work is in some sense held in the mind and known in its totality, if not all its specifics, before the work is actually executed. Because this knowledge is antecedent to its actual making, it can guide the means of its own realization: the ends help shape the means, and like a guide illuminate the path to be taken. In the Middle Ages this idea was familiar. Its most famous expression is in the *Poetria nova* of the poet-craftsman Geoffrey of Vinsauf, writing around 1200:

> If one should lay the foundation of a house, his rash hand does not leap into action; an internal string of the heart premeasures the work, and the inner person will draft the series in a particular order, and the hand of the heart

rather than of the body figures the whole thing; and it is a mental rather than a physical thing . . .

The prudent workman arranges everything in the mind before putting it 'out there'; arrangement or *dispositio* is an imaginative faculty.[15] The idea was not new: it is one of the oldest and most respectable concepts of how to go about things. It was to be repeated by Geoffrey Chaucer. Rhetoric used the word *consilium* to denote a rational plan of action (Cicero, *De inventione* I.xxv.36).[16] *Consilium* was, so to speak, the midwife of arrangement. Vitruvius had called 'arrangement', the first term of architecture and the second of the five parts of rhetoric, *ordinatio*. In his *Institutio oratoria* (VII, preface) Quintilian opens with the analogy between the rhetorician and the builder, each lending shape to their work through arrangement, *dispositio*.[17] The image of the architect therefore slipped as smoothly and naturally into rhetoric as it was later to do into scholastic discourse. This is how Vinsauf knew it. The ideation of means and ends long pre-dated Gothic. What it did not necessarily mean was that the actual production of a work of art would not encounter unforeseen difficulties, or for that matter possibilities. A plan was a guideline, not a fixed formula.

One might ask whether, rhetorical tradition aside, Vinsauf took a renewed interest in planning and pre-measurement because his culture encouraged him to do so. So much is suggested by one of the most powerful accounts of the rationalization of any art form, that provided by Dieter Kimpel and Robert Suckale for French Gothic architecture in the period from *circa* 1180, with special reference to Amiens Cathedral (pl. 28).[18] Kimpel and Suckale did more than underline the tendency in technologies to crystallize and sort themselves out, as the technology of rib-vaulted French Gothic undoubtedly did in the first century or so of its inception. By the late twelfth century it must have become apparent that this new way of building was becoming a norm; some 'rationalization' was inevitable. But for Kimpel and Suckale this rationalization had an important, indeed vital, contextual element. Gothic *savoir faire* improved, so the theory goes, because the prevailing historical conditions encouraged it to: under Philippe Auguste of France (1180–1223), political, economic and military relations with the rich Anglo-Norman domain provoked in France larger and improved military technologies, machine manufacture and logistical thinking – often the case with war. A more technocratic culture appeared in the domain of proto-capitalist industrial production in northern France, typically textile manufacture. From around 1200 there appeared

28 Amiens Cathedral, begun 1220, interior

improved methods of design, component manufacture and stone setting, whose 'new rationality' entailed more refined and standardized stone components, which could be measured and executed in advance by means of new types of detailed scale drawings.[19] Aggrandizement of format in building, as in engineering more generally, thus went with ever more microscopic pre-planning. Standardization conferred strategic advantages for building-site logistics and costs, since components grew in scale and efficiency, could be carved in advance all year round, made to regular specifications, and pre-assembled in such a way as hugely to increase the speed of building, so lowering labour costs. The assembly process, raising the powerful vertical shafting elements and buttresses of a great church before slotting in the thin walls, was a masterpiece of (quasi-modern) efficiency. The use in French construction (actually castle building) of fixed-price contracts, which passed on excess costs to the manufacturer, in contrast to the Anglo-Norman method of funding in which excess costs were state-subsidized, also kept costs down, as did carefully controlled interior detailing. In contrast, Anglo-Norman thick-wall construction and surface elaboration and finish imposed a very different, less efficient, cost regime.

The implications of this model – undoubtedly a 'rise of rationality' model – for agency are several, setting aside the (significant) difficulty that just this sort of pre-planning and rationality is already implicit, as Bony noted, in the design of Romanesque Durham. There is also some question as to how representative of the general situation in France Amiens really was. Still, according to Kimpel and Suckale, more importance was now accorded to the necessarily intellectual preconception of design and logistics, of which better drawing was part, so the profession of architect itself began to be reconceived. The architect rose socially in this period, the theory suggests, not as an artist, but as a technocrat, a constructor, albeit of a particularly audacious type.[20] Because Gothic architectural *consilium* required detailed scale drawings able to communicate designs impersonally, the architect as technocrat could now be based in a geographically fixed workplace, an office, and could operate remotely by means of on-site deputies, or *apparators* (the first occurrence of the term is in England), who put his solutions into effect. The architect supposedly became a remote, socially superior theoretician, in effect a model of bourgeois rationality working by means of the abstract, impersonal, even bureaucratic, medium of the drawing, and not by hand at all. His intellectual apotheosis is clear: mind and hand are now separate, and are mediated by drawing and speech. The accurate unambiguous circulation of ideas – to the quarry, to the building site – requires the distillation of that information in a form of recoverable notation: thus scale drawing and, ultimately, the need to communicate born of specialization enable that crucial process of crystallization of a style.

The strength, but also the weakness, of Kimpel and Suckale's account is that, because it is fundamentally a materialist account, it gives a much clearer picture of the forms of instrumental, rather than value, rationality involved in these developments: how things happened, not why. In its practical observation and economic grounding, it serves (and was intended to serve) as an antidote to the spiritualized and intellectualized medieval cathedral erected in the middle years of the twentieth century by von Simson, Panofsky and others. It explains much that is encountered in Gothic architecture of the period, whether in the cases of the cathedral of Amiens, begun in 1220, or of the standardized

Rayonnant production methods discussed by Freigang at Narbonne Cathedral later in the century, in which the smallest stone component is a microcosm of the greatest.[21] Careful graduation of the size of components had emerged at Saint-Denis by 1231.[22] It also allows a consideration of the relations of economic means to technical ends, and about the sociogenesis of the type of professional thinking that brought such projects to completion. It is fundamentally non-aesthetic in its interpretation of change.

In regard to value rationality, it might also fairly be pointed out that the tendencies to serial production and standardization apparent in French Gothic church building around 1200 are equally apparent in book design and manufacture in the same region at this time. In fact, one must be constantly on guard for the assumption that pre-Gothic methods were somehow less, or pre-rational. Indeed, as with books, so with buildings, the claim cannot be that the new methods introduced rationality where previously there had been none; rather, the impression is firmly of an intensification or clarification of existing rationales, the same 'sorting out'. This point may need stressing given that architecture was affected to a far greater extent than book production by economic conditions, more indeed than any other art form. The rationale of Parisian book production in the same years (for example, of the standardized Parisian Vulgate Bible), to say nothing of clarity of layout in its *ordinatio* or arrangement (see Chapter Eight), might have been shaped in part by economic considerations.[23] But it cannot have been wholly so. A book orders information in a way that a building cannot. The overarching question is what role the value accorded to rationality per se had as an antecedent condition for such new production methods, which seem to arise simultaneously in quite different areas of cultural activity. To think about the stupendous accomplishments of Gothic wholly in material terms is like seeing the 1960s space programme in the context of the wealth and industrial might of the United States, but not of the Cold War rhetoric of J. F. Kennedy and human aspirational imagination more generally. Great projects require ambition and will-power as well as means.

Persons, not historical conditions, create plans: invention is a matter of human agency. Without *consilium*, Vinsauf's pre-measurement in the heart, the virtuous circle of rational and technical advance could not have developed. In one important regard – to be explored in more detail presently – the technocratic model is demonstrably useful, because it sets the scene for a shift in thinking, almost certainly primarily French in origin and early development,

about human authorship more generally. It is less successful in bringing into focus the issue of inventive agency: why one architect's solutions differed aesthetically from another's, why one can speak of different 'Gothics' according to region (not least within France) and so on. To create a liberal bourgeois architect is surely also to create an individual capable of independent rational agency, which can, if needs be, work against a system as well as with it.

Invention brings to mind a further issue, which has had important consequences for the understanding of Continental Gothic as well as the Decorated Style. The claim of writers such as Panofsky and Bony that artistic initiative shifted in the late thirteenth century from the centre, France (Parisian France especially), to the margins was based upon a distinct view of the decline of French creative powers into something like academic routine. By 1300, according to Branner, 'the rest of Europe was moving ahead, leaving Paris in contemplation of its own dignified past'; Bony wrote of the 'academic codification' of French Rayonnant towards 1300 (pl. 29), Wilson even of 'creative scle-

29 Rouen, St Ouen, fourteenth and fifteenth centuries

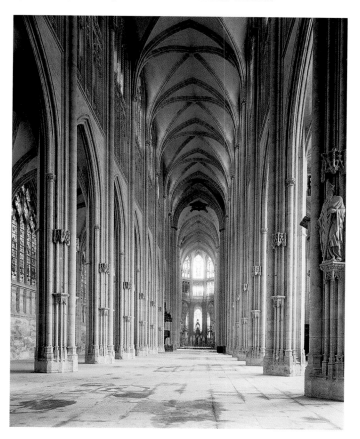

rosis'.[24] In transferring insights from modern industrial processes to the thirteenth century, Kimpel and Suckale not only followed in an honourable tradition established by Viollet-le-Duc, but also were well aware of the peril of serial production: that, as technologies improve and sort themselves out, the net result is standardization to the point of stereotyping – a virtue from the point of view of instrumental rationality, but a potential disaster from the perspective of inventive fertility. If the technocratic model is correct, it contained within itself, so to speak, the seeds of its own destruction: theoretically at least, the path from technical progress and rationalization to the decay of invention was set out no later than 1200. One disadvantage of this is clear: a rational plan was in essence a guideline, a framework for inventive development, like the notation of a jazz riff providing a basic structure of harmony and bars upon which musical invention is founded. To imagine that it was purely a constraint is unconsciously to pursue a notion of individual spontaneity or creative fantasy as against a notion of rule-assisted (as opposed to rule-directed) activity. Rayonnant was not, I suggest, as sclerotic as some accounts have suggested. The belief has been that those countries or regions that did not eventually fall under the sway of this new, typically northern French, technocratic dispensation – a dispensation suited to the extraordinary ambitions of High Gothic and Rayonnant in France – did not fall into the trap it set of over-systematization: hence, as it were, the 'freer context of the English artistic tradition' mentioned by Bony came to yield advantages in permitting the amazing inventive fertility of English art in the fourteenth century.[25] It is from this unhelpful starting point that the idea of the 'irrationality' of English art has been advanced in such a way as to deprive English art of rationality and, so to speak, Continental Rayonnant Gothic of its continuing inventive force.

Critiques of the Aesthetic and Authorial Agency

A significant but neglected issue in this discussion has been the fundamental question of authorial agency itself. The opponents of aesthetic readings of medieval art have much in common with the opponents of any idea of medieval authorial agency; often they share certain presuppositions. Suspicion of the whole notion of intentional agency on the part of such writers may be taken for granted: this was pre-eminently a feature of late twentieth-century literary theory and the proclaimed 'death' of the author; medieval

art historians soon issued variations of this theme.[26] Two points of view seem particularly ingrained. The first is that there was some implicit split between the concepts of art and religion: the concept of art is necessarily secular in its ends, and the concept of religion necessarily non-aesthetic. It was left to modernity to reconcile the two in a secular post-Romantic 'religion of art' in turn expelled by the functionalist and relativist stance of anthropology.[27] The formalist tendencies of modern art history were necessarily scientific or secularist in inclination: religion had to go on behind the back of the resulting practices. The second point is that the notion of medieval authorial agency was an ontological impossibility (i.e., impossible in the very nature of 'being'): it had to await the secular liberation of the concept of 'art' in the Renaissance, ridding God and theologians from the arena of culture. Only then may artistic human *auctores* be spoken of; and only then of art in 'our' sense. There is a third position that seems to owe much to Romantic corporatist ideas and which claims that collective agency was as or more important than individual agency in the realization of great works of art. In order to take the argument further, it is necessary to comment on these different positions with a view to setting them to one side, because they have either been unjustifiably influential or are simply wrong.

It must be admitted, first, that the modern stress on Neoplatonic thought in the Middle Ages has been particularly responsible for opening up the art–religion divide in such a way as to manufacture a theologized or idealized medieval art, whose social production was drawn into a corresponding hierarchy. The commonplace stance in twelfth-century theology (which itself entailed critique of some Neoplatonist thought) was that of Peter Lombard: because God alone is free and omnipotent, only he can create things *ex nihilo*, while men or angels can only shape that which is already created in such a way as to reflect true creation.[28] When God is depicted creating the world while wielding a set of architect's dividers (as he is in the early thirteenth-century Parisian Moralized Bibles) this is to be understood as a metaphor only. God is un-artisanal: God creates, man invents. And since the work of a human artist was held to consist of mechanical handicraft alone, it was held in low esteem by men of St Augustine's class and lofty mindset.

This is the tradition of Platonized, hierarchical and theological aesthetics explored and promoted in the mid-twentieth century by Gilson, De Bruyne, Panofsky, Sedlmayr, von Simson and others.[29] It is a belief system that, in its modernist guise, has ranked craft below concept. The impact

of such thinking – especially its combined tendency to theologize art and materialize human action – will be apparent at more than one point in this book (see Chapter Eight). Its desire to idealize art and especially architecture almost certainly helped provoke the earthy and in many ways justified counter-cultural revolt against such idealization in later twentieth-century critical writing about medieval art, power and conflict. Yet some of its tenets have less obviously underpinned (because they have served) more recent thinking about the image and its making, especially those aspects of it that demonstrate a Platonic suspicion of the image and an intellectualist disdain for the mental capacities of craft. I have in mind the type of argument in Michael Camille's *The Gothic Idol* (1989), whose discussion of the 'fallen fabrication' of art by men relies overwhelmingly on a particular reading of sources of a Neoplatonic or Augustinian complexion: Plotinus, Hugh of St Victor, William of Conches, St Bernard and St Bonaventure are summoned along with modern pseudo-Platonists (Deleuze, Baudrillard) to illustrate the point that 'Neoplatonic ideas were the basis of much medieval aesthetic theory'.[30] Much indeed, but not all.[31] Where the ultimately Neoplatonic position, according to Camille, relegated human image-making to a sublunary 'nonintellectual realm', rhetoric conveys precisely the opposite conclusion, namely that 'craft' is a respectable and inherently rational-intellectual activity involving *consilium*, or, in Aristotle's terms, both *téchnē* and *epistēmē*.[32] It is this fuller and more dignified conception of craft that, rightly, has engaged more recent scholars, and will engage this book.[33] It is also to be noted that the strongly (though unacknowledged) Neoplatonic vein in such recent critical thinking has implications for the study of 'marginality'.

Camille's intention to play God and man off against one another finds a corollary in the so-called *Bild-Anthropologie* ('image-anthropology') of Hans Belting.[34] Here the play-off is between the image and the artwork, between the domain of functional religion as a set of practices and the domain of the aesthetic. Robert Redfield made a (problematic) distinction between art and icon: art is all form, icon all content, myth and power.[35] Hans Belting's work places at the centre of the image's discussion the notion of *Kult* or 'operative context' – function, custom, myth, ritual and so on. According to it, the Middle Ages had no concept of art, merely of the image as a pre-aesthetic tool understandable only in its context of use (Jacques Rancière's term for this is an 'ethical' – or ends-directed – regime).[36] The transition from the utilitarian era of the image to that of the fully aestheticized art object occurred in the late Middle Ages

and Renaissance, the concept of the 'work of art' (and hence of the 'artist') being a construction of the fifteenth and sixteenth centuries, which neutralized and secularized the once powerful *Bild* in the name of an authorially driven, hierarchical 'representative regime', to cite Rancière again. Medieval representations are reduced to the status of 'images' with functional power but no aesthetic content, while Renaissance and post-Renaissance artworks possess aesthetic power but a diminished religious function, problematized further by the Reformation.

This extraordinarily ambitious model produces a number of interesting, and probably insurmountable, difficulties. It will be apparent from Belting's approach to the medieval that, to quote the anthropologist Alfred Gell, 'social anthropology is essentially, constitutionally, anti-art'.[37] Because the present book is not concerned with image theory as such, one may overlook the disquieting implication that images produced in, say, the Baroque period were devoid of cultic significance or attention because they were products of 'art'.[38] Again, one may pass over Belting's Erasmian condescension to the medieval image as a mere instrument that had to be transcended, like adolescence, in the search for an ultimately image-less ideal.[39] There is, in fact, little room for religious experience in such theories: anthropology drives out theology. More worrying for the present purposes is the inherently tautologous definition of art as that which is defined as art by Renaissance discourse. On a point of method, this confuses concepts (formed before the event) with conceptions (formed after the event). Thus the Florentine Renaissance undoubtedly had a remarkably articulate conception of art (after the event) because it produced the first history and 'theory' of art; but it does not follow that a culture that produced no theory or history of art had no *concept* of art (before the event). Yet this very confusion has resulted in the 'pre-aesthetic' medieval image, and, by implication, a diminished notion of medieval authorial responsibility. As other authorities sharing this perspective have recently put it of the fifteenth century (my italics), 'An artist was now conceived *for the first time* as an author, an *auctor* or founder, a legitimate point of origin for a painting or sculptor, or even a building.'[40]

Crucial to this general, and I think problematical, outlook is not only a suspicion of the idea that artists were sentient and thinking authors, but also a more worrying demotion of the sphere of the aesthetic itself. The 'anti-aesthetic' position derives especially from Frankfurt School thinkers such as Theodor Adorno and Walter Benjamin, who contested the sphere of the aesthetic as a sphere of elite bourgeois

ideology and as a betrayal of right-minded social principle.[41] Michael Camille, working inventively with such ideas, felt able to claim that 'The aesthetic anesthetizes. It annihilates function, taking the object of interest out of the realm of necessity into the disinterested contemplation of the subjective viewer's consciousness.'[42] But the target here is a view of the aesthetic closer to Kant than to any medieval notion of sense-based knowledge. To anaesthetize is, after all, to expunge sensation. The contrary is surely true, certainly in regard to function: aesthetic experience in the full bodily, passionate and imaginative sense was fundamental to the powers of persuasion that precisely *constituted* the image's function, what an image 'does'. David Freedberg is, I think, right to say that the power of images is particularized: 'We do not extend our empathy to humanity at large, nor to the godhead which is intelligible only to the intellect . . . This is why the miraculous nature of each image, indeed its efficacity too, is directly dependent on the way it looks.'[43] For this reason, too, separating the technology of art from the aesthetics of the presented art object is neither wise nor practically easy.[44] The pleasure taken in an object, as well as the sheer sensory impact of that object, might reinforce what even Belting concedes might be 'a sense of beauty that symbolizes a higher beauty'.[45] Collapsing the idea of the aesthetic into modern concepts of 'art', 'style' and 'history' in order to dispose of it in the service of an ideological critique of art history precisely undermines the functionalist account of the image that writers such as Belting have embraced. As Peggy Knapp puts it very exactly: 'where art is experienced purely ideologically, it fails to be fully experienced even ideologically'.[46] In such cases the will to theologize images, to deepen a sense of their ideological content by placing aesthetic experience in the charmed 'superstructure', or to stress their cultic, auratic or quasi-magical power only within a specific functional context (as opposed to within their appearance), is consistent with a search for a more general hierarchical paradigm of ulterior signification or depth that might be religious, moral, psychological or social-ideological. Given its Neoplatonic heritage, as noted above, this search for depth is understandable: beauty and truth lie beyond what is observable to the senses; that which is 'absent' is in some sense superior to that which is 'present'; the sense of technical magic invoked in making a thing is more important than its apparent forms; that which is not theologized must be earthily subversive.[47] To get to these 'depths', the aesthetic surfaces so beloved of medieval artists in their crafty pursuit of *color*, *varietas* and *pulchritudo* must first be cleared out of

the way.[48] The possibility that persuasion and invention might occur in the absolutely present realms of surface and depth working calculatedly *together* in the artist's hands and in the audience's sensory experience is, according to this doctrine, a sort of heresy. But it is nevertheless a heresy that the author of the present book subscribes to.

I have had to dwell on this point because entire models of understanding have since emanated from this critical ploy of separating surface and depth. It has even become difficult for those interested in the way medieval artists repainted and so reinterpreted older medieval paintings (as occurred in thirteenth- and fourteenth-century Tuscany) to imagine that the stimulus for such renewal could have been other than devotional or cultic in origin.[49] The fact that the *faces* of panel paintings of the Virgin Mary in particular were repainted within a generation or so of their initial execution might be explained by Byzantine devotional renewals of icons, but is more likely to evince aesthetic sensitivity to the face as a focus of human affect, of which religious devotion is itself an aspect. The concept of human beauty, *pulchritudo*, cannot have been irrelevant to the visualization of the Virgin Mary both as an ideal and as an agent of the Incarnation. Once again, the link between function and the aesthetic is pointlessly severed. In aiming to sink the discipline of art history as conventionally understood, the anti-aesthetic tendency has also disposed of one of the most important domains within which medieval art operated, flourished and possessed persuasive power, that of ordered feeling and exquisitely rational calculation: a striking outcome, when one ponders the bodily and far from dispassionate character of so much in Christian belief.[50]

A moment ago I noted a third position. This one is critical of (basically Platonic) elite beliefs about the priority of ideas in the conception of art, and in effect strips out any single-agent 'authorial' presence from the Middle Ages. It favours instead a communitarian model, in which the hand dominates the mind, and no one in particular dominates the making of great buildings. This position is adopted either by post-Romantics wedded to the social ideal of the craft cooperative, or by orthodox post-Renaissance thinkers who consider the notion of authorial identity in the Middle Ages improbable. The communitarian stance, represented by the work of John James on northern French Gothic cathedrals, has not proved influential, because although it produces very close, in effect stone-by-stone, readings of the buildings themselves, it is in direct conflict with everything known independently about the way such buildings were designed and managed.[51] According to James's initial beliefs,

great churches such as Chartres Cathedral were erected not under the control of specialist and long-term master masons with a clear 'line management system', but rather by itinerant gangs of contractors who simply came and went. There was little or no question of an initial conception or *consilium* because there was no controlling agent to form one and impose it; and in so far as longer-term presiding master masons appeared on cathedral worksites, the theory goes, they did so only from the mid-thirteenth century when economic contraction (in France) reduced worker mobility. In such buildings there was neither end nor beginning, no model and hence no perfectibility; and hence no authorial order. The Romantic virtues of social collaboration and 'authenticity', as well as Ruskinian 'roughness' (for Chartres in James's vision is a 'rough', organic, building), stand opposed to the modern 'smooth' virtues of rational design and manufacture.

Because this model has been so thoroughly criticized, it does not need extensive comment here.[52] It has at least two major disadvantages. The first concerns simple power relations. The logistics of a building such as Amiens inevitably required a high level of preconception and planning, which must have been run by someone. Large building sites posed major order problems. The York Minster fabric rolls for 1344–5 contain a vivid report by the master of the works on the deficiencies of the Minster workforce, including absenteeism, theft, quarrels amongst workmen and even wardens, neglect and disobedience.[53] In such cases of brute reality, inevitably 'leaders' would have emerged, and it is not surprising that by 1352 are found at York quasi-collegiate regulations for the control of the daily lives of the men on site. Though these instances post-date the thirteenth century, it is intrinsically unlikely that the issues they raise were new. Order in itself tells one nothing about the authorship of such buildings. But the communitarian model also runs quite counter to the documentary evidence that authoritative, well-rewarded architects were present on great church worksites from at least the late twelfth century at, for instance, Canterbury Cathedral and Westminster Abbey. In what lay their authority? Yet in other guises the utopian community model has persisted in literature on the formation of the 'author function' (the term is owed to Foucault) later in the Renaissance, which has continued to find a communitarian model of medieval architecture useful. As Marvin Trachtenberg puts it of 'an age without an author function in architecture', 'it was the community that built, not the individual or collaborative and conflicted pair of individual patron and architect'.[54]

For reasons to be set out shortly, it is hard to accord with this postponement of the concept of the human *auctor*. The notion of specifically *authorial* invention must itself take account of the extensive evidence that cathedral builders adapted initial designs in the process of their 'realization'.[55] Building activity is necessarily a dialectic between ideal and reality, and during the process of building – which could involve the collective wisdom of all those involved in a project – one might think of system and method (*téchnē*) emerging from within traditional know-how (*empeiría*), not least by trial and error. As Aristotle quips at the start of the *Metaphysics* (I.1), 'experience made art … but inexperience luck'. The suggestion that the 'impossible engineering' of the great Gothic cathedrals in the twelfth and thirteenth centuries actually advanced systematic know-how – in effect 'produced' intelligence of a productive sort – is therefore unlikely to be controversial. So it is unnecessary to have radically anti-individualist notions of pooled or 'distributed' cognition acting dynamically with artefacts to see that almost every rational creative act entails a process of 'discovery' in which things 'sort themselves out'.[56] Again, while two heads may be better than one, pooled understanding is not incompatible with the idea of a single sovereign author. A ship may have a crew in which each knows his part, but it also has a captain and navigator. And throughout the Middle Ages the notion of authorship was anyway present in the form of the patron or client (typically a churchman, noble or monarch) to whom works were ascribed in retrospect in conventional acts of *pietas*, regardless of the status of the artistic agency that made them. In hierarchical social complexes of power, author myths (i.e., the 'author function') necessarily emerged in order to symbolize (i.e., simplify and stabilize) the more complex social reality lying behind the whole process. As in the Middle Ages, a patron-centred culture will therefore tend in the long run to promote, not demote, the standing of art and artists, since first patrons, then artists, could be identified to their own advantage as causes or progenitors of works of art: either way, an individual is responsible, as the notion of a contract shows.[57] Medieval thought about causes therefore helps modern ideas about medieval authorship to develop.

Causes: Medieval Authorship and Professionalism

In regard to causes, Aristotle is as inescapable now as he was in the thirteenth century, since it was through his philosophy of causality that medieval commentators on Aristotle

generated ideas about authorship. Several texts were available to this end. In the *Ethics* (VI.4–5), Aristotle begins by drawing a distinction between making and acting.[58] We might consider making a form of action. But Aristotle is interested in outcomes or 'ends'. So for him the purpose of making and hence skill (*téchnē,* Latin *ars*) is to produce a *thing* (Aristotle takes the example of building), while action has as its end a *judgement*, ideally practical wisdom or *phronēsis. Téchnē* is thus a 'reasoned productive state' whose action is *poietike* – an idea that led Horace, among others, to think of poetry as something 'crafted', hence his work *Ars poetica,* literally the 'poetic craft'. In his *Metaphysics* (I.1) Aristotle considers *téchnē* to be a product of remembered experience from which general method and system is derived.[59] To know the reason for something is to understand its cause, and knowledge of causes is superior to action. So superior craftsmen, as it were, not only know *how* to do something, but *why* certain things are done to that end: they thus rank above manual labourers because they possess knowledge of invariant causes whose end is certain knowledge for its own sake, or *epistēmē* (Latin *scientia*). Superior craftsmen also form a clear plan in their mind (Greek *eidos* – the Latin *consilium*) before acting. Such knowledge can be stated independently of the action of making. On this basis they can actually teach those under them, and expect to be obeyed. Aristotle sees the cultivation of knowledge as being based not in utility but contemplation, and hence a form of leisure: so mathematics was developed in Egypt where there was a leisured priestly caste. It is in this idea that originates the 'regiminal' notion of craft knowledge as something like 'ruling' or 'governing' things or people.

There also persisted a quite basic social distinction between the arts cultivated for their own sake, or 'liberal' arts, and arts based in ordinary craft knowledge and handiwork, or 'mechanical' arts. As is well known, this hierarchical social model is found in writers such as Vitruvius and Pliny, as well as Christian authorities such as Augustine and the Victorines, in which skill, *ars*, tended to be drawn away from knowledge of causes towards work by hand. This strand of thinking has been pounced on greedily by critical theorists willing to demote the medieval artist. But, as has already been noted from Cicero and Geoffrey of Vinsauf, rhetorical tradition also emphasized the intellectual dimension of the skilled craftsman, the capacity to plan an image of the thing to be done beforehand, to *think* it through. In the course of the late Middle Ages the boundary between the liberal and the mechanical arts proved porous – witness the writings of Christine de Pisan and John Lydgate – though if there was a tendency, it was towards the promotion of the intellectual dimension of architecture.[60] Importantly, both Aristotle and the rhetorical tradition tend to give architects as their examples of such higher craftsmen. This was noticed in the thirteenth century by commentators. Aristotle's philosophy of causes enabled the learned aspect of the superior craftsmen eventually to gain the upper hand in medieval thought.

It will therefore repay looking a little closer at Aristotle's ideas about causes, because this is what was done in the twelfth century and especially the thirteenth; if they did it, so should we. The ideas are set out in the *Physics* (II.3) and the *Metaphysics* (V.2).[61] Aristotle explains that a thing (he gives the example of a bronze statue) has four causes: (1) the *material* cause (the stuff out of which the thing is made, e.g., bronze); (2) the *formal* cause (the shape, archetype or essence that provides its form); (3) the *efficient* cause (the source of the change that brings the thing about, e.g., 'art' or the necessary knowledge, the artist, the patron); and (4) the *final* cause (the end for the sake of which the thing is made at all, e.g., worship). The *final* cause is the most important. What is of interest here, however, is the complex issue of the *efficient* cause. The formal cause can already be understood in the light of Krautheimer's discussion of the use of formal archetypes in the creation of an essential architectural iconography (see above, p. 13).

The term *causa* is not particularly common in medieval art, but it is found in the middle of the period reviewed in this book in an inscription at Westminster Abbey, once on the marble base lifting up the shrine of St Edward the Confessor (pl. 30), probably finished in 1279 and decorated with Roman Cosmati mosaic.[62] The text read

Anno milleno domini cum septuageno et bis centeno cum completo quasi deno, hoc opus est factum quod Pet/rus duxit in actum, Romanus civis. Homo causam noscere si vis, rex fuit Henricus sancti presentis amicus.

Translated literally:

In the one thousandth, seventieth and two hundredth year with a decade nearly complete, this work was finished which Peter the Roman citizen fashioned. If you wish to know the *cause*, it was King Henry, friend of this saint.

Like many monumental inscriptions, the language is in verse and so has to scan, and is also compressed – it is not theoretical language. But it still reveals a problem. Note that there is a single straightforward cause, namely Henry III, the

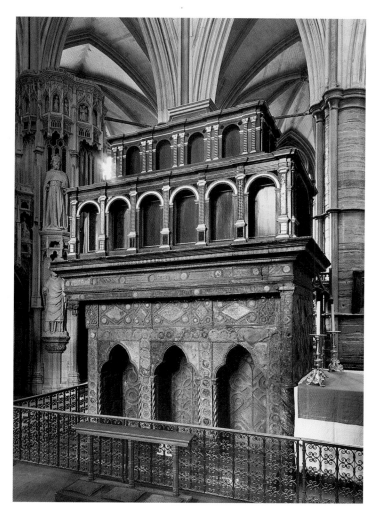

30 London, Westminster Abbey, shrine of St Edward the Confessor, completed 1279–80, from north-west

patron. But there is a second agent, Peter the Roman, who gave the thing form and so was the artist responsible for the work. Henry is therefore undoubtedly an efficient cause of the shrine. But Peter's importance is also noted, if more subtly. Numerically, the inscription divides into exactly two sets of eighty-five characters, at the exact centre of which is *Petrus* (as indicated by the slash). The master is thus numerically more central than the patron. This is likely to have been intentional, since Italian epigraphy of this type on works of art had for more than a century celebrated the work of artists.[63] Here, though, the method is more discreet, not least because of the importance of the saint and king within a patron-centred culture. But in effect, there are two efficient causes, not one, since Peter 'performed' the thing or brought it into being, and therefore also qualifies as an

agent of change. King Henry was simply the more remote of the two from the actual object.

Getting at the basis of this tricky but worthwhile question of who and what could count as an efficient cause, and how, was the aim of a series of brilliant writings developing Aristotle's doctrine of causes, produced in Paris in the 1230s and 1240s. These have been studied by Alistair Minnis in his work on medieval authorship. Minnis showed how a form of academic prologue that served as an introduction to biblical commentary in the schools came to be based on Aristotle's theory of causality: this was known as the 'Aristotelian prologue', and it superseded the so-called Type-C prologue used earlier.[64] Its theory was inevitably derived from commentaries on Aristotle's books *Physics* and *Metaphysics* now circulating in the schools. The commentaries evolved a way of refining the category of the efficient cause by, in effect, splitting it in two. A distinction was now drawn between a primary efficient cause, which 'moved' (i.e., a cause that produced change but did not itself move), and a secondary efficient cause, which 'operated' (i.e., a cause that was moved by the primary cause, and which in turn moved in order to produce something). This can be visualized by means of the little toy called Newton's cradle, in which swinging metal balls convey energy via a central ball, which, though struck, miraculously remains quite still. Thirteenth-century biblical commentators in Paris, such as Hugh of Saint-Cher and Guerric of Saint-Quentin, explained this idea by asking what relation God as the ultimate 'mover' had to the humans through whom his revelation was written down in the Bible. Around 1240 in a commentary on Isaiah, Guerric tackled this by arguing that the Holy Spirit was the primary moving cause of the Book of Isaiah, while Isaiah the man was the secondary operating cause who actually wielded the pen but also gave literary form to the prophecy. This 'split' efficient cause was known as the *duplex causa efficiens* or 'double efficient cause'.[65] God was the unmoved mover, the first *auctor*, whereas the human *auctor* was both 'moved' (by God) and 'moving' (in producing the text). Within this hierarchy of causes, human authorship was in effect analogous to divine authorship, except that it differed in relation to God's authority in being instrumental (since God cannot be moved from outside). The Aristotelians thus showed that the hierarchical relation between divine and human *auctoritas* might be rehearsed by analogy to ordinary human conditions. So, to return to the very human inscription at Westminster, Henry III might now be called the primary efficient cause, and Peter the Roman the secondary efficient, or instrumental, cause.

This discussion might seem a little obscure, but thinkers such as Hugh of Saint-Cher and Guerric of Saint-Quentin cannot be dismissed simply because they were theologians who served the ends of divine science. As John Marenbon has shown, theologians were, in fact, the most radical and creative thinkers of the day.[66] This is partly because they thought vividly. Their repeated use of the analogy of the *artifex*, and especially the architect, inherited from Aristotle and rhetoric, is vital. The present discussion is particularly justified because the consequences of this newly refined doctrine of causality were profound. This analogy arose because it is where Aristotle and the rhetoricians themselves started. The Aristotelian 'scheme' evolved quickly in the 1230s and 1240s in Paris and Oxford.[67] Within a generation a further move had taken place. In his disputations held in Paris between 1276 and 1292, Henry of Ghent argued that God alone can be called the *auctor* of the science of theology. Following Aristotle's *Metaphysics* I, Henry went on to say that in the manufactured arts, where there is a craftsman (*artifex*) who directs and regulates, and another who works by hand to put these things into effect, the *artifex* and not the manual operative is said to be the author (*auctor*) of the work. Henry then says that since the true author understands underlying reasoning and principles and is able to demonstrate them to others, he alone should be called the principal author (*debet dici auctor principalis*).[68]

Thus, within a generation of the 1240s it became possible in academic circles to think of authors as originators who gave form to something in 'their way', who created their own *modus tractandi* or way of treating subject matter. Because it was customary to create analogies for such ideas with architects, an idea formulated for the verbal arts immediately jumped across to the non-verbal arts. An artist too could not only be a primary moving cause, but also an author. The notion of authorship as such was already very old, well established in the ancient world. What the scholastic discussion brought about was a sharper sense, both social and theoretical, of what individual human authorship, as opposed to divine authority or *auctoritas* in general, consisted of; and that meant thinking about the relationship of a human *auctor* and personal style.

Far from being abstruse, such thought was not only very clever, but was also consciously practical. It was in fact precisely the relation of theory and practice that interested the theologians. They employed Aristotle's use of analogy to show exactly how various agents stood in relation to one another. Aristotle thought by means of simile and proportional analogy: as *a* stands to *b*, so *x* stands to *y*.

Consider the way he used the image of the statue, or the architect, to illustrate his reasoning. Henry of Ghent therefore argued that, in regard to *auctoritas*, the relation of God to man was proportional to that of the architect to the ordinary mason below him: the architect, like the master of theology, teaches the knowledge (*scientia*) to be applied, while the mason, like the lower clergy, merely puts the rules into effect, not needing to understand their underlying thinking.[69] Architects were not *God-like*, but *analogous to* God in proportion to their operatives. In one of his quodlibetal discussions in 1269, Thomas Aquinas again drew an analogy between the architect and the theologian in contrast to the ordinary priest and the jobbing builder; naturally, architects received higher wages. In the 1280s Gervase of Mont-Saint-Eloi provided an especially telling case: the disputation in the schools was superior to the act of preaching because disputation was 'architectonic', whereas preaching was merely operative.

Again, these are theories: but the use of commonplace analogy rooted them in social reality. In the pastorally minded thirteenth century this mattered. The theologians who used Aristotle's ethical and scientific theories to guide the formation of practical theology – 'moral theology' – in effect allowed his reasoning and his images to get into the wider culture. This happened because the thought of the schools passed down into the pastoral culture of the sermon and the confessional. This does not mean that the sophisticated theoretical moves of Parisian theologians in some way changed the standing or activity of architects themselves. The theories remained just that: and they were no more or less theoretical or practical than the corresponding doctrines of the Renaissance. The point is that moral theology, as a form of education and so persuasion, has to keep a grip on reality: in order to remain effective, such reality should be accurately observed. By no later than 1260 the Parisian Franciscan Nicholas de Biard (d. 1261) was able to claim in a sermon and *distinctio* that large buildings were wont to be ordered by one chief master (*unus magister principalis*) who issued verbal instructions by word to his craftsmen, who did all the manual labour but got lower fees.[70]

It is not unreasonable to see such comments as a form of social evidence, since an ineffective or implausible social image would ruin the point of any sermon. The statement about 'one chief master' is clear enough and contradicts any communitarian theory about work-site logistics. Biard says that such masters order things only by words (*qui solum ordinat ipsa verbo*), the word *ordinare* reflecting knowledge of traditional architectural language for 'arrange'. But the image

of a verbose and socially superior man who holds gloves and pointer and hands on his professional knowledge to manual workers is also a demonstration of the 'double efficient cause' being refined by Biard's scholastic contemporaries in Paris, the unmoved regiminal possessor of knowledge who 'moves' his underlings to work but also 'teaches'. The scholastic underpinning of such social commentary, actually estates satire, is generally missed by architectural historians who see in such passages either social commentary, empty rhetoric or a sort of spontaneous eruption of the idea of the architect–intellectual. The point is that the 'liberal bourgeois architect' identified by Kimpel and Suckale in exactly this period – the early to mid-thirteenth century – seems to have emerged *pari passu* with a corresponding new theoretical discourse. Panofsky's instinct about scholasticism was justified, not because it tells one anything secure about Gothic architecture, but because it was precisely the scholastics who engaged the idea of the architect to flesh out their ideas about authorship. The verbally articulate, leisured and hence knowledgeable architect was emerging as the *locus classicus* of what it was to be a professional, as other emergent professions, such as medicine, recognized. The mediating term was *doctor*, the agent who, possessing certain knowledge, could demonstrate it. Theologians, architects, medics and lawyers could claim to be *doctus*, not least in the context of what Philippe Buc calls the 'auto-exaltation' of *doctores* in the university of Paris.[71] It is this sense of socio-professional assertion based on the possession of certain knowledge that led Aquinas in his *Summa contra gentiles* to define the architect as possessing the same relation to those who work by hand as philosophy does, as a superordinate subject, to other forms of knowledge: superordinate subjects like philosophy are architectonic, and in virtue of this architects 'lay claim' (*vindicant*) to be called wise. It was on this basis that further exploration could be made of the craft not of making, but of political ruling itself, in which interest was being taken also in the late thirteenth century amongst Aristotelians.[72] Ultimately, however, the victim of this line of thought was the long-standing notion that craft itself possessed thought. What the universities of the thirteenth century began, those of the twentieth century brought to fruition with the 'turn to theory'.

It is not entirely surprising that the famous epitaph of the master architect of Notre-Dame, Pierre de Montreuil (d. 1267), in the Lady Chapel he built at St Germain-des-Prés in Paris, described him as *doctor lathomorum*, as exact an instance of commonplace Aristotelianism as one could hope for.[73] The term *studiosus*, generally meaning diligent or

skilled, was now occasionally transferred from the precious arts, where it was a human attribute, to designs themselves. In 1215 the chronicle of the bishops of Auxerre refers to the rebuilding of the cathedral with *ars studiosus*, 'learned art'.[74] A charter of 1321 for the disposition of funds for the sleek new Rayonnant abbey church of St Ouen in Rouen (see pl. 29) begun in 1318–19 opens with a preamble saying that since the old church had fallen into ruin, it had been undertaken to build a new one according to 'leading learned designs' (*previis tractatibus studiosis extruere disposuimus*), which were to be effected by what the document later calls 'hard-working and not unadvised craftsmen' (*industribus non inconsultis artificibus*).[75] Here is an assertion of a hierarchy of design and manufacture rather like that in Biard's mind, but illustrative of good custody by a corporate body wishing to renew its church properly. The notable point is that it is the designs themselves that are 'learned'.

By about 1260, then, a value rationality emerged in France that helped to promote increasingly articulate ideas about the intellectualized nature of professional architects and their designs. They were now construed as theoreticians because such assets as demonstrable knowledge were held to confer social superiority and so advance mobility; importantly, that claim was underpinned by the actual achievement of the men working in the Gothic style in Paris and its environs.[76] Social and technical superiority also meant conceptual and physical detachment from the hands-on process, a technocratic class distinction. Drawings became more important since their details enabled ever more subtle mediation between the new professions and the skilled labourer. Again, social 'reality' tends to affirm the increasing complexity of what would now be called building 'line management'. By the second half of the thirteenth century one encounters major architects, based in long-term established offices in urban centres, who were able to work remotely by delegation in such a way that site visits could be kept to a minimum – a sign that such masters were running concurrent projects in more than one place, and hence an indication of centralization. The contract of 1286 drawn up for Narbonne Cathedral mentioning its master mason, Jean Deschamps, makes such an arrangement explicit.[77] Such masters had an on-site and presumably very capable deputy or warden called variously an *apparator, apparillator, appareilleurs*, even *parlier*, a term that implies developed verbal as well as organizational abilities. The first recorded occurrence of the term *apparator* or *apparitor* in fact occurs in the centralized context of England, in the building accounts for the erection of St Stephen's Chapel in the Palace of Westminster,

in the 1290s (see pl. 25).[78] Remote control appeared in Siena no later than 1340.[79]

But the wider occurrence of remote management does not necessarily mean that the very elevated 'Aristotelian' view of the architect as developed in Paris itself moved more widely. It is true that these ideas emerged in tandem with Rayonnant, the most influential version of Gothic ever produced, and basically of Parisian origin. Yet there is a certain risk that, in pinpointing significant discursive changes, one may inadvertently homogenize or universalize not only the more complex social and practical reality of medieval architects, but also such theoretical manoeuvres as may have applied to them.[80] To repeat: what is being said here forms no part of a 'rise of rationality' argument or a cut-and-dried position about the 'rise of the artist'; the concern, rather, is with a new language and range of ideas by means of which practices and professional identity were in the process of being re-thought. Also, certainly in England and probably also in France, there is by the fourteenth century absolutely solid evidence for the clan- or family-based nature of architectural companies, notably those of the Canterbury and Ramsey families. Within such companies it is reasonable to imagine that discussion and compromise, as well as innovation, took place in a way that limited absolute authorial sovereignty without dispersing it vaguely into some notional larger 'community'.

Here follow two further points. First, despite the emergence of sharper theories of professional agency, northern European artists in other media such as sculpture, painting and metalwork were not drawn into the discussion. Architects remained special, not least because buildings had special functions. Second, the style of discourse about architects as authors that emerged in northern France somewhat before 1300, and which undoubtedly had an academic character, may have been untypical of other French regions and was not (so far as is known) strongly characteristic of England, notwithstanding the participation of Oxford in the new Aristotelianized discussion of causality. What is found in England is evidence for the more sophisticated centralized management of major building projects, which indicates something about the standing powers of architects.

The early occurrence of the term *apparator* in England is notable because it appears in the context of the French-, indeed Parisian-, influenced court of Edward I (1272–1307). Here centralization becomes evident. That London and Westminster were coming to dominate the horizons of architectural invention by 1290 is firmly established. Major court architects such as Michael of Canterbury (from Kent)

and John and William Ramsey (originally from the Fens, then Norwich- and London-based) had to have metropolitan offices.[81] It was also important at least to some of them to have lodgings at the sites of the regional projects that they were guiding. In 1325–6 Master John *cementarius*, probably John Ramsey, was given lodging at Ely Cathedral for the new works, while being based in Norwich.[82] His close relative William Ramsey, also of Norwich and London, took over the project at St Stephen's, Westminster, in 1337. In the same year Lichfield Cathedral contracted him to advise on the new presbytery planned there (pl. 31).[83] For each trip to Lichfield from London he received £1 and his expenses, including his servants, for a journey of four days either way. Since William, by then almost certainly also engaged at Gloucester, is an excellent example of multiple simultaneous contracting, the document is worth citing (my emphases):

31 Lichfield Cathedral, choir by William Ramsey, begun 1337 (left) and Lady Chapel (extreme right); note the nodding ogees in the arcading at lower right

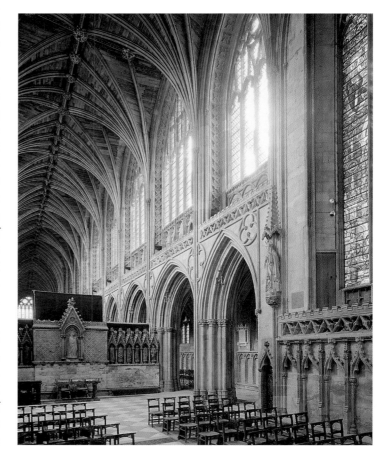

quod . . . Willelmus veniet ad supervidendam *fabricam ecclesie . . . et quod daret* sanum consilium *suum circa emendationem defectuum, et* ordinacionem *suam et informacionem aliis cementariis circa* instruccionem *novi operis ejusdem, et* precipiet *in omni adventu suo de Lond'* . . .

that William will come for the *overseeing* of the church's building . . . and will provide *sound counsel* regarding the repair of flaws, as well as *plans and drawings* for the other masons for the *edification* of the new works, and will *instruct* every time he comes from London . . .

Note that William is understood to be an occasional visitor and that he is under obligation to offer guidance whenever he is in Lichfield. The term *consilium* may be taken as ordinary counsel or advice (the term is often legal, and may go with *auxilium* if a feudal duty), but can also carry with it the sense of 'plan', 'foresight'.[84] *Informatio* is taken here in the sense of infusion with form, moulding or delineation, hence 'drawing', which follows *ordinatio*, usually meaning plan or arrangement, often down to quite small details. This phrase probably meant detailed plans, elevations and templates. *Instructio* means 'edify', sharing the root *struo* with 'construction' or 'construe'. To understand Master William's terms, in short, requires nothing more than a grip of traditional Latin rhetorical and architectural terminology: no academic doctrine is necessary, even if the passage conveys something of the idea of the architect being one who possesses authority and, in a sense, teaches.

Perhaps this is what Bony meant by the 'freer context of the English artistic tradition': that the English, unlike the French (Parisian French at least), did not formulate the architect as a species of technocrat.[85] Architects in England could, and did, walk with dons: so much is revealed by the presence at the high tables of New College, Oxford, and King's College, Cambridge, of such architects and timber engineers as William Wynard, Hugh Herland, Henry Yevele and John Wastell.[86] But this social status was never accompanied by an explicit doctrine. When, in the winter of 1400, the French architect Jean Mignot, summoned by the cathedral authorities of Milan to provide his *consilium* or expertise, uttered the famous and clearly unwelcome remark *ars sine scientia nihil est* ('practical skill without certain knowledge amounts to nothing'), he was epitomizing standard Aristotelian doctrine on the relation of *téchnē* and *epistēmē* in the superior craftsman; that his remark was perceived by the Italians in this way is proved by their pseudo-Aristotelian reply: *scientia sine arte nihil est.*[87] It had been the great English Aristotelian archbishop Robert Kilwardby (d. 1279)

who had stated that 'the speculative sciences are practical and the practical sciences speculative'.[88] Such chiastic formulas work either way because of the degree of interdependence of the terms; but it was typical of a French expert that he should prioritize the scholastic term *scientia*, and put it in a way that echoes the terms of Quintilian (*Institutio oratoria* II.20.3): *nihil ars sine materia.*

The French medieval achievement was, admittedly, specialized. But the conclusions are in the highest degree disturbing for the conventional view of artistic authorship as a creation, and indeed property, of the Italian Renaissance. The notion of authorship in the non-verbal arts, or of its mealy-mouthed modern counterpart the Foucauldian 'author function', continues to exert fascination even (indeed perhaps particularly) for those who distrust the whole concept. For them, it remains an accomplishment, essentially literary in nature and origin, of the circle of L. B. Alberti writing in Florence at the start of the fifteenth century. But the evidence of the thirteenth-century discussions of causality renders it much more likely that the same thinking had appeared about two hundred years earlier, not on the banks of the Arno, but the Seine. The most important Renaissance account of invention is that in Francesco di Giorgio's *Trattato* of *circa* 1482, where the basis of good design in architecture is provided not by Vitruvian *ratio* but scholastic *scienzia.*[89] The Parisians in this regard had without question already made the intellectual running, and the fatal step in the unfolding of their argument had occurred no later than the 1280s when thinkers such as Henry of Ghent had tied together the terms *artifex* and *auctor.* At around this time the detailed architectural drawing became the exemplification of the entire 'science' of form-generation in Gothic, in regard not only to the logistics of execution down to the smallest detail, but also the demonstration of thought in the process of 'drawing out' an artist's idea – what Italians were later to call *disegno.*[90] As Franklin Toker said of such ideas and practices, 'Alberti now assumes the role of godfather rather than father to a concept that had its roots in thirteenth-century France.'[91] It would be perverse to deny that the *quattrocento* advanced to a very high degree of articulation the idea of the artist–author and, perhaps more importantly, generalized this concept beyond its original domain of architecture to the other visual arts. But in doing so, recognition of the 'Gothic' origins of the necessary thinking was discounted, probably deliberately. A major factor in the demotion of the medieval artist–author was this artfully chauvinist forgetting.

Inventive Gathering: Drawing In, and Drawing Out

It is also possible to over-intellectualize the question of invention by dwelling on the strongly academic and hierarchical character of French thought about architects in the thirteenth century. In doing so, one may fall foul of a polarity between an artistic culture that is textualized, parchment-bound (graphic or written) and impersonal, and one that is 'charismatic', invested in the 'real presence' of the artist, oral tradition and physical engagement with things, craft. The cult of the artist is more likely to be produced by the former than the latter, because such cults are the product of textualized, intellectualized reflection shaped not by life but by literature.[92] My assessment is that this process had begun in intellectual circles no later than the thirteenth century. But is it necessary to choose between these cultures? Not really: rhetorical tradition, with its elevated notion of craft entailing preconception, enabled metaphors derived from craft to be applied to thought itself. The crucial point is that there was a certain porosity between the two activities.[93] What one might think of as the constrained frame for artwork, the plan, was that which provided the structured context for the actual execution of things. In buildings, quite as much as on the manuscript page (see Chapter Eight), the pleasures of ruling were also the pleasures of un-ruling.

The physicality of things, the understanding of materials in their points of tractability and intractability, mattered. Quintilian's *Institutio oratoria* (II.14.5 and XII.10) separates art, the artist and the work, *opus*.[94] In Book XII his examples are artists, not orators; but a work could manifestly be either verbal or physical. The use of the word *opus* in the Latin Middle Ages was very various: as Giles of Rome stated in his Aristotelian *De regimine principum* of the later 1270s, the word 'magnificence' takes its name *a magnis operibus* – from 'great works' considered general.[95] All that need be noted here is the widespread practice of using the word to denote the character of the way something had been *worked* in a particular place, or by particular groups, rather than *designed* in the more abstract sense. It is therefore a way of designating the *result*, not the *starting point* of a process whereby an object 'becomes', not 'is'.[96] Typically, what was made had been fashioned elsewhere: the famous term *opere francigeno* ('with French workmanship') occurs in a German chronicle relating to the construction of what would now be called a Rayonnant Gothic church, at Wimpfen im Thal around 1280.[97] It is unclear that this expression simply means 'style', or *modus*: it implies method. *Opus anglicanum* appears to be a continental European inventorial term for English medieval embroidery. In both cases, it is right to think of the designation as being that of a process (stonecutting, stitching) of the type that probably originated in trade exchange rather than aesthetic reflection or, if an idiom, a processual idiom in which the form speaks of its manufacture. Of this process of artifice, 'style' is an epiphenomenon.[98]

It was Paul Frankl who, following his teacher Heinrich Wölfflin, saw Gothic itself as a 'style of becoming', as the trace of a gradually unfolding process: the contrast is with the (supposedly) timeless fixity of the Renaissance concept of design.[99] The idea that some things are the product of a process, rather than simply of an initial design, will be a help throughout this study. It is one strength in the otherwise anti-aesthetic stance of Alfred Gell on the 'technology of enchantment', which examines the way in which something that appears to have been 'worked' impacts imaginatively and emotionally on the beholder.[100] Ovid's tag *opus superabat materiam* (*Metamorphoses* II.5), that is, 'the workmanship surpassed the materials', was reiterated frequently for this reason.[101] It is not meaningless to think of the rich surfaces of English buildings as having been 'worked' in a certain way conducive to an aesthetic of *varietas*, even if preliminary drawing of an exceptionally complex nature might have been involved in the initial stages. How, and to what extent, the most phenomenally complex achievements of English curvilinear Decorated Style, represented by the wall arcading of the Lady Chapel or Prior Crauden's Chapel at Ely (see pls 169, 167), were rehearsed in graphic elevations, or wooden models, is unknown: all that are left are the finished products. The bulk of architectural drawings of the period survive not from England (where they are virtually unknown) or indeed France, but the Holy Roman empire.[102] Some kind of drafting process must have been involved in order to standardize and discipline component manufacture, on grounds of cost alone.

One ancillary concept is 'cunning', the Old Norse root of which exactly captures the connection between knowledge, even erudition and wit, and dexterity. The fourteenth-century work at Ely or Exeter is full of cunning (see Chapter Six). Chaucer uses the word to describe the rhetorical power to describe architecture adequately (see p. 346). Only the Italians, in their self-laudatory monumental inscriptions dating to the twelfth and thirteenth century, spoke of the hand itself as being endowed with knowledge – for instance, that dated 1259 in Pisa about the great sculptor Nicola Pisano, mentioning his 'learned hand', *docta manus*.[103] It is a mistake, however, to think of this, or other, Italian uses

of the terms *doctus, magistri doctissimi Romani, doctissimus in arte, doctor . . . summus in arte* and *doctus in arte* and so on as having the same high academic sense as *doctor* in thirteenth-century Paris. As Michael Baxandall pointed out, the term *doctus* may mean absolutely learned (in the academic sense) or learned in a particular art – a usage actually closer to the modern idea of skill.[104] The term *studiosus* meaning both diligent and 'studied' was applied generically to patrons and to diligent or highly skilled artists, typically metalworkers or illuminators, but without any academic implication until it became possible to speak of 'learned design', as noted at St Ouen in 1321.[105] The notion of excogitative invention (i.e., finding out by thought) was not unknown in English artisanal circles in the fifteenth century, as when the carver William Hunt of London was paid for designing a roodloft at Winchester College in 1467–8 (*pro novo rodi soler imaginando et excogitando*).[106] Any doctrine of the 'mindful hand' still has to reckon with Aristotle's teleological view of the hand as an instrument existing for the sake of the mind.[107]

The threads of invention, then, were woven together by mind and hand, a process that entailed that material was first 'drawn in' before something new could in turn be 'drawn out'. How this material was gathered is secondary to the fact of gathering itself; any artist had to assemble material before arranging and treating it appropriately. An important medieval term for this activity was *collatio*, 'inventive gathering'.[108] An inventory of material having been formed, it was drawn upon, summoned in a process of recollection, which moved the mind to invention.[109] Invention is necessarily recollective and ruminative; in it, something great grows from something smaller, epitomized in brief. In visual invention, the closest one gets to this idea of a brief or epitome, what Hugh of St Victor called the 'brief and dependable abstract' (*Didascalicon* III.11), is the geometrical schema, on the basis of which Villard de Honnecourt developed his practical notion of easing invention by generating lineament from the seed of geometry.[110] Villard literally 'drew out' his designs by first 'drawing in' geometrical figures. His use of wrestler figures set close to architectural drawings (see pl. 16) indicates the extent to which he saw this process as ludic, a sort of serious effortful but productive play.

Two specific terms for the process of generating an artistic or verbal lineament were *traho-trahere* and *tracto-tractare*, whose meanings lay (suggestively) at the boundaries of movement, drawing, treating, investigating and discussing.[111] From them derive the words tract, trace, tractable, contract, protracted and so on. These terms were entirely practical

and it is important to note that their semantic range includes both notions of design and of workability. When canvas drawings of components were sent from London to the quarries at Caen for stone to be cut to shape for St Stephen's Chapel at Westminster in 1324 (see pl. 25), the expression for stonecutting was *tractare*.[112] A very common word for 'to draw' in the artistic sense was *protraho*, yielding the word *protractura*, and the French *portraire*. These terms figured increasingly as the volume of detailed administrative records expanded, for instance in England in the second half of the thirteenth century; in 1307 at Westminster Master Thomas the painter worked away emending various *depicturae* and *protracturae* in the palace in readiness for Edward II's coronation, making it clear that some work was painted, and some just drawn.[113] The builders of the church of St Didier at Avignon (see p. 261) were instructed by a contract of 1356 to follow 'a certain skin of parchment on which the church is drawn out' (*prout in quadam pergameni pelle in qua ipsa ecclesia est protracta*).[114]

In the academic sphere, this group of words was drawn into discussion of literary form in a way that approaches a notion of literary style. In biblical commentary, the initial ordering or disposition of the texts to hand was called the *ordo* or *forma tractatus*; the actual literary treatment or fashioning, the *modus* or *forma tractandi*. Together, these were the formal cause of a work.[115] The terms again move between shaping, investigating, discussing and treating, as with the unspecific sense of the word *tractatus* (design? treatment? treatise?) in the 1321 document for St Ouen cited earlier. Such versatile terms are of interest here precisely because they move between the spheres of theory and practice, and, like the term *opus*, cross the boundaries of different activities, whether they be textual, architectural or pictorial. This is one reason why the domains of theory and practice cannot be artificially severed. A major nexus for such terms was the written contract, where the theoretical had no choice but to negotiate with the practical. The *forma tractatus* and *modus tractandi* are reminders that *forma* and *modus* were also common, if not altogether specific, terms of a legal or academic nature used in art commissions, especially contracts, to designate the way in which something was to be done.[116] *Modus* is especially broad, designating something like measure, quantity or even manner. The terms *forma* and *modus* appear in the *Decretum* of Gratian, the fundamental text of Church law, in the writing of Aquinas and in preaching manuals.[117] They were used in 1273 to designate the planning of the new cathedral of Clermont-Ferrand.[118] They appear again in the eclectic Franco-Italian context of

the commissions of Charles of Anjou in southern Italy, specifically in a document of 1279 for the building of the abbey of Santa Maria di Realvalle.[119] In 1321 the painters, some of them English, employed by Pope John XXII at his residence at Sorgues, near Avignon (pp. 252–3), were directed by a *forma et modus* provided for them by the head painter, a Frenchman called Pierre du Puy, which in the context must mean a 'design'.[120]

One fourteenth-century account of what wall painters do leads to a final instance of the open boundary between the language of theory and practice. When churches or palaces were painted, the initial design of the pictures was typically set out by the master in charge, and was called the *ordinatio*. This is the normal Latin word, along with *dispositio*, for 'arrangement', which might mean narrative or artistic arrangement (choice of scenes, layout, order and so on), or the more fundamental rationale of structuring information by means of a book's layout, also called its *ordinatio*.[121] The activity of *ordinatio* is given entirely to the highest-paid master painters in the accounts of particulars for paintings in the palace at Westminster in 1307 and 1350.[122] This would have meant not just 'arrangement', but also the actual idiom of the murals in question. The English Dominican Robert Holcot noted in a sermon that painters omit nothing in their search for fullness, even the merest pleats of cloth (*plicas vestium*).[123] The well-known Dominican John Bromyard, who died around 1352, has a number of interesting things to say about architecture in fourteenth-century England (see p. 174) in his manual the *Summa predicantium*.[124] The *Summa* is itself a notable instance of scholastic *ordinatio* in having an alphabetical arrangement of examples for preaching. In it, John at one point describes what painters do when they invent. Such texts are astonishingly rare and illustrate the nexus between 'scholastic' terms and artistic activity. John alludes to painters (my emphases)

> ... *qui pulcras imagines diligenter* considerant *ut consimiles faciant. Et unam excellentem* pulcritudinem *vel* tractum colligunt *de una imagine et aliam de alia ut omnes illas excellentias in una imagine* ponant *et pulcerrimam faciant.*

> ... who diligently *ponder* beautiful images in order to make similar ones: they *gather together* one excellent beauty and *treatment* from one picture, and one from another, in such a way that they *place* all these excellent features in one most beautiful picture

John therefore thinks that painters, like scholars or rhetoricians, engage in *collatio* (ruminative gathering) before pro-

ceeding to invent. He distinguishes two terms, *pulchritudo* and *tractus*, which may be taken here to mean 'beauty' and 'design', which might mean design or treatment in the narrative sense: getting the story across well. He might have thought this because he had seen real painters at work. In view of the prescriptive dynamic of Ciceronian ideas of arrangement in preaching manuals, however, he might also have been thinking of rhetorical practice. Book Two of Cicero's *De inventione* (II.i.1–4) opens with an analogy between the act of drawing together the best from textual authorities, and the tale of the painter Zeuxis who, in order to paint a stunning painting of Helen, asked the citizens of Croton to provide their most beautiful girls, from whom he selected the best features of five.[125] Thus art's capacity to pick, choose and place well vanquished the accidents of nature. Bromyard probably knew this account and, like many educated commentators on the arts, framed his description of artistic *collatio* and *tractus* in similar terms. But it is impossible to say that he therefore lacked a sense of social reality. For one thing, Bromyard is considering the way beauty and treatment are derived not by copying people, but other artworks: here at least, the evidence of sources and models in actual wall painting shows that he was not wrong. It is useful to see that Bromyard did not immediately assume that painters automatically gave way to single authoritative pictorial traditions. His idea is that they invented by gathering and mixing.

'An ever rolling stream': Anachronic Authority and Modernity

There is an important ulterior reason for considering the theory and practice of invention at the frontier of concept and action, abstract as this might seem at first sight. It concerns the fully practical relationship of invention to the existing stock of (necessarily older) material, as it were the 'inventory'. All arts operate with regard to an inventory, whether they seek to imitate it, draw from it, adapt it or cast it aside. The last of these options is problematical because the inventory tends to carry with it lasting authority. There is much truth in the idea that the medieval relation of past and present was not one of distance or perspective, but of typological recurrence. That idea is central to Krautheimer's notion of typology explored in the previous chapter.[126] The moderns were supported on the shoulders of the ancients, and the balancing act was perpetual. All authorities, having been summoned, spoke with

a present, if not always equal, voice. *Collatio* entailed taking in all texts and pondering them. The discourse drawn out from such gathering and reflection was multi-layered rather than linear, cumulative rather than supersessive: it brings to mind Mary Carruthers's vivid image, 'a work of literature was not taught in isolation . . . but as an ever-rolling stream accumulating and adapting over time'.[127]

The virtue of considering the analogy of medieval biblical commentary and literature is twofold. The first is that it provides a huge, authentic and highly articulate body of evidence for concepts of authority in general, far larger than anything stated explicitly about the non-verbal arts in the Middle Ages. This evidence sustains the idea that the *auctoritates*, past and present, formed a continuum of constantly refreshed understanding that can be called tradition, though understood dynamically. Augustine's authority was no more superseded than the Psalms were 'quoted' in the medieval liturgy. Second, the implication of this is obvious, and important for medieval art history: the relation of old authorities to new did not concern 'modernity' or 'historicity'. The conceptual distancing necessary to produce self-conscious ideas of time is not consistent with the much more elastic yet closely woven medieval theory and practice of considering textual authority within the living actuality of what was handed on. Here is a particular value rationality that could see the good in authority per se, old or new: one might speak of 'anachronic' authority.[128] Not just that: then, as now, some things had a continuing, enduring power not reducible to specific historical conditions. By understanding the notion of cumulation, of the internalization of a cluster of ideas whole or fragmentary, we see that significances accrued around a work as a legitimate development of that power. The old and the new have a vital mutual relation stronger than a simple handing on, as in tradition in its most vapid sense. We are thinking of something 'lived' and not just studied.

I emphasize this because, if so, a very substantial obstacle is presented to any doctrine that speaks of medieval 'modernism' in the visual arts. The medieval–modern nexus, familiar from a reading of Pevsner, Meyer Schapiro, even Le Corbusier, needs commenting upon because it has been influential.[129] It is the basis of the idea that just as the modern was shaped by the medieval, so the medieval was shaped by the modern and by its language of progress, innovation, purity of form and necessity. As a starting point for criticism it has a certain power: it captures the radicalism of northern French Gothic of the twelfth and thirteenth centuries, the sense it conveys of rupture with the past, of

the determined reordering of aesthetic priorities, of success at the international level. Modernist parlance has long been used of this sort of architecture. Robert Branner, the most influential of the internationalist writers of the 1960s, wrote of thirteenth-century Parisian court-style buildings as

> virtuoso performances. Light and thin in the extreme, they mark the absolute victory of void over solid. Structurally each one is a spare skeleton from which the unnecessary parts have been removed . . . each is a speculation upon the nature of plane geometry, using the straight line, the circle, the arc and the square.[130]

Such terms enjoy quite as comfortable a fit with the works of Le Corbusier, or Mies van der Rohe, as does the intellectualist and moral language of pure forms and necessity.

A danger for a historical reading of such building styles arises, however, when what are illuminating similes – Gothic buildings are 'like' or 'bring to mind' modernist buildings – develop into extended metaphors in which an illuminating simile evolves to become not criticism, but explanation. A well-chosen simile or metaphor will make the imaginative and critical experience of Gothic more vivid. But modernism in the contemporary sense is not just a style or a metaphor: it is an entire *outlook* or *stance*, adopted at a particular historical moment and by leading individuals, which entails a transformed consciousness of the world as a whole. It is a movement, a set of beliefs, values and practices that promote an aggressive attitude towards both the future (which is to be grasped) and the past (which is to be challenged and repudiated). To reduce it to parity with a style label such as Gothic is greatly to weaken its true power – is in a sense to aestheticize a much more richly political concept. 'Modernism' began life as a word in manifestos. It tries to derive its power from its claim to be a transhistorical condition, a form of universal consciousness based on beliefs in universally progressive social and cultural transformation as a matter of necessity. Understandably, therefore, Marvin Trachtenberg writes of the Gothic flying buttress that its transformative force derived from (my italics) 'the powerful, *iconoclastic historicist urge* of the medieval *modernist movement*, the *power* of the *modernist consciousness* and *desire* to follow through in practice the *radical* direction that *rational analysis* indicated'.[131]

The problem is that it does not follow that, because modernist language enriches one's experience of these buildings, something like modernism must have explained them. One answer to this might be to hunt out examples of 'modernist' thinking in the Middle Ages. Medieval

notions of *modernitas* and *antiquitas* will certainly not help here.[132] The terms *modo* or *modernus* in medieval Latin have nothing to do with utopian future conditions, but rather with the present, whatever is done 'now' rather than 'then', those working formerly being the *antiqui*. *Modernus* or *modernitas* were not synonyms for what is now called 'modern' or 'modernity'. Hence they cannot have implied some sort of anti-classical or anti-historicist stance.[133] Modernity entails by contrast the self-conscious placing of the subject outside history in such a way that it exists in a conscious and reflective relation to the past. It is precisely such a notion of detachment that permits and encourages the use of 'time' words and concepts like 'historicist', 'revivalist', 'archaic' or 'retrospective' that had no medieval currency, and which may even have been weak in the Renaissance.[134]

Nor should modernism be confused with the widespread medieval discourse of improvement that borrowed much from classical thinking in serving Christian moral objectives. Medieval commentators, like their predecessors in the ancient world, understood perfectly well that buildings and works of art might be old, ugly and infirm: examples of this are legion. When writers such as Gervase of Canterbury and Giraldus Cambrensis commented on new Gothic buildings such as Canterbury and Lincoln their thought, often informed by Latin poetry or rhetoric, was antithetical: the new work (whether Romanesque or Gothic) was more subtle (Canterbury), sweeter, more beautiful (Lincoln), or less affected and contrived (Beverley), than the old work to which it was compared.[135] But this did not make their agenda 'progressive'. Antitheses like this were embedded in rhetorical technique that valued improvement and surpassing, not progress. By improvement we accept the rules; with progress, we cast them aside and adopt new ones. The legislative aesthetics of the most rigorous monastic orders such as the Cistercians were precisely drawing their authority from the past, from a vision of apostolic life and conduct. Their aims, like those of their sympathizers in the secular orders, were reformatory, restorative, geared to the idea of renewal rather than to some idea of emancipation via progress.[136] Such thought was governed by a fundamentally clerical Christian metaphorical idea of rejuvenation as spiritual and institutional renewal typical of ages of reform.[137] In the Metrical Life of St Hugh, the physical renewal of the cathedral of Lincoln and the casting aside of the old building is palpably a metaphor for inner spiritual edification and regeneration. The chronicle of the bishops of Auxerre relates that in 1215 the bishop decided to demolish the old cathedral 'burdened by its decrepit and rudimentary building at a time when cathedrals generally were raising up their heads adorned with admirable beauty', and employed men expert in the learned art of masonry to rebuild it so that it might be 'rejuvenated in a more elegant newness' (*in elegantiorem juvenesceret speciem novitatis*).[138] The passage is preceded by a wider observation, namely that the piety of people at this time 'burned' with the fervour of church building more generally: the image is a reminder of Glaber's 'white mantle of churches' being spread out in France two centuries earlier (p. 26). Even as late 1352, not long after the major outbreak of plague, the dean and chapter at Lichfield, which had employed William Ramsey on its new choir (see pl. 31), were still trying with God's help 'to restore to the beauty of newness (*ad novitatis decorem*)' the work that 'pious antiquity had built in its own style (*suo more*)' – a pious antiquity, incidentally, no older than 1200 and certainly Gothic.[139] To my mind aesthetic, rhetorical and ethical considerations cannot easily be disaggregated in such writing. Finally, it is worth bearing in mind that the only canonically authoritative vision of a 'future' architecture known to the Christian imaginary is the account of the Heavenly Jerusalem in Revelation 21, which is about as conservative a statement as one might wish of the aesthetic of *magnitudo* and *varietas* favoured since the Constantinian epoch: a flashily diverse Early Christian vision of gold, precious stones and great and high walls from which a truly modernist aesthetic, disdainful of such lack of sophistication, could only recoil. Those who reject the style label 'Gothic' for 'medieval modernism' do not escape the traps set by post-Romantic and modernist aesthetics; rather, they fall deeper into their clutches.

Invention and Tradition: Bristol–Norwich–Ely

If John Bromyard's account of invention by painters shows how it was (and remains) legitimate to construe artistic activity in rhetorical or scholastic terms, then architecture itself enables one to infer that artistically ambitious buildings were the outcome of processes of gathering, reflection and inventive drawing out that may be understood in the light of apparently loftier concepts of textual authority. In such accumulation, the established building or work of art becomes by analogy the physical gathering place for subsequent commentaries and innovations. Older buildings or parts of buildings were sources of *figurae*, not failed, repudiated and 'outdated' solutions isolated from subsequent work:

'source, glosses, citations, punctuation and decoration are all married up together'.[140] The role of the *auctor* was understood within that catena. It is easy to lose sight of this most practical of realities because of the growing importance of measured architectural drawing in the thirteenth and fourteenth centuries, which provided masons almost anywhere with an unprecedented variety of solutions and patterns, encouraging an eclectic and transformative art. Bodies of 'meaning' could not easily survive this abstract vehicle of transmission. But in contrast to the impersonal and intellectual medium of design lay the powerful and quasi-charismatic presence of the existing building stock. Buildings impress above all by their sheer physicality, and to be truly known they must be experienced. To witness a building is to encounter a presence that drawings cannot necessarily convey, particularly if that presence has been invested in specific materials or in the working of surfaces and volumes. The movement of attentive agents – patrons, clients or artists – mattered as much as that of depersonalized two-dimensional information. And this sense of presence naturally engaged with (because it embodied) actual charismatic individuals in the form of the relic cults of the great churches. To put it succinctly, the intellectual culture of the drawing had to contend with the even more vivid charismatic culture of artistic tradition and personality cult, and to see one necessarily prevailing over the other is to misunderstand the mixed and creative dynamic of much medieval art and the possibility that linear, progressive models alone may not serve us well in understanding it.

I am certainly not to the first to challenge the idea, evident in Jean Bony's writing, that the Decorated Style was the seminal product of revolutionary rather than evolutionary thinking in the period after 1245: the continuities between it and the work of the twelfth and thirteenth centuries have also been set out by Peter Draper and Nicola Coldstream, among others.[141] By about 1300 England possessed a huge and authoritative church building stock that remained an inescapable point of reference as an inventory of tried-and-tested stone building. To refer to it was not the product, as Pevsner seems to have thought, of conservatism, but of two specific factors.[142] The first can be understood if medieval invention in this period is thought of as a species of commentary moved (but not solely determined) by existing authority. The second was the character and extent of the building stock itself, which by 1300 had reached a point of saturation that coincided, if not with economic decline, with the end of a longer period of expansion. At this point the expansive heroic mode began

to experience constraints. At Lincoln, a giant building (see pl. 6), the heroic ambition of the earlier period entailed the successive building of three entirely new presbyteries within about a century and a half, the first provided in the late eleventh century by the founder, Remigius, the second under St Hugh in the 1190s (see pl. 14), and the third, the Angel Choir (see pl. 45), after permission had been gained to take down the city wall to the east in 1256.[143] The strong economy at that time underwrote an astonishing willingness repeatedly to clear away old work in the service of new needs or tastes, and the metaphorically rich language of renovation was always on hand to justify this outlook. But the type of comprehensive clearance of old work envisaged at Lincoln, or the ability to build within a relatively short span entirely new great churches to an incredible level of stylistic consistency, as well as related cities, as at Salisbury (1220–*circa* 1258), was on the whole the exception.[144]

The existing building stock, even if it consisted of substantial eleventh- and twelfth-century work, remained an asset rather than a liability. Buildings constructed in the post-Conquest heroic mode slowly began to exert a conceptual pull on the necessarily more physically limited projects of reworking, extension and adaptation that constituted so many projects in the Decorated Style. Some of the greatest centres of formal innovation consisted of great churches where, by necessity or design, substantial quantities of eleventh-, twelfth- and thirteenth-century work had to be retained. Older work provided something in contrast to which newer work could be displayed. For instance, it is highly unlikely to be coincidence that some of the most elaborate and experimental vaults erected in the first half of the fourteenth century, such as in the choir at Tewkesbury Abbey and over the nave of Malmesbury Abbey, were conceived in relation to manifestly different twelfth-century supporting elevations. The dynamic of the strong calculated contrast is fundamental to much late medieval aesthetic practice.

But older work was not simply tolerated. Gradually, something of importance was recognized in it. Instances of this take two forms: cases where a regional twelfth-century idiom newly energized particularly adventurous work of the period *circa* 1300; or cases where the actual heritage of a particular building brought about a kind of witty inventive appropriation, not because of some time-related idea of conservatism, but because the whole dynamic of building loss and replacement had changed.

To the first belong some features of two of the most extraordinary buildings of the era in Bristol: the Augustin-

ian church, now the cathedral, and St Mary Redcliffe. Nikolaus Pevsner, whose appreciation of the European stature of the work at St Augustine's, begun in or shortly after 1298, did much to mark out the subsequent agenda of study, observed that the arcade arches of the choir were uninterrupted by capitals except for the relatively small ones that sustained the vault shafts (pl. 32).[145] The resulting 'continuous' arcade mouldings he placed in the tradition of twelfth-century work actually on site, such as the dado wall arcading of the same church's chapterhouse, and work at Malmesbury, Glastonbury and Wells (the nave triforium), as an aspect of 'West Country' Romanesque or early Gothic whose virtues were rediscovered via Rayonnant streamlining.[146] Similar quite detailed collation occurs at around this time at Canterbury Cathedral, where Prior Eastry's screens in the choir dating to before 1304 cite small details of Prior Ernulf's work, begun before 1107.[147]

The device of capital-less wall shafts reappeared a very few years later (probably before 1320) in the interior of the

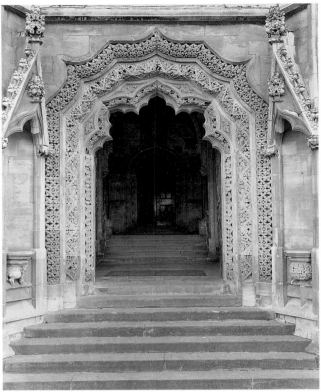

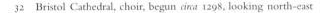

32 Bristol Cathedral, choir, begun *circa* 1298, looking north-east

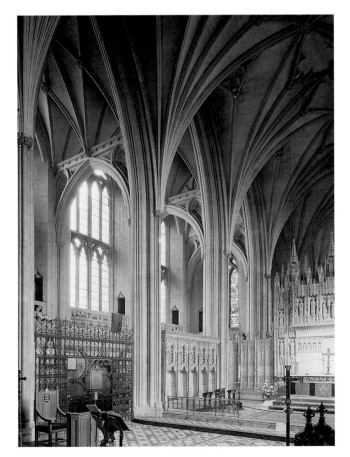

33 Bristol, St Mary Redcliffe, north porch, detail, *circa* 1320 (see also pl. 168)

polygonal north porch at St Mary Redcliffe, in the design of which Pevsner saw the same inventive flair and freedom (pl. 33). The exterior detailing of this porch, particularly its 'nodding' ogees and generous clumps of foliage, belongs in a direct line of development from work in St Augustine's and from the wooden bishop's throne at Exeter Cathedral designed *circa* 1313 (see pl. 103). The astonishing archway to the porch itself consists of a complex polygonal semi-oval of two orders in which the facets of the two outer orders are each curved inwards, so moving counter to the ogival cusps of the inner door frame. The origin of this interest in polygonal surrounds lies in the stellate niches around the choir and Lady Chapel at St Augustine's (see pl. 133); but because of the bravura cutting of the (now much recarved) arch orders themselves, the porch is, questionably, placed in an 'orientalist' context by Bony, who likened their detailing to Mudéjar decoration.[148] What perhaps happened at St Mary's was something more specific and local: an admiring riposte to the great multi-order Romanesque portals of the West Country, as at Malmesbury (south porch) and, especially in virtue of the porch's dedication to the Virgin Mary

terms Ely was far wealthier than Norwich, but both churches were forced into major campaigns of building by circumstances, as well as by choice. Because the two priories shared personnel and were relatively near one another, the history of formal invention in East Anglia from around 1300 was strongly influenced by the Ely–Norwich nexus. And because both great churches retained very substantial eleventh- and twelfth-century work, this nexus was formed in the midst of a substantial heritage that could not be cast aside, because to do so would be too costly. Each became a gathering place of invention in virtue of the retention of the old 'source'.

The way the fourteenth-century work at these churches developed in relation to the architecture already on site is instructive. When Hugh of Northwold (d. 1254), substantially at his own cost, erected the Gothic eastern extension to the choir at Ely in the years 1234–52 (pl. 35), his lavishly carved and marbled building closely followed the dimensions of the Romanesque elevations. But in idiom it was

35 Ely Cathedral, retrochoir, 1234–52

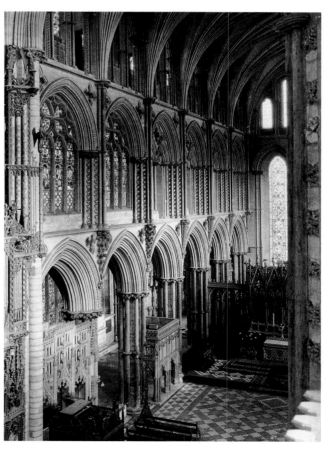

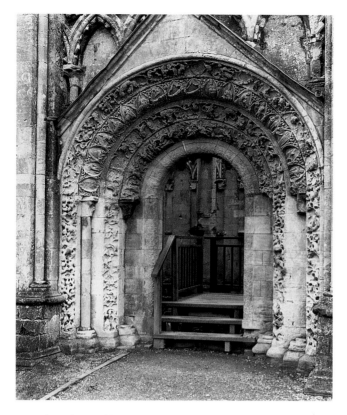

34 Glastonbury Abbey, Lady Chapel, north portal

(see p. 206), the Lady Chapel at Glastonbury (pl. 34), which are here consciously emulated but surpassed by means of Gothic contrapuntal compass-play of a type particular to Canterbury, Westminster and Bristol (see pl. 133) around 1300.[149] Bony was in a sense right to see such big, rich, centralized forms in the light of the semicircular arches of the twelfth century, his account of the sympathy of Late Gothic fantasy with late Romanesque art echoing a doctrine of his teacher, Henri Focillon (see p. 161); but like Focillon he may have been a little too prone to orientalizing and revivalist explanations.[150]

Instances of the practical adaptability of the Decorated Style to its much more immediate context include the cathedral priories at Norwich and Ely, also important centres of formal invention in England. Both were accident-prone. In 1272 the church and conventual buildings at Norwich were ravaged by a fire in the midst of a riot between the citizens and the priory men. In 1322 the central tower of Ely collapsed; in 1362 very strong west winds blew down the spire at Norwich onto the Romanesque presbytery, demolishing its upper stage. In diocesan

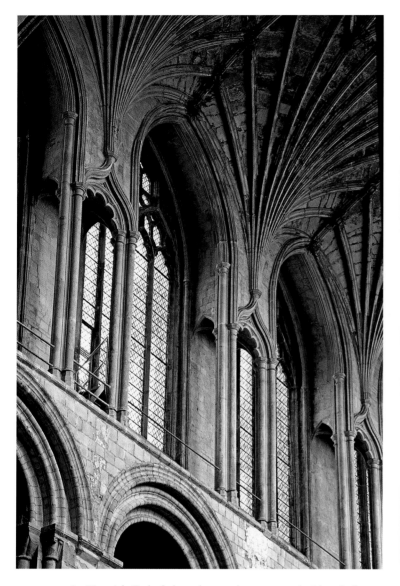

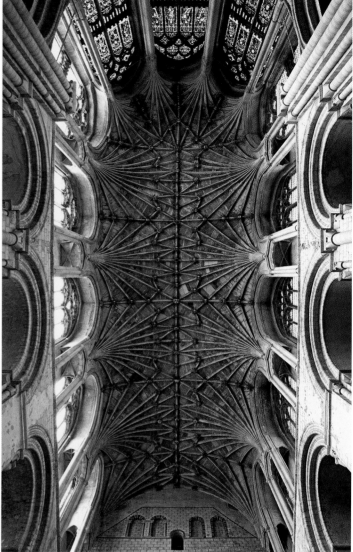

36 Norwich Cathedral, presbytery clearstory, north side, rebuilt after 1362

37 Norwich Cathedral, presbytery clearstory (1360s) and vault (1470s–1490s)

more closely related to the expansive thirteenth-century nave at Lincoln. It may be thought of as an opulent regional architecture proper to eastern England, as much as an 'Ely' type of architecture, responsive as it may have been in smaller details to the local cults.[151] Lincoln and Ely together did much to inaugurate a generally richer type of Gothic elevation than had been the case earlier. In his *Chronica majora* Matthew Paris of St Albans lauded Ely by saying that Northwold's work had indeed proceeded at his expense anew from the foundations, in magnificent fashion.[152] Northwold did not clear the entire church, but the example

of Lincoln might have suggested at least a long-term plan to do so. At Norwich, on the other hand, there was hardly any thirteenth-century work at all, bar the remodelling of its eastern Lady Chapel. Both it and Ely therefore offer a superlative opportunity to see what the fourteenth century made of a substantial body of post-Conquest building.

Norwich's instance belongs to the last phase of the Decorated Style. Following the collapse of its spire in 1362, the two Romanesque lower storeys of the main vessel of the eastern limb were retained and a new clearstory added between 1364 and 1386 (pls 36, 37).[153] The major shafts of

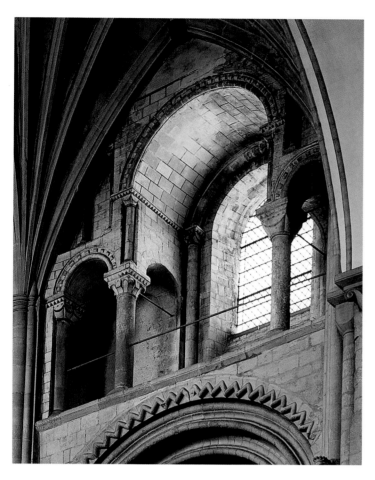

38 Norwich Cathedral, nave clearstory, looking north-west

39 Wells Cathedral, choir, 1330s

the elevation were discontinued at the string course below the clearstory, and the work above it was reconceived in the knowledge that, as in the remainder of the church, the main vessels were still to be ceiled in wood. The height of the clearstory was increased quite substantially, creating an external profile to the church in which the presbytery is markedly higher than the nave and transepts. All in all, the aesthetic of the new lantern-like work was governed by a huge increase in the width and height of the clearstory windows, and by a rejuvenation of the eleventh- and twelfth-century clearstory passage, itself permitted in part by the fact that it was not conceived to sustain a stone vault but some sort of wooden covering. Crucial to this is the potential of thick-wall construction to generate new effects. It is apparent that, as in the fourteenth-century choir at Wells, the possibilities suggested by the relation of passages, fenestration and vaulting in the older parts of the church were many. When the presbytery at Wells was rebuilt around

1330 to the highest standards imaginable in the fourteenth century (pl. 39), its architect, William Joy, found a new solution to the relation of the springing of a vault and the clearstory passages already used in the twelfth-century work at Wells and more generally in the English thick-wall tradition, by retaining the passages but smoothing the transition from the outer plain of the windows to the inner plain of the main supports by means of oblique wall surfaces through which the passages run. This effect was managed differently in the new choir at Lichfield (see pl. 31). When, in the 1350s and roughly coeval with the new work at Norwich, Peter Parler picked up the Wells feature and developed it at Prague Cathedral (see pl. 193), as now seems certain, he thereby introduced to Bohemia effects generated (in part) by the Anglo-Norman wall passage, by way of a form of unintended consequence.[154]

In the Romanesque work of the nave and transepts at Norwich (pl. 38), the clearstory windows are each framed

by two smaller arched aedicules that act as canopies over the wall passage; because the windows are relatively narrow, this triple composition can occupy an entire bay, the high shafts of the main elevation in effect passing between each triple group. In the new work at the east end (see pl. 36), the width of the main windows meant that this triplet was re-engineered in such a way that the shorter lateral aedicules, each furnished with a little vault, slid outwards into the position where the strong accent of a high shaft would normally be expected, each triplet sharing an aedicule with the next bay. Where the elevation got 'stronger' in the rational Anglo-Norman model, here it opens out suddenly into a 'weaker' void. And this void is sustained by dangerously thin shafts rather than stout colonettes, meaning that the passage aedicules dissolve when viewed obliquely, allowing the larger clearstory windows beyond to radiate through. Internally, the effect has the daring transparency and zestfulness, if not the remorseless logic, of French architecture, an exciting effect enhanced by the no less ambitious undertaking between 1472 and 1499 of a stone vault over this brittle and lucid substructure. Perhaps the play with slender tracery effects in the new choir of the Benedictine abbey (now the cathedral) of Gloucester (see pl. 43) had already been noted. So what moved the imagination of those responsible for the new clearstory was simultaneously the older work, on which they offered a commentary in the process of collating their ideas, and the introduction to Norwich of the expansive Rayonnant traceried window and related mural effects, which reconfigured the walls around it: the product was a rejuvenated continuity, a kind of inventive dialectic between old and new. Through a sort of replication, the old was made new.

The translucent and lofty new presbytery at Norwich shows that it was perfectly possible for an important, if ad hoc, project of the 1360s to regard an existing Romanesque fabric as an inventory of newly useful figures that, having been collated and pondered, could form a basis for variation. This project was one of limited ambition and cost, and was motivated in part by a desire to bring the new presbytery into line with at least some of the patterns of the old church. It was therefore driven by a particular rationale. Far more significant and influential were the works at Ely, begun in 1321 and radically extended after the collapse of the central tower in 1322, because these involved two new structures discontinuous with the great church itself, the Lady Chapel begun in 1321 and Prior Crauden's Chapel, under construction in the mid-1320s. The level of formal inventiveness at Ely, almost certainly involving the Ramsey

40 Ely Cathedral, Galilee porch, early thirteenth century, north side

family of architects then based in Norwich, is astonishingly high, and reflected the capacities of one of England's richest dioceses. The seed of this inventive potential lay at least in part in the Romanesque church or in structures attached to it by the early thirteenth century – works more than a century old by the time activity started anew in 1321. Ely's western transepts and towers, begun in the first half of the twelfth century but completed and revised under Bishop Geoffrey Ridel (1174–89), are themselves veritable inventories of unusual motifs and motif combinations.[155] For instance, the upper stages of the great west tower and transepts dating to after 1174 possess arcading with trefoil-headed arches, forms that did not gain wider currency even in France until after 1200. The round openings found in this work were studied by the architects of the octagon and Lady Chapel, where they are also found. Here too, significant play is made with shaft and arch effects to the point where, on the octagonal southern transept tower exteriors,

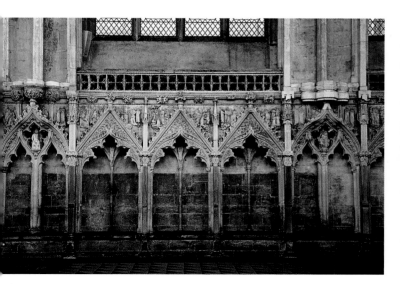

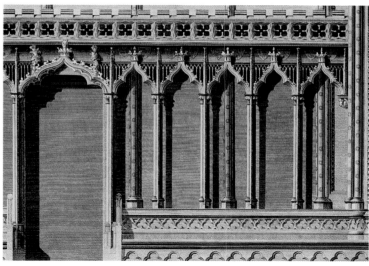

41 Ely Cathedral, Lady Chapel, wall arcading on south side towards west end, begun 1321

42 London, St Stephen's Chapel, Westminster, interior, detail of stalls on north side of upper chapel, by John Carter, published 1795

major shafts actually pass up in front of arch heads, so bisecting them. The same enjoyment in layering strong vertical accents is apparent in the 'syncopated' arcading of the side walls in the early thirteenth-century Galilee west entrance (pl. 40), and can be sensed even in the earliest parts of the fabric as in the case of the responds that pass up from ground level behind the transeptal wall walks. These effects need mentioning because, as John Maddison noted, they are clearly recapitulated in the virtuosic deployment of shafting passing behind and up through ornate canopies, foil forms and gable-work in the Lady Chapel wall arcading (pl. 41), and the odd triple canopies just above the arcade level of the octagon's base (see pl. 179), which mask the transition from one set of vault shafts to another as the elevation rises.[156] The casement mouldings of the Lady Chapel and Prior Crauden's Chapel arcades are anticipated in the Galilee; the form of the image-filled buttresses of the Lady Chapel's interior and exterior suggests study of the once-inhabited exterior buttresses of Bishop Northwold's presbytery.

The eleventh- and twelfth-century great church at Ely was no less an important inventory of ideas than Romanesque Peterborough or Bury St Edmunds, the most prestigious church in the region. Bury's huge west façade also ended in polygonal tower-like structures, and its surviving great gatehouse, also constructed before 1148, uses two motifs that again substantially anticipate French Gothic usage: large gables with flanking towers are placed over the

deep porches in its base, and the shafts and arches of its two upper stages demonstrate 'linkage' of tiers by their shafting, a practice not common in northern French church elevations until later in the century.[157] These giant churches were, in other words, not just instances of the heroic mode, but manifest examples of inventive precocity, which gave the process of ruminative *collatio* much to chew on.

There is another route to understanding the complex arch and shaft effects in such works as the Lady Chapel and the octagon at Ely, and that is to see in them direct or indirect references, via the work of the Ramsey firm of architects, to the new mode of lavish arcade design developed by Michael of Canterbury in St Stephen's Chapel at Westminster in 1292, where the mullions of the windows penetrated down behind the stall work and its elaborate cresting with ogee arches and crenellations (pl. 42). Virtuosic shaft effects, cutting through foiled forms, were a feature of the Rayonnant of St Urbain at Troyes, of Séez in Normandy and of late thirteenth-century Lichfield and York.[158] It does not matter that Ely's deployment of these tricks of layering, bisecting and interconnection is far more ambitious: it is possible to offer a perfectly coherent 'modernist' account of their generation which relies on the movement of shapes and motifs from centre to region, typically via the court at Westminster, in particular the personal agency of a select band of innovative Gothic architects who were responsible for these ideas.[159] Possible, but also theoretically problematical, since in English archi-

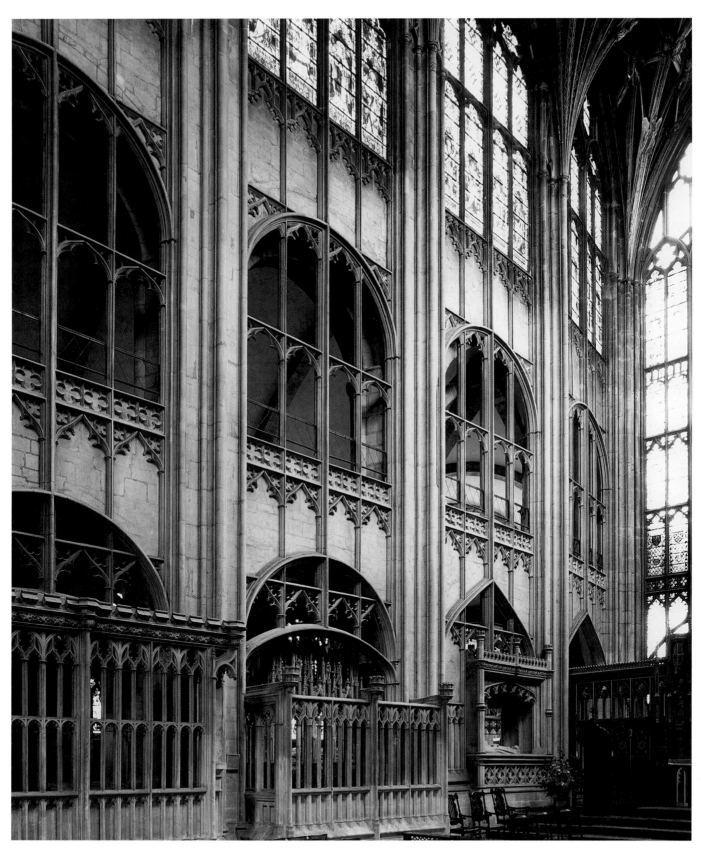

43 Gloucester Cathedral (formerly Abbey), choir, *circa* 1351–67

tecture, as in English picture making (or any artistic activity), to trace a 'source', no matter how influential, is not necessarily to proffer an explanation for its use.

The important point is that these two models of invention, one local and self-referential or internal, one centralized and cosmopolitan, were not incompatible or antagonistic. It is as possible for an avant-garde to provoke interest in existing artistic assets as for existing assets to sanction an avant-garde. No further demonstration is necessary to show that specific, new projects in the Decorated Style, such as St Stephen's Chapel at Westminster, had national consequences quite out of proportion to their size or degree of completion. But it is also clear that from around 1330 in London and Gloucester a new, more radical idiom, in effect a reissue of French Rayonnant known as Perpendicular, engendered a very different attitude to the existing building stock. Where at Wells, Norwich or Ely the Decorated Style engaged in creative gathering, commentary, elaboration, amplification and ultimately *confirmation* of what had gone before, the choir at Gloucester Abbey as recast in the mid-fourteenth century in an early version of Perpendicular (pl. 43) is perhaps the single most decided and brilliant act of inventive *refutation* in English medieval art. Apart from the rounded curvature of the elevation's arches, there is little or nothing in this astonishingly crisp cage-like ossature to indicate the fleshy plumpness of the Romanesque work lurking behind it. Here really was a new architecture whose sheer sparseness, uniformity and semantic neutrality — as heir to French radicalism — eventually gained nationwide success. It is with regard to such buildings that modernist metaphors — as metaphors — have some power. The path towards this dominance was not entirely smooth, and there were long-term projects in styles that included both Decorated and Perpendicular features, such as the massive rebuilding of the choir at York Minster from 1361, where harmony with work already begun was thought important. But by the late fourteenth and fifteenth centuries the homogeneity, versatility and (perhaps) economy of Perpendicular made it the style of choice, not least for the type of project favoured by the new patterns of spending of the time. At one level the price of this was to be high: building in the Perpendicular style in hundreds of churches, parish churches and chapels was to become the single greatest means of erasure of the Decorated Style and indeed anything built before it.

To understand the way the Decorated Style particularly could negotiate the existing archive not just by working with it, but also by being actively energized in the course

of reflection on it, is not, as John Maddison so wisely put it of Ely, 'to discount comparable features in more recent buildings', but is 'to acknowledge the role of the old fabric in moving the imagination of the masons in a particular direction'.[160] Grasping this movement of imagination seems to me crucial to the notion of collation and invention. It helps one understand why so many projects in the Decorated Style have to be seen as regionally — and locally inspired — one-offs. It also brings to mind Baxandall's salutary, but philosophically fundamental, warnings about 'influence': that the notion of influence from an active dispenser to a passive receiver discounts the more lively reality of an active agent who draws on, appropriates from, adapts, misunderstands, assimilates, transforms and so on.[161] This matters because it exposes the weak explanatory character of models of influence that simply assume that some things are 'influential'. When the agent acted upon acts back in turn, so responding intentionally, that agent is moved by a cause. This is why source tracing should not masquerade as explanation. The basis for positive causal agency is formed by historical circumstances, and it is in part within those circumstances that explanation must lie. So, in the field of medieval image making and invention, existing and often local conventions possessing authority will often be approved of per se. For Baxandall, these conventions exemplified the stronger notion of tradition as 'a discriminating view of the past in an active and reciprocal relation with a developing set of disposition and skills'. English medieval architectural aesthetics flourished within a framework in some ways more traditional and persistent than progressivist models of Gothic would allow. So, I shall suggest at a later point, did the figurative arts. In many cases the Decorated Style was obliged to negotiate actively and practically with existing building stocks when it created what were in effect substitutes for earlier buildings. In such cases, tradition did more than simply limit; it also guaranteed the new work. To see architects as using old work in acts of 'retrospection' is as problematical as the language of 'historicist' borrowing: in such cases what is concealed is an assumption about the 'progressivist' nature of invention. Local and specific dispositions had a further role in invention: they grounded the free movement of 'influential' and impersonal design ideas in specific existing discourses. What motivated the designers of the Ely Lady Chapel, like many projects of its time, was a form of discursive wit, often theological in origin, that saw signification in things. The origins of this mindset substantially pre-dated the fourteenth century. Inventive wit was

often extremely costly to implement, and by its very specificity produced results that, unlike French Rayonnant, could not possess universal validity precisely because of their contingent and ad hoc nature – and also their depth. But their transformative power, and their rationality, is not to be underestimated.

Conclusions

Much of what has been said in this chapter has attempted, in the face of recent critiques, to rehabilitate the agency of rational authors and with it – perhaps paradoxically – the agency of tradition in the Middle Ages. Notions of authorship, of personal style and individual responsibility, were greatly sharpened at the theoretical level, particularly in the academic regime of Paris at the time of the emergence of Rayonnant. The longer-term importance of this new focus was considerable, and in a sense was always to remain theoretical rather than practical. A crucial period in these developments seems to have been the second quarter of the thirteenth century, a time that witnessed theoretical change, logistical change and the formal crystallization of Gothic as a style. This last claim is ambitious, but it is consistent with the emergence of a culture of abstract parchment design that could project Gothic buildings as grammatically coherent entities without actually having to build them. In the Paris area especially, by about 1240 a comprehensive language of large- and small-scale forms had emerged in such a way that it could spread easily from domain to domain. The major technical issues of Gothic had by then been solved and a superb rationale of production developed, at least at sites such as Amiens.

Though there is little or no hard evidence that this style of French thinking about architects was made explicit in England, it is quite clear that not only was individual authorial agency just as highly developed there, but also that the climate of the times gave renewed and institutionalized emphasis to the rational dignity of craft activity: the crucial point is not to assume that, because the English were not 'academic' in the French sense, they were also 'irrational'. What the French scholastics did was bring to a particular level of self-consciousness the notion of the architect as a technocrat. It is difficult to see how the chameleon-like changes of style observable in different known architects when they moved from site to site, or flexed their inventive muscles at one site alone, could have been possible without the confidence of artistic self-

knowledge. Striking English examples of such freedom, to be discussed presently, include the contrasting work of the Ramseys at Norwich, Lichfield and London; the bravura display of *varietas* in the concurrent projects at Ely, again probably engineered consciously by the Ramsey firm of architects alone; and Exeter Cathedral, where Thomas of Witney, employed from 1313–16 onwards, designed stylistically precocious furnishings in wood and stone in varying modes (see pls 49, 103) before taking on the church as a whole. The same applies to the successful imitation of earlier work of the sort in the fourteenth-century nave at Beverley (see pl. 197), which continues both general and specific features of the thirteenth-century east end and transepts, down to dogtooth carving, while manifestly seeing in the chronologically older work points of departure for new motifs. Pevsner's term for this stylistic dissemblance, 'historicism', precisely fails to capture this close intelligent engagement with handiwork that, though of the past, still forms part of a present inventory. The language of fantasy and irrationality has to be cast aside: intelligent participation in a living tradition of ideas is precisely a sign of rationality.

Inventive freedoms flourish within constraints. The first of these were cultural. The Conquest had left England with a quite specific legacy of buildings to chew over and ponder. The Decorated Style at its most inventive in the generation or so after 1290, was an idiom that negotiated intelligently with this pre-existing visual milieu: its great strength was that, far from imposing universal conditions or academic norms, it could regard the universal from the point of view of a brilliantly creative and contextually responsive localism. It was a style the productive circumstances of which were often formed by the retention of a massive, in places heroic, building stock accumulated for more than two centuries since the Conquest. At one level this stock formed a huge constraint on the planning, scale and even design of any new works. Great churches newly built throughout in the Decorated Style, such as Exeter Cathedral (see pls 11, 12), were exceptional. At the level of invention it is reasonable to think that this heritage also proved extremely suggestive to architects whose formal language and training owed much to recent French and English practices. A second area of negotiation was with the highly developed, often local, traditions of religious and allegorical speculation – particularly the love of allegory, paradox and riddling – the roots of which substantially pre-dated the Conquest, and which helped to set the tone of English Gothic church building from its inception. Until

the late fourteenth century this pattern of local sensibility, anciently and deeply founded in the religious and seigneurial life of the country, provided the context for those active and reciprocal relations necessary to at least some forms of invention. Invention, as suggested earlier, was layered rather than linear, cumulative rather than supersessive. The other constraints, to which the book turns next, were material: the operation of patterns of spending and of larger-scale economic and social change, from the effects of which no patron or architect was, or is, exempt.

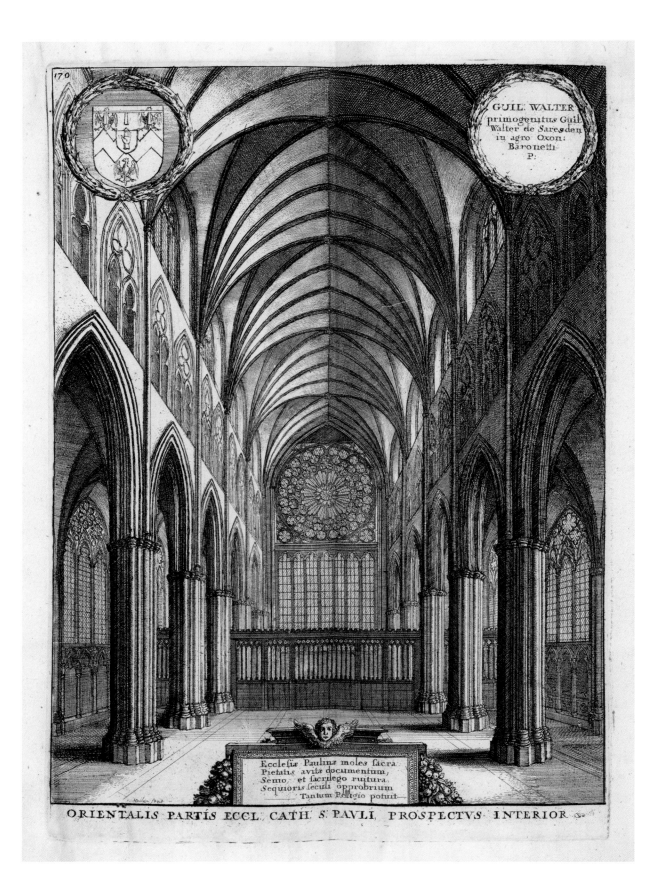

44 London, St Paul's Cathedral, presbytery, begun 1258, by Wenceslaus Hollar, 1658

3

MONEY AND MOTIVE

Charity, which is the bond which unites the Church,
is extended not only to the living but also to the dead that died in charity

Circle of Thomas Aquinas

'Nous sommes loin de posséder une histoire économique de l'architecture médiévale' lamented Robert Lopez in 1952, in a remark as true now as it was then; while much more about the economic history of Europe in this time of 'crisis' is known, or thought to be known, the systematic study of the economy of building has not developed so very far.[1] The present book cannot remedy this significant deficiency. But it can point to the art-historical importance of long-term economic developments, and of short- to medium-term changes in patterns of spending prompted by the cultural environment of patronage. To my knowledge, art-historical critiques of the Decorated Style and of four-teenth-century art more generally have tended to tackle this question simply by ignoring it.[2] It is as if, in their search for form and meaning, scholars have forgotten that things must first be paid for, ivory towers included. The economics of cathedral, castle and parish-church building, to say nothing of the many smaller projects for which fourteenth-century English art seems especially to have been admired in Europe, do not enter significantly into the art-historical literature.

Yet the hypothesis of the shift to the 'margins' developed by Bony and others is surely one that, by its very nature, raises a contextual question: was this shift in the landscape of invention not related to more general economic trends and patterns in spending? One contention of the present book is simple: questions of artistic invention and questions of economy are not always separable. Money cannot explain all: it is a necessary, but not a sufficient, condition for the creation of an artwork. But building and the figurative arts (see Part III) were demonstrably at least in part products of economic decisions taken within markets: they were commodities. It is possible for some individuals or corporations to do well even in difficult times, as recent history has shown. That some were doing very well in the fourteenth century is demonstrated by the Decorated Style, for without certain sorts of wealth – new wealth especially – the Decorated Style might not have emerged as it did, as a dominant force in the creation of an aesthetic of display and persuasion discussed in this book. The fourteenth century was a time of diversification and competition in markets; and competition, whether in the field of building or book illuminating, is the handmaid of innovation. The patterns will not necessarily be clear or decisive, and simple scientific and deterministic models will assuredly fail *us*. Human reasons matter as well as historical causes: spending is a form of informed human behaviour driven by value

rationality, and as such it is itself open to legitimate histori-cal enquiry and interpretation. Therefore both causes and reasons must be considered.

Boom and Bust?

What was the fate of the so-called building boom in north-western Europe of the eleventh to thirteenth cen-turies? If this 'boom' existed, when and where did it end, and what were the consequences? Was that which was actually buildable in 1100 only imaginable in 1350? The most energetic discussions of money in recent years have derived from a particular cultural critique not of the parish church or chapel, but of the cathedral church: the critique has had a certain symbolic quality in targeting the great signs of the 'Age of the Cathedrals'. Strictly speaking, this critique is not of concern here, important as it is. It stems from the (not uncontested) theory of Robert Lopez that the ambitions of the heroic mode in great church building in France were self-defeating, in being actually injurious to the economies that sustained them.[3] By 1300 this process had created a landscape of half-completed great churches, typically very lofty *chevets*, which were to remain that way, as at Beauvais, Tournai (cities particularly targeted by Lopez), Cologne and Narbonne (see pls 17, 19). The canon-ically outstanding High Gothic cathedrals – Paris, Chartres, Soissons, Bourges, Reims, Amiens (see pls 18, 28) – are also the ones largely completed by 1300; all were under way before 1225. They present a rare ideal of 'perfection' accom-plished, and it is on the basis of their totality that the usual narratives of Gothic are founded. Were architectural ambi-tion and long-term economic success in some sort of inverse relation to one another? The cultural critique, pursued by scholars such as Barbara Abou-el-Haj, has argued further that such enterprises, far from being the symbols of an irenic, Platonic corporate harmony, were instead agents of conflict and feudal oppression, straining relations between the cities and the grasping ecclesiastical corporations responsible for them.[4]

It is not the role or duty of the present discussion to adjudicate on the truth of these exchanges. Tensions, even bloody insurgency, also arose increasingly in the fourteenth century in England in cities dominated by large ecclesiasti-cal (often monastic) institutions that were not engaging in large-scale building work, as at St Albans, Bury St Edmunds and Norwich. And an emphasis on local political conflicts may distract from the issue of the larger macro-economic

cycle, perhaps even gradual systemic failure, which in the end governed all. The opening question is in a sense simpler: can the inability to complete very ambitious French Gothic churches, or the extremely protracted history of their com-pletion in the late Middle Ages, provide the basis for a more general model for understanding not only France, but also England? Was the end of the French 'building boom' in the thirteenth century, if it happened, more universal?

The daunting complexity and scale of this problem explain in part why architectural historians have not readily taken it on, let alone quantified it, systematically. In so far as there is a governing model, it holds that in France there was some sort of expansion in building activity beginning at the latest in the twelfth century and tailing off in, or towards the end of, the thirteenth century. The period after 1300 then witnessed either a plateau or a downturn aggra-vated by the Hundred Years War, which, along with demo-graphic contraction and plague, contributed to a long-term building recession lasting into the fifteenth century. Any substantial church building not complete by 1250 or 1300 therefore stood an increased risk of being stranded by the following century of 'crises' – though crisis and recession were not restricted to the late Middle Ages.[5] The objection is well taken that, in making such generalizations, a carica-ture of economic history is constructed.[6] Kimpel and Suckale subscribe simultaneously to a general notion of French economic and demographic expansion until the end of the thirteenth century, and to the Lopez theory about economic exhaustion, accompanying extraordinarily high tolerance of building-induced debt.[7] Data for the depth and extent of the boom drawn from the French building record itself, such as that provided by John James, are prone to revision, the boom lasting here from 1180 to 1220, there from 1160 to 1230, depending on region and sub-region, but not taking into account the economic prehistory of the Gothic style itself.[8] This sort of profile, noting a boom principally before 1200, is certainly consistent with a number of contemporary moral critiques of the lust for building (*libido aedificandi*) in the decades either side of 1200 associated with Hélinand de Froidmont, Peter the Chanter and Alexander Nequam, which at least some of the time applied to churches.[9]

It seems that very few buildings actually matched the (economically led?) efficiency of production sought and possibly achieved at Amiens.[10] The earliest stages of great church construction were in some ways cheaper to fund, and manifestly some projects could be pushed forward with impressive speed and determination: Chartres was largely

built between 1195 and 1220, the royal Cistercian church at Royaumont between 1228 and 1236, the choir at Tournai between 1243 and 1255, and the prodigiously costly east end and transepts of Westminster Abbey between 1245 and 1259 (see pls 21, 22); the superb choir of Séez Cathedral in Normandy was also raised swiftly in the 1260s and early 1270s.[11] 'Slow' medieval building was in no sense a constant or a given, and it will be obvious that outcomes varied enormously according to the scale and finish of the work, as well as the funding and production regime in place.[12] The more austere mode of vaulted construction in thirteenth-century France was doubtless cheaper per bay to realize than the opulent but smaller-scale English mode, which can be costed with reasonable precision.[13] In both, sharp rises in expenditure started to occur as the buildings rose to their more ornate and virtuosic upper parts (the triforium in England, the clearstory in France, the vaulting in both), since the stone components necessary for these and the vaults were more complex and specialized, and also more time-consuming and expensive to hoist and install at greater heights.[14] The cost of the extensive stained glass and ironwork needed to complete the new clearstories very probably crept up on, if it did not absolutely exceed, that of the framing stonework. Bearing in mind such practical constraints, ecclesiastical corporations of all types had a natural incentive to fund and complete the eastern, clerical end of such churches first, particularly if they had remunerative shrines, deferring work on the 'public' and processional naves as less inherently necessary. Nave-led cathedral building campaigns (Amiens, Metz) were less common.

What is suggestive is the difficulty that the loftiest of all great churches, particularly those more than 40 metres in height internally (see the table on p. 35), experienced regardless of their regional location: Beauvais' difficulties were amplified by the collapse of 1284, but the presence in the ranks of such geographically disparate projects as Cologne (begun 1248), Metz (begun perhaps in 1243) and Narbonne (begun 1268) – churches that all witnessed serious or terminal delays (see pl. 20) – suggests a combination of supraregional and local difficulties. Narbonne's problems in the fourteenth century have already been noted (p. 38). The gradual erosion of Cologne's economy was increasingly brought about by the commercial emergence of Lübeck at the head of the Hanseatic League.[15] The brick-built Marienkirche in Lübeck, begun in 1277, was the only German church whose internal dimensions approached those of Cologne Cathedral in rather less building time and in a cheaper medium: a sign of the capacity of new urban com-

mercial centres to emulate the older ecclesiastical corporations, which set the pattern for giant church building in the Baltic region (Gdansk, Marienkirche) in the next century. The same applies to the Iberian peninsula, where the *obra nueva* of the cathedral at Santiago de Compostela, planned in 1256–8 with a large eastern extension on the model of Royaumont, was abandoned totally by the 1270s.[16] The cathedrals at Burgos, Toledo and finally León (begun 1255) – the last a probable stimulus for the Santiago scheme – seem in contrast to have been started early enough to ensure some measure of progress before the fourteenth century.

The future of great and innovative church building was in no sense over, but its social basis and centre of gravity had in a sense 'exploded', rather as the 'shift to the margins' theory implies. Trends in terms of prodigy building were moving in favour of the Mediterranean regions of Iberia and France, the Balearics, Flanders, the Holy Roman empire, the Baltic and northern Italy – towards commerce, trade and new power centres, including Avignon and eventually Prague. Of the six loftiest Gothic projects, four (San Petronio in Bologna and the cathedrals of Milan, Palma and Florence) are in the Mediterranean sphere (p. 39). The funding practices of the old diocesan bodies in the northwest of continental Europe, combined with the spiralling costs of the largest projects, created a sort of hypersensitivity to local and more general economic conditions. In particular, the inherent structural deficiencies of the funding models for very lofty churches, begun on the crest of an economic wave and pursued quickly at the outset, were becoming evident: as the economic tide drew out, commissioners had to confront the prodigious cost implications of the upper stonework, ironwork and glazing. There is a chance that by 1300 or so the mounting evidence not of triumphant success, but rather of a growing list of horribly prominent relinquishments between the Rhineland and the Pyrenees, was an actual disincentive to this whole mode of building. Inventive initiative under these circumstances was likely to shift away from gigantic diocesan churches to the more sustainable smaller, richer projects that some authorities believe were coming to dominate the horizons of patronage and invention even before 1300: a point demonstrated by the history of the construction of prodigy towers and spires in the Holy Roman empire in the next century, where city parish funding was effective.[17] Gigantism was also a significant feature of much mendicant building, legislation against it notwithstanding, and it was this feature that created Bony's 'southern' feeling for ample space.[18] Several factors may therefore have coincided with unfortu-

nate results by the end of the thirteenth century. In all this, the position of castle and particularly smaller parish church building remains *terra incognita*. The question is why all such centrifugal tendencies have not yet been placed in any economic context.

England: Great Churches before 1350

'Marginal' England forms part of this pattern in so far as its economic trends did not demonstrably follow a model of decline or stagnation much before the mid-fourteenth century. There, perhaps, the soil of invention was proving richer and more fertile than in the old ecclesiastical centres of continental northern Europe. The happy survival of significant evidence for the length and cost of English great church building campaigns brings this situation into remarkable focus. The failure of the scheme at Santiago de Compostela begun in 1256–8 to provide the major shrine-church with a new east end planned in the manner of the ambitious French *chevets* was noted earlier. The same pattern of grandiose eastern extensions to older churches, partly in order to house shrines or shrine complexes, had already emerged in England, particularly after Canterbury Cathedral in the 1170s.[19] Some were, in a sense, incomparable: if the account of the monk Gervase is taken literally, the eastern arm of Canterbury was rebuilt at the rate of almost two bays a year, granted that the outside walls were retained after the fire of 1174.[20] Westminster Abbey was exceptional both in its prodigious lavishness and mode of funding largely by a layman, Henry III. But in these very years similar schemes were begun at Lincoln Cathedral (1256) and St Paul's in London (1258) (pl. 44). At Lincoln the so-called Angel Choir (pl. 45) was a five-bay retrochoir and shrine space, finished and dedicated in 1280: the total build-time was about twenty-four years, or just under five years per bay maximum including the aisles, high vaulting and roofs. The scheme at St Paul's was similar, but it now matched the twelve-bay Romanesque nave, creating a stupendous second church for the canons, largely complete by about 1312–14, entailing a build time of fifty-four or so years, or between four and five years per bay maximum.[21]

Detailed accounts do not survive for Lincoln or London, but a total sum is given in the *Historia Eliensis* for the similar six-bay retrochoir at Ely (see pl. 35), built under Bishop Hugh of Northwold between 1234 and 1252, more than seventeen or eighteen years, or three years maximum per bay. The accounts for Northwold's work show a total cost

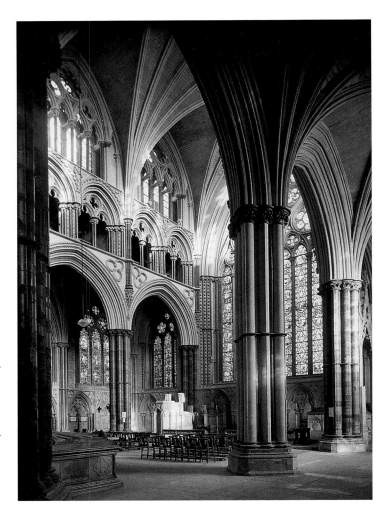

45 Lincoln Cathedral, Angel Choir, begun 1256

for it of £5,350, or about £900 per bay.[22] At Salisbury, the total cost up to 1266 according to a later memorandum was 42,000 marks (£28,000), which, taking into account the erection of the chapter house and cloister complex within that time, yields a very approximate cost per bay in the region of £800–£900.[23] The eastern ends of Lincoln and St Paul's had much in common with Salisbury and Ely in regard to the lavishness of their finish and general scale, established in their cases by the dimensions of the old Romanesque buildings on the site. If an average bay cost of £800–£900 is accepted, the projects at Lincoln and London may have cost in the region of £4,000–£4,500 and £9,600–£10,800, respectively. Comparative data for the next century is provided again by Ely, where the cost of the three bays of the presbytery, linking the octagon to Northwold's retrochoir and built by Bishop John Hotham

46 Ely Cathedral, presbytery, north side, 1322–37. For the lierne vault, see pl. 156

in the years 1322–37, was just over £2,000, or rather under £700 per bay for a building that competes in lavishness with the earlier work, and which accordingly took about five years per bay to erect (pl. 46).[24] The octagon cost £2,400 (see pl. 152).[25] The possibility that costs were actually lower in the first half of the fourteenth century is suggested also by the very full fabric rolls for Exeter Cathedral (see pls 11, 12), where costs per bay may have been as low as £300–£400.[26]

The important point is that not one of these undertakings failed. This cannot be put down to decreased ambition, for ambition is a relative concept: the lavish tradition of aesthetically complex buildings using marble, elaborate templates and extensive sculptural enrichment simply entailed a different sort of financial commitment to the lean and somewhat plain efficiency of the corresponding if often loftier French projects. Most of the schemes already mentioned used costly bar tracery in expansive windows, and had appreciably richer vault surface patterns than French practice allowed. All these traits persisted seamlessly in England in the period of the inauguration and development of the Decorated Style, between the late thirteenth century and the mid-fourteenth. Sustaining this general pattern of continuity required, and appears on the whole to have got, a healthy financial underpinning at diocesan level, and also a willingness to allow buildings to evolve in a way that smoothed spending and limited the risks of failure. The exceptions to this, such as the failure in 1290 of Edward I's substantial great church project for the Cistercians at Vale Royal, were likely to be political.[27]

Like France, but unlike Italy, England had relatively large and prosperous dioceses.[28] This conferred a significant

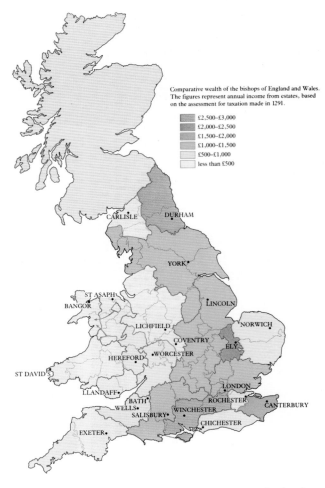

The figures represent annual income from estates, based on the assessment for taxation made in 1291.

Comparative wealth of the bishops of England and Wales.

£2,500–£3,000
£2,000–£2,500
£1,500–£2,000
£1,000–£1,500
£500–£1,000
less than £500

47 Map of comparative wealth of the dioceses of England and Wales in 1291 (from Alexander and Binski 1987, fig. 127)

advantage on cathedral building both motivated and funded by rich bishops. The relative wealth of the bishops of England is set out quite clearly in the *taxatio* of 1291 (pl. 47).[29] After Durham and Winchester comes Ely, followed by most of the dioceses in the south-eastern quadrant of England bar Norwich, Rochester and Chichester. The western dioceses including Wells and Exeter, the latter being the most comprehensive rebuild in the Decorated Style of all, were towards the bottom of the league, but benefited from the deep private resources and generosity of their bishops, which, as Audrey Erskine indicates in her edition of the Exeter fabric accounts, was the biggest single factor in their funding, easily surpassing the dean and chapter's outlay.[30] Bishop Bitton established an annual contribution to the Exeter fabric of £125, which his successor Walter

Stapledon continued and then, in 1325, greatly magnified to 1,000 marks or £666 13s. 4d.[31] In contrast, the socially superior scholar and papal chaplain John Grandisson, bishop of Exeter from 1327 to 1369 and founder of the collegiate church at Ottery St Mary, moaned to the papal curia in 1329 that he was short of funds and burdened by a wonderfully done but half-complete cathedral.[32] The cost of papal provision may have been a factor in these stresses. The prodigious works at Ely conducted after 1321 can be placed in the context of a simple comparison: by turns, as just noted, the octagon cost £2,400 and the new presbytery bays £2,000, sums close to the annual valuation of the property of the bishopric of £2,500, which made its holder, in one recent assessment, 'the lord of a dominion wealthier than all but the richest earls'.[33]

Variations of fortune and good will aside, a large number of churches of various ranks continued to pursue significant building or rebuilding from the late thirteenth century through to the middle decades of the fourteenth. In these years were built in large measure the nave of Beverley Minster (see pl. 197), the eastern limb of St Augustine's in Bristol (see pl. 32), much of the presbytery of Carlisle Cathedral, the eastern limb of Chester Abbey, the crossing, part of the presbytery and Lady Chapel at Ely, much of Exeter Cathedral, the transept and choir of Gloucester Abbey (see pl. 43), the central tower of Hereford Cathedral, the west front, nave, tower, presbytery and Lady Chapel of Lichfield Cathedral (see pl. 31), the tower of Lincoln Cathedral, the presbytery and Lady Chapel at St Albans Abbey, the tower and spire of Salisbury Cathedral, the eastern arm of Selby Abbey (see pl. 140), the vaults and much of the east end of Tewkesbury Abbey, the chapter house, central tower, Lady Chapel and presbytery of Wells Cathedral (see pl. 39), part of the presbytery at Winchester Cathedral, the nave of Worcester Cathedral, and the chapter house, nave and much of the west front of York Minster (see pl. 247). The list is a substantial one, and is a roll-call of some of England's most famous accomplishments in the visual arts.

This apparently robust general situation was supported by other factors whose character was institutional and cultural. For instance, the urban cathedrals of England were able to dominate the horizon because English towns had not developed major secondary or tertiary religious complexes that might act as 'surrogate' cathedrals. The situation of the major, sometimes pre-eminent, non-cathedral urban church – as found, for instance, in Toulouse, where the basilica of St Sernin positively outshone the more modest and physically ill-organized cathedral church – did not commonly

occur in England with the metropolitan exceptions of London, Canterbury and York. London, York and Norwich had preternaturally large numbers of parish churches, probably an inheritance of Anglo-Scandinavian patterns of urban parish development, but there is little evidence that the cathedrals suffered as a result. Norwich also raises another question, the challenge of ambitious mendicant building, and of the city more generally, and this will be returned to presently.

The specific common culture of great church building in England was also a major, perhaps dominant consideration. By 1300 cathedral chapters were markedly more disinclined to sponsor extensive and costly sculpted portals and façades of the sort designed and executed after 1220 or so at Wells, Salisbury, Westminster and London: Lichfield, Exeter and York were exceptions. This was countered, as this list has just shown, by the ability to complete very large single towers (Wells, Lichfield, Hereford) and even spires of a sort that had defeated many projects across the Channel. The spires of Lincoln, London and Salisbury were world-class prodigies, matched in Europe only by the later medieval and no less heroic projects at Cologne, Freiburg (in hand at the same time as Salisbury), Prague and Regensburg.[34] Another major point has already been noted in reflecting on collation and invention at Norwich and Ely: the apparently untroubled retention by English Gothic architects of the work of their eleventh- and twelfth-century forebears. In 1300 the cathedrals of Canterbury, London, Winchester, Durham, Ely, Norwich, Hereford and Chichester retained at the very least their Romanesque naves, as did the major monastic establishments of Westminster, Malmesbury, Pershore, Gloucester and Tewkesbury. The age when the presbyteries of major churches could be rebuilt twice or even three times – as at Laon (mid-twelfth- and early thirteenth-century east end) and Lincoln (presbytery rebuilt from *circa* 1192–4 and again from 1256) – had passed.

Several explanations for this conservative accommodation of chronologically older work may be put forward. The first is that stable pre-Gothic buildings proved practically useful as spaces into which the liturgical activity of a church could be decanted while other building operations were in hand. Second, the retention of such work automatically removed the expense of demolition and clearance that front-loaded the costs of major replacement work. The third, as noted in the previous chapter, is that fourteenth-century clients and architects recognized something admirable in the often heroic scale and inventive suggestiveness of pre-Gothic work. The generally considerable physical extent of elev-

enth- and twelfth-century Romanesque great churches in England relative to even their largest Continental counterparts meant that further expansion in the Gothic style created no unseemly discontinuities, not least when the presence of major shrines stimulated the construction of eastern extensions that complemented the already long naves. More often than not, the internal proportions of the elevations of major reworkings in the thirteenth and fourteenth centuries followed those of the older work, as at Ely. Instances where building lines changed significantly (as in the total height of the post-1362 choir at Norwich, or the choir at Gloucester) are uncommon.

Though these rebuildings moved forward in a piecemeal fashion, they did not bring about the radical changes of gear apparent in so many thirteenth-century undertakings on the Continent. English architecture in its age of greatest formal inventiveness did not witness a wholesale paradigm shift in planning, no matter how innovative some of its projects were spatially. The large-scale continuities were not so much those of recycling, but of something more like a pattern of accommodation that stepped back in order to step forward more vigorously. To understand them, the language of evolution, not revolution, fits best.

The Economic Context

The connection of larger movements in the regionalized and largely agrarian medieval economy and in English demography did not always mesh neatly with observable building practices: it was possible to press on with a building that was, in rational terms, unaffordable. Larger corporations and smaller groups of clients appear to have been willing to tolerate deficits and extended build times in order to achieve their ends. By the fifteenth century something in the economy encouraged the construction of quite large numbers of parish churches in the Perpendicular style, but not to the same extent as the construction of great churches: at this level, the purpose of new building was commonly adaptive, as in the redressing of twelfth-century fabrics with new stonework and vaulting (Winchester, Norwich). Such very general trends were not solely economic: they also exhibited the changing ways in which wealth was deployed. But it is possible to single out factors that were more or less constants in the period examined in this book.

One of these was the overwhelming importance of labour costs in any project; and these, reflecting the availability of labour, were strongly influenced by changes in the

size of the population. Economic historians and demographers seem, in general, to agree that while the thirteenth century in England was a time of economic and demographic expansion, the next century was one of stability or stagnation and then, after the late 1340s and the advent of plague, full-blown crisis.[35] The agenda of demographic study was set in the 1960s by Michael Postan, a neo-Malthusian interested in the relation of population growth, agricultural cultivation and the economy.[36] Postan argued that a slow downturn in population growth began even before 1300 and was accelerated by harvest failure and famine in the period 1315–17, a turning point presaging the first serious signs of economic and demographic stasis or retraction towards mid-century. This decline was the sign of a Malthusian population 'check', operating on a prior condition of over-population (of this famine is a typical sign); it appears to have occurred elsewhere in Europe.[37] Postan's findings have not gained universal consent: but clear contrary evidence of sustained demographic and economic growth in the period 1310–48 on the lines of the thirteenth-century experience has not been produced, and the local and regional pattern is not entirely consistent.[38] A stagnant or declining population should have had implications for labour costs, but much depends on the extent of the fluctuation, and the evidence for the period 1290–1345 is not as clear or dramatic as the evidence for the post-Black Death period when the figures are, in broad terms, unequivocal in terms of loss of population by a factor of at least one-third and possibly up to two-thirds, and subsequent rising wage rates.[39]

Study of medieval costs and specifically of the wage rates of builders was begun by the economist and statistician Thorold Rogers, whose compilation of data, though open to challenge, has set the terms of subsequent compilation and discussion.[40] Following the data from the thirteenth century, Rogers and his successors concluded that wage rates generally rose somewhat in the period 1265–1315, peaked around the time of the great famine in 1315–17, then flattened or dropped somewhat to *circa* 1340. The moving average of building wage rates was, however, still somewhat higher in the period 1315–40 than it was in the period 1290–1315. This might, in theory, match the idea that population growth, and so availability of labour, was stable or declining in this period. There may, however, have been variables. Masons received non-monetary payments, though by nature such workers were less dependent on customary payments than those on estates.[41] At certain projects there were also established grade scales, of which the best documented are those in the wage lists in the Exeter Cathedral fabric rolls: these were automatically stabilized and show no variance in the top summer grade (2s. 3d. per week, or 4d. a day) between 1299 and the late 1330s, famine and cattle murrain notwithstanding.[42] After 1348–9, and through to the end of the fourteenth century and beyond, the generally accepted pattern is far clearer, with a significant observable increase in wages to levels well above those in the years 1315–45 (see Chapter Ten, p. 355). It would not be wholly wrong to state that the Decorated Style began on the crest of the thirteenth-century wave of expansion, but faded away in the midst of more tangible economic changes that would have tended to push up the cost of building.

Labour costs would always have been a more significant determinant than costs of materials. The profile of building material costs in the period 1290–1350 is, according to some calculations, not unlike that of labour costs, with a long-term rise in prices in the thirteenth century peaking in the 1310s and 1320s, followed by a fall to mid-century, and then a very significant rise in the period 1350–70.[43] But this profile should be placed in the context of the ratio of labour to material costs evident in the record. The sacrist rolls of Ely Cathedral suggest that the cost ratio of wages to materials was roughly 3:2.[44] A specific instance is provided by the account for the still extant and beautiful window inserted into St Anselm's Chapel at Canterbury Cathedral in 1336 in the finest sparkling 'Kentish' style of Michael of Canterbury and his successors there and in London (pl. 48).[45] The labour cost £21 17s. 9d., the materials about half that at £10 4s., of which glass was much the highest at £6 13s., followed by the stone imported from Caen at £5 – a salutary reminder of the cost implications of the giant glazed clearstories of the great churches, particularly in France. On a small project, of the type that typified much fourteenth-century work in the Decorated Style, labour was therefore in a ratio of as much as 2:1 to materials. These costs would have varied across Europe: at the abbey church of La Chaise-Dieu (Haute-Loire) rebuilt from 1344 by Pope Clement VI, labour costs amounted to almost two-thirds of the total outlay in the years 1348–50 – notably, during the Black Death.[46]

Also, the more specialized or highly trained the skill, the greater the cost. Thus the usual top grade at Exeter Cathedral throughout the period 1300–40 was 2s. 3d. per week; but the grade for a few masons (John of Banbury, Robert Payne) working under Thomas of Witney's instruction between 1316 and about 1325 on the highly ornate stone liturgical apparatus of the cathedral choir, its high altar,

48 Canterbury Cathedral, St Anselm's Chapel, window dated 1336

reredos, sedilia and pulpitum (see pls 49 and 105), commanded up to 2s. 9d., higher than the 2s. 2d. paid to the very skilled joiner Robert of Galmpton for the wooden bishop's throne (see pl. 103), begun in 1313.[47] Established grades paid at long-term sites may distract from the higher cost of the most ornate works.

The building record is itself evidence of economic movement, but the evidence is extremely hard to gather and assess. According to Richard Morris, the profile of eighty-five major church building projects both begun and in progress throughout the thirteenth and fourteenth centuries shows in each case a strong average trend upwards until about 1280 or so, and then a marked decline in the course of the fourteenth century.[48] Hatcher and Bailey put Morris's findings next to a graph of long-term flows in English population in the same period, and the match is striking.[49] A thirty-year average tabulation of major projects shows a similar profile with peaks no later than 1280, a drop in the late thirteenth century, a recovery in the 1300s–1320s and a fall off towards 1350; after the 1310s and especially the 1320s the drop-off in projects begun is particularly notable, by as much as a factor of 50 per cent. A recovery after 1360 was followed by a period of lower levels of progress and new undertaking than in the previous half century.

This profile follows in very general outline the movement of the agrarian economy and wage rates for the building trade, not least in the noticeable mini-boom in the period between the 1300s and 1320s, which seems less easily linked to demographic fluctuation in the period 1315–17. The major royal castle-building projects being pursued throughout this period in Wales and at Windsor should also be recalled, though their importance cannot yet be quantified: if the 'heroic' mode persisted it did so principally in this period in military, not religious building.[50] Other factors such as the supply of silver and other coinage may have been at work, but it is also possible that the demand for skilled labour in religious building was being skewed after 1300 by an increasingly competitive market as new clients entered the lists, so pushing up activity and leading to a local renegotiation of labour costs.[51] Socio-cultural factors inevitably complicate any demographically based model. The drop in new major works after the 1320s is also thought-provoking, because it suggests that masters were hiring fewer skilled men, leading in effect to a skill surplus and greater mobility between large and small projects elsewhere, and possibly out of the country altogether. Later in this study, in Chapter Seven, I will point to the presence of cunning English masons, trained in the knowledge of the most fashionable smaller-scale work in Kent, London and East Anglia, as far afield as Scandinavia, the Iberian peninsula and Provence, typically after 1315–20 or so – in other words, to a significant degree of movement within the so-called margins. Because this movement appears to be documented particularly in the period 1315–35, a relationship between increased labour mobility and the European-wide agrarian crisis of 1315–22 should at least be considered, since although famine was widespread throughout Europe at this time, the resulting destabilization of employment patterns might have been a factor in eventually accelerating labour mobility in the search for work.[52] Court employment would have appeared especially attractive under any circumstances where there was a shortage of work or labour surplus.

In general, the relationship between the economy and really extensive building schemes would have been a long-term one, and the evidence does not sustain the idea that dramatic changes occurred between the late thirteenth

century and 1348 of a type that would have had a self-evident impact on the building record or idiom. It is even possible to argue that the long-term pattern throughout much of the fourteenth century was one of fundamental stability, despite the fissures in building campaigns observable in many buildings around the late 1340s. But the exceptionally highly worked character of many projects in the Decorated Style lent them their particular prestige and appeal. Quite apart from the issue of training up entire teams of men in such skills and getting them to collaborate on larger projects, as they must have done, such things included the technical difficulty of cutting, assembling and stabilizing windows with curved flowing tracery elements and the use of often almost microscopically small freestone carving, hypernaturalistic 'bubble' foliage, diaperwork and extraordinarily complex three-dimensional ogival templates, as well as colour, gilding and so on (see pls 142, 150, 224). Up to the 1340s the Decorated Style seems to have been in full bloom, with elaborate if small-scale works continuing to flourish in a way that points to broad underlying stability. The impact of the plague – actually repeated outbreaks from 1348 – will be re-examined in the final chapter. Clearly, regardless of the long-term movement of labour costs and the economy, this extraordinary manner of working things in stone conferred some sort of persistent advantage in the minds of clients whose personal, social and religious motivations had begun to count for as much as old-fashioned corporate ambition. Here cultural expectations about spending would have mattered as much as economic capacities.

The Ties that Bind:
Ornaments, Purgatory and Chantries

How money was spent on works of art and architecture was no less important than the general economic climate. The Decorated Style has the particular character of intensiveness: it was seldom an idiom of extensive rebuilding. Its nature is typically apparent in things that, in the thirteenth century, would have been less likely to engage the highest creative imaginations, for instance, smaller chapels, tombs and furnishings in churches of all types, particularly parish churches. The range of clients choosing it, and the range of institutions for which it was chosen, also widened markedly after 1300 or so. These considerations cannot readily be disaggregated. In outlining why this was the case, there are three very general considerations: the stabilization of certain genres, or near-genres, of church furniture or *ornamenta*

(genre as such was far more fluid in the Middle Ages); the diversification in number and kind of religious establishments, especially those associated with the development of the cult of memory and intercession; and the proliferation of new classes of patron.

First, *ornamenta*, those things that equipped a church with an array of objects that served it and its patrons' ends: a swelling and costly repertory of tombs, Easter sepulchres, sedilias, piscinas, altar retables, screens and so on, which may almost be described as genres of a very shifting or blurred kind.[53] These objects glamourized the increasingly stable and established forms of sacramental religion and the cult of memory that the previous century had done so much to codify. Major studies of the Decorated Style as a style (for example, Bock, Bony) have been unwilling to cede to these things the importance they deserve in their own right and undoubtedly had for their commissioners – a product, it seems to me, of the modernist absolutizing of architecture as a major art form of which I have already offered a critique (pp. 43–7). Indeed, because these objects were frequently architectural in form, particularly in regard to their use of 'micro-architecture', they blur the boundaries between media in a way consistent with the continuum of medieval aesthetic tradition discussed earlier (p. 45). They can in fact be shown to have been a sphere in which lively formal experimentation took place even prior to its extension into architecture 'proper'. Though the term *ornamenta* is taken from canon law, none of these objects was a canonical requirement: on this point, the ecumenical Church was, sensibly, surprisingly relaxed in its views.[54] They were *adiaphora*, matters of choice, neither proscribed nor prescribed. The role of canon law in provoking the production of church art forms, as opposed to monitoring their appearance and sanctioning their gradual development by creating an environment within which they could flourish, is a matter of discussion. The most important enforceable canons (especially nos. 19, 20 and 62) of the Fourth Lateran Council of 1215 related to the cleanliness and propriety of things used at Mass, the enclosure of the Host and of relics; after that followed the progressive introduction into England of devotion to Corpus Christi, formalized in the early fourteenth century by the so-called *Clementines* of Clement V, published in 1317 after his death.[55] Taken together, these formulations concerning the due care of and devotion to the sacraments may be connected to the emphasis on altars, altarpieces, piscinas, aumbries and enclosures for the Host that typifies church ornaments at all levels in the period roughly 1250–1350 and beyond.

But, despite all this neatening up, what characterizes public Church statement on such things is precisely its openness: it created a loose, as it were semi-regulated, texture or network of observation within which innovation could flourish. The extraordinary appearance of many fourteenth-century carved objects in churches is testimony to the paradox of a context of observance that sought dogmatic or doctrinal clarity, yet which was in most regards indifferent to artistic 'form'.[56] In loose networks in which there are areas open to interpretation, conflict arises, and it is possible to point to cases where the parallel shift towards greater sacramental dignity of display clashed with the ambitions of personal commemoration by tombs. The best instance is recorded by the visitation of Worcester cathedral priory in 1301 by Archbishop Winchelsea. Some years earlier Bishop Godfrey Giffard (d. 1302) in his lifetime had erected a tomb for himself just to the south of the high altar over the shrine of St Oswald, in such a way that the relics of a local saint also had to be removed. The convent complained that this tomb, erected with pinnacles in the manner of a tabernacle, a lofty and sumptuous erection of carved stone, was placed where the sedilia should go and prevented light from falling on the altar.[57] Winchelsea decided in the monks' favour, but whether or not they did anything about it is unclear. Within a generation at Exeter Cathedral the sedilia raised just by the high altar possess canopy work of astonishing transparency (pl. 49).

Such cases highlight the tendency to display by means of the medium of stone carving itself: *ornamenta*, being part of a newly legitimate and apparently permanent sphere of church practice, could now be the object of long-term art investment. For instance, it is a striking fact that, liturgically, no Easter sepulchre was ever expected to be set in stone, since they were by custom temporary liturgical paraphernalia.[58] Yet in the wake of the *Clementines*, and especially in the eastern counties of England after 1320 or so, stupendously carved stone sepulchres (or sacrament houses, or Tombs of Christ, the ambivalence is notable) became one of the main areas of patronal display, actually incorporating the tombs of their founders into their design (Heckington, Lincs.; Hawton, Notts.) (pl. 50).[59] The same applies to the increasing elaboration, with canopies, of stone reredoses behind altars (pl. 51) and of sedilia next to them.[60] In effect, the progressive settlement of provision for the sacraments led to an entirely new outlet for ambition, not least because the norms were determined so generously and the genres were so flexible. A richly furnished and fitted church chancel was a sign of the times.

49 Exeter Cathedral, high altar sedilia, detail

The second consideration was the cult of memory and intercession: to borrow a formula from Jacques le Goff, the scholastic 'systematization' of purgatory and the benefits of suffrages (the sacrifice by the living faithful on behalf of others, including the dead, of Mass, prayers, alms and other good works of piety) had been followed by a widespread and profound social success, of which the visual arts were an expression.[61] This systematization, which enshrined the efficacy of suffrages in alleviating purgatorial penalties, was set out in an appendix to the constitution *Cum sacrosancta* of the Second Council of Lyons in November 1274.[62] What mattered was not so much the existence of purgatory as a place, as the construction of a system of exchange in which the provision and gaining of suffrages acted as a form of spiritual currency. This system required the kindly provocation of that bond of Christian charity of the living towards the dead, those ties that bind, of which those in Aquinas's circle had written.[63] The Second Council of

50 Hawton (Notts.), parish church, Easter sepulchre and tomb of benefactor in chancel, looking north-west

51 Christchurch Priory (Dorset), choir and reredos, mid-fourteenth century

Lyons, as with much legal inscription, was not so much the start as the means of consolidation of the process of founding perpetual chantries that had started much earlier, and had been developing and gaining momentum throughout the thirteenth century: law crystallized and legitimized, but did not initiate. Nor did it inaugurate those strategies that developed to sweeten and articulate the bonds of charity and giving, strategies apparent, I suggest, in the eye-catchingly vulgar, colourful, pleasing and memorable object domain of the Decorated Style: chantries, tombs and any installations including memorials of the dead – those ties that, in the Thomist image of the chain or *vinculum*, bound together the Church.[64] These were older, and lay in the rhetorical notion that to gain favour one must first win it by *captatio benevolentiae*.[65] Audiences must be pleased, brought round, softened up. Yet in that poetic image of the bond that unites the living and the dead can be identified a true turning point, sanctioning and further-

ance of this domain of love and persuasion amongst the clerical and lay classes.

The practical outcomes of this strategy of winning favour in the spectator will be considered later in this book, since it was a central practical aesthetic issue of the time, and the Second Council of Lyons made it even more practical. It benefited individuals and groups, typically families or dynasties; more importantly, it redirected spending deep down to the parish level. The general diversification of English religious institutions in the twelfth and thirteenth centuries, not least the new mendicant orders of friars which served the growing urban sector, is well understood. As is well known, the Dominicans (from 1221) and the Franciscans (from 1224) were not at first in a position to make a significant impact on the history of commissioning in England, but by 1300 their attractiveness to many patrons, especially royalty, was evident.[66] Though their works could not compare with the French royal Dominican foundation

at Poissy outside Paris established in 1298 by Philippe IV of France, in effect a vaulted great church, Edward I and Eleanor of Castile sustained the major houses of friars in London, which possessed ample, if unvaulted churches with large windows, whose relationship to ambitious parish church building was mutually informing.[67] When, from the late thirteenth century, the friars consolidated properties within, as opposed to adjoining, city walls, as in Norwich (see pls 80, 81), their ambitions grew to the point where it is possible to speak of intramural competition with existing older corporations; the literary vehemence of the anti-fraternal critique of the friars' grip on lay patronage by the end of the fourteenth century speaks for itself (see Chapter Ten). By 1300 the foundation of larger monastic houses of Benedictines, Cistercians and Augustinians had virtually ceased, and in the case of the friars was itself declining.[68] At the same time the increasingly common failure of efforts to canonize members of the episcopal class, which had totally dominated the process up to that point (the failures included Grosseteste of Lincoln, Winchelsea of Canterbury and Marcia of Wells), relative to the one success of the period (Thomas of Hereford, canonized 1320), halted a process that had massively invigorated art and architecture before the mid-thirteenth century.[69] But it is not evident that this more complex and competitive environment necessarily set institutions in direct competition for resources, or disempowered older establishments creatively. The new church of the Augustinians in Bristol (see pl. 32), apparently begun in 1298 in close knowledge of the latest work at Westminster as well as in the West Country and elsewhere, remains one of the most important and imaginative projects in the history of the Decorated Style, and it remains to be shown how much in its formation should be attributed to its clerical staff or to its main lay supporters (according to some), the Berkeley family.[70]

What speaks particularly eloquently is the superimposition of the consequences of the constitution *Cum sacrosancta* of 1274 onto the pattern of religious endowment more generally. By 1300 alienations of land into mortmain for intercessionary purposes such as chantry foundations were booming.[71] This can be established by the simple device of tracking the licences for alienation into Mortmain (literally the 'dead hand' of the Church) of lands and rents. These licences were developed in 1280 as a way of controlling by official exemption the consequences of the Statute of Mortmain (*De viris religiosis*) of 1279, which forbade new alienation of lands and rents to the Church, so curbing the creation of new religious institutions.[72] As with the fortifi-

cation of houses or 'crenellation', state licensing serves as a useful, if incomplete, measure of change. Licences under the provision of 1280 swelled hugely in the period from around 1300, the jubilee year in which Boniface VIII granted a plenary indulgence or remission of sins to all those coming to Rome or who died en route, described by le Goff as 'the climactic moment in Purgatory's thirteenth-century triumph'.[73] Of the 2,182 licences granted in the period 1281–1534 before Henry VIII's attack on chantries, 42 per cent were granted between about 1300 and 1349. Alan Kreider, who supplied these figures, argues further that only about one-third of all such foundations were legally licensed. Licensing was costly, bureaucratic and hard to obtain, and tended to be circumvented by expedients such as time limitation.[74] It is therefore likely that, while licensing figures indicate only intentions to found intercessory institutions, the actual outcomes were even higher in number. The Statute of Mortmain was part of a much more general strategy by secular public power to restrain property acquisition by the Church; it was not directed at chantry foundations in particular – in 1280 a relatively new concept – but more especially at the landowning ambitions of the monastic orders. Chantry endowments did not simply replace monastic endowments, but they may very well point to a fragmenting pattern of support by more diverse clients of fewer and poorer beneficiaries, one notable increasingly after 1350.[75]

The role of bishops was also significant in setting up chantries, either in their cathedral churches, such as that founded in 1280 by Walter Bronescombe, bishop of Exeter (d. 1280), next to the newly built Lady Chapel of Exeter Cathedral, or those established at their places of birth by Godfrey Giffard, bishop of Worcester, at Boyton (Wilts.) in 1279 and Thomas Bitton, bishop of Exeter, at Bitton in 1299.[76] This early wave of clerically endowed chantries had strikingly long-term practical consequences, not least in the universities. To understand why, it is necessary to trace one example of a flourishing type of chantry organization, the academic college. Two bishops of modest origins – in fact the sons of freeholders – led the way. At Oxford in 1264 Walter of Merton, later bishop of Rochester (1274–7), established a college, and in 1311 Walter Stapledon, bishop of Exeter (d. 1326), a hall. By the fourteenth century the very substantial chapel erected towards 1300 for the scholars of Merton, swiftly furnished with costly stained glass (pl. 52), was proving to be a point of reference, partly because the scholars were provided with a useful 'rule' of quasi-monastic type, and partly because its architecture was graceful.[77] In

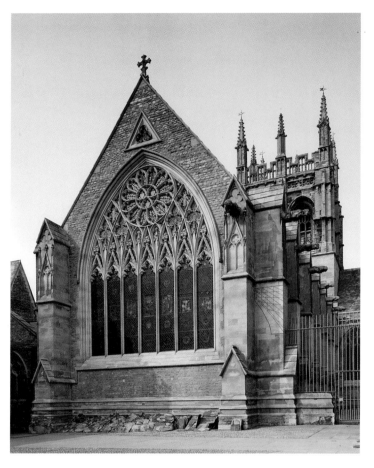

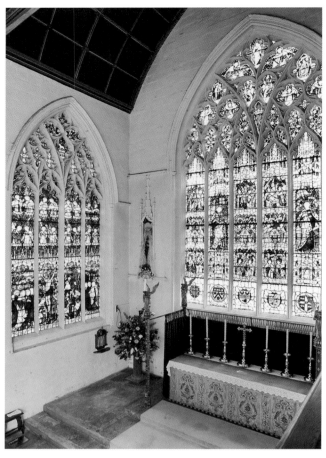

52 Oxford, Merton College, chapel showing east window, late thirteenth century

53 Cambridge, Little St Mary's, parish church, east end interior, 1340s

the 1260s Walter of Merton had his eyes on the possibility of a collegiate foundation at either Oxford or Cambridge, and appears to have developed what Nicholas Vincent has called a 'community of interests' with Hugh of Balsham, bishop of Ely (d. 1286), in endowing such foundations of scholars.[78] Hugh himself established a body of scholars within St John's Hospital in Cambridge in 1280, and then Peterhouse in 1284. The scholars of St John's Hospital were expected to live according to the quasi-monastic rule of Merton College.[79]

Little is known about early provision for the religious life of the scholars of Peterhouse before the statutes provided for the college by Simon de Montacute, bishop of Ely (1337–45), in 1344, which explicitly cite the example of Merton.[80] No chapel was provided for Peterhouse until the second quarter of the fourteenth century, presumably at the behest of Montacute. The chapel begun in the 1340s and

dedicated in 1352, and replacing an earlier church dedicated to St Peter standing at that time to the north adjacent to the main entrance to the new college, is now Little St Mary's parish church (pl. 53).[81] In configuration it was manifestly intended to be a slightly reduced copy of Merton College chapel, since it has a similar plan of a main chapel (in this case six, not seven bays long) with large east and lateral windows, and at its west end betrays signs of the start of a transeptal antechapel, abandoned probably in 1348–9.[82] Merton's chapel had been informed by late thirteenth-century metropolitan Rayonnant of the type commissioned in the chapel of the London house of the bishops of Ely (in Holborn) begun for John Kirkby in or before 1286 (pl. 54).[83] Indeed, Peterhouse's chapel was run up not only as a simplified copy of Merton's chapel but also, to judge from its splendid window tracery, of the Lady Chapel at Ely begun in 1321 (pl. 55), and eventually supported finan-

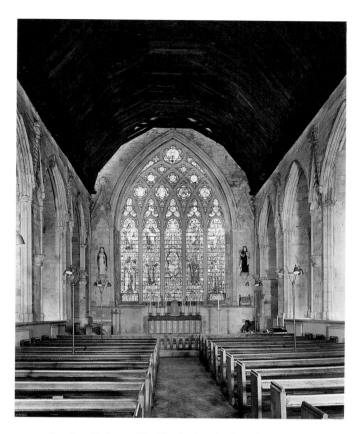

54 London, Holborn (Ely Place), chapel of London residence of the bishops of Ely, begun 1286

55 Ely Cathedral, Lady Chapel, east end exterior

cially by Montacute himself (see p. 215); behind its form may also be traced the chapel of the bishops of Ely at their London residence in Holborn.[84] Montacute's statutes of 1344 make provision for chantry Masses for him, the college's founders and their parents.[85] Since Montacute was amongst the first to be buried in the Lady Chapel at Ely, in 1345 (see p. 216), he was evidently especially devoted to the Virgin, which may in turn explain the change in dedication to Peterhouse's chapel by 1352.

The fact that decisions about intercessory foundations taken in Oxford in the late thirteenth century still had knock-on effects in Cambridge by the 1340s, which were stalled only by the Black Death, is secondary to the more general conclusions that can be drawn from this sort of episode, of which there were many dozens. The first is that the intimate connection of new chantry benefactions to high clerical property transactions exposes a very sophisticated sort of networking within a small circle of relatively rich men with similar ambitions and intentions. Second, because this circle was small, communication of ideas

within it was rapid, benefiting from a high degree of connectivity. Third, substantial patrons such as Montacute, an aristocrat, did not have to choose between commissions. The chapels of the bishops of Ely, the scholars of Merton and of Peterhouse, as well as the works at Ely Cathedral, were all sustained by a human network. In modern market theory parlance, the Decorated Style was driven by an 'oligopoly', a state of affairs in which there are few producers (clients, architects), who, being small in number, know the work of the others in the circle and are accordingly mutually influential.

Mandarins and Oligopoly

The extent of this network of mandarin churchmen is not difficult to pursue, since its form was that of the household and administration of the king. Edward I was not a sharp-eyed patron like his father, Henry III (whom Matthew Paris justifiably likened to the beady-eyed lynx): there is very

little direct evidence for Edward's tastes and inclinations, which have instead to be inferred from the surviving or recorded commissions of his reign.[86] He showed much less interest in continuing Henry's lavish endowment of Westminster Abbey, and was content to see his church-building initiatives curtailed by prevailing circumstances, his monastic foundation at Vale Royal begun in 1277 being broken off in 1290, and his new chapel at Westminster Palace begun in April 1292, St Stephen's (see pls 25, 63), discontinued by war-driven government spending cuts in 1297 when its lower chapel was scarcely finished.[87] Far more important, and indeed indicative of royal spending in the next century, was Edward's programme of castle building in Wales, the scope of which is quite likely to have skewed the entire regional economy of the north-west of England, as well as creating a sluice of architectural ideas from Europe whose flow is apparent at late thirteenth-century Chester Abbey.[88] His son Edward II (1307–27) in turn supported a new house of Dominicans at Kings Langley, Hertfordshire.[89] Edward III (1327–77) spent more on Windsor Castle (more than £50,000) than Henry III is estimated to have done on Westminster Abbey, a sum described by Colvin as 'the highest figure for any single building operation in the whole history of the king's works in the Middle Ages'.[90] In such a climate one would expect royal great church building to play a relatively insignificant role in architectural invention in comparison either to castles or much smaller projects such as St Stephen's at Westminster, a major foyer for architects and ideas in England under the guidance of its Kentish master, Michael of Canterbury (d. *circa* 1321).[91] The courtly artistic keynote in late thirteenth-century metropolitan circles, as perhaps in France, was struck by the luxury domestic building, typically chapels.[92] It is a striking consideration that Michael of Canterbury is not known to have undertaken extensive 'great church' work at all.

When St Stephen's is thought of as a foyer, what is meant is that not only were a significant number of influential masons and ideas gathered and 'hothoused' there before dispersing, rather as had been the case at Henry III's Westminster Abbey, but also that the royal household and administration were the leading vehicles for the development and propagation of style. Jean Bony was quite right to point to the role in this regard of men of power, mandarin bishops, who had started their careers as royal clerks, and who went on to hold the great offices of state or law, notably the wardrobe officials (the wardrobe was by now the main spending department of government), the Treasurers and

Chancellors. Bony singled out Walter of Merton, Chancellor of England from 1261 to 1274 before going as bishop to Rochester; his successor as Chancellor and Edward I's most important royal official, Robert Burnell, bishop of Bath and Wells (d. 1292); and Robert's *protégé* John Kirkby, Treasurer (1284–90) and bishop of Ely (1286–90).[93] Burnell acted as executor for the estate of Eleanor of Castile and was one of the commissioning agents of the crosses set up in her memory (see pls 101–2, 217).[94]

But this pattern was far more extensive and sustained. The new cathedral at Exeter was launched before 1280 by Bishop Walter Bronescombe, a former royal clerk. One of the earliest works in the Decorated Style following the latest style of Westminster, the tomb of William of Louth, bishop of Ely (d. 1298), in Ely Cathedral (see pl. 244), was commissioned for a former chancery and wardrobe officer.[95] The works at Exeter Cathedral were massively boosted by the personal wealth of Walter Stapledon, Treasurer of England in 1320 and 1322–6.[96] John Salmon, an Ely monk and prior, then bishop of Norwich (1299–1325), presided over the first works of the Ramsey family in the cloister, and served as Lord Chancellor from 1320 to 1323; a relative of Alan of Walsingham, the goldsmith and sacrist of Ely, he replaced as Chancellor his colleague John Hotham, who served as Treasurer and Chancellor before 1320 and as bishop of Ely from 1316 to 1337. Hotham supported much of the work done at Ely Cathedral after 1321 by the Ramseys and the great court carpenter William Hurley (see Chapter Six).[97] Walter Langton, bishop of Lichfield (1296–1321), builder of its Lady Chapel and *protégé* of Robert Burnell, had been Treasurer and Keeper of the Wardrobe, and his successor as bishop, Roger Northburgh (1322–38), who brought in William Ramsey to rebuild the presbytery (above, p. 62), had also been Keeper of the Wardrobe.[98] The mighty archbishop of York, William Melton (1317–40), had been Controller of the Wardrobe, Lord Privy Seal and Treasurer, as well as being a motivator of works at the Minster (see pl. 247) and at Patrington, Beverley and Selby.[99] And when John Drokensford, bishop of Wells (1309–29), inaugurated the rebuilding of the Lady Chapel and presbytery (see pls 39, 183) of his cathedral partly to house the relics of his predecessor as bishop, William Marcia (1293–1302), a former Controller of the Wardrobe, Treasurer and Chancellor was enshrining a former Controller of the Wardrobe and Treasurer, who never quite made it as a saint.[100]

The recitation of this dense list of scarcely a dozen or so men, many of whom actually presided over some of the most important decisions in the development of the Deco-

rated Style, has been necessary because it illustrates what constitutes a political and cultural oligarchy, a sort of club. To this elite group should be added monastic patrons, such as Prior Henry of Eastry at Christ Church Canterbury (1285–1331), and, of course, the architects themselves, of whom the named leading lights were Michael and his son Thomas of Canterbury (Canterbury, Westminster and Gloucester), John and his son William Ramsey (Norwich, probably Ely, Lichfield, London, probably Gloucester), and Thomas of Witney (Exeter, Wells), not forgetting the court carpenter William Hurley, who designed and erected the timber of the octagon at Ely.[101] The Canterbury and Ramsey families formed what were essentially closely knit clan-based companies, and I will hereafter refer to the Canterbury Company, and the Ramsey Company, without wishing to demote the importance of individual creative agency. It is a matter of reasonable assumption that members of family firms talk to one another. It is also a striking fact that the Canterburys, Ramseys, William Hurley and Thomas of Witney all had direct or indirect experience at St Stephen's Chapel, Westminster, which is why the term 'foyer' for that project seems apt. The agencies involved in some buildings such as the chapel at Ely Place in London and the astonishing work at Bristol Cathedral have not been named, though their participation in this remarkably select conversation cannot be gainsaid. In all, approximately fifteen to twenty people, many of them mentors and followers, or members of the same family or clan, can be positively identified, and the circulation of ideas between them traced. In all, they would scarcely have filled John Kirkby's smart new chapel in Holborn. This, in short, is oligopoly.

Social Mobility, Social Friction

Under an oligopoly, in which a select group of producers seems not to have had a large number of rivals, the pace of innovation, usually driven by the incentive of competition from rivalry, could be expected to slow. Indeed, with the exception of some of the more extreme forms of flowing tracery and vault patterning found in the north and west of England, most of the typical formal innovations in the Decorated Style had occurred at the latest by about 1320: micro-architectural forms, thickets of over-nourished-looking carved foliage crockets, finials and sprays, square-section buttresses with tracery lights, overhanging ogee arches, nodding ogee arches (see pl. 103), crenellations (see pl. 108), gables, lierne vaults (see pls 69, 156), wave mouldings (see

pl. 224) and reticulated tracery (see pl. 211) – in short, the prodigiously complex language of forms inaugurated progressively in the 1290s in the Eleanor Crosses and main elevations of St Stephen's Chapel, and almost fully apparent by the time Walter Stapledon furnished the choir of Exeter after 1313. The most creative phase, in other words, lasted no longer than thirty years; then, from 1320 to the 1340s, beginning with a significant shift in initiative to works in East Anglia and northern and eastern England more generally, the process of change was more like the diversification of a pre-existing repertory of forms and ideas to which wider social access was quickly being gained.

The pattern of rapid dispersal of this idiom was a product in part of the fact that England, with only seventeen bishoprics, had a much wider range of preferment below episcopal rank within the expanding class of curial administrators and lawyers who took up commissioning. This increased the number of interlinked networks involved. Numerous smaller projects commissioned by this class epitomized the way the Decorated Style manifested not old, but relatively new, professional wealth amongst careerist clerks whose experience of mainstream curial patronage was carried back by them to their places of origin. Such people included Richard of Potesgrave, the wealthy chancery clerk and king's chaplain who accompanied the body of Edward II from Berkeley to Gloucester, who before about 1333 built the chancel of the parish church of Heckington (Lincs.), where he was rector in the years 1308–45; in 1328 Potesgrave founded there a daily perpetual chantry for his soul and those of his parents (pl. 56). The chantry Mass was to be said after the daily Mass at the high altar. This private endowment was accordingly intended to mesh with the administration of the sacraments, and, as Veronica Sekules has shown, the elaborate sedilia and Tomb of Christ (or Easter sepulchre) in the chancel (see pl. 115) were set up with a view to this concerted provision.[102] The same sort of process occurred at Navenby (Lincs.), where Edward II's Chancellor and Keeper of the Privy Seal, William of Herlaston, presented by the king to the benefice in 1325, may have begun the work subsequently furnished with a Tomb of Christ.[103] At Heckington, Navenby and Patrington (Yorks.) and Hawton (Notts.) (see pls 50, 223) of the later 1330s, where clerical patronage seems probable, the sculpted objects in the chancel form voluble and eye-catching ensembles including tombs, provocations of memory and charity.[104] The actual idiom of these chancels is essentially local and not 'courtly', forming part of a network of objects in the Decorated Style made in the wake of the spread to the eastern counties of

56 Heckington (Lincs.), parish church

57 Bottisham (Cambs.), parish church, south nave exterior.
Compare the soft ogival quatrefoils in the aisle windows to pl. 63

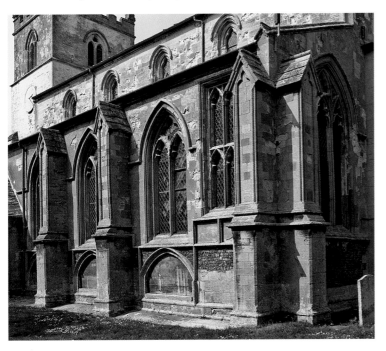

Corpus Christi observation. What is indisputable, though, is the sense conveyed by these furnishings of the vigorous impress of determined new clients from the political class who wished to keep up with the best in regional fashion. The list is not difficult to extend. It includes Hervey of Stanton (d. 1327), a chief justice of the king's bench and exchequer official under Edward II to whom John Hotham, bishop of Ely, granted the appropriation of the church of St Michael, Cambridge, for his new foundation of Michaelhouse, in 1324: there he built sprawling curvilinear windows and ornate furnishings.[105] Another figure is Justice Elias of Bekingham (d. after 1307), who donated a chalice and cloth to Bottisham church (Cambs.) and whose large brass memorial, probably London-made, was originally sited in the chancel there.[106] Elias's role in provision for the nave of this important and elegant building is not proven, but its smooth and rather soft detailing, framed cusped arches, drooping ogival tracery quatrefoils, continuous mouldings and stacked lights with uninterrupted and even free-standing mullions as well as transoms (pl. 57) undoubtedly point to contact with work of the period 1300–20 at Westminster and possibly Bristol (St Mary Redcliffe, north porch interior dado), so it is possible that Elias at least initiated a lasting connection with major London designers such as Michael and Thomas of Canterbury.[107]

The history of the tremendous eruption of this sort of patronage throughout England by 1310 or so onwards is so extensive that it cannot reasonably be considered in depth here, but a few points are salient. The number of great church projects sponsored by the laity was comparatively small – examples include the support for the new work at St Paul's Cathedral by Henry de Lacy, earl of Lincoln (d. 1311); the large but unusual gift to the works at Exeter Cathedral of £66 13s. 4d. from Henry de Courtenay, earl of Devon, in 1340; and the activity of the Berkeleys at Bristol and the Despencers at Tewkesbury (see pl. 276).[108] The emulative instincts of the many landowning families – the Despencers, the Cobhams, the Alards (pl. 58 and see pl. 106), the Beches, the Hastings – who commissioned dozens of sometimes sensationally elaborate tombs in the Decorated Style after about 1300 – are not in question, though it should be noted that the two preferred forms of tomb, the canopied effigial tomb and the monumental brass, were clerical innovations.[109] In almost all these cases one is dealing, in effect, with a culture of socially motivated copying, variation and amplification of influential models rather than seminal originality, given that in subject matter many seigneurial tombs possess a wit and impact of their

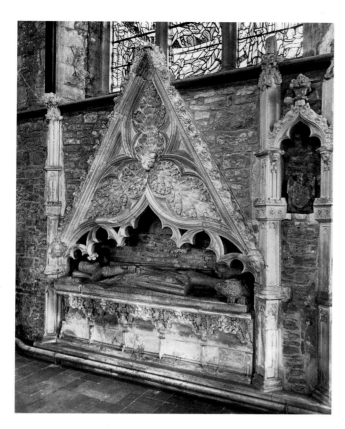

58 Winchelsea (Sussex), parish church, tomb of member of Alard family in north aisle, *circa* 1320

own.[110] Diversification of the market in these cases did not necessarily yield fundamental formal innovation.

More generally, the role of such local families in commissioning not only tombs but also the parish or larger churches containing them requires much further work. The type of family that paraded such tombs, chapels and chantries was the same as that which commissioned brightly illuminated Psalters and Books of Hours for private devotion, gift or just show and pleasure. In all such cases the display of family heraldry became a strikingly prominent measure of status. Of these families the outstanding example are the Luttrells of Irnham in Lincolnshire, the only clients of this class from whose circle survive not only one of the best-known Psalters of the day made for Sir Geoffrey Luttrell (British Library MS Add. 42130), who died in 1345 (see pl. 251), but also the lavish sculpted and gabled monument, probably a Tomb of Christ, erected in the 1340s and bearing the arms of Sutton and Luttrell to the north of the high altar in the parish church. This is carved in the fruity style of the piscinas, sedilias and Tombs of Christ of the eastern

region as a whole (see pl. 116).[111] In the commissioning of such books as the Luttrell Psalter, this class was attaining an altogether new importance. Psalters, and their slightly later companions the Books of Hours, were common types of illustrated book. At a rough estimate (based on a published survey of the most important illuminated books executed after 1190), of those Psalters and Hours about which anything remotely certain can be said concerning their patrons, lay commissions rose from 13 per cent of the recorded material by 1250, to 31 per cent by 1280, to 72 per cent in the period 1285–1385; this amounts to a 44 per cent increase between 1190 and 1280, and a 72 per cent increase in the period 1280–1380.[112] In the period 1190–1385 it would not be unreasonable to imagine an increase in lay commissioning of about 60 per cent, with clerical commissions in contrast falling from 96 per cent before 1250 to 28 per cent in the century 1280–1380. Whether or not this type of proportion accurately reflects the extent of lay patronage of the arts as a whole is unknown, but it provides prima facie evidence for believing that, in the field of book production at least, the market must have been expanding extraordinarily, not least among women where the growth in demand was great (pl. 59).[113] The commercial and inventive implications of this mobility for producers, illuminators especially, will be returned to later on (pp. 298–305); but that the sort of artworks considered here were commodities is not, to the present writer at least, in doubt.

So, more general cultural considerations, as well as economic capacities and trends, played their part. There is a wider case for seeing the period before 1300 as one of growing commercialization of English culture and society: symptoms include a much increased volume of commerce and currency in circulation; an ascendancy of trade, relative to the old landed elites; an urban population peaking around 1300 at about 20 per cent of the population; more numerous fairs and markets; a greater spirit of calculation and rational organization in the management of commercial affairs; increased written record keeping and bureaucracy; a growth in the status of law as the symbol of right order in society; increased friction, including communal action, against old vested interests; and formalization of rule-bound distinctions relating to rank and conduct.[114] These criteria for commercialization resemble the 'rise of rationality' case discussed earlier (p. 49); and that case has, in turn, been forcefully linked to the wider issue of social mobility.[115]

The fact of mobility and hence friction – often creative friction – between classes and institutions seems especially relevant as this book turns gradually from the economy and

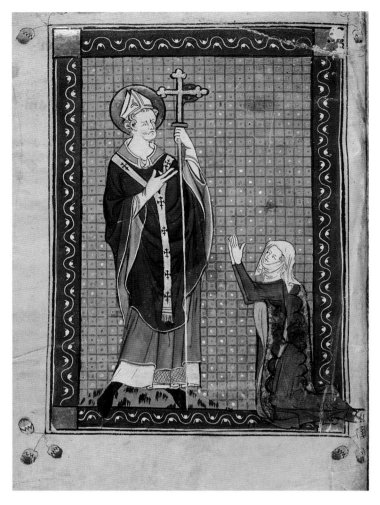

59 Hours of Alice de Reydon, before 1323, showing female patron with an archbishop saint (as the repainted form of the crosier shows, originally a bishop) (Cambridge, University Library MS Dd.4.17, fol. 1v)

the canon lawyer and bishop of London, Ralph Baldock (1304–13), ordered the removal from the city of an unorthodoxly shaped Crucifix, clearly a plague or *Gabelkreuz*, which had been sold by a German sculptor called Thidemann to the rector of the parish of St Mildred's, Poultry, not far from the cathedral. Described by one London source as a *crux horribilis*, a cross of horrible, alien character, this object cost £23, and seems to have appeared at St Mildred's because of the nearby Cologne Guildhall, the centre of commercial and family ties between London and Cologne, where this cross was probably made. In Germany these crosses were associated with devotion to Corpus Christi, observance of which may have begun among immigrant communities in London prior to the *Clementines* of 1317.[117] It proved alarmingly popular as a focus of devotion not least, one infers, for the local German trading community. Why the bishop suppressed it is, however, relevant to the issue of money. Ralph Baldock objected formally to the cross on the grounds of its odd shape, as a sort of abuse of symbolism. But it is also learnt that the unfortunate rector who bought the cross was roughed up by the canons of the cathedral. The reason for this is that in 1300 the chapter had enacted an ordinance which directed income from donations to the ancient great cross at the cathedral's north transept to the *novum opus*, the great new choir opened and measured in 1314 (p. 13). The rector had unwittingly promoted a new and striking rival cross to the cathedral's money-spinning one, and because it looked out of the ordinary he had played into the bishop's hands and incurred the canons' wrath. The signs are that the chapter of St Paul's was eager to insulate itself from the unruly urban mob that hemmed it in, and to get royal protection to that end. Not the least of their problems was that of local boys shooting arrows through their new stained-glass windows while trying to kill pigeons perched on the nearby buttresses.[118]

Such official censorship demonstrates, albeit indirectly, the power that an eye-catching image could have, or was thought to have, in influencing or shaping local religiously motivated donation. This relation of religion and money is a subtle but pervasive one. What was true of London in regard to suspicion, suppression and segregation was true of other cities with large and powerful religious corporations, of which the final example here is Norwich, which with Bristol was second only to London in size and development, a river port with longstanding links to continental Europe, and a recognized centre in the period for the production of Decorated architecture, sculpture, stained glass and illuminated manuscripts.

spending towards the more specific interpretative issues raised by the Decorated Style itself. To do so it will consider finally the relation of religious communities and organizations within cities, and the products of this relation in the visual sphere. At this point one might note that arguments about social rationality tend to overlook the part played by religion in articulating change. So far, I have been careful to note the importance of ideas that were not solely or typically Christian in the formation of reasons for patronage of the arts. But it is quite clear that where evidence arises of serious friction, even bloody conflict, in the changing landscape of the city, religion and its signs are implicated. One such, concerning London, I have discussed elsewhere as an episode in the sociology of aesthetics.[116] In 1305–6

Cloisters:

The Work of Bishop John Salmon at Norwich

Civil unrest had erupted in Norwich at the very end of the reign of Henry III when, in August 1272, the citizens, provoked by the prior's men who had closed the cathedral gates, hung out shields, bucklers and crossbows, and targeted the townsfolk, who in turn attacked and torched the cathedral and conventual buildings, so gutting all but the Lady Chapel. This was followed by extensive looting and even the killing of monks. King Henry dealt mercilessly with the ringleaders. The cathedral roofs were being rebuilt in 1273 and compensation for the prior and convent still being secured in 1275.[119] The first phase of recovery ended when Edward I and Queen Eleanor attended the reconsecration of the church in 1278. In preparation for this, the cathedral priory rehoused its collection of relics (like Exeter, Norwich had no single saint's shrine, but important relics), of which the most glamorous was a portion of the Holy Blood of Christ, which had come to Norwich from Fécamp in the previous century.[120] The Blood had miraculously survived the flames by creeping mysteriously to the far end of its little container to avoid them. The relics were raised securely for display on a special platform north of the high altar over the north aisle, and framed by new courtly-looking wall paintings including Christ with a vinescroll and images of important bishop saints (pl. 60), notably one of the newest, Richard of Chichester (d. 1253), canonized in 1262.[121] It is evident from this concerted display of nourishing sacramental and episcopal authority (the unofficial patron saint of the city, the low-born William of Norwich, was conspicuously absent) that the cathedral was engaging in a *rappel à l'ordre* after the 1272 conflict, which had been aimed at monastic, not episcopal authority.

As with the German Crucifix suppressed by Ralph Baldock, very near the surface of such tensions were to be found Eucharistic images or relics. The greatest urban crisis of the fourteenth century was to be the Peasants' Revolt of 1381. This took place during the feast of Corpus Christi in June: the revolt occurred at a time when public 'communitarian' observance was supposed to be at its height during the processions, plays and fraternity celebrations. It was on the feast day itself that Richard II pondered the assembled rioters from his vantage point at the Tower of London. As Margaret Aston has noted, the coincidence of events is highly likely to have been conscious, and more considered than the usual propensity for riots to happen on holidays, or in summer, as is still true.[122]

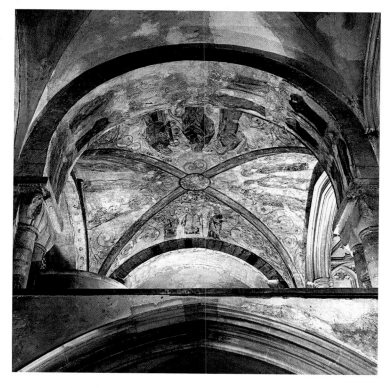

60 Norwich Cathedral, Ante-Reliquary Chapel platform with wall paintings, looking east, 1270s

The practical – though not necessarily psychological – consequences of the 1272 riot in Norwich were to last for generations, not least because the cathedral priory's substantial collection of manuscripts also appears to have been badly damaged by the fire, stimulating a prolonged period of replacement and donation that attracted to the cathedral some of the most glamorous fourteenth-century illuminated books to survive (pp. 327–34).[123] Whether or not the fire can have been as devastating as some of the sources claim, the cathedral priory decided that it required new conventual buildings including a chapter house (rebuilt from 1283, being glazed in 1301–2) and a cloister – ideal contexts for the rehearsal of the inventive refinements and luxuries of the Decorated Style.[124] At stake was the architectural standing of Norwich cathedral priory in relation to the region as a whole – something that John Salmon (bishop 1299–1325) seems both to have understood and to have been able to underwrite financially. This personal wealth mattered: Norwich was not a rich diocese in comparison with neighbouring Ely (see pl. 47), and it is perhaps not surprising that ideas first formulated at Norwich received their most elaborate statements in the richer of the two sees.

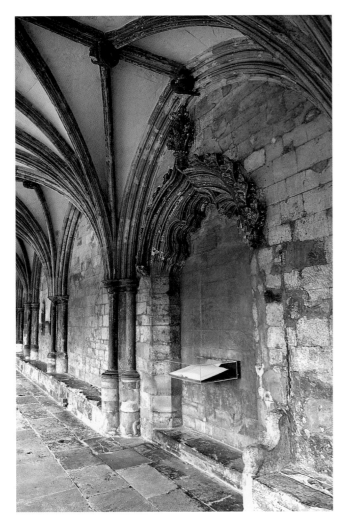

61 Norwich Cathedral, cloister east walk, slype door with jape vault bosses over, all work of the period 1297–1325

The Norwich cloister, the starting point here, is a remarkable space (pl. 61). Rebuilt from 1297, it is the largest surviving English monastic example of its type, and it is recorded as having taken 133 years to finish to 1430, a length of time that reveals something about the availability of funds at Norwich – even the master masons contributed. The time involved resulted principally from the vaulting and its astonishingly lavish programme of historiated vault bosses including a long sequence of Apocalypse scenes.[125] The very slightly larger secular cathedral cloister at Salisbury, far more lean and clean in detail and manner (and of course therefore cheaper), was in contrast finished within about a decade of 1263.[126]

Norwich cloister is of interest here for several reasons. It displays some of the most innovative ogival doorheads and tracery of the period. Whoever began the east walk tracery probably included members of the Curteis or Ramsey family of architects whose members had been employed as court masons and wall painters at Westminster in the 1290s. In 1297 they introduced ogee-flipped tracery arches into the new east walk derived directly from the windows of the lower chapel of St Stephen's designed around or before 1292, where the first work had ended also in 1297 (pls 62, 63), itself a low cloister-like vaulted space, whose first campaigns had ended in that same year. The work in the south cloister walk, provably in the hands of John and William Ramsey (i.e., the Ramsey Company), includes some of the most widely imitated fourteenth-century tracery in England (see pl. 160): its links to the work shortly to unfold at Ely Cathedral after 1321, also in the hands of the Ramsey Company, are well known, but the motifs introduced at this point spread throughout the region.[127] The origins of this inventive toying with tracery may have lain in late thirteenth-century work at Norwich itself, specifically its chapter house of the 1280s, but the effects, via the work of the Ramseys, can be traced as far as the Dordogne and the Auvergne as early as the 1330s (pp. 248, 264–5).[128]

Various, inventive and influential as was its tracery, the other outstanding feature of the Norwich cloister was its extraordinary and unprecedented proliferation of figurative vault bosses.[129] Earlier, I commented on the inventive sympathy that the Decorated Style tended to have for work of the twelfth century, not least at Norwich (pp. 72–4). It may have mattered that its Romanesque precursor, together with the old chapter house opening off the east walk, had elaborate arcades on twin columns with carved voussoirs and historiated capitals worthy of the twelfth-century cloisters of France, the capitals having fragmentary scenes derived, it has been suggested, from Homer or Ovid, reminiscent of the heroic and humanistic sensibilities of twelfth-century culture.[130] Such learned topics set a certain tone and standard of display. The Romanesque cloister may also have been served by elaborate sculpted doorways of the sort remaining at Ely (its prior's door, showing a *Christ in Majesty*); the radiating format of the figures on the arch over the Norwich prior's door inserted by John Salmon is unusual (pl. 64), but it has very distinguished Romanesque antecedents in France, also occurring prominently in Galicia on the vastly larger late twelfth-century Pórtico de la Gloria at Compostela (pl. 65). Perhaps this form preserved something antecedent to it in the old cloister; or perhaps it offered a contemporary solution to a decision not to place a sculpted tympanum over the doorway in order to

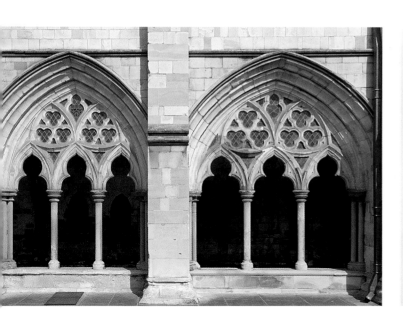

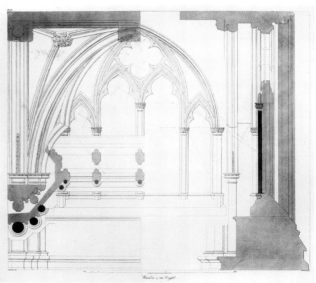

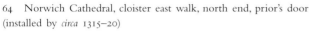

62 Norwich Cathedral, cloister east walk, tracery (compare the small ogee 'flips' on the arch tops to pl. 63), designed 1297

63 London, St Stephen's Chapel, Westminster, interior, by F. Mackenzie, published 1844. Detail of elevation of lower chapel, designed 1292–7

64 Norwich Cathedral, cloister east walk, north end, prior's door (installed by *circa* 1315–20)

65 Santiago de Compostela, Cathedral, Pórtico de la Gloria, 1180s

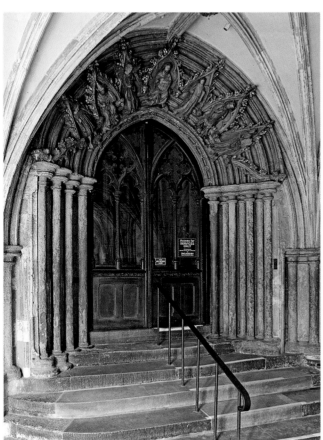

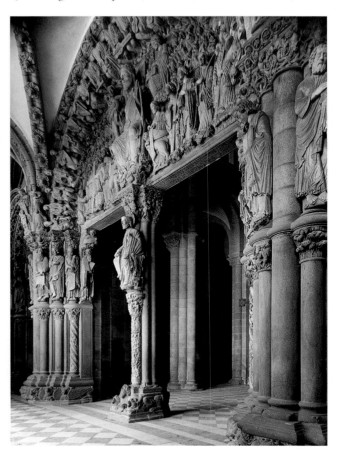

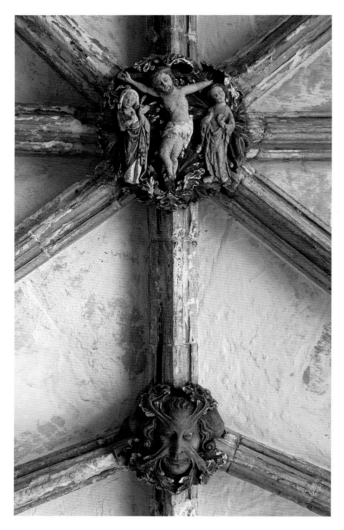

66 Norwich Cathedral, cloister east walk, north end, bosses of *Crucifixion* and green man

maximize the ingress of light from the cloister into the south choir aisle.

The themes of the fourteenth-century bosses at Norwich, however, are in no sense humanistic: the earliest sequences were based on the Passion of Christ (pl. 66) and continued in the south walk with the Apocalypse based on an illustrated French prose version.[131] And, subject matter aside, a fourteenth-century English building would not have been decorated in the same way as a twelfth-century one, since from the early thirteenth century the introduction (as at the east end of Worcester Cathedral) of carved vault bosses had created an entirely new genre of church decoration, which enabled topics to be pushed off arcade capitals and up onto vaults.[132] The use of such bosses at Norwich throughout the

building is unmatched amongst English great churches, but in principle it was by no means alone, since in 1296, the year before Bishop Walpole initiated the cloister at Norwich, Bishop Oliver Sutton had begun a very similar scheme in the cloister at Lincoln Cathedral opened to view around 1300, the wooden vault bosses of which set a high standard in their enjoyable miscellany and occasional flashes of inventive brilliance.[133] The openness at Norwich to a tone also being set in some secular cloisters, though lacking the lofty classical erudition of the twelfth century, is worth bearing in mind. The only real difference is that cloisters were integral to the monastic life, whereas they were peripheral to that of secular canons, for it was here, according to the Norwich customary of 1258–65, that the monks sat, conversed (during recreation) and recited the Psalter.[134]

Because the bosses may show signs of evolution of thought – probably John Salmon's thought – about how the cloister should be decorated, chronology matters because it sheds light on motive. Establishing chronology in this case is far from straightforward, because erecting the cloister involved three chronologically separable operations working in tandem: first, the construction of outer, and then the inner traceried walls looking onto the garth, the over-arches of which were at first built without their tracery inserts; second, the insertion of the tracery; and third the installation of the vaults beneath a timber covering. The chambers over the cloister also had to be raised. Because the tracery set into the openings, like the vaults, was added sequentially in clockwise fashion from the east, it provides a more or less datable panoramic unfolding of the possibilities of such design between 1297 and the late fourteenth century.[135] But the evidence of the figurative sculptures set into the over-arches of the south, west and north garth-side walls proves beyond doubt that these were set in their entirety no later than 1325–50, so the cloister was in effect roofed and functioning up to a century or so before the vaults were finally in place.[136] The walls rose well ahead of the tracery and the vaults and bosses.

There is a useful if succinct summary of the work in the cathedral's fifteenth-century First Register, which states that the east walk of the cloister was begun (*inceptum fuit*) in 1297 under Bishop Walpole (1289–99) and then funded by Bishop John Salmon (d. 1325), the former prior of Ely, together with friends. It says that Walpole began the cloister at the three bays in the middle of the east walk in front of the entrance to the chapter house begun in 1283, itself completed around 1300. Salmon then paid for the east walk bays running north and south from those before the chapter

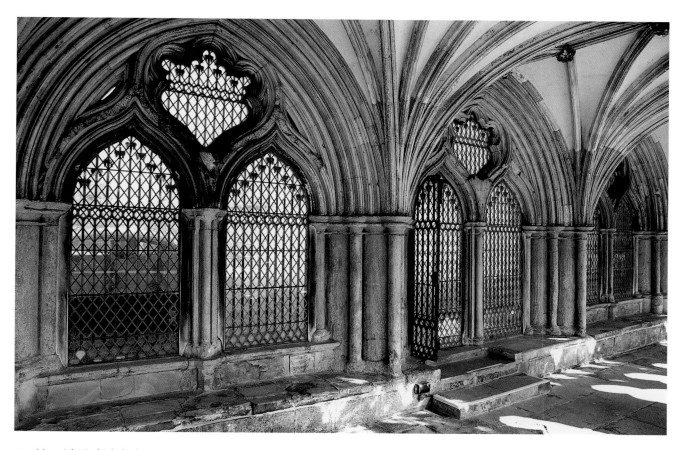

67 Norwich Cathedral, cloister east walk, central bays at chapter house entrance, looking south-east

house, including the portal to the church (*cum hostio ejusdem [ecclesiam]*).[137] Since Walpole barely began the work, the presumption must be that Salmon's men completed the installation of the east walk cloister tracery, inserted the beautiful multi-cusped ogival door to the slype (see pl. 61), the chapter house entrance tracery (pls 67, 68), the three ogival cupboards in the outer east wall, and the prior's door (see pl. 64), and also put in the whole of the vaulting of the east walk by about 1325.[138]

The east walk shows the most remarkable series of adjustments in the whole cloister, including a transformation of tracery forms from the courtly geometric and scarcely ogival shapes of the main garth-side tracery openings to the smooth ogival forms of the slype doorway, the cupboards, the curvilinear tracery inserted below the over-arches of the chapter house entrance bays, and the prior's door to the church along with the vaulting. These later works are clearly mostly coeval. The carving of the top finial over the image of Christ on the prior's portal at the north end is on the first stone of the vault ridge rib; the idiom of the vault

bosses by the prior's door resembles its sculptures very closely; and small adjustments were made to the flowing tracery inserted into the entrance bays of the chapter house showing that it went in at more or less the same time as the vaulting above.[139] Almost immediately, the left-hand baboon corbel of the cupboard next to the portal was smashed into to make way for the vault capital (see pl. 249).

To establish their date, the east cloister vaults, portal, cupboard and doors need to be placed in the context of the two precinct projects known to have been in hand around 1315, the Ethelbert Gate and the Carnary Chapel. The Ethelbert Gate leading into the south-west precinct from the city may have been damaged in 1272 and simple expediency made its repair a priority; what is seen now is a substantial refacing done under John Salmon, designed and executed together with its vaulting no later than 1310–15 and accounted for in 1316–17.[140] Its lierne vault (pl. 69) is similar to those in the north choir aisle of Ely Cathedral rebuilt after 1322. The tracery of the west face of the gate shows little contact with the cloister works except

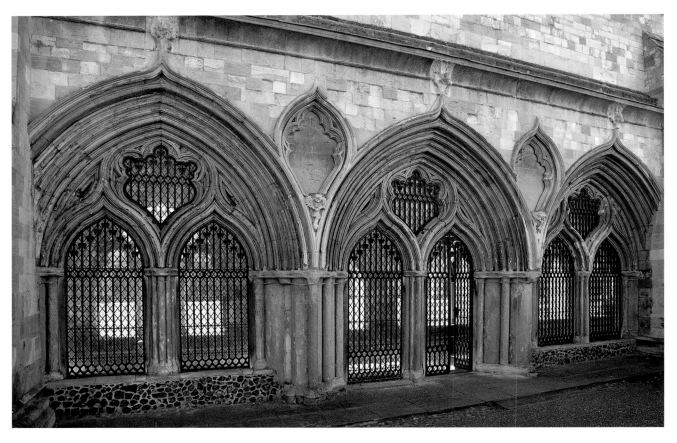

68 Norwich Cathedral, cloister east walk, central bays at chapter house entrance vestibule, looking north-west (for the tracery detailing, compare the tracery over the porch to the left of pl. 71)

at the level of the original flint flushwork patterning in its gable, which employed the bowed-triangular motif also found in the east cloister walk tracery; but the flushwork on the upper south side of the gate and on its east face (pl. 70) connects to the chapter house entrance tracery and the south and west cloister walks, respectively. This flushwork was probably completed last, and indicates that ogival arches with intervening soufflets, and four-petalled motifs, were entering the repertory only at the end of the period to 1315 or slightly later: was the gate begun by one set of masons and vaulted and decorated by the Ramseys?[141] This has implications for the earliest possible dating of the related cloister works.

The Carnary (or charnel) Chapel built by John Salmon outside the church's west entrance is no less relevant (pl. 71).[142] It is a two-storeyed structure dedicated to St John the Evangelist with a stone vaulted ossuary below and a chapel above. Expanding urban population had necessitated the founding of a similar charnel chapel by the abbot of

Bury St Edmunds in 1301.[143] That John's personal interest above all was engaged by the Carnary is proved by its foundation in 1316 as a chantry chapel for the saying of Masses for himself, his parents and his predecessors and successors. Salmon was particularly expressing his devotion to his patron saint. It was described as newly built, *de novo constructa*, by June 1319, and possesses the most astonishingly precocious rectilinear window tracery of the period: all the signs are that the chapel was actually started before 1316 and may have been open by 1317. At such a date it is a remarkable, and in its tone and design courtly, structure: a two-tier palace building with western turrets like St Stephen's at Westminster (see pl. 25) and the Sainte-Chapelle.[144] Apart from the prodigiously advanced rectilinear window tracery of the upper chapel, the round windows of the lower storey have barbed quatrefoil tracery belonging to the same range of formal possibilities as the delicate alternating ogival and triangular gables (i.e., ultimately 'Kentish' ogees and barbs) of the prior's door in the cloister, in essence a

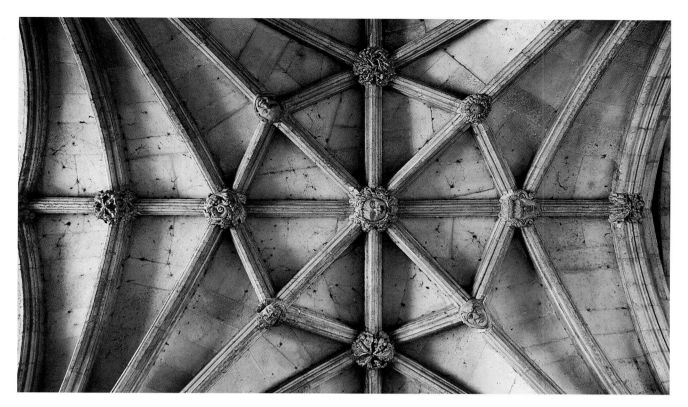

69 *(above)* Norwich Cathedral, Ethelbert Gate, vault, in place by 1316–17

70 *(below left)* Norwich Cathedral, Ethelbert Gate, east face, drawing by John Adey Repton, 1803 (Society of Antiquaries, Red portfolio, Norfolk)

71 *(below right)* Norwich Cathedral, Carnary Chapel, built for Bishop John Salmon, 1315–16

73　Cley (Norfolk) parish church (see also pls 195, 196), south porch boss showing the pursuit of Reynard the Fox

72　Norwich Cathedral, porch to bishop's hall, built for Bishop John Salmon, *circa* 1319–25, drawing by John Adey Repton (Society of Antiquaries, Red portfolio, Norfolk)

slimmed-down and bent-open filigree version of the same tracery extended inventively to a doorhead. The ogival blind tracery with curvilinear soufflets between the ogee arches running over the Carnary's west entrance porch is of the same general form as the tracery of the chapter house entrance (see pl. 68) and the lateral upper flushwork of the south side of the Ethelbert Gate; such motifs appeared in embryonic form in the blind tracery on the top shaft of the Eleanor Cross at Hardingstone (see pl. 121) and at St Augustine's, Bristol.[145] This suggests that the related works in the east walk of the cloister also date to no later than 1315–20.

Having built the Carnary Chapel, Salmon began a new hall and sculpted porch for his palace around 1319 when he acquired the land.[146] He was raised to Lord Chancellor in 1320. The hall porch of *circa* 1320 also survives as a datable criterion of Salmon's tastes at the time (pl. 72). It has a vault with bosses mostly of foliage, which, like the adjacent capitals, are undulating and clingy, flattened closer to the vault

rib and web, slightly different from the bunched, alert and more variegated foliage in the cloister, but very like the vaulting in the porch to the Carnary. Three of the bosses contain small 'moralities' including a lion-masked demon with lolling tongue presiding over a wimpled man and a hooded woman holding hands, standing perhaps for gossip or more probably lust; two figures holding an object writhe in a net; and a priest appears to grant absolution to a woman.[147] The subjects are generally in line with the cloister work but look a little later, closer to the vaulted south porch by the Ramsey Company at the parish church at Cley on the north Norfolk coast, which has a splendid boss of Reynard the fox stealing a chicken and being pursued by a woman (pl. 73), found also in the margins of the Gorleston Psalter (British Library MS Add. 49622, fol. 149v) and on folio 71v of the Ormesby Psalter (Oxford, Bodleian Library MS Douce 366).[148] The two-light windows of the porch's upper chamber have flowing divergent mouchettes of very modern form, apparent almost immediately on the front faces of some of the buttresses of the wall arcading of the Lady Chapel at Ely. Under Salmon too must have been developed the flowing tracery now set (in the seventeenth century?) into the windows of the bishop's palace chapel to the hall's south (pl. 74). These are remarkably early instances of a mode of tracery that was to spread through eastern England especially in the next three decades, commonly in Lincolnshire (for example, Grantham south

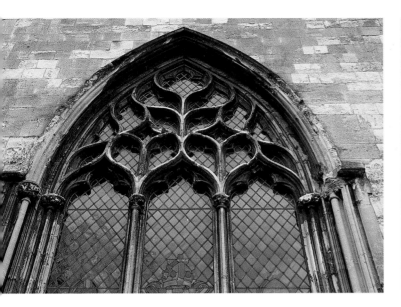

74 Norwich Cathedral, tracery from hall of bishop's residence, built for Bishop John Salmon, *circa* 1319–25

75 Norwich Cathedral, cloister east walk, southern half, foliage boss

chapel).[149] Together with the advanced use of split vertical mullions and cusped kite shapes in the Carnary windows, Salmon's patronage in effect oversaw no later than 1320 the emergence of the two main modes of tracery that would predominate in England by 1350, one curvilinear, one rectilinear. Norwich, with London, Bristol and Exeter, was a crucial participant in this first, most vital wave of innovation in the Decorated Style.

By comparison with the dated work on the Ethelbert Gate, the Carnary and the palace, the north end of the east cloister vault and related works accord well with a date of conception no later than 1315–20 because by then the necessary ideas were already in place in the precinct; the entry in the First Register is again a reminder that the prior's door pre-dates 1325. The important point is that it was at this juncture in the unfolding of the cloister that the decision was taken to shift to elaborate figurative bosses executed by the same team as the prior's door sculptures. The rationale of the east walk's distribution of figurative vault bosses was thus established by Salmon and, in all probability, the Ramseys. The three central bays before the chapter house entrance, and those to the south as far as the infirmary, have predominantly foliage bosses and green men (pl. 75). By one, I think correct, account the vaulting of these central bays and those to the south was installed before that of the six bays running to the north towards the portal. The initial absence of significant figurative sculpture at the

entrance of the chapter house or in its entrance vaulting, or in the bays extending from it to the south towards the infirmary, is striking: why should the chapter house entrance (often richly adorned in comparable monastic churches) or the bays to the south be so relatively plain, and those to the north so relatively rich? But it is easy to overlook the fact that the chapter house entrance was itself reconfigured with sculpted imagery when its curvilinear tracery was inserted (see pl. 67). Closely examined, it can be seen that the juncture of each pair of ogival arches forming the chapter house entrance once bore foliate image corbels, later struck off. These presumably sustained images framed by the inverted cusped teardrop shape in the arch head above, probably (in the light of the common association of chapter houses with the Virgin Mary) a seated *Virgin and Child* at the centre with censing angels to either side. These cusped openings are thus not oddly shaped windows, but in fact soufflet-shaped vesicas intended to enclose imagery, much like those on the beautiful Butler-Bowdon embroidered cope (London, Victoria and Albert Museum) and the wall arcading of the Lady Chapel at Ely (see pls 162, 190).[150] The ogival niches on the exterior east face of this entrance wall, originally within the chapter house vestibule, could have housed an *Annunciation*, as at Westminster (see pl. 68). Mary's presence would make sense in the light of the bosses in the six bays running north from the three central chapter house bays to the entrance to the choir aisle of the church,

Bony quite rightly likened the freedom of the handling of the ogival and triangular arches to goldsmiths' work; the delicacy and sparkle of the forms look like metalwork.[151] Complex counterpoints of major arches woven around with minor radiating arches are found in *Opus anglicanum* of the period, such as a lost early fourteenth-century cope from the Vatican known from a tinted drawing now in the Walker Art Gallery in Liverpool (see pl. 191).[152] A good example occurs on folio 147v of the Ormesby Psalter, local work that found its way into the choir of the cathedral a few years later.[153] And a further formal analogy exists, between the portal and the generous and high-quality illuminations in the Ramsey Psalter (St Paul im Lavantthal, Stiftsbibliothek Cod. xxv/2, 29; New York, Pierpont Morgan Library MS M.302) made for Ramsey Abbey at

77 Ramsey Psalter, *Martyrdom of St Thomas* and founders of Ramsey Abbey, *circa* 1310–20 (New York, Pierpont Morgan Library MS M.302, fol. 4v)

76 Norwich Cathedral, cloister east walk, laundry thief caught red-handed

depicting the *Passion of Christ* from the *Flagellation* to the *Harrowing of Hell*, various antics, the Evangelists, and by the door a bishop, presumably Salmon himself, being revered by a monk. The evolving tone is notable: amongst the bosses is found a vault-clinging acrobat and with it an arse-waving grotesque (his bottom is positioned with fearsome potential directly over the slype doorway) (see pl. 61), a washer-woman fending off a thief next to the *Carrying of the Cross* boss (possibly a parody of the cloth-bearing St Veronica) (pl. 76), and two buskers hard by the *Crucifixion* boss. In idiom these bosses are identical to the carvings over the prior's doorway, which keys into this same vaulting sequence.

The culmination of these bosses and other topics is the lavishly carved prior's door with figures of Christ the Judge, angels, St Peter and St Edmund, with John the Baptist and Moses (pl. 78). The idiom of the prior's door has invited comment because of the radiating setting of linked canopies of alternating width and form, perpendicular to the main arch mouldings, which as already noted has Romanesque antecedents. The figures beneath sit or stand in alternation.

78 Norwich Cathedral, cloister east walk, north end, prior's door, detail

some point in the second decade of the fourteenth century (pl. 77), in which the founder-figures of Ramsey with attributes at their feet sit and stand under linked alternating ogival and triangular gables handled with exactly the same richness and fluency.[154] The Ramsey family of masons working under Salmon on the cloister, and presumably on this portal, came from the area in which the Ramsey Psalter was produced.[155] This is not the last instance of a fundamental sympathy between masons, painters and illuminators in this period, because the Fenland manuscripts of the period include innovative ogival micro-architecture. It may be worth noting that a member of the Curteis family is recorded amongst the wall painters working in Westminster Palace in the years 1292–7.[156]

The imagery of the portal is certainly triumphalist. The angel to Christ's right originally held up the Crown of Thorns and Spear, and all the non-angelic figures trample vanquished opponents, though the choice of underlings is not obvious: one might have expected Herod or Salome under John the Baptist,[157] Pharaoh under Moses and Nero or Simon Magus under St Peter, but St John plants his feet acrobatically on the shoulders of an innocent-looking young man – an arrangement found in thirteenth-century French portal sculptures – who grips the arch moulding; and even Christ's footrest is not of a common form, being another prone male. The choice of St John the Baptist (the beardless head is a later replacement) in the honorific position to Christ's right brings to mind other images of the Baptist in the cloister, including his beheading in a south walk boss (pl. 79), and might connect simply to John Salmon as commissioner; a similar sequence of John–Peter–Christ with St Edmund opposite occurs on the Dominican Thornham Parva Retable painted in the Norwich region in the 1330s.[158] It may be that John and Moses are to be understood as forerunners of Christ, those especially who, in Luke 16:29–31 at the end of the parable of Dives and Lazarus, prophesied the Resurrection. As such, they continue theologically the sequence of *Passion* bosses ending with the

79 Norwich Cathedral, cloister south walk, *Decollation of St John the Baptist*

Harrowing of Hell, but in a context where a full Last Judgement was physically impossible to represent because of the decision to omit a tympanum.

What motivated this sudden burst of spiritual and jongleuric chatter in the cloister? Since no functional or symbolic reason is forthcoming one is faced with more human explanations. If it is true that the central and southern bays were vaulted first, the plan at that stage cannot have been to have a cloister furnished throughout with figurative bosses, and it would be irrational to argue that the scheme was vaulted and richly embossed at the north end first, the bosses then being abandoned at the centre and towards the south, and then reintroduced with the *Apocalypse* in the south walk. The episcopal-led team in effect changed the plan, and introduced the idea of figurative bosses in the north part of the east walk not much earlier than 1315. This would be consistent with Salmon's patronage in another way. His family chantry, the Carnary Chapel of St John, points to a devotion to the Evangelist (and also probably

the Baptist), which suggests that it was Salmon's plan to introduce bosses of the Apocalypse into the remaining walks of the cloister. The fact that these bosses were actually begun later than 1325 does not rule out the existence of a general plan for the bosses as a whole formulated by Salmon and his team, and adhered to until the fifteenth-century completion. At Westminster Abbey the choice of the Apocalypse and scenes from the Life of St John for paintings in the chapter house undertaken around 1400 may be explained by the name of the principal patron, also a John (of Northampton).[159] At Norwich, as noted, John the Baptist figures in the main portal and his martyrdom is on a boss in the central bay of the south walk. The north and west walks contain isolated bosses of the same fourteenth-century date, and the Passion sequence in the east walk 'overshot' in production, with a boss of the *Noli me tangere* of the same date being relocated at the east end of the north walk along with a later *Doubting Thomas* – certain evidence that the Passion sequence in the east walk was 'squeezed' by the earlier foliage bosses to the south, and pushed on past the portal to as yet non-existent vault bays in the north walk. This also explains why the Passion sequence begins with the Flagellation, actually truncating events starting earlier in the Gospels. The initial, simpler foliated scheme of bosses (see pl. 75) that forced this compromise was not Salmon's at all, but that of its *fundator*, Bishop Walpole. The first drawings for the cloister and its vaulting system must have been made before 1299, and possibly even vault components and bosses were made early on. The injunctions that Walpole, a scholar and former archdeacon, issued at Ely in 1300 just after his arrival as bishop from Norwich attempted to recapture monastic rigour by excluding seculars, strengthening communal eating, and keeping up appearances by proper attendance in church; women were to be kept at arm's length and showy dress was prohibited.[160] If Walpole had taken this line at Norwich, his aesthetic attitude to the cloister may also have been on the severe side. Walpole's prior, Henry Lakenham (resigned 1309–10), owned a copy of Hugo de Folieto's twelfth-century *De claustro animae*, an austere meditation on the cloister as possessing moral and spiritual significance that would not have sat well with the jollities that somersaulted their way in at Norwich under Salmon.[161] Perhaps, too, Walpole's initial plan amounted to a sober critique of the figurative enrichment of the Romanesque cloister.

John Salmon, though a monk by origin, was a man of different mettle. He was one of the courtier bishops, whose administrative power was at its height in the early 1320s

when he was Lord Chancellor. He had the means. But he also had the connections and sense of the way the larger world was moving. According to the documentation of his visitation of the priory in 1308, Salmon stressed the need for the monastic community to look good, since, as the statutes say, the cathedral was not only noble but also in the public eye (*in loco publico et famosa constructa*): his fault finding in this regard had mostly to do with poor monastic attendance at offices and badly corrected liturgical books.[162] Salmon was doubtless in part energized by the mounting ambitions of the Norwich mendicant orders as church builders and property developers. The four principal orders in Norwich, the Dominicans, Franciscans, Augustinians and Carmelites, were all located towards the fringes of the city. But from the 1260s a series of developments conspired to enhance their physical presence yet further; these were universal papal measures that strengthened and consolidated the main orders, but which in Norwich coincided almost exactly with the period of heightened tensions and then the explosion of urban feeling against the cathedral priory in 1272.[163] A bull of Clement IV in 1265 decreed that friars could have no possessions beyond the bounds of their precincts: but this simply had the side effect of encouraging them to enlarge their precincts. A constitution of Martin IV of 1281 then authorized the friars to take up sacramental and pastoral functions in any parish without episcopal assent, which obviously encroached on the interests and income of the secular Church. The net result of these measures was greater confidence and prosperity, and also mendicant churches throughout Europe that were enlarged in size hugely beyond the intentions of the original founders, which instantly encroached on the old cathedral corporations, for instance at Narbonne; before 1274 St Bonaventure had observed that the friars were tending to build taller buildings as a vertical solution to real estate prices.[164] In Norwich, clever estate consolidation enabled the opposite process, a sort of conventual sprawl, evident in enlarged parish-church-type structures with extensive ground plans. By the 1320s in Norwich, the Dominicans and Franciscans were building conventual churches and cloisters that were easily to exceed the scale of the city parish churches. The largest of these, the Blackfriars under way around 1327, still stands (pls 80, 81), its surviving fourteenth-century walls and windows being in the Decorated Style.[165] Demographically, Norwich was a city of friars, not monks. And the direction of their patronage in this period may be judged by the ornate sculpted (chapter house?) portal made for the Carmelites probably in the

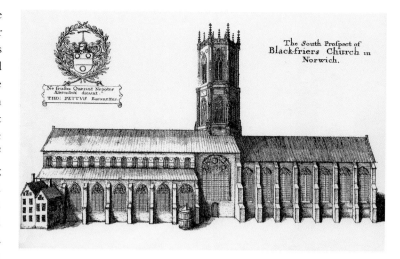

80 Norwich, Blackfriars, from south, from Dugdale 1817

1320s, now known as the Arminghall Arch, which surpasses much of the cloister sculpture in quality, and was designed by someone familiar with the Canterbury tomb of the Franciscan archbishop John Pecham (d. 1292).[166]

81 Norwich, Blackfriars, now St Andrew's Hall, east window after 1326, from north-east

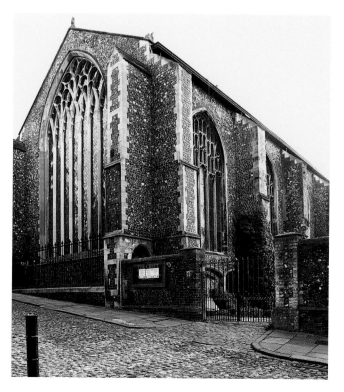

But it would be unhelpful to see the amplification of the sculptural content of the cathedral cloister under Bishop Salmon simply as an attempt to outdo the mendicants who, if the *Summa predicantium* of the Dominican John Bromyard is any guide, took no specific view of the edificatory role of cloisters except as metaphors for the inner arrangement of the soul in the austere tradition of Hugo de Folieto.[167] The cloisters of the Norwich Dominicans, under way after the cathedral cloister's east walk, are far less lavish in finish. It is better to think, not so much of a response to specific threats or opinions, as of the outcome of more than half a century of increasingly rapid change in which the institutionalized religious life of the city as a whole quickly diversified, creating a kind of creative friction and inventive *machismo*.[168] It is unclear whether anything positive can be deduced from Salmon's works about the cathedral corporation's relationship with the city as a whole. Given the dual status of the church and the extent of economic activity within the precinct, its enclosure was in a sense a formality. Buildings such as the Carnary, used for depositing the bones of city laity, were the objects of episcopal indulgences for all comers, one being issued for the Carnary itself by Salmon in 1317.[169] All this implies at least the recognition of a lay presence. It is known too that the landowning laity (such as Richard Uphall who helped with the chapter house in the 1280s) pitched in financially, and are depicted in the cloister vaults.[170] But again the evidence fails just when it matters. Almost nothing is known about actual public access to areas such as the cloisters at this time, and hence about lay public reception. Lay access may only have been of the most privileged (or financially generous?) type. 'Reception' is anyway a slippery category. An antithesis between lay and monastic taste would be misleading, since some monks might perfectly well have enjoyed these jocular carved vignettes, so consistent with the taste of the great Psalters that the monastic community was content to adopt for its church at the time (see p. 327). Cheerful demotic nonsense should not press one instantly to seek out 'secular' viewers. And one should not forget that it is characteristic of display that it sometimes exists for its own sake. These troublingly over-promoted social polarities will be considered again in considering marginalia (Chapter Eight).

There is a common characteristic of such hypothetical, competition-based accounts: they assume a form of motivation attentive to the lay and urban context of the cathedral more generally, and are in this sense outward-directed. The evidence points strongly to Salmon being the principal motivator of these projects and to his being a very signifi-

cant client, aware that his cathedral was in a 'public and celebrated space', as he had remarked himself in 1308. But it is doubtful, or at least contestable, that his motivation – in so far as this can be inferred from his commissions – went much beyond promoting his family and household, and above all the architectural standing of Norwich cathedral priory in the region as a whole. Salmon's outward-directedness was conventionally geared to status, to emulation. In this regard his cathedral priory's relations to the city may have mattered less than its standing in relation to cognate institutions in the region. His amplified and enriched cloister works in particular can be seen in the context of the ambitions of the one comparable institution that he knew and understood well, namely Ely, where planning and fundraising for major works were almost certainly under way by around 1316. As its former prior and a colleague of Ely's new bishop, John Hotham, Salmon was in a position to know that Ely cathedral priory was planning to build a lavishly sculpted and coloured Lady Chapel. The chronology is not impossible, since plans for a new Lady Chapel at Ely probably developed fully not long after 1316, when Hotham was installed, and may have been pondered earlier still (see Chapter Five). John eventually donated 20 marks to the building of the Ely octagon in 1324, and earlier in 1315 had lent the priory £200.[171] Both projects were to employ the Ramsey family, and there is a kinship between the tracery used in the chapter house entrance at Norwich, particularly the inverted cusped teardrop or soufflet motif, and a version of it in the wall arcading before the vault shafts of the Lady Chapel at Ely designed by 1321. There was, in other words, a strong Ely–Norwich 'axis' by no later than 1320, and one way of explaining this is by placing the collegial relationship of Salmon and Hotham in the context of their respective plans for their cathedrals.

Gates

Salmon, in other words, was a conventional great churchman. That Norwich cathedral, as *primus inter pares*, now moved in a quite different world from the heroic days of its eleventh-century apostolic ambitions and orientation towards the magnificence of Rome is clear. That world had shrunk, and capacities both economic and imaginative (for the two are linked) had diminished. Under these changing circumstances, a certain defensiveness might be understandable, and certainly Norwich was not alone in this period amongst religious corporations in cities in developing its

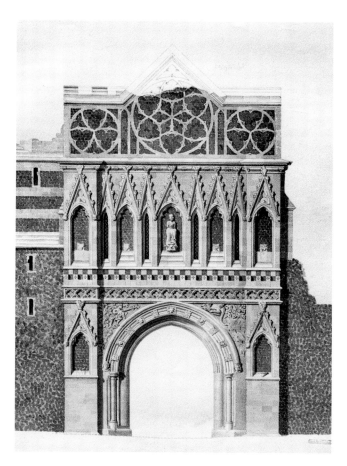

82 Norwich Cathedral, Ethelbert Gate, west face, drawing by John Adey Repton, 1803, showing original form of flint flushwork and statuary (Society of Antiquaries, Red portfolio, Norfolk). Note the image of Christ at centre, the row of quatrefoils and the crenellations with arrow slits over the arch. For the origin of the bowed triangles used in the topmost flushwork, see pl. 62 and pl. 95

in combat, to the left a bearded man in a cap armed with a round shield poking a sword at a wyvern or dragon on the other side, the whole set against a huge vinescroll. Sekules is right to position this imagery in the context of the cathedral priory's recovery of order in the precinct area. The vinescroll spreading beneath the figure of Christ perhaps alludes to the wall paintings framing the cathedral's relic of the Holy Blood, redisplayed by 1278.[174] Tombland, a place of bloodshed, is thus redeemed by Christ's sacrifice. But the gate's sculptures seem to deepen this theme of redemption and resistance to vice. According to the cathedral's First Register, the area outside the precinct faced down by the gate had been known as the 'land of St Michael'; here Herbert de Losinga, the cathedral's founder, had long ago erected a cross to act as a cautionary landmark (*ad cautelam*) with a 'most beautiful' figure of St Michael at its summit.[175] Small churches dedicated respectively to St Michael and St Ethelbert stood near the gate on either side of the precinct wall. The new gate's imagery was at once an epitome of the local liturgical landscape and also an allusion to some prior tradition of images of men or angels in conflict with demons, possibly even some such image on the former portal itself. St Michael is carved more than once in the cloister vault bosses, and there too is found a man with a round shield in combat with a dragon. Michael's example as the main angelic warrior and defender of the community against evil would not have been forgotten: what had happened once could happen again, especially in the fractious conditions of fourteenth-century cities. In the court milieu, angels also epitomized the identity of the series of portals in the Douce Apocalypse, whose free compositions are discussed in the next chapter. And it may be worth recalling too that the artistic lineage of the main façade of the Ethelbert Gate included the Eleanor Crosses set up in the 1290s, two of which were deliberately positioned by Edward I in Cheapside – London's equivalent of Tombland – and Charing. These too were *cautela*, warnings to the urban populace, in the same general tradition as that of Losinga's cross.

Earlier, I noted that English patrons of great church architecture tended not to concentrate resources on great portal façades, as was the case in continental Europe. Instead, a different form, the sub-fortified gatehouse, took on renewed prominence, and was energized in this period as a symbol of the new tensions of a century of 'crisis'. Not the least of these tensions was a mounting urban hostility towards older religious corporations, particularly, though not exclusively, the monasteries; another factor may have

precinct walls and gates in a way that continued to speak, albeit symbolically, of clear limits, so horribly infringed in 1272.[172] Norwich had two major gates facing the city space known as Tombland to the east of the precinct, which had been at the centre of the 1272 uprising. One of these, the gate to the south, called the Ethelbert Gate, led into the southern precinct, and its building history has already been discussed (pl. 82 and see pl. 70). Its crenellated west face towards the city had niches for seven substantial sculpted figures of whom the central one, over the main arch, was *Christ the Judge* showing his wounds, presumably like that on the prior's door in the cloister.[173] Below him were a row of crenellations with miniature arrow slits and a frieze of quatrefoils. To either side of the entrance arch were figures

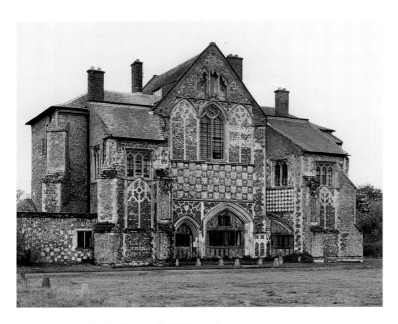

83 Butley Priory (Suffolk), gatehouse, 1320s

and a lion in combat over the portal in similar vein.[179] Bishop Salmon's palace gatehouse at Norwich, dating to around 1320 (see pl. 72), with its tall, slim and steeply gabled ogee-headed image niches, soft tracery and portcullis, anticipated the detailing of the impressive new gatehouse to the precinct of Bury St Edmunds (pl. 84), begun by Norwich- and Ely-related masons in response to a series of major attacks on East Anglia's greatest monastery in 1327 and completed later in the century; similar gates with licences to crenellate were erected at Peterborough and St Albans.[180]

The chancery licences for such crenellation of buildings were a mark of what Charles Coulson, in his studies of battlements and artful armament as a form of semiotics, identified as a sign of the 'social emulation and the prosperity of the sub-baronial class, lay and ecclesiastical': crenellation was 'seigneurially demonstrative'.[181] About 25 per cent of such licences were obtained by ecclesiastical bodies, often

been intra-institutional suspicion. Gatehouses or towers had long been formally innovative: that of the mid-twelfth century at Bury, with its continuous shafting and bold gables, is rightly seen in the context of the most advanced northern European Gothic innovation.[176] The powerful new symbolics of monarchy exhibited towards 1300 in castle building and the erection of memorial crosses placed tactically in cities with oversight of their commercial centres further helped to articulate the appearance of older thresholds between the traditional sphere of organized religion and land, and the fluid sphere of commerce and money. But the inventive range of precinct gateways as symbols of beautified territorialism is the remarkable thing. Flint flushwork makes its first appearances on the Ethelbert Gate and on the gatehouse at Butley Priory (Suffolk) by the 1320s (pl. 83). At the priories of Kirkham (Yorks.) and Butley, gatehouses were hung with carved shields. Fortified monastic and cathedral precinct walls were increasingly common.[177] One of the earliest surviving and really fine monastic precinct gates was that erected by St Augustine's Abbey in Canterbury before 1308 in the latest court manner of the Kentish masons; the Ethelbert Gate at Norwich followed close behind.[178] Both bore battlements. Even the relatively isolated monastery of St Benet Holme in the watery lowlands to the east of Norwich issued in a new edition of the Ethelbert Gate for its main portal in the late 1320s, flashing with knapped flint panels and sculpted with a hybrid man

84 Bury St Edmund's, abbey gatehouse, begun after 1327

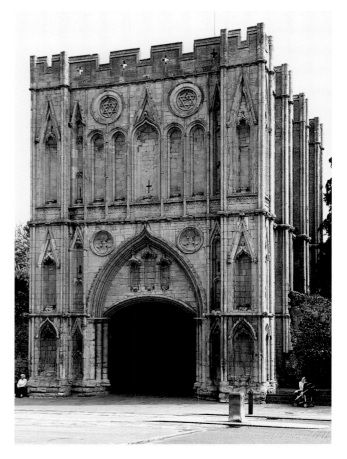

favoured by membership of the court and administration.[182] The Church participated in the image of worldly lordship. In these displays of status and war, freedom of invention flourished, for the eloquence of these new gates derived from their unconstrained ability to combine and deploy newly fashionable forms, of which heraldry and battlements and decorative flintwork – inaugurated apparently on the Ethelbert Gate itself – were examples. The spread of miniature battlements into the ornamental language of the Decorated Style was one of its defining features. The men that designed the showcase cloisters and gatehouses at Norwich under Bishop Salmon probably included William Lyngwode, trained on the Norfolk estates under Salmon but employed by Bishop Woodlock on the magnificent choir stalls at Winchester in 1308.[183] Invention crossed generic boundaries and physical territories. In France, the main church portal had become one of the two major areas of inventive *varietas*; in England, the threshold became not just a sign of architecture's ability to speak and admonish, but also of the movement of society and signs at large.

These gates are an aspect of the history of medieval architectural eloquence, not least in making use of the imagery of warfare. It is through them, in all their showy vulgarity, curiosity and latent savagery that this book now steps, to consider the aesthetic powers of the Decorated Style itself.

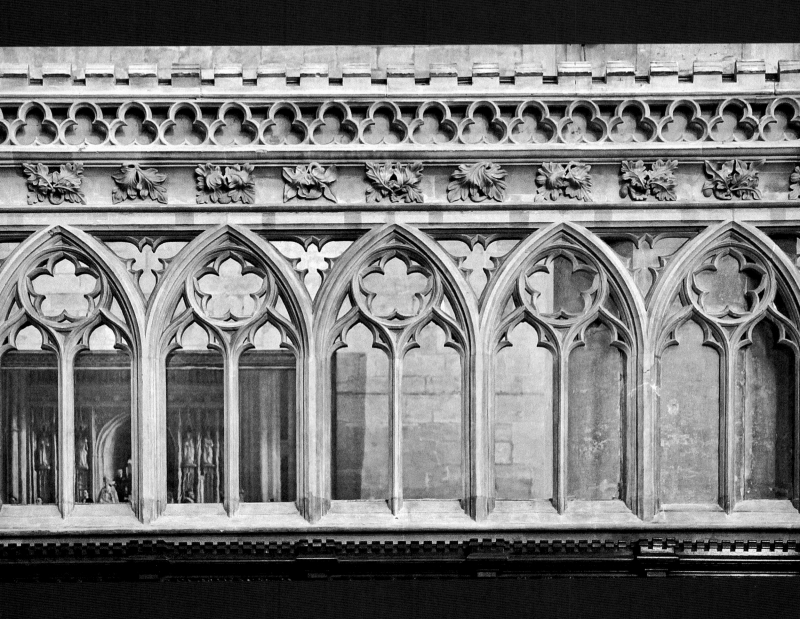

PART II
THE AESTHETICS OF THE DECORATED STYLE

Canterbury Cathedral, choir screens (detail of pl. 117)

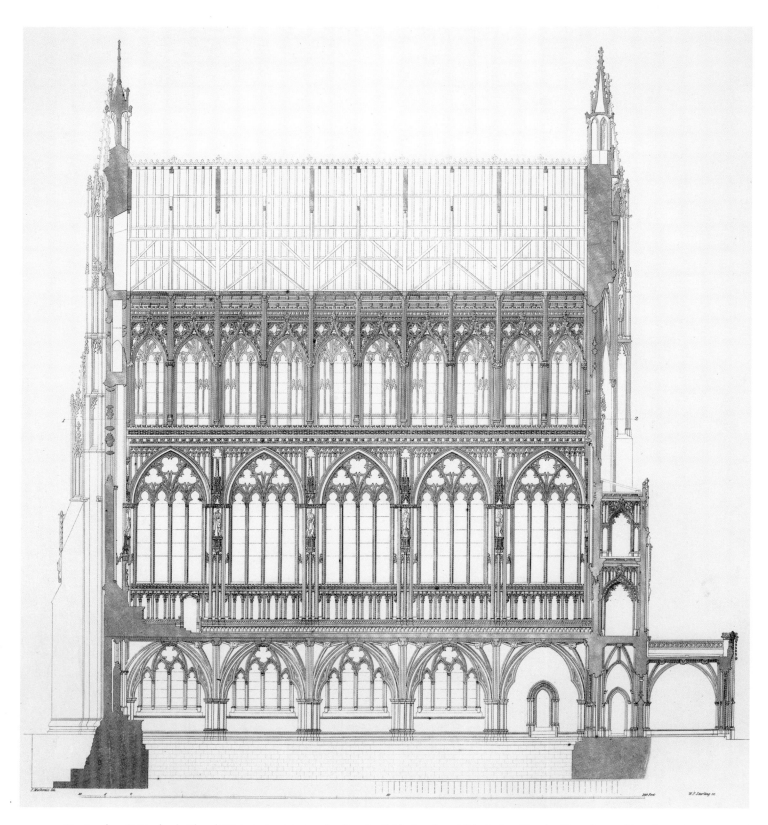

85 London, St Stephen's Chapel, Westminster, interior elevation, by F. Mackenzie, published 1844. The detailing of everything above the principal cornice of the upper chapel including the clearstory, as well as the interior statuary and canopies, is hypothetical. For the lower chapel, see pl. 63.

4

INVENTION ENERGIZED

Scale and Allegory

Thou art beautiful, O my love, as Tirzah, comely as Jerusalem, terrible as an army with banners

Song of Songs 6

Value and Pedigree

Recall a racy analogy that has been drawn between the lofty Gothic cathedral and the 'shimmering Postmodern towers of today's corporate headquarters'.[1] An instance is Richard Rogers's Lloyd's building in London, completed in 1986, the year of the Thatcherite 'Big Bang' which deregulated the financial markets. Then imagine a satisfying account of the Lloyd's building that related with perfect accuracy everything about its architect, and which traced the (Parisian) precursors of its high-tech design, the sourcing of its steel cladding, plate glass, ducts and pipes, and so on down to the smallest wingnut. Such an account would close off further enquiry; after all, it would have offered a dissection of the building as if it were the sum total of various expertises, styles and techniques. The modernist belief in architecture as an absolute aesthetic and technical activity, haughtily elevated above the generality of human experience, would have been affirmed. Confidence would have been secured in the firmly subordinate character of concepts, meaning, language, representation and the vagueries of emotion, anything that might subvert, render contingent or just humanize the purity of the concept. The Lloyd's building would be a summary of methods and preferences, but it would also be the brilliant outcome, the fulfilment, of a process of formal realization of the sort envisaged by Romantic aesthetics and their absolutized and purified artistic media.

But in leaving it there, we would of course be, if not wrong, at least imaginatively incurious. A formal account would tell us nothing about why we might find the Lloyd's building persuasive, beautiful, or for that matter ugly. It would be like a text subjected to the critical literary tenets of New Criticism. Forms – contrary to some outmoded art-historical beliefs – do not operate within a charmed space set apart from human experience. To ponder Lloyd's without thinking about the consciousness of late twentieth-century corporate capitalism would be to see, but not to understand. Expertises, techniques, even styles, are not only issues of *preference*; they are also matters of *value*. Values are not simply preferences. A man who, at lunch, chooses a salad because he doesn't fancy the lamb chops is expressing a preference; a woman who chooses the salad and not the lamb chops because she is a vegetarian is expressing a value:

121

were she to tuck into the chops, she would be indulging in an act of betrayal. A preference will not, as a rule, determine a value; but a value will tend at the very least to influence a preference. Yet the apparent outcome – two people eating salad – will be the same. To live according to one's values (one's 'value rationality') is to flourish, to bring one's concepts and beliefs fully into line with one's thoughts, acts and experiences. To study sympathetically what, in their eyes, once made people flourish, what benefited them, is to engage in that process of imaginative interpretation of experience called *Verstehen*. Its ends, ideally, are to capture something like that easy immediate understanding, that 'knowing', which we ourselves have, or think we have, in relation to the products of our own time whose full meaning seems so effortlessly transparent to us.

No one pretends that this historical and hermeneutic ambition is easy. When reflecting on culturally remote buildings of the Gothic era, what we actually see, can only see, are the apparent outcomes of choices and human actions, which in the first instance demonstrate preferences – *mere* preferences, as it were. But we know from the most vivid assertions of human value in the Middle Ages that at least sometimes what sustained these choices were wider values, sometimes thoroughly thought-through ones. Aesthetic experiences are not always entirely separable from value judgements. By the twelfth century at the latest, an extreme but clear version of this truth had been established: monastic writers on ethics and the religious life saw that what we eat, wear and say, as well as how we build, *makes* us something. To build and to furnish a church according to a rule is to conform to a *habitus* that necessarily connects all aspects of experience within a 'legislative aesthetic'.[2]

Bernard of Clairvaux, a spokesman for this in some ways admirable position, did not win all the arguments. Such 'legislative aesthetics' were a specialized instance of a larger form of understanding that has continued today in the belief that medieval visual arts *necessarily* served ethical ends. In fact, this is not quite so: not everything in the present book can be subjected to moral, religious or political scrutiny, or was even directed towards such ends; and in asserting the importance of values one should guard against excessive attention to them. Much discussed in this book was a form of serious inventive play sometimes directed at producing an effect, sometimes being valued as an end in itself. It was also such play that brought 'form' and 'content' (to speak anachronistically) into a productive and satisfying relation.

An approach to the arts that traces the play of shapes as consciously separate from experience and value is, I suggest,

one unlikely of itself to shed much light on this very human issue of what people actually need, and how they react to art. Not that the means are necessarily unimportant. Without any classification and taxonomy based on detailed technical criticism of form and a sense of the historical pattern of causes or chronology, the search for values is futile, at least in any account based on actual evidence: whether taxonomy and classification precede one another (taxonomy may implicitly follow an a priori rule of thumb) is a secondary question. In 1817 it would not have troubled Thomas Rickman, who, having discussed the classical orders, then set out under the genus Gothic the species Norman, Early English, Decorated English and Perpendicular English as if they were in fact orders, yet in a way remarkably free of value judgement.[3] Rickman and his followers described the evolution of these species in time order, 'Perp' following the development of the Decorated Style and emerging in the London–Gloucester sphere around 1330. But the post-Second World War refinement of the documentary history of the king's works was to produce another possibility, in fact a very eminent pedigree.[4] What Rickman had seen as distinct and sequential styles, the Decorated Style and Perpendicular, could in fact be shown to have had a common ancestor, an edenic prototype, in the suavely ambivalent and complex chapel of St Stephen in the Palace of Westminster (pl. 85), begun under Edward I in April 1292 and completed almost sixty years later, being almost wholly destroyed, bar its crypt, in the fire in the palace in 1834. The exterior of this building (see pl. 25), certainly designed in 1292 by Michael of Canterbury, revealed a debt to the Rayonnant 'grid' of continuous vertical mullions developed in mid-thirteenth-century France as a way of connecting and smoothing the relationship of the clearstory to triforium of great churches. This grid also formed the basis of the Perpendicular Style in the south transept of Gloucester Abbey by the 1330s. The truth of this was first revealed in an eccentric book by Maurice Hastings published in 1955 – a text that arrived at the right general conclusions for the wrong reasons: 'the Perpendicular style', Hastings stated, 'is the lineal descendant of Rayonnant'.[5] Hastings, however, saw this aloof, courtly and cosmopolitan idiom as being separate from the English 'norm' of the Decorated Style itself, by which he meant the 'provincial' ornate and curvilinear idioms of Exeter and Ely. John Harvey, the romantic nationalist doyen of the study of Perpendicular, challenged Hastings's fundamental conclusion about the debt of St Stephen's to French Rayonnant, and indeed about its Perpendicular character: he in effect wrote

the chapel out of the history of that style.[6] It seems to have been easier for Harvey to admit Islamic influence in the Decorated Style than French influence on Perpendicular.

But what both Hastings and Harvey overlooked was another feature of St Stephen's, one first properly recognized by Jean Bony and most systematically developed by Christopher Wilson. Bony regarded St Stephen's as a stylistically ambivalent building, both 'proto-Curvilinear' and 'pre-Perpendicular'.[7] Wilson followed Hastings in seeing the Perpendicular Style as 'Rayonnant taken to its ultimate conclusion', via the all-important St Stephen's.[8] Its interior elevation, making extensive use of 'micro-architecture', ogee arches and complex shafting, while striking the particular note of smooth 'Kentish' curvilinear subtlety and soft sparkle typical of the Canterbury Company, could also be seen as the single most coherent early statement of many features of the Decorated Style as it was to appear at Wells, Norwich and Exeter, often in the hands of men provably trained in the Westminster workshop. Formally speaking, the chapel therefore already contained within itself many of the dialectical possibilities of the Decorated Style as moulded by that fertile generation of 1290–1320. Styles are not, in fact, governed by dialectics at all, or for that matter forces, but people; nor do they develop by a sort of inevitable and satisfying genetic unfolding of possibilities towards one end, like one of those little Japanese paper flowers that miraculously bloom when dropped into water. The tendency to dialectical or binary thinking is questioned throughout the present book except in so far as it provides an heuristic device. The point is that the intellectual landscape is now far clearer, and in a sense simpler, than it once was. Somehow, the most advanced English architecture of the years around 1300 was engaged with the French accomplishment of the preceding century. Two somewhat different modes were being negotiated, with brilliant results, yet fundamentally within one system.

Vrai maçonnerie: *The Gothic Canon of Form*

This negotiation is held to have taken place in regard to two features especially: the large traceried French Rayonnant window introduced into England around 1240, which in Bony's words 'set off a chain-reaction that was eventually to transform every aspect of the English architectural tradition'; and the small canopied niche or tabernacle, identified by Henning Bock as 'das bestimmende Leitmotiv der englischen Architektur' of the fourteenth century, also derived in regard to its formal language from France, particularly from elaborate French cathedral portals.[9] In France each of these two realms of form was the principal sphere of the operation of *varietas*, to a far greater extent than the main interior elevation. The great window and the micro-architectural tabernacle, spreading irresistibly to the elevations of great churches as much as to the smallest unit of church furniture or tomb, came up against pre-existing English architectural tradition in such a way as to energize the entire process of invention. Bony believed that the wholesale adoption of what he thought of as the French 'system' would eventually be antipathetic to true formal inventiveness. Whether this amounts to a fair assessment of later Rayonnant is disputable.

The idea that English freedoms resulted from what (artificially) may be seen as dialectical encounters of two types – formal and significatory – will be pursued here. Encounters of this creative order in turn resulted in a process of transposition, of representations of forms in new contexts. So the French Rayonnant window and triforium provided the basis of the Perpendicular main elevation; the tabernacle, the foundation for the very particular creative freedoms observed by the Decorated main elevation. In all such cases of creative engagement, freedom arose from a certain impurity; and impurity was the product of a search for formal variety, a traditional virtue of medieval aesthetics that was not solely, or indeed typically, architectural in type or restricted to England. To understand what Bony meant by the 'freer context of the English artistic tradition', in comparison with French system, is to address those powers of invention that arose from mixture, not least the mixture of ideas drawn from media other than architecture: here the English, and the socially and economically dynamic English context around 1300, proved exceptionally fertile.[10] What the English exploited so brilliantly was a truth perhaps now revealed more by postmodern rather than modernist thought: that, to repeat, architecture consists in the relation to that which it is not. In a sense, what follows is necessarily not conventional architectural history.

What provided the necessary preliminary inventory was the emergence in Paris and northern France in the crucial period around 1225–50 of a settled and versatile formal vocabulary that could be transposed easily and quickly from domain to domain. French Rayonnant, as formulated in the Paris region around 1230, and probably the most internationally successful art style of the medieval period, was successful because its character was that of a universalizing, norm-driven discipline that sought harmony of form down

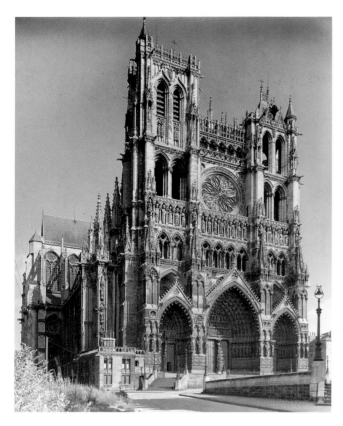

86 Amiens Cathedral, west front, begun mid-1220s

to the smallest detail. It tended to semantic neutrality, to a
non-local 'universalism'. It is not misleading to think of a
'canon' of forms, which included the resilient geometric
divisions of Rayonnant windows, which could be softened
and extended almost at will, and the Gothic niche consist-
ing of an arch with shafts surmounted by a gable and
flanked by pinnacles. The gradual emergence of the Gothic
niche can be traced on the grand scale from the addition,
in the mid-twelfth century (as on the great tower gatehouse
at Bury St Edmunds), of gables to arch and flanking buttress
compositions, via the west portal façades of Laon and
Amiens (pl. 86), to the one ensemble that lent supreme
status to the type. This was the canopied reliquary platform
and main precious reliquary upon it in the Sainte-Chapelle,
recorded in a drawing in the Gaignières collection (pl. 87
and see pl. 24).[11] This reproduced on a smaller scale the

87 *(right)* Reliquary platform and main shrine, Sainte-Chapelle,
1240s, as drawn by P.-L. Ransonnette before the Revolution
(Paris, BnF Est. Oa 9, fol. 64)

vocabulary of the west portals at Amiens designed around 1220; a satellite of it is the surviving shrine of St Taurin in the cathedral at Evreux in Normandy, dated before 1255.[12]

The traceried window and canopied niche travelled swiftly together to the English court by the 1240s and 1250s. What facilitated this rapid spread to all media, courtly clientage aside, was the capacity of these forms to serve as an image of things that had once had a rational function – gables to imply anterior roofing, buttresses and pinnacles to stabilize the structure, and so on. To generate such formal epitomes of altogether more complex realities entailed aesthetic reflection: it was to develop a sense of a style. Since the major technological issues of Gothic had been more or less solved by 1240 (and the 1240s seems to be a crucial decade in many areas of activity in this book), it was becoming apparent that the formal language of Gothic could be detached from its context of function, or assumed function. This power of transposition, which was taken to considerable lengths not least in England, was labelled 'akyrism' by Paul Frankl.[13] It enjoyed no obvious causal relation with the use of architectural drawing, which is certainly better documented from exactly this period onwards; yet drawing remained the most obvious means of severing form from context. Had drawing archives existed – and the evidence suggests that they must have done at least in some places, for instance at Westminster – they must also have outlasted particular artists, and come to posses an authority of their own.

For Frankl, the principle of akyrism was a virtue of pluralism, even though the notion of 'mannerist' impropriety that the term conveys depended upon what Vitruvius had condemned as incorrectness in the representation of things that ran against authority.[14] French, or French-influenced, practice in relation to these transpositions remained much more resolutely, if unconsciously Vitruvian, whether in regard to shrines, tombs, stained-glass windows, manuscripts or ivories. In all these media the Gothic canopy in all its complexity retained a fundamental strictness, a sort of grammar, in its combination of forms, and witnessed a veritable explosion of use in the period 1250–1300. A useful concept emerges from within the Franco-Flemish milieu in a tomb contract struck in the early years of the fourteenth century in Tournai for the memorial of an archdeacon of Ghent.[15] The incised tomb slab was to show the effigy surrounded by image towers acting as a 'pourtrait de vraie machonnerie', demonstrated in a preliminary parchment drawing. Such stone or brass inlaid slabs were noted for their prodigious displays of minutely observed architecture.

88 Shrine of St Gertrude of Nivelles, 1272–98, condition before 1940

The word 'vrai' conveys the formal literalism of *ratio* and decorum, especially strongly indeed for being bound in a contract of which a drawing was an integral part. Given what has been said about literal transposition in the metalwork of the Sainte-Chapelle, it is not surprising to learn of a similar drawing, again a 'pourtraiture', devised according to a commissioning document of 1272 by the goldsmith Jakenez d'Anchin for the magnificently architectural shrine of St Gertrude of Nivelles, wrecked during the Second World War (pl. 88).[16] One reason for believing that the use of drawings was but one aspect of this new formal 'expertise' is that the actual language of contracting and inventorizing in regard to architectural forms was itself sharpening at this time.[17] It is not known if the contract drawn up between the chapter of Beverley Minster and the London goldsmith Roger of Farringdon for a new feretory for the remains of St John of Beverley in 1292 was directed by a drawing. But it was to be made *cum platis et columpnis de opere cementario et ymaginibus subtilis operis et decori . . . et cum tabernaculis et pinnaculis partis anterioris et posterioris*, that is,

'with plates and columns like masonry and with subtly fashioned and handsome images ... and with canopies and pinnacles before and behind'.[18] Here again a grammar of forms is more or less explicit, and in regard to the English milieu an important stimulus would once again have been provided by French models, this time at Westminster.

Westminster: Portals of Invention

The most important known early example of this trend in England was the carved and painted altarpiece commissioned by Henry III for the high altar of Westminster Abbey not long after 1259 and probably installed in time for the new church's dedication in 1269. Known as the Westminster Retable, the minutely carved and richly adorned micro-architectural oak panel was certainly designed by an artist intimately familiar with Picard and Parisian architecture of the 1240s or 1250s, its use of decorative glass inlay pointing firmly to study of the Sainte-Chapelle itself (pl. 89).[19] Even in the choice of some of its themes, such as gracefully posed images of the patron saints of the abbey (St Peter) and the image at the centre of a globe-holding Christ as Saviour, the altarpiece, in an extraordinary act of concentration, recalls vividly French portal façades of the sort in Paris and Reims. It also conceals its character as a piece of delicate oak joinery with an elaborate masquerade of metalwork-derived effects contrived in paint, glass and putty. Such an ensemble defeats categorical thinking about different media. In its elegant variety and harmonious resourcefulness, it set the entire tone for the objects subsequently raised in the sanctuary of the abbey, including court-circle tombs and furnishings. The retable was a pacesetter of the highest order.

Crucial to its design was a strict imitation of real architectural motifs – crocketed gables over trefoil arches, buttresses, pinnacles and shafts – derived down to the smallest moulding from French Gothic portals such as those at Amiens. This can only have happened by the same sort of process as that which led to the making of the great shrine at Nivelles first designed in the 1270s, except in reverse, so that where a wooden or graphic model for a final gold object might be expected, a painted wooden object instead imitates a preciously decorated one. The main and subsidiary reliquaries in the Sainte-Chapelle together with its paintings and other applied decorations dedicated in 1248 would have equipped a Parisian goldsmith with the right range of information, and it is very much to the point that when, in 1249, Henry III turned his mind to the equipping

of the high altar of the abbey on which the retable was eventually to stand, he specifically employed a French goldsmith, John the Frenchman (*Francigena*), to advise about the decoration of its chalice.[20] Henry's preference for a French goldsmith for the main altar of his abbey is extremely suggestive. It is not beyond possibility that John the Frenchman also designed the high-altar retable. The high altar was a sort of formal microcosm of the architecture of the new abbey church as a whole, except that Henry III's full-scale architectural project was in many regards far less strict in its assimilation of ideas drawn from Reims, Paris and Amiens to English building methods (see p. 40). In its wonderful and perfect compression of ideas into a small space, the retable brings to mind a passage in a rude poem composed around 1260 by the French against Henry III in which Henry, rapt by his visit to the Sainte-Chapelle in 1254, wishes to roll it off to London in a cart, as if it were an ark. Henry had, as it were, already assimilated the chapel by distilling it down to a thing of portable scale, but huge specific gravity.[21] This concentration of effect was to be important not least because it set a fashion both for a certain type of detailing and for the choice of Parisian-style sacral metalwork that lasted into the next century.[22]

The Westminster Retable is a classic, indeed somewhat studied, instance of the formal settlement, the 'canonical' Gothic, that emerged in northern France and Paris especially around 1240. This settlement followed an extremely dynamic and productive phase of experimentation in which architecture as an entire domain of composition first arose seriously in the Gothic arts, the pictorial arts especially. Another of Westminster's cynosures, Reims Cathedral, was instrumental in this phase. By 1210 the immense increase in the height of the clearstories of French High Gothic churches inaugurated at Chartres and Soissons, and the introduction of bar tracery, had created the ideal context for gigantic displays of stained glass in strongly vertical compositions that increasingly favoured the use of architectural motifs and slender, full-length figures. At some point between 1211 and 1241 when its east end was opened, indeed probably from the 1230s, a quite exceptional scheme of glazing was developed for the clearstory of the chevet hemicycle at Reims, showing images of the suffragan cathedrals of the archdiocesan church accompanied by powerful guardian angels, all set beneath images of the Apostles.[23] In idiom the work, bold and various, resembles the art of Villard de Honnecourt, who knew it. Six of the angels perched atop the gables of the churches blow huge trumpets, evoking Matthew 24:31 and the Apocalypse, Revela-

89 London, Westminster Abbey, Westminster Retable, 1260s, central compartment showing the Virgin Mary, Christ and St John

90 Reims Cathedral, apse clearstory stained glass, showing suffragan cathedral of Soissons, second quarter of the thirteenth century

Tournai as well as Reims itself (pl. 90) – are presented as actual church fronts or façades with mighty portals, windows and towers. Because each building represents a distinct place, the designs are necessarily varied, and there is some debate as to the extent to which their architecture is a summary of the actual buildings in question since some of them had as yet no properly developed fronts of this sort; but this variety was anyway a preference in the development of French architectural decoration on portals of the period.[26] In his portfolio of *circa* 1230 (fol. 31) Villard notes carefully that the little canopies over the angels on the exterior buttresses of the chevet of Reims were all slightly different in form.[27]

It has been suggested that the Reims glazing scheme, one suitable principally for an archdiocesan church, was without progeny, but this may be open to qualification. Reims Cathedral was very thoroughly studied by the architects and craftsmen employed at Westminster Abbey from 1245, and it is inherently probable that its unusual and impressive hemicycle windows were noted by them. It may not be coincidental that the one English monument of the late thirteenth century that shows an archbishop with his suffragans, the tomb of John Pecham, archbishop of Canterbury (d. 1292), at Canterbury Cathedral, reveals detailed study of the west front of Reims, since it was from the outer gables at Reims that the Canterbury architect derived the cusped patera in its gable.[28] The churches depicted in the glass at Reims would offer one explanation for a curious feature of English court manuscript illuminations in the following two decades or so. In Anglo-Norman Apocalypses the opening letters to the Seven Churches are illustrated by means of little groups of buildings like rows of terraced houses, but in two Apocalypse manuscripts associated with the court or its circle, the remarkable Douce Apocalypse (Oxford, Bodleian Library MS Douce 180) and its sister in Paris (Bibliothèque nationale de France MS lat. 10474) of the 1260s, each letter composed by St John is accompanied by a bold and separate image, illustrating the corresponding church.[29] In the particularly rich compositions in the Douce manuscript, the buildings secrete images of angels representing the *genius loci* of each church. It is possible that the hemicycle churches at Reims with their presiding angels may themselves have acknowledged patterns of representation of the Apocalypse that showed angels posed on top of the churches. In Douce, the angels are tucked into the building, but exegetically may be understood as the churches' bishops. What in the Reims hemicycle had been an image of quasi-apocalyptic power has in Douce been rendered as

tion: 8, 9 and 11 – an image of the preaching of the Church in the present time.[24] They answer to the sculpted angels on the buttresses of the exterior of the chevet.[25] In concept, the eight suffragan cathedrals of the archdioceses represented – Amiens, Châlons, Laon, Soissons, Beauvais, Noyon,

something more like the complex English seal designs of the period, such as that of Southwick Priory, ingeniously contrived so as to explore the enjoyable potential of wall thickness to house figures, while also signalling 'identity'.[30]

The Seven Churches in the Douce Apocalypse and its sister manuscript are of interest here partly because they show that, like their immediate French forebears in glass and micro-architectural portal sculpture, their artists took pleasure in evolving extraordinarily monumental yet free compositions of architectural forms which disallowed repetition. In effect, these little fictions are the most advanced pictorial statement of their time of what architecture might look like. These miniature churches can perfectly well be understood as proto-Decorated gate compositions anticipating the remarkably inventive free combination of forms on the precinct gateways discussed in the last chapter, at Canterbury, Norwich, St Benet Holme and Bury (see pls 82, 84). The emergent tendency from around 1260 in France and its artistically dependent regions, on the contrary, was for the lancet compositions in stained-glass windows to become more regularized or repetitive, forming a homogeneous network of enclosures for figures in window after window, matching the architecture: the nave glazing at Strasbourg Cathedral is an excellent instance. This also holds true of the front-line illuminated Parisian books of the period such as the St Louis Psalter (Bibliothèque nationale de France MS lat. 10525) and its sister Psalter in Cambridge (Fitzwilliam Museum MS 300) of around 1260–70, where literal reference is made to contemporary Gothic design in Paris but with the aim, again, of creating an even pattern, a steady repetitive texture page after page, in which architecture literally rises above figurative composition (pl. 91).[31] North-eastern French work of the last quarter of the century such as the Psalter and Hours of Yolande of Soissons (New York, Pierpont Morgan Library MS M729), with points of contact with the use of repeat canopy work at York or Exeter in composition and detailing, is a little more various.[32] In English pictorial art the preference was manifestly for architecture to become much more closely assimilated into the art of narrative itself, becoming a kind of expressive, eventful, and so necessarily very variegated, landscape. In Douce, the substantial doors of each church are shut, responding to the verse *ecce sto ad ostium et pulso* (Behold, I stand at the gate and knock) in Revelation 3:20, but creating a pre-revelatory potential realized in Revelation 4:1, when the gates to heaven are actually opened. Closing and opening possess a sort of emotional and imaginative energy. It was in the service of this intellectual depth and wit that the English

91 Isabella Psalter, *King David Told of the Death of Absalom*, Paris, 1260–70 (Cambridge, Fitzwilliam Museum MS 300, fol. IIIv)

were attracted to the brilliant *varietas* of the earlier French compositions of the sort at Reims, just when the French themselves were moving towards something more lofty and regular in the decades after 1240. And it was just at this moment that the Westminster Retable, a masterpiece of strict Parisian literalism, arrived on the English court scene.

The Douce manuscript, quite possibly originally planned in the early or mid-1260s for Henry III or Eleanor of Provence, left incomplete and then passed to the Lord Edward and Eleanor of Castile (its prefixed French text bears their arms), and including anti-Montfortian heraldry responding to the Barons' War ending in 1264, is an exceptionally important yardstick of the diverging tendencies in architectural self-representation in England and France from the 1260s onwards. Its links to, and possible dependence on,

92 (above) Douce Apocalypse, *St John's Vision of the Seven Candlesticks*, circa 1265, (Oxford, Bodleian Library MS Douce 180, p. 3)

93 (right) London, Westminster Abbey, Westminster Retable, St Peter

the Westminster Retable and the paintings in the king's chamber at Westminster are now increasingly evident.[33] That conscious choice was involved in this sophisticated process is shown by the knowledge the Douce artist had of the all-important reliquary platform in the Sainte-Chapelle, the canopy of which he cites down to small details such as the little circlets in the gable canopy in his illustration of the Son of Man on page 3 of the book (pl. 92 and see pl. 87).[34] The Douce artist probably knew the frame of the Westminster Retable itself (pl. 93); and the artists of these works were anyway intimately connected. But what is striking is the freedom, rather than the dependence, of the Douce artist from the new French trend to absolute regularity, and from a specifically French language of forms. Nothing is known about the origins of this most extraordinary book artist – if that is what he was solely – but his micro-architecture shows that his instincts were Anglo-Norman and not Parisian. His iconographic sources themselves bound him to tried-and-tested formulae for the Seven Churches first shown together in a group as neatly individuated structures, since this is how they are shown in the Anglo-Norman Apocalypses being produced in some numbers in the middle years of the thirteenth century – the formula

was certainly older since it is found in the twelfth-century *Liber Floridus* in Wolfenbüttel.[35]

But the Douce artist also studied innovative architecture in his immediate environment at Westminster. The church of Smyrna on page 5 (pl. 94) shows a portal zone with vibrantly coloured layered semicircular arches of a type recorded on the central tympanum of the north transept portal of Westminster Abbey in a drawing of *circa* 1713; above, the angel is set in a variant of the bowed triangular window that Westminster derived from the Sainte-Chapelle for its gallery windows, but handled in a way specific to the exterior of the abbey's versions where the over-arch is placed on short colonettes and the lower curve of the triangle sits beneath (pl. 95); but in Douce the lower curve

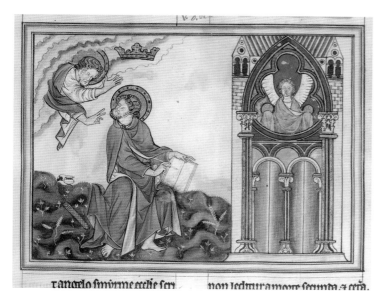

94 *(above)* Douce Apocalypse, *St John Writes to the Church of Smyrna*, circa 1265 (Oxford, Bodleian Library MS Douce 180, p. 5)

95 *(right)* London, Westminster Abbey, gallery window of apsidal chapel, south side exterior

of the triangle is isolated, indicating an instinctive misunderstanding of French practice improbable in a French artist.[36] The magnificent church of Sardis on page 8 (pl. 96) is reminiscent of the inner face of the cloister door in the abbey's south choir aisle, with narrow pointed arches framing the portal and a row of quatrefoils above forming a parapet, whose general detailing may be derived from the more elaborately sculpted quatrefoils that formed the parapet of the *jubé* of Chartres Cathedral.[37] The Douce artist was careful to observe the diapered texture peculiar to the abbey's elevations when adorning the spaces over the flanking arches. The artist very probably noted Robert of Beverley's new external composition for the south side of the abbey nave, begun in 1259–60, with its patterns of windows flanked by narrow pointed arches at aisle and clearstory level.[38]

Tiny details indicate the artist's extraordinary 'reach'. The central portal of Sardis has a little spandrel beneath its over-arch, with a sexfoil within multiple rings positioned over a much smaller trefoil; above the arch is a panel of spreading branched naturalistic foliage. The detailing is strikingly similar to the tracery of at least one bay of the inner aisle triforium of the cathedral at Le Mans within the zone of the Gothic of Normandy (pl. 97), and similar foliage panels and combinations of foiled form may be found in the

chevet and nave clearstory of Bayeux Cathedral.[39] Other motifs, such as the unadorned triangular linked gables of Laodicea, which resemble the aumbry in St Martin's Chapel at Salisbury Cathedral, and the swelling cinquefoil cusped arch of Thyatira (see pl. 127), similar to the detailing of the early north door at Salisbury's prebendal church of Potterne, Wiltshire, imply that the Douce artist was familiar in some way with Salisbury and the work of Elias of Dereham.[40] Such researches would be utterly untypical of a 'Parisian' French artist in England, but they could signal an exceptionally resourceful southern English, Norman or Anglo-Norman court artist taking note of Parisian French ideas. Douce's sister manuscript in Paris (MS lat. 10474) is in some regard more French in the detailing of its rendition of the Churches, since its version of Thyatira (fol. 4) shows French-style pinnacles with gablets, and a pedimental gable with a rose window sustained to either side on colonettes in a way much more reminiscent of the image of Reims in the clearstory glass of that cathedral.

One might ask why it is legitimate to cite the multi-modality of admittedly brilliant English illumination of the 1260s in connection with the greater responsibilities of architecture more generally, given that in comparison with *vrai machonnerie* the buildings in Douce are manifestly unbuildable, small-scale fictions evaporating at the turn of

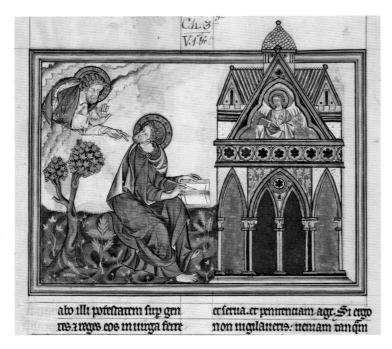

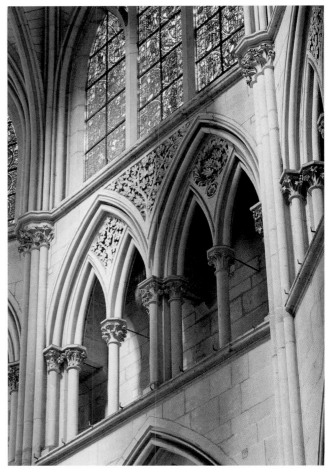

96 (above) Douce Apocalypse, *St John Writes to the Church of Sardis*, *circa* 1265 (Oxford, Bodleian Library MS Douce 180, p. 8)

97 (right) Le Mans Cathedral, choir inner aisle triforium

a page, and might be dismissed as such. But it was one of the great insights of Jean Bony to recognize that such evidence is not only inherently useful and enriching, but also guides us more fundamentally to those issues of precisely what architecture is or is not – to the indistinct borderlines between media that point to situations of inventive conjuncture, and indeed to the issue of fiction itself. Though the Decorated Style is properly dated only from the last decade or so of the thirteenth century, the eclecticism of the Douce artist is already indicative of movement towards eloquent mixture typical of its particular imaginary.

As Bony recognized, the eclecticism of courtliness mattered in regard to mixture. His use of analogies from book and wall painting, and from the art of carpentry, is particularly important in understanding this creatively borderline zone. It is at such points that Bony, in so many ways a modernist in sensibility, reveals insights about the mixture of media typical of pre- and post-modernity. One instance cited by him is the copied evidence of the gilded fictive architecture in the Bible murals of the Painted Chamber in the Palace of Westminster (destroyed in 1834) (pls 98, 99), which, because of their more modern motifs, he very reasonably attributed to the 1290s.[41] Henning Bock had already

noted their importance.[42] These thickly peopled landscapes of architecture made common use of brittle lightweight structures topped with little corbelled cornices and balustrades with rows of quatrefoils and battlements, in which the figures were placed rather like the angels in the Churches in Douce, but gesticulating to one another, and with that French touch of delicacy and elegance creating in effect a sort of Gothic Punch and Judy stage set. Some of the motifs showed a continuing interest in earlier Parisian detailing of the sort that might have entered Westminster from the 1240s, such as the scene showing Naaman before the king of Syria lodged in a tribune whose balustrade consists of two rows of French-style crockets with a quatrefoil frieze above (pl. 98), a combination found at the top of the towers of Notre-Dame, only there minus the telltale crenellations; square-section buttresses with tracery lights, supporting trefoil arches, occur in the Theophilus legend on the north transept portal of Notre-Dame and on the canopy of Louis of France (d. 1260) formerly at Royaumont (now at Saint-

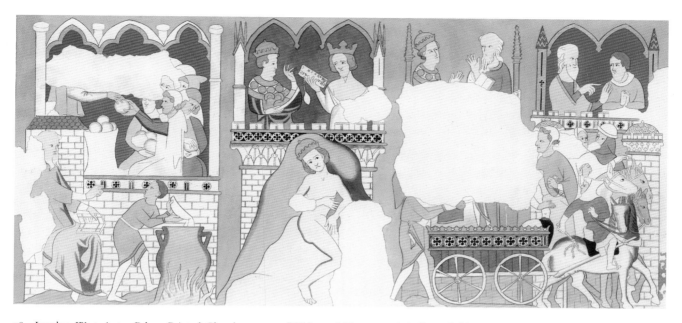

98 London, Westminster Palace, Painted Chamber, story of Elisha and Naaman, originally probably 1292–7, engraved after watercolour copy by Charles Stothard, 1819 (*Vetusta monumenta*, VI)

Denis).[43] The vertical crocketing on the tower buttresses of Notre-Dame was clearly known at least indirectly to the author of the canopy in the mural of St Faith in Westminster Abbey (pl. 100), the figurative art of which conforms in almost all regards with the late thirteenth century or the early fourteenth. Total modernity was less important to such painters than the search for cheerful narrative *varietas* required by the several hundred feet of painting involved in this scheme: the demands of narrative variety itself would have goaded the sensibility of painters. Some of the devices, like the gabled tabernacle with lean-to flanks in the story of King Hezekiah, anticipated fourteenth-century tripartite Gothic niche forms at Ely (see pl. 179), Butley Priory (see pl. 83, gable top) and elsewhere, and were presumably studied by the Ramsey Company in the time of their employment at St Stephen's next door to the Painted Chamber.[44] And the use in the murals of cornices with rows of foils and battlements was nothing if not fashionable in the 1280s and 1290s and the decades following (see pls 42, 82, 108, 114, 117). Bony spotted that the entire fiction of the little narrative mansions may have had its origin in temporary installation art, namely a type of 'temporary tribune' built for court occasions such as tourneys. It was, he stated, 'part of the refinements of Court art to translate forms from one material into another and to enlarge or reduce them in size, specially in the freer context of the

English artistic tradition'. Canvas and timber structures, cheerfully painted – medieval theatre *apparati* so to speak – were one aspect of a process that was later to lead to 'the translation into stone of forms first conceived in wood' in Perpendicular architecture, notably the choir at Gloucester (see pl. 43), 'that masterpiece of joinery in stone'.[45]

99 London, Westminster Palace, Painted Chamber, story of Zedekiah and Nebuzaradan, originally probably 1292–7, engraved after watercolour copy by Chares Stothard, 1819 (*Vetusta monumenta*, VI)

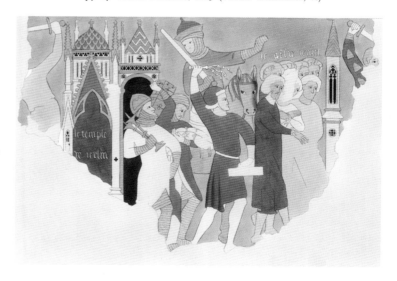

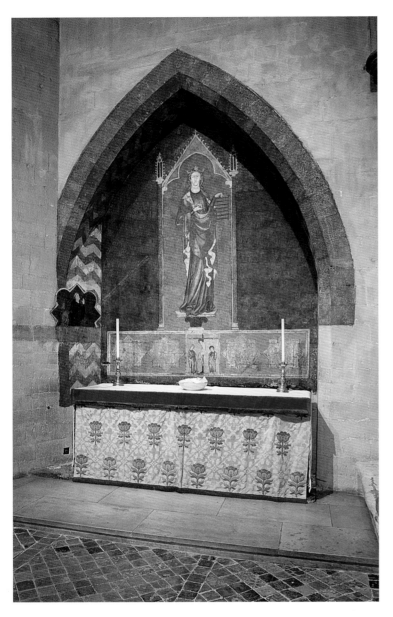

100 London, Westminster Abbey, wall painting of St Faith in St Faith's Chapel, *circa* 1300

ensembles of the loftiest sort, such as the Sainte-Chapelle and its satellites including the Westminster Retable and other furnishings of the abbey and palace, displayed a technically eclectic art of selection and re-mixture, not always dominated by obvious causal hierarchies of the media themselves. It was for this reason that court arts tended to provoke paradigmatic shifts of idiom of the sorts that have interested developmental art history. One such shift occurred in Paris in or around the 1240s, another at Westminster in the 1250s–1260s and again in the 1290s. That these court projects (with the exception, of Westminster Abbey itself) were as a rule neither of the heroic scale nor of the very smallest is of interest, since creative conjuncture was most likely to occur in middling-sized, well-funded undertakings that could afford to engage several media side by side, as in the goldsmithery, woodwork, sculpture, glass inlay and paint of the Sainte-Chapelle of the 1240s.[46] Even in the case of the abbey it makes sense to see its greatest powers of invention operating at levels of scale well below those of its main elevations. One would not expect long-standing traditions to lie behind, or necessarily to emerge from, these highly contingent and specialized conversations: what typified them instead was a brilliant ability to react on the spot to absolutely specific needs, including rising to the occasion when confronted with the narrative demands of exceptionally large wall-painting cycles. In regard to this eclecticism the most important early works in the Decorated Style were 'courtly'.

Exeter: Episcopal Hubris

Bony's thoughts about joinery lead to that all-important phase in the generation of the Decorated Style starting around 1290 with the erection of the Eleanor Crosses and the commissioning of St Stephen's Chapel, and culminating in the years after 1310 with the provision of the choir furniture of Exeter Cathedral under Bishop Walter Stapledon (1308–26). None of these projects was large, but, perhaps as a result, each was marked by an extraordinary density of ideas. The Eleanor Crosses, twelve panoptical spire-like prayer stations commemorating the procession in 1290 of Eleanor of Castile's body from Harby to Westminster, were almost certainly modelled on the series of crosses called *montjoies* that marked out the route of Louis IX's funeral procession from Paris to Saint-Denis in 1270.[47] As with the little inhabited Churches in the Douce Apocalypse, a basically French-derived schema was rendered even richer and

Though Bony did not bring this very enriching idea fully to light, the fictions and storytelling of courts seem important to this tendency to transpose and variegate. This is partly because the narrative art of the painter, as of any narrator, is intended to create a world that is imaginatively absorbing and constantly stimulated by variety: variety is what keeps everything moving, stops it becoming boring. Variety is about resource: it helped that courts were the single most well-informed artistic foyers of the day. Court

formally more eclectic by the teams of artists responsible. To a greater extent than the *montjoies*, which appear from a few surviving drawings to have had a more limited formal repertory of metalwork-like diaper carving, small canopies and statues, the Eleanor Crosses aimed at conscious inventive differentiation, emulation of the French model provoking surpassing mixture: battlements, quatrefoil balustrades, diaperwork, early 'flowing' tracery, ogee arches, gables adorned with rows of shaggy crockets, and sundry motifs drawn from Rayonnant architecture are all deployed freely and delicately. The protean masterpiece of this eclectic approach is the cross at Hardingstone outside Northampton (pl. 102); the most beautiful totality is the sleek cross at Geddington (pl. 101), perhaps the latest of the series, the surfaces of which are as subtly wrought and undulating as the finest goldsmiths' work. Because most of the crosses have disappeared without detailed visual record – most but not all are included in surviving accounts for the years 1291–4 – it is impossible to be sure, but it is likely that no one design was repeated, and several teams were involved.[48]

The 'borderline' aspect of the Eleanor Crosses set a brilliant example for designers in the following two or three decades, the most extraordinary fruit of which was an object so egotistical that conventional source-driven methods seem at first sight inadequate to the task of accounting for it. This is the astonishing bishop's throne, or more properly throne canopy (pl. 103), erected in the choir at Exeter Cathedral by, and for, Walter Stapledon, in effect a tall painted oak canopy and tower, 16 metres (53 ft) high, over the bishop's seating place at the east end of the south side of the choir stalls. The Eleanor Crosses belonged to a readily identifiable 'genre' of wayside memorials. This was only true of the Exeter throne in so far as there was a medieval tradition of raising canopies over prestigious, typically royal or papal, seating places. So far as is known, the English had never made much use of large-scale canopies or ciboria over altars in churches, in contrast to Italian practice of the period, though a stimulus to this practice was the reliquary platform and canopy of the Sainte-Chapelle.[49] Huge canopies over thrones or seats are not otherwise known in England before this date; the elaborate fourteenth-century thrones at Wells (see pl. 39, right side) and St David's are responses to the Exeter instance.

But what also counts at Exeter are the details of the formal realization of the structure, certainly designed by an architect but in such a way that oak manufacture freed the design from the gravitational constraints of *vrai machonnerie* in a way consistent with the pictorial arts, to pursue Bony's

theme of multi-media analogy.[50] The structure consists of four basic stages: an unobstructed enclosure for the bishop surmounted by a single vaulted space on four substantial buttresses, each face fronted with massive overhanging ogee arches in turn fronting taller gabled canopies and battlements; an intermediate tower zone enclosed by tracery, with cusped trefoils of the sort in the windows of the later Lady Chapel at Wells Cathedral (1320s) (see pl. 183); and an open image niche above sustaining, finally, the spire at the top.[51] Ample scope was created for image tabernacles. But the formal language itself is extraordinary, since the oversailing ogee arches of the main enclosure, in which double-curved arches are placed on curved 'shoulders' canted forward from the plane, have 'nodding' ogival tops also found in the arches of the intermediate level. The plentiful gabular and pinnacular forms are larded with a sort of undulating overgrown hothouse foliage that serves at once to enrich and to confuse the lines of the structure.

101 Geddington (Northants.), Eleanor Cross, 1290s, detail

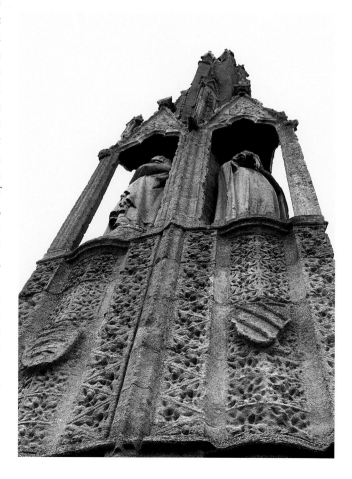

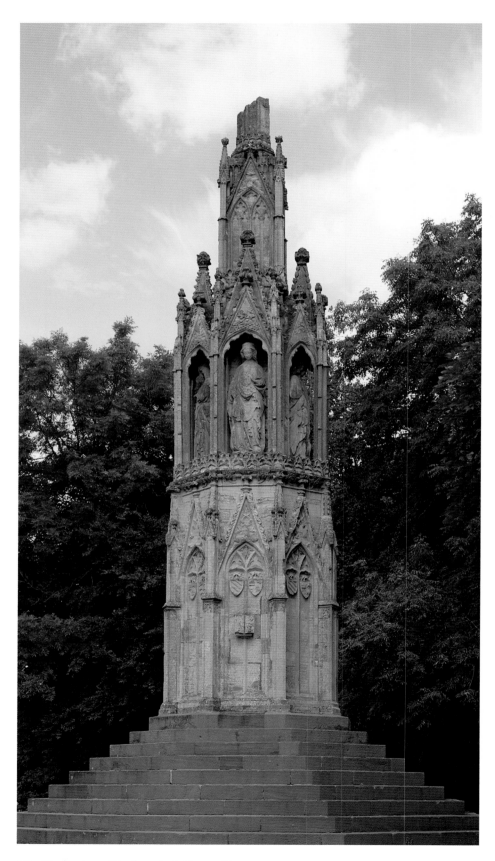

102 Hardingstone (Northampton), Eleanor Cross, 1290s

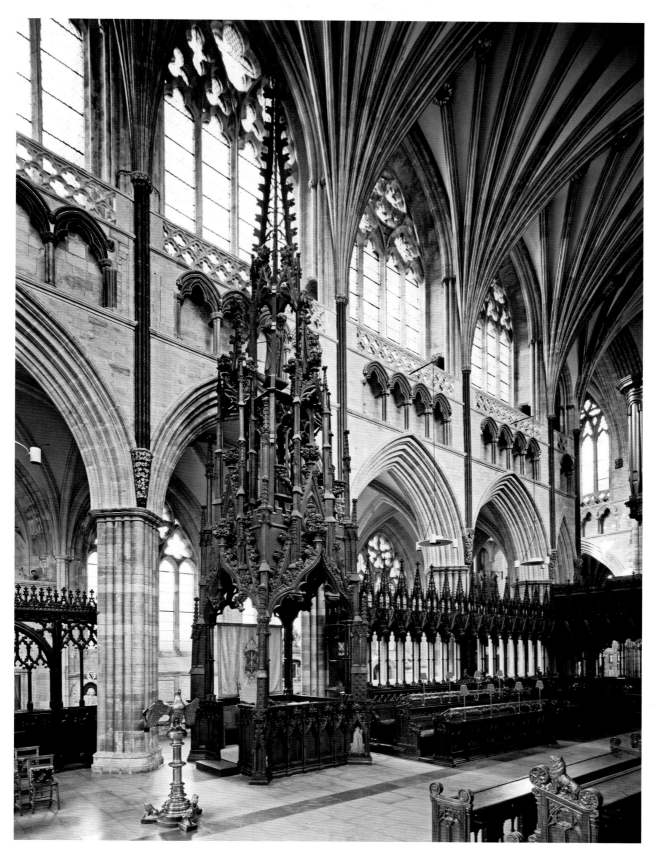

103 Exeter Cathedral, bishop's throne and choir, looking south-west

The canopy is, in fact, the first assuredly datable total instance of the 'curvilinear' phase of the Decorated Style that came to dominate taste across almost the whole of England by the period 1320–40. Its production is pinpointed fairly exactly in the Exeter Cathedral fabric accounts. In the account for midsummer 1313 are noted the costs of the timber for the bishop's throne (called *sedes episcopi*) and wages of one Thomas of Winton seeking out and felling timber on the bishop's estates.[52] This Thomas, undoubtedly the important architect Thomas of Witney whose career started at St Stephen's Chapel in the 1290s, was at work with a fairly substantial team of carpenters and sawyers.[53] The actual making (*factura*) of the throne by a woodworker called Robert of Galmpton is outlined in the midsummer account for 1317, the accounts for 1313–16 being missing; images were being made by the end of 1317, and the structure was eventually painted and inscribed in the years 1320–23.[54] The whole process took nigh on a decade. But the vital phase was started when Thomas of Witney went looking for timber in the spring or summer of 1313, since his team of experts must by then have decided what manner of thing it was they had in hand, and that implies that the generating drawings and templates for the structure had already been executed at the very least in outline. Ambitious projects such as the canopy have a way of evolving over time, and it is clear that changes were made to the initial plans of 1313: the central tower section is now believed to have been the product of a revision.[55] But the provision of images by 1317 suggests that it is wiser to think of the throne as representing the stylistic situation around 1310–15 rather than around 1320. By this decade elaborate or technically demanding projects in wood were gaining in status.

In 1310 or so no such object existed in England. The Eleanor Crosses anticipated it in their multi-staged zestful overall shape and combination of forms, but were solid sleek polygonal objects with tighter profiles, lacking the distinctive transparency and four-square orthogonal plan of the Exeter throne that wood encouraged. They also distributed detailing carefully into different zones of intensity, unlike the overall effect of the throne and its incessant ambiguation of line. Spire symbolism was gaining in prominence around 1310. By the second decade of the fourteenth century St Paul's Cathedral in London and Lincoln Cathedral either possessed or were being furnished with prodigious timber and lead spires well over the 400-foot mark, and plans were probably being settled for the stone one at Salisbury, again on a similar scale. These were distinctive markers of episcopal status on the exterior of churches: the Exeter throne seems to have been calculated to make an impact throughout the interior of the cathedral (see pl. 12).[56] Its proportions are distinctively steep, the base width to total height ratio being a little over 1:5. It would be possible to make such a thing on a small scale in gold, and it is possible that the throne was a giant version of smaller items of spire-like liturgical metalwork. But the earlier remarks about the architectural glass at Reims provoke a further line of thought. Unlike the polygonal Eleanor Crosses, the Exeter throne may be seen head-on as a four-square elevation, and the kind of preliminary drawing that would have been needed for this may readily be imagined. It would have resembled closely the tapering multi-stage canopies that became fashionable in the tall thin lights of stained-glass windows in the period 1250–1300.[57] Indeed, it is quite possible that the Exeter throne was itself prompted by canopied stained glass, not so much of the sort then being produced in England, but rather of the French type. The nearest analogies by far in terms of overall shape and proportion at that date are provided by the scheme of glazing in the Lady Chapel of Rouen Cathedral, also under way in the decade 1310–20 (pl. 104).[58] This scheme matters because it showed sixteen figures of saintly archbishops of Rouen set under splendid tall and elaborate orthogonally designed canopies which have the crucial feature of an unobstructed lower unit for displaying the standing figures of the pontiffs, with canopy work above including openwork tower stages ending in steep spires. As a source it satisfied the requirement that such canopies should consciously mark the standing of local bishops. To be sure, the French canopies have a different repertory of forms and certainly do not have the ogival motifs that so distinguish the lines of the Exeter object. But the fundamental resemblance is undeniable. Nor is it historically improbable. The dean and chapter of Rouen owned the manor and parish of Ottery St Mary not far from Exeter. The throne's patron, the modestly born but ambitious and rich Bishop Stapledon, had entered royal service by 1312; in February 1313 he received royal powers to act for Edward II in Gascony, and was in France, probably in Paris and Gascony, until May; he returned to France in 1315.[59] More specifically, by 1318, and almost certainly earlier, Exeter Cathedral was sourcing white, and possibly also coloured, glass in Rouen itself.[60] Even if Stapledon had not visited Rouen and its new stained-glass works in 1313, there is nothing intrinsically improbable in positing a direct connection between the designs he must have approved in outline for his seat in 1313, his own French travels in royal service, and the Rouen–Exeter supply chain. Such inter-

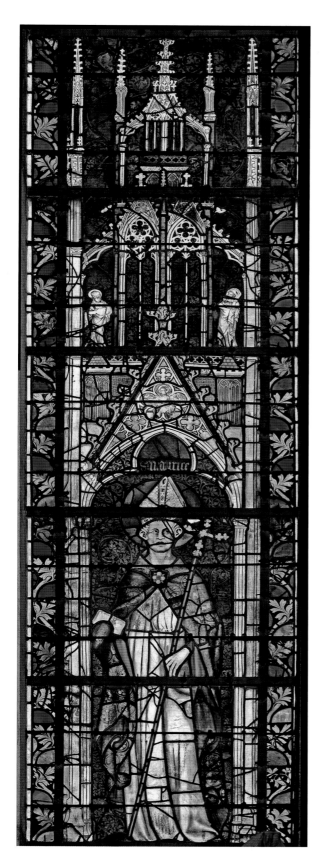

media connections are often reciprocal. It is unlikely to be coincidental that very good analogies to the Exeter throne are later found in the stained-glass canopy work of the Lady Chapel at Wells, possibly designed in the 1320s for a project also under the control of Thomas of Witney.[61] And the notion of depicting the major prelates of a church in a series was to be influential later in the great west window of York Minster finished in 1338–9 (see pl. 139), where influence from the glass-painting styles of the Paris–Rouen area is even more evident.[62]

In sum, there is much to gain by seeing an early and prodigious instance of the Decorated Style in the 'border-line' context of a giant piece of church furnishing, and moreover in the light of the movement of pictorial ideas whose character was unpredictable and ad hoc. Stapledon's parvenu personal ambitions and sheer wealth are likely to have counted for much here: his enthronement in 1308 was grand.[63] But Veronica Sekules has also rightly drawn attention to the careful institutional emphasis at Exeter, apparent in the late thirteenth century, on its liturgy and the high standing of its bishops.[64] Exeter, like Wells and Salisbury, was a church with important small relics but no major cult. The magnification and enrichment of its liturgies with art and music, its stress on the liturgical censing of its enthroned bishops and on the feast of *cathedra Petri* (the cathedral was dedicated to St Peter amongst others), point to a style of observance whose character was compensatory, regional and strongly aesthetic. Sekules thinks of the cultivation of a 'cult' of bishops at Exeter — exactly the sort of thing that would prompt scrutiny of schemes such as that at Rouen Cathedral, which also promoted the outstanding sainted prelates of Normandy. It might be worth recalling André Vauchez's insight that, in their vast dioceses, 'the English bishops seemed like the successors of the ancient kings'.[65] There was perhaps only one other example, that of the prince-bishops of Durham, whose status and sovereignty were to be so carefully cultivated later in the century when Bishop Hatfield (d. 1381) raised his extraordinary, if aesthetically less satisfactory, tomb throne in the choir there after 1362.[66]

But ambition comes at a price. Bishop Stapledon began well, became Treasurer of England, yet ended abominably in 1326, decapitated with a breadknife by the London mob at the foot — a supreme irony — of the Cheapside Eleanor Cross.[67]

104 Rouen Cathedral, Lady Chapel, stained glass, *Archbishop Maurice, circa* 1310–20

Exeter represents the most complete and precocious surviving instance of a project governed by one principal master mason, Thomas of Witney (recorded at the head of the Exeter Cathedral works in the years 1316–42), which nevertheless shows within itself the most startling variety pointing to a lively interest in other media. It is as if the styles it represents had come into the world quickly and fully formed. Walter Stapledon never lived to see the dedication in 1328 of the high altar of the cathedral he had so remarkably furnished, by which time the high-altar reredos, sedilia, pulpitum and throne were all complete and accounted for.[68] The great oak throne canopy demonstrates the importance of bravura invention in woodwork that so distinguished English art in the fourteenth century, as is apparent from the great choir stalls of the sort under way at Winchester Cathedral a few years earlier.[69] It may not be coincidence that the first major statement of this new florid style, exploring the decorative possibilities of huge creeping foliage forms, was itself an object of botanical origin. Smaller carved wooden objects, such as the citole or gittern made around 1300–10 and later in the possession of Elizabeth I (see pl. 272), exhibit in microscosm the same sense of reverie in the natural and artificial, the relief textures consisting of very finely shaped oak, vine, hawthorn and mulberry leaves pressed tightly together with (erotic?) japes about hunting not unlike the great *Beatus* page of the Peterborough Psalter in Brussels (see pl. 270).[70]

For stonecutters, the throne helped to inaugurate a particularly lavish sensibility that crossed to and fro between media and developed steadily over the next thirty or forty years via such projects as the Lady Chapel at Ely (from 1321) down to the erection, probably in the 1340s, of the so-called Percy tomb at Beverley Minster (see pl. 170).[71] Its use of nodding arches, a device deployed very tentatively and on a small scale elsewhere before 1310–20 (Berkeley chapel at Bristol Cathedral, in the east wall niche of the anteroom; the shrine of St Edburga at Stanton Harcourt, Oxon., where, as on the pulpitum at Exeter, nodding ogees are a 'corner' motif), immediately placed it in the vanguard because of the new size and freedom of the motif; the form is displayed prominently on the north porch of St Mary Redcliffe in Bristol (see pls 33, 168).[72] The throne's overhanging ogees, a different but related idea, also occur on Thomas of Witney's pulpitum in Exeter Cathedral. These look very much like a softened version of a device already present nearly a century earlier on the west façade at Wells, where in the lowest zone of niches the trefoil canopies are pulled forward and topped by a gable that projects along with the top trefoil lobe. The same feature appears on the mid-thirteenth-century pulpitum at Salisbury.[73] The ogival collegiate stall canopies in the upper chapel of St Stephen's Chapel at Westminster (see pl. 42), perhaps designed by 1297, may have been the immediate source for Thomas of Witney's thinking – stalls, seats and other abodes are important to this whole sensibility; but earlier West Country practice would also have been relevant for Exeter.[74] The delicacy of the Exeter reredos and the adjoining openwork sedilia (see pl. 49), raised presumably before the high altar dedication in 1328, is in keeping with the fine sensitive lines of the work at Westminster. Its transparency may also have taken into account the debacle at Worcester in 1302 when Bishop Giffard's tomb was reproved by the archbishop of Canterbury because it prevented light falling on the high altar.[75] But what could not be deduced from anything at St Stephen's is the lavish thickset ornate handling of carving on the throne and on the main west front of the Exeter pulpitum itself, under way by 1317 and mostly complete by 1325.[76] The pulpitum (pl. 105) stands in the midst of rapid developments common to the southern and western counties in the crucial period before 1320: it has lierne vaults and foliage sprays in the spandrels like those on the tombs at Winchelsea in East Sussex (see pls 58, 106).[77]

Witney's career took him eventually to Wells and to a fruitful collaboration with William Joy, who raised the magnificently subtle presbytery there after Witney's work on the Lady Chapel at the very east end, started *circa* 1323–4 (see pls 39, 183): and it was at Wells that the various lessons learnt from the furnishing at Exeter were applied on a larger scale.[78] The relevance of Exeter as an experimental foyer in which, as I suggested earlier, creative conjuncture could flourish in middling-sized, well-funded undertakings that engaged various media side by side is not hard to demonstrate given the clarity of its documentation. Single-master overall control manifestly did not rule out, indeed obviously tolerated and perhaps even encouraged, a sort of inter-craft rivalry that produced results despite wage differentials (recall pp. 88–9, the difference at Exeter between the wages of the top stone carvers and the joiners). The sphere of 'heroic' emulation now operated in a more physically limited, but also more nuanced, world of formal inventiveness.

One central constituent of this sphere of inventiveness was the way in which the same forms were used either on large and small scales or in shifting contexts of scale, in a kind of symbiosis. A precocious instance of this is found on

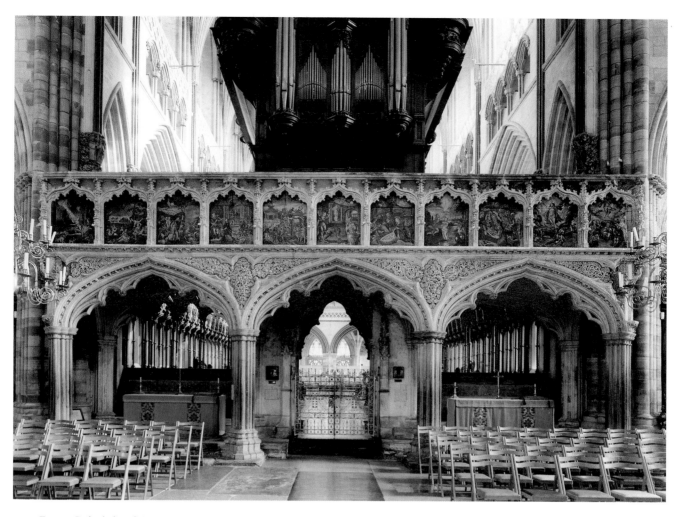

105 Exeter Cathedral, pulpitum

the handsome canopied effigial tomb in the south aisle of the parish church at Winchelsea, rebuilt after 1287 (pl. 106). Thomas of Witney himself may have worked on the church at Winchelsea before his association with Winchester and Exeter, though the tomb post-dates his activity there. It is now thought to commemorate Stephen Alard (d. 1327), who founded a chantry at the Lady altar in this aisle in 1312, and in conception it should date to the years towards the start of the period 1312–27, since it is joined in the aisle by a similar tomb to a member of the Maufe family who probably died before 1311.[79] Its format was inaugurated around 1300 by the canopied tomb of Edward I's brother Edmund Crouchback, earl of Lancaster (d. 1296), in the sanctuary at Westminster Abbey (pl. 107), a triple-gabled canopy composition derived in turn from French cathedral portals in which a wide central gabled bay is flanked by two narrower

ones.[80] In keeping with the new direction of style apparent also on the throne at Exeter, the tomb's lines are hugely enriched with ogee arches and cusps and lines of generously shaped hyper-real foliage. Following the main elevations of Westminster Abbey (see pl. 21), the Crouchback tomb and some of the Eleanor Crosses (see pl. 101), diaperwork is used comprehensively to enliven the flat surfaces. The main gable has a radically softened variant of the so-called Kentish barbed trefoil motif found on the canopy of the tomb of Bishop Bradfield (d. 1283) in Rochester Cathedral and later in the windows at Chartham in Kent (see pl. 202), and a further nod to Kentish prototypes is suggested by the subtle canting of the tomb's front in which the outer bays are angled towards the backing wall, on the model of the canopy of the prior's seat in the chapter house at Canterbury provided for Henry of Eastry before 1304 (pl. 108).

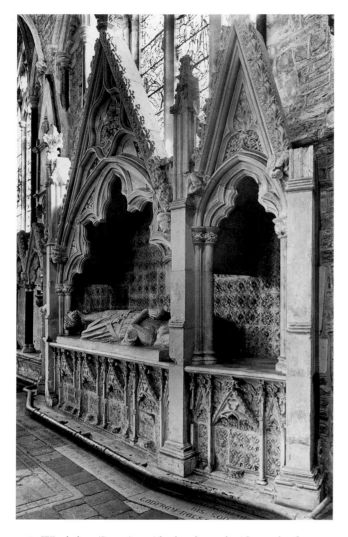

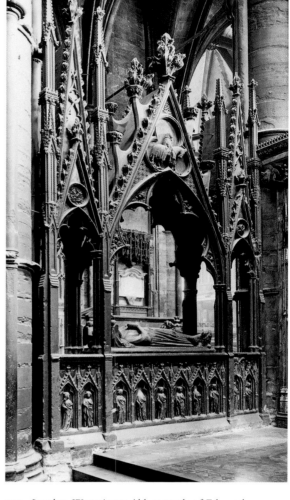

106 Winchelsea (Sussex), parish church, south aisle, tomb of Stephen Alard (d. 1327)

107 London, Westminster Abbey, tomb of Edmund Crouchback, earl of Lancaster (d. 1296)

What draws attention here to the Alard tomb is the delicate row of little canopies on the tomb chest and its outer flanks, designed to house figurines; it takes only a moment to see that these little housings are a perfect microcosm of the main design of the tomb, but one in which the narrow flanking bays are shared by the adjoining main gable. Every detail is there, including the gable trefoil, the cinquefoil ogival cusping and the pointed trefoils in the flanking gables. It is as if no opportunity were lost to confirm the connection between portal motifs and the passage of death; but the pleasure taken in this telescopy of forms is undeniable. The linked solution must have suggested the arrangement of the other Alard tombs, equally curious and eye-catching (see pl. 58), chained up in a row in the north

aisle, again in connection with a chantry foundation of 1319. The origin of this practice of proportional subdivision or 'homology', to cite Panofsky's famous discussion of the Gothic 'scholastic' principle of the 'progressive divisibility' of parts which governed the composition of entire buildings, their traceried windows especially, lies more deeply within Gothic invention itself.[81] Perhaps it is an aspect of ingenuity itself, like those Bach fugues in which a single subject appears hugely lengthened or augmented in time, in combination with itself shrunk in time by diminution, or turned upside down: for in these cunning devices is found satisfaction, elation even.

A free attitude to the scale of forms is a comprehensive aspect of the Decorated Style in general. It concerns more

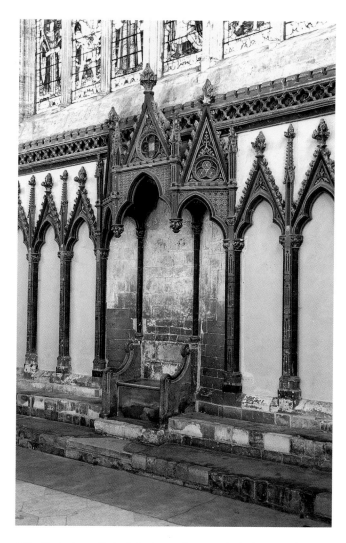

108 Canterbury Cathedral, chapter house, prior's throne and canopy (1280s or 1290s)

than the real possibility that – as at Exeter – formal solutions were being developed first on small or middling objects whose character as architecture might, from an absolutist perspective, be disputable. What seems to be claimed by these resourceful designers is that things do not always have a 'natural' scale at all: in which case, inventions achieved in a chapel-sized structure could legitimately be transferred to a great church. The satisfying main elevation of the choir and presbytery at Wells engineered by William Joy around 1329 makes specific use of motifs generated from the main interior elevations and stalls of St Stephen's Chapel at Westminster for its wall passages and ornately canopied 'triforium' stage (see pls 39, 42, 85).[82] The slightly later south transept and choir (see pl. 43) of Gloucester

Abbey offer a related but different 'reading', this time of the exterior elevations at St Stephen's (see pl. 25).[83] The English masons who, not long after 1328, erected a striking openwork screen in the Kent-Westminster mode at the opening to the eastern octagon of Trondheim Cathedral in Norway (see pl. 198) thought nothing of massively inflating a screen form, the prior history of which was based in chapel and parish church architecture (see Chapter Seven). In this telescoping of forms lay real generative power – and aesthetic freedom – to create and transfer ideas regardless of their functional character or decorum. The 'strange, completely atectonic' ogee arch, as François Bucher put it, is the most common sign of this formal utopia.[84] More deeply, it was a vehicle by which these astonishing objects recognized their own artificiality, recognition possible only in a state of fully aesthetic engagement.

This is why it is not strictly true to see the Decorated Style as a triumph of the 'Idea' of micro-architecture in Gothic art of the late medieval period, as advanced by Bucher.[85] The force of Bucher's general argument must of course be underlined. He saw the rise of this Idea as a direct result of what he called 'the end of thirteenth-century optimism' with the collapse of Beauvais Cathedral (see pl. 17) and the various crises of the fourteenth century: the reduced size of commissions was counterbalanced by the enrichment of details.[86] This is broadly right. But the relation of scale is, as Bucher acknowledged, a fully reciprocal one: great architecture informed a 'canonical' Gothic style that then reappeared *in nuce* in a host of small-scale contexts; but these forms in turn, in England especially, became part of the discourse of larger-scale building in, so to speak, a simultaneous realization of two infinities. The point is not that a single scale came to dominate aesthetic realization, but rather that in England, and more widely, scale itself became entirely relative.[87] The heroic and magnificent mode of great scale, and the mode of miniature, or of the munificent, were and are mutually dependent aspects of the same thing. This is why it is misleading to trap architecture between the great and the small.[88] A moment ago I used the related analogy of diminution and augmentation of subject matter in counterpoint. Abbreviation (*abbreviatio*) and amplification (*amplificatio, dilatatio*) in the use of subject matter was a basic technique of rhetoric. Poetic practice was its theoretical home around 1200, and for an understanding of it one turns first to Geoffrey of Vinsauf and John of Garland.[89] The point about a musical figure that can be shrunk or amplified is that it works equally well in either state, indeed even better when the two states are simultane-

ously combined. Aesthetic engagement is rendered dynamic precisely by the slippage from great to small and back again. So it should not be surprising that the epoch of heroic gigantism in church building coincided with an increasing, actually astonishing, hyper-miniaturization in such art forms as French ivories, seals (see pl. 220) and book illumination (see pl. 259), in which the idea of *multum in parvo* was taken to lengths seldom seen in medieval art before 1300. Physical compression of this sort was favoured by a web of market and cultural factors (for example, the utility of handy single-volume editions of the new Parisian edition of the Vulgate Bible): behind these microscopic feats of nano-aesthetics lay clever thinking, indeed even a certain consumerist genius. One of the earliest reflections on the trend to value microscopic decoration is found in Giraldus Cambrensis's late twelfth-century *Topography of Ireland*. Giraldus describes not a modern book, but one that might nevertheless have engaged his sympathy as one who wrote in a period when fine interlace was used extensively in English illumination. It was the early medieval Gospels of Kildare:

> ... If you look at them carelessly and casually and not too closely, you may judge them to be mere daubs rather than careful compositions. You will see nothing subtle where everything is subtle. But if you take the trouble to look very closely, and penetrate with your eyes to the secrets of the artistry, you will notice such intricacies, so delicate and subtle, so close together and well-knitted, so involved and bound together, and so fresh still in their colourings that you will not hesitate to declare that all these things must have been the result of the work not of men, but of angels ...

Giraldus was confronted with the fractal-like art of something very like the Book of Kells but thought of it in Horatian terms of close and distant looking.[90] In regard to this peering in and stepping back, C. W. Bynum has drawn a distinction between *admiratio* – standing back in wonder – and *imitatio* – stepping forward to study, peer at and assimilate.[91] Small things, not normally associated with conventional ideas of *magnificentia* yet possessing their own minificence, can undoubtedly occasion large sentiments and high language.[92] They are especially likely to occasion feelings of the uncanny, for the aesthetics of the very small provoke in us a special form of fascination that does not accord superficially with the aesthetics of magnification, but is in fact connected to them.

So to think, with Bucher, of one scale as being *the* scale, so to speak, is to misidentify the issue. The most sensitive

exploration of the paradox of scale and wonder occasioned by the miniature is Gaston Bachelard's *La poétique de l'espace* (1958).[93] For Bachelard, the apprehension of space is a function of the imaginative possession of the world, so that the better we are at miniaturizing the world, the better we are at possessing it. Values are condensed and enriched in miniature. Affective readings of this are not new: Bucher wrote of the 'emotionally laden' character of small forms and spaces; Bony suggested that 'overtones of dream or mystery always accompany the hollowing-out of masses of masonry'.[94] Miniature, the realm of the tiny, that 'little particle of dream', is related closely to the imaginative psychology of fantasy and romance: thus, says Bachelard, 'the minuscule, a narrow gate', opens up an entire world that 'contains the attributes of greatness. Miniature is one of the refuges of greatness.'[95] Inversion of size is an aspect of the creation of a domain of delight, which is to say more than that we find tiny things 'charming' (though this is often true): in small things we may perceive astonishing difficulty, something deadly serious as well as pleasing. In the excitation of delight, attraction and captivation may lie something deeper, more compelling: an allure and a sense of adventure that enlarges us, the spectators. The narrow gate – the portal and tabernacle motif of the Gothic canon – is the threshold at which we arrive and through which we pass, intensified, for in travelling we are moved both externally and internally.

Giant buildings like Bourges and Beauvais were, it seems to me, built for reasons that connected aesthetic experience to an enlarging conception of human imagination and action: resources, techniques of this sort are not deployed simply for pleasure, but to instantiate and underwrite power. There is of course also a risk in such thinking of opening out the charmed – or awesome – spaces not of the Middle Ages but of Romanticism, and so of reverting to the contrast between the play of rationality and irrationality.[96] But noting that medieval art created special effects is a reminder that these effects were created rationally, artfully. The point is not to sever the connection between the desired imaginary and the actual aesthetic of things that are crafted and which are experienced aesthetically. The passage *into* something requires first an encounter *with* something made: the realm, possibly vast, of the imagination starts somewhere. These adventures, typical of the medieval romance imaginary, move within ordinary aesthetic experience, for it is within the encounter with the agency of ordinary apprehensible objects that lies the allure, this power of captivation, the initial grip of the imagination and reasoning powers that impels us forward. This is the power of persuasion, the

'process of bringing someone to consent to believe something with confidence in its truth'.[97] This power was not a matter simply of object agency or subject agency: it entailed a transaction between subject-creator, object and 'viewer'. In this social transaction persuasion, confidence, *fides*, was vital, and in securing that confidence the agency of the surface appearance of Gothic objects was fundamental.

This introduces a substantial issue in the formation and signification of the Decorated Style: in persuading, something sometimes was also being believed. What needs to be demonstrated next is the way that symbol was openly absorbed *into* practice, and one way of doing this is to consider one particular and very common form of motif where the evidence is plentiful.

Ludic Incongruities: The Castle

The imagery of portals – whether actual gateways to churches or cathedral precincts, or gateways envisioned in illustrations of the Bible or of ideas of spiritual authority – had tremendous formal and conceptual power. The portals on the Westminster Retable, which intensify our looking into a wonderfully formed world of images, exactly capture this power. They not only concentrated the activity of invention but also, in implying physical or spiritual movement, encounter, adventure, resistance, admission and so on, possessed an emotional vitality found throughout religious and secular or romance allegories of the period, in a way that was mutually informing and energizing. The most fruitful terrain for this pursuit is that complex and incongruous elision of ideas of the church, the portal and the battlemented wall, that meeting of temple and fortress, in which allegory played a demonstrable role. At this juncture lay real possibilities for persuasion that were made apparent practically and vividly in the repertory of the Decorated Style. The text *ecce sto ad ostium et pulso* (Behold, I stand at the gate and knock), in Revelation 3:20 has already been noted. Ezekiel's description of the closed east door, the *porta clausa* of the sanctuary (Ezekiel 44:1–3) opened to no man because God has entered it, and within which only the prince may eat bread before the Lord, was a type for the gated Christian sanctuary of the priest and Mass and an allegory of the Incarnation. In contrast, the twelve great gates of the Heavenly Jerusalem, the object of our hope, are open by day (Revelation 21:25).[98] It is not coincidental that the extraordinary displays of micro-architecture and crowded registers of small-scale figurative sculpture on French Gothic portals

in particular proved such magnetic attractions to any English Gothic artist seeking to widen their inventive horizons.

At its height in the twelfth and thirteenth centuries, the 'allegorical mode' of interpretation allowed intelligent, learned Latin commentators to come to terms with the architecture of the Church, style regardless, as possessing an ordered signification rich with exegetical potential. Bede, Honorius Augustodunensis and the Victorines developed a discussion of the symbolism of religious building that, born of biblical exegesis, was then deployed in the interpretation of actual churches.[99] Some modern commentators, suspicious of the constraining power of thematic preconception over their absolutist models of formalist shape-play, have remained sceptical or wary of the possibility that exegesis actually informed buildings in the first place. Jean Bony admitted to his discussion of court architecture the Arthurianism of Edward I and what he called somewhat nebulously 'that romantic quality of life', without being remotely concerned with the heritage of religious thought about building and metaphor that demonstrably underwrote the 'romantic'.[100] Indeed, he never seriously discussed castles actual or figurative.[101] His account strikes the secularist note of the rationalist tradition, without actually satisfying secular interests. For him, it seems, religious or secular signification of any type was secondary to, and separable from, the imperatives of form. This cannot in fact have been entirely so. But for the present purposes, this whole question is practical as well as polemical: reasonable evidence is needed that the vivid thinking of the Bible and its later spiritual interpreters significantly preceded the literal manifestation or bodying forth of an idiomatic idea, and that metaphor not only preceded the sphere of the realization of real things, but was also sufficiently exact to have shaped it too. In doing so, one may find that the allegorical mode, though a form of Bible reading that was passing out of fashion by 1300, nevertheless had persistent and fertile consequences.[102] The era of metaphor and exegesis had yet to end, not least because, having entered pastoral hagiography in such works as the Metrical Life of St Hugh of Lincoln, it passed into the realm of romance itself.

One history of this priority of metaphor arises especially from the all-important nexus of war and the Christian chivalric. That the vocabulary of fourteenth-century art is 'seigneurial' in regard to its heraldic and military display scarcely needs emphasizing: the evidence is everywhere. But what is less apparent in discussion of this nexus is that all-important dynamic of the secular and the religious, that negotiation of seeming incommensurables or actual incon-

gruities that so energized the production of allegory itself, by creating a sort of friction or paradox. Allegory helped opposites become friends; theology found pleasurable and lasting discomfort in paradox. Contention or struggle is central to artful play.[103] The conflicted zone between the military and the peaceable was allegorically productive – and therefore stimulating to the play of invention in the visual arts – precisely because it entailed an energizing ambivalence, not closure.

It is, first, far from misleading to think of the thirteenth-century Church as the Church Militant. The reform movement of the twelfth and thirteenth centuries associated with the allegorical *lectio* possessed a certain militancy of outlook in the sense that any movement aiming at purification of both the Church and society more generally, and which originated within a spiritual elite, would have a battle on its hands, against sin. The Rule of St Benedict refers to its followers doing 'battle under the Lord Christ', taking up the bright weapons of obedience. The Pauline epistles (Ephesians 6) contain an extended conceit relating to the spiritual armour of God against the wiles of the Devil. The question was historically sensitive in England because the Normans deliberately connected great church building both physically and stylistically with castle construction, as at Durham, Lincoln, Norwich and Old Sarum, so creating a formidably political architectural landscape.[104] Bishops were lords, and in terms of class distinction the Church and the nobility were the same. Great church fronts such as that of Abbot Suger's Saint-Denis near Paris still bear battlements. The Church was the vassal of God, the mighty refuge of Psalm 90.

But as the twelfth-century Church itself recognized, to crenellate a church in such a way as to make it look like a castle is *prima facie* an incongruity, since churches are not military establishments. Ecumenical pronouncements on this problem of militarization, such as that issued at the First Lateran Council of 1123, which prohibited the encastellation of churches by laymen, simply point to the extent of the problem, for there is no shortage of evidence that in this period lay and spiritual authorities were doing just that.[105] Churchmen warned repeatedly of the risks of associating too closely with armed elites. Bernard of Clairvaux's treatise on the duties of bishops criticized lordly display and mounted entourages; puritanical canons such as Hugues de Fouilly stated that monasteries should not bear battlements or demonstrate lordly pride. St Bernard understood this psychology exactly: he was noble by origin and considered virtue rare in the nobility; he had turned his life

round in a moment of Damascene conversion while en route to join his brothers at a siege.[106] In England after the martyrdom of Becket, the liberation of the Church from military, as from public power, was symbolized by the joyful flight of the canons from the sterile military compound of Old Sarum to a new, castle-free, cathedral site at Salisbury in 1220.[107]

Yet in the field of architectural practice the signs are that from the second quarter of the thirteenth century a process of aestheticization of the military was under way in which churches borrowed the look, but not the substance, of the fortress. The crenellated high walls of Westminster Abbey raised by Henry III to face the city of London are simply eloquent cresting directed at the mob, unlike the practical *ecclesia fortis* of twelfth-century Lincoln Cathedral (see pl. 6). The abbey's main model, Reims Cathedral, was scheduled to have crenellations, comprehensible in the light of the dismal and violent relations between the archbishop and the city in the 1230s, and possibly provocative of them.[108] At Westminster too, carved and painted heraldry made its first sustained appearance in a church interior, certainly as part of an original plan to decorate the choir aisles of the building as the Tower of David, hung with a thousand bucklers (Song of Songs 4:4).[109] The east end of Exeter Cathedral completed in the wake of Westminster was thoroughly crenellated (see pl. 12): the external image of the great church was changing by no later than the 1270s. By now one may think of a process of normalization, but not of compulsion, since some sort of decorum must have suggested to the canons of Wells Cathedral, whose beautiful new fourteenth-century east end simply has openwork traceried parapets, that their church should not be decorated like their bishop's palace, fiercely crenellated by Robert Burnell at the end of the previous century: even so, the choir interior elevation bears tiny crenellations.[110] And of course the pretty miniaturized battlements that Bony so rightly identified as a crucial feature of the Decorated Style by the end of the thirteenth century, as on the Eleanor Crosses, manifestly cannot have had a functional purpose, except in so far as they functioned as signs.[111]

Here, as Charles Coulson suggests, was a symbolic as much as a practical domain. Rejecting a functionalist account, Coulson thinks of the adoption of the militarized aesthetic as being the product of an entire imaginary, a 'will-to-crenellate' as it were. Fortification more generally is illuminated 'by showing how the *moeurs* of the seigneurial milieu were adapted by the closed corporations of the Church into forms nearly related but recognizably distinc-

109 Salisbury Cathedral, brass of Bishop Robert Wyvill (d. 1375), from Waller 1864/1975

the dispersed possessions of the Church and recovered, like an intrepid champion, the castle of Sherborne, which had been withheld by military violence for two centuries; and he also procured the restoration to Salisbury of the Chace of Bere. He died in the castle in 1375. The Chace of Bere must be the rabbity warren at the bottom. It is obvious that this tomb pushes the encastlement of the upper clergy to a sort of logical conclusion. It is a monument to restoration, to the recapturing of things lost, to the shielding and reclamation of the Church. It also suggests very strongly a ludic reference to the encastlement of virtue explored specifically in the case of the Virgin Mary. It is a reminder of one other episcopal tomb, that of Philip von Heinsberg, archbishop of Cologne (d. 1191), in Cologne Cathedral, supplied retrospectively and looking like an overblown toy castle, commemorating in the most obvious fashion the fact that he provided fortifications for the city of Cologne.[114] Thirteenth-century episcopal tombs at Amiens and Ely also bear small battlements in allusion to God the *refugium* of Psalms 89 and 90.[115]

Something had authorized this new and very enjoyable game, a game as serious as a tournament. What it was is unclear, but it would have included a developing pastoral discourse, emerging from the moral theology of the twelfth-century exegetes and taking forms accessible to the seigneurial classes, in which the military became a positive metaphor for the good – an enlargement or vulgarization of the old monastic idea of life itself as an internalized conflict or *psychomachia*. The history of this process has been set out elsewhere.[116] One of its presiding geniuses was Robert Grosseteste, bishop of Lincoln from 1235 to 1253. Grosseteste the teacher was a master of associative psychology. In his *pastoralia* he was very given to using martial imagery. It was almost certainly he who first developed the image of the so-called shield of faith or *scutum fidei* (as well as the 'shield of goodwill' and the 'shield of the heart') in his pre-1231 *dicta*. Shield imagery was of course already developed in the celebrated theme of Christ the noble knight-lover in the *Ancrene Wisse*, whose shield, reinforcement against evil and temptation, was his body spread on the Cross. Such similitudes had for a generation and more been a crucial rhetorical weapon in pastoral preaching and the dissemination of moral theology. They were intended to connect the courageous magnanimity of the warrior class with the magnanimity of the battle for the soul.[117] In his analysis of the English illustrated manuscript of Peraldus's widely known *Summa* of Vices (British Library MS 3244), written *circa* 1236, Michael Evans noted the relative frequency with which English spiritual writers from the

tive'.[112] Indeed so, for no layman ever conceived so witty a memorial as the extraordinary brass in Salisbury Cathedral commemorating Bishop Robert Wyvill (d. 1375) (pl. 109), who in 1337 had obtained a licence to crenellate his manor, of which the city of Salisbury was part.[113] The brass shows the bishop in prayer within a spectacular fortress with baileys, towers, ramparts, portcullises and arrow slits. A small but wiry armed man with a shield and a double pick stands squarely and defiantly at the entrance. The epitaph explains that Robert of happy memory prudently gathered together

twelfth century onwards deployed military metaphors and knightly allegories in the service of (typically monastic or anchoritic) spiritual edification, as in the *Ancrene Wisse*. That these ideas had entered the visual domain of the seigneurs is proved by the direct response to the Christ-knight metaphor in the framing of the *Crucifixion* image in the mid-fourteenth-century Fitzwarin Psalter (Bibliothèque nationale de France, MS lat. 765, fol. 22). Here, a Crucifixion group is lodged serenely within a towering fortress.[118]

What these images capture is the very diverse but also gravid context that military devices seem to have enjoyed particularly in England, where this licit and artfully contained thought-world of savagery and gentility was especially common. The pastoral agenda enabled what had been rather specialized monastic and clerical ideas to be drawn into the instruction of the parish and household, so creating, in plan at least, a common symbolic language − common at least to the landed class − which could use military imagery in the way set out by Henry, duke of Lancaster in his *Livre de Seyntz Medicines* (1354) in regard to sin: the castle is his body, the treasure within his soul; to confess is to show how sins have entered the very tower in the castle's midst, its 'keep' the heart within.[119] In this complex an extraordinary catena of ideas can be identified: body, castle, temple, refuge, Incarnation, sacrament, health, redemption. To tug one link in the chain is to rattle others further down.

The point about such links, conscious as they were, is that they were at one level extremely enjoyable: it is not wrong to see ludic pleasure in such images, and in this sense Bony was justified in pointing to 'a general tone of playfulness' in the English understanding of Gothic more generally.[120] What he underestimated was the importance of the ludic in invention more generally, national boundaries regardless, since it seems to me that the French too were capable of play, as the portal compositions of their great churches prove especially in their manipulation of small-scale architectural and figurative detail.[121] An apt illustration of the way in which prior allegorical thinking of quite a complex order dovetailed with formal innovation and got under (or into) the skin of architectural imagery is provided by an object that, although French, was part of a commission that without question exerted an almost disproportionate influence on the art and architecture of England at the end of the thirteenth century and beyond: the piscina (the drain for washing the liturgical vessels as well as the priest's hands at Mass) by the high altar of the church of St Urbain in Troyes, in Champagne (pls 110, 111).[122] The church of St Urbain was founded by Jacques Pantaléon, the French pope

110 Troyes, St Urbain, high altar piscina, 1270s

Urban IV (1261–4), the instigator of the cult of Corpus Christi, at his birthplace in the city. The church itself, begun by Urban and continued as far as the nave by his prosperous nephew, Cardinal Ancher Pantaléon of Troyes (d. 1286), is a sparkling masterpiece of Rayonnant risk-taking, though not so risky that some of its general and specific features did not make their impact as far away as York (chapter house and vestibule) and Exeter (presbytery elevation).[123] Its piscina just to the south of the high altar consists of two bays with gabled trefoil arches with damaged figural sculpture set between the gables, the composition being crowned by four polygonal gabled and crenellated turrets bristling with lively armed men who peer out menacingly between the merlons with crossbows and other weapons. The central group shows the *Coronation of the Virgin* with, on each side, two clerical donor figures, one holding a model of the church's apse, the other a model of its choir or transept. The figures are now decapitated, but since the figure to the left wears the *rationale* it seems beyond ques-

111 Troyes, St Urbain, high altar piscina, detail of canopy

tion that he is Pope Urban and that the other figure is his nephew Ancher. This probably places the insertion of the piscina into the wall in the 1270s rather than the 1260s, but no matter: the framework of the piscina is a microcosm of the church's more general akyristic transposition of motifs; gable forms appear in its double-layered window tracery, for instance.

Mary's presence at St Urbain is itself readily explicable, since both Urban and Ancher were former canons of Laon, one of the great centres of the cult of the Virgin and the collection of her miracles. But why should Mary be crowned by Christ within a castle beneath turrets thick with soldiers, and on a piscina? That the Virgin Mary was associated with military-chivalric ideas in general needs no demonstration here. The Song of Songs, a text central to the poetics of the Incarnation, musters the imagery of the nightwatchmen who keep the city (3:3); indeed, the spouse of Christ is fair and terrible: *pulchra es amica mea suavis et decora sict Hierusalem terribilis ut castrorum acies ordinate* (thou art beautiful, O

my love, sweet and comely as Jerusalem: terrible as an army set in array) (Song of Songs 6:3). Central too is Isaiah's grand foretelling of the coming of Christ: *et gaudebit sponsus super sponsam . . . super muros tuos Hierusalem constitui custodes* (And the bridegroom shall rejoice over the bride: and thy God shall rejoice over thee. Upon thy walls, O Jerusalem, I have appointed watchmen, all the day and all the night: they shall never hold their peace) (Isaiah 62:5–6).

The catena is in part provably built up of readings of the Song of Songs and Isaiah; but these are joined by another tradition of speculation that explored more deeply the mystery of the Incarnation itself: that Christ has found his way into the impregnable bastion of virtue. Interestingly for a French liturgical object, this tradition had been hugely reinforced by English theologians.[124] By no later than 1100 exegesis of the Virgin Mary as a castle connected the Song of Songs with St Luke's Gospel 10:38: *et ipse [Jesus] intravit in quoddam castellum* (he entered into a certain town) – the *castellum* in question here is the town of Bethany, home of

Mary and Martha. This text was investigated for the idea that Mary's body was in effect a castle, in which Jesus sought refuge at the Incarnation. The idea is apparent in a homily of Ralph d'Escures, later archbishop of Canterbury (1114–22), which in turn influenced the commentary on the lessons for the feast of the Assumption, and on the Song of Songs, assembled by Honorius Augustodunensis, the *Sigillum*, written *circa* 1100 at Worcester. Honorius was an influential participant in writing on the signification of architecture and the parts of buildings in the Bedan tradition. No less important was Honorius's circle in speculation on the idea of the Coronation of the Virgin as part of the development of the liturgy of the feast of the Assumption. This early participation of theologians in the use of castle metaphors for the Incarnation, and in the imagery of the Coronation of the Virgin herself, is striking, because it connects all the imagery found on the piscina to a distinct but much older body of thought. The links of the catena begin to connect. The piscina's imagery, for all its charm and initial sense of incongruity, claims allegorical depth.

At this point Robert Grosseteste re-enters the discussion, since Robert was a master, if not the absolute originator, of various conceits of the body as a temple or castle as pastoral devices.[125] In such likenesses the Christian person might be compared to a castle inhabited by the soul; or to a temple inhabited by God, as in 1 Corinthians 3:16–17. The English textual tradition is well known for such devices, found in the *Ancrene Wisse, Sawle's Ward, The Abbey of the Holy Ghost, Piers Plowman, Castle of Perseverance* and so on. But the greatest of these was Robert's *Château d'amour*, a further exploration of the theme already explored by Ralph d'Escures and Honorius, and which had been developed meanwhile by Ailred of Rievaulx.[126] Robert presided over a cathedral dedicated to the Virgin Mary that itself had come, in the preceding century, to resemble a castle.[127] *Château d'amour*, composed in the 1230s or 1240s, enjoyed persistent dissemination in French and English. It may even have influenced the early fourteenth-century allegorical frescoes in the lower church of the basilica of San Francesco at Assisi, presumably in part because the text reflects on the voluntary poverty of the Virgin, and perhaps more generally as a long-term result of Grosseteste's sympathy for the Franciscans.

Château d'amour amplifies the idea of Mary as the castle in which Christ seeks lodging. The fortress set on a rock is an impregnable bastion of virtue, a defence against the world, the flesh and the Devil. It possesses four towers surrounding a keep, three baileys and seven barbicans, each with a gate. The keep is coloured green, blue and red, and is as white as snow within. From its well issue four streams, which fill the moat. At its centre is a throne of ivory set on steps. The moralization that follows states that the castle is the Virgin Mary who defends us; the rock is her heart; the foundation is her faith, the green base, blue and red walls standing for the three Theological Virtues, Faith, Hope and Charity. The four towers are the four cardinal virtues, Justice, Fortitude, Prudence and Temperance. The highest bailey is the Virgin Mary's virginity, the middle one her chastity and the lowest her marriage. The seven barbicans represent the Virtues that defeat the Seven Deadly Sins. The throne is the throne of Mary and more particularly Christ; the well is the spring of Grace. Christ enters through a closed door leaving it again still closed. The *porta clausa* of the sanctuary in Ezekiel 44:1–3 is finally opened, yet shut. The prince is within.

Château d'amour, like much good mnemonic teaching material, offers a painting in words, carefully set out and coloured in order to come readily to the mind's eye. The Troyes piscina belongs to its tradition of thought only in important essentials, such as the throne of Mary within and the four turrets at the top, rather than as a pedantic point-by-point illustration of it. There is no evidence that Urban IV or Ancher actually knew the writings of Grosseteste, though the Assisi evidence shows that they were known in some form in Franciscan or curial circles. But the concept of the well as the spring of Grace is specifically suited to the rendering immaculate by water of the priest's fingers, as well as the vessels used in the sacrament of the Mass, which was the principal function of a piscina. The military character of the piscina brings to mind the sentiments of Honorius Augustodunensis in his *Gemma animae* on the analogy of the sacraments and warfare: *missa quoque imitatur cujusdam pugnae conflictum* (the Mass itself imitating armed struggle). The idea is captured perfectly by the piscina in the chapel of St Gilles in the early fourteenth-century Burgundian priory church of St Thibault-en-Auxois not so far from Troyes, which has a vaulted canopy topped with four tiny polygonal crenellated towers. The triangle Troyes–Auxerre–Auxois to the south-east of Paris seems to have had special importance for, and kinship with, English design at this time: a factor in this may have been the development of English interests in the county of Champagne through the marriage of Edward I's brother Edmund, earl of Lancaster to Blanche of Artois in 1276.

The piscina at Troyes is a specific instance of the way that reconciling two incongruous ideas, in this case of the

112 *(above)* Luttrell Psalter, *Castle of Love*, circa 1340 (London, BL MS Add. 42130, fol. 75v)

113 *(right)* Peterborough Psalter, *Castle of Love*, circa 1310 (Brussels, Bibliothèque royale de Belgique MS 9961–2, fol. 91v)

temple and fortress, created an inventive dynamic that shaped commentary on the sacraments as the necessary means whereby we are returned to God. The adventure of exclusion, entrance and enclosure expresses hope and desire; we seek peace within the refuge as a place of communion and of relief from suffering, and in it we place our confidence as a bulwark, for God is a mighty fortress.[128] It is quite unhelpful to think of such objects in terms of dual 'secular' and 'religious' imperatives. The Castle of Love as a court pageant, in which a castle enclosing maidens is assailed cheerfully by young knights trying their virtue, is recorded in Italy in the early thirteenth century prior to Grosseteste's pastoral writings, and Loomis accordingly assumed that its underlying thinking was secular, then appropriated by the Church (Loomis, like Bony, was inclined to see in chivalric imagery a solely secularist or 'Arthurian' interest).[129] But not only did the theology long pre-date the 'romance': even in its courtly form, the Castle of Love remained, in England at least, an image subject to religious reading. This is proved by its occurrence in two of the great English Psalters of the period. One is on folio 75v of the Luttrell Psalter, the great book made for Sir Geoffrey Luttrell in the second quarter of the fourteenth century, in this case probably illustrating the preceding Psalm 37:13: *et vim faciebant qui quaerebant animam meam* (and they that sought my soul used violence), the castle being the soul's refuge (pl. 112).[130] The

other is the Castle of Love on folio 91v of the Peterborough Psalter (Brussels, Bibliothèque royale de Belgique MSS 9961–2) illuminated in the early fourteenth century, where the castle, enclosing at the top a dignified crowned woman encircled by her maidens, fends off a knightly siege (pl. 113).[131] The picture is placed in a text column with the collect *Deus qui es sanctorum tuorum splendor* (God who is the splendour of your saints), which continues: 'make us your servants of the holy mother of the Lord the Virgin Mary and of all your saints everywhere; watch over us with your protection, even those joined to us neither by friendship nor blood; having repelled all the deceiving tricks of the enemy from the whole Christian people, concede to them their return to their original heavenly home.'[132] The collect, proceeding with an invocation of the Virgin Mary, the watchful protection of God, the repulsion of the enemy and the return of Christians to their original home, epitomizes very precisely the pastoral thinking that the Castle image, as a type, tried to engage.

Should one generalize from such things as the Troyes piscina to the larger aesthetic questions of the day? To be sure, the church of St Urbain itself rises lofty and sleek in its neutrality: the earthbound eloquence of the piscina, as perhaps also with its window glass, which also contains little crenellations, is felt all the more given its haughtily cerebral architectural context. Not everything can, or should, be

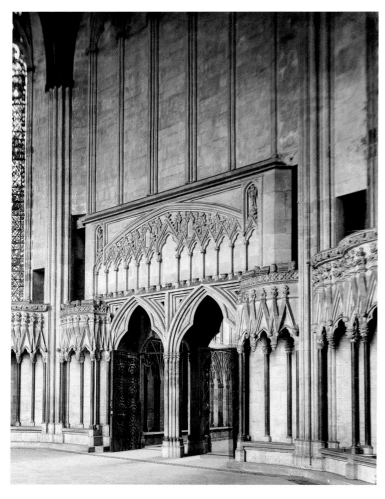

114 York Minster, chapter house, entrance wall, looking south-west, 1280s

and thence of the English Decorated Style.[134] The piscina was part of this, but whether or not the role of English theologians in formulating its basic ideas in the first place made it attractive back in England is as yet undemonstrable. English architects and sculptors had for some time been using fine double piscinas in churches, and the setting, as at Troyes, of expanses of figurative carving above arcades was already known at Worcester Cathedral (aisles), Westminster Abbey (radiating chapels and aisles) and Salisbury Cathedral (the tomb of Bishop Giles Bridport, of *circa* 1262), partly in response to earlier French models. The Troyes piscina, dating to not much before 1270, could only have lent shape to existing English practices. As is well known, the late thirteenth-century work at York Minster on its chapter house and vestibule, begun around 1280 and completed by 1290 or so, offers direct testimony to the St Urbain 'portfolio' as drawn up, presumably, no later than the 1270s. The chapter house, vaulted in wood by the late 1280s, picks up tracery motifs and smaller details from St Urbain's choir and transepts, and its linked stall canopies may themselves reflect study of the piscina.[135] In one case the link is very specific. To either side of the inner entrance to the chapter house are bow-fronted crenellated sentinels for the custodians of the chapter meetings to perch in (pl. 114). These continue the rhythm of gables and shafts found on the stalls, but are topped by a cornice of quatrefoils and merlons from which peep out the carved heads of little figures, as found on the piscina. This, combined especially with the elegant form of a standing *Virgin and Child* carved on the trumeau at the entrance between these two sentinels, should confirm that the battlement figures of the Troyes piscina were to be seen as custodians, watchmen, of a Marian building, following Isaiah 62:5–6.

The area of eastern England including York and the regions to its south contains a suficently large number of fourteenth-century variations on this theme for one to ask whether there were other objects hereabouts that followed the Troyes piscina or the line of thought it represented. Two objects within Grosseteste's own diocese are particularly notable. Lincolnshire was remarkable for fabulously carved objects whose functional character itself betrays a certain (and perhaps provocative) indecision or ambivalence, not least as to whether they are sacrament shrines, tombs of Christ or Easter sepuchres. The sedilia in the chancel at Heckington (pl. 115), for example, are striking for the way that the spandrel zone above the arcade gables is used for reliefs of the *Coronation of the Virgin*, angels and saints. The Luttrell church at Irnham contains a lavishly carved three-

subjected to allegorical reading. But the question is worth asking because St Urbain's ideas seem to have travelled to England as part of a portfolio that undoubtedly included drawings of the piscina itself. As well as thinking about the political links between England and Champagne after 1276, it would be good to know more about the 'Johannes Anglicus' who in 1267 was serving as the church's *magister fabricae* and was at the very least administering funding, since he misappropriated it.[133] Johannes is a help in pointing to the type of link at the administrative level that might have facilitated the movement of designs from Troyes to England, to a far greater extent, as it happens, than within France itself.

Whatever the exact nature of the channels of communication, St Urbain has long been seen as a part of the genealogy of English Rayonnant in the late thirteenth century,

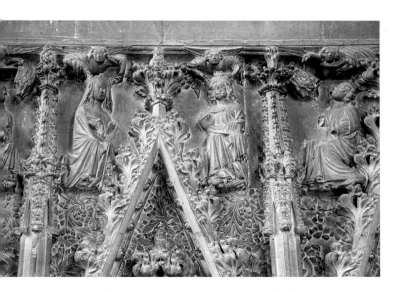

115 Heckington (Lincs.), parish church, detail of chancel sedilia, 1330s, showing the *Coronation of the Virgin*

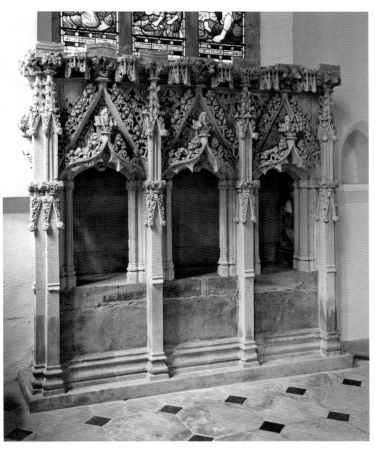

116 Irnham (Lincs.), parish church, north aisle east end, ?Easter sepulchre bearing Luttrell arms, *circa* 1340

bay monument dating perhaps to the 1340s (pl. 116), bearing the arms of Luttrell and Sutton – the owners of the Luttrell Psalter itself. The object is now at the east end of the north aisle, but this cannot have been its original location or orientation: it appears to have come from the north side of the chancel bays, which suggests that it was some sort of Easter sepulchre, though its central image is of the Virgin and Child and the shields of the donors are placed in the outer spandrels.[136] The bays consist of squat and elaborate nodding ogee arches and gables with intervening pinnacles in the finest lavish style of the region, the sort of decoration that could apply to a tomb, a piscina or sedilia. In fact, its style is not wholly regional. Within, it has a remarkable miniature West Country-style net vault, on the model of the choir at Wells. And that it might reveal at least indirect knowledge of the Troyes piscina, where the patrons are shown figuratively in the same relative position, is indicated by the six little polygonal gableted and crenellated turrets along the top frame which closely resemble those in the same position at Troyes, yet which here serve a solely decorative purpose; they are uninhabited. Knowledge of a 'Castle of Love' prototype might at least place the Castle of Love in the Luttrell Psalter noted earlier in some sort of context. Chapter Three noted the remarkable flourishing in the eastern counties of sculpted Easter sepulchres or Sacrament houses produced in the wake of the *Clementines* after 1320 or so. The cult of Corpus Christi was directly implicated in this fashion; and that cult had begun with the patron of St Urban.

In tracing these shifting patterns of form and signification, it is important not to foist allegorical readings on buildings at large, and so establish some hard schedule of meaning. The point is not to establish invariant rules but to understand the role that allegory sometimes had in the initial inventive generation of forms, by giving them a latency or depth, a capacity to move things forwards, which made them attractive as models. The role of French art and architecture in the formation of this militarized aesthetic generally is worth pondering. In the thirteenth century a great church such as Chartres was rather thoroughly fitted out with images and devices of a military nature – representations of military saints and heraldry, for instance, as in the cathedral's windows and portals. The free combination of church, city and castle motifs on the town canopies of French portals has already been noted. English religious architecture after 1250 was, however, far more prone to employ military detailing, notwithstanding the possibility

153

that its initial concepts were, as I have indicated, launched in the Anglo-French domain. By the fourteenth and fifteenth centuries the exterior and interior militarization of English parish churches, the major growth area of the times, was almost universal. Why this should have been so has not been accounted for, and certainly warns us that any attempt at a solely religious-symbolic explanation would be fruitless. The will-to-crenellate had social as well as religious aspects: castellation expressed noble rank and was 'seigneurially demonstrative'.[137]

This pattern was settling down in the visual arts by the last two decades of the thirteenth century, of which period Bony noted that the crenellated cornice had started to become 'one of the most remarkable and most English of the new forms of style'.[138] In such cornices a horizontal corbel stage supports a balustrade or open quatrefoils or trefoils, with a battlemented zone above, often minutely carved or painted with arrow slits. Edward I's princes were given toy castles to play with, and there is something of the miniature fort, and of the ludic more generally, about these displays.[139] Among the earliest instances of such a cornice are the sentinels by the chapter house doors at York discussed above. But the little band of quatrefoils that runs beneath the merlons there was not derived from the Troyes piscina. In France the quatrefoil frieze is found no later than around 1230 at the gallery stage of the west front of Notre-Dame as well as on its towers; it is found in the Isabella Psalter in Cambridge (Fitzwilliam Museum MS 300) (see pl. 91) and in the Lady Chapel of St Germer-de-Fly, both by the 1260s.[140] By the time the Dominican church at Poissy had been designed at the end of the century quatrefoil balustrades ringed the entire church. The crucial point, however, is that at this time the French did not habitually combine such rows of foils with crenellations.[141] A reason for this may be that the French simply took a more traditional view of the incongruity of coupling solid merlons, designed to have a protective function, to delicate open-work bands of trefoil below whose character is decorative. But that the French may also have been tied down by some value-driven inhibition about the display of castle detailing is suggested by the fact that introducing battlements to the main interior elevation of a religious building was virtually unknown there.

In England from 1290 the situation was quite different. After the tentative instances at York including the chapter house and, it should be recalled, the use of carved shields in the main elevation of the nave, crenellated cornices appear on the Eleanor Crosses, in the biblical scenes of the Painted Chamber (see pl. 98), on the main cornice beneath the clearstory of the upper chapel of St Stephen possibly designed in its entirety by 1292 (see pl. 85), and in the wall arcading of the chapter house and around the choir enclosure at Canterbury before 1304 (pl. 117 and see pl. 108) – in the last two cases the work of Michael of Canterbury and his company. It is very unlikely to be a coincidence that extended embattled and foiled cornices, running the entire length of an interior, were first provably used in buildings with wooden roofs and continuous wall plates whose elevations were not interrupted by vault cones or prominent vault shafts, or, as in the choir at Canterbury, were set over a strongly horizontal zone of woodwork stalls in such a way as to permit sight of the aisle windows. It was from the specialized context of roofed buildings that the principal great churches with crenellated and also vaulted interiors – the choirs at Ely, Wells and Lichfield of the 1320s and 1330s – emerged in the next generation, since William Joy's Wells choir and John and William Ramsey's work at Ely and Lichfield (see pls 31, 39, 46) were all ultimately dependent on court projects of the 1290s such as St Stephen's. At Ely the octagon interior has double-ranked crenellations, and the new presbytery bays inserted by Bishop Hotham bear small neat battlements and rows of foils along the balustrades at gallery and clearstory level, as well as shields; a similar feature occurs at Wells and Lichfield before the clearstory wall passage. By the 1330s these forms, often relatively inconspicuous, were a more routinized aspect of the way the English liked things to look. A Kentish-style crenellated cornice adorns the chest of the tomb of Pope John XXII (d. 1334) at Avignon (see pl. 214). Meanwhile, at the smaller scale of the Troyes piscina, the play with castle ideas was extremely frequent, as on the pinnacles of the tomb of Edmund Crouchback (see pl. 107) and its successors in the sanctuary of Westminster Abbey, on the bishop's throne at Exeter, on the tombs at Winchelsea and in the great works opening at Ely after 1320. By the second quarter of the century are found a cistern and laver at Battle Hall near Leeds in Kent, framed with Kentish tracery but serviced within by a little bow-fronted turreted fortress with leonine spouts in the tradition of lion aquamaniles.[142] Later, the nave of the parish church at Finedon in Northamptonshire was braced by a strainer arch with curved cresting with openwork quatrefoils and merlons that can only be described as ludic: similar curved crenellations occur in the mid-fourteenth-century Fitzwarin Psalter. In England, once launched, an idea acknowledged few boundaries.

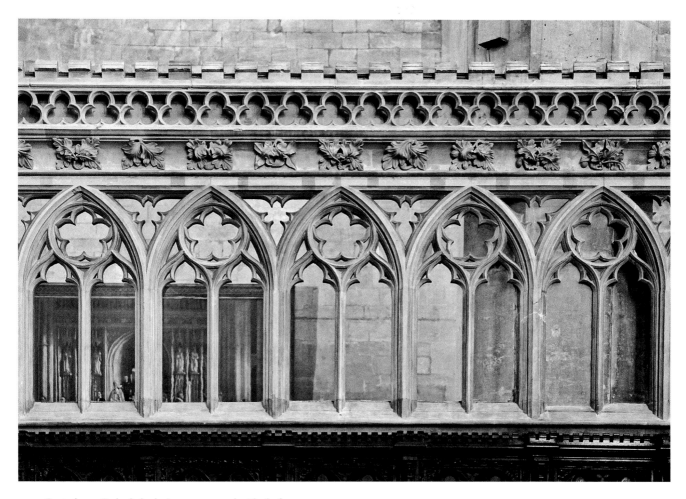

117 Canterbury Cathedral, choir screens, north side, before 1304

The Palace

The nexus of war and religion, savagery and self-control, created one area of creative friction and play; a second area was in a sense subtler, in being less obviously incongruous, namely that of church and palace. Henning Bock singled out the canopied inhabited niche as one of the defining motifs of the Decorated Style.[143] A very common medieval term for free-standing canopies over images in churches was *tabernaculum*, the original currency of which is almost exclusive to the Vulgate Old Testament, the Pauline Epistles and Revelation (Hebrews 9:11, Revelation 21:3). In the Bedan scheme of interpretation, it had distinct priestly, mystical and typological denotations: Bede in his *De tabernaculo* and *De templo* demonstrated the exegetical possibilities of a term that mystically designated the universal Church, completed in the Heavenly Jerusalem.[144] The Tabernacle enclosing the Ark of the Covenant became a sort of archetypal church, and an object, as Jeffrey Hamburger puts it, of 'intense desire'.[145] Augustine's poetic commentary on Psalm 41 includes the most important early demonstration of the idea of the tabernacle as a thing of 'wonder' (*tabernaculum admirabile*).[146] St John in his Gospel (14:2), however, speaks of *mansiones* (from the Greek μοναί or 'abodes'): *In domo Patris mei mansiones multae sunt* (In my father's house there are many mansions); this term did not carry the liturgical resonance of *tabernaculum*, and nor did it denote anything physically or socially grand. Its use in regard to what would now be called 'art' was rare. Palatial splendour was better conveyed by the term *aula* (Genesis 45:16; Kings 7:9, etc.) meaning, in effect, palace. This too could become a liturgical or para-liturgical term; thus St Ethelwold's prayer for St Etheldreda in his Benedictional says that the queen has both an earthly and a celestial court, *celesta aula*.[147] In his account

of the death of Hugh of Northwold (d. 1254), the bishop of Ely who built the new retrochoir for St Etheldreda (see pl. 35), Matthew Paris moves from describing Hugh's new and most noble sanctuary, *presbiterium nobilissimum*, to the way he prepared for himself a heavenly palace, *palatia celesta*, by his charity.[148] Around 1400 the tremendous painted assembly of figures praising the merciful Christ in Henry III's radiant marbled chapter house at Westminster Abbey – a building that is increasingly being regarded as having been conceived as much as a palace as a monastic building – was gathered together under the inscription *latreia in aula formosa* (worship in the palace beautiful).[149] The Gothic style had for two centuries proved to be as versatile a vehicle for ideas of noble domesticity (*domus, palatium, aula*) as of religion.

In any style that gives particular emphasis to formal invention such as the Decorated Style, borderlines of this type are stimulating. French portal micro-architecture of the thirteenth century was probably the most productive single area where the association of ideas that would now be considered, from a later rationalist perspective, to be 'religious' or 'secular', produced the greatest range of formal solutions. French illuminated micro-architecture is also instructive. The St Louis Psalter, made in Paris probably in the 1260s, contains an extensive series of prefatory Old Testament illustrations, which, their narrative variety and context notwithstanding, are framed by a two-bay Gothic structure reproduced with near-total regularity page after page, minor variations of detail aside. The steady repetitive effect is like the new, more homogeneous, use of repeated gablets over portal figures inaugurated on the west façade of Reims from the mid-1250s and, in its rose window and gable details, close to the interior and exterior south transept of Notre-Dame begun by John de Chelles early in 1257.[150] A similar if more varied sort of proscenium occurs in a northern French copy of *La Sainte Abbaye* (British Library MS Add. 28162) in the 1290s.[151] In the St Louis Psalter this stage set may be read spatially in two directions. The two arched and gabled zones, sustained inconveniently at their juncture by a slim colonette in such a way as to bisect and interrupt the narrative scenes, are surmounted by a second stage with regularly disposed very narrow traceried windows with intervening buttresses and pinnacles, with a shingled roof above. The lower part is seen frontally, the upper transversally, a state of affairs that would invoke the arrangement of parts more typical of a portalled transept than of a west front, were it not for the rather sheer form of the little second stage, which could be the upper storey of a southern French mendicant church, or for that matter a hall. The play

118 Paris, Notre-Dame, *clôture*, detail

with gables, tracery and narrow windows might just be a free variation on the radiating chapels and upper stages of Notre-Dame's exterior as it developed from the mid-thirteenth century onwards. So *aula* might suit these buildings better than *ecclesia*, though the point is that it is not necessary to choose. In the St Louis Psalter (fol. 85v) and its sister book the Isabella Psalter (see pl. 91), the palace of King David has square-headed traceried windows like those of the chapel of the royal residence at St Germain-en-Laye built by the Saint-Denis master in the 1230s.[152] It is possible that for the Psalter artists the chapel represented 'palace' architecture in general. A similar shift is found on the fourteenth-century choir *clôture* of Notre-Dame (pl. 118).[153] There, the sculpted scenarios from the Bible are placed under a row of linked gables, above which rise square-topped crenellated buttresses, tiny domestic-looking embattled walls with slit-like windows, and petite dormers set against the roof. Numerous little crenellated buildings occur within the scenes. The *clôture* is an unusual reminiscence, perhaps, of the rows of battlements around the choir at Canterbury of the same period (see pl. 117). A later and even more magnificent instance of this combination is provided by the tabernacle work depicted in the choir-stall paintings of Cologne Cathedral, between 1332 and 1349.[154]

This semantic mixture was doubtless especially true of courtly or metropolitan buildings or artworks in which a

certain promiscuity of formal mixture might be expected. Notwithstanding minor differences of detailing, the French courtly context has helped here more than once, not least in accounting in part for the innovative form of such English works as the Eleanor Crosses raised in the 1290s and based at least in part on a model from the circle of St Louis himself. The Crosses, displaying graceful statues of the dead queen under canopies of almost fabulous variety of form, are a *locus classicus* of canopied architecture, which, given their character as wayside abodes, might justifiably invoke the term *mansions*.[155] But quite clearly by 1300 English artists were thinking hard about the *mansio*, *aula* or *tabernaculum* in a way that made the by-then complete Eleanor Crosses particularly useful to them.

Altar decorations had already occupied the avant-garde since the commissioning of the Westminster Retable discussed earlier. A splendid and relatively unsung instance is the superb scheme of wall paintings on the east chancel wall of the parish church at Little Wenham, not far from Ipswich in Suffolk.[156] The church shows every sign of having been raised at the end of the thirteenth century, its patronage being connected to the ownership of Little Wenham Hall nearby, an early example of English construction in brick perhaps reflecting ease of access via the Suffolk coast to Flanders. The hall is now believed to have been built between 1270 and 1295 by a clerk called Roger de Holebrok, who may have been in royal service.[157] The paintings in the church were done around the end of this period. Whoever commissioned them certainly had good connections in the neighbouring diocese of London and the court. They are amongst the finest of their type and date in England, their appearance rendered unusual by the oxidization of the lead-white pigment used for flesh tones.[158] To the north of the altar are an enthroned *Virgin and Child* (pl. 119), censed by curly-haired angels and seated beneath a canopy of three bays with cusped arches and generous vine-leaf crocketing. The image resembles the enthroned Virgin and Child with saints and angels on folio 131v of the Psalter of Robert de Lisle (British Library MS Arundel 83, pt II) (see pl. 134), Westminster-related work of the 1300s in which Mary also holds a little sprouting *virga*, and where the canopy work, based on something like the courtly tomb of Archbishop Pecham at Canterbury, has grape-bearing vine-leaf crockets on the gable. In the Psalter these foreshadow the *Crucifixion of Christ* on the opposite page, folio 132 (see pl. 135); in the mural, they anticipate the sacrifice at the altar.[159] To the altar's south is an even more ambitious composition showing St Margaret, St Catherine and St

119 Little Wenham (Suffolk) parish church, east wall, painting of Virgin and Child with angels, *circa* 1300

Mary Magdalen (pl. 120) posing affectedly under canopies above which rises a second structure of roofs, gabled and crocketed dormer windows and ornate cresting, the whole composition being topped by a slender zigzag shingled spire on the model of Old St Paul's, as shown in the little drawing of the cathedral accompanying the entry in the *Annales Paulini* for the year 1314 for the consecration and measurement of the building.[160] So rich and lofty is this reredos-like fantasia of linked tabernacles that it is a reminder that within the diocese, for instance at Copford not far away in Essex (a residence of the bishop of London), there remain grandiose Romanesque chancel wall paintings packed with figures under aedicules alluding to the City of God. Little Wenham is a later version of this sort of display, linking

120 Little Wenham (Suffolk) parish church, east wall, *St Margaret*, *St Catherine* and *St Mary Magdalene*

121 Hardingstone (Northampton), Eleanor Cross, detail of superstructure

more directly to developments first traceable in the French-influenced environment of altar art at Westminster (the altar mural of St Faith in Westminster Abbey with Parisian detailing on its canopy following the high-altar retable, see pls 93, 100), and then more widely apparent in England by the 1330s, such as the triple-niched reredos above the altar in the Lady Chapel at Patrington in Yorkshire.[161]

Little Wenham's art pays compliment to such earlier schemes, but the specific character of its more recent research is readily identifiable. The buttresses and gables of the three main canopies jab upwards into the fenestrated upper zone creating the triangular layered effect beloved of the latest French portal compositions. The cusped pointed

arches directly over the saints have small neat crockets like those in the wall arcading of the Lady Chapel of St Germain-des-Prés in Paris finished in the 1250s, or the earlier dado arcading of the Sainte-Chapelle. As in the St Louis Psalter, the arrangement of gables sliding in front of a transversely viewed upper stage as if they fronted a lower aisle, like the chevet aisles of Notre-Dame, is again encountered. Some knowledge, direct or indirect, of French or related Franco-Flemish works via the sluice of Ipswich may be implicit. On the other hand, the arrangement of the three saints under canopies is essentially that found on the Eleanor Crosses such as that at Hardingstone (pl. 121), in which the gables over the Eleanor statues on the second

stage have similar radiating sprays of foliage on their faces, while the gables on the third stage reach up and in front of blind traceried windows above. Little Wenham's canopies do not pick up the sinuous ogee cusping found at Hardingstone, though they have the same creeping crockets on their top gable edge. What all this suggests is that the painters, in creating a painted equivalent of a stone altar reredos with linked canopies, studied something very like the Crosses, but, as it were, unfolded and spatchcocked the polygonal design of their second tier to form a flat expanse of connected tabernacle work. These paintings may well be amongst the earliest derivatives of the Crosses themselves. Study of English sources is implicit in the little hoodmoulds over the short traceried dormer windows of the upper stage – similar moulds over two-light traceries openings are found on Little Wenham Hall itself. But it is unclear what could have accounted for the general form of the fenestrated upper stage with very elaborate dormers and metalwork cresting: extant English instances of windows with gables in secular buildings such as Stokesay Castle hall (after 1291) are not dormers and are plainer in detailing, and in this they followed the most grandiose example of all, the great hall of the archbishops of Canterbury begun by Hubert Walter (1193–1205).[162] Perhaps the fiction was based upon some form of secular urban building now lost: the outcome is a strange hybrid.

As with the Parisian instances, it can be said that here, *mansio* and *aula* are blended cheerfully and with a speed and assurance typical of revolutionary eras of art, whose techniques of artifice and allure were constantly evolving. That these techniques involved the crafting of forms and surfaces will be apparent from the next chapter.

122 Hardingstone (Northampton), Eleanor Cross, detail of base

5

ARTIFICE AND ALLURE

But many subtil compassinges,
Babewinnes and pinacles,
Imageries and tabernacles,
I saw and ful eek of windowes,
As flakes falle in grete snowes

Geoffrey Chaucer, *The House of Fame*

Ogees

By the time the Eleanor Cross at Hardingstone (pl. 122 and see pl. 102) was designed and built in the early to mid-1290s, the ogee arch (probably from the French *ogive* or 'pointed' arch) was established as part, albeit a limited part, of the formal repertory of court masons quite as much as the miniature battlement. Ogee arches were very variable in form, but their basic constituent was a continuous curve passing smoothly from convex to concave. Their increasingly widespread use in art and architecture in north-west Europe in the late thirteenth century engaged Jean Bony in particular, because to him, as to his teacher Focillon, the ogee was by origin an exotic or 'oriental' form whose origins in some way coloured its subsequent meaning.[1] Here a little history of scholarship is unavoidable. To Henri Focillon (1881–1943), such forms had a dual significance. First, they constituted symptoms of the inner condition of an entire visual culture. In his brief but influential book *La vie des formes* (1934), Focillon set out what he saw as the life cycle of all styles, passing through experimental, classic

and baroque phases: hence he was able to think of the late phases of Romanesque and Gothic art as having an inherent kinship. This idea also pervades his chapters on medieval style in his *Art d'Occident* (1938), a text re-edited as *The Art of the West* by Bony.[2] So, in discussing 'Gothic Baroque', Focillon saw the ogee arch as a symptom of a process 'which was affecting the system to its depths' by setting architecture in motion and demonstrating the 'internal disorganization' of a once-rational style.[3] The rectilinearity of the Perpendicular Style, on the other hand, was 'the revenge of the straight line' supplanting 'the capricious sinuosities of curve and counter-curve'. This was one of the most powerful formulations shaping Jean Bony's account of the Decorated Style as a reaction against French 'classical' systematization and rationality.

Focillon's view was exceedingly unscientific: it entailed psychologizing and moralizing about art as exhibiting a sort of late-stage pathology that implied a secret desire for 'health'. He himself stated: 'Perhaps I myself suffer from a tendency . . . to look for the stability and grandeur of an intellectual "order" in thirteenth-century art.'[4] In keeping

123 Venice, basilica of San Marco, west façade, north portal

with Prosper Merimée and John Ruskin, Focillon's belief in a life cycle of forms necessarily entailed value judgements about purity and decadence.[5] In the *Seven Lamps of Architecture* (1849), Ruskin had seen the introduction into Gothic window tracery of sinuous and intersecting forms as 'a change which sacrificed a great principle of truth' that was to be 'ultimately ruinous'; it was an aspect of the 'declining and morbid taste of the later architects'.[6]

Apart from being symptomatic of the declining health of a culture – and not far behind looms the greatest account of medieval decadence, Johann Huizinga's *Waning of the Middle Ages* (1919) – such artistic forms were of interest to Focillon, secondly, in virtue of their supposed derivation from outside the natural circuit of European medieval art. The orientation of Focillon's work is obvious from his study *L'art bouddhique* (1921). Focillon was followed in this by his son-in-law and student Jurgis Baltrušaitis (1873–1944), whose book *Le Moyen Age fantastique: antiquités et exotismes dans l'art gothique* appeared in 1955.[7] Baltrušaitis was engaged by the transmission of forms and by the internal necessities driving their development. So the ogee arch appeared first in India, and was then taken up by the decorative arts of

the Tang dynasty.[8] Gradually, it moved westwards and came to articulate the Gothic taste for the fantastic. The ogee's movement and assimilation (if that is the word) illustrate Baltrušaitis's strongly syncretistic inclinations – his preoccupation with the union or reconciliation of culturally diverse or opposite practices or beliefs. The drawn figures he used to indicate this harmony or reconciliation are themselves masterpieces of syncretistic sleight of hand, his thin-line ductus reducing early medieval Tang mirror frames and Gothic stone arches to the same supple and essentially similar language of forms, while smoothing over differences of medium, technique, scale and context.[9] An important aspect of this narrative was that 'oriental' forms continued to be understood by their western adaptors as just that: things derived from an unproblematized 'east'.

In writing about the English fourteenth century, Jean Bony himself retained much of Focillon's dualistic paradigm of rationality and fantasy, and, like Focillon and Baltrušaitis, pursued the ogee arch as a 'sacred' and 'old eastern motif' from India to China via Buddhism, and thence to Asia Minor and the Mediterranean in tandem with 'other exotic forms' of supposed Islamic origin such as the barbed foil.[10] Bony particularly stressed the 'Saracenic' ogee's appearance in Venice over a series of doorways at San Marco (pl. 123) made from the middle third of the thirteenth century onwards, but he saw no necessary continuity between this and the important surge in the ogee's use in France and England later in the century, which, with a touch of Focillon-like mood-speak, he associated with *fin de siècle* romanticism. The San Marco doorways indeed appear to be the first conspicuous use of ogees in major sculpture or architecture in Latin culture, and it is important to note their sacral context, as opposed to the domestic context within which ogees flourished later in Venetian architecture. The tendency to easternize the ogee arch, and to assume that because something has 'eastern' ancestry its significations are tied down by that ancestry, is remarkably persistent. Of the ogival door lunettes of San Marco, Otto Demus wrote of an undercurrent of 'Saracenic taste'; in her study of Venice and the East, Deborah Howard notes that, though the ogee was in fact uncommon in Islamic architectural tradition, it was adopted on secular buildings by Venetian merchants as a 'trademark' alluding to a 'mental image of the Orient'.[11] According to her, emulation of Islamic models was encouraged by the casting off of the repressive yoke of Byzantium after the Fourth Crusade of 1204, which enabled the adoption of simple French-inspired pointed and then ogee arches, the latter derived from smaller Muslim artefacts such

124 Jerusalem, Aqsa Mosque, minbar (destroyed), 1168–74

sized the destabilizing character of the form, for instance in the thirteenth-century Qutb Mosque in Delhi, in which ogees are used for major arcade arches in a way almost unknown in the West, where the ogee head was used at most for doorways, and then subsidiary tracery.[14] In such cases 'oriental' practice was manifestly either unknown, irrelevant or resisted. Overwhelmingly the most common arch or dome profile found in 'Islamic' art is a variant of the four-centred arch, as a rule absent from Venetian and north-western Gothic architecture. Indeed, around 1250 by far the most confident display of what are essentially ogee arches – actually arches formed from curving dolphins, but producing ogival sub-arches – was to be found not in Venice but rather in papal Rome, in the arches over the numerous scenes painted in the 1240s in the Gothic Hall of the complex of Santi Quattro Coronati made for a prominent member of the Conti family.[15] These revived the ogival arches also made from dolphins in the Constantinian mosaics of Santa Costanza, also in Rome.[16] At around the same time, *circa* 1244, Giangaetano Orsini, the future Pope Nicholas III, commissioned his seal as cardinal: it includes an image of the Virgin Mary beneath a niche with a gentle ogee arch.[17] A reasonably observant English witness to work of this sort could quite easily have concluded that ogee arches had papal authorization, and the English presence at the curia was strong: again, Roman artists were working at Westminster no later than the late 1260s.

At stake in this discussion, however, is something more substantial: the validity of the medieval 'orientalist' paradigm as a whole, its assumptions about the otherness of Islamic art and its preoccupation with the hermeneutics of identity.[18] In its favour might be the socio-economic conditions set out in the earlier chapter on money, which favoured the quick rise of new markets and new wealth at exactly the time that the commercial and economic power of Venice was reaching its apogee and the Mongol empire its greatest extent and degree of consolidation. Fashion in dress and armour is a case in point. It might be the case that the ogival or swelling onion-dome bascinets (helmets) with spikes that appear in English knightly brasses around 1340 reflect Turkish or Persian fashions in armour of the same period, often fitting under ogival canopies.[19] Syrian or Egyptian decorative glassware with ornate arabesque forms as represented by the thirteenth-century Luck of Edenhall manifestly made its way to Europe by the fourteenth century.[20] It is not difficult to imagine – to the romantically inclined – that the energetic knightly classes sought to obtain luxury goods, or caught sight of formally 'exotic'

as the (destroyed) minbar Nur al-Din in the Aqsa Mosque in Jerusalem (pl. 124) of 1168–74.[12] The ogee is thus kept well clear of Byzantium, the early ogee-headed doorways and bulbous cupolas of San Marco being considered under the rubric of 'architectural orientalization'.[13]

In all this, the comparatively limited role of the ogee in Islamic architecture is an obstacle, since the Islamic sphere not only lacked prestigious exemplars for the large-scale use of ogees that might have influenced the course of western patronage, but also used the ogee in conspicuous positions only in rare, even eccentric, situations, which only empha-

novelties, which they wished to appropriate and eventually adorn with magic powers. So it has been necessary to identify any occasion on which English medieval patrons might have directly accessed 'eastern' art – whether Indian, Persian, Arabic or Mongolian, such as a timely English diplomatic expedition to Mongol Persia in 1292 led by Sir Geoffrey de Langley, who had a sculptor called Robert in his party.[21] Such immediacy of derivation, or purported derivation (since by 1291–2 the ogee arch was already part of the English repertory), reinforced the 'orientalist' identity of such borrowings; and it also set aside the very real possibility of coincidence, as if double-curved arches could not be generated from within a system by 'western' compass play.[22]

But is this what the evidence shows? The first stages of the narrative of the ogee in Gothic art are dominated entirely by *ars sacra*, tombs and illumination. A late twelfth-century south-western French disk reliquary of silver gilt, possibly from the abbey of Belleperche (Tarn-et-Garonne), shows a figure of Christ in Majesty within a mandorla whose top and bottom edges are turned gently into ogees.[23] A major instance may probably be placed in the 1230s: the trefoil-ogee form of the canopy over the effigy of the part-Slav Queen Ingeborg of France (d. 1236) on her now-lost bronze tomb at Corbeil, as depicted in a drawing in the Gaignières collection in Oxford (pl. 125).[24] According to the inscription on the canopy arch, the tomb was made by Hugo de Plailly (*Plagliaco*, in the Senlis-Gonesse area) in 1236 or later, though the style of the tomb is not consistent with a date after the mid-century. This arch form appears also on the recorded tomb of Pierre de Dreux, count of Brittany (d. 1250).[25] There is no serious reason to doubt the authenticity of the Gaignières record on these points.

The earliest north-western ogees in illustrations are found not in the French, but in the Anglo-Norman domain in the 1260s. Jean Bony drew attention to the appearance of an ogee in the representation of the Church of Pergamos on page 6 of the Douce Apocalypse (pl. 126). Pergamos encloses its angel beneath an arch consisting of a cusp and square barb or shoulder, on which is placed the bottom part of a swelling ogee arch whose top is markedly stiffened into a little triangular point, rather less smoothly than the little ogee 'flips' in late thirteenth-century tracery, as in the lower chapel of St Stephen at Westminster (see pl. 63) and the east walk of the cloister at Norwich. Bony omitted to note that a second ogee, this time rounded and swelling smoothly, tops out the Church of Thyatira on page 7 of Douce (pl. 127), and that yet another occurs in Douce's sister manuscript in Paris on folio 14v, this time for the *Measuring of the Temple*

125 Bronze tomb plate of Queen Ingeborg of France (d. 1236), formerly at Corbeil (Oxford, Bodleian Library MS Gough Drawings Gaignières 2 (18,347), no. 22)

in Revelation 11:1 (pl. 128). The presence of no fewer than three ogee arches in these related manuscripts suggests that the use of the ogee before 1270, in the Anglo-Norman domain at least, has almost certainly been underestimated. But what matters is the context. Bony was right to cite the epistolary text 'John to the seven churches which are in Asia' (*Iohannes septem ecclesiis quae sunt in Asia*) (Revelation 1:4), yet he continued to stress the Islamic, not Christian, derivation of the form.[26] In fact, the Anglo-Norman Apocalypses

126 Douce Apocalypse, *St John Writes to the Church of Pergamos*, *circa* 1265 (Oxford, Bodleian Library MS Douce 180, p. 6)

127 Douce Apocalypse, *St John Writes to the Church of Thyatira*, *circa* 1265 (Oxford, Bodleian Library MS Douce 180, p. 7)

had already made something of a tradition of the use of unusual barbed and arched forms for the Churches of Asia or for the Temple of Solomon.[27] Barbed arch forms were used in the murals on the window jambs of the Painted Chamber in Westminster Palace by the 1260s.[28] In Douce, the Paris manuscript and the Painted Chamber the ogee or barbed arches are all gilded, which reinforces the association of the forms with metalwork, a point already deducible from the early ogee on the bronze tomb of Queen Ingeborg.[29]

By the 1260s, then, a supremely intelligent, observant and resourceful team of Anglo-Norman book illuminators clearly made no larger claim for ogee arches than that they could stand for Christian buildings in Asia, since the sacral context of these little buildings is manifestly not Islamic. It is probably significant that almost all the earliest examples of ogee arches in Anglo-French – and indeed in Venetian – art and architecture occur in Christian sacral contexts. Contrary to the 'orientalist' idea, the ogee might have been understood no less as a Christian sign in some way characteristic of the art of the Mediterranean considered generally as an open and permeable zone of commercial and cultural exchange. The unusual shouldered or barbed ogee of Douce's Pergamos, a form then unknown in France, undoubtedly resembles such works as the minbar in the Aqsa Mosque in Jerusalem (see pl. 124); but it also occurs within high-status Siculo-Norman art as an inlaid pattern on the inside back of the twelfth-century royal throne in

the cathedral of Monreale made under William II (d. 1189) following his endowment in the 1170s (pl. 129).[30] It might therefore have been known to Anglo-Norman Gothic artists either via some Islamic source or via the intermediary of the highly assimilative Norman royal domain in the Mediterranean (William II married Joan, daughter of Henry II of England), in which forms did not necessarily retain

128 *The Measuring of the Temple*, Apocalypse, *circa* 1265 (Paris, BnF MS lat. 10474, fol. 14v)

165

129 Monreale Cathedral, throne, 1170s, watercolour by M. C. Robb, 1939

130 Aachen Cathedral, reliquary from Antioch, *circa* 1000

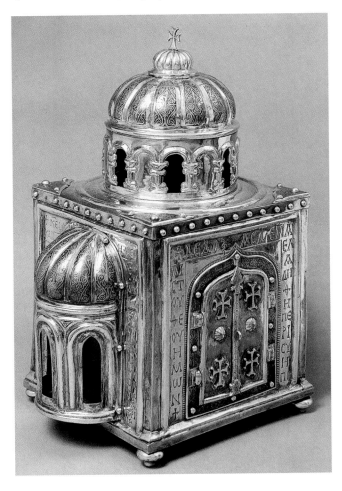

clear ethnic or religious significances useful to modern cultural historians preoccupied with hermeneutic stability. On this basis it cannot be said that by 1200 the ogee form was exclusively 'Islamic' in signification. It was also a Latin court motif.

A further argument against sole derivation of the ogee from the Islamic sphere is that nowhere in the canon of English medieval decorative art or architecture is the ogee found in conjunction with other patterns or motifs also demonstrably of Islamic origin. Motifs tend to move together in patterns of association; the ogee was at most associated with barbed quatrefoil forms whose origins lay, again, in European metalwork.

The major element missing from the discussion is certainly Byzantium itself, pressed gently to one side by 'orientalist' thinking. The ogee arched canopy over the enthroned Christ on folio 14 of the Syriac Rabbula Gospels finished in 586 proves that Byzantine art in Asia Minor had deployed this form long before Islamic art; even before the sack of Constantinople in 1204, Greek Christian objects bearing ogees in this same tradition were already known in the treasuries of northern Europe, such as the little reliquary of *circa* 1000 from Antioch with Greek script and an ogee arch, now at Aachen (pl. 130).[31] The Douce Apocalypse's use of ogee arches for its Churches of Asia reveals a deeper level of thinking and knowledge than one might expect at first. In one important regard, the ogee in both Byzantine and Islamic art shares one preponderant feature: its relatively small scale. This is as true of Byzantine *ars sacra* and illumination as it is of smaller woodwork or ivory objects of Islamic (often Egyptian or Syrian) origin.[32] The ogee arch plays a small but identifiable role in Byzantine precious and illuminated art. Thus ogival patterns appear in Constantinopolitan *cloisonné* enamel icon revetments from the eleventh or twelfth century, and ogees are used unambiguously for both arch and dome forms in courtly works of the twelfth century such as the canopy over the *Annunciation* on folio 127v of the Homilies of James of Kokkinobaphos in the Vatican.[33]

The accelerated movement of Byzantine *ars sacra* after 1204 was also a factor in this situation. In the 1230s a major channel for Byzantine court metalwork opened with Louis IX's acquisition of the Crown of Thorns from the royal palace of Constantinople in 1239. Byzantine reliquaries or lamps figured in the collection housed in the great shrine of the Sainte-Chapelle built for the purpose.[34] Once in Paris, Byzantine motifs had a second major platform, via 'canonical' Gothic. Christopher Wilson has demonstrated

131 London, Westminster Abbey, Westminster Retable, 1260s, painted enamel surface, with ogees indicated

so central to the aesthetic of the Decorated Style. Such a process would also be comprehensible in the light of the relocation of Byzantine artefacts to Venice after the sack of Constantinople in 1204, which resulted in the cladding of San Marco itself with Byzantine *spolia* just before it itself acquired ogival-headed doorways.[36] The reframing of Byzantine enamels beneath Gothic-type crocketed ogee arches in the most prestigious example of Venetian metalwork, the Pala d'Oro of the mid-1340s, shows how, to an expansive trading republic, an element of formal *diversitas* could signal its claims to be heir to Rome and to Constantinople as great empires: semiotic specificity precisely narrows that which should be understood broadly. A final point is demonstrable from the veined beauty of marble. It is manifest from the internal marble revetments of a church such as San Marco in Venice that the Rorschach-test-like mirror patterns deliberately exploited for 'reading' in such marble veneer decorations could incorporate chains of flowing and ogival forms, as is true of the basilica's north transept north wall. The ogee-headed doorways there can and should be seen in the larger context of the sort of playful patterning appropriate to the beauty of marble, suited to the pliant outline of ogival curves.

In drawing attention to Byzantium as well as Islam one is, of course, continuing to play the 'origins' game by setting up an alternative line of descent and hinting at some other stable hermeneutic. It will be apparent from what has been said here that this whole method is, if not questionable, at least not fully rewarding. Nor are origins all: things are gained, as well as lost, in translation, if translated they were. It is not impossible that ogee arches were also derived internally from within the system of Rayonnant compass play or the pliant art of the goldsmith. What really matters is why certain visual cultures are disposed to adopt, invent or exploit a form in the way they do. That which a 'system' of art eventually does with a form aesthetically is eventually as important as what that form may 'mean' originally. The ogee had rapidly become a fertile device within the English Gothic repertory of formal invention by the 1260s, and the fact that it was so useful depended upon the inherent openness of the architectural arts to conversations with other media. It would be consistent with other practices of the Decorated Style that some of its more versatile forms would originate in Lilliput, rather than Brobdingnag, which entitles one to consider especially the precious arts of illuminating and metalwork. Interestingly, the penetration of the ogee into French architecture and painting post-dated 1270.[37] There, it began to flourish only in such works as

that such motifs on the Westminster Retable as the star and cross pattern, lobed lozenges and concave-sided octagons and crosses that form its frame, and also the *cloisonné*-style patterning above its outer gables, were anticipated in the early interior decoration of Hagia Sophia, prior to their adoption in Islamic art.[35] It is important to note that one of these 'Constantinopolitan' patterns, that with lobed lozenges and concave-sided octagons that forms the glass-fronted enamel patterning above the gables over the images of St Peter and St Paul on the retable (pl. 131, compare also pl. 151), actually falls into a four-sided ogival figure. If so, the ogee might well have developed out of Byzantine, and particularly Constantinopolitan precious decorative arts associated especially with courtly relic cults, rather than from architecture – a mode of development absolutely suited to the relative conception of scale and 'minificence'

132 Auxerre Cathedral, west façade, north portal, embrasures

found in the Douce Apocalypse of barbed and ogival forms persisted in the minutely finished, metalwork-like and not satisfactorily dated reliefs of the west portals of Auxerre Cathedral (*circa* 1270?) (pl. 132). Flattened ogees of the form connecting to trefoils above as used in the Auxerre *Genesis* medallions were adopted for the extremely ductile detailing on the base of the Hardingstone Eleanor Cross in the 1290s (see pl. 122), where the inner moulding of the ogee was pulled down and into a flattened projecting cusp just beneath the tufts of foliage supporting shields, following the form of the polylobes at Auxerre.[39] Thereafter, the English occurrences of ogees are well known: the canopy buttresses of the tomb of Archbishop Pecham (d. 1292) at Canterbury; the side gables of the tomb of Edmund Crouchback (d. 1296) at Westminster (see pl. 107); the window tracery of the lower chapel of St Stephen, Westminster, begun in 1292 (see pl. 63); and the window tracery of the chapter house at Wells Cathedral of the 1290s (see pl. 181). Among the first larger-scale ogees were those used in England in the 'reredos' or eastern wall arcade of the Lady Chapel of the Augustinians at Bristol dating to the very early fourteenth century and perhaps designed around 1298 (pl. 133).[40] The ogee arches at Bristol have delicate cusped and barbed ogival tracery that perfects the tracery of the Douce Apocalypse's Pergamos. It is therefore justified to see the ogee as a floating, precious, sacral and by no means large-scale form in the period to 1300 or so.

English Gothic in the 1290s was the first version of the style in Europe to see the possibilities of the ogee in manipulating church window tracery, being followed swiftly by areas peripheral to the Parisian zone such as the Lake Constance region (for example, Salem).[41] It seems also to have used the barbed foil with greater freedom and profit. The barbed foil, also a metalwork device by origin, was a definitive motif of so-called Kentish tracery of the sort emerging no later than the 1280s, as on the cusping of the tomb of Bishop Bradfield (d. 1283) in Rochester Cathedral.[42] Its potential lay in its ability to generate strong alternating rhythms of flexible arches and sharp triangular forms. The outcome of this is witnessed in the construction of tracery motifs arranged around circular or semicircular shapes, for instance in the windows of the lower stage of the Carnary Chapel at Norwich built by John Salmon from *circa* 1315, and its neighbour the prior's doorway in the cathedral cloister, where the metalwork-like effect of the spry radiating ogees and barbs has already been noted (see pls 71, 78). It is exactly in this context of fine goldsmithy that the tiny, chain-like interlinked motifs found in the Ormesby Psalter

the later Sainte-Chapelle Lectionary (British Library MS Add. 17341), in the so-called picture book of Madame Marie produced in the Mons region in the circle of the great shrine of St Gertrude at Nivelles (Paris, Bibliothèque nationale de France MS nouv. acq. fr. 16251) (see pl. 88); and also on that shrine itself, under way in the 1270s and 1280s and complete by 1298, the terminal elevations of which resemble Thyatira in the Douce Apocalypse (see pl. 127) in combining galleries and broad soft ogees placed over pointed arches, again reinforcing the extent to which the ogee was especially at home in a sacral metalwork milieu.[38]

It was in fact from within this melting pot of English and north-eastern French practices that the particular solutions of the 1290s in England seem in turn to have developed. By the late thirteenth century the connection already

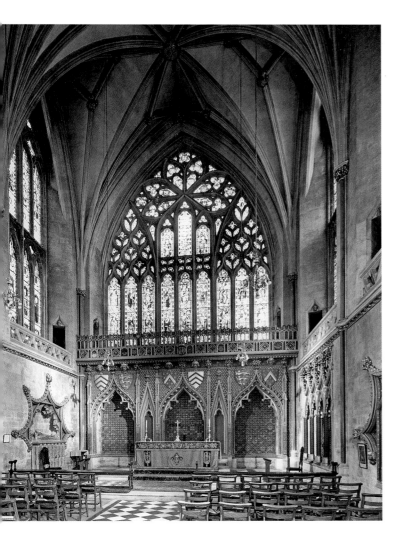

133 Bristol Cathedral, Lady Chapel

from Thame in 1310–11; and it occurs in manuscript illumination datable to the period 1310–20, notably in a series of monastic commissions in the Midlands and Fenlands: in the Tickhill Psalter (New York, Public Library MS Spencer 26), in hand in 1313–14; in the Ramsey Psalter possibly still in hand in 1316 (see pl. 77); and in the Peterborough Psalter in Brussels (Bibliothèque royale de Belgique MS 9961–2), possibly complete by 1308 and certainly by November 1318 (see pl. 271), where an extraordinary array of flattened cusped ogees framing some of the typological miniatures serves to indicate either how much has been lost from the field of architecture or how far the miniature arts went in experimentation.[44] In the Peterborough manuscript the sheer number of typological miniatures forced the painters into a bravura display of variety.

Curvilinearity

What this may indicate is that, for the English, ogival forms had a particular eloquence, a sort of rhetorical energy. This can be demonstrated in practice by situations of choice, for instance two of the most beautiful micro-architectural and figurative compositions of the 1300s, the confronted *Virgin and Child* and *Crucifixion* on folios 131v and 132 of the Psalter of Robert de Lisle (British Library, MS Arundel 83 [II]) (pls 134, 135).[45] Here some sort of option was clearly open to the artist, and he took advantage of it to create a special language of enshrining. On folio 131v the Virgin, Child, angels and saints are housed in a true *tabernaculum* similar in all regards to the courtly tomb compositions of the 1290s at Canterbury and Westminster (for example, pl. 107). The forms are sharp and crisply alert, canonically Gothic. But opposite, the *Crucifixion* is wound around with the most startling ogival forms, here upright, there arranged horizontally for the arms of the Cross. It is not wrong to liken this to the arrangement of a traceried window such as that of the Mayor's Chapel in Bristol; and yet the contrast with the placid erect classicism of the *Virgin and Child* tabernacle opposite seems conscious, as if the ogee were itself a commentary on the theme of Christ's own agonizingly bent and curved frame. These two images form a diptych and offer a sort of mutual commentary; they are to be experienced against one another in their different styles.[46] The artist of the embroidered cope in the Lateran (probably given by Edward I to Boniface VIII before 1303), who arranged the *Crucifixion* within swelling bends and curves (pl. 136), thought similarly in using the radiating cusped

(Oxford, Bodleian Library MS Douce 366) should be placed; the Ormesby Psalter is probably Norwich work of this period, and a decade or two later actually found its way into the possession of the subprior's stall of the same cathedral (see Chapter Nine). Given the strong tradition of interlace in English manuscript art and embroidery since the Insular period – witness the catenas of quatrefoils on the Syon cope – the invocation of specifically Islamic sources to explain such bijouterie is unnecessary.[43] The pliancy of form and common use of ogees in English embroidery are the final demonstration of the sacral origins of the motif.

The ogee's general entry into the figurative arts in England from the decade 1300–10 onwards was strong and assured. It is found in the glass of the side windows of the chapel of Merton College, Oxford, delivered by wagons

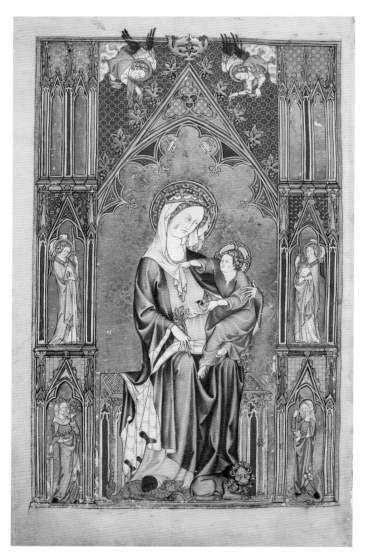

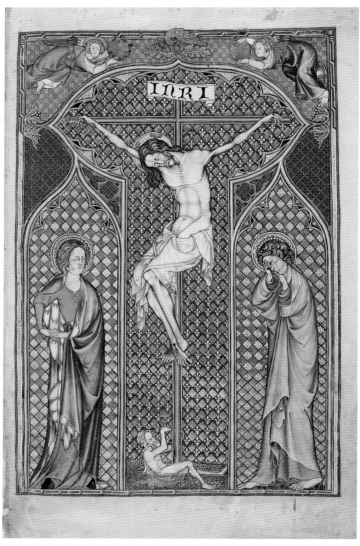

134 *Virgin and Child*, Psalter of Robert de Lisle, *circa* 1300–10 (London, BL MS Arundel 83 [II], fol. 131v)

135 *Crucifixion*, Psalter of Robert de Lisle, *circa* 1300–10 (London, BL MS Arundel 83 [II], fol. 132)

forms to follow Christ's arms, rather than the Cross itself.[47] It seems anachronistic to think of the ogee as an 'expressionistic' device: indeed, Pevsner's particular form of expressionist thinking led him to a similar conclusion about such ogees as those in the De Lisle Psalter by emphasizing its embodiment of passion not just in the figures but in the entire network of lines.[48] For the present writer, Pevsner made the mistake of assimilating this use of expressive line to the idea of English irrationality. I would put it differently: in the De Lisle Psalter, the quickening of sensibility and deepening of biblical allusion that the serpentine forms bring about is cool and deliberate. Christ's bent and tor-

tured form on the Cross has exegetical and affective depth – 'but I am a worm and no man: the reproach of men and the outcast of people' (Psalm 21:7) – and in turn softens and bends us.[49] So much was recognized in the thirteenth century when at least one reactionary critic noted that the iconography of the Crucifixion itself was being changed in order that it might look more painful.[50] 'My soul melted' (*anima mea liquefacta est*) (Song of Songs 5:6), are words given to the Virgin Mary swooning at the base of the Cross. An affective account of an artificial form is not, in fact, inauthentic to the newly rhetorical arts of the period, for artifice is always a means of enriching religious experience

subliminally yet rationally. It is therefore important to understand that the use of formal devices in this way is not a search for ideas or images 'expressed' by the art, nor a means of symbolizing or emoting: it is a way of underlining and emphasizing allusion. Its character is indicative. Another notable point in the De Lisle images is the way in which the forms are affective in a way that the people are not: their quiet restraint – actually very typical of the arts in England after 1300 – is almost a foil to the lines of emphasis. Such were the forces that the ogee, whatever its origins, was capable of unleashing. Perhaps one should move beyond consideration of the sources and 'identity' of the ogee towards apprehension of its power.

Only practical criticism can flesh out these ideas. In the next chapter I will examine these ideas more deeply in regard to the great works at Ely cathedral priory begun in the 1320s, in order to ponder the role of signification at the simultaneous level of structure and surface in the formation of the aesthetic of a building such as the Lady Chapel (see pl. 154). Significatory thinking, I will suggest, in fact forms not just a part of some hinted-at level of ulterior meaning located just beyond the surface or imposed upon it after the event, but is actually a fundamental part, a part 'within' so to speak, of the Lady Chapel's *dispositio* or arrangement, for it is here that the 'thinking' of the building begins and then flows up out onto the surface, its colours and forms.

Ely is perhaps the central instance of the aesthetics of nurtured complexity that so tested the boundaries between the natural and the artificial in an age that, to my mind, was disposed more to the latter – I think for instance of the labile architectural components of the Lady Chapel's wall arcading. The Decorated Style revelled intelligently in conceits that used this boundary of incongruity to flesh out exegetical wit. Here curvilinearity played a part. An example of the way window tracery displayed conscious variety is provided by the eastern extension of Dorchester Abbey in Oxfordshire, probably of the 1330s (pl. 137).[51] Like Bristol, Dorchester is an instance of the highly inventive commissioning typical of the fourteenth-century Augustinian canons. The extension placed at its centre an unusual reticulated east window, and to its south an elaborate set of canopied sedilia below a window with rectilinear tracery and small figurines attached to its mullions just above the transom. In a display of variegation of the sort experienced in the De Lisle Psalter, on the north was yet another window with curious flowing tracery branching in stacked Y-shaped formation from a central stem, depicting the *Tree of Jesse* with, again, small figures of the Prophets and Ances-

136 Rome, Lateran, embroidered cope, detail of *Crucifixion*

137 Dorchester Abbey (Oxon.), Jesse window

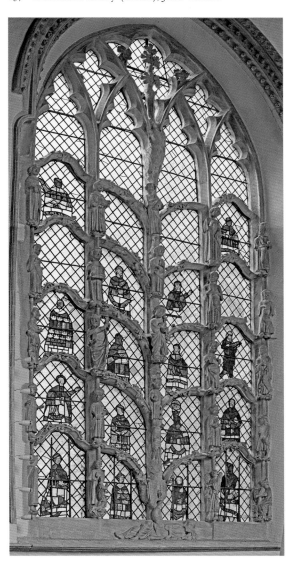

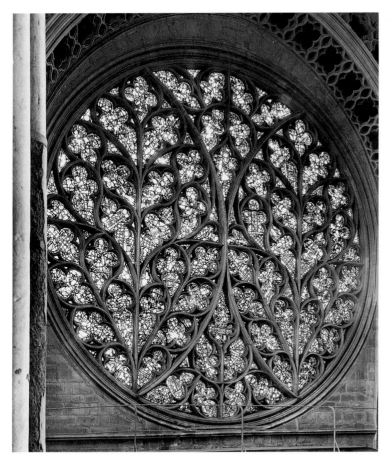

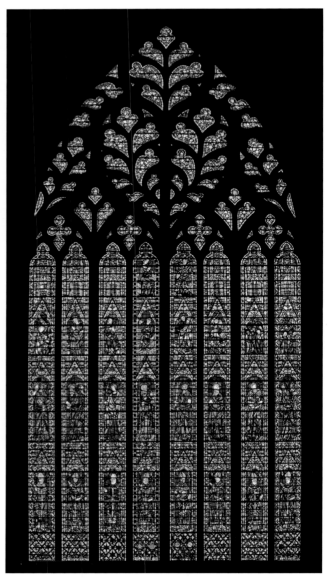

138 *(above)* Lincoln Cathedral, south transept, rose window

139 *(right)* York Minster, nave west window, completed 1339

tors of Christ attached to its mullions and an image of the Crucified at the top; additional images of Prophets are set into the glass, so perception shifts from one medium to another in a seamless switch from surface to surface, opacity to transparency. This ludic shift from the organic to the inorganic, the solid to the transparent, could be allegorized at will, and was to be a fertile focus of Gothic invention in, for instance, late fifteenth-century Germany.[52]

Given that English window design was probably the single most widely influential aspect of the Decorated Style, the imaginative attention given to it at this time can hardly be overstated. One important consequence of the gradual mutation of geometrically formed Rayonnant tracery into the softer ductile shapes permitted by the ogee double curve was that English window tracery lines quickly developed a formidable freedom of line associated with 'flowing' tracery. Flowing tracery is already present in tiny details on the Hardingstone Cross, for instance on its topmost tier (see pl. 121), and ogee reticulated tracery, produced, as Francis Bond showed, by cutting the tops and bottoms of linked circlets, seems to have appeared no later than *circa* 1300–10 in the cloister at Westminster Abbey (see pl. 211).[53] Remarkable instances of flowing tracery appeared by *circa* 1320 in the projects commissioned by Bishop Salmon at Norwich (see pl. 74); after 1330 or so at Grantham parish church; in the huge oculus of the south transept at Lincoln Cathedral; and in the expansive east windows permitted in the northern region by the high, flat, east wall terminations at Carlisle and Selby, and the west nave window at York finished in 1338–9 (pls 138–40).[54]

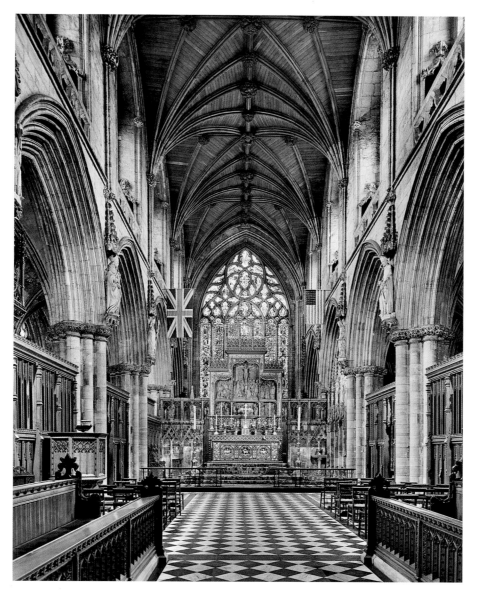

140 Selby Abbey, choir and presbytery

The absorbing complexity and sheer scale of such windows, beginning in the mid-thirteenth century in the great flat terminal walls of Westminster and Lincoln (see pls 22, 45), seem to have been associated with a certain self-conscious poetics that enabled these displays of luminosity to be placed at the centre of more elaborate image systems.[55] Such poetics were perhaps more explicit in England given the greater use there of interior sculpture on the main elevations of great churches. But the idea that large brilliant windows were in a sense objects of affective attention was plainly not only English. In France, the new requirement was for tall, skeletally thin, glassy and spacious buildings whose ambitious upper parts would not twist or collapse (see pl. 17). This brittle yet dazzling ossature of stone, eventually ruled by a strict geometric matrix, left less room for flesh, and surface. The possibility that this extraordinary inversion of the common-sense properties of a material such as glass was in some way perceived as actually miraculous, though not enunciated explicitly, is indicated by the attention given by observers to the vaults and windows of French buildings of this era, where it can fairly be said that their attainments surpassed anything that had ever been seen. Jean

173

de Jandun's celebrated – and in their focus on design very unusual – comments on Notre-Dame and the Sainte-Chapelle in 1323 are a case in point: his longest passage on Notre-Dame, immediately following his remarks on its vaulting, concerns its two transeptal rose windows, called by him 'o's after the fourth vowel, which have within them 'smaller orbs and circlets of wondrous artifice, some arranged thus circularly, others angularly [which] surround windows glowing (*rutilantes*) with precious colours'; in the Sainte-Chapelle (see pl. 24) is noted the 'beautiful transparency of the glowing red windows all round' – a halo of brilliance indeed, echoing Suger's notion of *lux continua*.[56] Jandun's Gothic reverie – which ends with rapture, being 'carried off' – is of interest here not least because of his model of proportionality between the external elegance of these buildings and the inner beauty of the worshippers within (for proportionality, see p. 60). At no point could such pleasure be described as just sensuous despite its origin in the senses. In Jandun, as in the earlier Neoplatonists, a process of revelatory enlargement and self-transcendence is at work. It is also most unlikely to be coincidental that the rose windows of Notre-Dame as well as those of its nave and radiating chapels exerted extraordinary influence on European Gothic within a very few years, not least at Westminster and St Paul's, buildings large and affluent enough to accommodate such architectural pyrotechnics.

But not all such imaginative thinking was in the – actually rather rare – anagogic vein. By about 1330, particularly in the east and north of England, such window tracery may have come to seem as if it were in some sense mimetic: order was sought in complexity by the instinct of 'seeing as'. The south transept rose at Lincoln (see pl. 138) is very reasonably perceivable as two giant vertically arranged leaf forms with veins, a departure from any idea that this window, the so-called bishop's eye (after the Metrical Life) might be ocular in form ('seeing as' was in fact a natural objective of allegorical exposition of building). By the time of the mature phase of the Decorated Style from the 1320s onwards, it is likely that such open and ornate windows had gripped the poetic imagination and were an aspect, perhaps the major aspect, of *sublimitas* in such structures, and certainly *subtilitas* – Chaucer's *subtil compassinges*. The same was undoubtedly true of the large Perpendicular windows of the sort at the east end of the choir of Gloucester Abbey, glazed in the 1350s.[57]

Because the imagery of foliage forms is so important to Gothic art of this period, it seems natural in the first instance to see the new melting and curving shapes in English tracery in the east and north of England especially as following the cadence, spring and curl of vegetation, not least in virtue of their complex systems of 'veins', as in the leaf-like shapes of the Lincoln transept. But such forms are often ambivalent, and so suggestive of other possibilities. Another object that was coming to be represented as a leaf-like lobed or scalloped form in the period 1300–50 was the human heart itself. This was often shown as a pear-shaped object held point upwards, but after 1300 or so a new form (the 'iconic' one) had started to appear point downwards with the familiar two-lobed top.[58] The imagery of the heart as a site of the affections was never more important than now. Earlier I cited a passage on the rhetorical, and also spiritual, relation of beauty and disposition – the so-called *pulchritudo cordis* – in Bromyard's *Summa*, a work of the second quarter of the fourteenth century. In the same passage Bromyard goes on to say that the *intentio* or affect of the beautified Christian heart should be directed and indeed opened first to God, just as in a church the more beautiful parts, together with the most beautiful windows, face eastwards, by means of which the whole church is lit up and adorned; thus too should our hearts be open to God, who, like the sun, rose and dwelt among us.[59] Bromyard's words are figurative, metaphorical, an intensely affective form of 'seeing as' that brings something to the idea of a window. But the possibility that some intelligent critics saw Christ and sun imagery in, or radiating from, the huge windows at the east end of English churches had no doubt already been opened up before 1280 in the Angel Choir at Lincoln Cathedral (see pl. 45). Such were the poetic consequences of the adoption of the large multi-light Rayonnant window. Bromyard's vividly affective language takes on particular intensity in the light of the exactly concurrent tendency of the 1330s and 1340s, in some major English church windows, of curvilinear tracery actually to resolve into what was becoming the new scalloped heart shape in the window head, as in the 'Heart of Yorkshire' west window of the nave of York Minster itself, ready for glazing no later than 1338–9, or less emphatically in the great east windows at Selby Abbey and Heckington of the same period (see pls 139, 140, 248). The ambivalence of the form – plant or flesh? – cannot be entirely set aside, yet it is interesting that the stained glass of the west window at York contains Eucharistic symbols (the Pelican, the *Agnus Dei*) in the apertures immediately beneath the heart-like form.[60]

Clearly Bromyard was not setting out an idea for a window. He was associated with western England, not Lincolnshire or Yorkshire where curvilinear window tracery was

paramount; nor are such windows 'illustrations' of his sentiment. The question is how forms both instil and attract affective reading. In the De Lisle Psalter lies an affinity between the affectivity of the Crucifixion and the serpentine ogee arches of its window-like tracery. A similar idea, again with the Yorkshire–Lincolnshire zone of flowing tracery, is found at St Peter, Barton-upon-Humber, where a window in the north aisle has a little Crucifix carved with other figurines just at the point where the flowing tracery branches out into the window head in a way originally found in the Jesse window at Dorchester.[61] In watching a window resolve as if by a movement into a heart shape we may also understand how an ostensive if paradoxical form, that of a heart (or a Cross) in a window, can provoke that sudden shimmer of wonder that moves us to follow or develop a train of thought: as Grosseteste argued, it is we ourselves who are the Temples of God. Tracery evolved in England as a technology of knowing delight, a sign of the virtue of complex variety as rich with exegetical possibilities as the richness and the veininess of marble in the ancient world.

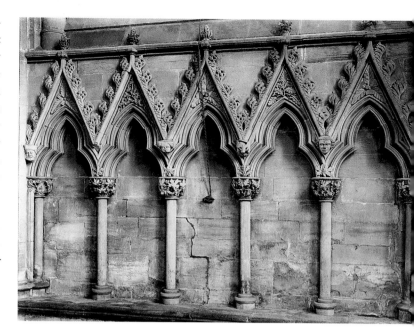

141 Southwell Minster, chapter house, wall arcade, late thirteenth century

The Onward March of Science?

The supreme artifice of such works inevitably falls into a relation with the brilliant observation of the natural world that is often taken to be a defining character of the arts in north-western Europe from the middle of the thirteenth century. Not that the artfulness of such 'naturalistic' or 'Aristotelian' triumphs as the sculptures of Reims and Naumburg is in question: recent commentaries have tried to stress precisely the calculated and artificial nature of coloured lifelike sculpted human representation.[62] Yet by common consent this extraordinary phase in the arts of sculpture in France, England, Germany and Spain had run its course by no later than around 1300: figural representation and carved foliage especially had already begun to retreat into a world of the self-referential and abstract. In England at least, this was no more than the restoration of a norm: since the late twelfth century the English had produced extraordinarily vigorous but essentially abstracted foliage carving called 'stiff leaf' which owed as much to the forge as to mother nature, a form of analogue foliage that possessed squirming vitality and a touch of the supernal in its linkage of the sacral arts and things observed in life. The trick of capturing the literal appearance of oak, vine, ivy and other leaves proved to be a fashion inaugurated in the 1240s at Westminster under the influence of Reims and

Paris, sparkling at Southwell Minster (pl. 141) in its chapter house around 1290, yet less prominent during the first decades of the fourteenth century.[63] The pattern in book art is the same, though some English Gothic illuminators never lost touch with the great Byzantine tradition of plant design that they had used into the thirteenth century: the south-eastern English Windmill Psalter (New York, Pierpont Morgan Library MS M 102), made as late as the 1270s or 1280s, also under Parisian influence, still used Byzantine blossom foliage side by side with 'real' leaves on its page to Psalm 1 (fol. 1v).[64]

In place of the very short-lived regime of imitation arose a species of wonder-foliage, at first shaggy and generous, then seaweed-like, bubbly and knobbly, undulating, crawling and spinning in a way improbable in biology, consciously disregarding the empirical and the natural, reaching beyond the criteria by which reality can be judged – actually a foliate phantasmagoria beyond anyone's dreams. These new effects are seen within the limitations of Rayonnant at York by 1300, but especially on those smaller constructs that aim to delight the viewer, such as the tombs at Winchelsea (see pls 58, 106), the bravura wall arcading in the Lady Chapel at Ely and the chancel monuments of Lincolnshire and Nottinghamshire (see pls 115–16, 223–4); some of these vegetal effects had been inaugurated on woodwork objects such as the bishop's throne canopy at Exeter around 1315 (see pl.

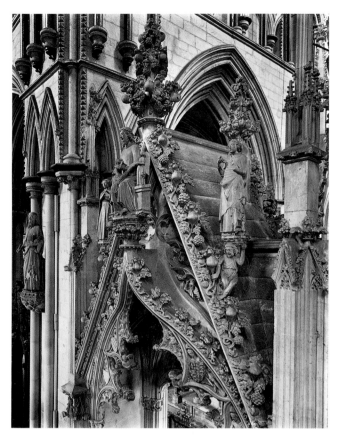

142 Beverley Minster, Percy tomb, 1340s detail of canopy (see also pl. 170)

103). They culminate on the canopy of the Percy tomb at Beverley Minster (pl. 142), a textbook contrast to Southwell. In the course of these decades this new style of foliage became a norm within the European Rayonnant system as much as within the Decorated Style; it may be greeted at Bayonne as much as Bury St Edmunds. That clever design thinking was at work in the underlying choices will be obvious. The new undulating forms of foliage followed and completed the lines of a new architecture of substance and curvature, in the same way that the flattened regularity of mimetic foliage complemented the dry sharp geometrical matrix of late thirteenth-century design, notably window design in which snowflake regularity yet variety was the order of the day. Such undulating foliage was not, in fact, technically easier to realize than the Southwell type of foliage, as a scrutiny of the brilliantly perilous undercutting of fourteenth-century foliage forms at Lincoln and Ely shows. It also offered greater inventive possibilities. The freeze-dried naturalism of Southwell – never were the

words *nature morte* more apt – was quickly recognized as a sort of inventive trap that not only circumscribed specific formal invention but, more problematically, also inhibited the telescopy of scale, that shifting from Lilliput to Brobdingnag so central to the aesthetics of the Decorated Style.[65] An oak leaf has a finite natural scale, and this was understood by late thirteenth-century English carvers who placed such leaves at levels near the eye where their natural scale plausibly underwrote the illusion, as in the chapter house arcading at Southwell. But it is precisely any absolute sense of scale that the Decorated Style challenged: its needs were better furnished by hyper-real foliage that could expand and contract miraculously, here pressed impeccably into the tiniest spandrel, there swelling into vast strange leaf forms, spreading indomitably across much larger surfaces in a way that would destroy the plausibility of naturalistic reference. Examples are the tombs at Winchelsea, the pulpitum at Exeter (see pl. 105) and the south wall niches of the anteroom to the Berkeley Chapel at St Augustine's in Bristol (pl. 143), where concave gables sprout immense flabby-looking single leaves of hyper-foliage.[66] The demands of hyper-reality provoked a rejection of the crisply banal integument of oak and vine leaves in favour of a surpassingly weird order of nurtured complexity.[67] At this point Gothic artifice quite clearly insists that it is superior to nature, indifferent to its accidents. This claim was implicit in art–nature texts such as the Metrical Life of St Hugh: now art made it explicit.

This ordered complexity lies at the heart of any discussion of the relation of artifice and imitation. Earlier, I criti-

143 Bristol Cathedral, Berkeley Chapel anteroom, south wall, detail

cized what I consider to be simplistic orientalist models for understanding out-of-the-ordinary forms. At stake now is another analysis, developing in the middle of the twentieth century, which perceived in English art a cultural inclination towards empiricism and observation – which I shall call the 'onward march of science' model propounded by one of the greatest authorities on the Decorated Style, Nikolaus Pevsner (1902–1983), in his studies of *The Englishness of English Art* (1956) and, above all, *The Leaves of Southwell* (1945). The aim of Pevsner's essay on Southwell was to show how the late thirteenth-century carved foliage assumed 'a new significance as one of the purest symbols surviving in Britain of Western thought, our thought, in its loftiest mode'.[68] The theory was a simple, in fact a more or less classic 'rise of rationality' one: the emergence of Aristotelian natural science in the thirteenth-century universities somehow brought in its train an interest in the visual arts in a nominalist, particular description and representation of the observable living world. This, in Pevsner's words, exhibited a 'balance between science and revelation or between experience and authority such as Europe had not known since the days of Aristotle': Panofsky too heralded it as the 'victory of Aristotelianism'.[69] Pevsner's larger agenda was in part to establish a lineage for the English national tradition of empirical scientific enquiry: in his Reith Lectures on *The Englishness of English Art* he said: 'Whether one thinks of the Utilitarians of the nineteenth century or of Francis Bacon or of Roger Bacon, Duns and Occam, they all have in common their unshakable faith in reason and experience.'[70] There is more than a whiff of Whig history about this belief in the inevitable onward progress of English science, a touch of secularity in the foregrounding of the domain of science, and – it should be noted – a disinclination, in Pevsner's case, to consider the implications of the reversal, or superannuation, of these 'scientific' traits after 1300. Panofsky, however, took this head on by arguing that the shift of the system away from this 'Aristotelian' mode indicated flight from reasoned enquiry towards mysticism and subjective sophistication, one feature of which was a new preference for 'somewhat archaic solutions' and a 'revival of a pre-Gothic tendency toward the abstract'.[71]

The radical mimetic phase of Gothic art, of the 1240s to around 1300, was fairly short, and it should not be surprising that those seeking a latent empiricism in the Middle Ages would have been attracted by that phase's apparent interest in the surface actuality of things, the scientific–rationalistic standpoint being naturally drawn to the mimetic. In regard to empirical practice, though, medieval intellectual life was relatively weak, at least in comparison to the thoroughly unrepresentative scientific revolution in western Europe a few centuries later. The dazzling feats of mimesis apparent in mid- and late thirteenth-century sculptural art in France, England and Germany did not exactly endure into the next century: the 'look' (and I mean not least the physiognomical 'look') of much fourteenth-century English sculpture bears nothing of the psychology, that charismatic-seeming flashing out or *corruscazione* of the soul (as Dante put it), apparent in the arts of Westminster or Lincoln, or Reims or Naumburg.[72] This reorientation or even retreat from the domain of the psychologically apparent is hard to reconcile with a linear narrative of mimetic 'progress'.

And there is a further problem that has to detain any serious discussion of the lofty domains, not of the normal but of the super-normal, of religious sensibility and aesthetic engagement in representing physical things more generally. As Caroline Bynum understood in relation to the representation of the human body in this period, a sort of paradox is encountered that challenges an Aristotelian-derived account of mimesis: that it was in fact Platonic or Augustinian or Franciscan thinkers, 'those with the sharpest sense of body/soul conflict', and 'the most ferocious ascetic practices', such as St Bernard, who (to quote Bynum) 'had the clearest and most passionate awareness of the potential of the body to reveal the divine'.[73] It seems to have been specifically within the ascetic or the mystical-revelatory mode that the figurative arts in northern Europe towards and around 1300, and in such works as the Douce Apocalypse and the Rothschild Canticles, took the body as a thing to be arranged and clothed in brilliance, in such a way as to enthral us with a display of movement, of physical marvellousness, that is still vivid and elevating and slightly odd.[74] That this hyper-mimetic mode was religiously and ethically directed, not 'scientific', as well as being astonishing in itself, seems to the present writer to be beyond dispute.

The widespread use of angelic imagery from the thirteenth century onwards seems especially to have focused the inventive resources of artists, sculptors particularly, on the body as a vehicle for states of revelation, dream or ecstasy. In the Douce Apocalypse it is generally the angels who convey exaltation and rapture through the difficult or unexpected character of their postures, and I have traced the same supercharged manner in the angelic imagery of the famous choir at Lincoln (see pl. 45).[75] This period, the 1260s or so, was laying the groundwork for later subtleties. It may be coincidental that a former dean of Lincoln, Roger Mortival, bishop of Salisbury (d. 1330), was provided with

144 Salisbury Cathedral, tomb of Bishop Mortival (d. 1330), detail of canopy

a tomb in the north choir aisle at Salisbury Cathedral of fine canopied type (pl. 144), the broad swelling central arch of which is topped not by bulbous crawling crockets but by little angels pensively or dreamily resting their heads on their hands in a way that looks, but may not be, Mediterranean in derivation: there is a certain Gestalt wit in the angel–crocket 'switch'.[76] The semantic range of this posture should also be noted, suggesting as it does the pose of Jesse (reredos of Christchurch Priory, Hampshire) (see pl. 279) or St John the visionary rapt on Patmos. It was chosen for the pair of angels in the slightly later low reliefs over the central door of the west front of Exeter (see pl. 300), leading in to the tomb space of Bishop Grandisson (d. 1369), the patron.[77]

The Douce Apocalypse is a monument of supreme technical ability to the emergence of the aesthetics of the Decorated Style, as interesting for its invention of micro-architecture as for its position in the history of painting at Westminster around 1260. But its prophetic nature I think goes further: in it is embodied, in muscle, skin, fur and hair, that elated, engaging, painstaking and seductive *curiositas* of much representation, in painting but especially in sculpture, of the next two generations of artists in England. The Douce master's 'tactile values', sombre colouring and grasp of the curvature and poise of human movement are not that of a mere book artist, but of a sculptor alert to the gravid weight and texture of things, pregnant with possibility: the delicate colouring and delightfully worked surfaces of the sculpted narratives about the Virgin Mary in the Lady Chapel at Ely

are in exactly this manner (Chapter Six). His art's physical marvellousness was the final resort of the heroic mode of the previous century or two, some of whose most striking bodily metaphors anticipate Douce's physicality. Compare the pick-a-back giants and dwarfs, Prophets and Apostles, in the south transept glazing at Chartres Cathedral (see pl. 26), and the dazzling image in Douce of St John carried rapt on the back of the angel towards the Heavenly Jerusalem (pl. 145). John grips his wrist firmly round the angel's waist as it, in turn, hauls up the visionary's weight with his right arm and points, simultaneously, to the New Jerusalem ahead. In the visual arts this sort of athletic motif emerged no later than eleventh-century Rome, and, in virtue of the Douce master's extraordinary range of intellectual reference, it should be recalled that shoulder carrying is a common motif in Greek and Roman art and heroic thought. In the *Aeneid* (II.804) Aeneas carries his father Anchises on his back but, even more strikingly, in Ovid's *Metamorphoses* (XV.148–52) a Pythagorean stands on the shoulders of Atlas to expound knowledge hidden from the ancients:[78]

> The great Unknown than men have never seen
> Shall be the things I sing, the first and last.
> So let us walk the skies among the stars
> To see earth fade in dreary wilderness,
> Ride clouds in glory, climb to Atlas' shoulders.

145 Douce Apocalypse, *St John Carried to the Heavenly Jerusalem*, *circa* 1265 (Oxford, Bodleian Library MS Douce 180, p. 92)

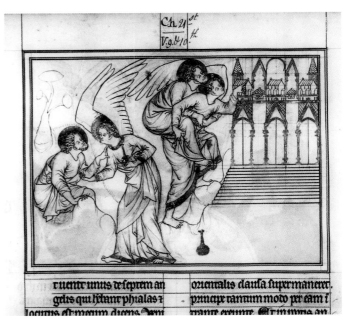

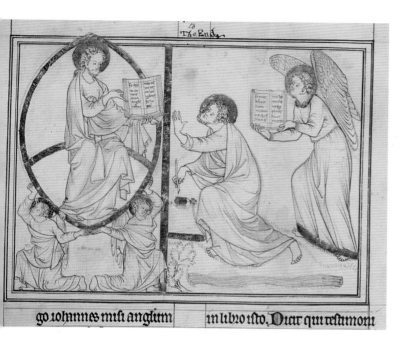

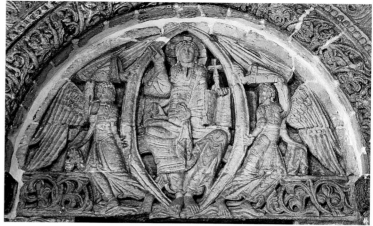

146 *(left)* Douce Apocalypse, *St John before Christ*, *circa* 1265 (Oxford, Bodleian Library MS Douce 180, p. 97)

147 *(above)* Ely Cathedral, prior's door, *circa* 1135

Well might one think of the angel with the millstone in Revelation 18, whose strength is beyond human comprehension, as being a medieval Hercules. Around 1200, and again around 1260, a sublime physicality was connected to astonishing powers of observation and invention.

And there is a further continuity. In discussing the Decorated Style in architecture I have already commented on the profound, indeed explicit, sympathy that fourteenth-century designers often felt for the imaginative, inventive and physical powers of their eleventh- and twelfth-century forebears. In any comprehensive theory of the arts in this period, the same sort of sympathy should emerge in the field of representation. I do not think it remotely surprising that the Douce master himself also summoned up 'Romanesque' solutions in his successful efforts to embody the wonderful. So when on page 97 of the manuscript Christ explains his revelation to St John, he turns towards the saint within a mandorla propped up on the shoulders of two symmetrically placed atlas-like angels (pl. 146). These are citations of Romanesque examples of Christ within a mandorla supported by angels who turn dramatically outwards but bend backwards, as in the *Ascension* scene at the top of the east Crucifixion window in Poitiers Cathedral provided by Henry II before 1189, the sculpted tympanum of the prior's door at Ely Cathedral (pl. 147), or the even earlier portal at Anzy-le-Duc (Saône-et-Loire).[79] French late Romanesque and early Gothic sculpture continued to be a source for marvellous and strange solutions in England

well into the fourteenth century, as on the tomb of Sir Richard de Stapledon (d. 1332) in Exeter Cathedral, which bears cusps ending in human heads in a way found earlier on the west central and south transept doorways of Bourges Cathedral (pls 148, 149). To reiterate, this is most definitely not a matter of historicist 'citation', 'retrospection' or 'archaism', as Panofsky put it earlier: it amounts to a collation of known existing solutions newly and consciously deployed for their continuing enjoyable energy and power to provoke.

Artifice and Allure:
Surface, Colour and Social Outcome

Because the agency of things — and it must be admitted how elusive that agency is — stands at the centre of the present book, it is necessary to explore what the Decorated Style actually 'did'. Mimesis alone is not the starting point here. I have already indicated that it is better not to think of these arts as solely or essentially mimetic: to see their final ambition simply as imitation is a weakness, an imaginative deficiency, of the 'scientific' argument. 'Illusion' is a rationalistic category produced by Renaissance and post-Renaissance epistemology, which weakens a sense of the way that artefacts possessed agency, produced sensations and feeling rather than replicating them.[80] Experience is specific: in suggesting that a thing persuades simply because it is persuasive, we fall into tautology. At their greatest, these arts

148 *(above)* Exeter Cathedral, tomb of Richard de Stapledon (d. 1332)

149 *(right)* Bourges Cathedral, west front, central portal, mid-thirteenth century, detail

deployed both imitation and artifice to brilliant and persuasive ends. To persuade is to bring someone *to* something, so involving a transitive movement towards a judgement *about* something. That the practices of this style had a general design on its observers is clear: its art (historically viewed) was intended, I think, to work within a milieu of exchange nurtured ultimately by the Christian doctrine of suffrages, explored in Chapter Three, which entailed capturing and winning over the observer in order to gain, as well as to dispense. (This last point exposes a weakness in notions of 'reception' that are passive, overlooking the affective or active dimension of response.) It is for this reason that one cannot necessarily sever the effects of artworks from thoughts about religion, the saints, the good life, power, giving and so on.[81] That the greatest artworks of the time aimed artificially to build special, and (more rarely) exalted worlds which the commissioners, artists and observers all entered and then, reason engaged, inhabited with conviction seems to me consistent with the harnessing of so many

different media (architecture, sound, music) at considerable expense to create occasions that can still be understood (very generally) and enjoyed.

It is not the aim of such a discussion to suggest, mechanistically, that the Decorated Style inevitably produced a certain response, far from it: in trying to understand why things were intended to have the power to attract one can at most think of a predisposition, a general plan of attack, rather than a formula or prescription for an experience. Experience necessarily depends on subjective attention and on the particular occasions (viewing, liturgy) in which the objects as well as the subjects participate – what might be thought of as 'situational agency'. For this reason it is contingent and not readily replicated. Because it was (and is) social and psychological, such experiences are, paradoxically, absolutely specific and yet hit-and-miss: from an historical point of view, at almost no point is it certain who the audiences of many of the works discussed in this book were, how 'elite' or otherwise their educations and presuppositions

were, and whether they remotely enjoyed the outcome. The fact is that people disagree about things both beautiful and true. The Decorated Style was at most geared to stimulate a certain sort of stance (affective and intellectual) towards it in turn, and this can only be established by inference.

The least common of these experiences was 'wonder': the sort of outcome in which judgement and feeling might momentarily be suspended in the face of some grand experience of the sublime or transcendental.[82] Art experience is not as a rule like this: it is more ambivalent, operating within the norms of nature. Virtually all significant experiences of buildings or ambitious artworks begin as sensory experiences of a sort of complexity, of *varietas*. When one says that an audience is to be allured or drawn in, or that thought begins in wonder – wonder at the thing, and wonder at its making – one is not speaking of some domain of the supernatural.[83] As Jaeger says, 'nontranscendental' aesthetics are concerned with surfaces, appearances, sense perceptions; Christian art inevitably has a 'sensual, surface-bound aspect'.[84] Imitation, beauty and allegory all enter the equation: but all are effects of surface, dependent upon experience – on this basis the emotions and mind are moved.[85]

What shapes experience of surfaces is to an important degree the way they are crafted. In saying this one is indicating more than that crafting was an important aspect of the medieval imaginary.[86] Some apprehension of craft is necessary to the eloquence agency of the object, and so to its experience. The craft aspect of artworks (not their formal properties or being but the ways they were thought to have come *into* being) is discussed by Alfred Gell as a 'technology of enchantment'.[87] An 'enchanting' object (the terminology is problematical, coloured by post-Romantic ideas of magic and charm) might well have an intricacy of design in which sheer technical power overcame the subject's will, particularly if embodying a particularly powerful subject matter, but if the processes leading to that outcome were themselves thought to be almost magical in their power, the power was even greater, leading to social outcomes in the form, for instance, of greater gift giving. Alfred Gell, in an effort to clear ethnography of western-style aestheticism, set aside the aesthetic experience of objects and instead attributed their power to the sense of their 'magical' facture. In so displacing the agency of objects onto their making and away from their appearance, Gell's position is problematical for the purposes here: it underestimates the extent of non-western aesthetic apprehension of art, and it cannot account for the sense of wonder sometimes felt at non-man-made things.[88] An instance (nature aside) would be the impress of

a seal, appearing as a form of imprinting agency without a human agent.[89] Yet in stressing that making, crafting, has a role in the total apprehension of the object, Gell was on to something: to speak of a work having an 'effect' is to use a term derived from *efficere* and *facere*, to form, fashion or make. His work has the virtue of returning us to the efficacy of the thing itself, as well as to the way that persuasion operates in social contexts, is 'educated'. Gell's notion of agency is akin to a notion of persuasive experience.

I have already made some suggestions how things work to persuade in regard to the character of the ogee and curvilinearity as an inventive – and affective – resource. This was a particularly highly developed and subtle instance of a truth applicable more generally to medieval aesthetics in their search for astonishing scale or breathtaking variety: that the dazzle of these arts lay in part in bravura displays of difficulty or virtuosity in the making of things. Smallness of effect is important to this, in deriving from apparently miraculous dexterity, so eliciting the question 'How was it done?' In such dexterity lay an almost disproportionate value for the unskilled spectator: this is why small things can register greatness. But it is the worked and articulated surface of sculpture especially, scraped, gouged, then disciplined and articulated, coloured and tinsillated with gold, that creates the impression or 'intention' of the object: and it was in regard to surface that the Decorated Style was so adroitly gauged. Here artistic and rhetorical tradition was helpful. Beauty, *venustas*, is treated by Isidore of Seville as a way of adding to buildings for ornament or decoration (*decor*), such as painted ceiling panels or multicoloured marbles. Beauty is a virtue of a building's surfaces, not its underlying form: like *varietas* it is not a purely architectural or structural virtue. In rhetoric, arrangement (*dispositio* or *ordinatio*) is clothed with eloquence, much as a building is clothed with beauty. In his *Summa predicantium* John Bromyard uses the terms *dispositio* and *ordinatio* to refer to the setting out by a builder of a cloister; this arrangement is the foundation of the building's as well as the heart's moral beauty.[90] *Bona ordinatio* is of course an inner spiritual ordering, or *taxis*. But it is also the basis for the way things are then rendered articulate.

In the articulation of surfaces and their aesthetic apprehension two qualities are especially important: working or fashioning, *opus*, and colour (pl. 150). The word *opus* emphasizes process, *becoming*: Gothic objects are formed in such a way that they seem still to be forming themselves before our eyes. Beauty words such as *pulcher* occur in combination both with *decor* and *opus*: thus the beautifully embattled

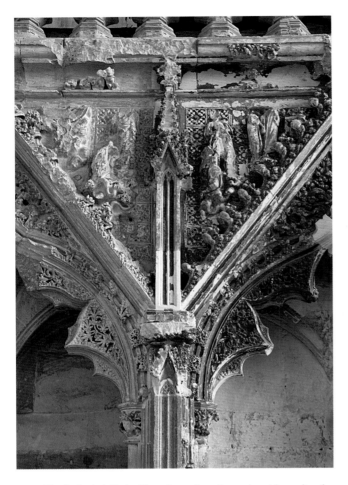

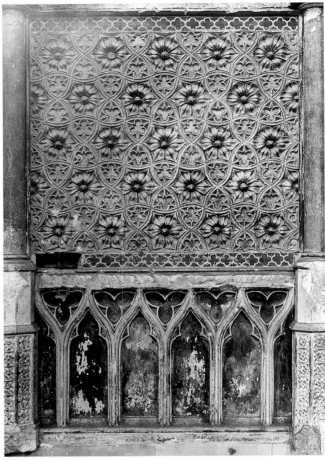

150 Ely Cathedral, Lady Chapel, north wall arcade with medieval polychromy

151 Canterbury Cathedral, diapered screen to south of high altar and shrine of St Dunstan, before 1304

choir screens at Canterbury raised before 1304 (pl. 151) were made by Prior Eastry, who 'adorned them subtly and handsomely with the most beautiful work of stone sculpture' (*pulcherrimo opere lapideo subtiliter inciso decenter adornavit*).[91] Note also the use of *subtilitas*, derived from the admirable close weaving of threads in cloth, of fine things woven or stitched whose physical character is not immediately apparent, like *Opus anglicanum*.[92] Buildings, as opposed to art objects, are less subtle in themselves than being contrived subtly, or made by subtle people (for instance, the 'greatly subtle' William of Sens, master of works at Canterbury).[93] Colour is universally important, however, for it too is a means to allurement and a means of indicating change, suffusing. It is central to the educational tactics of Christian allegorical writing such as Grosseteste's *Château d'amour*. Underpinning this was the substantial heritage of medieval mnemonic theory, and not least the thinking of Aristotle,

who maintained that we perceive form as surface colour. Mary Carruthers has demonstrated how colour, beauty, variety and surface or skin words are connected in medieval Latin.[94] Crucial to this is the notion that beauty and brilliance really are skin deep, and that what occasions pleasure are the effects of surface. Colour – the way forms actually manifest themselves – and variety are pleasurably persuasive. Though articulated in very specialized, as it were 'elite' sources (but what other sources are there to use?), these non-transcendental effects are probably human universals, not dependent upon class or education.

This last point was picked up by medieval critics particularly with regard to non-elite perception. The paradoxes of the ascetic tradition are particularly helpful when trying to understand the bases of aesthetic pleasure as a form of imaginative regard, not least because its own language is itself often fully aesthetic. The connection of colour, as an

agent of seduction, to impurity and sexual vice lies deep within Christian moral thought, as in Tertullian.[95] St Bernard understood it well in regard to the way art instantiates feelings that produce judgements and actions, what Carruthers calls 'credit-worthy belief'.[96] In the *Apologia* of *circa* 1125 Bernard's indignation is directed at general public conduct before reliquaries and images.[97] Monks are indifferent to the senses or to the wonder of fools (*stultorum admiratio*). The mere sight of the wondrous if costly vanities in churches (*visu sumptuosarum . . . mirandarum vanitatum*) inflames men to give, not to pray; thus wealth is derived from wealth and money attracts money – *pecunia pecuniam trahit*. Bernard knowingly declares that he does not know how this 'deal' (*pactum*) came about; but the fact is that eyes latch on to gold, and purses fly open; the most beautiful form of a saint is shown off and thought to be the more holy, the more highly coloured it is: *et eo creditur sanctior, quo coloratior*. Bernard, a brilliant rhetorician and a no less clever psychologist, of course understood the 'deal' perfectly well. While high-minded reasoning is for the learned, the unlettered and carnal public moves (for him) in the instinctual appetitive domain of pleasure and feeling – a good old rhetorician's prejudice. The glow of colour and jewellery induces unsubtle sensuous pleasure, a sort of admiring stupefaction. Subtleties are wasted on the masses; but the brilliant halo, the dangerous beauty and beautiful speech of surfaces, is enough to persuade. The deal is struck, even though in the process far too much money is spent.

St Bernard's stance cannot, and should not, stand for all medieval experience, and yet it embodies one powerful truth: he understood intuitively that the arts operate psychologically and socially, offering one instance of the Gell principle that easily sneered-at astonishment is exploitable and has social outcomes in greater gift giving.[98] The Decorated Style was a peculiarly concentrated instance of this general truth. At their worst, colour and dazzle are repulsive techniques of distraction or error. Yet through them we may also be won over, pleasurably persuaded – and so our good will is secured. These techniques aim to secure favour, *captatio benevolentiae*; they secure confidence, that persuasion by both feeling and, critically, reason that allows us to feel trust beyond intellectual conviction. Often, if not invariably, the miraculously carved surfaces of objects in the Decorated Style were warmed and articulated by colour, as an examination of the better-preserved minutely painted bays of the wall arcading of the Lady Chapel at Ely demonstrates (see pl. 150). Such colour undoubtedly produces an affect; but it also helps to clarify the actual lines of a building whose wall surfaces are miraculously woven, by picking out shafts and motifs, so exposing the work's interior line and direction of thought or *intentio*: that the scheme was worked out 'along these lines'.

It is important to see that the 'signification' of buildings was mediated aesthetically rather than simply through 'symbols'. Carruthers points out that allegory was one of the 'colours' of rhetoric and hence an aspect of ostensive sensory beauty.[99] Indeed, there was a recognized model for seeing the sense of something as woven within a layer or surface – I choose the textile metaphor deliberately – as if in clothing (we speak of 'revetments' or 'cladding' in regard to precious or marble surfaces, after all). Medieval theory of allegory encapsulated the idea of the eloquence or beauty of clothing by means of the fictional 'integument', a surface or cladding cast over 'deeper' truths. In this widely known idea, stemming from Augustine, truths are represented under fictional garments – the garments of allegory – that in their engaging brilliance provoke admiration, which, in turn, prompts enquiry. By the end of the thirteenth century the 'poetic mode' of scriptural exegesis claimed the authority of Aristotle's *Metaphysics* and *Rhetoric* for the idea that the poetic mode excites us to wonder, which in turn excites us to enquiry: thus knowledge 'takes shape'. The fictional surface of allegory is a veil whose form may itself be borrowed from elsewhere in order to get an idea across, as in the so-called Egyptian gold argument that sanctioned the use of non-Christian 'clothing' to convey Christian thinking.[100] But it does not follow from this that signification – if it is present – necessarily covers over what is aesthetically apprehended, rather the contrary. The painted, glazed and carved layers of a structure are eloquent precisely by virtue of the way they work signification into the warp and weft of the cladding, as if in a primal phenomenon. In this the woven line remains central.

Thinking of stylistic effects in the Decorated Style as matters of pure fantasy or magical thinking will mislead us quite as much as reducing them to a simple genealogy of style. The 'deal' is that we should be fully engaged by, and have confidence in, a work of art because of its astonishing skill, the way it deliberately 'puts on' something. Out-and-out fantasy, on the contrary, is a species of disengagement, which is why the dazzle of mimetic or solid 'reality' effect is often important in persuasion. The two go hand in hand. Consider the common motif of instability and transience in secular fantasy architecture in literature. Mann has explored this instability in relation to literary architecture between Ovid's *House of Fame* and Chaucer's version.[101] One striking

motif of true fantasy architecture is that it is likened to paper, thin, flexible and vulnerable. In Bertilak's castle in *Sir Gawain and the Green Knight* (lines 794–802) is encountered an eclectic style of building much in the idiom of the examples discussed earlier in this chapter: a hall with towers, battlements and very tall carved pinnacles, so many painted and clustered pinnacles indeed that the whole thing seemed to be cut out of paper (*Þat pared out of papure purely hit semed*).[102] Behind this powerful imaginary lies a social reality, of the temporary, ludic, wooden and paper devices used in court ceremonial that may themselves have been important vehicles for inventive innovation. Transience and a flexible sense of scale are central to this uninhibited mirage-like aesthetic of tinsel.

Amongst the most common architectural fantasy objects encountered in medieval romance in the course of adventure are, naturally, seigneurial things: halls, castles and tombs, all of which are designed and then found in such a way as to lead in the reader or audience. Central to this is technical difficulty, things so extraordinary and hybrid that the nature of their facture is called into question – is it stone, or paper? – one may recall the hesitation of *pared out of papure purely hit semed*. Again, constant encounter with strangeness and instability is necessary to this register of experience. Consider the 'castle of marvels' in Wolfram von Eschenbach's early thirteenth-century *Parzifal*.[103] This building is contrived by a noble magician, Clinschor, out of magical things sent to him from Africa. As well as being constructed of exoticisms, it is full of instabilities, as Gawain soon finds out: a hall floor as slippery as ice, a bed of wonders that thrashes to and fro, a ceiling that opens to the elements, and so on. These hazards furnish the knightly quest. Once overcome, their ultimate product is ethical development and governance of the self: what doesn't kill you makes you stronger. Like the fantastic quest, the fantasy domain of unstable architecture creates a countervailing impulse towards moral reality and confident stability.

Wonders such as automata, speaking images and other ingenious contrivances also typify the literary tomb in this period. The ancient world created the concept of the marvellous tomb – for instance, that of King Mausolus at Halicarnassus; and since such tombs were also exceedingly large and beautiful (*mirae magnitudinis et pulchritudinis* is a phrase used of Halicarnassus), and since the words *pulcher* and *sepulcher* were related (compare Matthew 23:27), the common notion of the 'tomb beautiful' in medieval romance was not far off.[104] Chrétien de Troyes's *Lancelot* of the 1170s is a starting point, with its extraordinary future tombs with mysteriously prophetic inscriptions and challenges encountered by Lancelot, for such tombs are involved in knightly 'selection tests'.[105] Benoît de Sainte-Maure's influential mid-twelfth-century Old French verse *Roman de Troie* describes the Tomb of Hector as being made in a way 'rich, and strange, and marvellous' (*riche e estrange e merveillos*).[106] Elaborate and mysterious inscriptions are but one aspect of the tomb's new ingenuity and magical cunning. Thus in the late fourteenth-century poem *St Erkenwald* a marvellous tomb is found, the lid of which is embellished with gargoyles and bright gold letters whose sentiments were 'runish'.[107] The authors certainly had in mind the by now widespread use of brass lettering and imagery on tomb slabs, a thirteenth-century development.

The rise of the 'tomb beautiful' in twelfth-century and later literature accords approximately with the development of effigial and canopied tombs in churches, first as very high-status objects, second (after 1250 or so) as more socially inclusive ones. The modern image of the castle, hall and tomb as objects of knowing delight was not a figment of the literary imagination. The period from 1200 or 1250 through to the mid-fourteenth century was especially critical. In discussing the ornate integument of colour, foliage, micro-architecture and figuration cast over buildings in the Decorated Style, it has been seen how it was deployed principally on things that served the administration of the sacraments (decorated altars, tombs of Christ or Easter sepulchres, sedilia, piscinae) or the doctrines of intercession and suffrages (Lady Chapels, tombs, chantries). The medium of virtuoso painted stone carving could now be supported by long-term art investment, since the consolidation of the encircling aesthetic and doctrinal issues was largely complete. Because the socio-economic conditions were favourable, the market for such items was expanding. It is not wrong to think of lay patronage in particular as exerting an almost irresistible force in the propagation of this value system. For instance, the Cistercian Order pragmatically acknowledged the pressure from exceptionally high-status patrons in its legislation of 1263, which directed the abbey of Royaumont, the French royal burial church, to return its high-altar decorations to the ancient modesty and simplicity of the order, but to leave alone the (as is known, highly coloured and eye-catching) royal tombs in the church.[108] The painted, inscribed and glossily enamelled tombs were to continue to exert their magic. The period 1250–1350 was one that saw exceptionally subtle thought about the significatory potential of the materials used for tombs and effigies: white marble and bronze were used for episcopal and royal

effigies in France; brilliantly painted surfaces were used, more often, for tombs of un-anointed royalty; and that most sophisticated of materials, alabaster, off-white, translucent and almost adipose in its deathly inner glow, emerged by the fourteenth century as a favoured material for the effigy, being used first for an English tomb effigy for Edward II at Gloucester (see pl. 219).

In all this I have argued for the importance of the regime of the aesthetic as being that regime within which persuasion (affective, intellectual, moral) is possible. The domain of the beautiful was often, if not inevitably, connected to the domain of usefulness in medieval thought, not least because it provoked that 'acuity of regard' central to the winning of favour, capturing that benevolence, that charity, of which Aquinas writes in describing the bond between the living and the dead.[109] At work in the Decorated Style were strategies that hoped to win the favour of the spectator by catching their eye, delighting them and disposing them to confidence. This relation was not one between active object and passive subject (i.e., 'reception'); on the contrary, tombs, sacrament houses, images and chantries did not simply dispense something to an audience, but also provoked a relation of giving, a 'deal', which engaged by an irresistible process of captivation the charitable instincts of those able to bring them to fruition in the form of soul-gifts. If the experience worked, it worked *socially*, within human occasion and by means of creating a sense of well-being. The particular difficulties and rewards of minutely fashioned sculpture are central to this. In a neglected passage composed not long after 1307, the *Commendatio lamentabilis* on the death of Edward I, whose court had done so much to develop the Decorated Style in its early stages, says of Edward that none was more magnificent in giving – *nullus magnificentior in donis* – since he was never mournful except when his dearest ones died; their sins he rescued by perpetual alms, constructing for the dead exceedingly artful tombs made with the most delicate (*curiosius*) carving.[110] The allusion must be to the memorials for Eleanor of Castile (see pls 101, 102); but central to this passage is the explicit linkage of giving, magnificence, perpetual alms and the artfulness and subtlety of tombs in praise of a man's charity towards the dead.

The Decorated Style was the triumph of an artificial, not a natural, order. It is in no sense wishful thinking to state that the aesthetics of artfulness and carefulness in carving served to create confidence in a virtuous economy of giving and receiving; the map of religious art in particular had grown more complex, more nuanced, and also more competitive. Its landscape included some of the most ornate and ambitious buildings ever raised in England: hence this book moves next to Ely, where the art of the chisel was never more apparent.

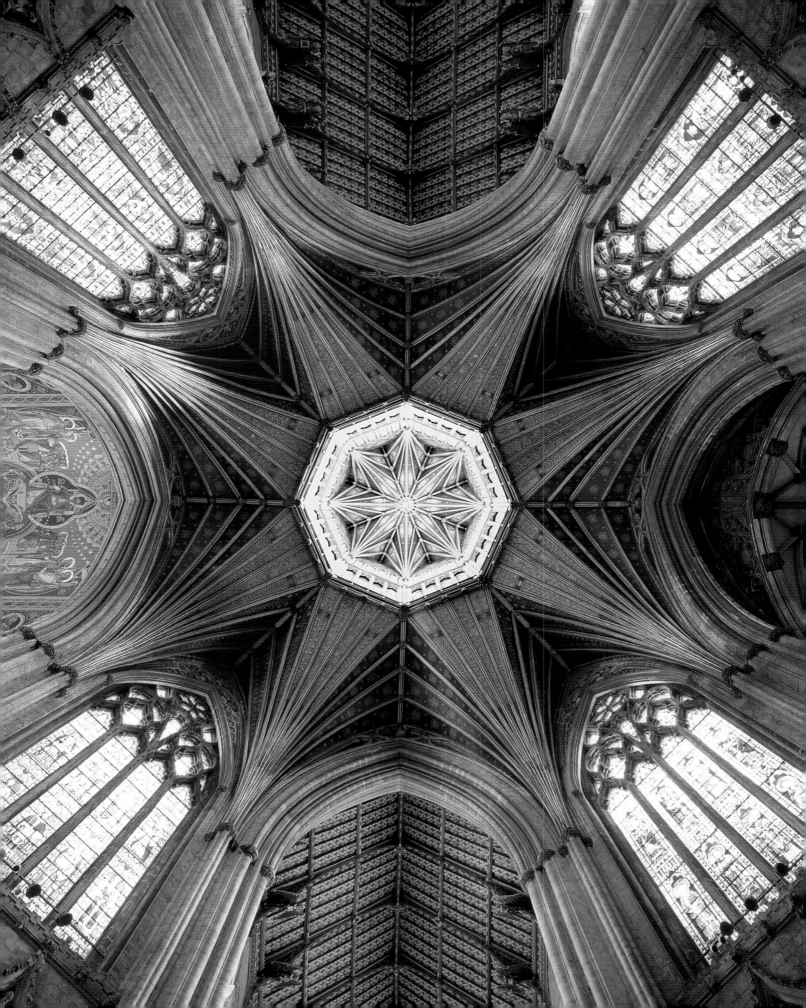

6

SOLOMON'S HOUSE

Wonder at Ely

And king Solomon gave unto the queen of Sheba all her desire, whatsoever she asked, beside that which
Solomon gave her of his royal bounty

3 Kings 10

In my account of the Decorated Style I have more than once stressed the responsiveness of this mode to specific contexts and traditions, quite as much as to more generalized stylistic movements. This helps to explain the fact that many of its most outstanding achievements are unique to themselves: the Decorated Style was a style of the brilliantly unexpected set piece. The extraordinary buildings at Ely Cathedral began in 1321 with a new Lady Chapel; this was followed from 1322 by a new octagonal crossing tower (pl. 152), new presbytery bays, a new chapel and chambers for the prior and also enlarged conventual buildings (pl. 153). The result was a veritable tour de force of architectural diversity. Though designed in fundamentally the same idiom, each building displays numerous variations of 'touch', as if designed by a different architect or raised by different hands. And yet, as far as is known, the team of men responsible was small: a core triumvirate of men of religion acting as patrons, and a very select band of masons and carpenters almost certainly including the Ramsey Company. The buildings were under different administrative regimes; but such differences cannot in themselves explain the subtle but prodigious language of variation apparent in the outcome.[1] Through delicate inflection the inventive unity and conceptual totality of the project was magnified. This was a fully intentional plan, whose objective was almost certainly to elevate Ely to a position of architectural pre-eminence amongst the cathedral priories and abbeys of eastern England, three of which (Norwich, Bury and Peterborough) had already received additions in the Gothic style but of a more limited sort. To accomplish this, the patrons and architects understood the old-fashioned qualities of mixture as well as of thinking big; their work has a range of reference, intellectual depth and generosity of outlook that belies entirely what might be expected of a very cold and fairly isolated community surrounded by water. Pierre de Celle, who, as noted above (p. 49), saw the English inclination to fantastic imagining as a product of their watery situation, would have had a field day in the Fens. But Ely was prosperous and sophisticated. St Etheldreda, its patron saint, presided over a coalescence of resources, a willingness to take magnificent risks and a force of imagination unusual even in England. It is a gross error to imagine that such

152 Ely Cathedral, octagon, 1322–42, stone base completed 1328

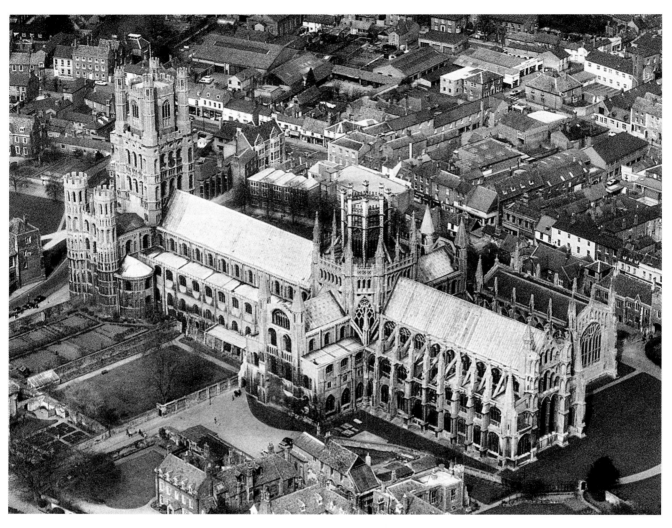

153 Ely Cathedral, aerial view from south-east

communities were provincial in outlook. Preoccupied with universal forms (devotion to the Virgin Mary; centralized church planning), Ely revived – I think deliberately – something of the cosmopolitan heroic mode of bygone centuries, and did so more brilliantly than almost any other religious community in western Europe at the time.

Events and Men

The story of what happened at Ely when its central tower collapsed in 1322 is familiar enough to students of English medieval art. The Romanesque campanile with its bells toppled on the night of 12–13 February, just after the singing of Matins; the monks suspected that something was about to happen and, carefully avoiding the choir, returned to the dormitory and thus escaped unharmed when the tower crashed down as if in an earthquake, as the local chronicle says.[2] It probably damaged the neighbouring bays of the nave and those of the presbytery not rebuilt by Hugh of Northwold, but the shrines further to the east were safe.[3] The liturgical heart of the cathedral, its choir and main altars, stopped dead. The drama threw the cathedral priory's officials into confusion; they, or rather their sacrist, Alan, recovered and totally reconceived the central part of the church; and they – and again quite probably in fact Alan – were careful enough to record the course of events in a summary later entered into the priory's chronicle (*Chronicon Eliensis*), a document here called the 'Walsingham memorandum'. To it this chapter will return, not least on account

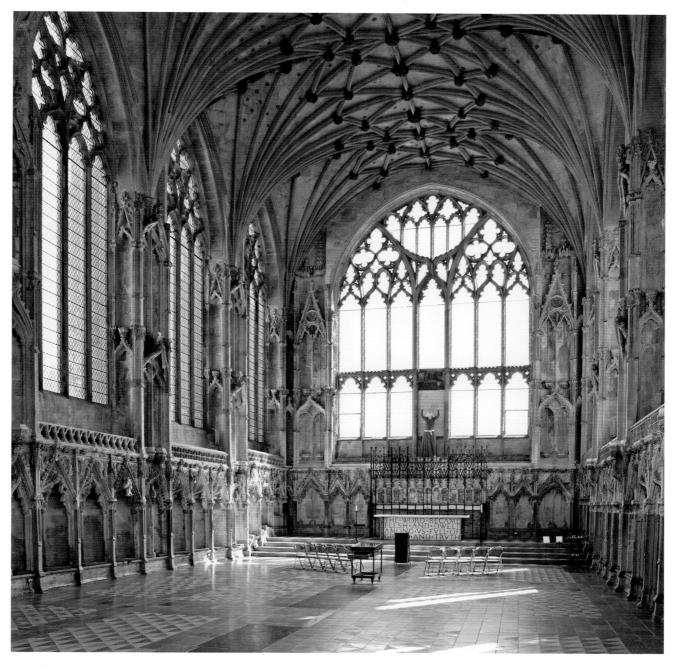

154 Ely Cathedral, Lady Chapel, 1321–49

of its unusually resonant language. The thinking involved in this recovery must have been in part practical: and yet there is enough evidence to think that the octagon in particular was the product of a dazzling reconciliation of common sense and high aesthetic ideals.

In 1321–2 Ely was better placed than it had been to manage such a crisis. An immediate frustration was that on 25 March 1321, the feast of the Annunciation, Alan of Walsingham, then subprior, had set the first stone of a new and unprecedentedly large Lady Chapel to the north of the presbytery (pl. 154).[4] The date was manifestly liturgical, and so presumably marked symbolically the end of some period, perhaps even years, of planning and fund-raising that may even have seen the start of actual work. Though the tower

155 Ely Cathedral, Prior Crauden's Chapel, from south-east, *circa* 1325

collapse eleven months later did not impinge directly on the new chapel, it plainly forced a reordering of priorities, to say nothing of the tremendous logistics required in moving the monastic offices elsewhere in the church for the duration, and the strengthening of roads and bridges in readiness for building-work transportation to Ely. By then, however, the cathedral priory was in the hands of three well-connected and apparently extremely capable men: the bishop from 1316, John Hotham; Alan of Walsingham, who was promoted from subprior to the more eminent position of sacrist late in 1321 – a promotion probably in the hands of the bishop;[5] and John of Crauden, made prior in 1321. The prior quickly began work on his new and wonderfully ornate chapel and study, accounted for by 1325 (pl. 155).[6] A fragment remains of his kneeling figure as donor, largely smashed away, attached to the shaft at the north-east corner of the chapel and facing the altar. The Walsingham memorandum gives an unusually vivid, and largely verifiable, account of the disaster of 1322 and its planning aftermath. The site having been cleared, the centre of the church was reconceived in octagonal form and the stone base of the

octagon built between 1322 and 1328; immediately, the wooden vault and lantern (variously called the *novum opus*, *campanile* or *lanterna*) were raised on top of it and largely completed by 1342.[7] The three new presbytery bays (pl. 156 and see pl. 46), the bishop's responsibility, were rebuilt at the same time, and mostly finished by the time of Hotham's death after a long illness in 1337.[8]

The Lady Chapel, meanwhile, was very probably set aside or soft-pedalled until the stonework of the octagon at least was completed in 1328. Its administration or funding had been delegated by Alan of Walsingham to a monk, John of Wisbech, who died in the same year that the chapel was being glazed, 1349. It was dedicated in 1352–3.[9] The bishops also contributed to the Lady Chapel: in fact, the bishop was understood by custom to be responsible for all building work, the sacrist for repairs.[10] The Ely chronicle gives the total duration of the work on the Lady Chapel as twenty-eight years and thirteen weeks, a precise figure which means that, having been begun on the feast of the Annunciation in 1321, the work was completed the week before the feast of the Visitation (2 July) in 1349.[11] Again, the calculation includes a symbolical or liturgical element, for this was not only a major Marian feast but also, being the seventh month, echoed the completion in the seventh month of Solomon's Temple (3 Kings 8:2). This last observation will be followed up shortly, but it introduces a quite fundamental point about the chapel: that, difficulties of funding and completion notwithstanding, the buildings at Ely reveal a quite remarkable depth and care of thought.

The works at the cathedral priory were therefore settling down by 1350, but they brought in their wake a number of subsequent refinements, such as the rebalancing of the illumination of the presbytery and retrochoir by the removal of gallery roofs and the installation of large traceried windows in the aisles and gallery in the mid- and late fourteenth century, in order better to show off the main shrines, in effect by a floodlighting operation: Hugh of Northworld's rather gloomy if opulent building (see pl. 35) had been superseded. This sustained instinct for appearances and tactical presentation matters, because it may reveal something about the mindset of the works begun in the 1320s.

In writing a book about aesthetics I have been careful not to lose sight of the economic base. An aspect of the sound management that now prevailed at Ely was improved handling of affairs. Ely was a rich diocese, but by 1320 the priory had been under financial stress because of the mismanagement of the prior, John of Fressingfield, an incompetent and probably senile hanger on who was 'retired' in

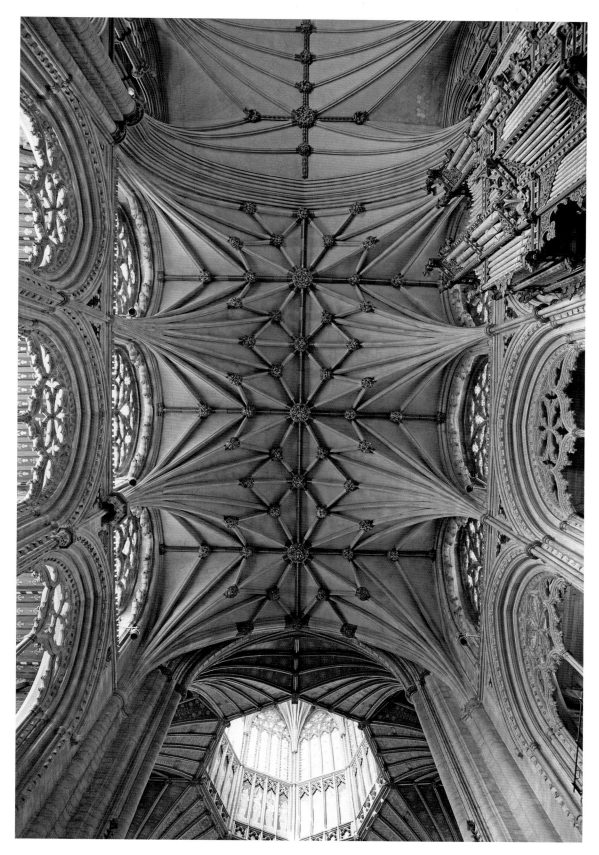

156 Ely Cathedral, vault of presbytery, completed 1337 (see also pl. 46)

February 1321: the extent of debts of more than £3,000, about three times the annual income from the monastic estates, was methodically recorded by John of Crauden in the so-called *Status prioratus* of 1324–5.[12] The administration and powers of audit seem to have been strengthened.[13] It has been established beyond doubt that the major works were funded by differently administered revenue streams, the total costs being summarized in the *Chronicon*, which includes the Walsingham memorandum. The octagon, supervised by the sacrist's office, cost £2,408; the presbytery bays under the bishop's authority cost £2,034 (though there are no itemized accounts, just a summary); and the prior's new chapel and rooms cost £138 by 1324–5.[14] The cost of the astonishingly ornate Lady Chapel is unfortunately unknown. In addition, the priory was quite willing to continue to tolerate debts incurred to the major Italian banking companies such as the Peruzzi.

Many subtleties, however, are lost in the extant accounts, most frustratingly hard evidence for the architects responsible. This complex question has tended to resolve increasingly in favour of the Ramsey Company, based at that time in Norwich and London, as the principal consultants; certainly the Ely–Norwich 'axis' is best explained by the presence of at least one Ramsey family member on site, and by the activity there also of the mason John Attegrene, documented at both cathedral priories in these years. If, as seems likely, John and William Ramsey were responsible for the major aesthetic decisions, Ely represents much their most important commission after the conventual work at Norwich, before William was employed by St Paul's Cathedral in London in 1332. The other major figure was the court carpenter William Hurley, to whom the wooden part of the octagon can safely be attributed, though he himself is only firmly documented at the *novum opus* from 1334. He must, however, have been closely involved with the project from its inception, so well integrated are the stone and wooden parts of the octagon. These were busy men; and the likelihood that they practised remote management via on-site deputies is strong (see p. 61): and that raises an issue about the movement of drawings and templates, as well as personnel, from London and Norwich to Ely.

Almost all the important decisions taken at Ely remain mysterious, and not much can be gleaned from what is known of the administrative triumvirate in charge. Hotham, Alan and John were serious men, Alan and John themselves being deemed episcopal material; Alan served as sacrist (1321–41) and then as prior (1341–63/4), and while both he and John were elected as bishops of Ely, they fell foul of

the process of papal provision that acted against internal monastic candidates: Crauden was passed over in 1337 by the noble Simon de Montacute, and Walsingham was beaten to it by Thomas de Lisle, a papal envoy, in 1345.[15] John Hotham in particular was a tremendous force for stability and administrative efficiency. His twenty-one-year episcopate was long, though his last three years were debilitated by a stroke; his resources as bishop of Ely were lordly.[16] Hotham had also grown by moving around, for though his family origins were in Yorkshire, near Beverley, he had spent time in Ireland before his rise in the royal administration, becoming Chancellor of the Exchequer (1312–16), Treasurer (1317–18) and Lord Chancellor (1318–20). A court man, Hotham was a smooth pragmatist, rising with the favour of Gaveston and fending off the Despencers before going over to Queen Isabella in 1326–7, being restored as Chancellor in 1327. After his consecration in 1316 he travelled to Avignon with John Salmon of Norwich in order to conduct business with Pope John xxii; he also had connections in Gascony. When the works at Ely began in 1321, Hotham was in effect on sabbatical leave from royal service. It is not surprising that he retained momentum as an ex-civil servant when he shook out Fressingfield and brought in his new 'team' of Adam and John. Of his taste nothing is known, and nor can much be surmised about the extent of his responsibility in opening up lines of artistic communication between Ely, Norwich and Yorkshire in the years to come.[17]

Like Hotham, John of Crauden (d. 1341), probably a local man, had courtly connections, since Queen Philippa gave him a set of jewelled robes used at her churching, which he converted into liturgical copes; Hotham entertained her in a new set of chambers at Ely.[18] It had been Crauden's job as prior to write about the tower's fall to Edward ii in 1322 while trying to gain respite from payments to the Exchequer.[19] As a patron, John was Ely's equivalent of Henry of Eastry at Canterbury, and there are grounds for thinking that, of this triumvirate, his tastes were the most lavish and cosmopolitan. An example of the type of illumination he commissioned is provided by the obituary roll of 1337 conveying the news of Hotham's death to Canterbury (Canterbury Cathedral ms Charta antiqua e. 191).[20]

The traditional hero of the operation has always been Alan of Walsingham (d. 1364).[21] Assuming he lived to about seventy, Alan was born in the mid-1290s, and was at least in his late twenties when the tower fell. Alan by lineage is generally believed to have been a Saloman, a member of a distinguished family of hereditary goldsmiths of Ely Cathedral, which included John Salmon, prior of Ely to 1299 and

then bishop of Norwich, and apparently Alan's uncle.[22] Alan's father was Adam of Walsingham, and F. R. Chapman very reasonably posited some early connection between Alan and the Augustinian priory of Walsingham in Norfolk. Alan first appears in the record assisting at the opening of a reliquary of St Alban before Edward II at Ely in 1314. By then he had presumably been professed as a Benedictine and must have been at least nineteen, which again suggests a birth date in the 1290s. The chronicler of this event describes Alan as *peritus in opere aurifabrili*, which is to say already trained or experienced as a goldsmith.[23] Since this was the most high-status craft, especially within Benedictine tradition (compare the two presumed or actual goldsmiths at St Albans Abbey, Walter of Colchester and Matthew Paris), it carried with it the implication that Alan was also gifted with a more general prudence. It placed Alan at the heart of the liturgical work of the cathedral priory. One had confidence in goldsmiths: the Ely *Chronicon* calls Alan *vir artificiosus*, conventional monastic language for one gifted generally with practical (including artistic) virtues, in the tradition of St Dunstan.[24] Alan is next encountered as *custos* of the Lady altar then in the south aisle of the presbytery, in 1318–19 – an important time to be in charge of the main Lady altar.[25] Amongst his first acts having become sacrist late in 1321 was to upgrade the *selda* or workshop of the abbey goldsmiths on the north side of the precinct – hereditary family territory as it were.[26]

The opening of the reliquary of Alban at Easter 1314 proved unfortunate for Ely. The claim at St Albans, supported amongst others by the great Matthew Paris, was that Ely had misappropriated the relics of the protomartyr Alban during the Danish invasions; Ely on the other hand argued that the relics had been brought legitimately from St Albans just after the Conquest.[27] Whatever the truth of the matter, Edward II decided against the claim of Ely to possess Alban's relics. This was almost certainly because a few days earlier Edward had stopped at St Albans while making his way north on a new Scottish military campaign and had commended himself there to the protection of St Alban; it was thus expedient to neutralize Ely's claim.[28] Ely instantly got its revenge when Edward's forces were trounced by the Scottish army at Bannockburn in June. But they had lost a significant saintly presence; and Alan's witness to these events may have been formative.

It is possible that in the wake of the St Alban debacle attention at Ely turned instead to the question of sustaining revenues and maintaining status by building a new Lady Chapel. The bishop, the former monk and almoner John

Ketton, may have been perceived as less than successful in worldly affairs; the appointment of the courtier Hotham as his successor would have promised better contacts.[29] It is worth recalling that in 1320 important Lady chapels had been begun by bishops: Richard Poore's at Salisbury, Walter Suffield's at Norwich and Walter Langton's at Lichfield (see pl. 31). Hotham is likely to have been similarly important at Ely, and the chapel begun there was completed by another bishop, Simon de Montacute. But until 1320 Hotham was taken up with government: the debt problem had not been solved, and the years 1315–17 were debilitated by harvest failure and famine. It is precisely in such relatively low periods that plans are hatched. Since Alan was the Lady altar *custos* any enterprising suggestion put forward about provision for the Virgin at this time is also likely to have come from him. Given the growing prestige of Walsingham as a Marian shrine, one wonders why more has not been made of Alan's toponymic.[30] The two largest Lady chapels of the region were now at Peterborough and Bury St Edmunds, the latter a natural model as a shrine church for Ely. But Walsingham was by far the greatest Marian pilgrimage site, and Ely was placed strategically between north Norfolk and the major population centres to the west and south. This casts doubt on the alternative view that, because Alan was not obviously associated with the Lady Chapel project after he had laid the first stone, the plan came instead from John of Wisbech.[31] Against this is are two considerations: first, the Lady Chapel is extremely carefully and professionally planned and it is intrinsically probable that its arrangements were settled at the very least in the form of detailed drawings rather before 1321; second, there is no evidence that John was a man of particular distinction: the chronicle describes him as no more than a simple monk, a winning gesture for fund-raising and miracle-witnessing, but not necessarily a sign of architectural or artistic competence.[32] Alan probably had to delegate the work to John of Wisbech after the unexpected collapse of the tower, while Hotham had to look after the presbytery. The octagon and Alan's traditional role in its conception may have been a distraction from the possibility that both schemes were his in important essentials. The ceremony on Lady Day 1321 was the end of a phase of reflection and planning, not the beginning.

But before the first stone was set, the foundations had to be dug. For that to happen, the Lady Chapel had to be measured out: and it was when its dimensions were established that the seeds of invention were sown, since whoever established the dimensions was also someone of intellectual curiosity.

Solomon's House

The new Lady Chapel was to be sited to the north of the presbytery, connected at its south-west corner to the north transept and communicating with the church by means of passages from the north aisle (see pl. 154). The archaeological evidence suggests that this area had been a lay cemetery, and was relatively unencumbered by buildings, though the new passage that ran obliquely from the north aisle to the chapel was built over a similar feature, suggesting some earlier, probably limited, structure on the site.[33] Clearance was needed to create manoeuvring space for lifting gear; properties and walls in the vicinity of the *hospicium* and sacristy were still being demolished for the chapel in 1322–3, after the setting out was finished and masons employed.[34] Philip Dixon has shown that the access routes to the new chapel allowed for a cunning dual filtration system separating the monks from the laity (pl. 157).[35] Lay access was gained at ground-floor level from the north aisle of the church via the ornate crenellated and tabernacled portal in the aisle, furnished with images of censing angels and the

157 Ely Cathedral, plan of Lady Chapel showing access routes from the choir via bridge (monks) and north aisle of great church (laity). Plan by Philip Dixon

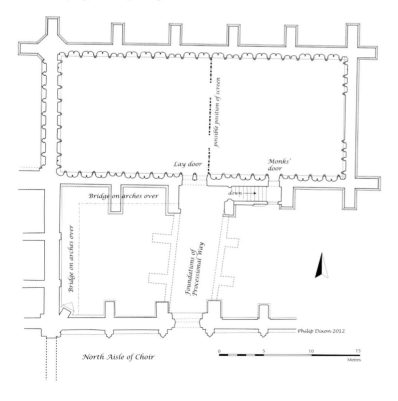

Virgin Mary (and perhaps to either side the *Annunciation*, celebrating the day of the building's foundation), and thence through the pair of doors near the middle of the chapel's south wall. Monastic access was obtained independently from the choir via a system of raised enclosed wooden passages on the exterior of the transept and chapel, leading over the lay passageway to the chapel's east end. This proves that the logistics of the new chapel were strongly informed by the concern expressed in Bishop Walpole's injunctions of 1300 that monks and laypeople, women especially, were coming into inappropriate contact in the vicinity of the old Lady altar in the south aisle of the presbytery, and that they should be partitioned.[36] The old chapel was limited in size, occupying no more than two bays of the south aisle with its west entrance immediately adjacent to the high altar. Since lay access was preponderantly from the precinct's north side, its position was inconvenient. It is reasonable to assume that the pathways to the new chapel formed in 1321 implied some sort of liturgical barrier within the chapel itself. So the dual standing of the cathedral priory, both monastic and lay, was an issue.

It has long been noted that several Lady chapels in the region were located on the north side of a major church: at Thetford Priory, Peterborough and Bury.[37] But the same general layout occurred in the mid-thirteenth century at the Augustinian church at Bristol, and the planning at Ely was manifestly influenced by the immediate local factors of traditional lay routes of access, lay burial and sufficient space. Two of the regional Lady chapels were admittedly impressive. That at Peterborough (pl. 158) was raised *circa* 1280 and was consecrated in 1290.[38] Like Ely, it was sited hard by the north of the presbytery and had five bays with large lateral geometrical bar-tracery windows in the Lincoln manner. Its buttresses were relatively slight, and it had a steeply pitched roof with a painted wooden vault with stencilled crowned 'M's and the arms of England within lozenges (like the nave), parts of which were later reused in the choir.[39] Its apparently impressive east window glass contained the subject of Julian the Apostate; according to Gunton this chapel was also accessed from the north aisle by a passage with chambers over.[40] The chapel measured about 97 by 30 feet (30 × 9 m), resembling the interior dimensions of the Sainte-Chapelle and the Lady Chapel of St Germain-des-Prés in Paris, finished in the 1250s: it may not be coincidental that the official responsible for the building was called William Paris.[41] The Lady Chapel at Bury St Edmunds was begun in July 1275 and measured about 70–80 feet long by about 40 feet wide (21–24 × 12 m); less is known about its appearance.[42] It

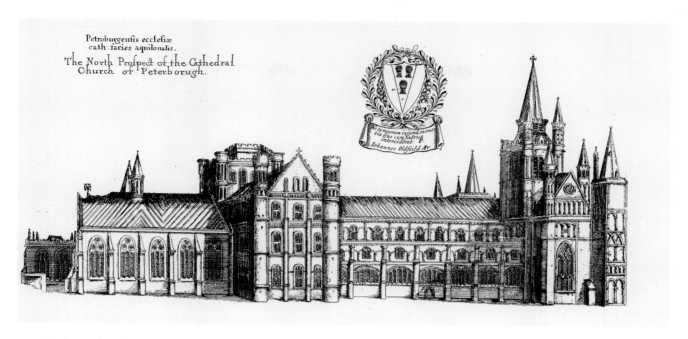

158 Peterborough Cathedral, north side showing Lady Chapel at east end in seventeenth century (from Gunton 1696 / 1990)

seems unlikely, however, that any of the regional chapels could match up to what was planned at Ely.

When, in 1314, the great cathedral of St Paul's was measured, the allusion was to the measuring of the Temple in the Apocalypse. At Ely measurement proves to be no less biblical. The Lady Chapel is not a perfect rectangle, but its footprint is almost exactly a double square with an east–west measurement from the backs of the facing wall niches of 30.9 metres (101 ft) and a north–south measurement of 15.24 metres (50 ft), established from the facing window mullions. This looks very like an intention to measure out a building of 100 by 50 feet, the interior dimension being very slightly 'squeezed' longitudinally by a factor well within the tolerances of a building of that date.

These (unremarked) dimensions of the plan's envelope and very unusual length–width ratio of 2:1 throw out some interesting possibilities. It is evident, first, that the Ely chapel is substantially larger than any other example of its date in England, and also differently proportioned, being wide for its length. Second, the width of the building immediately confronted the architect with an exceptionally broad space to vault. Whatever had to cover the chapel had to be about 14 metres wide, wider than the presbytery of the great church itself, indeed about as wide as the nave of York Minster or Amiens (see pl. 28), though narrower than the chapter house at York at around 18 metres (60 ft). It is notable that the wide vaults at York are all of timber; the vault of the Ely chapel is of stone, and its bosses and design are compatible in style with a date in the second quarter of the fourteenth century.[43] Though the building is not a great church, its vault, like that over the nave of Girona Cathedral erected after 1416, is undoubtedly one of the prodigy vaults of the late Middle Ages.

To choose a stone vault of such width for a subsidiary building implies mighty ambition, since architects or patrons do not as a rule create substantial and expensive problems for themselves without very good cause. It certainly raised the physical stature of the Lady Chapel almost to that of the shrine space of St Etheldreda. But it was also, I suggest, the logical consequence of a decision to adopt a specific mensural type: that of the plan of the House of Solomon, in which was placed his seat of judgement, described in 3 Kings 7:1–2, 7:

> *domum autem suam edificavit Salomon tredecim annis et ad perfectum usque perduxit edificavit quoque domum saltus Libani centum cubitorum longitudinis et quinquaginta cubitorum latitudinis et triginta cubitorum altitudinis . . . porticum quoque solii in qua tribunal est fecit . . .*

And Solomon built his own house in thirteen years, and brought it to perfection. He built also the house of the forest of Libanus. The length of it was a hundred cubits,

and the breadth fifty cubits, and the height thirty cubits … He made also the porch of the throne, wherein is the seat of judgement …

The governing biblical measurement was the ground plan of 100 by 50 cubits, the feature of a building that, as seen in discussing Krautheimer's notion of copying (p. 13), was the most readily ascertainable aspect of a building's essence: no Gothic building of ambition would have vaults only 30 feet high. The proportions of the plan, and also the translation of cubits into feet, follow almost to the letter. The Lady Chapel's most basic arrangement, its plan, is therefore evident: it is typological. Solomon is invoked not just as a model patron, but also as an instance of the Old Law that it was appropriate for the Church to surpass in the service of the New and especially of Mary. That very year the Solomonic ideal had been cited in the charter for the disposition of funds for St Ouen in Rouen (see pl. 29), and Stephen Murray maintains that the envelope of no less a building than the Sainte-Chapelle in Paris (see pl. 24) follows the same mensural schema.[44] But Solomon, together with Sheba, also provided types for Christ and the Church – and it is from this kernel that thought about Mary could germinate and grow.

To those accustomed to think of the Ely Lady Chapel as a magnificent instance of popular devotion to the Virgin, this rather learned foundation may at first sight be a surprise, and it was certainly uncommon; but it did no more than supply a starting point, a cognitive fiction provoking further inventive thought, for which the Virgin Mary frequently provided stimulus. The idea of Solomon's House runs like a deep *cantus firmus* beneath and through the polyphony of the textures above; it is whence the thinking starts, and whither it returns. To demonstrate the truth of this, it serves only to examine the building from its plan upwards, but in doing so it will be necessary to set aside completely any belief that symbolism 'can have been no more than a partial and superficial factor in the design process'.[45] The word 'superficial' here is objectionable because it implies something detachable lying over something else, namely aesthetic and human experience.[46] If one insists on seeing the Lady Chapel as the end product of the accumulation of design patterns separable from the 'content' of a work of art, this holds true; but to do so represents an impoverished, and I think anachronistic, view of how medieval invention actually worked, which was by bringing style into an appropriate and effective working relation with the ordered material to hand. A clear line of thought, which can only be described as symbolic or dis-

cursive, runs up and right through this building from bones to surface. It so deeply affected and constrained its making that to consider symbolism as partial or superficial, as a sort of optional add on, could not be right. On the contrary, it is woven densely into the building.

In keeping with the other major statements of the Decorated Style of the time at Bristol, Wells and Norwich, the Lady Chapel at Ely is a phenomenally well-informed and eclectic building. An aspect of this resourcefulness was the way its specific design decisions engaged with what one might think of as universal symbolic forms. Not all the formal solutions could, admittedly, be deduced from the plan, no matter how resonant its measures might be. If, as seems apparent from its measurements, the Ely Lady Chapel contained within itself a biblically sanctioned spatial schema, it joined a long tradition of religious buildings whose general dimensions were either biblically sanctioned or imparted miraculously by supernatural means to ordinary obedient mortals by means of building miracles (see Chapter One). I have already mentioned the vision of Gunzo, to whom the dimensions of the new basilica of Cluny were dictated by St Peter and St Paul, and also the vision of the measuring out of a chapel by St Thomas at Devizes. Such miracles seem to fall out of favour after 1200, but it is worth noting that two Marian buildings in the region of Ely were associated with instances of them. At the Cluniac priory of Thetford the location of the Lady Chapel to the north of the choir was by tradition dictated in a vision by the Virgin Mary herself.[47] And according to a late literary tradition (Pynson's Ballad, of the late fifteenth century), the Holy House at Walsingham, which stood for the house of the Holy Family in which the Annunciation took place, was based on measurements that had been imparted by the Virgin Mary in a vision to Richeldis de Faverches in 1061. These Richeldis noted well: 'In mynds well she marked both length and brede'.[48] This obedience of mind is important to the tradition of supernaturally imparted measurement or building plans, and if, as I suppose, the vision of Richeldis had some basis in earlier tradition at Walsingham, it would have been know to Alan. There is no evidence that this revelation had any consequences for the actual design of the Holy House, placed, like the Ely Lady Chapel, on the north side of the priory church.[49] It is, however, the type of thing that influences the movement of mind of ingenious patrons in ways that have to be met equally ingeniously by architects. It 'got things going'.

When the Lady Chapel was designed, its interior elevation (pl. 159 and see pl. 154) was formed into five bays with

159 Ely Cathedral, Lady Chapel, elevation of south wall showing lay door

160 Norwich Cathedral, cloister south walk, tracery designed by the Ramsey Company, 1320s–1330s

large windows divided by four strong 'beats' consisting of interior buttress piers whose surfaces were covered with tabernacles for large-scale sculpted images. The extraordinary degree of surface articulation of these piers arises in part from the decision to extend vault shafts up from the seating plinth forming the basis of the wall arcade, then vertically through and behind the tabernacle work on the piers. The outcome is a sort of bravura woven architecture, in which the nodding ogee arch, entering English architecture for the first time perhaps ten to fifteen years earlier, plays an unprecedentedly large part in softening, yet accommodating, the basic structural thinking. The wall arcading uses major nodding ogees for the pier divisions and minor ogees for the three intervening bays of arcade. The form of these piers and their external buttresses strongly implies an intention to vault the building: cognate structures with wooden coverings have plainer wall surfaces without such shafting. The major shafts that rise through the tabernacles had a traditional sustaining role. Each shaft rises from the

plinth to arcade level where it has attached to it the small figure of a king seated on a throne, around whom the nodding ogival canopy work forms a supple kite-shaped cusped frame or nook. These forms come in their essentials – though not their superlative finish – from the cloister works at Norwich Cathedral (pl. 160 and see pl. 67).

There are thus four kings, two of whom seem to be identifiable. The first, on the third pier from the east on the south side to the right of the lay entrance, directly beneath the smashed *Annunciation* and *Visitation* narratives carved over the arcading, is certainly David (pl. 161), holding his harp, which rests in its bag on the throne. This is manifestly a citation of the text of the Annunciation itself in Luke 1:32, in which Christ is promised the throne of David. The coordination at this point deserves comment because the coincidental layout of shaft figures and narratives had to be determined to the letter at the outset, in a way that implies the existence of detailed preliminary drawings. If Christ is promised the throne of David, Mary, in exegetical tradition, gains the throne of Solomon: and Solomon himself is likely to be the king in the bay just to the east of the lay entrance, with his right leg proudly crossing his left, holding a sword and what appears to be the base of a sceptre (pl. 162). The vault is thus sustained by kings of the House of David in a vertical unfolding of the ground plan. There is no need to comment at length here on the very substantial exegetical tradition of seeing kings, priests and saints as pillars, columns and supports of the Church, stemming from St Paul (Galatians 2:9), and present metaphorically or literally

161 Ely Cathedral, Lady Chapel, south wall arcade, *King David with Harp*

162 Ely Cathedral, Lady Chapel, south wall arcade, *King Solomon*

in the Gothic era at Saint-Denis, Canterbury, the Sainte-Chapelle and Cologne Cathedral.[50] At this point the Lady Chapel does no more than plumb universal and traditional Christian thinking, though with unusual thoroughness, since the minor shafts dividing the back of the arcade bays have small standing images of ecclesiastics above their capitals, representing the priesthood at large. That this 'heroic' anthropomorphic imagery of kings and priests persists on the small but intense scale at Ely seems to me consistent with the arguments pursued throughout this book: minificence is but one aspect of magnificence.

So far the Davidic-Solomonic foundation of thought holds true. It can be pursued further by looking again at 3 Kings 7. In this chapter Solomon, having built his house, raised before it a porch in which he set his seat of judgement; here it was that he exercised wisdom. In 3 Kings it was to this place that the queen of Sheba came with an

immense quantity of gold (*aurum infinitum nimis*) in order to test the king; when she had seen the wisdom of Solomon and the house that he had built (10:4) she was drained in spirit (*non habebat ultra spiritum*), yet gave the great king 120 talents of gold, spices and jewels; he meanwhile gave her all that she desired and sought from him. Thereafter the king received great quantities of gold, from which he fashioned the outer layer of a throne of ivory set upon six steps each with two lions upon it (3 Kings 10: 18–20). This was to be his seat of judgement.

It is at this point that 3 Kings opens out thought about Mary and giving. Patristic commentary saw in the queen of Sheba a type for the Church.[51] By the twelfth century Peter Damian and Nicholas of Clairvaux, a 'secretary' of St Bernard, had placed the Virgin Mary herself on the ivory throne of Solomon.[52] It remained for late twelfth- and thirteenth-century textual and visual commentary to refine

and order the concept of the throne of Wisdom, retaining Mary and glossing the six steps on either side as the Virtues and the lions as the Apostles, for instance on folio 50v of the Vienna Moralized Bible (Österreichische Nationalbibliothek Cod. Vindobonensis 2554), around 1220.[53] The outcomes by the late thirteenth century were images such as those painted at Gurk (Carinthia) and in the *Verger de Soulas* manuscripts (for example, Paris, Bibliothèque nationale de France MS fr. 9220), in which the Throne of Solomon is arranged in pyramidal form with Mary on the throne at the top and the lions, Virtues and Apostles or Prophets arranged in pairs on the steps mounting up to it.[54]

Thus the throne image generally falls into a septet, with three pairs of lions and steps to either side of the central elevated image of Mary, and the Virtues and Apostles following suit. The east window of the Lady Chapel (see pls 55, 154) consists of a multiform window of seven lights grouped into a pattern of three–one–three, with a reversed curve enclosing further divisions above (but that at the west end has eight lights, see pl. 178). This is exactly the septet format that might be expected if this window had been intended to display a Throne of Solomon. The window is divided and reinforced by a mullion at about one-third of its height. The resulting enclosures can be mentally inhabited with, below the mullion, the six steps with their lions in the three outer lights on each side and a *Crucifixion* in the middle light over the altar and retable; above it, also at the centre, the Virgin Mary enthroned with two additional lion supporters, and to either side the groups of Virtues, Prophets or Apostles. The implicit composition is like that prefacing the Pucelle workshop copy of the *Miracles of the Virgin* by Gauthier de Coincy (Bibliothèque nationale de France n.a. fr. 24541, fol. 1v).[55] The Ely window of course accompanies an extensive series of *Miracles of the Virgin* over the wall arcades. The nine lights in the window head could have enclosed a topic such as the *Coronation of the Virgin* or the *Gifts of the Holy Spirit*; the arrangement of the niches on the exterior of the east gable strongly implies a *Coronation* at its apex (see pl. 55). None of the glass of this window survives, so this is only an estimation of its possible contents, and it could have been decorated otherwise. But a *sedes sapientie* would follow logically from the elevated biblical schema informing the building as a whole. It would not have been the first magnificently enthroned image of the Virgin and Child known at Ely: an earlier one had been melted down by William the Conqueror.[56]

An implication of this is that the design of the window tracery was set out with the scheme of glazing already in mind, probably, if not necessarily, at the start of the entire process of careful preliminary design that seems to have governed even the smallest elements of the chapel. The elegant and very ornate head of the east window of the parish church at Mildenhall (see pl. 192), not far from Ely, executed before 1344, was clearly designed to incorporate an *Assumption* in its central vesica. A design of *circa* 1320 for the Ely tracery would not be inappropriate given the nature of the most advanced tracery designs being made on the Ely–Norwich axis (see p. 102). The west window of the parish church at Snettisham, Norfolk, probably of the 1330s, belongs in the same line of descent. But the glass was clearly manufactured later. The first report is provided by the *Chronicon*, which states that by July 1349 the ironwork and glass of two windows on each side of the chapel had been provided together with the east front or *agabulam orientale*, the term 'gable' here being understood to include the whole wall and great east window.[57] The side windows were presumably those at the very east end of the chapel, and it could be deduced from this that the east window glass too had been completed by 1349.[58]

An east window with figures of some size filling its tracery lights would have extended the arrangement, on all the upper wall surfaces, of single and pairs of almost life-size sculpted figures within the niche work created by the two tiers of canopy work that wraps around the buttress piers and extends across the end walls. All these figures vanished as a result of post-Reformation iconoclasm, but their general size and some small details of content can be inferred from the extensive remains of paint that indicates their silhouettes. In the upper tier on the east wall (pl. 163), to the south of the high altar, can just be made out figures of angels with the Instruments of the Passion, alluding to the presence of Christ the Judge.[59] The cathedral's stone store retains fragments of painted figures of suitable size, including the torso and feet of a winged seraph placed on a sphere decorated with wheel spokes (pl. 164), and the torso of a male holding a scroll with a hood on his shoulders of the sort fashionable around 1340: these may well have come from the Lady Chapel niches.[60] Other evidence is provided by the very faint shadow of an inscription on the vertical east face of the second buttress pier from the west end on the south side: *S[ancte] Augus[tine] archi[episcope] ora pro nobis* (St Augustine of Canterbury pray for us), which clinches the identification of at least some of these figures as saints of the English people accompanied by intercessory inscriptions.

Two thoughts arise from reflection on the astonishing density and richness of the original imagery of this chapel.

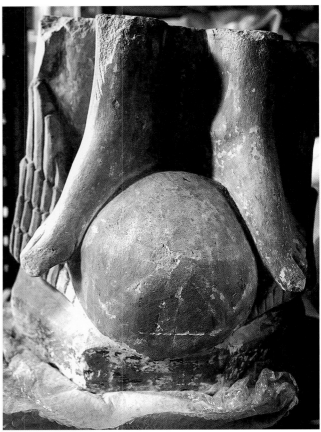

163 *(left)* Ely Cathedral, Lady Chapel, vacant tabernacles in the upper stage of the east wall, south side. The right niche shows traces of a painting of an angel descending with the Crown of Thorns

164 *(above)* Ely Cathedral, stone store, feet and wheel of seraph

First, the monastic history of the church took great pride in the extent of the Lady Chapel's sculptures: the *Chronicon* notes carefully that there were no less than 147 images not including those in the altar reredos and at the portal of the entry to the chapel from the north aisle.[61] Counting and measuring are long-standing signs of the mentality of magnificence, and should indicate a belief at Ely that they had done something remarkable. Everything in Solomon's Temple is counted or measured. It is not difficult to establish what it was they were measuring themselves against, because those responsible would have taken into account Solomonic splendour, the typological and poetic implications of the House of Solomon and the imagery of Solomon, Sheba and the Virgin Mary, and the desire for a comprehensive display of the saints of the English, and then considered what obvious models there might be.

By 1320 two buildings in particular anticipated the idea of placing statuary on the walls between the windows of a chapel: St Stephen's at Westminster and the chapel of the bishops of Ely at Holborn designed in the 1280s, where the corbels for statues still remain (see pls 54, 85, where the present statuary is hypothetical).[62] But another precursor must be mentioned in the light of the sheer extent of what was to be undertaken at Ely itself, not a chapel interior at all, but a façade: that of Wells Cathedral erected in the early thirteenth century. There are specific reasons for thinking that the new works at Wells, its chapter house especially, along with some other West Country sources, were studied closely by those in charge of the *novum opus*, that is, the central tower at Ely. The glories of their chapter houses seem to have mattered to religious institutions that enjoyed emulative comparison. For instance, the late thirteenth–

century chapter house at Evesham Abbey built under Abbot John of Brockhampton (1282–1316) was artfully built with a beautiful vault with bosses, but no central column, its size and beauty placing it 'amongst the first rank of all the chapter houses of the realm', according to its chronicle.[63] But the west front of Wells is particularly likely to have enjoyed national standing, and not just significant regional acknowledgement of the sort evident in the fourteenth-century west front of Exeter Cathedral, which was eventually readjusted to look like it.[64] The great façade, with more than four hundred sculptures, was by then a century or so old; yet its thematic emphasis, design and sheer scale would already have yielded food for thought for the Ely Lady Chapel. At its heart were images of the *Virgin and Child* and the *Coronation of the Virgin* with, above them, *Solomon* and *Sheba*. Small narrative sculptures abounded, and the façade above has full-length figures disposed in tabernacle work. I have suggested elsewhere that the aesthetic of the Wells façade and its nooks and habitations was informed by commentaries on the Song of Songs.[65] Commissioners at Ely would have noticed that by removing the deep plinth the façade consists of a horizontal zone of paired arches with foil-shaped openings above, secreting figures; then a shallow seam of biblical narratives, also arranged in foils; and above, buttresses and flats consisting of two tiers of standing images folding around the various surfaces (pl. 165, compare pls 159, 163). Wells was not something just to be acknowledged in passing: it provided a successful and remarkable schema that could be collated, pondered and then involuted to provide an interior format for a church not intending to build a façade at all. This process of chewing over, involuting and finally intensifying established 'heroic' solutions is typical of the practitioners of the Decorated Style. The disposition of small narrative sculptures over the arcade gables at Ely also found earlier authority in the west and south-west of England at Worcester Cathedral and Salisbury (tomb of Bishop Bridport, d. 1262), to say nothing of the subtle impact of the works at St Urbain at Troyes, which can be traced in the micro-architectural tracery on the front face of at least one arcade buttress in the Lady Chapel. Again, the use of projecting gables over trefoil arches on the façade at Wells and the pulpitum at Salisbury anticipate the 'nodding' ogee arches and gables in the Lady Chapel.[66]

What energized these consultations, collations and choices were theological curiosity and an ability to think across what would later be defined as genres. This last capacity brings one to a second elision at Ely, one of church and palace, explored earlier in discussing the tabernacle and hall

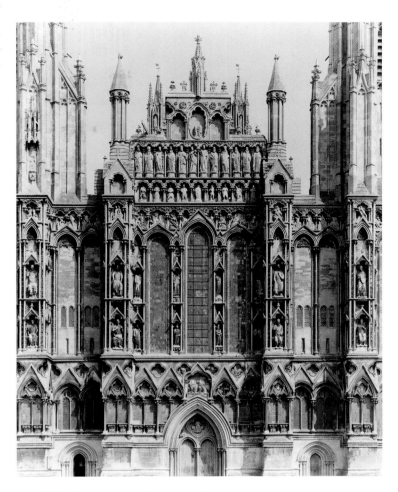

165 Wells Cathedral, west front, central bays

(p. 155). The Lady Chapel is formed from a spiritualized, Marian, understanding of the House of Solomon. Its aesthetic is clearly in the first instance 'ecclesiastical'. But it was Solomon's example that made the glories of the Temple and House 'kingly'. In the account of the building of Solomon's Temple in 3 Kings 6:29–32 its walls were carved round about with diverse carvings and turned motifs (*per circuitum scalpsit variis celaturis et torno*), including cherubim and palm trees; these are described as made as if protruding and emerging from the walls (*quasi prominentes de pariete et egredientes*), and with them were doors carved in relief with palm trees and cherubim (*et scalpsit in eis picturam cherubin et palmarum species et anaglyfa valde prominente*). In 3 Kings 7:16–17 the capitals of the porch of the Temple made by Hiram of Tyre were made in the manner of a network, and 'chain-work woven together with wonderful art' (*quasi in modum retis et catenarum sibi invicem miro opere contextarum*).

201

166 Psalter, *Judgement of Solomon*, *circa* 1340 (Oxford, Bodleian Library MS Douce 131, fol. 96v)

The Lady Chapel's cherubs and other figures, set hard by the most complex foliage forms, are consistent with this Solomonic aesthetic, even, perhaps, down to the bravura weaving of its shafts and foiled motifs – bearing in mind that this is the aesthetic of the Temple, not of Solomon's House.[67] But in regard to the House, it was presumably this curious and wonderful aesthetic of carved complexity that prompted the artist of the Bible pictures in a Psalter made in the second quarter of the fourteenth century (Oxford, Bodleian Library MS Douce 131) to set the lofty topic of the Judgement of Solomon himself within a most extraordinary structure: the king and the two women are enclosed by a large sprawling foliated ogee arch above which rises a cacophony of curious architectural motifs, barred windows, knobbly foliage corbels, crenellations and roofs, inhabited by gesticulating and conniving courtiers (pl. 166).[68] This

'palace' speaks much the same formal language as the superbly ornate side niches of Prior Crauden's residential chapel completed by 1325 with its ogee-arched nooks, seething foliage, crenellations and protruding heads (pl. 167). This is, therefore, an aesthetic that belongs at one and the same time in the church and in the palace, House and Temple. It was not without seriousness; nor was it without pleasure, and a courtly sense of the ludic. In such instances, close looking is the natural accompaniment of grand ideas.

Arrangement

But it was up to the skilled specialists employed by the authorities at Ely to invest these ideas with a specific formal language. This they did in such a way as to disclose the working of architects very well informed about developments in the Decorated Style across much of the country in that critical first period of formal development and experiment between 1290 and 1320. Whoever designed the Lady Chapel, Prior Crauden's Chapel, the new presbytery bays and the octagon had direct links with the west and south-west of England (Exeter, Wells, Bristol), the north (York), the south-east (London) and the east (Norwich).[69] As well as the royal carpenter William Hurley, a colleague of William Ramsey in the royal works, the surviving documents name one master without a surname, John, and (later) William Ramsey himself. The Ramsey Company, specifically John Ramsey of Norwich and his relative William, who went on to a brilliant London career, seem the most probable authors simply in virtue of the many similarities between Ely and their work, and of the manifest supraregional success of their operation. Ely was not, in fact, a place of localism: its patronage was part of a national mainstream. Its brilliance was rooted in its powerful tradition of Romanesque invention, and then in a skilled sifting and collation, inventive gathering, of that which was new. The fact that each of these projects has a slightly different 'touch' in regard to its finish need not mean that there were as many controlling minds as there were buildings: such inflections demonstrated skilled variety, and pointed to the sheer extent of the skilled workforce available at Ely. In fact, the range of treatments is not much greater than that apparent in the commissions of the period under John Salmon at Norwich. It appears from the Ely sacrist's accounts that, architects aside, the workforces were teamed up according to funding stream and administration: so in 1323–4 tools were sharpened respectively for the sacrist's masons and the

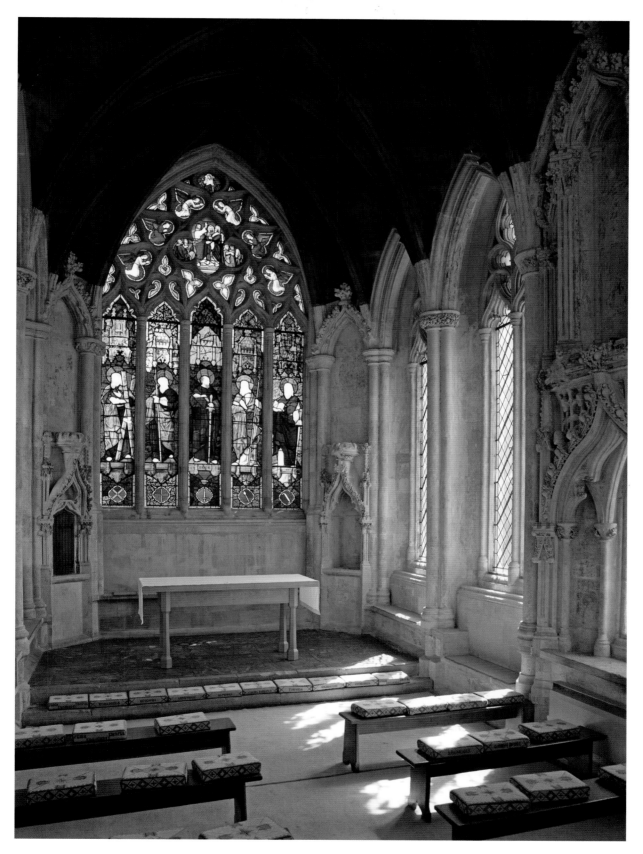

167 Ely Cathedral, Prior Crauden's Chapel, accounted for in 1325 (see also pl. 187 for a continuation of the south wall westwards)

bishop's masons (i.e., for the octagon and presbytery respectively).[70] Did such teams develop their own ways of interpreting the controlling *ordinatio* of drawings and templates provided by the masters? The ordering of specific groups of masons by funding stream perhaps set up a subtle mechanism of competitiveness and outdoing between the teams, guaranteed to produce striking results.

An analysis of the Lady Chapel itself is hampered by the almost total lack of specific documentation about authorship and costs, and there is additionally a very slight doubt as to when the manufacture of components for it had actually begun. The foundations had been dug before 25 March 1321, when the first stone was set, which means that by that point the dimensions and design were largely established. The Lady Chapel, I have suggested, was the product of a period of sustained mulling over and planning, unlike the octagon. It is impossible to say for sure whether the most elaborate and costly part of the chapel, its labour-intensive and Purbeck marble-dressed wall arcading and sculpted narratives beneath the windows, was already in manufacture in March 1321, but this possibility exists, and allowance must be made for ordering in the freestone and marble needed, much of which may already have been on site. Things would have slowed after the emergency of the following year until 1328 when the stonework of the octagon was complete, and even to 1337 when the masonry of the presbytery was nearing completion; much work is referred to between 1337 and 1349. It is reasonable to assume that, of all the teams assembled at Ely, that of the Lady Chapel, the first to be begun and the last to be finished, involved the greatest changes of personnel. Yet, below the level of the lierne vault, all hangs together very well.

Invention at Ely can be considered by examining the gathering and ordering of motifs, and their treatment, discussed below under *vaghezza*. First, gathering or collation. At Ely invention began at home. I noted in Chapter Two that the elaborate shaft–arch effects and casement mouldings of the twelfth- and thirteenth-century work (in the latter case the wall arcading of the western Galilee and the form of the presbytery's external buttress niches) were taken into account by the designers of the wall niches and tabernacles of the Lady Chapel and Prior Crauden's Chapel (see pls 40, 41, 159, 167).[71] As already noted, interest was taken in work in the West Country starting with the façade at Wells, and moving to St Augustine's at Bristol (after 1298) and Exeter (from the late 1270s), and also St Mary Redcliffe, Bristol (before 1320?). The large ogee arches and cornice with alternating heads and fleurons on the east wall

of the Lady Chapel at St Augustine's (see pl. 133) pre-date the similar treatment of the east wall of the corresponding chapel at Ely.[72] The central part of the Bristol east window contains a transom consisting of openwork squared quadrilobes (also a Ramsey motif) similar to the openwork balustrade under the windows of the Lady Chapel (see pls 133, 159, and see also pl. 70).[73] Larger nodding ogees appeared first in the West Country at Exeter on the bishop's throne around 1313 and at the corners of the pulpitum there under way by 1317 (see pls 103, 105). The pulpitum has ornately cusped spandrels like the later bays in the new Ely presbytery. The strange lobed drop- or heart-shaped foiled motifs with points opposed to two lobes, which ring the head of the east window (see pl. 167) and fill the central oculus of the west window of Prior Crauden's Chapel, and which also form the triplet image niches beneath the windows of the octagon, are anticipated in the choir window tracery at Exeter.[74]

That those in authority at Ely were familiar with the exterior of St Stephen's Chapel at Westminster has been established in regard to the interior elevation of the octagon lantern (see pl. 179), which reproduces the Rayonnant linkage of its two stages by mullions, as on the court chapel's exterior, and whose panelling preserves detailing developed in the circle of Michael of Canterbury, such as concave-sided hexagons.[75] St Stephen's was important in possessing a lierne vault in its lower chapel possibly in place by 1297, a vault type that appeared in the Ethelbert Gate at Norwich before 1316–17 (see pl. 69) and then in the north aisle of the new presbytery bays at Ely designed in 1322.[76] The interior of the upper chapel of St Stephen (see pls 42, 85) was largely unbuilt in 1315–20, but if it was eventually raised according to designs drawn up as early as 1292 it was intended to have wall arcading also forming stalls, the ogival canopies and crenellated balustrade of which passed in front of the window mullions continued downwards as wall shafts to the plinth. Ely's use of continuous vault, but not window, shafts is certainly a variation of this idea, as is its openwork parapet beneath the windows; like St Stephen's Chapel, its window embrasures also have tabernacles. The slim polygonal wall shafts within the stalls have concave facets that characterized the shafts rising to sustain image corbels between the windows of St Stephen's; such fluting is typical of bases and capitals in the new Ely presbytery bays.

The Ely designers were familiar with Rayonnant ideas from more than one source, either derived from some centrally located archive of drawings at Westminster or via more far-flung contacts. A third certain source was the tomb of

Bishop William of Louth (d. 1298) in the presbytery of the church (see pl. 244), again Westminster-related work, and itself a masterpiece of painted micro-architectural detailing of the sort in the Lady Chapel.[77] It is also intrinsically likely that the octagon scheme took into account the largest single wooden-vaulted and centrally planned space of the period, the chapter house at York (see pl. 114), complete by around 1290. The use in the Lady Chapel of Purbeck marble shafting for the freestone canopy work of the stalls is also consistent with the chapter house stall work at York. Together, York and Westminster were crucial access points for French-derived Rayonnant ideas.

Of all the established major workshops of the generation, the Ramsey Company had the sort of contacts that might account for these far-flung references. The early records of the Ramseys at St Stephen's along with Thomas of Witney indicate central court training for some of them. A master mason called John appears in the Ely accounts for the *novum opus* and one called William Ramsey occurs later on for minor works; in addition the mason John Attegrene, also working at Ely in this period, went on to work within the Ramsey-based project of the cloisters at Norwich, and may have been an on-site deputy or *apparator*, a term first used in the St Stephen's Chapel accounts in the 1290s.[78] Ramsey regional 'reach' in this period is apparent at such substantial parish churches as Snettisham and Cley (see pl. 195) in Norfolk.[79] And the Ramseys were the principal artists in that other regional developer's dream, the Norwich precinct and cloister operations under Bishop Salmon before 1325 (see p. 101). That Salmon was both influential at, and influenced by, Ely seems likely, but it is not difficult to demonstrate that specific choices at Ely were already being worked out at Norwich, which should clinch the Ramsey connection. Ely and Norwich were certainly in a two-way dialogue.[80] Take, for instance, one of the most beautiful and eloquent forms at Ely, the cusped frames of the seated kings in the Lady Chapel wall arcade which follow the subtle 'nodding' curves of the minor arch heads to either side, as well as the bold obeisance of the over-arch. The king is seated on a throne that backs onto the major vault shaft, so that the king is sheltered within this curvy bower, though his feet rest on a small polygonal base sustained by a foliage corbel which protrudes from the point of intersection of the minor arch heads and the central foiled frame (see pl. 162). The instance nearest to this *circa* 1320 is the three flowing tracery inserts to the chapter house entrance at Norwich discussed above (see pl. 67), where in each case an image corbel was located at the same point of intersec-

tion between the minor arch heads and the cusped curving motif in the arch head above, these frames being understood not as apertures but as frames for images, as vesicas – detail almost entirely struck off by later iconoclasm, but which followed from the change of plan inaugurated by Salmon in the cloister around 1315–20 (see p. 109). The framing motif, four-sided and cusped but flattened at the top and more acutely pointed below, is the kite-shaped motif occurring either high up in the tracery of the Carnary at Norwich (see pl. 71), the cathedral's south cloister walk (see pl. 160, left side), and again in the very top two lights of the Lady Chapel's east window. The well-known 'Ramsey' four-petal motif in the south walk and in the flint flushwork on the east face of the Ethelbert Gate (see pl. 160, right side, compare pl. 70) also informs the tribune tracery in the new presbytery bays (see pl. 46) and the balustrade of the Lady Chapel at Ely. The tracery of the side windows and east end corner niches of Prior Crauden's Chapel is also close to Salmon's palace porch (see pls 155, 167, compare pl. 72), and minute details of the miniature tracery lights atop the shafting of the wall arcading in the Lady Chapel prove that its masons were versed in this Norwich idiom. Yet with the exception of the palace porch at Norwich, there are no nodding ogees at all in the extant work there; Ely's soft pliable handling and vigorous use of the nodding form is distinctive for a building of the period and differs from the occasionally rather frilly touch of the Ramsey masons, but the underlying schemas point to Ramsey authorship.

Vaghezza

The Lady Chapel's extraordinary richness of collation and arrangement is beyond dispute. But, after disposition, what of the particular aesthetic force of the chapel's treatment, its ostensive covering of beauty, which is an aspect of what rhetoricians called *elocutio* or style? The interior of the Lady Chapel has a very particular blend of dryness and suppleness, its 'touch' as well as its repertory of specific forms being quite different from the elegant understated smoothness of the work of, say, Michael of Canterbury at St Stephen's or at Canterbury. Crucial to this paradoxical mixture of the brittle and the ample is the often-remarked emphasis on the nodding ogee as a constitutive form of the main elevations, a use more marked than in any interior in this style to date and perhaps matched only at this time on the exterior of the north porch of St Mary Redcliffe, Bristol, also around or possibly before 1320 (pl. 168 and see pl. 33):

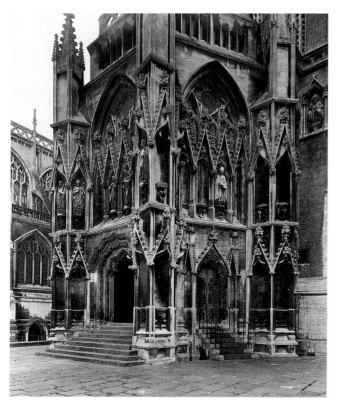

168 *(above)* Bristol, St Mary Redcliffe, north porch, *circa* 1320

169 *(right)* Ely Cathedral, Lady Chapel, south wall arcade

in the fifteenth century William of Worcestre designated the Bristol chapel the 'principal Lady Chapel' of the church, its inner chamber housing a cult image of the Virgin Mary.[81] As at Ely the niches contained images of kings. Though the aesthetic balance of the interior at Ely has been totally upset by the loss of the statuary in the upper niches, the zone of sheer visual activity above the stalls (pl. 169) must always have been apparent. Pevsner's appreciation of this arcading is astute, for there is something in his form of empathetic (actually expressionistic) writing that is especially well suited to grappling with experiences such as this: so the seamless mixture of architectural and undulating vegetal forms at Ely is a form of ambiguation, attractive in its (Wölfflinian) movement and unclarity.[82] It operates in fact as a very complex form of emphasis. The main visual technique is certainly movement, which, important as it is to formalist empathy theory in the modern era, also played a long-recognized role in the arts of persuasion. Quintilian (*Institutio oratoria* II.13.8–10) argued that while rhetoric has rules, it cannot be bound by hard and fast laws: expediency,

rhetorical effectiveness, directs that we should be flexible in applying skills. This was an aspect of *varietas*. Central to it was the notion of change and movement, or 'variation of activity' in pedagogic language.[83] Quintilian used the analogy of the human body: stiffly erect bodies possess little grace (*gratia*) and are stiff (*rigens opus*) from top to toe. Flexibility on the other hand shows and instils change: action and emotion, or animation (*motus dat actum quendam et adfectum*). Helpfully, here he uses the analogy of sculpture: in the representation of action or animation lies praiseworthy difficulty.

Medieval theory of invention and behaviour was familiar with this line of thought: Vinsauf in his *Poetria nova* explicitly praises difficulty, but the notion that change and movement were central to intelligent behaviour, attention, allure and the expressive force of things is apparent in the writings of moral theologians as well as poets and, I have suggested elsewhere, to the affect of central religious signs like the Crucifixion.[84] In the previous chapter I noted that some artists of the period explicitly chose lively ogival arch forms

to accompany the image of the Crucifixion itself, as in the De Lisle Psalter (see pl. 135). Though not expressive of any particular passion, so much as being intransitively 'expressive', the use of the ogee here can be said to energize human affect without necessarily articulating it: affect (sensation) in general is heightened to a point of greater receptiveness, but actual emotion is not prescribed, and nor is this activity rule-bound. To repeat, this is not a form of emoting or symbolizing, but a means of emphasis. The aim in the language of contemporary *pastoralia* is to excite or inflame, to gain attention, and so ultimately to persuade. My suggestion is that the prominence of the nodding ogee in a Marian building cannot simply be seen as part of an elaborate game of commentary by 'irrational' English artists on the strictures of 'rational' and formally strict French Rayonnant, but is instead to be seen as a conscious artful strategy to engage an audience unconsciously – I am thinking again of that reciprocal, but cunning, bond of charity and technical allure explored in the previous chapter (p. 179). This activity, this engaging unruliness, was not rule-bound, formulaic or guaranteed: the outcome for any one spectator could not be prescribed. What to one person might be alluring, to another might be repulsive or the occasion for fascination in its more negative (and then common) sense. This, after all, is the history of iconoclasm.

At Ely, nevertheless, is witnessed a voluptuous language of insinuation, winding, bending and curving: an art of coral, intricate and digressive, here plain and smooth, there knotted and coagulated and apparently ever-changing. Figures such as the kings within the arcade stalls that front and sustain the vaulting shafts are sheltered in tiny hollows, *sinus*, formed by the swelling curved forms of the arcade tracery (see pls 161, 162): it is Lazarus who goes into the refuge of Abraham's bosom (*in sinum Abrahe*), in paradise (Luke 16:22). To insinuate is to impart to the mind indirectly or covertly, to instil subtly and imperceptibly. *Insinuatio* in medieval commentaries on Cicero was the idea that the listener is led along or guided subtly through a text or speech: one of these commentaries, beginning *Ut ait Quintilianus*, reads: 'Likewise insinuation is the beginning of a rhetorical speech secretly seducing the minds of the audience . . . Especially insinuation is secrecy . . . because it greatly bends about and softens up the hearer. For we say "to insinuate" is "to curve around".'[85] In sum, just as the 'woven' aesthetic of shafts, arches, vegetal and human sculpted forms in the Lady Chapel embodies subtlety (*subtilitas*), that passage over and under of threads in admirable weaving, the nodding ogee and its incessant undulation not only leads us along unknowingly by insinuation while 'enclosing' significance; this cunning also actually sweetens, softens, bends and disposes us by its wandering. And throughout – as is also apparent in the eastern part of the chapel where it is better preserved – is found colour, the final weapon in the arsenal of persuasion, for no form, no matter how minute, was not carefully tricked out in red, blue and gold. Colouring, in this case by means of grey marble shafting in the arcading and by paintwork (see pl. 150), is the final aspect of this affective and pleasurably persuasive milieu.[86]

Long-standing language uses familiar in the ancient and medieval worlds, and developed later, help here; so let me press this line of argument a little further by considering some more words that may (to an extent) clear the present discussion of the charge that it is simply a form of Pevsnerian expressionism. The association of moving or curving forms and affect is captured much more exactly than in English or Latin by the Italian *vaghezza*, 'loveliness', 'delight', 'longing'. The word stems from the Latin *vagor* (to wander or to go to and fro), but lends to it a particular positive yet delicate affect. This word usage was already familiar to Dante, Petrarch and Boccaccio (for example, Emilia's narcissistic *canzone* at the end of Day 1 of the *Decameron*); Chaucer may have known of this idea, and it was demonstrably important in the later Italian aesthetic theory of Agnolo Firenzuola.[87] There is admittedly a risk in retro-fitting early fourteenth-century England with literary and artistic ideas and terminology whose principal circulation at this date was Italian, and whose major artistic flowering occurred a century or two later. No matter: in this case the idea is worth pursuing since the ideas were embedded within long-standing rhetorical tradition before the Renaissance, as David Summers long ago showed with regard to the so-called *figura serpentinata*.[88] The term *vaghezza* alerts us to the subtle way that 'moving' things induce a positive affect: we are (or, more strictly, may be) charmed or sweetened and accordingly in thrall, in love. Medieval theory of the passions discriminated between the powers of concupiscence (attraction) and irascibility (repulsion): the soul may be influenced to desire, disdain, love or fear something, and so is drawn to, or drawn away.[89] Dante captures the place of movement of the soul and body in regard to love when, in *Purgatorio* 18:19–27, he says that the mind is set in motion by what is pleasing, bending or inclines towards the object of pleasure: 'that bending is love' (*quel piegare è amor*).

Central to this is the idea that the affective motion of delight is at once sweet and soft or 'easy', *dulcis* and

suavis – and thus persuasive.[90] In book two of *Della pittura* (1436), Leon Battista Alberti, in keeping with the rhetoricians, praises the representation of movements – for instance the delightful serpentine curling of hair – especially if they are moderate and sweet (*moderati e dolci*).[91] In later usage the term *vaghezza* applies especially to the dangerous allure of feminine beauty: fifteenth- and sixteenth-century art theory turned the negative notion of the instability and mutability of the female, derived ultimately from Aristotle, into a positive artistic virtue.[92] In his maverick text *The Analysis of Beauty* (1753), William Hogarth set out an account of the 'line of beauty' as a perfectly judged serpentine s-bend ogival form, presumably – as Pevsner pointed out – quite unconscious of the use of this common underlying curved structure for English Gothic sculpture and architecture.[93] It is a striking possibility that the artifice of the early fourteenth century had already implanted something like this virtue into its own inventive capacities, but particularly in commissions with a strongly feminine association. Perhaps this soft, melting and technically astonishing aesthetic of 'sweet talking' was an unusual aspect of the cult of Mary herself, since there is a striking continuity between the wonderfully undercut foliage of the portals of the twelfth-century Lady Chapel at Glastonbury, the miraculous reversed and undercut curves and nodding ogees of the north porch at St Mary Redcliffe, also a Marian building, and the Lady Chapel arcading at Ely (see pls 33–4, 168–9).[94] Another instance, quite possibly planned before 1321, is the dado arcading of the Lady Chapel at Lichfield Cathedral, which contains gently nodding ogee arches (see pl. 31).[95] Big ogee arches had appeared on the east wall of the Lady Chapel at St Augustine's, Bristol, not long after 1298 (see pl. 133). The Eleanor Crosses, the most romantic memorials of the age (see pls 101, 102), make astonishing play with tracery effects including curvilinear ogival forms, and it has been suggested that there is Marian subtext in the queenly form of their statuary.[96] Indeed, the greatest example of the curvilinear aesthetic in northern England, the Percy tomb in Beverley Minster – near John Hotham's home territory – dating probably to the 1340s and possessing a giant nodding ogee arch (pl. 170), commemorates a female member of the Percy family.[97]

In all these cases the effects are remarkable. But it is not a question of dealing with astonishment premised upon surprise and shock – that sudden utterly unexpected experience of which the Greek philosopher Michael Psellos wrote when he described a particular icon of the Virgin Mary that ravished him as a bolt of lightning by its beauty,

170 Beverley Minster, Percy tomb, 1340s (see also pl. 142)

depriving him of strength and reason.[98] Such experience – transcendant because it concerns loss of will under extraordinary circumstances – is not unlike Chaucer's account of Troilus's reaction to the beauty of Criseyde which left him 'astoned' – not bending, but thunderstruck.[99] Rather, here is found something more gradual, as it were the subtle seduction and moving caress of love poetry. The work at Ely may occasion surprise, but it also rewards slow, repeated looking. This looking might have been pleasurable in itself; but one cannot be certain that it did not also entail thoughts about a person – a great person, a model of virtue and charity. That which is technically astonishing served to create a seductive frame for Mary, whose image came alive and who truly possessed the power to transform, as her miracles show: for her, the lamp of sacrifice burnt at its brightest, yet also subtlest.

And if the transfer to Ely of ideas that were fundamentally rhetorical in origin and usage seems anachronistic, there is one small piece of evidence that suggests that thinking of one fairly stable tradition of language in regard to the virtue of soft, delightful and 'easy' movement was not inconceivable in the fourteenth-century English milieu. It is provided by an entry dated 1382 in a chapter act book of Beverley Minster (see pl. 197) – scarcely 'high art' literature – referring to the location of a tomb in the middle of the church at the juncture of the old 'studied' work and the more artless or relaxed (*inadfectatus*) newer work (*in medio ecclesiae quo opus inadfectatum opus prium ingeni concrepuit*), which means the junction of the thirteenth- and the fourteenth-century parts.[100] This is where the fourteenth-century work, continuous in many ways with the older parts to the east of the church, introduces ogee arches and flowing tracery, not 'naturalistic' in the mimetic sense, but 'natural' in the sense of unforced or unstudied, a skill of the persuader, as Quintilian has already shown, whereby art conceals art.

In the midst of this subtle emollience, this longing, is clearly ambiguity or elusiveness, the feeling that the eye is in some sense thrown over by an accumulation of complexity: it is tempting to look closer in order to gain rational understanding to the point where we 'get it'.[101] Chaucer expresses the idea of the mind-work involved in understanding the wondrous very exactly in remarking of the complex aesthetic of the House of Fame that it was 'so *wonderlych* ywrought/ That hit *astonyeth* yit my thought/ And maketh al my wit to *swynke* [i.e., labour]' (see p. 346). And this doctrine of wonder preceding enquiry had already been set out (with the help of Aristotle) in conventional theory of allegory and integumental meaning.

In all this discussion of whether, and how, things attract, there lies a quite fundamental problem. To understand the notion of allure is as hard as saying anything accurate or rewarding about pleasure. The most interesting aesthetic concepts often tend to be ambivalent, and it is vital to any discussion about the agency of subjects and objects that allowance is made for the possibility of failure and repulsion, as much as success and attraction. Here the image of 'love' is helpful too: we cannot love everything and everyone, unless we are 'on' something. In this is seen how the most developed strategies of the Decorated Style embodied a marked element of risk. The risk of vice arising from allure and seduction, the sense of a tricky borderline to be negotiated or crossed, is of course all part of the fun. Movement and especially wandering (*error*) can signal vice, and in such

words can be traced the frontiers of danger, as in the relation of *cura* (carefulness) and *curiositas* (vice of the eyes) – both relevant to highly worked sculpture. This applies particularly to the concept of *vaghezza* in relation to the perception that wandering was at once profoundly attractive yet also morally dangerous.[102]

Before turning to the miraculous here is one final reflection on the analysis of Ely's wonderful art as an art of persuasion, seduction, ambivalence and insinuation: that its powers of arousal, of fascination – in its more negative sense – were as apparent to the hammer-happy iconoclasts who smashed its imagery so comprehensively in the course of the Reformation as they doubtless were to the audiences that first produced and witnessed it. To suggest that this had to do with text and idolatry is to lose sight of the deeper issue: iconoclasm of such an attentive sort has an aesthetic character.[103] Iconoclasm is the perverse mirror image of the intention of such artworks. To say that it has made the task of working out what miracles were actually depicted at Ely far harder is secondary to the way iconoclasm acknowledges special and enduring powers.

Mary and Miracles

A power to transform beyond the sweet medicine of artful persuasion is apparent above all in the domain of the miraculous. The Lady Chapel's art, is, I think, designed to make us feel better. So too are miracles. Another very important aspect of ordering in it is the shape given to narrative, amply present in the chapel in the form of the *Life and Miracles of the Virgin Mary* carved and coloured in the spandrels over the wall arcading. The miracles, along with the chapel's many tiny micro-architectural flourishes, are much the smallest items in the building, and in their astonishing beauty and detail of surface and finish, texture, colour and detail lies one of the greatest instances in European art of the relation of minificence and magnificence; greatness and smallness go hand in hand here not in the spirit of some 'miniaturist tendency', but because the movement, close looking and polyfocal ponderation required by their relation are agents of wondering in themselves.[104] In the first legible miracle at the east end of the south wall, showing in all probability St Bonitus at Mass, the altar is covered in a minutely painted striped frontal, and the chalice and corporal cloth are perfectly formed in stone. These tiny effects are at once sweet and extraordinary and are repeated throughout the scheme. They are greeted too in France in

this period in the astonishing, though fragmentary, four-teenth-century painted stone retable of two tiers in the axial chapel of the cathedral of Narbonne, depicting the lives of Christ and the Virgin Mary, with dozens of prettily painted and carved figures, castles and other details, all inhabiting the same absorbing small-scale world of tiny delight.[105]

The lusty Ely iconoclasts who went at this little world so mercilessly after the Reformation were fanatically hostile to scrutiny, thought and choice, and left almost all the scenes wrecks. There are numerous points of uncertainty of iden-tification. M. R. James, whose commentary of 1895 remains the most thorough, thought he could identify about three-quarters of the scenes.[106] What survives indicates the same meticulous planning as that running through the building more generally: the sculptures were executed by more than one team to an astonishing level of virtuosity, and their narrative art is richly inventive. To understand the narrative ordering one should recall the dual filtration system that led laypeople into the chapel via the doors in the midst of the south wall, and the monks into its east end via external passages leading to the south door in the second bay from the east. It is intrinsically improbable that this cunning segregation was then immediately abandoned in the build-ing itself, remixing monks and women; so it must be assumed that there was a (probably wooden) partition screen across the chapel, which, though it has left no trace, may probably be located immediately to the west of the southern main entrance (see pl. 157). Ironwork for the doors (presumably north and south doors) of the parclose screen in the chapel was made in 1373 at the same time as the provision near the high altar of a new glass window by Bishop Barnet: these indicate a transverse screen.[107] It will be noted that on both sides of the chapel the polychromy survives (or was more fully executed) best to the east of this position, suggesting that there was always some partition at this point. The screen may have resembled those later executed in the choir of St Margaret's, King's Lynn.

An argument in favour of this division is that the arcade narratives seem to have been planned with some such punctuation of space and surface in mind. The undeniable starting point is over the entrance door in the middle of the south wall, with the beginning of the *Life of the Virgin* at the moment when Joachim's offering is rejected. We enter the chapel when Mary herself enters the world, then turn and move westwards in clockwise fashion following the accounts of Anna and Joachim, the Birth of the Virgin, her Presentation and upbringing in the Temple (pl. 171), her marriage and then the Annunciation and Visitation, which

fall over the vault shaft showing King David, following Luke 1:32 (see pl. 161). The narrative of the Nativity, Flight into Egypt, Presentation, Baptism and Passion of Christ then unravels seriatim across the west wall, with the death, funeral and Assumption of the Virgin continuing on the north wall. The Assumption falls directly opposite the Annunciation and Visitation scenes, showing that the 'Davidic' axis of the chapel was meant to mark the three major Marian feasts (25 March, 2 July, 15 August). The *Miracles* begin in the second bay from the west with St Basil, Julian the Apostate and St George. There follow the clerk who fell from a bridge with his harp, and was rescued from drowning; pos-sibly the clerk who knew only one Mass (of the Virgin Mary); the tale of the prisoners and the devils; and Pope Leo who, tempted, had one hand cut off, which was restored by the Virgin. Many of the miracles towards the east of the north wall are unclear, but at the east end they include the popular story of the Jewish boy of Bourges.

Nothing remains on the east, altar, wall, and the first miracle at the east end of the south wall is likewise lost: here, perhaps, the iconoclasts began the work at the height of their energy. The first surviving scene to the east end of the south wall is the account of a bishop celebrating Mass who is given a vestment by the Virgin Mary, and who gives thanks; in the next bay a male in a state of near total undress sprawls forwards as if either semi-conscious or ready for a good lashing, before a large angel (pl. 172, right bay). James suggested that this was the miracle of St Hildephonsus, archbishop of Toledo, a champion of the Virgin whom she rewarded with a vestment for his use alone; but this was donned by his successor Siagrus, whom it choked to death. More probably, however, the tale is that of another vestment miracle, that of St Bonitus or Bonet, who celebrated Mass in a church of St Michael one night in the presence of Mary and the angels and was rewarded with the gift of a vestment; an inebriated clerk who also tried to worship in the same church collapsed while drunk and, instead of being flogged, was miraculously and mercifully sent home to bed. The Bonitus story explains the large angel, presumably Michael, and the collapsed and dishevelled man, who adopts more or less the prone position of Theophilus asleep before the altar of the Virgin in the Smithfield Decretals, folio 170v.[108]

At this point the miracles take on a specific focus. If this is the Bonitus legend, it is not only a warning about the perils of nocturnal drinking and the sin of gluttony. St Bonitus, unlike St Hildephonsus, was a regional saint whose cult was noted at Norwich Cathedral because its founder, Herbert de Losinga, had witnessed Bonitus's vestment at

171 Ely Cathedral, Lady Chapel, south wall, *Presentation of the Virgin in the Temple*

172 Ely Cathedral, Lady Chapel, south wall, east end, St Bonitus gives thanks at an altar; St Michael dismisses the sprawling drunken clerk

Clermont.[109] The Bonitus legend, if that is what it is, introduces a sequence of stories focused around the monastic entrance to the church. Next a nun is encountered, seduced into the world and eloping with a hawking male companion, but whose absence is covered by the Virgin; the nun eventually returns (the temptations of the world, disobedience); above the door is the famous story of the clerk Theophilus, signifying the sin of pride (pl. 173); and just west of it is the legend of the pregnant abbess (lust, disobedience) (pl. 174). The next story is either that of the woodman whose leg was restored by the Virgin, or of the farmer whose leg was healed by St Hippolytus with her help. The latter may be preferred because, again, Hippolytus was a saint of regional importance, a relic being at Norwich.[110] If so the Norwich–Ely 'axis' is restated in hagiography as well as idiom. Finally, just by the site of the proposed screen, is the usurer who was redeemed by a modest gift of bread. Next to it is the tale of Joachim's offering, gift giving again as it were, starting off the whole narrative.

Broadly, then, the generality of people were provided with edifying narratives about Mary and Christ, and the monks with racy moralizing tales about human failings and vices, particularly sex and booze. The miracles began on the north wall within the 'lay' space, 'hooking' the spectators and leading them to wonder what lay eastwards beyond the barrier. The screenage would have had access doors at either end, and it is likely that the laity were allowed into the eastern enclosure when the monks were not celebrating Masses or singing offices, which involved cantors and boys.[111] When they were, however, the monks entered in humility beneath Theophilus, and were made mindful of the snares and perils of the flesh shown to either side of their portal. Such doorway concentrations of moralizing imagery were long established in medieval art, for instance, on the great Romanesque portals of Moissac (Luxuria) and Souillac (Theophilus), and it should be recalled that the legend of Theophilus, the greatest rebuke to clerical ambition, is displayed magnificently on the north transept portal of Notre-Dame in Paris, precisely within the canon's *clôture* or enclosed space.[112]

I have already suggested that, of all the buildings at Ely, the Lady Chapel may have enjoyed the longest period of

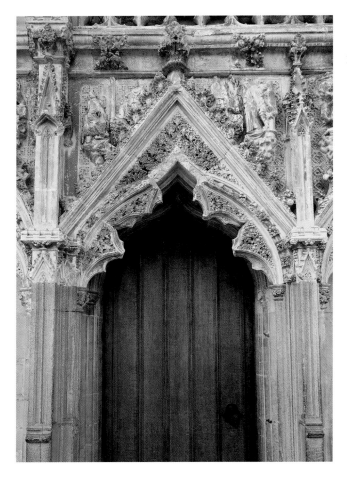

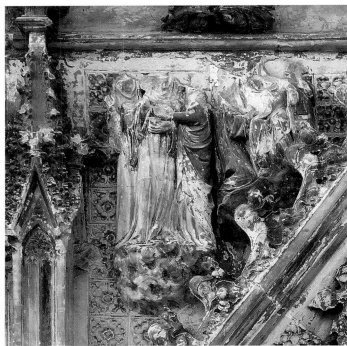

173 *(right)* Ely Cathedral, Lady Chapel, south wall, monk's door (see plan, pl. 157); above, Theophilus prays to the Virgin Mary (left) and is released from his bond (right)

174 *(above)* Ely Cathedral, Lady Chapel, south wall, the bishop 'tests' the pregnant abbess's breasts

gestation, and there is some uncertainty as to when it was conceived and the manufacture of components started: but a date not long after 1315–16 is possible, with the formal commencement in March 1321. This issue needs to be raised because, if the Marian legends in particular were selected and drafted rather before 1321 as I suppose, they emerge as quite possibly the earliest instance of their type in England, pre-dating, according to one view of its date, the thirty-five miracles in the margins of the Queen Mary Psalter (British Library MS Royal 2.B.VII).[113] M. R. James pinpointed very fairly the comparable Marian sequences. Apart from the Queen Mary Psalter (1310s or 1320s), which is statistically the least close in overall correspondence, the closest are, in order of general coincidence, the Smithfield Decretals (British Library MS Royal 10.E.IV), the Carew-Poyntz Hours (Cambridge, Fitzwilliam Museum MS 48) and the Taymouth Hours (British Library MS Yates Thompson 13), works all dating to *circa* 1330, and rather later still in the case of the Carew-Poyntz manuscript.[114] Of these, the Smithfield Decretals was made for a male member of the Batayle family;

the other books, the Taymouth Hours especially (possibly commissioned by Queen Philippa), were probably for female patrons. Ely and the Taymouth Hours include the image of Theophilus kneeling before an altar with an image of the Virgin Mary on folio 159v, and the image of the bishop testing the delivered abbess's breasts on folio 157v, grouped in the same way as the Ely scene (pls 173, left, 175; pls 174, 176). Lesser correspondences are to be found in the Neville of Hornby Hours (British Library MS Egerton 2781) and in the Bohun manuscripts.[115] Four of these, all works of after 1330 or so, maintain a specific sequential pairing found also in the Lady Chapel, that of the legends of Theophilus and the pregnant abbess, including the Taymouth Hours (fols 156v–160v), the Neville of Hornby Hours (fols 21v–23v) and some Bohun books.[116] It remains to be shown that this arose ultimately because of the particular physical arrangements in the Lady Chapel itself.

The hinterland of this remarkable series of images is less easy to establish, since as a rule Marian cycles did not have a strong local flavour. Only a sketch is possible here. Though

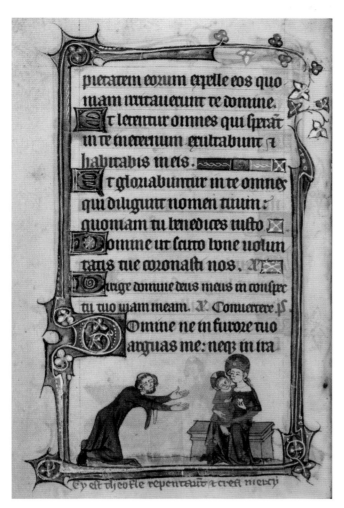

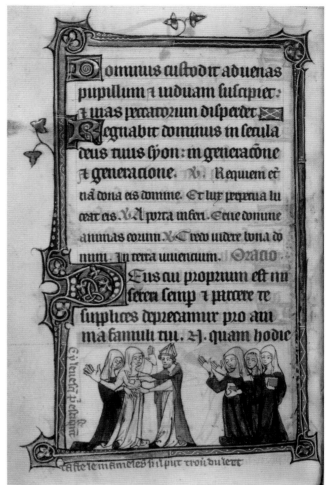

175 Taymouth Hours, *Theophilus before the Virgin Mary*, 1330s (BL MS Yates Thompson 13, fol. 159v), compare pl. 173

176 Taymouth Hours, the bishop tests the pregnant abbess's breasts, 1330s (BL MS Yates Thompson 13, fol. 157v), compare pl. 174

the possibility of some regional inflection at Ely has been noted, the cycles closest to it in general (the Smithfield Decretals, Taymouth Hours and Queen Mary Psalter) were almost certainly London- or court-made products. That is not to deny the formative importance of regional English monasticism for the collection of Marian miracles since the twelfth century. Particularly central for this, as for the development of the feast of the Immaculate Conception, was Anselm of Bury (abbot 1121–48), who expanded in number the widely known 'core' Marian miracles; Dominic of Evesham and William of Malmesbury were also important contributors.[117] The texts of these three compilers were eventually amalgamated by Alberic, a canon of St Paul's Cathedral, and this in turn provided the basis for vernacular translations.[118] Collections, admittedly unillustrated, existed

at Bury and Peterborough, both of which possessed new Lady chapels; but of Marian compilations at Ely nothing is known at all. Of the thirteenth-century Bury chapel's imagery all that can be said is that a later source implies that the chapel possessed at its high altar a series of typological images echoing closely those once in the chapter house at Worcester – an instance of the regional persistence of typology.[119] One of the verses in Bury's Marian windows showing the Magi bore the caption *Hic in honore dei dant mistica dona Sabei* (Here, in God's honour, they give the mystical gifts of Sheba). In addition (though the source is confused), were windows around an image of the Virgin showing the death of Herod, Theophilus, the Magi and the healing of a sick child; on one of the walls were images, presumably murals, of the monk drowning and raised by

213

the Virgin, and the Jewish boy of Bourges, also on an altar painting nearby.[120]

It is impossible to say that Ely derived its images from Bury; and the same holds true for Marian compilations in the Fens themselves. It is known only that the east window of the Lady Chapel at Peterborough contained an image of Julian the Apostate. But textual, rather than pictorial, compilations were evidently pursued with astonishing energy regionally, since by far the largest of all collections of Marian miracles, numbering about five hundred and sorted carefully and somewhat scholastically by topic (miracles linked to feasts, images, secular and regular clergy and laity), was compiled by a monk at Thorney in the Fens by 1409 (Cambridge, Sidney Sussex College MS 95).[121] Only a minority of these miracles is in any sense 'local', including St Bonitus (III, 20), and the relation to Ely is not instructive.

There is one final reason for emphasizing the metropolitan, rather than regional-monastic, dimension of the Marian imagery at Ely. It is that a very similar nexus exists between the Smithfield Decretals, the Taymouth Hours and the imagery of the misericords executed in the late 1330s for the choir stalls of Ely Cathedral (pl. 177) under the mastership of William Hurley, the London-based carpenter responsible for the octagon, being complete by 1342.[122] Grössinger specifies the similarity of such subjects as Reynard the Fox, St Eustace, Adam and Eve, and John the Baptist, the latter laid out narrative-fashion as in a manuscript, resembling folios 106v–107v of the Taymouth Hours scenes of the same subject.[123] In the case of the Lady Chapel sculptures these particular manuscripts would not have had priority in time, though they may have had earlier antecedents reflected in turn at Ely. But the coincidence of two points of reference, including the choir stalls, is notable. Whoever

177 Ely Cathedral, choir stall misericord, *Decollation of St John the Baptist*, late 1330s

formulated the Marian stories at Ely had a metropolitan connection of some sort, ideas travelling with the main authorities in charge of the masonry and timber respectively, namely the Ramseys and Hurley, their courtly colleague. The sculptures presuppose extraordinary textual and visual research, but they tell us too about the range, as impresarios of imagery more generally, such masters in charge had: and that notion is consistent with their elevated position professionally. But the important point is not ascertaining the origin of the imagery or even, necessarily, its exact meanings, but rather attempting to understand to what ends so much engagingly executed narrative surface was directed.

The Gifts of Sheba: Funding and Completing the Lady Chapel

To suggest that the aesthetic, and so psychological, engagement of visitors to the Lady Chapel had material motives in mind is not to deny the reality and force of devotion to the Virgin Mary that these works were intended to inflame. It illustrates the truth of the idea that astonishing technical accomplishments in the arts cannot readily be severed from the ideals and people they serve. Taken together, as they must be at Ely, one sees methods of softening up in order to give more, the basic psychological tactics of which were so accurately pinpointed by St Bernard in his *Apologia* (p. 183). But not all the tactics were crude or populist. If what has been said here so far is true, the Lady Chapel was as fundamentally theological in conception as any major European building of its time, a biblical proportion for its most basic ground plan generating an unfolding of thought about Solomon and the House of David, the queen of Sheba, Solomon, Mary and Wisdom, and the edificatory and moral virtues of the narratives, apocryphal or otherwise, about Mary herself and her Son. The entrance routes, screenage and direction of the narrative images indicated the way through an unfolding experience of Mary.

Funding all this was obviously important. It matters less that the actual completion of the Lady Chapel, first of the buildings at Ely to be begun but last to be completed, was protracted. At Ely, the course of the works was shaped by the considerable initial investment in labour, and to a lesser extent materials, entailed by the manufacture of the wall arcading and narratives, the components of which may or may not have been begun even before March 1321. No exact calculation of the unexpected impact of the adjacent *novum opus* after 1322 is possible. It is also apparent that the

subsequent installation of the wide vault was rushed or undertaken in such a way as to compromise the quality of work, as is apparent on the upper exterior walls, where the masonry coursing is very inexact. The presence of substantial continuous vault shafts certainly implies rib vaulting of some sort. It has been suggested that the vault was actually inserted in the following century.[124] Against this are two things: the fact that the bosses on its ridge rib are manifestly of the period 1325–50 in style and fashion; and second, a neglected reference in the Lady Chapel accounts for 1383–4 to the purchase of a small number of 'estrich' boards (i.e., Baltic timber) for rejoining its vault, which implies subsequent settlement of a stone vault already in place.[125] The relative crudity of the installation (though the design itself is subtle), and especially of the little bosses, which bear no relation in quality to the narrative reliefs, implies a different team of workmen from those used earlier.

If so, the evidence suggests that the Lady Chapel experienced at least two important injections of funding: an initial one before or around 1321 providing for the sculpted lower parts, and a subsequent one that eventually enabled the ambitious stone vault to be installed; the provision of dozens of larger standing images for the wall tabernacles could follow in train. Evidence for funding in the early phase is fragmentary. John Crauden expended money on it by 1324–5 and John Hotham bequeathed £100 for the fabric of the chapel in his will.[126] It is evident from the *Chronicon* that around 1321, or after the fall of the tower in 1322, the monks were also very eager to highlight any financially winning miraculous or semi-miraculous events, probably recorded by Alan of Walsingham. One learns first of the miraculous rediscovery in a London sewer of a magnificent Cross-relic donated to the abbey by King Edgar but stolen in 1322; and second of the clerk of Weston struck dumb but cured by St Etheldreda.[127] Thirdly, when John of Wisbech summoned his men to dig out the four-square foundation of the Lady Chapel, he found a bronze urn containing plenty of coins with which he kept the workers happy.[128] The first two miracles pertain to Etheldreda, but the third occurred with the tacit intervention of Mary. Later that century a sacrist of Worcester Cathedral found a cache of gold coins in its monastic cemetery that sustained the works there.[129] Whether or not John really found anything at Ely is unknown.[130] The miraculous provision of funding for a building was a monastic commonplace; according to Conrad Rudolph, building miracles became more focused on money after the urbanization of Europe, particularly if, by implication, those projects were more than usually lavish: the miracle is a sign of the expenditure to come.[131] John is presumably the small kneeling monk carved on the corbel at the main entrance to the Lady Chapel, near where he was to be buried.[132] This is amongst the earliest work on the chapel: an initial assumption clearly was that he, or at any rate a monk, could with God's help be deemed its chief founder or provider.

The crucial figure, however, in the subsequent rejuvenation of patronage was certainly no monk, but a cleric, the bishop of Ely, Simon de Montacute (1337–45), a former papal chaplain, familiar clerk of Edward III and formerly bishop of Worcester.[133] The Ely *Chronicon* strongly hints at Montacute's appropriation of the whole Lady Chapel project: though it was already started (*incepta*), Montacute spent sumptuously and greatly on it; he was ardently devoted to the scheme but himself died before it could be completed.[134] It is significant that the *Chronicon* reverts to the narrative of John of Wisbech's work in its account of Montacute's rather than Hotham's episcopate; more significant still, that Montacute elected to be buried not in the presbytery of the great church, as had been the case for his predecessors, but before the high altar of the Lady Chapel.[135] This is not unlike the action of a *fundator* such as Hugh of Northwold, buried at the heart of 'his' presbytery, or Alan of Walsingham, buried at the western side of the *novum opus*. Montacute's devotion to the Virgin Mary may explain the re-dedication to her of the church of St Peter attached to Peterhouse (for which he provided statutes in 1344) in Cambridge, now the parish church of Little St Mary's, a building in important respects a copy of the Ely building, as its spreading tracery windows show (see pl. 53). And conclusive evidence of this appropriative outlook, as well as of Montacute's noble origin, is provided by the depiction of his arms on carved shields on the west exterior wall of the chapel at the left midpoint next to the window's transom (pl. 178).[136] This level cannot have been reached before 1337, and heraldry does not appear at all in the lower areas of the building. The *Chronicon* knowingly states of Montacute that he followed the example of Simeon the high priest as read in Ecclesiasticus (50:1): 'who in his life propped up the house and in his days fortified the Temple, by him also the height of the temple was founded; the double building and the high walls of the temple'.[137] Though overlooked, this glancing remark may suggest that Montacute was known to have completed the main elevations, on which he duly slung his shield.

The chapel was officially completed on the feast of the Visitation (2 July) 1349, which might mean that its vault, later repaired in the 1380s, was installed before that point.[138]

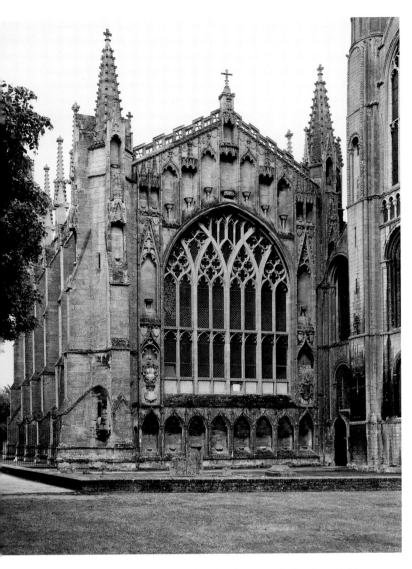

178 Ely Cathedral, Lady Chapel west end, showing shields at midpoint by window transom

Bishop Montacute was buried there). Payments to three or four glaziers in the chapel occurred also in 1356–7.[140] This indicates without doubt that much of the glazing at the east end of the chapel pre-dated 1352–3, with a further glass window in the vicinity of the high altar being added by Bishop Barnet around 1373.[141]

The provision by Henry of Grosmont, duke of Lancaster (d. 1361), of a window is especially striking. In the year following this account, 1354, Henry began the *Livre de Seyntz Medicines*, a text with much evidence of strong Marian devotion as well as uses of military imagery (p. 148 above).[142] He assisted with the foundation of the Dominican priory at Thetford (1335), which is known to have been glazed, possibly at his behest, in a fashion similar to that of the extant glass in the Lady Chapel of the period; and along with Edward III he is depicted on the splendid brass of Sir Hugh Hastings (d. 1347) at Elsing in Norfolk, which he probably knew about because he was Hugh's executor, and which is also sometimes compared in idiom to the Lady Chapel glazing.[143] He was also involved in the foundation of Corpus Christi College in Cambridge and was evidently a very substantial and intelligent man, one of the few 'literary' figures of the period actually engaged in art patronage.

The authorities at Ely would not only have reckoned with the passing support of a few major patrons like Henry of Grosmont. Their thought, even before 1320, would have been about the ways in which devotion to Mary could benefit the priory steadily. About this issue of revenue generation little exact can be said of the early period. It is known that by the fourteenth century Ely's register of diocesan revenues in the *Liber niger* opened with a recitation of the years of the Virgin Mary's life at which the Annunciation, Passion and her death occurred in a kind of sacral tally amounting to sixty-three years, one month and four days.[144] At the major house of Westminster Abbey, at least prior to royal appropriation of the works there in 1245, the Lady altar was especially prominent in the acquisition of property for the house even a generation prior to the building of the axial Lady Chapel there from 1220.[145] How widespread this practice was is unknown. But such Ely records as exist for income to the Lady altar from rents and oblations imply that oblations were the more important.[146] John of Wisbech's pot of coins was associated with the digging of a foundation of a building programmatically disposed to advertise the virtue of gift giving. To the House of Solomon came the queen of Sheba bringing gifts (3 Kings 10) and then giving lavishly. Typologically (Isaiah 60:6; Psalm 71:10), Sheba foreshadowed the gifts of the Three

But accounts for the years from 1349 up to the dedication in 1352–3 show that much remained to be done.[139] References are found to the provision of altar cloths and curtains; to repairs to the leading of the roof; to William Ymagour for five images, £3; to John Bale for four images at £1 6s.; to oil and colours for painting including £9 of gold; to John Painter for working on seven images for £1; to William Pyroun £22 for glass; and to Symon of Lenn (Lynn) for the duke of Lancaster's window £12 13s., with glass being purchased and carried from Yarmouth; and in addition £53 10s. of paving, which suggests that vault scaffolding and centring was out of the way by 1352 (and probably by 1345, when

Magi. Regional typology alone made the connection explicit: we enter the Lady Chapel as Sheba entered the House of Solomon, and as the Three Kings came to Mary and Jesus. We too are to be open-handed.

What is implicit in the chapel's intellectual programme is implicit too in its art. I have suggested in this study that the aesthetic of works like the Lady Chapel was one by means of which patrons and institutions were able to allure and win the favour and confidence of their supporters, both male and female, in the hope that their work would fructify. At work was a belief in the reciprocity of giving. To suppose so is to point to the possibility, no more, that under Bishop Hotham and Alan of Walsingham the perceived probability of the collapse of the cathedral's central tower had pointed to the need for a 'development office' to raise the resources needed to make the church secure. But events took over: not impossibly, the digging of the foundation for the chapel itself precipitated the collapse. The disaster of 1322 lay partly in the fact that the cathedral had neither a liturgical heart nor the development office needed to get it going again. In origin, the Lady Chapel was planned to discipline and promote the cult of the Virgin Mary, to organize and delight potential gift givers, and to warm them up and soften them, like wax, as a prelude to visiting the main shrine of St Etheldreda, over which presided the image of Mary herself, the very model of virginity. To do this, the monks set out what was, in effect, a second presbytery which alone could enable Ely to outstrip its eminent neighbours at Bury, Norwich, Peterborough and Walsingham.

But when the tower eventually fell, the priory and its architects were poised once again to measure out a building whose claims were even more grandiose. The Lady Chapel aimed to allure: it was an instance of that form of influence called 'soft power'. But the octagon raised after 1322 was a statement of the wonderful, which placed Ely's imaginative and technical supremacy beyond doubt.

The Octagon

The Lady Chapel introduced to Ely a new idea of exceptionally wide vaulting, provoked, as I have suggested, by an underlying symbolic *ordinatio*. In the aftermath of the collapse of the central tower in February 1322 there was less time for leisurely planning and choice; but the trauma enabled at least a rethink of the focus of the great church, the space beneath what was to be called the 'new campanile'. Since there is every sign that work pressed on rapidly, the

decision-making process must have been swift. Yet the Walsingham memorandum conveys the sort of caution or prudence that actually magnifies subsequent heroic accomplishment.[147] Alan, it says, had the church cleared,

> . . . and measured out into eight parts by architectural art the place in which the new campanile was to be built, in which eight stone piers sustaining the whole building were to be raised, and beneath which the choir and its stalls would later on be constructed; and he had [this place] dug and investigated until he located solid ground upon which the work's foundations might be begun. And when these eight carefully investigated spots had been packed with stones and sand, then at last he began the eight piers with their associated stonework . . .

Clearly there was a belief that the foundations had failed, and this suggests that there can have been no preconceived idea of what a new crossing might look like: it all depended on a substratum that may have been adversely prone to changes in ground-water levels. But implicit in what happened next were two considerations. The first − undemonstrable but possible − is the likelihood that a similar disaster was to be averted in the future by reconceiving the central space of the church. A stone tower and spire must have been deemed too hazardous. As it is, the most conspicuous marker of Ely's status at this time was not its crossing but its mighty west front and tower, topped at some point after 1229 by a slim wooden spire erected by Hugh of Northwold, which stood until the late fourteenth century: it was this spire, not the octagon, that was visible across the fens, and this tower that came to bear the greatest bells.[148] Plainly, in 1321 it was decided that any new central space could be vaulted in wood, even splendidly so. It can only have been such knowledge that allowed Alan and his men, despairing of a conventionally planned tower, to think through the building from the top down, working round what remained of the four major crossing piers with a view to their eventual removal, and then connecting and mightily reinforcing the adjacent piers of the nave, presbytery and transepts to form an octagon with short diagonal sides. In effect the crossing was to be structurally similar to, but larger than, a wood-vaulted chapter house with large windows and no central support. How, exactly, the space was to be covered may not have been settled or evident at first. Philip Dixon has pointed out that the topmost interior masonry of the octagon nearing completion in 1328 reveals signs of provision for an entirely different form of covering to that realized, namely a low spire supported within the octagon on stone corbels

which were never deployed.[149] It has also been noted that, since octagonal or polygonal towers were already a well-established feature of Rhenish and English Romanesque architecture, as on Ely's own west front, the conception of a polygonal central tower was not wholly new.[150] Yet the west front of Ely and other Romanesque instances of polygonal superstructures show that they did not necessarily entail polygonal planning at ground-plan level. Alan's prodding about to secure new foundations suggests a prudent departure (and hence, perhaps, innovation) from what went before at ground level. The octagon's total design as a crossing-cum-lantern or campanile (pl. 179) is quite simply of a different order of ambition and, I think, eclecticism of reference, which has always rendered exact comparison difficult.

Alan's thinking must, in the first instance, have been practical. But, as Plato said (*Republic* 2), necessity is the mother of invention, and it does not follow that because Alan and his men thought prudentially, they did not also think brilliantly and broadly. The general narrative of the octagon's construction is well established and can be traced in the *Chronicon* and the sacrist rolls. The stone base with its arches, niches, crenellations and windows was completed in six years, in 1328, and was probably the work of the Ramsey Company, particularly John Ramsey given the presence in the sacrist's rolls of a mason called Master John from 1322–3, and other evidence. The timber vaulting and lantern took another thirteen years or so, and was the work of the court carpenter William Hurley, documented on site from 1334, but clearly implicated from 1322 in view of the imaginative priority of the timber construction – the absence of sacrist's rolls from 1326 to 1334 probably hides his presence earlier.[151] The main tierceron vault of the octagon sustaining the lantern was itself being painted from 1334 to 1337, and so installed in the years 1328–34.[152] But the lantern itself took at least another five years: what may have been its principal vertical angle posts were lifted in 1334–5 while its window tracery roundels or 'Oes' were being tied with iron and covered with canvas; and its main vault boss, 'le principale Keye', was being prepared in 1339–40.[153] Of the octagon structures, the lantern was the most complex and possibly the most problematical part of the whole thing: it weighs about 450 tons. In all, the *novum opus* lasted a total of twenty years to 1342, by which time Alan had become prior; glazing, painting and leading went on after 1350.[154]

It is possible to shed some light on what Alan, John and William had studied in order to raise the octagon. For all the new sense of space of church buildings in the Decorated Style, in these years there were not so many great church projects rising in the new style that spoke of specifically fourteenth-century spatial ideas: the choirs of Exeter and Wells (see pls 11, 39), and the naves of Beverley Minster and Lichfield, were not in the grand sense spatially experimental but conventional, and even the voluminous wood-vaulted nave of York Minster begun in 1291 borrowed its massive frame from its mid-thirteenth-century transepts.[155] The octagon at Ely is therefore an extraordinary departure, creating an unprecedentedly centralized space whose width at the cardinal sides (it is very slightly irregular) is about 65 feet or 20 metres, and at the diagonals about 72 feet, or 23 metres. This huge void brings to mind the 23-metre stone vault of the nave of Girona Cathedral erected following expertises in 1386 and 1416, which show that such a span was favoured because it was quicker and cheaper to build, despite being of stone.[156] But Girona was a sign of the austere, late medieval gigantism of Catalonia and the Balearics; the earlier medieval tradition of eastern or central rotundas in north-western Europe (St Augustine's at Canterbury, St Germain at Auxerre, Flavigny, St Bénigne at Dijon, Saint-Bertin, St Gereon in Cologne, Trondheim [see pl. 198], etc.) was not proving to be of significant interest to English Gothic designers after 1250 for all their purported interest in 'space'.[157]

The exception was the round or polygonal English chapter house, and it is quite clear that in 1322 two such buildings immediately came to mind to furnish the *novum opus* with ideas. The first was the chapter house at York Minster completed in the 1280s, which, at about 60 feet or 18 metres across, was thought-provokingly large and demonstrated the capacity of a timber vault to free up a centralized and brilliantly lit space without a central support. The Ely teams very probably had in their midst drawings of the York chapter house complex and its sophisticated Rayonnant detailing.[158] But even more similar formally is the somewhat smaller stone-vaulted chapter house at Wells, designed by someone familiar with London work of the 1280s and 1290s, and completed by about 1307. With characteristic astuteness, Peter Kidson noted that the tierceron vault of the Ely octagon was a 'vastly enlarged' version of the Wells vault, with the central cone of ribs removed and replaced with a lantern (pl. 180).[159] John Maddison amplified this connection, noting the exterior continuous galleries that crown both structures, a feature also of the north porch of St Mary Redcliffe in Bristol, and the unusual design of the major buttresses with angled, not flat faces (pls 181, 182, compare pl. 168).[160] Again, what stimulated these

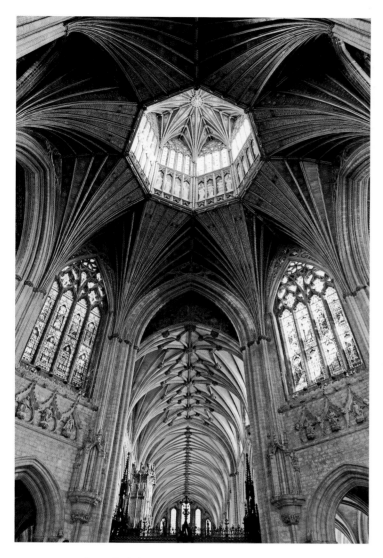

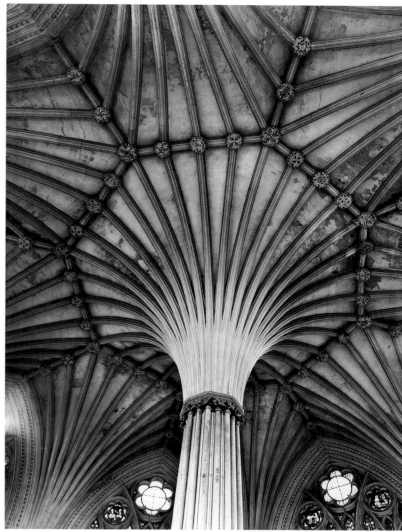

179 Ely Cathedral, octagon

180 Wells Cathedral, chapter house, completed early 1300s, central pillar and vault cone

regional connections was the preparatory work for the Lady Chapel, which, as I suggested earlier (p. 200), took the substantial format of the Wells west front as a starting point for its own speculation on how to display figurative sculpture.

It may be going too far to posit an 'Ely–Wells–Bristol' axis to match that established with Norwich, but it is worth noting that the exquisite Lady Chapel at Wells (pl. 183), begun a year or two after the octagon, is the only other English instance of polygonal, indeed quasi-domical, interior church planning of the period.[161] The architects of both projects, the Ramseys and Thomas of Witney, had either trained at St Stephen's Chapel in Westminster or knew it; and, as Christopher Wilson has noted, the design of the

internal elevation of William Hurley's octagon lantern is in all probability based on the exterior elevation of the royal chapel on which he also worked (see pls 25, 179).[162] In this, the lantern anticipates the Perpendicular elevation of the south transept of Gloucester Abbey of the 1330s. By 1320 the leading patrons and producers of the Decorated Style and Perpendicular participated in a pooled understanding of the styles' capabilities, which may have been sustained by substantial archives of drawings in such major centres as London, Bristol and Norwich. The octagon, presbytery bays and prior's chapel were all designed by the same architect or team of architects, and then subcontracted locally. From the first three sacrist rolls relating to the *novum opus* in the

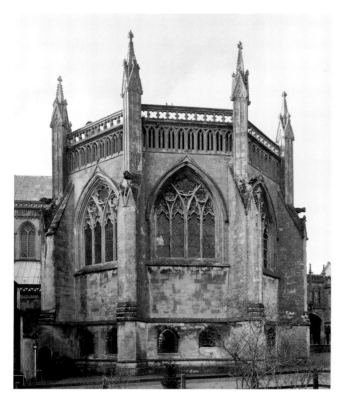

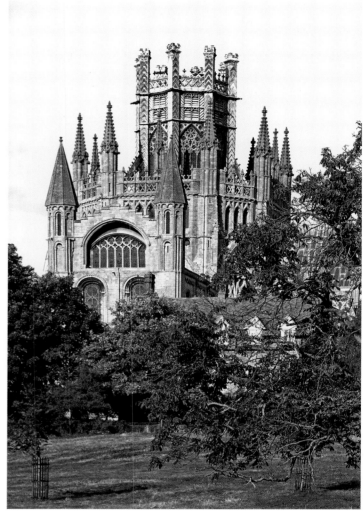

181 *(above)* Wells Cathedral, chapter house, exterior looking north-west

182 *(right)* Ely Cathedral, octagon exterior, looking north-west

years 1322–6, timber for templates was being acquired in 1322–3, Peter the quarryman was being given robes, cranes were being set up, and Master John the mason was being paid a fee or retainer over and above his wages.[163] Taken together this indicates prompt consolidation and also a degree of remote management, since John was supplied with a chamber at Ely only in 1325–6.[164] In 1323–4 a payment of 3s. 4d. was made to someone from London for the ordination of the new work (*dat. cuidam de Londonia ad ordinand. novum opus*). This has provoked no end of discussion, but the solution may well lie in the sum: it is the cost of one template, as is shown by a record in 1335–6 of two templates purchased for the Ramseys at Norwich.[165] If so, a template was being sent up from London for the octagon's stone base, either from one of the London-based Ramseys or, less probably, from William Hurley.

But this a detail: the significant point is that a redacted version of French Rayonnant, derived from the court, rather than of 'curvilinear' Gothic, was used to express an architectural conception beyond anything hitherto seen in England.

An Heroic Measurement

The Lady Chapel at Ely was not the only building measured out by an underlying module whose origin was significant: in that case it was Solomonic, Solomon prefiguring Christ, Mary the Throne of Wisdom, the maternal temple. The octagon took as its starting point not the Bible, not Jerusalem, but Rome: it was both new Jerusalem and new Rome. It may not be a coincidence that both structures contain typologically significant measurements. Whoever established the dimensions of the octagon possessed one piece of information that could have come from an architect, or from someone with cosmopolitan intellectual reach. The octagon is remarkably wide, but it is also exceedingly lofty (see pl. 152). To the central boss of the lantern vault it stands 42.98 metres tall, just over 141 feet.

220

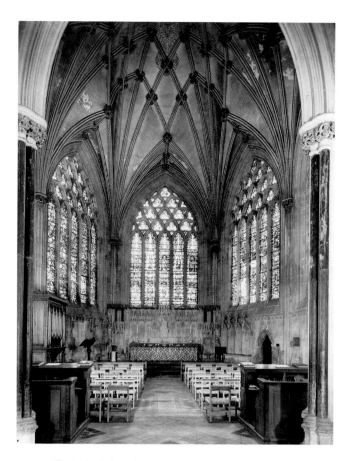

183 Wells Cathedral, Lady Chapel, complete by 1326

of serene smoothness of a true domical structure. And it is not the only building to have taken account of the Pantheon's measurement, one fairly easily ascertained because the Pantheon is a hemisphere. Ely is unusual in extending a lantern stage upwards from the dome and oculus. An earlier instance based on the same measurement is the octagonal Romanesque Baptistery in Florence (pl. 184), considered by Marvin Trachtenberg to be the 'root' building of the Duomo's building group.[168] The Baptistery has a small lantern atop its structure which illuminates the interior, a less conspicuous feature than at Ely but the same marker nonetheless. The building is based on a module of 72 Florentine *braccia*, which supplies the dimensions of its sides and the total height to the top of its lantern; as at Ely, the underlying module took account of the lantern. Seventy-two Florentine *braccia* correspond to just over 42 metres, or 'one Pantheon'. So when Giotto's campanile next to the cathedral was measured out at 144 *braccia* it arrived simultaneously at the 'Heavenly Jerusalem' measure in Revelation 21:17 and at 'two Pantheons' – a fair comment on the relation of the old and new order of things.[169] That this concept was ingrained specifically in Florence's Duomo group is evident from the cathedral itself, and decisions taken by Arnolfo di Cambio around 1296 when the new cathedral was planned and started: the 72-*braccia* unit of the Baptistery supplied the initial module for the width of the

This measurement is difficult or impossible to derive from any of the known dimensions of the Romanesque church, based on the perch, and it appears not to have been affected by the reconstruction work on the lantern, which certainly saved it, by Essex and Scott.[166] Its origin is theoretically, and almost certainly actually, very simple: the present total internal height is almost exactly the same as that of the Pantheon in Rome, 43 metres (see pl. 4). The Pantheon has no lantern or cupola, so its height is necessarily measured from its oculus. The Ely octagon also has an oculus. But it is not a literal copy of the Pantheon so much as an invocation or interpretation of its archetypal form, in which the total measure retains the model's essence within the constraints of the technology available. The form, of course, matters. Peter Kidson was quite right to state of it that 'The vivid shaft of light that passes vertically through the gloom of the vaults creates an effect unlike anything else in architecture, unless it be the dome of the Pantheon.'[167] The octagon is only loosely speaking a dome, lacking the formal property

184 Florence, Baptistery, cathedral west front and Campanile

façade and eventually the height of the great dome of Brunelleschi, again 144 *braccia*, or two Pantheons.

Florence and Ely cathedrals were simultaneously measuring things out on a Jerusalem–Rome modular basis. Brunelleschi's dome was later, but Ely's designers could have known the Baptistery and the basics of Arnolfo's cathedral plan of 1296, and certainly the Pantheon. Had they been acquainted with the contemporary Florentine historian Giovanni Villani, they might also have been led to believe that the Baptistery was itself a converted Roman temple.[170] In any event, this single measure should at least shed light on the two alternative non-English models for the octagon also proposed in the literature: the hexagonal crossing of very different dimensions already in place in the cathedral of Siena, and the cathedral in Florence: a choice between the two Italian options would settle on Florence, or some combination of Florence–Rome.[171] It is interesting to note the presence of a baptistery in this hypothetical calculation, in view of the summoning of the symbolism of the centrally planned martyrium in scholarly investigation of the octagon. Such structures enjoyed a certain semantic versatility. For this reason the scepticism about Bony's idea that the octagon's planning was possibly informed by late antique models, backed by the suggestion that this must be wrong because the octagon is not strictly a 'martyrium', is not entirely justified, not least because it implies a firmness of genre inappropriate to the time.[172]

What is even more striking is the concentration of potential archetypes in this list, especially the Pantheon and Florence Cathedral, which are dedicated specifically to the Virgin Mary. Bede in his history of the English Church (Book 2:5) ingrained in English letters the story of Pope Boniface's acquisition of the Pantheon and his re-dedication of it to the Virgin Mary. The *Mirabilia urbis Romae* relates that the Pantheon was dedicated by Agrippa to Cybele, mother of the gods, a pagan 'type' for Mary, mother of all the saints: indeed, Cybele had dictated its very form. It was known by then as Santa Maria Rotonda, not Santa Maria ad Martyres.[173] It is mentioned as such in the itinerary to Rome and its great churches made by Archbishop Sigeric of Canterbury in 990.[174] The dedication of Ely Cathedral had been re-established in 1252 by Hugh of Northwold at the opening of his new presbytery: the whole church was dedicated in honour of the Virgin Mary, St Peter and St Etheldreda.[175] The vault bosses of the presbytery make this compound dedication explicit.[176] Given Ely's level of interest in the virgin Etheldreda and above all in Mary herself, the notion that the octagon involved continued and connected thought about universals – universal forms, universal saints – cannot be ruled out. What pertained to Mary pertained to the entire building, and was so to speak a matter of its 'deep' form.

And there is an additional possibility that returns to chapter houses. In the Metrical Life of St Hugh of Lincoln, composed probably by Henry of Avranches around 1220, is a description of the new chapter house at Lincoln Cathedral:[177]

> Beside the cathedral stands the chapter house, of a kind that never Roman roof possessed; the coined wealth of Croesus would scarcely make a start on the marvellous work of it. Its entrance way is like a square portico, while inside there extends a circular space, rivalling Solomon's Temple in its stonework and art.

The passage is notable, first, because its description of a portico fronting a circular space is consistent both with the octagonal chapter house and vestibule at Lincoln and with the Pantheon itself; second, because it deliberately deploys the topos of outdoing in comparing favourably the chapter's vault with an *apex Romanus*, which could only mean the Pantheon's dome; and third, because of the commonplace of prodigious ancient wealth (and so cupidity) personified by Croesus. Master Gregorius's text on the marvels of Rome, full of little ironies as it is, says in its chapter 21 that the Pantheon has a spacious portico and a roof that was once completely gilded, the gold having been scraped away by the greedy Romans.[178] Gregorius, influenced by the earlier *Mirabilia urbis Romae*, which also refers to the splendidly gilt dome, is known to us because fourteenth-century monastic compilers who used and preserved his work, such as Ranulph Higden, were fascinated by Rome's marvels and antiquities – and Higden was a contemporary of Alan of Walsingham.[179] The mendicants were also interested in the Pantheon of the gods themselves: in one of Robert Holcot's sermons reproving idolatry, the friar takes the opportunity to describe the Pantheon, and amongst his sources were doubtless Fulgentius and the *Mirabilia*.[180] One of the source types cited at Ely, the great chapter houses, carried with them a memory of *romanitas* for those who sought to form it. All that happened at Ely was that the connection was, perhaps, taken more literally still.

The octagon seems to belong to an eminent history of buildings either likened after the event to the Pantheon or which took the Pantheon as a form, as traced by Richard Krautheimer.[181] It sufficed that such successors should be round, or domed, or encircled by niches, or dedicated to

Mary. Ely satisfies all these in virtue of the dedication of the church of 1252, and reveals also the literal imitation of dimension too. Its octagon witnesses an extraordinary act of aesthetic and thematic concentration, as if it were a kind of navel, or *omphalos*. The first sense it engaged after sight was sound: terminologically it was the new campanile, but it was also the singing place for the offices. It was (in modern parlance) a 'performative' space. The crossing tower was raised over the cathedral priory's choir, closed off at its west end towards the nave by the pulpitum screens, with a choir altar dedicated by convention (and not insignificantly) to St Peter on its eastern side, and the high altar area yet further east.[182] The bells recovered and repaired after the collapse of 1322 were named Peter, for the altar below, and Baunce (Middle English for 'bong').[183] These were removed to the central tower at the west end, which thereafter fulfilled the role of the great campanile. In 1341–2, at around the time of the lantern tower's completion, at least four bells were made and probably hung in it; there were six bells in all at the Dissolution.[184] The ropes for ringing them are thought to have passed down through the structure to the south transept.[185] If, as is possible, the lantern was thought the most vulnerable part of the structure, very heavy bells would have been ruled out. That ringing was a precarious business involving precise calculation of the possible dislocation of members under stress is suggested by a seventeenth-century report of the lantern that, 'when the bells ring, the wood-work thereof shaketh and gapeth (no defect but perfection of structure) and exactly chocketh into the joynts again'.[186] The stone west tower was deemed to be the correct hanging space for the major peal of bells, and was reinforced with a new timber and iron frame in 1345–6.[187] For it at least four substantial bells were cast and new clappers made for a peal of around six bells (including presumably Peter and Baunce). Their total weight as given in the sacrist's rolls was between 6 and 7 tons. The bells rang a sort of hierarchy of sound: the largest and lowest, at 2.8 tons, was called Walsingham after the new prior, who paid for it – truly the *fundator* both practically and sonically; then came the Saviour at 1.7 tons, John at 1.2 tons and Mary at 0.97 tons, the peal rising up by tones or semitones.[188] The names of the octagon's bells are unknown. Also largely unknown, because of post-Reformation loss, is the nature of the liturgical singing performed in the choir; but from extant fragments it is likely that it was at least partly polyphonic, and an organ played in the choir too.[189]

Bells and organs were aspects of a building's grandiose eloquence. Yet the idea of a navel or gathering place was more than sensory, powerful as this must undoubtedly have been given the acoustic and psychological properties of singing up into north-western Europe's loftiest dome. It was also thematic: and here the notion of a pantheon as a collective of the mighty is also helpful. The imagery of the octagon possesses comprehensiveness (see pl. 179). Christ the Judge and Saviour presides at the top in the carved and painted boss, tugging aside his tunic to reveal his side wound (pl. 185). Below, the narrative of St Etheldreda and the abbey's foundation on the corbels of the major shafts provides the foundation story, the originating myth of the institution, ringing the altar of St Peter (pl. 186); above, twelve niches, in four sets of three, were provided on each diagonal wall for seated Apostles, with label stops carved with the heads of Prophets (see pl. 179); tiny figures of the Evangelists are placed over the major crossing arches; and the glass of the octagon and lantern was filled with images of the church's ancient founders, specifically those connected to St Etheldreda such as St Wilfrid and King Egfrid.[190] Along the outer north wall of the choir towards the 'lay' entrances to the church were enclosed the relics of the founders and benefactors of the church, which survived the collapse of 1322. The imagery in the lantern glass was arranged with tall standing figures with accompanying heraldic block borders.

The intention of the octagon was in the fullest sense 'choric', weaving together all the significant strands that constituted the institution's history and identity, particularly those woven from the lives of remarkable people. The octagon did for fourteenth-century Ely what a façade had done for thirteenth-century Wells: it summarized and concentrated both affect and history and, like the Wells front, combined both sight and sound. But this concentration was not new. It was authorized by the great pre-Gothic shrine and image collectives of the Romanesque era at Canterbury, Winchester and Ely itself: the shrine space of the previous centuries at Ely had already authorized this notion of the collective in displaying a cluster of shrines of the formidable clan of sainted progeny of King Anna – Etheldreda, Withburga, Sexburga and Ermenilda. Founder images had become fashionable in the region, as in the painted nave ceiling at Peterborough and in the illuminations in the Ramsey Psalter (see pl. 77).[191] But in such cases the framework was conventional. At Ely, on the contrary, it is remarkable, and is the product of an astonishing culmination of inventive energy and vision; so while calling the octagon a 'pantheon' is, in a sense, anachronistic, it is not entirely misleading. In turning, as seems possible, to utterly unex-

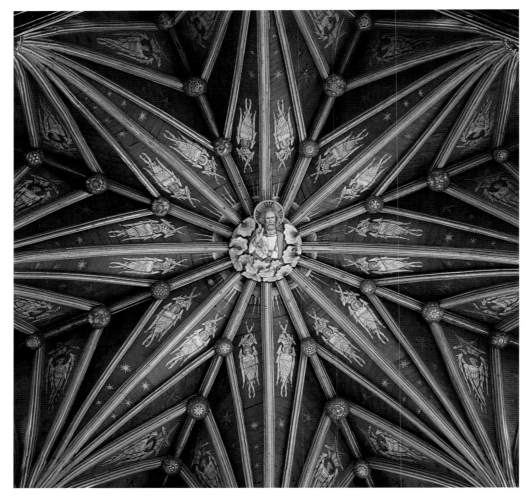

185 Ely Cathedral, octagon, central boss, 1339–40

pected and possibly very ancient models beyond the Alps, Ely's commissioners reawakened and rearticulated older yet also indigenous patterns of thought.

The Walsingham Memorandum

Unique artworks such as the Ely octagon challenge accepted explanatory models for the obvious reason that they are outside the normal, or apparently normal, order of things. Where the Lady Chapel elicits close looking at its surfaces, the universal and giant form of the octagon is assimilated

186 Ely Cathedral, octagon, corbel from *Life of St Etheldreda*: the miracle of the sprouting staff, 1322–8

224

more or less in an instant of revelation. Here a case has been made that, on the basis of its form, dimensions, location and imagery, the octagon may have owed something to typical models, *figurae*, in the Mediterranean sphere. Even the crowning image of its lantern boss, of a half-length Christ framed by scalloped clouds, blessing and revealing His side wound (see pl. 185), argues in favour of this. Though Christ is not shown in Majesty but as a merciful Judge, his image performs a role analogous to the Pantokrator at the centre of domical spaces at Daphni; the Cappella Palatina and Martorana in Palermo; the eastern cupola of San Marco in Venice; and Parigoritissa and the Kariye Camii in Constantinople (finished by 1320 or so), the last being suggestive not only in virtue of the relative scale of the Pantokrator but also its framing by Christ's ancestors; Prophets are found at Venice and Parigoritissa.[192] The frequency of such dome mosaics in both the Byzantine and Norman spheres is notable. After all, the English chronicle reception of Hagia Sophia's art into the fourteenth century, even at places such as monastic Tynmouth, is notable.[193] To suggest such a link may seem incongruous; but we must guard against the possibility that the true incongruity lies in the character of our assumptions.

Further grounds for thinking that someone at Ely may have been more than usually interested in artistic developments in southern Europe and the Mediterranean are provided by the poorly preserved paintings in the prior's chapel built by 1325, which consist of an *Annunciation* to either side of the west window, and a now-dim *Crucifixion* of the enlarged Golgotha type on the adjacent south wall, recorded in a nineteenth-century watercolour copy (pl. 187). This work looks as though it was produced under the influence of the type of Sienese panel and fresco painting coming to the attention of northern patrons from the 1320s onwards in, for instance, commissions related to Norwich cathedral priory (see Chapter Nine) or, for that matter, courtly Paris.[194] It is worth emphasizing that the prior's chapel also possesses an elaborate tile mosaic pavement showing the *Fall*, heraldic lions and elaborate guilloche patterns in the nave.[195] The *Fall* implies some sort of programmatic link with the *Annunciation* and *Crucifixion* murals at the west end, but the presence within the central zone of the pavement in the nave of a linked guilloche and quincunx motif is particularly suggestive (pl. 188). Guilloches are a common form in Cistercian mosaic tiling (for example, Rievaulx Abbey), but the use of the quincunx motif in which the minor roundels are shared looks like an allusion to specifically Roman Cosmati mosaics of the type at San Prassede, descending from late

187 Ely Cathedral, Prior Crauden's Chapel, watercolour copy by William Burges of the *Crucifixion* in south-east bay, 1320s?

Roman instances such as the floor at Santa Maria della Piazza in Ancona.[196] The fashion for such patterns in England had recently been set by the Westminster court, where the shrine pavement in Westminster Abbey consists of heptacunx motifs with shared roundels, and the inlaid lid of a small cosmatesque tomb in the south aisle preserves exactly the same pattern as that of the Ely chapel's floor.[197] The only issue is whose taste the Ely pavement manifests, since the assumption that the pavement and murals were installed immediately around 1325 by Prior Crauden has to take account of the fact that the chapel also became the private domain of Alan of Walsingham when he became prior in 1341, and it remains to be shown that these artworks with their touches of southern warmth were not in fact his undertaking. Emphasizing the substantial triumvirate of men in charge of the works, Hotham, Crauden and Walsingham, seems preferable to the idea, noted by Bock, that connections with Italian, specifically Florentine, bankers and tax gatherers helped to influence the works of art.[198] Not that

188 Ely Cathedral, Prior Crauden's Chapel, detail of tiled pavement guilloche, 1320s?

there is any shortage of evidence for the reality of Italian banking connections at Ely: in 1337 John Crauden acknowledged a debt to the Peruzzi of £400 to be levied in default of payment on lands and chattels.[199] In the reign of Edward II, the Peruzzi had tended to work less with the king and more with the Despencers – an interesting byway when one considers that William Hurley, the master of the octagon and lantern, was being paid by the Peruzzi while in the employ of Hugh le Despencer at Caerphilly in 1325–6 at a time when Ely was paying *exhennia* (gifts) to Hugh himself.[200] But by then the octagon's design was probably already settled, and there is no reason to credit any of the many Italian clerks and bankers mentioned in the diocesan records of Ely and elsewhere from the 1240s onwards with any aesthetic influence.[201] They might have aided connectivity, but without some prior scheme they were no more influential at Ely than anywhere else in England at the time.

The fact is that there may be some substance to the belief, implicit in the priory's *Chronicon*, that the crucial figure was Alan himself, and that this was Alan's own opinion. There is a tendency to think that a text such as the *Chronicon* so post-dates the events it relates that it cannot be but a formalized description long after the event. Yet Alan was long-lived, dying in 1364 and so perpetuating beliefs that would have been carried down at Ely into the following century, the relevant parts of the *Chronicon* being by then long composed, though those parts of the extant manuscripts in question were compiled no earlier than 1366 and possibly before *circa* 1388.[202] The signs are that the remarkable passage describing the events of 1322 and the subsequent raising of the octagon was originally written not *about* Alan, but *by* him, and that it entered the formal chronicle not long after 1364–6. Usually this text is treated as ordinary documentary evidence for what happened, and justly so – in this sense the Walsingham memorandum is Ely's equivalent of Gervase's account of the works at late twelfth-century Canterbury. But no text is free of ulterior thinking and settled conventions, and for this reason a slightly different type of reading is proposed here, and it should be understood in the light of Dorothy Owen's remark that, under Alan, the administration of the priory was tightened up to the extent that he 'undoubtedly recorded copies of material affecting him'.[203] It is notable that the Ely *Chronicon* expands very markedly in detail and extent in its treatment of events from Bishop Hotham's time onwards. A sign of this is the inclusion of specific and corroborable details close to Alan's interest as sacrist, such as the involvement of an Ely monk, Robert of Rickling, in the recovery of King Edgar's stolen Cross.[204]

Here is the passage in full, starting at the point where Alan is made sacrist in 1321:

In whose time, many and various extremely serious things happened while he was sacrist, particularly in the very year of his appointment. For during the night before the feast day of St Ermenilda [13 March 1322], after matins had been sung in St Catherine's chapel (the monks did not dare to sing it in the choir because of the threatened collapse) and a procession having been made to the shrines in her honour, the convent, getting back to the dormitory, found the brothers scarcely back in their beds when behold! – suddenly and swiftly the campanile over the choir fell with such a noise and crash that it was reckoned that an earthquake had happened, yet without harming or crushing anyone in the fall. Another

wondrous thing happened, more ascribable to a miracle than to nature: that in that horrible collapse and massive collision of rubble, which shook the entire town of Ely, the large and beautiful building raised over the tombs of the virgin saints was nevertheless preserved from any damage and injury by God's protection and by beloved St Etheldreda's merits, as is to be hoped, whence Glory to Christ!

After which exceedingly damnable and regrettable occurrence, the newly appointed sacrist Alan, greatly grieving and saddened, scarcely knew which way to turn or what might be done by way of repairing such a wreck. But restored in spirit by God's help and by that of His most holy mother Mary, and greatly placing his faith in the merits of the virgin St Etheldreda, *he put his hand to mighty things* [Proverbs 31:19]; and first he had the stones and timbers piled up in the rubble cleared from the church with great labour and sundry costs; and likewise cleaned away as quickly as possible the excess dust thereabouts; with architectural art he measured out into eight parts the place in which the new campanile was to be built, in which eight stone piers sustaining the whole building were to be raised, and beneath which the choir and its stalls should later on be constructed; and he had [this place] dug and investigated until he located solid ground upon which the work's foundations might be begun. And when these eight carefully investigated spots had been packed with stones and sand, then at last he began the eight piers with their associated masonry, which were erected as far as the upper stage in six years, in AD 1328. And at once in that year, the most artful wooden structure of the new campanile, conceived with the highest and most wonderful ingenuity of mind to be raised over the said stonework, was started, and with great and burdensome outlay, especially for the huge timbers needed for assembling the said structure, sought far and wide and at length found with great difficulty and purchased at great cost, carried by land and by sea to Ely, and then carved, wrought and assembled for that work by cunning workmen; with God's help it was brought to an honourable and long-wished-for conclusion.[205]

Two things stand out instantly. The first is that the most important agent in the initial process of architectural *ordinatio* was Alan, who measured out the octagon with 'architectural art' (*arte architectonica*). The second is that the beautiful passage stating that the 'most artful' wooden campanile was conceived with 'the highest and most wonderful

ingenuity of mind' (*summo ac mirabili mentis ingenio ymaginata*) is the most fulsome – and justifiable – passage of admiration accorded to any English building, or at least building process, in the fourteenth century. Since there is a principal agent involved in the process, the new sacrist Alan, the implication is that the powers of inventive imagination were in the first instance his alone: having deployed 'architectural art', the weight of the passage then falls on the verb *ymaginata*. This allows the author perfectly legitimately to postpone the issue of workmanship and practical realization, and instead to press home a notion central to this text, namely that the octagon was conceived with the loftiest, or highest, ingenuity of mind or *ingenium mentis*. In architectural *consilium* or preconception (p. 51), arrangement or *dispositio* is an essentially imaginative faculty, one with which a patron as much as an architect might be blessed. Only last do we learn of the ingenious but unnamed workmen who carved, wrought and assembled the work.

The compiler of this text was at this moment swept along by the thrill of great imagining and great accomplishment. But to reinforce this sense of achievement, the sheer grandeur and difficulty of the events in question have to be given emphasis, for difficulties were part of the game and the heroic must encounter and shove aside mighty obstacles. The sacrist thus had to bear heavy burdens (*onera gravia*) in his very first year. The monks had a lucky escape while getting back to their dormitory – an idea mentioned in an earlier account of the fall of the tower at Beverley Minster when the canons return to their houses just in time.[206] It matters that the fall of the tower should be considered to be earthquake-like, as if it were some phenomenon of nature, a wonder in itself. Matthew Paris was fond of likening such collapses to earthquakes, and a similar passage occurs in Giraldus Cambrensis's Life of St Remigius describing the fall of the tower at Gloucester Abbey, earthquake-like in its character, and yet by divine dispensation sparing from injury the many gathered in the church for Mass.[207] At Ely the presbytery and shrines are safely guarded by St Etheldreda. To emphasize the psychological impact of the disaster the text then falls into a turn of phrase used by Cicero and quite common in later sources: Alan was so distressed that he scarcely knew which way to turn or what might be done (*quo se verteret vel quid ageret . . . penitus ignorabat*).[208] But confidence is restored, and heroic action and thought follow. The church is cleared with great labour (*cum magno labore*). Its *dispositio* follows by way of prudent investigation and strengthening of the foundations, so securing Vitruvian *firmitas*; the campanile is carefully laid out and

thought through wonderfully. The materials needed are, of course, acquired with great and burdensome cost (*maximis et oneris expensis*); its timbers are huge (*grossum*), sought far and wide with great difficulty (*longe lateque requirendis et difficultate . . . inventis*) and cost (*magno precio comparatis*), and carried to Ely by land and sea (*per terram et per mare . . . adductis*) to be fashioned by cunning workmen (*ingeniosos artifices*). Everything in this passage is drawn out on an enlarged and enlarging scale: obstacles encountered, and prudent vigorous action undertaken, are supreme. Well one might speak, as in war, of a building 'campaign', won with God's help.

I have already suggested that this 'heroic' mode of writing has an exceptionally distinguished pedigree in the annals of specifically Benedictine medieval patronage from no later than the tenth century, typically those relating how monastic patrons north and south of the Alps overcame spectacular difficulties while trying to move columns or marbles from Rome or Byzantium to glorify their churches, and so acknowledged the Mediterranean core of western aesthetic values: it is found in texts about Montecassino, Durham, Fleury and Saint-Denis (p. 27).[209] Abbot Suger's *De consecratione* is more inflated in its language than the later spare Latin of the *Chronicon*, but in it is this well-known passage:

> In carrying out all these plans my first thought was for the concordance and harmony of the ancient and the new work. By reflection, by enquiry and by investigation through different regions of remote districts, we endeavoured to learn where we might obtain marble columns or columns the equivalent thereof. Since we found none, only one thing was left to us, distressed in mind and spirit: we might obtain them from Rome (for in Rome we had often seen wonderful ones [*mirabiles*] in the Palace of Diocletian and other Baths) by safe ships through the Mediterranean, thence through the English sea and the tortuous windings of the River Seine, at great expense (*magno sumptu*) to our friends . . . For many years . . . we were perplexed, thinking and making enquiries,' when suddenly the generous munificence of the Almighty . . . revealed to the astonishment of all . . . very fine and excellent (*decentes et peroptimas*) columns.[210]

Suger, unlike Alan, was not tackling the aftermath of a catastrophe, but this passage still has something to teach us about the *Chronicon*: there is the same tone of self-regard, the stress on careful enquiry and investigation of the possibilities, the search in remote places, the mental distress and perplexity at the frustration of aims, the allusion to the carriage of great materials by sea, the emphasis on the great

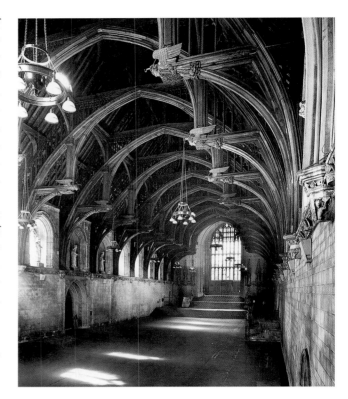

189 London, Westminster Hall

expense of these labours, and the conclusive intervention of divine assistance. In fact, the emotional narrative or movement underlying both accounts – Alan's especially – from consternation, through steadfastness in adversity, to hope and eventually triumph, was well charted in medieval monastic rhetoric.[211] The Ely *Chronicon* is a late – I think in England at any rate the latest – statement of the same tradition of heightened and enlarging narrative in relation to a building of stature. There, the 'movement of stones' idea had last occurred, not coincidentally, in an epitaph on the great Roman Cosmati pavement, imported with papal assistance in the 1260s by King Henry III for the sanctuary of Westminster Abbey (see pl. 23): it stated that the abbot, Richard of Ware (d. 1283), 'carries the stones which he had carried here from Rome' (*portat lapides quos huc portavit ab urbe*).[212] The Walsingham memorandum is less explicitly concerned with stones: heroic carriage is concerned with great trees rather than columns, perhaps appropriately so when one considers that the greatest triumphs of fourteenth-century engineering were those of English carpentry, not masonry. The Ely octagon and the roof of Westminster Hall made for Richard II, while different

228

in their exact technologies, shared a vital virtue usually attributed to soldiers: courage (pl. 189).[213] The Walsingham memorandum does undoubtedly concern great thinking, great action and strong nerves.

In general, this enlarged view of human motivation – which of course also accompanied an enlarged view of divine intervention in the form of the building miracle – was becoming less common in regard to the visual arts in the centuries after 1200 in England. The Walsingham memorandum appears to persist with it. Even as the historical record was being set down, the wonders of Ely – 'that noble isle which takes its name from the slippery one' – were reckoned to be its lantern, its Lady Chapel, as well as its productive mills, vineyards and streams. The citation is from a short poem copied onto a flyleaf of Lambeth Palace MS 448, where it is preceded, significantly enough, by a tabulation of the dimensions of Noah's Ark, the very first Wonder of the World in Gregory of Tours's newly Christianized list of wonders.[214] Local self-belief mattered as much to Gothic Ely as it was to do to Renaissance Florence, albeit a very different cultural domain. The leap of imagination entailed by this analogy is considerable, almost incongruous; but it is helpful in two regards. When Brunelleschi erected the dome of Florence Cathedral he created a dome with a lantern larger than its supposed earlier models. It cannot be said that fifteenth-century Italy was familiar with the engineering triumphs in wood of earlier fourteenth-century England, which also in effect produced a Gothic dome with an unusually large lantern, though the traffic between the countries might well have permitted such knowledge. Yet, as will be seen in the next chapter, fourteenth-century Ely was of interest to patrons as far away as southern France.

And Vasari notes something else: that some men are created small in stature but with greatness of mind and heart. He meant Filippo Brunelleschi, a model of the truth that beneath the clods of earth are sometimes hidden veins of gold, a man blessed with great loftiness of intellect whose first training in design was that of a goldsmith. It is probably – though not certainly – a coincidence that the two greatest European domes of the period were raised by men reputed to have had early training as goldsmiths, Alan of Walsingham and Brunelleschi, of whom it can be said that great things emerged from the fashioning of very small ones. At this moment monastic rhetoric and Renaissance chauvinism appear fleetingly to connect. The Walsingham memorandum stands at the end, not at the beginning, of perceived tradition, of art myth; and it deployed the heroic mode to capture the drive and ambition that brought into being one of the most remarkable of all English buildings.

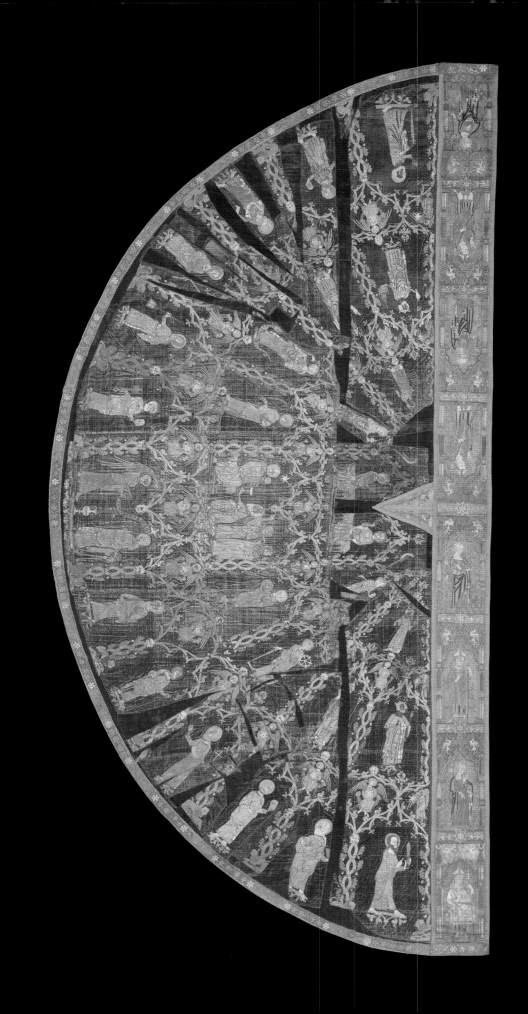

THE ENGLISH ABROAD

...it can probably be said that it was the example of the English Decorated that acted most decisively on
the shaping of the movement of stylistic re.newal in fourteenth-century Europe

Jean Bony, *The Decorated Style* (1979)

Opus Anglicanum

When Vasari mentioned Brunelleschi's early training as a goldsmith, he made the point that it was through this craft that design was acquired. Few if any true architects in medieval England provably received training as goldsmiths; yet those working in the Decorated Style seemed especially responsive to what could be learned from the other arts – emphatically not to be understood in terms of the post-medieval idea of the *artes minores*.[1] The most internationally recognized English art industries of the era between the mid-thirteenth century and the mid-fifteenth were embroidery and alabaster carving, scarcely (albeit by later criteria) 'major' art forms; and it was only embroidery that attracted overseas the epithet 'English work' or *Opus anglicanum*.[2] Throughout its history in the Middle Ages, starting in the Anglo-Saxon period, embroidery in England enjoyed a distinct social *cachet* that emphasized its high standing: for commentators on monastic and aristocratic mores it embodied the virtue of *prudentia*, being that most unusual thing, a socially acceptable craft for the high born (especially women) – it was a feminine version of goldsmithery.[3] The biblical account of Solomon's Temple had closely associated

the term *opus* with cleverness: Hiram of Tyre, a metalworker (3 Kings 7:14) who was full of wisdom, understanding and learning (*plenum sapientia et intelligentia et doctrina*) who wrought all Solomon's work (*opus*). How right that such virtues of mind should apply to a medium used in courtly and liturgical display. That embroidery was often seen as a form of gold working is demonstrated by the common term for the delicate borders and fringes of vestments and liturgical cloths, 'orphrey', from *aurifrigium* or *aurifrasium*, which is to say 'Phrygian gold', for the king of Phrygia was the golden-touched Midas. Latin tradition preserved Pliny's idea that embroidery itself was discovered by the Phrygians. An *aurifusarius* looked after vestments, not necessarily smelting. In 1246 Matthew Paris reported, in scarcely neutral vein, that Pope Innocent IV had coveted the type of embroidered gold work displayed by English clerics on their vestments (pl. 190) and had used the Cistercians (another jibe) to obtain it from London merchants.[4] Matthew's remark that, in regard to such gold work, the pope saw England as a 'garden of delights (*hortus deliciarum*), truly an inexhaustible well (*puteus*)' ripe for papal extortion, was particularly cruel, since by it he meant neither the respectable compilation on theology of that name by Herrad of Hohenbourg, nor the

190 Butler-Bowdon cope, *circa* 1320? (London, Victoria and Albert Museum)

association between flowers, meadows and the effects of pleasing variety, but rather the garden of pleasures – Roman cupidity for gold.

Opus anglicanum as a term is at once specific and vague. It may have been used of embroideries employing the technique of underside couching, indicating, like the term *opere francigeno*, a method of manufacture: but such terms cannot and should not bear too much by way of interpretation.[5] At least *Opus anglicanum* and cognate expressions such as 'London work' had the merit of relatively frequent use in inventories. There is a good chance that of all English artistic exports at this time, with the possible exception of illuminated books, luxury embroidery would have been the first to convey abroad to any extent the latest directions of English art. Importantly, these contacts would have been established first at the highest levels of patronage, and so were influential as well as far-flung. A 'political' dimension to the medium is implicit in the earliest references to it in the Gothic period. The curial and dynastic connections of Queen Eleanor of Castile almost certainly explain the earliest mention of English embroideries in the possession of Toledo Cathedral, which by April 1277 possessed a cope with 'London orphreys' (*orofres de Londres*).[6] Before his death in 1275 the archbishop of Toledo, Sancho II, had obtained a stole and maniple of English work (*estola e manipulo de obra de Ingalaterra*); by 1281 Pope Nicholas III possessed embroideries later described as *de opere anglicano*.[7]

High-level diplomatic gift giving was certainly the major vehicle for this: in 1291 the Franciscan pope Nicholas IV thanked Edward I for the gift of a cope and other variously worked cloths; and in 1297 the French Dominican cardinal Hugues Aycelin bequeathed to his brother the archbishop of Narbonne a cope embroidered with a Tree of Jesse, also given to him by King Edward.[8] The term 'English work' appears commonly in papal inventories drawn up under Boniface VIII, though not so often as is sometimes claimed, and usually in order only to distinguish English embroidery from Cypriot or Roman work.[9] Still, English work made a high-level appearance in May 1313 when the Gascon pope Clement V (1305–14) was described as wearing a very beautiful cope of English embroidery when delivering a sermon at the canonization of Celestine V at Avignon.[10] There are reasons for thinking that Clement, who as the former archbishop of Bordeaux was the senior prelate in the French domain of Edward I, was acquainted with the English court; and it is likely to have been from this source that he acquired the two copes that he gave to his former cathedral at Saint-Bertrand-de-Comminges, possibly before 1309.[11]

Note the geography and the people involved, for it is relevant to any account of the spread of English ideas in this period. The directions are to the south and west of the British Isles, into western and southern France and Iberia: *Opus anglicanum* is far less well represented by survivals in northern France, Germany and Scandinavia, to say nothing of new centres of power such as Prague. The people in question were high-level clerics, members of the mendicant orders and the papal curia, and monarchs. Avignon increasingly entered the picture, not least after 1316 with the accession as pope of another Frenchman, John XXII (1316–34), of whom more presently. John too received *Opus anglicanum* as gifts: a London-made cope from Queen Isabella in 1317 just after his accession; a cope from Archbishop Reynolds in 1322; and one from John Hotham, bishop of Ely, in 1333.[12] One of these, now lost, may have found its way into the Vatican treasury, where it was later drawn (pl. 191).[13] For fewer than three weeks (it must be admitted) Pope John owned the richly illuminated Psalter obtained indirectly from Abbot Geoffrey of Peterborough, now in Brussels (see pls 270, 271); and his tomb in Avignon Cathedral (see pl. 214) was designed by someone closely familiar with architecture in south-east England.

Embroideries, illuminations and ornately carved tombs: such objects – on the whole small, intricate and densely worked 'high-value' goods often functioning as political gifts – seem to map out the successes, and also the limits, of the English abroad. The question is whether this domain of objects and media provides the basis for wider understanding of English art and architecture at this time, and about the extent to which it was freighted with value.

Subtilitas

The well-known liking for *Opus anglicanum* in such socially lofty circles showed no more than the value placed upon certain hard-to-obtain, high-value fashion items, and cannot remotely be described as illustrating some deeper allegiance to specifically 'English' aesthetic values. What was valued in it is not always clear. But what the aesthetic consisted of is manifest: worked surfaces of no great size, subtly and exquisitely handled, consisting of complex stitched networks of foliate and architectural enclosures and images set off against luxurious ground colours. There is a certain playfulness of tone: green men, and wonderfully worked and vividly depicted birds appear much as they do in contemporary English liturgical book illumination (see pl. 265); so too do

191 Lost Vatican cope, possibly from Pope John XXII, *circa* 1310–20; seventeenth-century watercolour copy, Walker Art Gallery, Liverpool

musical angels.[14] These chirruping little conceits, so suitable for the function of copes as processional and choir garb, luxurious bowers of the clerical body in liturgical performance including singing, may have been what caught the eyes of Spanish and Italian inventory makers supervising them in Continental vestries. Perhaps there was some more deep-seated mental connection between the English and their economy of wool, stitching and weaving, especially in the eastern seaboard regions. An appreciation of *Opus anglicanum* might just as well start with the praise heaped upon English textiles in the twelfth and thirteenth centuries by Chrétien de Troyes (referring especially to London): for several European authors, such textiles included broadcloths, worsteds, serges and scarlet wear, particularly *Escarlate de Nichole* or 'Lincoln' scarlets (but not 'Lincoln green'), and their prices were second only to Asian silks at the time.[15] Though the older cloth-making centres were in relative decline in the middle of the period of the appearance of the ascendancy of *Opus anglicanum*, roughly the century 1250–1350, the English connection was clear.

Not only that, but this or any textile manufacture of the finer kind was the form of workmanship most often described by the term *subtilis* referring literally to the thread passing below the warp (*sub-tilis*), the finest thread, which is hard to grasp or see but which is fundamental to the integrity of the whole fabric: it is often used specifically for embroidery and metalwork.[16] It is known from Giraldus Cambrensis's extraordinary appreciation of the finesse of Insular art (p. 144), interlace and spirals – a finesse no less typical of English book art in his own time or indeed of the fourteenth century (see pl. 290) – that the English placed high value too on the presence of such *subtilitas* in painting. The verbal link extended commonly also to metalwork; and, as noted, embroidery and the finest goldworking were close.

Hence the 'eye' of the embroiderer or of the goldsmith may also fairly be seen in the astonishing supple and florid frames and bowers on the great English copes (processional garb) and chasubles (Mass vestments) of the time: star-and-cross patterns as on the Vatican cope, circles as on the Anagni cope, flowing and woven tracery on the Comminges, Lateran and Butler-Bowdon copes (see pl. 190), and so on.[17] Not uncommonly, these pliant, linked and spiralling forms produce tracery of advanced type. The lost Vatican cope (see pl. 191) had radiating pointed arches threaded around its principal arch frames rather in the spirit of the

233

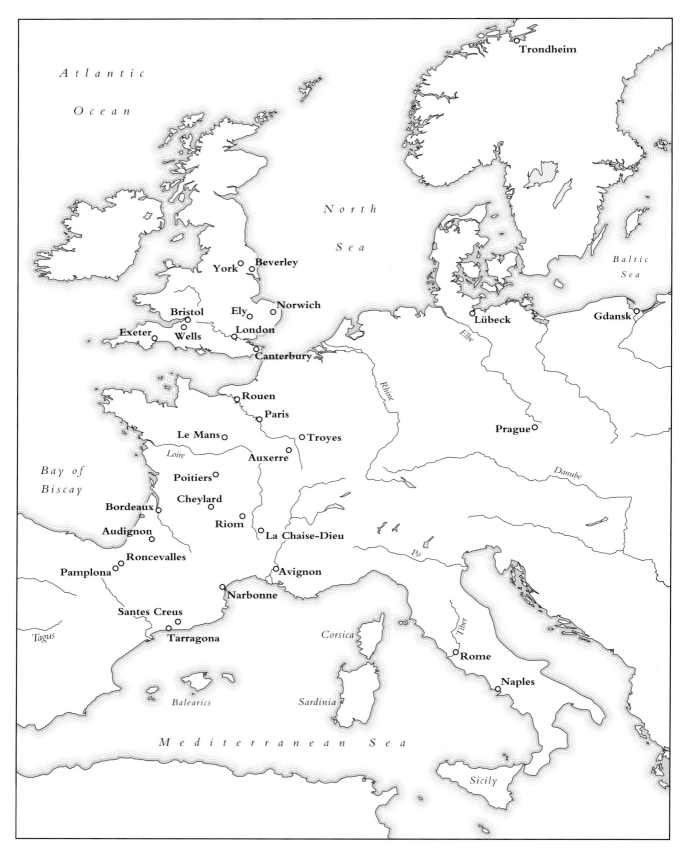

Fig. 1 Map showing principle sites discussed in Chapter Seven

prior's door in the cloister of Norwich Cathedral (see pl. 78).[18] The Butler-Bowdon cope has the same squashed inverted teardrop vesicas (actually large soufflets) enclosing figures as the tracery of the entrance to the Norwich chapter house (see pl. 67).[19] One of the most precocious instances is the extraordinary counter-curved filament work on a cope at Saint-Bertrand-de-Comminges possibly given by Clement V before 1309: such counter-curves had by then only just (if at all) appeared at St Augustine's in Bristol, but in their complexity these sparkling tangles anticipate by almost two centuries the Manueline Gothic of the portal of the so-called *capellas imperfeitas* at the abbey of Batalha in Portugal, founded in 1387.[20] The conical form of the cope as a vestment created an inviting context for enclosure formats that resembled those rose windows where the arches of the lights point inwards to the centre (for example, Châlons-en-Champagne Cathedral and the lower west rose at Reims Cathedral): the (French?) cope at Lyons and the Toledo, Butler-Bowdon, the lost Vatican and the Pienza copes have this form, with micro-architecture that is either conventional or woven curvilinear.[21]

As in any enjoyably ludic process of invention exploiting elective affinities, the currency from clothing to stone was two-way: a *tailleur* is, after all, a worker either in the cutting of cloth or of stone. The contemporary dispersal of the 'Notre-Dame' type of rose window across northern Europe seems, in certain contexts, to have shaped even religious and secular garb: the fashion for cutting shoes with the pattern of the east rose of St Paul's Cathedral (see pl. 44) is noted of Absalon's footwear in Chaucer's *Miller's Tale*, and is recorded in the wall paintings of the 1350s in St Stephen's Chapel, Westminster.[22] Window tracery of French type adorns the mitre of the effigy of Bishop Hugh de Chatillon (d. 1352) at Saint-Bertrand-de-Comminges. The decoration of conoidal surfaces with tracery is a reminder of perhaps the greatest miracle of English formal transition in the period: the way the tracery plan of a Rayonnant rose window spread over the under-surface of the English fan vault, an innovation of the mid-fourteenth century in western England, which might have arisen from experimentations in the use of tracery on flexible surfaces such as textiles.[23]

Continental Europe: First Steps

Jean Bony, alert to the openness of the English aesthetic outlook, saw the connection too, as part of his fundamental (and justifiable) claim that much is gained in the interpreta-

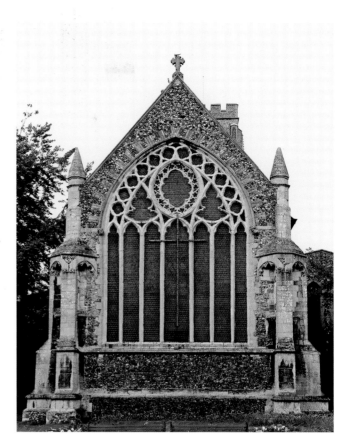

192 Mildenhall (Suffolk), parish church, east window, *circa* 1310–40

tion of the Decorated Style by looking at media other than architecture. A favourite focus of his was carpentry, in which he saw not only a particular inventive freedom but also a sort of English national talent or cunning.[24] In his account of the Decorated Style and linear patterns and networks, he also stated that *Opus anglicanum* 'affected architecture in more than one way', for instance in the use of chains of quatrefoils as borders in traceried windows such as the east window of St Mary's parish church at Mildenhall near Ely, influenced by the window tracery of Prior Crauden's Chapel (pls 192 and see pl. 167).[25] The Mildenhall window, executed early in the period between 1309 and 1344, raises a further but related point: its ornate, iconically static composition, surely planned to hold an *Assumption* in its topmost vesica, also brings to mind the tiny chains of openwork quatrefoils used as frames in pliant goldsmithery, pilgrims' badges and reliquaries throughout Europe.[26] The English enjoyment of forms common to precious and portable media which themselves spoke a widely recognized and international language enhanced the likelihood

of their favourable reception in areas with a correspondingly open viewpoint. Bony's claim about embroidery and other media in England was therefore larger, and concerned the formative impact of the Decorated Style in continental Europe. Naturally given to dialectical thinking, Bony saw Late Gothic as being renewed and energized by a synthesis of two polarities, one 'southern' – a new feeling for space derived especially from the mendicant churches of southern Europe – and one 'northern', by 'the new networks' of pattern from England that rejuvenated the essential linearity of Gothic.[27] This placed him within a mode of synthetic art-historical thinking about deeper national characteristics and formal evolution found also in Panofsky, who himself was taken up with north–south dialectics and the issue of centrality and marginality. Nikolaus Pevsner too emphasized the English sense of pleasure in overall decoration, that *horror vacui* or fear of empty surfaces that produced elaborate wall arcading; and he too anticipated Bony in stressing the general importance of embroidery. His emphasis on line in fact echoed the formalism of Roger Fry and ultimately the collectivism of Wilhelm Worringer.[28]

Not surprisingly, it was particularly in regard to the English designing of vaults that critical emphasis on linear networks proved most provocative. In a premonitory discussion of the relation of windows to vaults in English Gothic around 1300, Peter Kidson pointed to the development of lierne vaults (vaults with small ribs that connect the major transverse, ridge and diagonal ribs of a vault and in effect encircle the main boss) as a step towards extending to vaults generally 'the kind of pattern produced by window tracery' beginning in late thirteenth-century York, but flowering prodigiously in a series of experiments in vault design in the West Country at Exeter (the pulpitum) and particularly the choir at Wells, designed in the 1320s by William Joy (see pl. 39).[29] The Wells choir vault is a masterpiece of so-called net vaulting, described by Paul Crossley as 'the earliest attempts anywhere in the Gothic world explicitly to approximate vault forms with window decoration'.[30] Vaulting patterns and systems predominated in the first discussions of the dissemination of the Decorated Style, because they pertained to the very area that, in the previous half century or so, had produced the most challenging art-historical analysis in general: Germany. The post-war work of Karl-Heinz Clasen, Pevsner and Bock opened out a newly internationalist perspective on the importance of English art for the formation of German and central European Late Gothic, beginning, as Pevsner pointed out in his 1959 review of Clasen's *Deutsche Gewölbe der Spätgotik*, with the

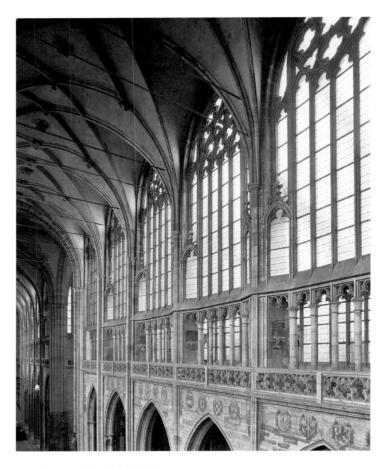

193 Prague Cathedral, choir, begun 1344

so-called crazy vault of the choir of Lincoln Cathedral, of around 1200.[31] The general orientation of discussion was therefore eastwards from Britain, focusing especially on the influential masterpiece of central Europe, Prague Cathedral (pl. 193), begun in 1344 by an architect of southern French training, Matthew of Arras, but continued and developed by Peter Parler after 1356 for the Emperor Charles IV. Prague was, and despite some later researches remains, the most high-status instance of the impact of English ideas about vaulting (including Bristol-derived 'flying' vault ribs), elevation and portal design on the Continent. Though the critical fortune of the idea of Peter Parler's direct study in England has tended to oscillate (and since he was born in 1333 any such studies must have occurred between about 1349 and 1356), the accumulated evidence for his informed scrutiny of the choir of Wells Cathedral, St Augustine's at Bristol, the collegiate church at Ottery St Mary and sundry related buildings in eastern England is strong and is set out fully elsewhere.[32]

Though the final outcome at Prague was in most ways resolutely Rayonnant, its attention to Wells places it in a similar position to Ely Cathedral, which, as I have suggested, also considered Wells Cathedral's Gothic works to be an authoritative inventory of good ideas. At Ely the interest and outcome were markedly different; but the point is that in neither case can Wells have suggested itself as a model for functional or political reasons. This is especially obvious from the grand perspective of the imperial coronation and shrine church of the Luxembourg dynasty in Prague, in relation to which Wells was a minor provincial diocese that had experienced serious institutional reversals until well into the thirteenth century. In comparison with the royal abbey church of Westminster (see pl. 21), in one sense a far more natural, if specialized and old-fashioned model for Prague in terms of its stylistic eclecticism or courtly sense of *varietas*, Wells can have mattered only for one reason: its reputation as a centre of extraordinary formal invention in architecture. What this in turn implies is the conceptual primacy in such cases of artistic, as opposed to patronal, initiative. Prague Cathedral looks the way it does because of Peter Parler's standing as an *auctor*, and because the deep-rooted diversity of the English building tradition in some way chimed in with the culture of Prague.[33] But Prague was never so 'English' that Charles IV elected to employ William Joy to design St Vitus's Cathedral – there were limits to internationalism, and given the eloquence and *mores* necessary in great architects, one cannot help but wonder if the ability to speak foreign languages was not a factor. Again, the rich aesthetic of English building had such grave cost implications for the Continental model of lofty building that it too must have been off-putting.

Prague seems exceptional, because as well as being of very high status, it offers the prospect of something that did not characterize the English role in Europe: in it the *ordinatio* of the major elevation of a Rayonnant church was set out after study of an English great church, even if it was not wholly transformed by such study. This, in a sense, is the predicament of 'influence' subsequently established by Jean Bony's stimulating thoughts about the European impact of the Decorated.[34] Bony did not in fact prioritize the German experience at all: Prague was only subsequent to a second wave of influence from England in the fourteenth century. The first wave, according to him, had seen interest in English vaulting networks, particularly of the tierceron type, in northern Germany and the Baltic region, at Marienburg near Gdansk; the typically German triradial vault used in the Lübeck area early in the century may have stemmed from interest in English chapter house vaulting.[35] These observations have since been countered by sceptics who maintain, with some reason, that Bony's underlying emphasis on the loss of creative momentum in Continental Rayonnant prevented him from seeing the origins of these vault types not in England at all, but in continental European Rayonnant itself; and the whole issue of the use of tierceron and lierne vaults in Iberia at the same time remains relatively unexplored.[36]

Bony's model is artificial, but it gets near to the heart of the issue of English influence in two regards. First, in setting English influence out in terms of window tracery (to the south and west of the British Isles) or vault design (the German lands), Bony was conceding that the impact of an overarching *ordinatio* was secondary to the fragmentation of the Decorated Style into assimilable but separate components: Bony's account is of the success of English *elocutio*, rather than of English planning, elevation design and engineering. Masters of smaller- or middling-scale invention, the English were notable, the theory goes, for detailing, for humour, for subtlety, lightening and nuancing buildings by line and surface and lending them charm and a sense of the exquisite or surprising – but not for fundamentally changing the nature of building itself.

Second, Bony's internationalism had the merit of taking the argument out of the German sector, where it had largely begun, and reorientating the entire discussion on a north–south basis, which, as I have suggested, underlay the dialectical process that he saw at work in Late Gothic: southern European spatiality, in dialogue with English renewed linearity. Bony himself was far more engaged by Mediterranean France, by the English territories in Gascony, by Iberia and by Italy – the lands of *Opus anglicanum*, as it were; and it was in this regard that his newest observations had their greatest force. His reorientation of interest skirted round the core territories of Capetian Gothic, presumably because of the resistance to external influence implicit in the increasingly dominant Rayonnant system of the Paris area. It also bypassed older political connections such as those with Normandy, the architecture of which increasingly parted company with England after the loss of the duchy in 1204.[37] Even so, before about 1350 Bony could write only of 'a scattering of English inspired novelties, none of which launched a trend'.[38] The reason for this, it must be assumed, is that, for Bony, English invention never possessed the 'universality validity' and rational coherence of French Rayonnant.[39] By taking English Gothic on a European pilgrimage, Bony was able to expose a truth about it

abroad and at home: that it was precisely not a style of universality, complete in itself, but rather a kind of catalyst, a cue to further thought, English spice for European meat.

Before 1350 or so Scandinavia, France and Iberia provide far more plentiful evidence of English design or actual workmanship in the arts than the German-speaking territories and central Europe. This of course leaves some room for wondering exactly what is meant by 'influence' more generally, and at what point one can clearly speak of influential contact, not happenstance. At stake here is the entire notion of what in Bony's account appears to be a theory of the internationalist legitimation of the Decorated Style: that it mattered less in itself than as a galvanizing force or catalyst in the renewal of the international 'movement' called Gothic. But whether this was really compatible with the idea that England assumed the mantle from France is unclear.

North Sea Gothic:
The Octagon of Trondheim Cathedral

Bony's exploration of English influence concerns formal features that, as the study of *Opus anglicanum* suggests, cannot be described as purely architectural, not least the patterning of window tracery and vaults: architectural features, but ones subject to a wider aesthetic regime. In mapping the distribution throughout England of so-called Kentish tracery motifs of a type that appeared in the two decades before 1300, it is obvious that such shapes remained, with some exceptions (Kirkham, Gloucester), concentrated in the south-east.[40] But an account of any movement of ideas outside England has to mention the issue of traffic within and around it, not least because of the country's extended and developed coastline and concentration of population near the seaboards, especially in cities with strong navigation links: London, Norwich–Yarmouth and Bristol were major population and trading cities, as well as leading centres of architectural innovation. The practical difference between the trading of ideas around this coastline and further afield was only a matter of degree, granted that the fundamentals of English building tradition assured such traffic an easier reception than was the case abroad. So when, in the course of the late fourteenth century, the large chapel-of-ease of St Nicholas in King's Lynn (pl. 194), uniquely for East Anglia, adopted for its nave and chancel doors the polygonal and countercurved arches found much earlier in Bristol at St Augustine's and St Mary Redcliffe (see pls 33, 133) and at Berkeley Castle, the emergence of

194 King's Lynn (Norfolk), St Nicholas, north door of chancel, late fourteenth century; compare pls 33 and 133

a sort of 'port' Gothic may be suspected.[41] West Country ideas may have moved easily around the coast and via Yarmouth to the Ramsey workshops at Norwich and London. Minor ports such as Cley (pl. 195) on the north Norfolk coast were graced, while their economy permitted it, by exceedingly ornate parish churches, in Cley's case the work of the Ramsey Company, with displays of Norwich-style frilly window tracery and curvaceous ogival doorheads worthy of San Marco in Venice.[42] But the nave elevation at Cley (pl. 196), with conspicuous canopied image brackets in its main spandrels, also points north-west, across the Wash to the Humber estuary and to Selby Abbey in Yorkshire (see pl. 140), where the same format was adopted for the

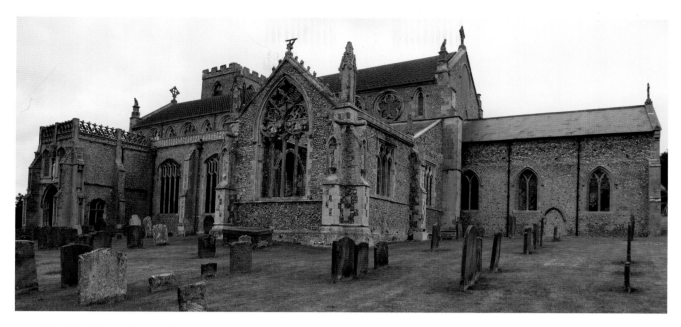

195 Cley (Norfolk), parish church, exterior, 1320s

fourteenth-century choir elevation, and also to Beverley Minster, where, as at Cley, carved musicians adorn the fourteenth-century elevations of the nave (pl. 197).[43] The flowing tracery and undulating foliage of Lincolnshire and Yorkshire presumably spread there as rapidly via coastal links, with centres such as Norwich, Lynn and Ely, as by patrons with Yorkshire roots working in the south-east, such as John Hotham.[44] The directions of influence, as in any trade, were reciprocal: the Ramseys' first elevation for the new south choir bays of Ely Cathedral paid for by Bishop Hotham seems to have taken account of the carved shields over the main arcade at York Minster, while the fourteenth-century work at York betrays study of the great workshops in London, East Anglia and the West Country. In such cases 'influence', always a difficult notion, really consists of a sort of pattern that can be corroborated without too much difficulty. What is needed here then is patterns, links: isolated motifs or works of art may help, but they do not always constitute the sort of evidence of connected thinking that typifies a style or a movement of taste. It was both an advantage and a disadvantage of the English formal approach that it was exceedingly rich in such ideas.

To think of a community of ideas around the North Sea is not misleading, and it is perhaps natural to turn to a building facing it with long-standing English links which has been unduly disregarded in accounts of the Decorated Style: the reworked octagon and screen at the east end of

196 Cley (Norfolk), parish church

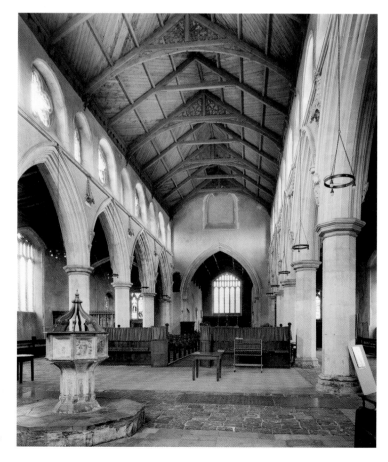

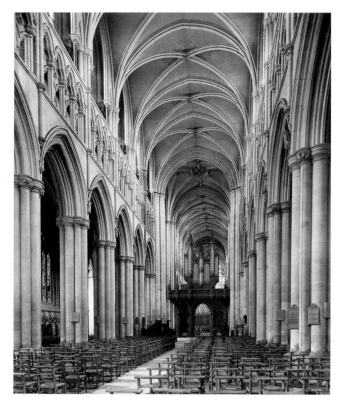

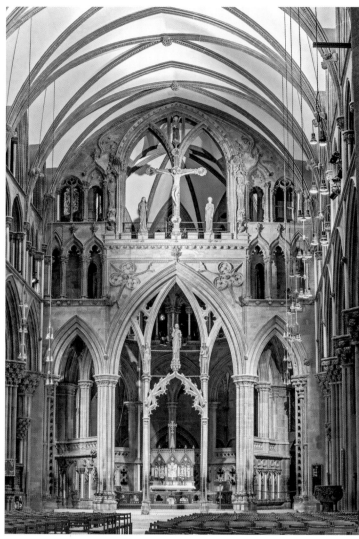

197 *(above)* Beverley Minster, nave

198 *(right)* Trondheim Cathedral, screen before octagon, after 1328

Trondheim Cathedral in Norway (pl. 198).[45] The very substantial archdiocesan cathedral of Nidaros had developed close contacts with England since the mid-twelfth century, partly because it was the shrine church of a saint, the martyr king Olaf, widely revered in England, partly because of the strong political and cultural connections between England and Norway before 1300 which drew Trondheim, Bergen and Stavanger into a similar cultural orbit: these were at their closest during the long reigns of Henry III and King Håkon IV (1217–63). Trondheim Cathedral, though much restored after a series of fires, reveals close contacts with major Romanesque and Gothic structures of this period along the eastern side of England, including the former choir of York Minster and Gothic works in Lincoln and London. By no later than 1250, the figurative arts in Norway were also recognizably close to their English counterparts, not least in the Trondheim area itself.[46] These connections were certainly established by the time that Archbishop Øystein (1161–88), who had spent a period of exile in England, began to reconfigure the east end of the church with an octagonal termina-

tion at some point in the 1170s. The new eastern octagon was intended to house the shrine of St Olaf, and is generally held to belong to a tradition of eastern rotundas (St Germain at Auxerre, Flavigny, St Bénigne at Dijon, St Bertin at Saint-Omer, St Pierre-le-Vif at Sens, and so forth), of which the more influential at Trondheim included the Trinity Chapel and corona at Canterbury Cathedral and the rotunda for St Edmund at Bury built by King Cnut.[47] St Olaf's cult, as formulated liturgically by Øystein among others, owed some of its imagery to the English martyr cults of Edmund and Becket; indeed, the earliest surviving Latin liturgical evidence for Olaf's cult is English. This remarkable pattern continued well into the thirteenth century when the choir, west front (begun 1248) and nave at Trondheim were rebuilt in idioms closely informed both in architecture and sculp-

ture by Lincoln and Westminster.[48] Trondheim was never drawn into the new pattern of Parisian Rayonnant represented in Scandinavia by the coronation cathedral of Uppsala in Sweden, continued after 1287 by the Parisian architect Etienne de Bonneuil. By the 1300s the artistic dispensation in Norway was being more directly influenced by the Rhineland, through trade, than by Anglo-Scandinavian royal and episcopal tradition; but by then Trondheim Cathedral's architectural development was almost over. Its fourteenth-century work strongly implies the involvement of English masons, and it is striking testimony to the duration of 'English' sensibility at Trondheim that its most important shrine area should have been furnished in a way consistent with much in the Decorated Style.

What brought this about was a serious fire in the cathedral in April 1328, that appears to have focused on the octagon and shrine area. Over the following summer, Archbishop Eilif Arnesson Korte (1309–32) appealed for assistance to the dioceses of Nidaros including, among others, the bishops of Bergen and Stavanger; indulgences were issued to promote the work.[49] The surviving correspondence relates that the woodwork of the cathedral, its stonework, bells and arches 'high and low' all suffered, and the walls were fractured. When Norwich suffered a comprehensive fire in 1272 the recovery period was in the region of three to six years, so it is probable that while Eilif set the tone of the works, his successor Pål Bårdsson (1333–46) completed them. Neither of the prelates is known to have contacted English dioceses; in fact, it is not obvious from the octagon and screen as repaired after 1328 that an English cathedral was necessarily contacted at all. Its nature suggests the guidance of masons whose main area of activity was nothing grander than the English parish church or chapel.[50]

The octagon is very properly seen as the final stage of the completion of the twelfth-century work rather than the inauguration point of a new cathedral.[51] In the first quarter of the thirteenth century the western face of the octagon apparently consisted of a screen wall stretching across the width of the choir and over the three major arcade arches leading into the octagon's ambulatory and shrine. This triplet of two lower outer aisle arches and one central major arch brings to mind the sort of juncture of octagon and nave produced under different circumstances at the abbey of Ferrières-en-Gâtinais in the archdiocese of Sens.[52] In fact, a prelude to this triple-arched eastern composition, one familiar in many later mendicant churches, had already been established under Archbishop Øystein in the apsed chapel connected to the northern side of the octagon, and erected,

some maintain, for a relic of the Holy Blood that arrived in Trondheim in 1165.[53] The great church's arrangement differed in scale and in the inclusion across the mouth of the octagon of substantial pillars with crocketed shafts of the sort used slightly earlier in the eastern transepts and (it may be hypothesized) in the lost east end of Lincoln Cathedral, where their Marian and priestly connotations were especially apt.[54] After 1328 only the outer pair of crocketed pillars of the composition at Trondheim was retained, and the bulk of the central screen wall was rebuilt with only traces of the earlier Gothic work at its flanks surviving and adjoining the choir walls. To either side of the screen, new passages opening out westwards at triforium and clearstory levels connected directly with the octagon (pl. 199). It may be deduced from the remaining fourteenth-century work that in 1328 the octagon incurred damage to its vault, clearstory, triforium and arcade, and screen area.

Much of the new interior of the octagon consisted of rebuilding and upgrading the basically early thirteenth-century structure. This entailed the insertion of new stone screens with quatrefoil openings separating the ambulatory from the inner sanctum of the shrine, and the insertion of new tracery at the triforium level. Since the erection of the octagon, the detailing at Trondheim had tended to have a certain thickset florid coarseness.[55] This trait reappeared in the new tracery of the triforium openings, with ample foliate capitals yet further beefed up in the restoration of much of the detailing in the 1870s and 1880s. But the tracery inserted after 1328 and recorded in photographs dating to before the 1870s restoration (pl. 200) was of Kentish type, with, at triforium level, barbed quatrefoils alternating with 'cut' ogival reticulation and other forms in the arch heads well established in south-eastern England by no later than 1310. The borrowings are manifestly not from the main elevation of an English great church, where such a triforium would be unexpected: the ogival tracery in the new choir triforium bays at Ely Cathedral (see pl. 46) and in the choir triforium of Carlisle Cathedral are exceptions that prove the rule, and the tracery at Ely is far more brilliantly worked. Their character is essentially that of parish church-style tracery apertures. No exact English analogies for the surviving figurative sculpture of the octagon ambulatory screen suggest themselves, though the image at the left entrance to the octagon of a smirking eyebrow-less man tugging the hood from his curly-haired round head in a sort of 'hats off!' gesture (pl. 201) somewhat resembles, in his complacent look and carefully drilled eyes, the heads on the bosses of the Ethelbert Gate vault at Norwich, before 1316–17.

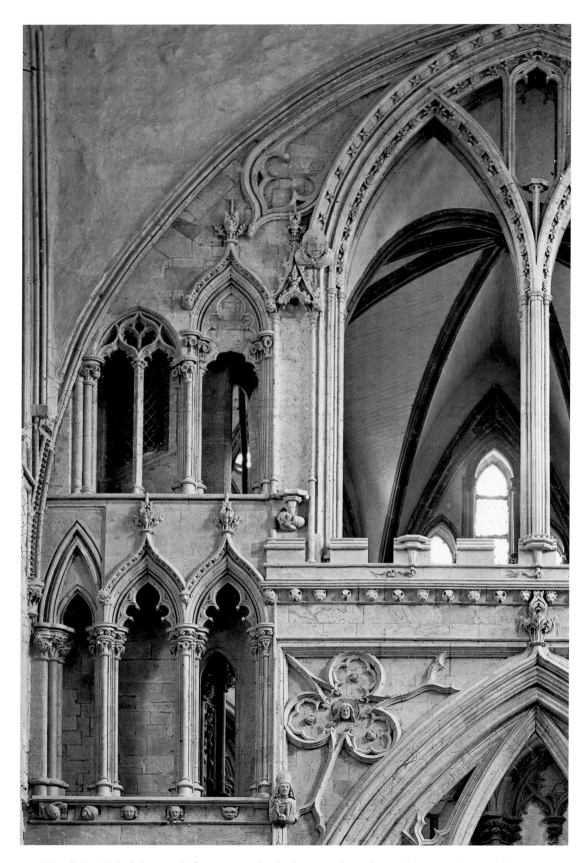

199 Trondheim Cathedral, screen before octagon, detail of passages, from nineteenth-century photograph

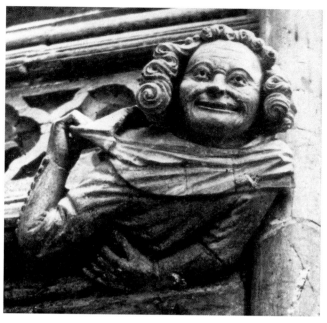

200 *(above)* Trondheim Cathedral, octagon triforium, before 1870s restoration, showing 'Kentish' tracery

201 *(right)* Trondheim Cathedral, man tugging hood aside at north entry to octagon ambulatory

The same thinking, resting content with the extension to a great church of forms whose English context of use was more modest, typifies the big screen installed at this time at the mouth of the octagon facing the choir. The general composition of this remarkable object, the tracery network of which was intended to display the rood (see pl. 198), is allied, as already noted, to the triple-arched composition of the apsidal north chapel, probably designed in the 1160s. There, the rather muscular detailing lends the arrangement weight and dignity in so relatively small a space. The four-teenth-century version in the great church greatly slims down and sharpens the detailing, creating something more like an immense set piece of liturgical furnishing. Its formal language is the same as the octagon's new designs, with assertive and not always entirely coherent use of Kentish detailing. Over-scaled barbed trefoils fill the two spandrels over the main central arch, with long rubbery barbs com-parable to those in the gable of the tomb of Bishop Brad-field (d. 1283) at Rochester, the window tracery of the chancel of Chartham church in Kent (pl. 202) or the window of 1336 in St Anselm's Chapel in Canterbury Cathedral (see pls 48, 151), though at Trondheim they fuse with the blunt ends of mouchettes in the fashion of the blind tracery over the main arches of the octagon base at Ely (see pl. 179).[56] Even larger drooping mouchettes slope along the sides of the topmost arch beneath the vault, a citation of the tracery recorded on the arch flanks of the east window of St Stephen's Chapel, Westminster, completed

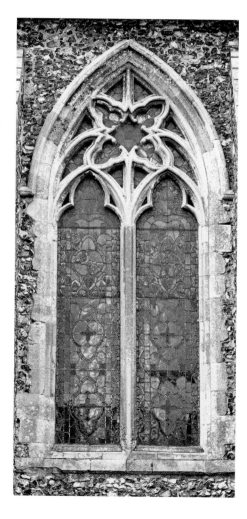

202 Chartham (Kent), parish church, chancel window, early fourteenth century

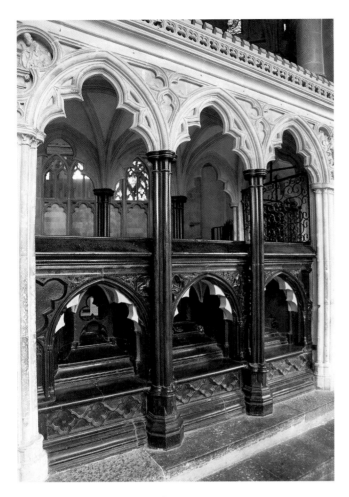

203 Canterbury Cathedral, tomb of Archbishop Simon Meopham (d. 1333), looking north-east

in the early 1330s. The statue niches just below these mouchettes have projecting ogival canopies also derived from the stalls of St Stephen's. The lines of cornices and arches are studded English-fashion with masks and fleurons, and a big crenellated cornice divides the central composition in two, but in a way that relates rather casually to the building lines of the flanking triforium and clearstory stages. Numerous smaller telltale details reinforce the connection with Kent and the London area. The tracery of the subset of arches beneath the main central arch is elaborately subcusped and is sustained on octagonal concave-faceted shafting of a type used from the 1190s at Lincoln (the concave rings and abaci at Trondheim also look Lincoln-inspired), but more immediately in time by Michael of Canterbury for the main image shafts in the upper chapel of St Stephen's Chapel certainly installed by then.[57] Other analogies to

Kentish detailing of *circa* 1330 are provided by the screen's bases and capitals, which somewhat resemble those on Archbishop Meopham's tomb at Canterbury (d. 1333), perhaps by Michael's son Thomas of Canterbury; Meopham was archbishop at the time of the Trondheim fire and its aftermath (pl. 203).[58] Also similar to his tomb are the rather thick balustrades with rows of quatrefoils surmounting the octagon inner screens (compare the tomb's coping and plinth) and the cusped roundels in the octagon's arcade heads with ogival barbs, akin to the tomb's main arcade. The coping of the inner octagon screens was originally set with small, now detached, sculpted heads in a fashion strongly reminiscent of the tomb of Archbishop Hubert Walter (d. 1205) in Canterbury Cathedral, again suggesting eclectic Kentish study.[59] At the top of its central cusped arch is a finial consisting of a circuit of carved heads under an octagonally arranged quatrefoil cornice with battlements of the sort so popular in Kent from around 1290 (see pls 108, 117).

The Trondheim screen is the most concerted instance of eclectic English-style detailing outside the British Isles other than the tomb of Pope John xxii (d. 1334) at Avignon, discussed below, a near-contemporary work that exhibits knowledge of a very similar range of English, particularly Kentish and London, works. Its format is also, apparently, one that was long established in England, but in physically much smaller environments, not great churches. One such was the lower chapel of St Stephen's at Westminster, where the existence of some sort of tripartite chancel division can be demonstrated, though it cannot have been of any great height: its detailing may have been similar.[60] In Essex, in the diocese of London, are two parish church chancel screens that resemble its general form, at Stebbing (pl. 204) and Great Bardfield, the first (much restored) about contemporary with the Trondheim screen, the second dating to the period 1360–90.[61] Together with arcade screens such as that in the Kentish-influenced parish church at Bottisham near Cambridge, the evidence suggests that Trondheim's creative hinterland lay in parish church or chapel furnishing on the eastern side of England of the previous generation, since giant screens of this order were not a feature of great churches there. Such screens were, in turn, interpretations of a type of Gothic screen established before 1300 in Kent at Westwell (pl. 205) and Capel-le-Ferne, but in origin belonging to the first establishment of the Roman Church in that region in the seventh century. In this type, the entrance to chancel and apse was separated by a transverse arcade of three arches, before which was placed an altar. Of these, the most important instances were at Reculver,

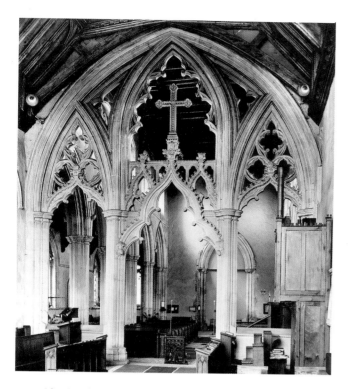

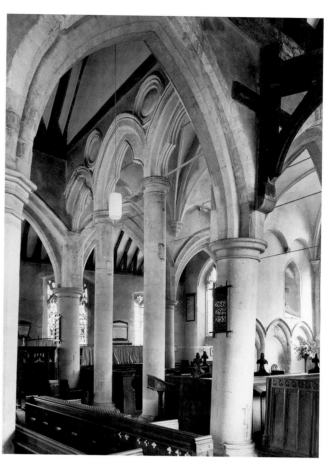

204 *(above)* Stebbing (Essex), parish church, chancel screen, largely restored

205 *(right)* Westwell (Kent), parish church, triple arcade with apertures over, at entrance to chancel, thirteenth century

founded in the late seventh century, and St Pancras in Canterbury.[62] The association of the screen at Reculver with a large stone cross, attested in 1296, is notable given the rood-screen function of the Gothic partitions. Another version of such screening had been developed in the quasi-palatine context of the fourth-century church of Santa Croce in Gerusalemme in Rome, sometimes associated with the Empress Helena, discoverer of the True Cross – a consideration of at least potential relevance to the related design of the north chapel at Trondheim as a reliquary chapel for the Holy Blood, and to the use of such arcade screens to display roods.[63] A similar form of triple arcade is depicted in the sixth-century *palatium* mosaic in Sant'Apollinare Nuovo in Ravenna, echoing a form of basilican structure depicted at Tabarka in Tunisia *circa* 400 and described by Krautheimer as one of the 'hallmarks of African church planning'.[64] The seventh-century Kentish instances might have been direct introductions from Rome, or manifestations of the influence of African-born churchmen in Kent such as St Adrian, made abbot of St Augustine's by Theodore of Tarsus.

The gap between Rome, Early Christian Africa and Gothic Scandinavia is, at one level, astonishing. But the actual antiquity or origin of the form was not in itself an issue: the Trondheim screen was not an instance of 'archaism'. It simply demonstrates the way a form now known to be of considerable antiquity proved useful in the very unusual context at Trondheim of an eastern octagon and shrine space and which, no less importantly, travelled across the North Sea together with a very distinctive repertory of formal motifs. After Trondheim, the narrative of this English style in Scandinavia ended.

The English in France: Aquitaine and Her Neighbours

Trondheim's architectural development in some ways resembled that of many English cathedrals acquiring Decorated furnishings in the same period. By this time English influence in Scandinavia more generally was in fact retreating, particularly in its figurative arts, increasingly allied to north-

ern Germany. And, to go altogether in another direction, it raises a question about the situation in those Continental territories actually under English control, specifically in western France in the region of Aquitaine, which included Bordeaux, Guyenne and Gascony. The economic importance and value of this region to the English under Edward II and Edward III prior to the confiscation of Guyenne by the French in 1337, not least in regard to the wine trade, needs no emphasis, and the role of English governors with East Anglian connections such as Sir Oliver de Ingham (d. 1344), twice Seneschal of Gascony, is worth recalling.[65] Yet in art and architecture English influence or affinity there had been negligible or absent, and certainly less than in twelfth- and thirteenth-century Normandy before its loss in 1204, and it is not clear that the situation in the fourteenth century at the outbreak of the Hundred Years War differed seriously.[66] The senior cathedral of the archdiocese, Bordeaux, in effect the capital of the English possessions in France, consists of a French Rayonnant choir and a nave typical of the Romanesque of Poitou; to the south, the cathedral at Bayonne, begun in the wake of Reims Cathedral and with reference to it, is also Rayonnant in outcome, though possessing a tierceron vault at the crossing of a type already present in the same position at Amiens. Of the two port cathedrals, the substantially later western parts of the nave and west porch at Bayonne (the vault includes a boss with the arms of France and England quartered) show the closest affinities with work in the Decorated Style. The upper nave walls of the western towers possess mixed Rayonnant and flowing tracery also found in the transepts at Bordeaux, and the porch has ornate octagonal corner towers with layers of arcading that actually increase in circumference stage by stage upwards; the detailing of these features with ogival shafts and double-layered 'bubble' foliage is of a type that any mason from (say) Bury St Edmunds would have noted, though the work is of much later date. It is at such junctures that can be sensed, not the seminal nature of the Decorated Style, but its commonality with those unexpected aspects of French Rayonnant that analysis has tended to sidestep.

There are isolated one-off examples of English idiom in this region. Jean Bony's narrative of Gascony as 'another natural point of entry for English artists' drew attention to a two-tier stone reredos screen in the small rural Romanesque church of Notre-Dame at Audignon, near Saint-Sever in the hinterland of Bayonne (pl. 206).[67] The screen, covered in brightly restored fifteenth-century paintwork and images, closes off the church's apse and allows access to it through a single flattened-ogival southern doorway. It consists of two superimposed ranks of canopy work with square-section buttresses and crocketed gables with cusping. The arrangement is a hardened version of the sort of arcading on the eastern face of the pulpitum screen at Southwell Minster of the 1330s, in which single gabled niches in the lower rank are subdivided in the upper (pl. 207). With regard to east Midlands work, the Audignon screen betrays one specifically Lincolnshire mannerism notable from *circa* 1330: the omission in each niche of a pointed arch in such a way that the rather sharp cusping instead projects inwards directly from the gable, a feature of the Easter sepulchres at Navenby and Heckington (see pl. 223), which, I will suggest shortly, were studied as far afield as Avignon.[68] The ultimately English genesis of the idiom is therefore likely. But the jejune, coarse and apparently hastily executed detailing lacks the soft sophisticated ripeness of the Decorated Style: so where an elegant openwork wave moulding along the top might be expected, as at Southwell, is found instead just a crude row of trefoils in relief, and ogees and ornate carving are studiously avoided as being, presumably, beyond the technical means of the craftsmen involved. Audignon is Decorated in shorthand. Indicative of a date nearer the middle of the century is the format itself, since by 1330 the use of complex canopied altar screens was limited only to a very few major churches in England, such as Exeter (*circa* 1315–25).[69] While the arrangement with a low lateral door is certainly reminiscent too of English altar screens, the impact of a later pulpitum screen such as Southwell's seems more probable. Two-tier sculpted retables had certainly appeared in the Franco-Iberian borderlands by the 1340s, as exemplified by one executed in alabaster datable to the 1340s at Corneilla-de-Conflent (Pyrénées-Orientales).[70] Audignon is not the product of a concerted wave of English influence, but some sort of incidental eruption of minor English-trained stone carving in the Bayonne area no earlier than the 1330s. What is striking is that so western French a church should be connected, albeit at the most minute level, with the most eastern side of England.

A similar issue is raised by a rather more impressive set of murals to be found to the east of the English-controlled territories, in the Dordogne, in the small free-standing chapel of the former Château du Cheylard in Saint-Geniès, near Montignac (pl. 208). Long known through copies in published surveys of French Gothic wall painting, the paintings comprehensively adorn the two-bay vaulted structure dated to 1329 by an inscription by its west door, and attributed to one Gaubert (*Gausbertus*), the lord of

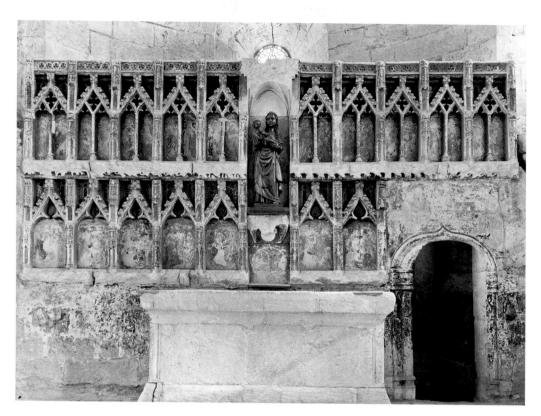

206 Audignon (Landes), parish church, high altar reredos screen, mid-fourteenth century?

207 Southwell Minster, pulpitum, looking north-west, 1330s

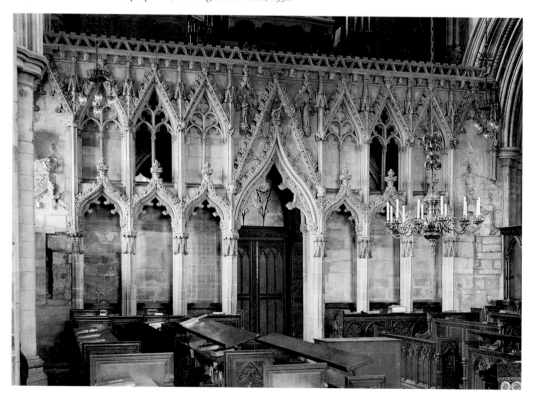

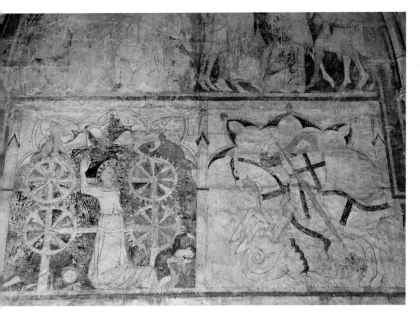

208 Cheylard, chapel of *château*, murals of St Catherine and St George on south wall, *circa* 1329

209 Norwich Cathedral, cloister south walk, doorway to refectory, *circa* 1320–30

Saint-Geniès.[71] Formally organized bay by bay, the pictures couple New Testament material in the upper panels with images in the lower panels of saints including Christopher and Francis (west wall), Andrew, Michael and Peter (north wall) and Paul, Theodore?, Catherine and George (south wall). In fact, despite George's presence (for George was very popular in France), the idiom of the paintings is not on the whole English; what is interesting here are the elaborately cusped frames of some of the scenes, notably of St Catherine with her wheels and of St George on horseback. The rectangular frames contain cusping in which the diagonal cusps directed outwards to the frame corners are pointed and the topmost cusp is ogivally headed, each cusp being itself sub-cusped. The origin of this sort of cusping is not hard to trace, and it is not French: the same alternation is found in the south-east cloister walk door leading to the infirmary at Norwich, work designed not later than the 1320s by the Ramseys (pl. 209). These may pre-date the complex cusped frames on the north porch doorways of St Mary Redcliffe at Bristol (see pl. 33). Given the origin of the Ramseys in the Fenland area, it is not surprising to find similar frames used rather before 1320 in the great Psalters illuminated for abbeys in that area, the Ramsey Psalter and the Peterborough Psalter in Brussels complete by 1318 (see pls 78, 270): not only the forms but also the context, over bold figurative composition, are extremely similar.[72] That

some such source is implied at Cheylard is suggested also by the canopy painted over the *Baptism of Christ* on the east wall, which consists of a cusped gable remarkably similar to some in the Peterborough Psalter.[73] When more than one overlap of this type happens in a single work of art, it is fair to begin to identify an indicative pattern. Similar frames occur on English enamels of the 1330s and 1340s.[74] Their artistic genesis is not in doubt, though it is unclear in principle whether they could have travelled from (say) Bristol, Lynn or Norwich–Yarmouth.

But at this point the remarkable penetration abroad at high social levels of English embroidery and other figurative arts should be recalled: for example, the Peterborough Psalter (see pl. 270) donated by Geoffrey of Crowland, abbot of Peterborough, to a papal nuncio in 1317 or 1318, whence it passed briefly into the hands of Pope John XXII.[75] So by 1318 at least two major French patrons, one of south-western French origin and the other royal, had seen such work at Avignon. To find some sort of reflection of it or its like in the Limousin *circa* 1330 is not so surprising. By adding painting and illuminating into the narrative of 'English abroad', that narrative is greatly enriched, though it does not so far point to anything other than disconnected episodes. And that impression is sustained further by studying material to the south-west of the English-controlled area of France, across the Pyrenees in Navarre.

210 Roncesvalles, chapter house exterior, reticulated tracery, ?mid-fourteenth century

211 London, Westminster Abbey, cloister east walk, reticulated tracery, 1300s

Navarre: Roncesvalles and Pamplona

The history of specifically English cultural contact with the Iberian peninsula is so unexplored, and apparently so complicated, that a only few suggestions can be sketched out here, beginning with the sectors nearest Gascony and moving to the south-west.[76] Since the twelfth century in Iberia, as much as in western France, signs of knowledge of English art and architecture do not form part of a meaningful pattern. By far the most convincing liaison with English Romanesque figurative art was shown by the extraordinary paintings, badly damaged in the Spanish Civil War, in the chapter house of the Aragonese royal monastery of Sigena founded by Sanchia, queen of Aragon, in 1183.[77] Dating to the decades after the foundation, these murals correspond closely to the finest painting and illuminating being conducted at Winchester, Canterbury and also probably the English court at the end of the twelfth century. The qualitative gulf between these works and their later Gothic followers is striking. Though wall paintings with English, probably court, mannerisms occurred as far west as Salamanca Cathedral (St Martin's Chapel) by 1260 or so, the murals at Sigena technically speaking far surpassed anything in the Gothic era.[78] This quality has in all probability to be ascribed to accidents of royal patronage, which by their nature lie outside normal cultural networks, in so far as those exist.

The kingdom of Navarre, contiguous with the southern English territories in France and focused on the cathedral city of Pamplona, but governed by a French dynasty, reinforces this point. By the middle years of the fourteenth century the most distinctively English of window tracery types may have spread as far as the religious community at Roncesvalles, within the architectural orbit of Pamplona, in the Pyrenees. The collegiate church at Roncesvalles was rebuilt in a fluent late twelfth-century Parisian idiom by King Sancho VII of Navarre (d. 1234), brother-in-law of Richard I of England; Sancho was eventually buried there. His remains were placed in the chapter house or chapel of St Augustin, an imprecisely dated structure of the middle years of the fourteenth century covered with the same sort of tierceron vault as those in the crossings at Amiens and Bayonne and the presbytery of Toledo Cathedral, of which a centrally planned variant, perhaps the model for that at Roncesvalles, is found in the mid-fourteenth-century chapter house (the Capilla Barbazana) of Pamplona Cathedral itself. The point is that the west window of the chapter house at Roncesvalles (pl. 210) possesses very fine ogee-reticulated tracery of the sort developed in England by about 1310. The date of this tracery is not certain since the reticulations are restored and the exterior masonry adjoining the window arch reveals signs of disturbance, so there is a possibility that the window is a later medieval insertion

212 Mural of *Passion of Christ* by Iohannes Oliveri from refectory, Pamplona Cathedral, dated 1330 (now Museo de Navarra, Pamplona)

or repair. Similar tracery occurs on the stone choir enclosure in the chevet of Toulouse Cathedral probably raised for Archbishop Bernard de Rousergue in the third quarter of the fifteenth century.[79] A fourteenth-century date for the window is accepted by some authorities, however, and exactly this type of tracery was used before 1358 at Tarragona in an English-influenced context (see pl. 241).[80] In the fourteenth century Roncesvalles, a prominent and independent-minded Augustinian community, was at the peak of its prosperity and could certainly afford such work. And there might be a more specific reason for open-mindedness about the possibility of the window's early date. Strategically, Roncesvalles was favourably placed in regard to England. As the gateway to the pilgrimage road across northern Iberia, since the early thirteenth century Roncesvalles had kept a hospice at Charing near the royal mews in London, founded by William Marshal II, for would-be pilgrims to Compostela; coin finds at Roncesvalles indicate long-standing links to the British Isles.[81] Since one window of the chapter house and also the adjoining bays of the cloister of Westminster Abbey possessed – and was probably the birthplace of – net tracery of the sort at Roncesvalles (pl. 211), the possibility arises that an allusion to the English royal burial church followed from the decision to relocate Sancho's body, and the Charing link would have facilitated it.[82] If so, this would indicate a high-level but specialized form of contact running rather against the Parisian sympathies expressed in the main church, but understandable from an English perspective in the light of the chivalric associations of the place with the legend of Charlemagne and Roland as well as with pilgrimage. 'Rouncivale' and 'Pampilon' figure in the writing of Chaucer and Langland.[83]

Were more known about the origins of the English illuminated manuscript of the Westminster coronation order of *circa* 1390–1400 now in Pamplona (Archivo General de Navarra MS 197), such high-level links might be shown to have been more common.[84] In fact, the evidence for English incursion into the major regional centre, Pamplona itself, under Joan II, is ambivalent. Central to it are no architectural works as such, but rather the decoration of the magnificent refectory adjoining the cloister of Pamplona Cathedral. Pamplona's affluence and attractiveness as a centre of employment under Joan II is evident from the haughty courtliness of the cloister and from its lavish furnishing. This luxuriance was owed in part to the presence in the cathedral of a community of resident canons to whose needs it answered. There are no grounds for connecting any of the work to the suggested employment on

213 Tiptoft Missal, *Te Igitur* page, 1320s (New York, Pierpont Morgan Library MS M. 107, fol. 142)

the cloister of one William the Englishman, linked also to the cathedral at Huesca in Aragon in 1338.[85] Attention here turns instead to the refectory, completed in about 1330.

The date derives from a large and very fine mural formerly adorning the dais wall of the refectory, but now remounted in the Museo de Navarra in Pamplona (pl. 212). More than six metres high, the mural depicts in three tiers the *Passion of Christ*: from the top, the *Flagellation*, the *Carrying of the Cross*, the *Crucifixion*, with the thieves, and the *Burial* and *Resurrection*, with prophets including David and Solomon in tabernacles to either side, and with heraldry at the base. The image bears Latin *tituli* in leonine hexameters and has an inscription at the bottom stating that in 1330 (or 1335) Iohannes Périz de Stella, who was the head of the works of the cathedral, built the refectory, and Iohannes Oliveri painted the image above.[86] Calvaries of this type are known in Iberian Romanesque art, and there is little in the iconography of the picture that could not also have been derived from French, or for that matter English, Gospel

sequences: Christ is often shown looking back over the Cross while carrying it in northern French and Fenland art of the period, and his wearing of a gown in this scene is also found in northern France.[87] Iohannes Oliveri was evidently familiar with central Italian (Giottesque?) *Passion* painting, to judge by the angels that float next to the Crucifixion weeping, rending their tunics or bearing chalices. Yet since the 1950s this picture has been drawn particularly into discussion of English fourteenth-century London and East Anglian art.[88] Though the stylistic identity of the picture is mixed, there is something to be said for this perspective, since some of the facial types – those of Longinus and Christ on the Cross, for instance, are drawn in a way with affinities to the male heads in the frame of the *Te Igitur* page (fol. 142) of the Tiptoft Missal (New York, Pierpont Morgan Library MS M. 107) of the 1320s (pl. 213) – in so far as analogies between illumination and larger-scale painting allow.[89] The deep-set eyes and furrowed brows with inverted triangular eyebrows are notable in this regard. Also, the format of Prophets in the border is similar to that of the *Beatus* page (fol. 9v) of the Ormesby Psalter, of about 1320 (see pl. 291).[90] The architectural frames and various patterns in the pictures are not wholeheartedly English in idiom, however: for instance, the placing of Prophets beneath cusped arches in tiers in the border resembles the slightly earlier east-wall glazing of the transepts of St Nazaire in Carcassonne. The burning, coal-black eyes of many of the faces seem inconsistent with English or French practice. But the impression of some sort of contact with English painting is strong.

The Pamplona mural possesses the mixed yet focused character of the best courtly art of the period; indeed, Iohannes Oliveri could be considered to be a Navarrese court painter heading a team who 'spoke' Spanish, French, Tuscan and English. In 1332 he is described as *pintor de Pomplona* in a document for work on a wax image, a royal commission.[91] In fact, the documentary evidence proves that his career had already been developed elsewhere, at the most cosmopolitan of all artistic courts of the period: that of papal Avignon, under John XXII.

Avignon Under Pope John XXII (1316–34)

THE PAINTERS

These conditions are to an extent implicit in the rather rich documentation of the teams of painters employed at the start of the pontificate of the French-born pope John XXII in and around Avignon, an area enjoying a boom since the papacy moved there in 1309, and especially after John's accession in 1316 when building activity began in earnest. John, formerly Jacques Duèse, was born *circa* 1244 in Cahors, of bourgeois stock. He was aged about seventy-two when he was elected, and quickly began work at two residences near Avignon, Noves and Sorgues; Avignon itself remained in the hands of the kings of Naples until 1348, and John retained the old palace there (he had been a bishop of Avignon) and developed instead the satellite residences.[92] Sorgues, to the northeast, became a sort of court for visiting French and Angevin princes, so any artists working there were, in effect, catering to one of the most cosmopolitan audiences in western Europe. Unfortunately, none of their work survives, but a certain amount can be inferred from the archives.

Long before his Pamplona commission, the painter Iohannes Oliveri is recorded in October 1316 working at the papal residence at Noves to the south-east of Avignon; at this point he was in a team with painters called Jean Daussures (i.e., of Auxerre), Jean Angles or Langlois (i.e., the Englishman) and Perrot Lenorman – toponymics that suggest origins no further west in France than Normandy.[93] The pope, however, employed a second and apparently more dominant team of painters led from 1316–17 by a Franciscan from Toulouse, Petrus *de ordo minorum pictor* and *pictor domini nostri*, that is, Petrus de Podio or Pierre du Puy. He was connected both with Sorgues and Avignon into the 1320s, and his mates were called Petrus Massonerius (Pierre Masonnier) and Thomas Daristot.[94] Pierre du Puy had been sent for from Toulouse by the pope's agents in August 1316 together with his assistants and *familia*; he was presumably of western French origin, though Thomas Daristot was called *pictor Anglicus, de Anglia* or *Anglicus* in 1321–2.[95] Aristot is a small settlement in the Pyrenees south of Andorra, near Cerdaña, which might indicate that Thomas, though English, had settled more locally. He was called *magister* and undertook to paint the great hall at Sorgues according to the *forma* and *modus* (see pp. 65–6) supplied by him by Pierre du Puy (*juxta modum et formam datam per fratrem Petrum de Podio*).[96] By 1321 these two teams had blended at Sorgues in such a way that their pecking order is apparent: Pierre Masonnier was paid more than Iohannes Oliveri, who in turn was paid more than Jean Angles, and Thomas Daristot followed the designs of Pierre du Puy.[97] Pierre (d. 1328?) and Thomas carried on working in and around Avignon until the early 1330s, which strongly argues for the support of John XXII himself.[98] But by then Iohannes Oliveri was a court painter in Pamplona, and some sort of rising star.

Three points emerge from the Avignon records. The first is the limited role accorded to painters with Italian names. The second is that the different teams were mixed together. This is what one would expect of new court centres lacking deep-rooted traditions of style. Yet the teams tended to retain their identity in the long run, like little companies in which fixed associations were embedded despite passing commissions. This raises the possibility that when Iohannes Oliveri left Avignon and arrived at Pamplona at some point between 1321–2 and 1330, he took with him his Noves team of 1316, formed of Jean Daussures, Jean Angles and Perrot Lenorman: names that imply about the right range of training for the Pamplona refectory mural, bearing in mind also its probably Avignon-derived knowledge of Tuscan painting. Finally, the men in both teams with English toponymics were subordinates – even Oliveri was at this stage a middling-ranked artist, and none of his team worked in Avignon Cathedral. There is no evidence that Oliveri himself was English: but he worked with Anglo-Norman painters. His team was not responsible for the *ordinatio* or basic design of paintings recorded in the *forma et modus* supplied by Pierre du Puy. Why it was at Avignon at all is obscure, beyond the obvious consideration that the papal building boom in Avignon created employment. Refugee status around 1315 may be worth pondering given the widespread agrarian crisis of the period until at least 1322, which may have had a role in promoting labour mobility and particularly in the movement of skilled labour between courts (p. 89).

The painters' situation is, in fact, quite the reverse of that implied by the tomb erected for John XXII himself in the cathedral of Notre-Dame-des-Doms in Avignon. In this case, English planning and detailing are more apparent than in virtually any work in continental Europe in the pre-plague years.

Avignon Cathedral: The Tomb of John XXII

The tomb erected for John XXII (d. 4 December 1334) in the chapel of St Joseph in Avignon Cathedral (pl. 214) is undocumented, so one must proceed by inference.[99] Whoever drew up its specification had a sound professional knowledge of designs developed within the English royal works in the previous generation or so. This in turn implies some line of communication between the pope's agents and

214 Avignon Cathedral, tomb of Pope John XXII (d. 1334)

contacts in London, which, in turn, given the standing of the project as the first major curial tomb to be erected in Avignon, implies (while it does not guarantee) high diplomatic contact. Though the tomb shares its stylistic ancestry with the screen and octagon at Trondheim of the same period, how it came about is unknown. These two major examples demonstrate that the international success of Kentish Decorated was second in importance only to the Continental dissemination of curvilinear tracery, which tended to come from the east and north of England.

John's training at Montpellier, professional experience as bishop of Fréjus and also Avignon, administrative experience at the Angevin court of Naples and record of appointing French cardinals, would lead one to expect an inclination towards western and Mediterranean French or Italian visual culture. But it has already been seen that his court wall painters were notable for the relative absence of Italians amongst them, and that he obtained *Opus anglicanum* and fine English illuminated books as well as royally gifted English goldsmiths' work: such gifts came from, amongst others, Edward II and Queen Isabella at John's accession.[100] The issue of cultural 'identity' under this in many ways most French of popes is highly ambivalent. Scholars have looked to him for the encouragement of Italian proto-humanism on French soil, for attracting to Avignon Italian poets and English men of letters, and for the start of the papal library at Avignon (works by Pliny, Valerius Maximus and the Senecas): those he encouraged included Nicholas Trivet and Richard of Bury – an important figure in the story – as well as Petrarch, summoned from Bologna in 1326.[101] Indeed, the notion of John's anti-Italianism is to an extent itself Petrarchan in origin, to judge by one of the poet's anecdotes about John's political sentiments in the 1320s; and Petrarch was hardly neutral in the matter.[102] But Pope John's 'classicism' would not, nor could it, rule out a 'Gothic' sensibility, and it would be simplistic to assume that, because the great Sienese master Simone Martini arrived in Avignon around 1335 after John's death, John had in some way been intent on keeping Italians out of his circle of artists previously.[103] The texture of his thinking was obviously more complex. John was a lawyer, an ascetic and an intellectual.[104] His papal decrees included conservative, stoic critiques of excessive elaboration by the use of hockets in liturgical music, an inebriating offence against the chastity (*pudicitia*) of plainsong.[105] Yet his tomb, on the contrary, is a masterpiece of *subtilitas* and curiosity of the type that the English excelled in. Spikily ornate and providing a frame originally filled with small carved figures, it is hard to believe that,

even had this tomb been commissioned and erected after his death, it would in some way flatly have contradicted the nature of the man. If death reveals one's true nature, John's was certainly 'Gothic', and if a question is posed by it, it concerns quite as much his relationship to London as to Paris, since no other pope of the Middle Ages was provided with an 'English' tomb.

His monument, in many places restored but preserving enough original detailing to help here, is a fine, if not supremely fine, instance of a type of ornately canopied tomb with image niches and stacked, and in this case partly linked, openwork spires that French and English architects had been developing for aristocratic patrons since the late thirteenth century. The tomb is orientated east–west, with a wall niche, probably a tomb, in the wall opposite its east end (pl. 215), and is placed beneath a vault boss of the *Virgin and Child* (pl. 216). It consists of a double-sided, free-standing structure, five bays in length and one deep; the three central bays sustain a complex openwork structure of canopies culminating in a tabernacle and spire, the two outer bays being slightly less lofty. The tomb-chest occupies the three-bay central section with gabled canopies rising from niched shafts passing up in front of its arcaded sides. The two outer bays have oversailing ogival niches at the base. The serried graduated rank of five gables across the main façades brings to mind the portal-derived essence of such micro-architectural ensembles (for example, the west front of St Nicaise, Reims). French instances of ornate tabernacle work are the recorded tombs of Marie de Montmirel and Enguerrand de Coucy at Longpont, Beatrice de Provence at St Jean de Malte in Aix-en-Provence and Cardinal Jean Cholet at St Lucien, Beauvais.[106] The detailing shows that any French Rayonnant sources for the tomb had been conclusively filtered through an English-trained mind inspired by this very same French tradition. Such a choice, otherwise unknown in the annals of papal patronage, either implies a stance in regard to mainstream French, as well as Italian, art, or the function of the tomb as some sort of gift, since gifts are the single most simple way of accounting for sudden ruptures of taste.

In its detailing and enjoyment of obliquely set canopy work, the tomb is a speculation on the extraordinary repertory of tabernacle forms developed in England in the crucial period 1290–1320, most notably on the Eleanor Crosses and such spire compositions as the throne at Exeter Cathedral, and the throne in the choir at Wells, of the 1330s or so (see pl. 39, to right). Especially akin to extant wood engineering is the tiered upper structure of openwork tab-

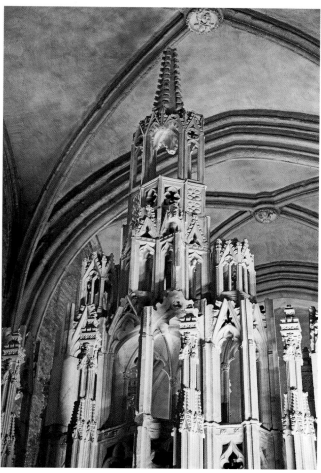

215 *(above)* Avignon Cathedral, tomb niche to east of tomb of John XXII

216 *(right)* Avignon Cathedral, detail of spire of tomb of John XXII, with boss of *Virgin and Child* over

ernacles, reminiscent of the second stage of the Exeter throne. The triple-bay central unit of the tomb's main faces is a much-elaborated variant of the canopy work on the tomb of Edmund Crouchback (d. 1296) at Westminster Abbey and its derivatives for the tomb of Bishop William of Louth (d. 1298) at Ely Cathedral and that attributed to Stephen Alard (d. 1327) at Winchelsea, all probably from the circle of Michael of Canterbury (see pls 106–7, 244).[107] In Avignon's case, the effigy rests not under a wider central arch but is enclosed behind the main canopy shafts in the fashion of some French and English effigial tombs (Enguerrand de Coucy and Peter of Aigueblanche, bishop of Hereford). The solid two-tier bases of the outer flanking canopies bring to mind the tracery-faced outer canopy buttresses of the tomb of Archbishop Pecham (d. 1292) at Canterbury, also from the circle of Michael of Canterbury.[108] The central of the five bays of the Avignon tomb stands slightly proud of its flanking and slightly canted neighbours as on the Stephen Alard tomb at Winchelsea.

The English nature of the idiom was first recognized by Francis Bond, though he overlooked the salient point about the detailing, its almost wholly courtly and Kentish character.[109] The topmost spire (pl. 216), an obliquely set structure with a part-diapered, part-tracery openwork base and canopy, is a variant in plan and elevation of the Geddington Cross probably of the mid-1290s (pl. 217). The diaperwork is used on the Crouchback tomb at Westminster, on the Alard tombs at Winchelsea, and on a number of works at Canterbury within the Kentish network. The overhanging ogees on the bases of the outer bays resemble the stall canopies of St Stephen's Chapel, Westminster, and of the Exeter throne (see pls 42, 103). The vertical mouldings and main arches are studded with fleurons pasted across their hollows in a way reminiscent of the entrance arch of the gate of St Augustine's Abbey in Canterbury, of the 1300s. Another Kentish signature motif is the now badly damaged openwork balustrade with crenellations and framed pointed quatrefoils atop the main tomb chest (pl. 218), similar to the chapter house arcading and the choir screens of Canterbury Cathedral (see pl. 117), but with the foils framed and given slight ogee points like the quatrefoil frieze below the panel-

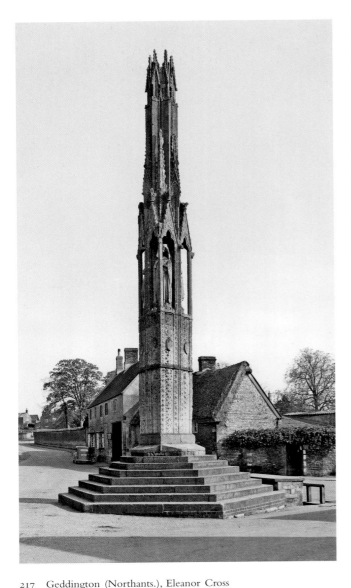

217 Geddington (Northants.), Eleanor Cross

218 Avignon Cathedral, tomb of Pope John XXII, embattled cornice, detail

ling of the octagon lantern at Ely raised after 1328. The main pinnacles of each buttress shaft terminate in Westminster and Canterbury fashion in square crenellated tops; the gables' ogival cinquefoils and cusps fall into the same sphere, since the ogival cinquefoil cusps, which also feature on the micro-architectural gables, are derived from the choir screens at Canterbury and St Stephen's Chapel. Ogee-headed arches, greatly altered in detailing by later repair, adorn the base of each end face of the tomb. Barbed pointed trefoils, used extensively in court and other commissions in south-east England since the 1280s, occur in the gables of the weeper arcades on the sides of the tomb chest and in the gablets of the canopies above. The interior tracery panels at the head and feet of the (lost) effigy contain pretty ogival cusping beneath square heads of a type encountered in the murals at Cheylard and the Peterborough Psalter. The topmost tracery of the towers flanking the central spire consists of small two-light windows with ogival soufflets, a form first developed before 1320 in the cloister at Norwich. The vaults of the canopy work possess ridge ribs with miniature English-style knotty and rosette bosses. Finally, opposite the eastern end of the tomb, as presently conserved and rearranged in the correct east–west orientation, is the low sub-cusped tomb niche framed with a row of diaper (see pl. 215). The form is, again, one developed in arch-heads at Norwich and Bristol by about 1320, but the large-unit diapering with ogival quatrefoil or cinquefoil leaves is explicitly derived, as on the main tomb, from the diaperwork on the choir screen at Canterbury (see pl. 151, lower left) and related works.

The repertory of detail shows conclusively that this tomb was designed by someone very well versed in court and Kentish practices as they stood no later than about 1320, the canopy work itself being little more than an extrapolation from the bravura tabernacle designs of the same period, granted that no English tomb definitely made before 1320 possesses a canopy of such ambition. Court tombs of the 1320s at Westminster such as that of Aymer de Valence (after 1324) adhered to the single ciborium model out of regard to the context of pre-existing memorials there, and the only sphere in which lofty openwork canopies were being developed to this extent was that of church furnishings such as the stone sedilia at Exeter Cathedral, probably linked to the construction of the high-altar reredos between 1317 and 1325 (see pl. 49), where the top tier of canopies shows the same preoccupation with open tripod-like canopy planning found on the throne in the cathedral, and at Avignon. Virtually nothing like this is found in this region of Mediter-

ranean France and Spain with the more modest exception of the obliquely turned spire on the tomb of Jaime II at Santes Creus (see pl. 229, left), noted below.

The implication of this is that the general conception of Pope John's tomb was more advanced than its detailing, by the standards of English tombs. From this derive two different inferences: that the tomb was executed early in John's pontificate by a mason ahead of developments in England; or, as is usually supposed, that it was executed towards or around the time of his death by a team whose detailing had not changed significantly since about 1320 but who were taking into account developments in linked canopy work on English tombs in the intervening decade or so. There is something to be said for either option in the absence of documentation, but more for the latter.

Since John had been a bishop of Avignon and was old at his election, the notion that he would have demonstrated a commitment to the Avignonese papacy by promptly raising his own tomb in his former cathedral is consistent with his personal history, his investments in the papal residences in the region early in his pontificate, and a desire in the wake of the damaging division apparent at the conclave of 1314–16 to stabilize the current situation by a statement of intent. It has to be said that there was no strong tradition of popes commissioning their own tombs. But John's plan could have been to establish a Duèse-De Via prelatial mausoleum, since his nephew Jacques de Via (d. 1317), whom he made a cardinal in 1316, had followed him as bishop of Avignon and had died there. In favour of this argument are three specific points. First, the ornate but restored wall tomb next to the pope's is usually ascribed to Jacques himself.[110] Second, the arms of Jacques and his uncle are shown on the exterior west wall beneath a window.[111] Third, the chapel is associated with veneration of the tomb of St Agricole of Avignon, who formed a 'pair' with his father St Magnus: did this suggest a later pairing of familially related curial tombs?[112] The vault of the chapel displays two bosses, one of the Virgin Mary (over the tomb) and another of St Peter wearing the papal tiara, holding a set of keys: neither is in an English idiom or obviously datable before the 1320s. The history of the dedication of the side altars and chapels of Avignon Cathedral is not straightforward. Such bosses would be consistent with a dedication to All Saints or the Apostles, though the evidence is not probative.[113] It does not, however, follow that, because a mausoleum was planned and built, its tombs were made immediately, and it is worth recalling that another family member, also devoted to the Virgin Mary, Pope John's other

nephew, Cardinal Arnaud de Via (d. 1335), was an extensive builder and the founder of the church of St Marie in Villeneuve-lès-Avignon.[114]

The English evidence from this period is central to the problem. The only English tomb that remotely resembles Pope John's is that of Edward II (pl. 219), raised in the choir at Gloucester after 1327. John's tomb is usually regarded as a successor of Edward's and not as a potential model for it: following Bond and others, Jean Bony considered it a 'hardened version' of that at Gloucester.[115] The papal tomb, being free-standing within a comparatively ample vaulted chamber, is substantially larger and taller than Edward's, cramped beneath the Romanesque arcade of the choir at Gloucester; but the detailing of the royal tomb is more advanced and, it must be said, superior in conception and execution. Unfortunately, the circumstances of the commissioning of Edward's tomb are disputed.[116] The possibility that John's tomb was not only earlier than, but even a model for, Edward's is an exciting one, but one that has to overcome some difficulties.[117] The first is that the only earlier instance of a papal tomb type influencing an English royal tomb, that of Henry III at Westminster, was not (in the general scheme of things) a success, and one is bound to question the *prima facie* likelihood that Edward II's tomb was the direct result of the expatriation of English design ideas to Mediterranean France and back again via the papal curia: Occam's razor favours the simplest solution, which is that such designs were first developed and used in England.[118] Second, as regards detailing, many of the motifs on the Avignon tomb, such as the ogival cinquefoils, were still being used in prestige commissions in Kent as late as the early to mid-1330s, the date of the window of St Anselm's Chapel at Canterbury made in 1336 (see pl. 48): this type of work had not been discontinued by the 1330s, and is apparent also at Trondheim after 1328.[119]

The blend of materials originally used on the tomb is particularly significant, since it was apparently filled with small white marble figures of French manufacture, of which two examples survive in the Musée du Petit Palais in Avignon.[120] Their date is consistent with the period *circa* 1330. More strikingly, an eyewitness account of the tomb before its vandalism during the Revolution, dated around 1784, states explicitly that the papal effigy 'est d'alabâtre transparent', the adjective being hard to gainsay.[121] The immediate analogy for the mix of alabaster or white marble with freestone is, again, the tomb of Edward II, the earliest known English tomb to use alabaster, along with Purbeck. Other English instances of a mixture of contrasting stones

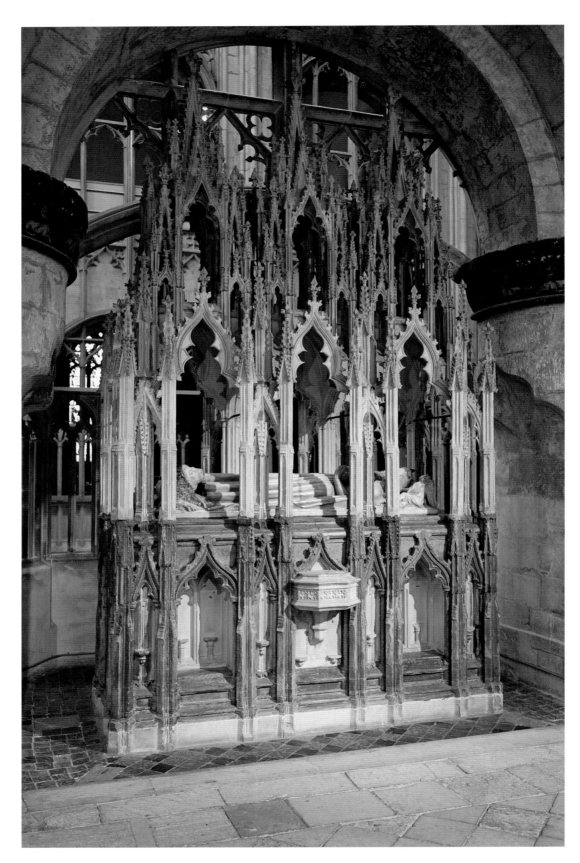

219 Gloucester Cathedral (formerly Abbey), tomb of King Edward II (d. 1327)

include the cloister of St Paul's in London (from *circa* 1332) and the tomb of Archbishop Meopham at Canterbury Cathedral (d. 1333) (see pl. 203). A third, almost unnoted, instance from the very same years in the British Isles is a series of fragments found at Dunfermline Abbey from the arcading of a tomb made of black and white gilt marble, almost certainly identifiable as that of Robert the Bruce (d. 1329), made in Paris in 1329: the detailing of the fragments looks French.[122] If John's tomb was actually executed around 1320, it anticipated not only the general form of Edward's tomb but also its mixed stone techniques, more common by 1330. In this regard it would, again, stand in magnificent isolation, since no earlier French or papal tomb used alabaster to this extent. This points to the likelihood that John's tomb was made later in the period 1316–34 by an English designer instructed to produce something akin to Edward II's tomb at Gloucester but physically bigger: a date in the early 1330s would satisfy most of the evidence. Such a designer, of earlier London or Kentish training and with contacts in the alabaster industry, would have been content to work alongside French masons and sculptors, further developing their tradition of using white marbles for figurative work. If the painters worked in teams of mixed origin and training, so probably did the masons.

However it is to be dated, the tomb's English courtly language of spectacular open canopy work and sparkling tracery is what matters for the present purpose. The presence of such an idiomatically distinct but ambitious object in far-away Avignon presupposes some sort of high-level contact with London and Westminster between 1316 and 1334, since there was hardly a far-flung European market for such things. Masons with English-sounding names are known at the papal court in this period, but no association with tomb manufacture is demonstrable; the identification of chapels is uncertain and the tendency in England at least was for high-status tombs to be designed by leading architects such as Michael or Thomas of Canterbury, not subordinates.[123]

Because Anglo-papal relations had favoured gift giving since Clement IV had eased Henry III's acquisition of the Cosmati pavement before the high altar at Westminster Abbey in the years 1266–8, the issue of agency points to those in the circle of the English court with sustained links to John XXII.[124] Since Avignon was now the most important legal and administrative hub of its type, the movement of influential and well-connected English clerics there was commonplace – such figures as John Hotham and John Salmon had travelled there right at the start of John's pontificate, and the list of attendees at his court, including English chaplains, is promising enough. One instance would be John Grandisson, a chaplain to John who was in Avignon in 1327–8 when the pope appointed him to the see of Exeter. But Grandisson at this point had yet to emerge as a patron of the works at his cathedral, and appears to have taken as much from the sub-Italian culture of the curia as he gave to it (see Chapter Nine), including perhaps his decision to be buried at the liturgical west end of the nave, a practice of recent papal burials in Old St Peter's in Rome. He was not associated, so far as is known, with Kentish work.

Assuming a date for the tomb in the early 1330s raises the case of another cleric who appeared in Avignon and rapidly gained papal preferment before John's death in 1334: Richard of Bury (1287–1345), whose connections with the English court were more long-standing and substantial than Grandisson's. Richard of Bury was, in fact, a courtier-politician of the first rank, being a king's clerk by 1312 and working within the household of the future Edward III, possibly being his tutor in the period *circa* 1323–6.[125] Bury had incurred the wrath of Edward II by supporting Isabella and Mortimer, and at the accession of Edward III rose rapidly to power within the state departments, starting at the wardrobe.[126] With Edward's support he became bishop of Durham in 1333. His importance lies in his activity in Avignon. In 1330 he was an envoy to Avignon negotiating papal support for the coup that ended the regency of Isabella and Mortimer. He returned to Avignon for the greater part of 1333 on high diplomacy and was made a papal chaplain (an honorific position) by John XXII, who presented him with a rochet in anticipation of the next vacant bishopric in England; Richard obtained yet further gifts for the pope while in Avignon.[127] Gift giving, unlike correspondence, is usually reciprocal. At this time he met Petrarch, leaving around November, just over a year before the death of John late in 1334.[128] His correspondence with Petrarch was unrewarding from the Italian's point of view, since Richard was swept away by high office and did not reply to the poet's letter regarding the nature of Thule. Petrarch nevertheless described him as a man of 'ardent mind'. Richard is often credited with the authorship of the most well-known text about books and book-lovers in the Middle Ages, the *Philobiblon*, composed in the 1340s possibly with the help of the Dominican Robert Holcot.[129] Its epistolary form has indicated the impact of Richard's Avignon years and contacts with early humanists. Whether or not he owned Italian illuminated manuscripts is unknown, but possible (see Chapter Nine). One other piece

220 Seal of Richard of Bury, bishop of Durham (made *circa* 1334)

Ramsey, William's daughter, who kept the company running after her father's death) when the time came for her and her son Edward III to commission her own, part-alabaster, tomb for the Friars Minor at Newgate in London.[131] There is no positive evidence that Isabella was involved in the commissioning of Edward II's tomb at Gloucester; had this been so she must have acted between 1327 and 1330. But her recorded influence in ensuring a dignified burial in Westminster Abbey for her second son, John of Eltham (d. 1336), also with an effigy and other figures in alabaster (pl. 221 and see pl. 296), considered together with the choice of alabaster for her own tomb, renders her by far the most prominent English patron of this material at the time, and hence of the idiom of the tombs themselves.[132] Edward III clearly backed her. As already noted, John XXII's effigy was described in the 1780s as being made of alabaster – a substantial and early instance of its use, and one difficult to reconcile with what is known of English or French tomb design around 1320 but better suited to the fashion for tombs using that material from the late 1320s and 1330s. Once again, the signs are that English contacts arose not because of some generalized wave of 'influence' but only as a result of specialized, but now obscure, circumstances. This is beyond proof, but the possibilities can be narrowed down.

of evidence proves that he was a discriminating patron: though Richard was not a builder, by early 1335 he had abandoned his first, and somewhat prosaic, personal seal as bishop of Durham for a new one of extraordinary beauty of French type (pl. 220), and quite possibly the work of a French goldsmith, which probably demonstrated the resources open to him as his spectacular ascent in the government continued.[130]

Richard was not at Avignon when John died: but the pope was about ninety at his death, and some prior arrangement for his tomb seems inherently probable, assuming it had not in fact been made several years earlier. Of the leading Englishmen of the day, Richard of Bury was one of the few simultaneously close enough to the curia at Avignon and the English court in the years 1330–33 to bring about the sort of memorial eventually erected. His allegiance to Queen Isabella is especially important in one respect. Isabella (d. 1358), to whom Pope John had shown leniency at the time of the fall of Mortimer in 1330, was herself a patron of the Ramsey Company (actually Agnes

221 London, Westminster Abbey, alabaster effigy of John of Eltham (d. 1336)

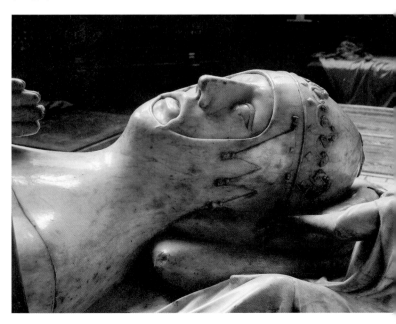

222 Avignon, St Didier, choir north side, tomb of Cardinal
Bertrand de Déaux (d. 1355)

223 Heckington (Lincs.), Easter sepulchre, 1320s

Curial Commissions in France Shortly after 1350: Avignon and La Chaise-Dieu

The 'afterlife' of such elaborately canopied tombs with gables and linked spires is represented in England by the Despencer tombs at Tewkesbury (Hugh III Despencer) and, in clerical circles, by the sleek tomb from the circle of William Ramsey erected for Archbishop Stratford (d. 1348) at Canterbury Cathedral.[133] To this series, in virtue of its general form, might well be added the canopied tomb of Pope Innocent VI (d. 1362) at the now half-ruined Chartreuse at Villeneuve-lès-Avignon, in preparation in 1361 before his death.[134] But there is one further object in Avignon that suggests that the incidental occurrence of English-influenced tomb-design there was not over.

This is the tomb of Cardinal Bertrand de Déaux (d. 1355) on the north side of the choir of the church of

St Didier in Avignon, which he paid for (pl. 222), and which was built in the years 1356–9.[135] Unlike the free-standing tombs of John XXII and Innocent VI, this is a wall monument. Its effigy and tomb chest have gone, but the remaining superstructure consists of a three-bay pinnacled composition with a very tall slim central niche with lean-to flanks, the central niche having a gabled top and the outer lower flanking niches having ogees. The flanks are connected to the centre by means of cusped flying buttresses and small cornices with rows of quatrefoils. The effect is not unlike the cross-section of a Gothic basilica; but while end-on compositions were not unknown in patrician Roman tomb design (Luca Savelli in Santa Maria in Aracoeli), this one differs.[136] The particular form of the St Didier monument seems especially indebted to such eastern English Easter sepulchres of the 1330s as those at Heckington and Hawton (pls 223, 224).[137] Setting aside the original

224 Hawton (Notts.), Easter sepulchre, 1320s, detail (see also pl. 50)

base, the superstructure is close in composition to the sepulchre at Heckington in regard to the overall composition with lean-to flanks connected by flying buttresses, the pinnacles and finials of the central niche reaching up to the top frame of the monument. Hawton's outer flanking 'aisles' have ogival tops. The central niche of the St Didier tomb has a small relief of the ascent of Cardinal Bertrand's soul set in a vesica. Undeniable as the visual resemblance is, the fact that the Hawton and Heckington monuments are also connected with patronal tombs and chantry endowments and are also on the north side of their respective chancels is a further point of similarity to St Didier. It is impossible to say whether this tomb was actually intended to be an Easter sepulchre on the lines of its English antecedents, but the coincidences are notable, though they lie at the level of overall design and not the detailing, which looks French in its handicraft, not English. They imply that, since this was the founder's tomb, it was planned in this form at the outset, perhaps being included in the drawing according to which the church was executed.[138]

Bertrand de Déaux was a Frenchman born at Blauzac, and had been made a cardinal by Benedict XII in 1338. He owned a fine illuminated Bolognese missal, so his taste was evidently as mixed as that of many curial members.[139] The church of St Didier is well documented in so far as a contract survives for its erection, dated May 1356. The church was to be built according to a design drawn out on parchment. The contract names the principal masters as Johannes Posterii de Salone, Guillelmus Eberardi de Sancto Maximino, Guillelmus Payslotros de Sancto Molan de Insula and Jacobus Laugerii fils de Guilhem Laugier d'Avignin, all on the face of it local men. Of these one only stands out, Guillaume Eberard, since in Occitan orthography 'b' and 'v' are interchangeable: the name might, in fact, be William Evrard. This is only mentioned because by the fifteenth century there was a family of masons called Evrard in Norwich, one of whom, Robert, erected the cathedral spire.[140] Such a company, if of much longer standing, might have been familiar with eastern English work more generally. One must, however, be careful about names and what they might suggest.

Beyond that nothing is known, though thoughts about Avignon end with the fact that its role was always two-way: if the English gave, they also received. In 1355, the year of the death of Cardinal Bertrand, another senior English cleric also died in Avignon, William Bateman, bishop of Norwich, Edward III's ambassador. It is impossible to know whether he contributed to the Avignon artistic scene. Bateman was a typical curial official of his day, a canon lawyer and, significantly, a former archdeacon of Norwich and dean of Lincoln (1340–44) who was provided by Clement VI to the see of Norwich in 1344.[141] His professional experience in England coincided with the regions that produced some of the most ornate sculpted monuments of the time. The presence in Avignon of Norwich bishops such as Ayermin and Bateman in the second quarter of the century may well have something to do with the Italianate tenor of some Norwich-produced book illumination of the time such as the Gorleston Psalter (see Chapter Nine). Such processes were always reciprocal. Indeed, in 1354 Bateman acquired in Avignon a beautiful French silver-gilt beaker with a crenellated top bearing the arms of Etienne Aubert, that is, Innocent VI; this is now the Founder's Cup in Trinity Hall (pl. 225), the Cambridge college that Bateman had founded in 1350.[142] It shows what Avignonese gift exchange consisted of; but from all these examples no general rule may be derived. The keynote in all such exchanges was not conformity to some process, but an enduring capacity to surprise.

The final instance within the Avignonese milieu leads north to the Benedictine abbey of La Chaise-Dieu, in the

complete by about 1349, is not in doubt.[145] At the centre of its choir stood Clement's tomb, executed in 1350 by Pierre Boye in Villeneuve-lès-Avignon according to a detailed protocol for the figurines around it, using marble dragged from Aigues-Mortes as well as Mosan alabaster.[146]

The focus here, however, is neither Clement's tomb nor the great choir pulpitum with its three broad ogee arches, reminiscent of the pulpitums of Exeter and St David's. It is the gabled tomb set against the choir enclosure in the south aisle at the east end, sometimes, but possibly wrongly, attributed to the abbot of La Chaise-Dieu under Clement, Renaud de Montclar (d. 1346), and probably of the 1350s (pl. 226).[147] The canopied wall tomb stands forwards from

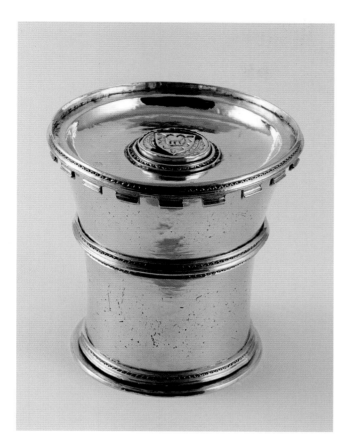

225 Trinity Hall, Cambridge, Founder's Cup acquired by William Bateman in 1354

226 La Chaise-Dieu Abbey, tomb in south choir aisle formerly ascribed to Renaud de Montclar (d. 1346), with door to choir beyond, looking north-east

Auvergne towards Clermont-Ferrand. Its abbey church was rebuilt as his mausoleum by Pope Clement VI (1342–52), born Pierre Roger in the Limousin, a former monk of the abbey and also a great secular cleric and former archbishop of Rouen.[143] Of all the Avignonese popes Clement, in virtue of his consolidation of Avignon as the papal residence and administrative centre (after its liberty had been purchased by him from the kingdom of Naples), was the greatest patron. He was complex, and the tenor of the Italian-executed wall paintings in such private apartments in the papal palace as the Chambre du Cerf, celebrating the arts of hunting and depicting small semi-naked boys disporting themselves while bathing, was scarcely monastic: his arts were worthy both of ancient Roman garden painting and of the sort of pastoral decorations commissioned within a few years by Charles V in the Parisian residence of Hôtel Saint-Pol.[144] Clement, as they say, was no saint. Yet the severity of the new church at La Chaise-Dieu, declared exempt from episcopal control in 1342, begun in 1344 and

the choir enclosure next to a doorway leading into the choir itself, with pretty sub-cusping not unlike that of the doorheads recorded in the vestibule of St Stephen's Chapel at Westminster, the work of the Ramseys.[148] Bony was the first to note that the tomb's main arch has a distinctive row of pierced suspended and linked quatrefoils resembling the layout of the east window of the parish church at Mildenhall in Suffolk and also the circuit of linked trefoil forms in the east window of Prior Crauden's Chapel at Ely (see pls 192, 167) – geographically closely related works of the 1320s or 1330s also from the Ramsey circle: Mildenhall is near Lakenheath, an important Ely chapter manor which Crauden visited.[149] To this analogy might be added the row of fleurons studding the mouldings of the arch and gable, also English practice found on the tomb of John XXII. Bony did not note that the little quatrefoils contain pretty, low-relief carvings of musician angels, a subject much more common in stained glass than in tomb sculpture, occurring for instance in England in the glazing of the Lady Chapel at Ely. The east window at Mildenhall church, dedicated to the Virgin Mary, may have contained an *Assumption* or a standing *Virgin and Child*, and it is intrinsically likely that its circuit of quatrefoils was intended to contain angelic and possibly musical imagery, since the association of Mary with musical imagery was as common in England as anywhere.[150] The top rose of the east window of Tewkesbury Abbey, glazed in the 1330s, contains a *Coronation of the Virgin* ringed by roundels with musical angels.[151] Angel musicians occur in roundels on the interior soffits of the windows of the north transept of Westminster Abbey.[152] Better-informed French artists might have known that the thirteenth-century main west rose window of Reims Cathedral, devoted to the Assumption, has a circuit of musician angels in roundels.[153] It is nevertheless not wrong to see an English dimension to the tomb, participating as it does, Avignonese-fashion, in more than one tradition of funerary art. So it is gratifying to note that traces of wall painting on the soffit of the arch and at the top of the rear wall including two angels with a dove indicate a lost Marian subject, probably an *Annunciation*, on this part of the tomb. What is also clear, however, is that the hands employed in the actual carving of this tomb were not demonstrably English: it is a question here of design language rather than manufacture.

Evidence of this sort is indicative of a richer concept of influence only when it can be shown to belong to a pattern, and in this respect there is one other feature of the building of La Chaise-Dieu that again points to the Ely region, though it is not noted by Bony. This is the tracery of its

227 La Chaise-Dieu Abbey, cloister north walk, late fourteenth century

cloister, which consists of paired lights topped with quatrefoil soufflets, in other words curvilinear tracery (pl. 227). The dating of the cloister of La Chaise-Dieu, of which the northern and western walks alone survive, is not exact. Its vault bosses contain heraldry indicating that it was begun at the west end of the north walk under Abbot André Ayraud de Chanac (1377–1420), probably in the 1380s, but it was completed substantially later with only small variation of the principal mouldings of the arcading.[154] A date in the 1380s is not impossible for the design: a cloister was a necessity for a Benedictine community. The chronology matters in so far as the tracery openings of the existing walks presuppose knowledge of curvilinear tracery of a type first developed in the English eastern region. Though the proportions differ and the tracery is more thick-set, the composition is essentially the same as that of the earlier tracery

228 Ely Cathedral, gallery before north triforium of retrochoir, ?1370s

inserted at tribune level into the four easternmost bays of the presbytery of Ely Cathedral in the fourteenth century (pl. 228).[155] Its pattern, involving a large soufflet set over paired lights with subsidiary soufflets, was developed in all its essentials in the cloister (see pl. 68) and Ethelbert Gate at Norwich before 1320, and perhaps even earlier at court, since a prototype exists in the blind tracery of the upper stage of the Hardingstone Cross (see pl. 121). The work at Ely was part of the strategic rebalancing of the interior illumination of Bishop Northwold's presbytery and main shrine of St Etheldreda forced by the construction of the octagon, and the signs are that, though it was begun by the 1360s, these particular windows were not installed before the 1370s.[156] This Norwich–Ely form had already appeared in miniature in the two-light tracery of the openwork towers flanking the central spire of John XXII's tomb at

Avignon (see pl. 216); cusped soufflets are found in the window heads of the chapel erected in the Palais des Papes under Clement VI and consecrated before his death in 1352: the introduction of the constituent elements of curvilinear window tracery in France had certainly begun before 1350. But at La Chaise-Dieu the Ely composition is fully reproduced. Together with the south aisle tomb, this constitutes a pattern, and it bridges the gap between the commissioning of exceptional smaller-scale and highly worked objects in the Decorated Style by French patrons, and that sphere of 'influence' more properly speaking, in which English curvilinear design began to have a more widespread and perhaps less specialized pattern of occurrence. But that narrative, beginning fully around 1370 or 1380, is more properly that of Late Gothic.

What's in a Name? Iberia and the English

Among various fourteenth-century documents noted by Marcel Durliat is one dated 1303, specifying an arrangement between the bishop and chapter of Valencia Cathedral and a master mason, Nicolas de Antona, who was to lead, direct, make and construct the necessary works (*ad ducendum, dirigendum, faciendum et construendum*).[157] The terms show that he directed not only the building works but was also a sort of artist impresario in charge of the provision of such stained-glass windows, images and paintings as were necessary for the adornment of the cathedral. Nicolas belonged to a new breed of super-competent architects on the model of the professional aristocracy established in Paris in the previous century. Two other scholars, Sanpere and de Lasarte, give *Antona* as 'Southampton', but equally probably it was Antonne, near Périgueux, north-east of Bordeaux.[158] It must be said that if Nicolas was in fact English, his charge was untypical of the English experience charted so far in this chapter. His commission uses such strong words as *ducere* and *dirigere*, indicative of the provision of the principal *ordinatio* of a great church. The physical evidence of the nave of Valencia Cathedral begun in 1303 does not speak particularly eloquently of the working of an English mind. In all probability, given his name and responsibilities, Nicolas was French. A connection to England seems arbitrary.

What's in a name? Bony's writing is open to the charge that he tended to exclude human contingency from his formalist readings; John Harvey's, that he placed too much faith in names. Identity and thought are (fortunately) not the same: what matters is hard evidence of mental prepara-

229 Santes Creus Abbey, tombs of the kings of Aragon, that of Pere III El Gran (d. 1285) in the foreground, looking south-west

completed in 1341.[160] Jaime II of Aragon (d. 1327) contributed to the cost of the cloister works, and his arms together with those of his Angevin queen Blanche of Naples (d. 1310) are depicted on the cloister capitals. In many regards the tone and detailing of the cloister, especially its tracery and foliage forms, were derived from the two tombs in the church commemorating Jaime and Blanche (begun *circa* 1310) and Pere III El Gran (d. 1285, tomb begun 1291) (pl. 229).[161] Jaime clearly took the initiative; but given his date of death he cannot have been directly responsible for the last phase of the development of the cloister, its west walk, in some ways functionally the least essential part. The plan of the cloister complex at Santes Creus is like that of the nearby Cistercian monastery at Poblet, in which the refectory adjoins the south cloister walk and lavabo. By 1331 the north and east (chapter house) walks had been completed.[162] Their tracery, particularly that on the north side much restored in the 1950s, is of a spare geometric southern French Rayonnant type introduced on the tomb canopies of Pere III and Jaime II in the main church.[163] The east walk introduces soft heart-shaped motifs in the lights, but a stronger dynamic of evolution is apparent in the ogival tracery of the south walk to the west of the lavabo, and especially by the distinctive tracery of the west walk (pl. 230). This is mightily curvilinear, with mouchettes and soufflets. It is accompanied by carved capitals of great imaginative vivacity and, in comparison to the cloister generally, notably homogeneous type.

Curvilinear window tracery of this type had not so far made any impression in southern Iberia, and this leads to an important general point. With the exception of the cathedral of León, Iberia as a whole possessed no strong tradition of great church construction in the Rayonnant style, which might be thought at the time the one serious competitor for the bravura English manner of the period. Where Rayonnant effects did appear, they did not direct the overall *parti* of great churches but instead furnished motifs. This was certainly the case in Catalonia. The (almost wholly restored) tracery in the cloister at Vic (after 1323) and in the lofty cloister at Lleida Cathedral (pl. 231) has spectacular geometric compositions in many ways similar to the windows of the choir, transepts and nave of Exeter Cathedral (see pl. 12): the same note of *varietas* is struck in each window or opening by means of Rayonnant principles of form generation; this was picked up by smaller sculpted objects made in the region.[164] Santes Creus, while introducing Rayonnant motifs on its tombs and cloister, belongs within this pattern yet diverges from it, as if formal

tion and training. For instance, it is difficult, in the light of the surviving evidence, to know what to make of the presence at Huesca in 1338 of a master of the works called Guillermo Inglés.[159] Yet there is one case where the epithet *Anglicus* can be connected to work that actually looks English. It is provided by Santes Creus in Catalonia.

SANTES CREUS AND RAYNARD DE FONOYLL

The important Cistercian monastery and mausoleum of the kings of Aragon at Santes Creus in Catalonia possesses a vaulted cloister begun, according to one record, in 1313 and

230 Santes Creus Abbey, cloister, showing junction of west and north walks, 1320s–1330s

inventiveness were a matter of choice. This understanding of Rayonnant as a force for generating motifs legitimized what came next.

It is in explanation of the new, alternative, curvilinearity at Santes Creus that the name of Raynard de Fonoyll has been advanced. The history of Master Raynard was set out first by Puig i Cadafalch, who published a document in the archdiocesan archives of Tarragona dated early in 1331 that records a deposition by Raynard de Fonoyll the Englishman, mason (*Ego Raynardus dez Fonoyll Anglicus lapicida*), to the effect that he bound himself by oath on the Gospels and by homage to serve the works of the monastery, namely the cloister and the refectory (*ad facienda opera ipsius monasterii vestri scilicet claustri et refectorii*); and that for the dura-

231 Lleida Cathedral, cloister, second quarter of the fourteenth century

tion of this work he would use his own instruments and tools, and that he would undertake no other work without permission. In return, he expected no other masons to be admitted to these works without his prior consent, and sought to hold the position of *mandator* and *ordinator* in regard to all workmen under him. He also asked for board and lodging and provision for his two apprentices (*discipulis meis*).[165] In 1340 he was still working on the cloister and taking on new staff, though by 1341 the work was evidently complete and in 1342 he had become the vassal of a local lord, which may suggest a loosening of his ties with the monastery. By 1352 Master Raynard had moved on to other commissions, first at Montblanc near Poblet; by 1362 he was attempting to establish legitimate heirs; and finally he was master of the works at Tarragona Cathedral, retaining (but shedding) property held there with his wife Elicsendis in 1373, suggesting that he was probably not born before about 1300.[166]

The date of Raynard's commission, eighteen or so years after the start of the cloister, suggests that he was not principally responsible for the bulk of the work in the north and east walks but rather those parts of the south walk running along the (lost) refectory west of the lavabo, and the west walk. This is indicated both by the development of ogival tracery in the western section of the south walk and by the character and distribution of sculpture in the cloister. Together, these show that if Fonoyll had been working in the cloister before 1331, perhaps in some more junior capacity, his artistic identity emerged fully only in the latest work on the west and south-west sectors, of which he himself had presumably been given exclusive control in that year. The basic design of the cloister's piers and shafting is of local Rayonnant type. But the design of the west walk tracery is of a type found solely at this date in England, north-west of Norwich at Great Walsingham (east end and tower, pls 232, 233), Mileham, Beeston and a variant form at the slipper chapel at Houghton St Giles, all in Norfolk, and in part under Fitzalan patronage.[167] At Santes Creus there is some adjustment: the trio of soufflets over three ogee arches of each opening is varied by means of inverting the tracery of the bottom two soufflets to form that at the apex; and the tracery mouldings are more complex than their English models, and follow those throughout the cloister in turn based on the royal tombs in the church. So this is English design, local Rayonnant implementation. Windows composed on the basis of this vocabulary of mouchettes and soufflets were conceivable after the design of the east window of the Lady Chapel at St Augustine's at Bristol (see pl. 133), and one of the main elements of the Norfolk pattern is already found at the head of the tracery now in the east window of the bishop's palace chapel at Norwich (see pl. 74), probably by William or John Ramsey *circa* 1320.[168] Both Great Walsingham and Beeston (formerly) possess cusped round windows in the nave clerestory, also found at Cley in Norfolk and used again by the Ramseys for the Carnary Chapel crypt at Norwich (see pls 71, 195). Evidence that the windows at Great Walsingham were in place not much later than 1330 is provided by the superb though fragmentary stained glass in the top lights of the south aisle east window, which also argues for very substantial (court?) contacts for whoever worked on these designs. The English windows are thicker-set and are not interrupted by capitals as at Santes Creus, but the inference must be that whoever designed the Catalan examples was in some way familiar with related work in Norfolk. If this part of the cloister is in fact to be ascribed to Master Raynard, he himself may have made or obtained the necessary drawings before 1331, which places the development of the English models (quite plausibly) before 1330 – unless it

232 Great Walsingham (Norfolk), parish church, tower window

233 Great Walsingham (Norfolk), parish church, east window of north aisle, *circa* 1330

is assumed that he made subsequent visits to England or was in some way communicating with English artists after 1330. Alternatively, the west walk work represents the last phase of his employment on the cloister towards 1340, though it seems inherently probable that the last phases would concern not the tracery and carving but the vaults.

A tracery design is one thing – reticulated tracery has already been encountered at another royal tomb church, Roncesvalles, albeit of uncertain date – but a whole pattern of formal associations is needed to clinch the matter, and that pattern at Santes Creus is strengthened by the sculpture of the associated capitals of the cloister walks. Given the Cistercian context, a scheme less in tune with the mindset

of St Bernard in regard to the hazards of *curiositas* in the cloister is hard to imagine, for throughout are found bold and costly chimeras executed in a variety of hands depicting baleful winged masks, hybrids and antics of the most vivid sort. Santes Creus is a trenchant illustration of the point that the moralists did not speak for the majority. It completely outstrips the coolly decorous work at Norwich of the same era. Perhaps royal sponsorship had permitted a breach of decorum, since this tone is evident in the first work done in the cloister before 1327. The sculpture of the cloister has not yet been pondered systematically, but it points to the activity of several teams falling into two broad concentrations of work. The first is in the south-eastern

234 Santes Creus Abbey, cloister, east walk, figure of mason often identified as Raynard de Fonoll, but without authority

235 Santes Creus Abbey, cloister, west walk, capital sculptures, after 1331

sector, which includes figures carved (and in many places recut) in a coarse and rather plain style, with thickset and broad smooth detailing (pl. 234). This work has occasionally been compared, not entirely convincingly, to English sculpture of the type at Adderbury and Hanwell in Oxfordshire.[169] A slightly different language is spoken by the corresponding work in the west walk, the west end of the south walk, and the north walk. Here the qualitative level is generally higher, hybrids or japes are conceived with no less remarkable inventiveness, and technique and texture are brought to a high level of finish: the west walk is more homogenous in these regards than any other, and the idiomatic resemblance to English work of the period as close as to anything in the region between Toulouse, Avignon and Tarragona. The tracery and the carving hang together quite coherently, bringing to mind the passage in the deposition of Raynard de Fonoyll that other masters were to be excluded from his commission. The analogies – and they are no more exact than that – seem to be less with sculpture than with manuscript illumination made in the east Midlands or East Anglia such as the later and most distinctive work in the Luttrell Psalter (British Library MS Add. 42130) of the late 1330s or 1340s.[170] Some of the sculpted images have the same assertive scale and strange haunting power as those in the Luttrell Psalter. The taste for hybrid forms is a commonplace, but the attitude to mixture is especially similar: winged busts of bishops (pls 235 and see pl. 252); a liking for bat-like profiles, or actual bats and owls (pls 236–40); flares of folded drapery shooting straight out

from heads (see pl. 235); a marked taste for open-mouthed hooting or screeching animals or faces (pl. 240); the broad flat staring look with strongly delineated cheeks of many of the facial features in that manuscript's repertory; and wovern wyverns (see pls 254, 255). Hybrids like these were not by any means solely English in nature: work analogous to that in the cloister can be found on the corbels of the great audience chamber of Clement VI at Avignon, datable to the 1340s. The important point is that this extraordinary body of sculpture is not inconsistent with the notion of an English controlling hand presiding over a team of mixed origin, and with a date in the 1330s or so.

Taking the tracery and sculpture together, the simplest explanation for the situation at Santes Creus is the conventional one: it was conducted by a team, probably of mixed origin, under Raynard de Fonoyll between 1331 and 1341, members of which were English or who had drawings of English material to hand. Some of the artistic identities were formed in Lincolnshire and Norfolk, quite possibly no later than the 1320s. That Raynard was actually English – 'Raynard' is not a common English name – is unclear, and it is perhaps more probable that he had simply acquired the designation *Anglicus* as a result of experience in some prominent English workshop such as the Ramsey Company. Indeed, the surname Fonoyll was (and is) apparently common in the Tarragona region.[171] Still, though not as strong as the term *Anglus natione* used in the twelfth century of William the Englishman at Canterbury, the expression *Anglicus* cannot be circumvented easily, since it is an epithet

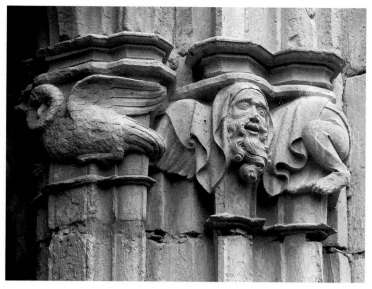

236 Santes Creus Abbey, cloister, south walk, bat

237 Santes Creus Abbey, cloister, north walk, owl and hybrid

238 Luttrell Psalter, *circa* 1340 (London, BL MS Add. 42130, fol. 164) (for the bat, compare pl. 236)

239 Luttrell Psalter, *circa* 1340 (London, BL MS Add. 42130, fol. 52) (for the bat's wing face at top, compare pl. 240, and for the owl in right margin, pl. 237)

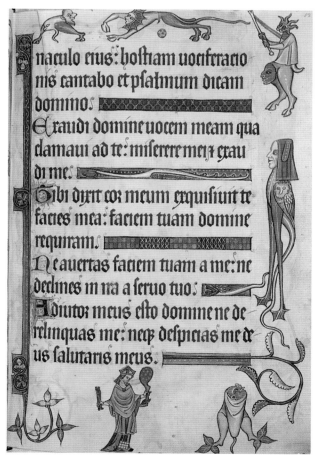

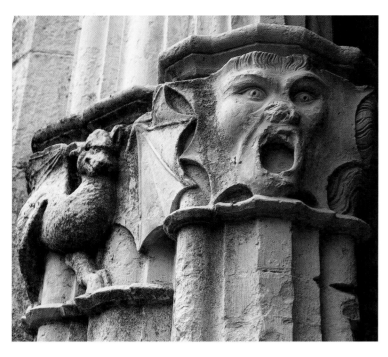

240 Santes Creus Abbey, cloister, west walk, howling face

that might hint at a professional, not ancestral, affiliation.[172] The possibility exists that he was actually French or Catalan in origin, partly English by experience.

Be that as it may, this account of the chronology of work in the cloister accords better with the evidence than the suggestion that the curvilinear tracery in question was the product of a campaign on the cloister tracery in 1503 conducted under a Burgundian master, Guillem Moret.[173] This tracery is not a French-derived Flamboyant type of the sort found in the work *circa* 1500 at Troyes Cathedral (here the Catalan term 'Flamíger' is unhelpful, in failing to distinguish between various forms of curvilinearity); account has to be taken of the need in all works for subsequent repairs, since it is intrinsically unlikely that a cloister made under royal sponsorship and declared complete in 1341 would be left without tracery until 1503; and the heraldry and fashions in the cloister sculptures are consistent solely with a four-teenth-century date. The sheer quantity and verve of the work indicate artists familiar with marginal work in England of a sort now most commonly preserved in manuscript illumination and woodcarving. Santes Creus may perhaps have been an early instance of high regard for English small-scale carving that evidently persisted later in Catalonia when one Pere ça Anglada executed the choir stalls of Barcelona Cathedral with misericords of the English two-branch supporter type; in this case a name and an idiom also appear to coincide.[174]

It might be objected that Fonoyll's curvilinear work at Santes Creus had no architectural afterlife in Catalonia. In suggesting that in fact it did, it is unnecessary to go so far as Josep Vives i Miret, who attributed to Fonoyll the same grandiose role in the paternity of Catalonian Gothic art as Harry Fett had to Matthew Paris in regard to the Gothic art of Norway.[175] Valuable evidence is provided by the inte-rior elevation of the chapel of Santa Maria de los Sastres, on the north side of Tarragona Cathedral, adjoining the cloister (pl. 241).[176] The chapel was completed by 1358–9, since it was then that its windows were glazed; it was being furnished in the 1360s.[177] The chapel is a vaulted apse with a traceried gallery consisting of ogee-headed and crocketed arcading with intervening buttresses; on one side above are blind tracery windows consisting of ogee-reticulated tracery of the type at Roncesvalles.[178] Pairs of sculpted figures of relevance to the chapel's dedication stand to either side of the vault shafts. At a date no later than the 1350s such detailing could most easily have been derived in this sort of combination from English – particularly eastern English – tomb, screen or architectural designs where such motifs were, by then, commonplaces. Fonoyll was not a master of the works at Tarragona until the 1360s, but it is at least possible that he had a role in the design of this building before emerging as head man a little later. Tarragona is testimony to the assimilation of such forms in Iberian great church design by the mid-fourteenth century.

241 Tarragona Cathedral, chapel of Santa Maria de los Sastres, interior, 1350s

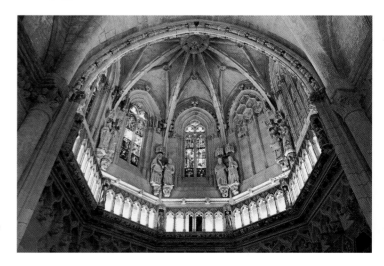

The work at Santes Creus is contemporary with that on the tomb of John XXII at Avignon and on the screen at Trondheim: yet it reveals ideas and skills originating not in the region of the Thames estuary but in East Anglia and the east Midlands. By the 1330s some sort of diaspora of ideas was under way to the point where the earliest Continental curvilinear tracery of this type – earlier in all probability than that of uncertain date at Roncesvalles, but belonging to the same southern English 'species' (the east end of Beeston church in Norfolk alone possesses windows with all the forms noted at these sites) – had appeared near the Mediterranean before it was to emerge in central and northern France. Such things are not the outcomes of processes but of specific, if obscure human negotiations of the sort explicable especially by court cultures. That English curvilinear designs continued to circulate in the region to the north of Tarragona towards 1400 is shown by the royal apartments of Poblet near Santes Creus, which possess windows with intersecting ogees and mouchettes (pl. 242) of a type developed especially in Lincolnshire and Yorkshire (Heckington, Sleaford, Selby, Beverley) two generations earlier (see pls 248, 140).[179] At no point were vaulting systems especially influenced by England. Lierne vaults appear, as has been noted, in the presbytery of Toledo Cathedral completed in the late thirteenth century – one of the earliest places to hold and identify *Opus anglicanum* – and such vaults, of a type used in the Ethelbert gatehouse at Norwich, at Pershore and Westminster, can be found throughout the late Middle Ages in Aragon (Jaca Cathedral, nave aisles), whence they probably spread to Mexico (the Franciscan church at Huejotzingo) by the sixteenth century.[180] The final stage of this diaspora in Europe – so to speak its 'Atlantic' phase – is represented by the extraordinary work at the abbey of Batalha in Portugal founded in the 1380s, in so far as that work can be separated from later restoration.[181] But that there was a sustained interest in motifs and motif combinations of tracery especially in the Tarragona area until 1400 or later seems clear. To demonstrate this the name of *Raynardus dez Fonoyll Anglicus lapicida* would not strictly be needed, but it helps.

Transformation?

Jean Bony's concluding belief that the Decorated Style was a 'revitalizing' moment that 'acted most decisively on the shaping of the movements of stylistic renewal in fourteenth-century Europe', and which eventually superseded the Ray-

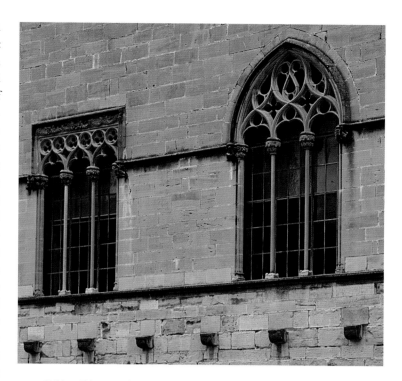

242 Poblet Abbey, royal apartments, late fourteenth century

onnant, is not entirely borne out by the evidence considered in this chapter.[182] What seems to be witnessed before 1350 or so is a series of short-lived episodes, in effect sudden eruptions of English idiom and workmanship, most of which may be explicable by particular circumstances, none of which had the direction or momentum of a 'movement', and few, if any, of which had any longer-term consequences. Bony's image of a 'scattering of English-inspired novelties' up to around 1350 seems more judicious.[183] The distribution of those works undoubtedly produced either by English hands or, more usually, under some form of English influence is notable. It is more apparent, if hardly dense, in those areas that preserve *Opus anglicanum* embroideries – western and southern France and Iberia rather than northern France, Germany and central Europe. This could have been coincidental, and certainly does not provide hard evidence of some underlying connection between the art forms. But the geographical leaning is nevertheless sufficiently striking to warrant remark: it suggests, very generally, that English political and commercial interests in north-west and western France, court connections in Iberia, and long-standing Mediterranean ties, had slowly reoriented English cultural influence away from its earlier Germanic and Scandinavian spheres of activity.

273

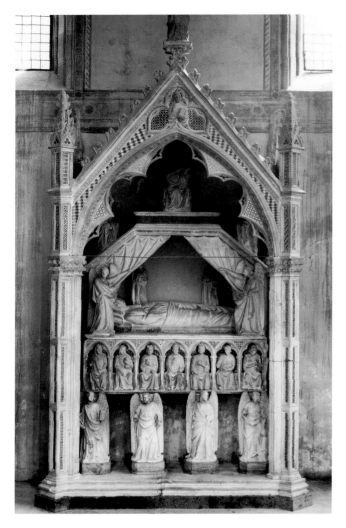

243 Naples, Santa Maria Donna Regina, tomb of Mary of Hungary (d. 1323)

What the pattern traced in this chapter does indicate very strongly is, first, that English idioms crop up in places where there was not already a strong and independent tradition of Rayonnant design. Second is the role that new court centres, with their tastes for high-value luxury goods, played in the propagation of ideas. Apart from Trondheim, a church with long-standing English contacts in this period, the most vivid instances of English idiom are almost all at courts or in centres that played a role in court culture, such as Pamplona, Avignon and Santes Creus; the sharing of personnel between Pamplona and Avignon underlies the importance of networks of this type. To underline this point the Angevin court at Naples might be added. The canopied tomb provided in 1325 by the Sienese sculptor Tino da Camaino for Mary of Hungary, the widow of Charles II d'Anjou, at the nunnery of Santa Maria Donna Regina in Naples, which she rebuilt (pl. 243), is one of the few Italian monuments whose detailing can be explained by knowledge of English models. Its cusped and sub-cusped main arch with an ogival trefoil pressed into the gable implies more or less direct knowledge of the tomb of Edmund Crouchback at Westminster and more especially its derivative, the tomb of Bishop William of Louth at Ely (d. 1298) (pl. 244), since the latter explains the use of the lower cusp of the main gable trefoil to form a support for a figure within the trefoil.[184] A slightly later instance of a type of English detailing in which a gabled trefoil arch is richly adorned with undulating foliage surfaces is provided by the drawings for a *tramezzo* and associated tabernacle in Santa Croce in Florence dated to the mid-1330s.[185] The court model is also reinforced by the discovery of Yorkshire-style curvilinear tracery in the south cloister walk of Bellapais Abbey in northern Cyprus – surely its most far-flung known occurrence to date: this was probably erected by the Lusignan Hugh IV (1324–59).[186]

The Naples and Bellapais instances are courtly, but are no more evidence for an argument about English 'influence' in the Italian domain as a whole than is the Westminster Abbey Cosmati pavement for a generalized Italian 'influence' in England: the point is the specific and contingent character of the occurrences. Arguments for English influence in the earliest paintings by the so-called Northern master working in the late 1270s in the right transept of the upper church of San Francesco at Assisi again overlook the debt owed by this unusual and probably site-specific team of artists to the Rayonnant of the upper Rhineland.[187] Finally, Prague itself was a new court centre and attracted artists from Avignon and Italy. A direct link was established

The theory of English stimulus to Late Gothic art is, in its way, another theory of origination, the difficulties of which are not unlike those arising in tracing the origin of motifs such as ogee arches. Within the Focillon-Bony model of style lies an expectation, perhaps only part conscious, that art systems require some sort of creative re-fertilization, a sort of genetic boosting, by exterior forces: in the case of late medieval art, for 'orient', read 'English', a kind of 'Other' within the Gothic system. To think eugenically in this way is to make an assumption about the fertility or otherwise of the recipient system, as well as the power of the donor. And it is also to assume that origins in some way necessarily colour subsequent signification. This may sometimes be the case, but as has been seen it is not always so.

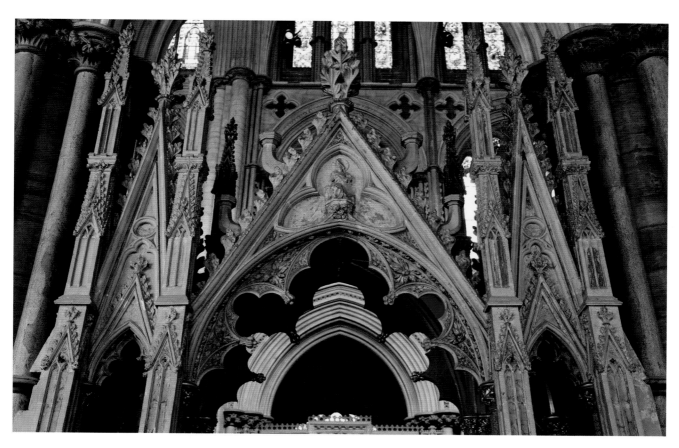

244　Ely Cathedral, tomb of Bishop William of Louth (d. 1298), detail looking north

when the Emperor Charles IV drew the Narbonne-trained architect Matthew of Arras away from the curia at Avignon in 1344: had Matthew developed an 'English' orientation as a result of seeing work such as the tomb of John XXII at Avignon, an orientation that anticipated Peter Parler's dazzling powers of assimilation of English West Country and court work in St Vitus's Cathedral?[188] Yet even in Prague (see pl. 193), the quite specific sense of English workmanship, that 'touch' that lies within the actual handiwork provided by many of these courtly examples, is almost entirely lost in a transformative act of interpretation of vaulting and elevation design of which only great minds are capable. Prague is an exceptional instance of a brilliant architect, Peter Parler, consciously turning to specific English centres for astonishing solutions. It is not a demonstration of a wider truth about the fortunes of the Decorated Style in central Europe, and a proper balance remains to be struck between the evidence for undoubted English influence there and in Germany, and the role of Continental Rayonnant as a continuing creative force. The real narrative of

English influence in central or eastern European vault design (notably Poland) begins later than the period covered by this book, with responses to the choir vault at Ely and the nave vault of Canterbury.[189]

In any event, there are grounds for suspecting the inaccuracy or at least weakness of any general internationalist model of European-wide stylistic development of the sort proposed by Bony that does not also take account of the underlying structures of patronage, cross-media development and the inventive capacities of Rayonnant. There is only one clear instance of an architect, Raynard de Fonoyll, working in an English style who was given overall control of a substantial building project – even then a partly complete cloister and not a great church: his later emergence as master mason at Tarragona seems also to be exceptional. It might be replied to this that, after William of Sens at Canterbury in 1179, no continental European architect was ceded corresponding control of an important English building project, though an architect of French origin called John Morow (Jean Moreau?) contributed significantly to

the building of the Cistercian abbey of Melrose in Scotland some time after 1395, in effect reintroducing curvilinear tracery to the British Isles, but (from a Scottish perspective) in its more politically acceptable French rather than English form.[190] The problem more generally with internationalist hypotheses is that they underestimate the impermeable, and so inherently conservative or resistant, character of national and regional barriers and enduring local sensibilities, which only substantial patronage, unexpected gifts or works of genius can overcome. The English were evidently deemed to be exceptionally good at versatile, smaller-scale, cunningly wrought and jocular work of a set-piece sort, their patterning of windows, vaults and other surfaces being a particular expression of that most important medieval value, pleasurable variety. The perception of their art was evidently that it was both courtly and satisfyingly ludic. That they were capable of heroic engineering, particularly in wood, has been already established at Ely: but the fate of that capacity in European eyes was much less certain.

And it remains to be shown that the types of opportunity for English work traced in this itinerary applied within the royal heartlands of French Gothic. The signs are that on the whole they did not, and this reveals something important about the resistance of regional or national practice. While English illuminators are known in Paris from the late thirteenth century, there appears to be only one significant instance of an English *imagier* documented in the tax and other records of Paris between the 1290s and about 1330. This was Guillaume de Nourriche, who is eventually found working with Robert de Lannoy and an evidently English colleague, Gautier L'Engles, on sculptures for the Parisian hospital of St Jacques-aux-Pèlerins.[191] Guillaume is not recorded after 1329–30, and in reflecting on his name and origin it is worth pondering the common occurrence of the name William in the Ramsey clan of architects, also of Norwich: was he an expatriated member of this family? But efforts to attribute extant works from this project only emphasize the central problem of a name: that unless it can be linked to a particularity of idiom, it proves nothing at all.

More generally, given the size of the skilled workforce still in demand in England throughout this period, it is remarkable to find Englishmen, or at the very least their ideas, abroad in such numbers. On the whole the evidence points to the movement of design, less so of large numbers of skilled workmen, since the 'touch' of English hands is not always apparent in works that are, intellectually speaking, English. In so far as it happened, did the movement of

English masons follow the dispersal by gift of art forms such as *Opus anglicanum*, or arise from the power of attraction of new court centres relatively free of mainstream French influence? Or was demand in England for this type of work slowly starting to flatten for economic reasons, causing a progressive labour surplus? How many skilled men were driven further afield by famine and disaster in England before 1320; and how many simply opted to settle abroad in warmer climes? Only further work on specific human agency, rather than superhuman artistic forces, will tell.

That, finally, leaves mainstream France, the home of the supposedly doctrinaire Rayonnant, and a concluding point that, strictly speaking, falls outside the chronological limits of the present study, but which acts as a kind of sequel to it. This is the development in central and northern France in the late fourteenth century of curvilinear flowing tracery within the Rayonnant system of wall articulation. The importance of English flowing tracery developed in the English eastern regions with great rapidity around 1310–30, and first emphasized by Camille Enlart, was acknowledged by Bony, even if it plays a disproportionately small role in his book.[192] Because the formal history of the development of ogival tracery in England at this time is well understood, earlier in this study I shifted attention to the affective and wondrous dimension of the largest windows of the period, particularly those in Yorkshire and Lincolnshire (see pls 139–40, 247, 248), where the format of great church building with tall flat east ends particularly encouraged such extraordinary displays of flowing tracery. The later history of Flamboyant design in France is, in part, the history of the completion of large flat terminal walls of transepts and west façades left stranded as projects were hindered by the downturn in great church building at the height of the Rayonnant era but revived as the French regional economies grew again towards 1500.[193] I suggested that Gothic vaults and windows were inherent objects of astonishment for the French and English alike, since it was here that the role of *varietas* in provoking admiration can particularly be followed.

The adoption from around 1370 in certain crucial circles in France of English-style flowing tracery seems to confirm that window design remained a constant focus of innovation within Rayonnant itself. One instance at the head of this development has already been noted: the possibility that the cloister tracery of La Chaise-Dieu, another curial mausoleum, revealed knowledge of an English model known either directly or mediated via curial architecture at Avignon. By then – assuming the fourteenth-century date of the curvilinear work in the cloister at Santes Creus, at

Roncesvalles and Tarragona to be correct – English-style reticulated tracery was already known, albeit rarely, in Navarre and Catalonia. Thereafter, the process is consistent with the pattern just noted of specific but not obviously consequential occurrences of English influence within particular networks, though the network was getting tighter in a way that points to the formation of a new idiom.[194] In Normandy, by the end of the century the west façade of Rouen appears to have been planned on the model of such English screen façades as Wells, but with curvilinear tracery.[195] The curial circle of Avignon is represented by the chapels established by Cardinal Jean de Lagrange (d. 1402) on the north side of the nave of Amiens Cathedral, of which he was bishop from 1373: Lagrange had tombs both at Amiens and Avignon.[196]

The other network seems to have focused on the patronage of Jean, duc de Berry (1340–1416). In the second half of the 1380s Jean, who had been a hostage in England in the 1360s, commissioned an astonishing fireplace in the great hall of his palace in Poitiers (pl. 245), whose back-lit gallery displays three gabled window-like openings with curvilinear tracery furnished with a trio of large soft traceried mouchettes of a type found earlier in the English Midlands (south aisle of Barkby, Leics.).[197] The fireplace – which needs to be imagined in the rather serious company of the work of the Roman fresco painters employed in this palace by Philippe IV earlier in the century – is an instance of the courtly ludic later developed in the interiors of the house of Jacques Coeur in Bourges. But the shift to the sacral arts was swift. When, in the mid-1390s, Jean's masons introduced ogival tracery into the windows of his pretty chapel at Riom near Clermont (pl. 246), the promise of La Chaise-Dieu nearby was fulfilled: at Riom the window forms derive from eastern English flowing tracery, specifically of the sort in the clearstory-level windows of the west façade towers of York Minster, before 1339 (pl. 247).[198] The chapel also has a ridge-rib vault. By no later than 1380–90, the manifestly English innovation of flowing tracery had penetrated beneath the skin of Rayonnant, but in the sort of context that, as in England in the late thirteenth century, demonstrated the incomparable advantage to a style of being adopted within the innermost circles of power. In the next century the coupling of paired ogee lights with soufflets of a type developed in fairly modest English parish churches by 1330 became an extremely common, supra-regional, feature of French window tracery, to say nothing of ogee reticulation. In the fifteenth-century cloister of the *priorale* at Souvigny there is even a variant of the crazy vault at

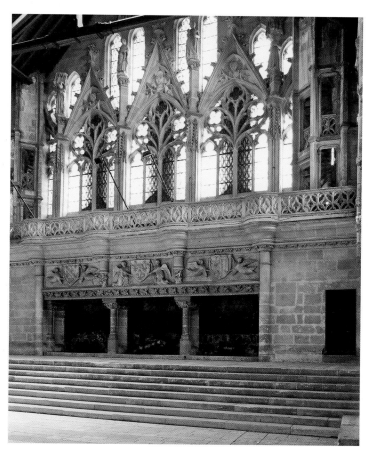

245 Poitiers, palace of Jean, duc de Berry, great hall, fireplace, 1380s

Lincoln. Ideas long since set aside in England were revived and infused with fresh blood.

Earlier I discussed the discourse of rationality and its rise, which has governed approaches to French Rayonnant and its derivatives by scholars of a modernist mindset; and I have already tried to indicate why this formulation is both powerful and misleading. It captures something of the intellectualist dimension that was claimed for (and probably by) architects in the Paris region from the mid-thirteenth century, and it recognizes the most obvious truth about Rayonnant, that its European-wide success derived from its systematic character. But a price has been paid by the furtherance of this model: it has tended to overemphasize the 'logic' and ultimately stiffening of the French approach and, *pari passu*, to underestimate the aesthetic logic of the English approach, of which I think its evident powers of stylistic ambiguation were an aspect.[199] One outcome of this has been a difficulty in formulating any corresponding concept of an independent French Decorated Style in the face of

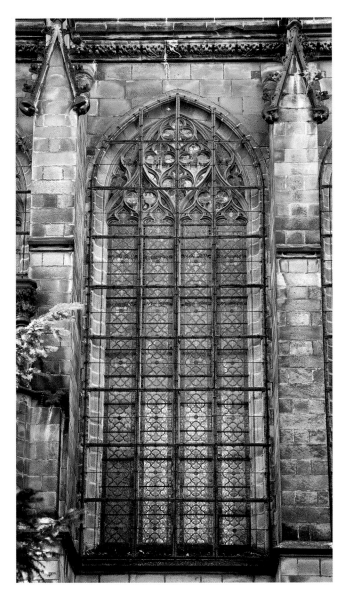

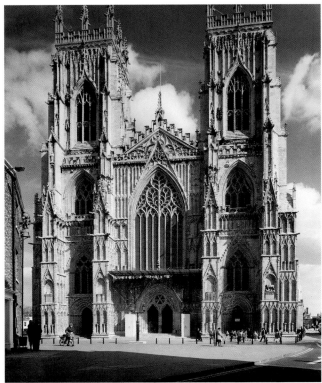

246 *(left)* Riom, Sainte-Chapelle, south side window, 1390s (compare pl. 247, tracery of second tier of tower windows)

247 *(above)* York Minster, west front, fourteenth century; towers fifteenth century

the really quite extensive evidence that by the middle of the fourteenth century French designers were using ogee arches with generous crocket foliage, sub-cusping, elementary curvilinear tracery and strong contrasts of effect, central features of current English idiom differing only in specifics of line and form. Aesthetically, for instance, little separates the splendid double-layered sub-cusped tracery of the slype doorway of the cloister at Norwich, datable before 1325 (see pl. 61), and the (slightly later) raised central section of the painted wooden high-altar retable in the Burgundian priory church of St Thibault-en-Auxois.[200] The latter work points to the possibility that, in both cases, forms such as double-layered cusps had common points of origin in carefully carved, layered and pinned carpentry structures. 'Influence' cannot always be assumed.

But there is another important outcome, namely the habitual use of a metaphor, that of centre and margin, or centre and periphery, pursued by mid-twentieth-century art historians to trace the forces of creativity of the time. Erwin Panofsky was speaking with characteristic bravura when he observed at the start of *Gothic Architecture and Scholasticism* that in the period after the reign of St Louis (d. 1270) there was a 'gradual decomposition of the existing system' in which

Both in intellectual and in artistic life . . . we can observe a growing trend towards decentralization. The creative impulses tended to shift from what had been the center to what had been the periphery: to south France, to Italy, to the Germanic countries, and to England, which, in the 13th century had shown a tendency toward splendid isolation.[201]

278

In the light of this, Bony's step in claiming that the transferral of leadership from northern France to England just at the point when its new Rayonnant enjoyed 'unquestioned artistic supremacy over the whole of western Christendom' was a small one academically.[202] But it had already started to ingrain a kind of bipolarity in discussions of the dynamics of invention and meaning that took on real force by the end of the twentieth century as that polarity itself was much more obviously and deliberately politicized. And with that spatial metaphor in mind, it is time to move to the margins themselves, those 'other' spaces within, rather than outside, the boundary of a culture. In my next chapter, I consider the field of representation and suggest that 'centres' are in fact much more open to mixture and complexity than the centre–margin polarity has, so far, allowed.

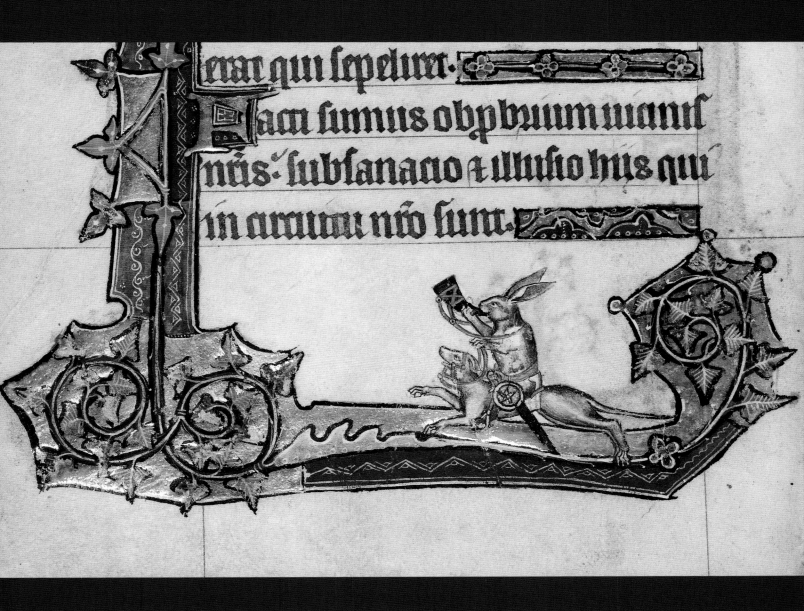

PART III

ARTIFICE, AUTHORITY AND FIGURATION

Macclesfield Psalter, rabbit outrider sounds horn (detail of pl. 263)

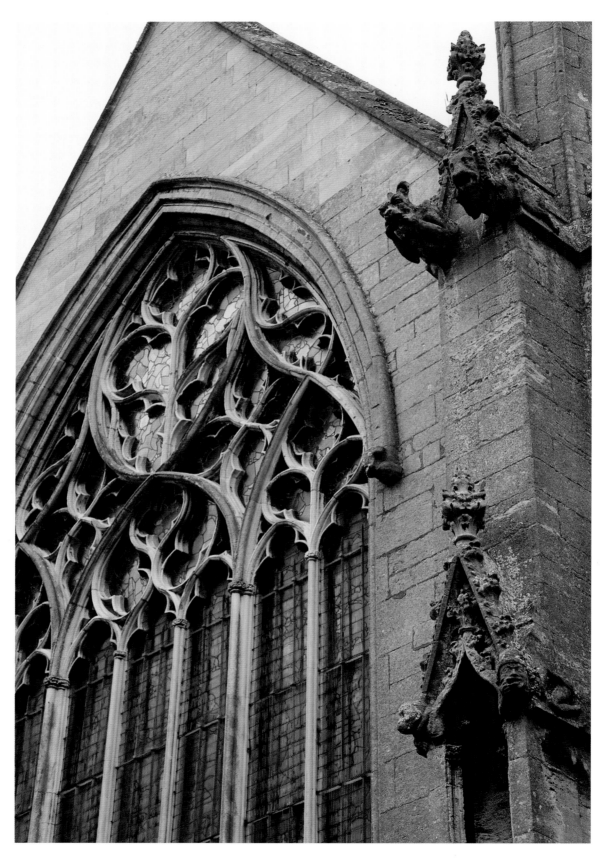

248 Heckington (Lincs.), parish church, east window and gargoyles, 1330s

8

THE PLEASURES OF UNRULING

I always say that my west window has all the exuberance of Chaucer without,
happily, any of the concomitant crudities of his period

Reverend Lord Henry D'Ascoyne, in *Kind Hearts and Coronets* (1949)

Concomitant Crudities

In these pages I have tried to show how the critical appraisal of Gothic art has been informed by ideas that have generated a pervasive language of metaphor with little or no actual basis in medieval discourse. One metaphor, that of modernism, I have already discussed. The second is that of the marginal. This has enjoyed extraordinary critical attention in the last few decades, but it had already started to steer ideas about the course of invention in Gothic architecture rather earlier. In the case of the 'shift to the periphery' argument exemplified by Panofsky and Bony, among others, the thinking was geo-cultural (it is a theory about French hegemony), whereas the notion of marginality that is now more familiar is fully socio-political. Both versions, however, share the core idea that the centre of this metaphorical space of activity is either prone to becoming creatively exhausted or is actually in itself essentially 'dead', numbed by its own authority. The most forceful repertories of invention arrive on and belong to the margins; and it is from there that the centre seeks refreshment and reinvigoration, even perhaps a sense of itself. Set out like this, such ideas seem overly categorical, stark and unrealistic: and it is

an important objection to such reasoning that it is, in fact, too dualistic in its tendencies, an insight that will already be apparent both to rhetoricians and certain post-structuralists. To volunteer a critique of the notion of marginality in the field of representation, in the borders of the Gothic illuminated manuscript as much as on the peripheries of buildings (pl. 248), is not to suggest that one should abandon the study of what may be called the margins, or cease to get pleasure from them, or to see that they could serve an end. For one thing, pleasure needs putting back. It is rather to use the phenomenon of the marginal to open out a debate about our own historical and critical thinking about the larger domain of the aesthetic, not least given Laura Kendrick's observation that 'For the current generation of art historians, restoring significance to the marginal is a symbolic act'.[1]

It is probably fair to say that all medievalists know that of late this topic has been powerfully influenced by the theories of scholasticism – by which I mean the writings of such modern scholastics as Foucault, Derrida and Baudrillard. The critical strategy has been to posit binary oppositions between, say, high and low, or centre and periphery, and then read or deconstruct those oppositions in socio-

cultural, psychoanalytical or post-structuralist terms. The ideas did not appear first in the study of medieval art. Consider Bronislaw Geremek's *The Margins of Society in Late Medieval Paris* (1987, first published in Polish in 1971) or, following Bakhtin, the use of high and low culture in Peter Stallybrass's and Allon White's carnivalesque *The Politics and Poetics of Transgression* (1986).[2] The latter uses a Freudian model, in which the low or marginal returns to haunt the individual consciousness: the 'most powerful symbolic repertoires' are found 'at borders, margins and edges, rather than at the accepted centre of the social body'.[3] The edges are, to be sure, in constant dialogue with the centre, which, presumably, is not the site of the most powerful symbolic repertoires; somehow the edges are more 'real'. In his study *Image on the Edge* (1992), Michael Camille transplanted these themes into the almost ideal territory of what he called 'genitalia in marginalia'. He identified a 'myopic dead centre', in resistance to which, but in collusion with which, the marginal formed itself, an art that flourished 'by virtue of the absolute hegemony of the system it sought to subvert'.[4] Camille, echoing such writers as Stallybrass and White and particularly the Derridean concept of the *supplement*, argued that the centre was itself dependent upon the margins for its 'continued existence'.[5] The illuminated page was the scenario not for pleasure, but for collusive power play, for the hermeneutics of suspicion. Medieval marginal art also possessed a certain playful freedom, operating as a free play of signs without the prosaic constraint of the market. A great strength of this insight is that it recognized the ludic basis of medieval invention, serious or otherwise – a view shared by the present writer and amplified in this book.[6]

Here, I will emphasize particularly the areas of mediation, of ambiguity, that the illuminated page provided, which are often occluded by those emphasizing a transgressive, dualistic and conflictual cultural politics. The best recent critiques of marginality such as Camille's have understood mixture and ambiguation, yet have persisted in setting against them a binary socio-cultural and usually class-based critique, thus, to my mind, straining the back of their own theory. In questioning the empirical strength of this model I am myself cautioning against binary thinking in Derridian fashion – but in a way based on antecedent ideas evident in Aristotle and rhetorical thinking, rather than postmodernism.

At this point any critique of the marginal faces a significant absence. The recognition that medieval marginal imagery is a sitting duck for deconstruction has gained ground because the concept of such imagery itself is absent from medieval discourse. A simple initial question to ask about any cultural phenomenon is what contemporaries themselves said about it. Considering the enormous quantities of what is now called 'marginal' imagery produced by artists in all media, the extent of medieval commentary on it is, in fact, virtually nil, and such as there is tends to be early and reveals quite specific agendas.[7] As a coinage, the 'marginal' in ordinary speech belongs to the early modern period, though Chaucer refers once to the 'margyn' of a page in his work on the astrolabe: 'border' seems to be more usual at this time.[8] In the crucial period 1250–1350 in northern Europe, no sustained or unambiguous commentary on manuscript marginalia has been identified, least of all in those countries or regions, England, northern France and Flanders especially, where its occurrence is prodigious.[9] This separates it clearly from fashions in dress which did attract negative comment (see Chapter Nine), and one must ask why this should be so. A well-known passage by Odofredus of Bologna (d. 1265) mentions the extravagance of a student who could have gone either to Bologna or Paris but who, having gained an allowance from his father, opted for Paris and blew it all on manuscripts that 'chattered' with gold letters (*fecit libros suos babuinare de literis aureis*). This is a comment less (if at all) on marginality than on the misuse of wealth, and belongs to ordinary Christian-moral discourse about money and pride.[10] Having (presumably canon law) textbooks that babble is an idle waste of money, empty eloquence in comparison with the virtues of true study, sobriety and learning. *Babuinare* derives from the late Latin word *babulus*, a babbler or fool: from it extend such words as baboon or *babuin*, Chaucer's *babewynne* (as in *The House of Fame*, p. 346) meaning a muzzle, gob, face or mask (pl. 249). The preacher John Bromyard makes use of 'baboonery' when he contrasts stones with grinning heads, which vainly appear to support a building, with modest plain stones hidden away elsewhere that do the real work; the Dominican Robert Holcot did similar work in his sermons, and it is the 'sermonal' approach to such topics that has come to prevail.[11] But in comparison even with such thin and ambivalent writing as survives on architecture, the fact is that what are now designated as marginalia were almost wholly bypassed by contemporary commentary. There is no prima facie evidence to think that they represented either a virtue or a problem. In fact, there is little evidence for thinking that marginalia in our sense – as a genre defined by a socio-spatial metaphor – were deemed to have existed at all. The modern redeployment of the marginal as a metaphor of yet larger, deeper power relations is an instance of

249 Norwich Cathedral, cloister east walk, damaged baboon

'persuasive definition', in which a term is subtly redefined in order to serve a new purpose, but not necessarily with the aid of verifiable evidence.

In the hands of modern critics, nevertheless, moral interpretations and imperatives (the elision of the two is often unremarked) have been pushed forward as if they provided natural functional or justificatory rationales for marginal imagery. This is not to say that moral readings themselves are categorically wrong. In some cases, as with the display of carved topics on the exterior of fourteenth-century parish churches such as that at Heckington (Lincs.) (see pl. 248), they seem apt, and work since they are sometimes (though rarely) underwritten by inscriptions that stabilize their meaning, such as the head of 'Richard in the corner' (*Ricardus in angulo*) punitively stuck on a buttress at Frampton near Boston for foreswearing Christ, now forever waiting for Godot.[12] But care should be taken in assuming that such things always served pastoral ends: if moralists are sought out, it should not be surprising to find moralization, and behind every such reading lies the thinking of a latter-

day Henry D'Ascoyne as cited in my mischievous opening epitaph. The usual reading of St Bernard's *Apologia* as a normative text of universal relevance on the morality of images is the central sign of this approach. Bernard is not concerned with marginality but with the curious. It is with his writing that Lilian Randall began her celebrated and still very useful survey of marginal imagery, while Karl Wentersdorf's study of scatalogy in marginalia proceeds from the assumption that 'it is difficult to believe that the scatological figures were introduced *primarily* as comical and thus diverting elements'.[13] To proceed on the basis of such undemonstrable assumptions is immediately to remove such images from the sphere of the aesthetic (i.e., geared to producing a certain experience or sensation), and is instead to conscript them automatically to moral or political commentary. But it has rightly been pointed out that, even in Bernard, there is little or no evidence that 'precept-based moral pedagogy' was the principal purpose of what is now classified as 'marginal' imagery.[14] As John Gage showed, Bernard's language of ridicule, directed at an excess of *varietas*, echoes the opening of Horace's *Ars poetica* where the concerns are rhetorical and aesthetic.[15]

I have already noted that the aesthetic is held in some way to obscure the political or moral 'objectives' of medieval image making. In particular, it supposedly blocks the modern search for political or social allegory. The objections to this have already been stated: to reiterate a point made by Peggy Knapp in her study of Chaucer, 'where art is experienced purely ideologically, it fails to be fully experienced even ideologically'.[16] This issue is not beyond, but within, the domain of the aesthetic. And let me be clear on another point: to interrogate the current language of medieval marginality is not, as some might think, to silence that which is now deemed 'marginalized'. On the contrary: it is to suggest that actual harm is done to any social or political investigation if it is imagined that things intended for elites in fact spoke with non-elite voices.

Because the marginal exposes quite basic issues of method and ideology in the study of medieval art, it is justifiable to consider it further. Here, my critique will be developed in three stages. The first will challenge the assumption that it is right to privilege the margins as the principal site of the inventively polymorphous and the richly symbolic. All the lines of argument and evidence in the present book have converged on the contrary idea that mixture, variety and complexity were amongst the objectives of medieval visual art generally. The cleansing or neutering of the 'centre' as a site of invention or depth is, I suggest, a necessary if sub-

liminal precondition for the assertion of the powers of the marginal, but is founded upon a misconception, indeed under-estimation, of the role of complexity in the experience of delight, both then and now. In other words, what was true of the margins was necessarily true of the centre and, as I observed earlier in these pages, I favour an impure or mixed centre combining with the serious and delightful on the edge. In a sense, both components shared the common elements of a single, not a dual, system. Cicero described this very precisely in *De oratore* (II.262) when he said that though serious and humorous subject matters may differ, they share a single rationale, *unam rationem*.[17] Each participated in what has been called 'imaginative luxuriance'.[18]

What, then, of the idea that the polysemous margin is structurally predisposed to engage in subversion? The second stage or argument will examine the claim that the centre and the margin are not reflective of social and political reality, but constitutive of it, and are thus engaged in the manufacture of ideology. The method is to try to distance the critic from overly literal 'social' readings of medieval marginal images, while simultaneously deploying the 'reality effect' of precisely such readings in a strategy to justify ideological insight. What I will call the 'Merry England' realist reading of marginalia is one in which social insight is held necessarily to have a claim on our moral attention. In the path of this, it seems to me, lies one substantial obstacle. It is that a very large percentage of all medieval marginal imagery is actually, and deliberately, nonsense. In possessing sense, but not reference, and in so lying outside the domain of the common sense or referential, it is necessarily beyond the domain of the moral in any practical sense of the term. Its sense is rhetorical or artificial, and therein lies the experience of pleasure. But modern moral allegory prefers to deny the sphere of the aesthetic and so the pleasurable. In reply to this it will be necessary to consider the manuscript page, the main forum of debate, as a single stage of invention.

In doing so, a third general problem is encountered. It is that the modern reading of the marginal as a form of moral or political allegory is invested in a cultural politics necessarily suspicious of, or even downright hostile to, the high cultural centre that it itself seeks to subvert. The margin is held to be a space of subversive utopian sign play in which oral, vernacular or folk tradition play a large role. It is characteristic of this line of reasoning that it takes no serious historical view of how, where and when the manuscript margin in particular morphed into the arrangements seen so commonly in the period 1250–1350. Nor does it (because

it cannot) take such a view of oral, vernacular or folk tradition. It is, in short, hard on judgement, soft on origins. But there is a counter-argument that precisely looks at origins and which necessarily sets aside the idea that marginal art is essentially the sole domain of 'low' culture. It is that the culture of marginalia originated in, and shared many quite well-documented features of, high clerical and Latinate culture, as it expressed itself (I shall suggest) in the small-group humour of literate young men. This suggestion may be shocking to those accustomed to only one style of cultural critique. But it is the reading that is, to me at least, the most consistent with the evidence.

Unsullied Centres, 'Merrie England' and Nonsense

The first issue, that of the pluralistic margin confronting and subverting the hegemonic 'dead' centre, can be tackled swiftly. In discussing artistic agency earlier, in Chapter Two, I suggested that these accounts are shaped by a form of default Neoplatonism encouraged in the modern era by the sorts of text that major commentators of the period – Panofsky, Gilson, De Bruyne and von Simson – placed in the scholarly forum for attention.[19] In so theologizing art making, the role of sensory pleasure, of the fleshily persuasive, was discouraged: because the aesthetic was held to anaesthetize, medieval art could be drawn into something that looks very much like a regime of disinterested and lofty contemplation. In the first part of this book I drew attention to a quite contrary, and I think equally representative and long-standing, tradition of variety, mixture and magnificence in medieval aesthetics absolutely at the centre of that which was most valued by the people who made art. It is from this basis – that medieval aesthetics are pluralistic, profoundly sensory and central to understanding how art worked at all – that the present writer was able to interrogate and reject unitary (I think actually modernist) concepts such as that of a 'Court Style'. It was the intellectualized, modernist aesthetics of the mid-twentieth century – and not just the counterculturalism of the 1960s – that produced that apparently postmodern phenomenon of the last thirty years or so, the thrillingly dirty subversive margin and the cleansed lofty 'dead' centre. In order that high culture and the centre should be subverted or actually toppled, the nature and extent of their power had first to be established. To them had to be credited a pure, unsullied absence of all the things attributed to the margins or 'low culture': humour, sensuality, pleasure, satire, carnival, freedom. No

question of ludic invention there, at the centre. The thrills of the margins are premised upon the theological otherness of the centre, its sublime simplicity, beauty and power. The centre became a place of moral and intellectual purity, a space of *disinfectant*: the postmodern medieval margin is the prehensile extrusion of the modernist obsession with hygiene. Because the margins partake in a different, dirty symbolic repertory, their essence and purpose must therefore be both different from and contrary to that of the centre: and in this rebellion lies the assumption that the margins are a site both of moral commentary and authentic, untrammelled subversion.

An early but representative formulation of this viewpoint is by one of the first modern writers to consider the margins, Meyer Schapiro, writing in 1939. To him, the jongleuric freedom of the musician, as represented in Romanesque sculpture, lies in the ability to 'improvise a sensual music, *in contrast* [my italics] to the set liturgical music of the church'; the artists on the margins insert this freedom into 'a context controlled by the church', by which means they 'affirm their own autonomy as performers and their conception of art as a spectacle for the senses'.[20] The astonishing implication – that 'official' liturgical art or music was in some way non-sensory – should be noted carefully.[21] Camille's account of the centre and margins is, to my mind, no less governed by a discrete Platonism: the lofty, purified and rational centre confronts the base margins in the way that the rational part of the soul confronts the appetitive part, the first corresponding to the ruler class, the second to the productive or labouring class (Plato, *Republic*, IV): it is this (metaphysical) hierarchy and implicit elitism that underlies the postmodern class-based interpretation of the pages of the Luttrell Psalter.[22]

This Platonizing stance, sapping the centre of things of any pleasurable content, therefore proved useful to the mid-twentieth-century agenda: it cleansed and modernized things, and it allowed in (or so it thought) a socially responsible progressive art history based on a neat binary opposition. The problem is that it also significantly misrepresented much medieval aesthetic activity. Arguably the literary and theoretical turn of the late twentieth century was based upon an undisclosed, politically convenient, but in fact absolutely conventional, investment in a theologized authoritarian centre that the margins 'naturally' subvert. They can only subvert, because the model in use is implicitly dualistic and concerned with power and its strategies – and only they can subvert, because it is only the margins, as the site of appetite, that are in some sense authentically 'alive'.[23]

There is a second way in which this model owed a greater debt to previous thought than it was prepared to acknowledge. It introduces the 'Merrie England' argument. It is well to remember that English marginalia were first seriously rehabilitated in the middle of the twentieth century by social progressives and profound sympathizers of the Decorated Style such as Nikolaus Pevsner, who in *The Englishness of English Art* (1956) saw 'baboonery' as being English in origin.[24] Pevsner's thoughts on the subject were moved by his agenda of exposing the way that scientific enquiry and empiricism were embedded in the English national character (what I earlier characterized as the 'onward march of science' approach). His 'Merrie England' appreciation of the margins is necessarily infused with naturalistic readings that are at once empiricist and picturesque, and which form a prelude to thoughts about 'Hogarth and Observed Life'.[25] The margins are seen as a place for the depiction of flora and fauna and what he calls 'scenes from everyday life', of which ideal illustrations are the thirteenth-century Bird Psalter (Cambridge, Fitzwilliam Museum MS 2–1954), first discussed at length by a founder of the science of ecology, G. Evelyn Hutchinson (pl. 250), and the Luttrell Psalter, worked up for the Luttrell family of Irnham in a succession of campaigns in the second quarter of the fourteenth century (pls 251, 252).[26] The Luttrell Psalter's copious border images of peasants, lords, agriculture and 'folk' pastimes have become the *locus classicus* of this type of study. The English empiricist mindset, sceptical of rhetoric, prosaic in its concerns and unshakable in its 'faith in reason and experience', was pursued by Pevsner in the domain of Latin chronicle writing, and seems to have provoked later studies of English literary 'realistic observation' as a quality of English medieval historical practice.[27]

More recent, and perhaps more sophisticated, readings of works such as the Luttrell Psalter have placed the issue of historical realism at the centre of the discussion by challenging simple reflection theories of historical truth – hence the title of Michael Camille's study *Mirror in Parchment* (1998). Camille argued that 'there are problems with mirrors apart from the fact that we see what we want to see in them'.[28] So 'realistic observation' is no more than a solipsistic or subjective fantasy projection masquerading as empiricism. It is, admittedly, difficult not to have some reservations about the 'onward march of science' model for understanding book art in the sense – understood very well by Camille – that such art is often artificial. But artifice and truth are not necessarily alternatives, and the following, and I think inescapable, question arises about the anti-reflection theory:

250 Bird Psalter, Psalm 1, with rabbit, hounds and birds, *circa* 1270–80 (Cambridge, Fitzwilliam Museum MS 2–1954, fol. 1)

what is it that gives to any historical account persuasive force, moral and political clarity, and a claim to general acceptance, other than some apprehension of reality? Can we simultaneously claim moral and historical insight and at the same time reject outright the idea that representations, however artful, actually tell us something more or less objectively verifiable to which we can all reasonably consent?

This claim goes deeper than stating that contextual interpretation lends a semblance of authenticity, a 'reality effect' to what is said: this is itself true, but should go beyond the suggestive and arbitrary sketching in of 'contexts' that happen to fit. Yet the solution to this conundrum in a number of recent accounts – for instance, recent work on the Luttrell Psalter – has been to proceed as if this problem did not exist: the reflection theory is criticized, but the act of interpretation of something 'out there' nevertheless continues apace. The pursuit of meaning is incessant, and is

advanced by the logocentric idea that marginalia are to be 'read' rather than savoured: text imposes a procrustean, artificial order of intellectual control on that which is precisely not to be controlled. Why, in fact, should we control the ludicrous (in the true sense of the word)? The resultant readings come, despite themselves, to resemble the iconographic traditions, the decoding exercises, of which they themselves are critical.[29] In effect, the need for a verifiable historical base produces a form of crypto-realism. Iconography reappears on the back of socially 'responsible' art history. It has a subject domain, that of the 'popular' or marginalized, which, like religion, possesses a special authenticity. For its sake questions of irony, ambiguity or absurdity may be set aside. The gap between artful deconstruction and illustrated social history closes perceptibly to the point where the two merge.

This returns to the main thread of argument. If it has already been decided that the centre–margin issue is about power play, it has also been ceded that the margins, by virtue of the nature of the metaphor, are *ipso facto* subversive. More importantly, it has also been conceded that the margins operate within a rational social world. Exactly how that world is viewed (and particularly the 'continuities' of folk and oral practice transmitted by high-art documents such as the great illuminated Psalters) is secondary. Yet immediately there arises another, and perhaps insuperable, obstacle to this style of interpretation. It is that astonishing quantities of marginal art do not operate in a rational social world. They manifest sense – or rather nonsense – but not reference, and so elude a rational or truth-driven account altogether. The 'Merrie England' reading, even as carefully reformulated and controlled by postmodernism, is basically rational in its practices and claims, because it is these that lend to it its ultimate goal of attaining moral authority to pronounce on the past. But earlier in this book, I pointed out the powerfully ludic drive in English artfulness whose understanding requires less a sense of social reality than a sense of artifice – to say nothing of a sense of humour. It is these drives that need to be understood in order better to understand the phenomenon of the border.

It is not wrong to see many marginal images as representations: in the end, a plough is a plough. But a large proportion of marginalia are not representations in this referential sense. Many consist of preposterous, ambiguous or actually impossible relations and combinations of animals, people and things (pl. 252) at which St Bernard railed in his *Apologia*. They are found aplenty in the Cistercian cloister at Santes Creus discussed in the last chapter (see pls

251 Luttrell Psalter, bird joke, Luttrell arms, ploughing, *circa* 1340 (London, BL MS Add. 42130, fol. 52)

252 Luttrell Psalter, crowned bird and winged bishop, compare pl. 235 (London, BL MS Add. 42130, fol. 175)

235–7, 240, 254). Chaucer, bearing in mind Horace's *Ars poetica*, called them 'japes'.[30] In their strangeness, japes can and should be understood primarily as inventive fun, not instrumentally 'pointing to' something else. It is perfectly legitimate formally to analyse japes into component parts, according to certain customary formations, like chiastic terms in rhetoric: Lucy Sandler calls these 'discernible principles of order and construction', though clearly these principles were hardly laws or even guidelines, more habits.[31] Japes and marginalia therefore embody the sense of order or disorder typical of a style. The problem is that the notion that some things might simply provide meaningless or irreducibly ambiguous pleasure is problematical to one kind of modern interpretative mind that has been inclined to see not just meaning, but also import, in everything.[32] If import is not apparent, it must be imposed. The joke must not be enjoyed, it must be *explained*. Interpretation, the obsession

with meaning or concept, short circuits the beautiful immediacy, the instant flash, of humour in which delight lies. The complexity of this lies partly in the fact that one medieval idea of laughter, of witty contumely, was rooted in the Aristotelian idea that laughter is the expression of moral superiority or contempt and so was not concept-free.[33] But against this was the other idea of laughter, *hilaritas*, a sort of beneficial and virtuous humour. Not all laughing was bad; silliness was legitimate or virtuous.

The question, then, is how and whether significance is ascribed to the outcomes, and what room may be found for that which is unexpected, or just beyond interpretation. In recent years the academic school of ironic interpretation has tended to get the upper hand, to the point where the sphere of the ironic has been expanded to a point where it risks losing real power.[34] If everything is ironic (or for that matter political), nothing is. I cannot, for instance, see

the force of the suggestion that the Castle of Love in the Peterborough Psalter in Brussels, discussed in Chapter Four (see pl. 113), should be deemed ironic, for this is to confuse a powerful literary device with a standard medieval practice of deploying carnal images to flesh out spiritual ideals, in this case illustrating the adjoining collect in the Psalter text.[35] It may indeed be the case that irony, historically speaking, is easier to identify and deal with than humour: but that is not in itself reason to give it free rein.

In expressing suspicion about suspicion, as it were, it serves not to lose sight of the ludic production of sense or nonsense particularly within small groups. Much the most lucid and well-informed discussion of this question is found in Noel Malcolm's discussion of *impossibilia* – reversals of the natural order of things – in his study of the origins of English literary nonsense.[36] The 'world turned upside down' device has a long history in the cultural life of European art and letters, originating in antiquity and flourishing in the Middle Ages.[37] Malcolm points to three general classes of *impossibilia*. The first is dystopian, referring to a state of affairs in which everything is as bad as it can get, and in which harmony and authority break down. An example of dystopian imagery is an animal playing the lute or harp as a symbol of the breakdown of harmony and authority: a common one is the harp-playing ass, known in the fables of Phaedrus, connected to Boethius in *Pictor in carmine*, used in *Carmina Burana* and found widely in twelfth- and thirteenth-century English religious art.[38] The second class is utopian, meaning a state in which things cannot get any better – a class not represented very commonly in marginal images. One thing connects the dystopian and utopian: each is in some way a commentary, typically satirical, on an actual order of things political or cultural – so the ass and the harp occur in religious contexts where the rigours of liturgical performance might really matter, such as illuminated Psalters, or painted on the mid-thirteenth-century ceiling over the monks' choir at Peterborough (see pl. 274), where its sheer braying crassness would have doubtless cruelly highlighted any deficiencies in human musical performance beneath. Apes frequently occur parodying clerical behaviour (pl. 253). What in general controls and directs such images are not just the constraints of satire (a literary form that, though it 'jumps about' by nature, is still a literary form), but their dependence on an actual state of affairs on which they can comment meaningfully. Of these forms, Malcolm concludes that 'fantasy which makes sense, however fantastic, is not nonsense'.[39]

This condition applies less, if at all, to the third class of *impossibilia*, the hyperbolic (referring to a state of fantastic

253 Psalter, Flanders, *circa* 1300, simian singer (Cambridge, CUL MS Add. 4085, fol. 1)

exaggeration), in which nonsensical forms make no reference to the actual world, but rather generate themselves for the sake of nonsense itself.[40] A statistically significant proportion of marginalia, such as the giant, luridly coloured and fantastically formed monsters in the Luttrell Psalter and the cloister at Santes Creus (pls 251, 252, 254), falls into this class: in fact, in the Luttrell Psalter it predominates. Striking coincidences are found between such work as that at Santes Creus and the style of jape found in eastern English clerical drawing related regionally to the Luttrell Psalter such as an *Oculus sacerdotis* containing church constitutions and synodalia of the 1340s, eventually owned by Norwich Cathedral (Cambridge University Library MS ii.2.7) (pls 254, 255).[41] The origins again lie in antiquity, not least in the Greek writer Lucian, in whose 'True Story' – itself probably a satire of the claims of travel literature – weird combinations of men and creatures and amazing transpositions of scale are encountered, which bring to mind the sorts of confronta-

254 Santes Creus Abbey, cloister, west walk, j(ape) and interwoven dragons

255 *Oculus sacerdotis* and *synodalia*, eastern England, *circa* 1340 (Cambridge, CUL MS II.2.7, fol. 43v)

tion in Norfolk-made Psalters of the fourteenth century in which soldiers encounter vast snails (Ormesby Psalter), or men are disconcerted by gigantic flatfish (Macclesfield Psalter; Cambridge, Fitzwilliam Museum MS 1–2005) (pl. 256).[42] The point is that, in their hyperbolic form, such images cannot be described as being satirical, parodic or referential in purpose. All they could refer to would be a

nonsense world at large, what Jurgis Baltrušaitis referred to as an 'anti-universe'.[43] Their relations to each other and (in the case of hybrid forms) within themselves are instead artificial. In such cases the ancillary purposes might be to intensify an emotion, act as a marker, bring a topic to mind, or demonstrate the protean power of some inventive imaginations – which is why their proliferation throughout illu-

256 Macclesfield Psalter, skate surprise, *circa* 1330–40 (Cambridge, Fitzwilliam Museum MS 1–2005, fol. 68)

minated manuscripts may signify something about the producers as well as the consumers of such books.[44] Even nonsense can be useful. This has been lost sight of because we have been conditioned of late to think that things should possess larger moral or political significance beyond their apparent form. It is as if nonsensical or hyperbolic imagery has been dragged into the spheres of the dystopian or utopian, without very careful thought as to where and why these various categories might overlap or be kept separate.

Literary models of the impossible can help to clarify such questions providing one recalls that the medieval sense of genre was often weak or blurred, and also the ways in which imagery, particularly Christian imagery, resisted literary practice. It is known, for instance, that actual parody, even burlesque (the inappropriate confusion or exchange of the high and the low) was a feature of European medieval literature in regard to hymns, sermons and liturgies, such as the *Missa potatorum* or drunkard's Mass.[45] Such textual affronts to decorum – which of course presuppose a grip on the whole concept of decorum in the first place – are unknown in the sphere of the central images of Christianity: there are no burlesque medieval representations of the Crucifixion or of the Virgin Mary or the Holy Trinity. But there are certainly copious enjoyable mixtures of the high and the low in the marginalia of Psalters and Books of Hours (see pl. 265), about which it is difficult to draw any conclusion other than that huge pleasure must have been taken in the tension between 'high' style and 'low' subject matter. The statistical preponderance of parodic or burlesque topics in the borders of liturgical books especially (see pl. 253) is an index of the absolute legitimacy of this relationship very near the centre of Christian iconography.

The parodic and nonsensical flourished not because they stood in antagonism to the 'centre', but because they were an aspect of it. There is every reason to think that these negotiations went on right at the heart of thought about texts and images. To establish this is to begin to tackle issues of agency and origins – by whom, when and where images on the margins were developed and spread.

Marginalia in manuscripts flourished in the way they did because the sometimes (to our eyes) startling juxtapositions they created were possible only by getting the 'mix' right. To understand how this mixture was achieved, it is necessary to consider its origins; and that in turn requires a consideration of the subtle relationship of the ruly and the unruly, that tension I have followed throughout this book between the constraints of rational invention and the

(sometimes rebellious) powers of formal ambiguation that lend to those constraints real power. One thing is clear: this question is an historical one, at the heart of which – contrary to much recent thought on the subject – lie aesthetic issues of wider relevance.

The obvious place to start is with the form of the manuscript page itself. One engaging theory about the page and the letters within it, proposed by Laura Kendrick, identifies a watershed in the course of the twelfth and thirteenth centuries that produced the Gothic manuscript page.[46] According to this theory, the early medieval decoration of illuminated letters of scripture and commentary was a metaphor, high-minded and moral, of the spiritual struggle with evil and the intellectual struggle involved in the labyrinthine act of interpretation, working itself out in an heroic, active and often violent and fantastic language of forms. This dynamic was an externalization, a somatic objectification, of an inner struggle or *psychomachia* typical of the enclosed monastic culture that dominated book production. It accords very well at first sight with some of the observations made earlier in the present book about the heroic mode, at its height around 1200.

The theory is also one of change. Kendrick observed:

From the mid-twelfth century on, in Psalters and prayer-books made for pious laypeople, and made increasingly outside monastic scriptoria, figures of danger and struggle – of combat, pursuit, ensnarement, fascination, and folly or sin – were located *outside* the letter, in the margins of the page surrounding the text or in the blank spaces at the ends of lines. The initial letter came to be depicted as a site of order, hierarchy, and stable authority, while struggle was marginalized.[47]

In this process of exorcism, larger initial letters and their text blocks were 'tamed and regularized', while still-dangerous images were pushed out into the margins beyond the text block. This is indeed what seems to be the case in many books of the thirteenth century. In passing, it should be noted that this theory makes certain assumptions. The first is that heroic images of struggle and combat are *necessarily* construed as having moral or tropological content: the theory sees no difficulty with the idea that monastic moral significations, proper to the 'early' medieval period, could be carried over into the frequently very different repertory of marginalia known from the Gothic era. A second assumption concerns the sphere of aesthetic decision making. Kendrick questions one explanation of this process of reordering the page offered by Carl Nordenfalk: that, since the illumi-

nated books in question tended to diminish in size in this period, the initials and the borders were rearranged in order to retain the content of the previous 'heroic' schemes, producing the simpler initials and the more complex image-filled borders.[48] Kendrick objects to such practical manoeuvres on the grounds that their suggested motivation was purely ornamental. To involve aesthetic (or practical) decision making is held in some way to be incompatible with the drama of power play, morality and apotropaic force that are held to lie at the heart of this process. The present writer has already sketched out some reasons why this dichotomy between the aesthetic and the significatory, and why this emphasis on the language of power, purity and danger, may be unhelpful: the sensory domain of the aesthetic is itself a domain of power. The sort of thought in question leads into a perception of style as 'pretty surface' or mere decoration, whose origins lie in Romantic, not medieval aesthetics, in which complex manoeuvres of surface are central to all, not some, aesthetic experience. Kendrick may therefore not be right when she suggests that only early medieval books possess 'impure' decoration. Yet the notion of impurity is central to her concept of exorcism (rather than enjoyment), and so is unavoidable.

A more powerful objection to this line of reasoning arises from the explanation it offers of why change happened at all. The illuminated page is seen as a space in which ultimately social and referential metaphors of power, purity and danger are thrashed out and resolved. The changes that motivate any development must, *ipso facto*, be social in origin: they are held to lie in a shift to a literate, lay market for religious books, and a gradual diminution in importance of monastic production and reading. The changes are thus 'lay-intended'. But granted that this *form* of explanation may be legitimate, has the right *process* of change been identified? It has already been seen (Chapter Three) that in the field of illuminated book production the market must have been expanding extraordinarily in the direction of lay commissioning, especially in the course of the thirteenth century. Yet the nature of this market requires careful differentiation, because it did not solely involve lay patrons or consumers. Jumping from the austere monastic world of the early twelfth-century St Albans Psalter to the courtly and indubitably lay world of the late thirteenth-century Psalter and Hours of Yolande of Soissons creates a clear enough contrast for the heuristic purpose of comparison: but it also raises a question about the crucial period *circa* 1150–1250, which has tended to be overlooked by theories that are fundamentally soft on origins.[49]

By 1250–1300 the trends were clear. Before and around the middle of the thirteenth century, however, it is far from obvious that the new arrangements on the page that produced Gothic border imagery were occurring first or solely in books made for the pastoral guidance of 'pious' laypeople. Quite the contrary: the evidence points to the investment in this process of monastic and especially clerical patronage, not least in the schools and universities. This in turn indicates a different kind of account of Gothic book marginalia in their earliest forms: that they were the product of changes in the way pages were deployed and decorated in order to restructure information, which did not in the first instance affect lay patrons at all, but which may very well have implicated 'experts' and book producers. It is within this rather more specialized type of context, I suggest, that the pleasures of unruling were first cultivated.

The Pleasures of Unruling

Lilian Randall thought that Gothic manuscript marginalia began in earnest around 1250 and persisted for about one century.[50] This profile has tended to be accepted subsequently, and it is not wholly inaccurate. It creates the impression that marginalia died out after 1350 and that they formed one indivisible phenomenon, like a genre. For the present purposes a few general points only are needed. The first is that, well before 1200, it is quite clear that the potential of the text borders of clerical manuscripts to be used for pictorial comment on authorities was already well developed. An instance is the handsome copy of Peter Lombard's glosses on the Psalms in Cambridge (Trinity College MS B.5.4) produced in the circle of Thomas Becket and his assistant Herbert of Bosham, under whose tutelage marginal images were introduced wittily reattributing the border glosses.[51] It is not wrong to see the first stages of such border art as evolving from within the practice of glossing. The point is the clerically intended nature of the work. Between 1180 and 1250, in certain texts of Hrabanus Maurus such as *De universo*, Matthew Paris's chronicles and the illustrated works of Giraldus Cambrensis – all certainly clerical or monastic books – the borders are freely used for a variety of images, grotesque, moralizing or otherwise.[52] But the best instances of the process in hand were published first by Carl Nordenfalk: drolleries including hunting and animals mimicking liturgical acts, some of which appear to be *imagines verborum* of wordplays, in the borders of the registers of Innocent III dating to around 1200 produced

within the papal administration itself. One of these, in the Register for the first year of Innocent's pontificate (1198–9) (Rome, Vatican Archives Reg. Vat. 4), shows a dog or fox standing in a hooded vestment holding a candle before a boar bearing an aspergillum, an obvious clerkly expansion of the text from Isaiah 56:10 cited in the adjoining letter from Innocent to two Icelandic bishops urging them to mend the ways of their flock: 'his watchmen are all blind. They are all ignorant: dumb dogs not able to bark, seeing vain things, sleeping, and loving dreams.'[53] The little image is much in the spirit of the dog, rabbit and other animal jokes in the *fabliaux* and later Psalters and Hours. Randall omitted such work and so dated the rise of the border drollery rather too late, and in doing so in effect underestimated the clerical or secretarial role in its development.

It is generally recognized that the practice of extending bars and amusing ornaments out from initial letters and framing bars into the borders of illuminated Psalters or Bibles was also under way in the period 1200–50, as in the early thirteenth-century Huntingfield Psalter.[54] The manuscripts generally attributed to the illuminator W. de Brailes, recorded in Oxford in the 1230s and 1240s, are included amongst the earliest developed instances of this practice.[55] In books of the period 1250–75, such as the Rutland Psalter and the Salvin Hours, it is increasingly developed.[56] Apart from the works of de Brailes, the most coherent instances in England occur in manuscripts of the 1260s or so, linked to the Bible and written by the scribe William of Devon (London, British Library MS Royal 1.D.1) (pl. 257): these include the Egerton Hours and the Cuerden Psalter.[57] The basis of the page design of these works, which include increasingly prodigious use of bridge and bar-like structures extending from initials and surrounding the text block, as well as plentiful bird and animal ornament, was provided by Parisian illuminators (Robert Branner's so-called Grusch atelier) of the same period.[58] Many, but not all the books in this category were lay-intended. It is also evident that exactly the same methods were being extended to scholarly texts for expert study, such as a copy of Aristotle's *Libri naturales* of the same period, the 1260s.[59] They are exceedingly common in fine academic books made in Paris in the late thirteenth and early fourteenth centuries, such as the compilation on the *Artes* in British Library MS Burney 275 (pl. 258).[60] They seem to be a part of the 'look' of de luxe Gothic books of the period, particularly those produced in England, northern France and northern Italy.

Two points emerge from this. The first is that while plentiful and clearly very marketable lay-intended Psalters

257 Bible of William of Devon, Genesis, Oxford?, 1260s (London, BL MS Royal 1.D.1, fol. 5)

and Books of Hours were without doubt an important focus of such new work, the use of these images in clerically intended books, including the works of Aristotle, seems to have emerged at exactly the same time, and increasingly by the 1260s. Illuminators such as W. de Brailes made both kinds of text, and they served a market. But it is difficult to see why marginalia should have been exorcised from major initials into the borders of works whose nature was not sacred, and which had no pastoral purpose: other processes must have been at work. The second point is that what these books have in common is not necessarily audience or function, but origin, since overwhelmingly their most likely places of production were Oxford or Paris. It is important to remember that some books intended for

258 *Artes*, Geometry, *circa* 1310 (London, BL MS Burney 275, fol. 293)

259 Psalter, Paris, *circa* 1270 (Cambridge, CUL MS Ee.4.24, fol. 31)

English audiences, but including the latest taste for borders and line endings stuffed with rabbits, birds and fish, were executed in Paris, such as the remarkable Psalter dating to about 1270 in Cambridge (University Library MS Ee.4.24) (pl. 259).[61] It is a feature of much present-day criticism of the marginal that it examines it almost wholly from the premise of audience and function, not production. But if, as I suppose, such marginalia were especially prone to emerge in books made at certain junctures and under certain market conditions – for instance, university cities with large populations of clerks – the question is why.

Any student of Romanesque book illumination will be familiar with the notion that a more or less standardized book and page format, enabling readers to find their way around, was not an invention of the Gothic period, any more than was the concept of ordered information itself. What is undeniable, however, is that the market for clearly ordered illuminated manuscripts expanded and diversified beyond recognition in the course of the late twelfth and thirteenth centuries: perhaps the most widely acknowledged achievement of this process was the standardized Parisian Vulgate Bible, which formed the matrix of printed small-format Bibles to the present day. One is entitled to see in such thirteenth-century books not only a much wider impact of the technology of information they embodied, but also signs of a more general standardization of format and design. Part of this process entailed a new structuration and presentation of material by means of the planning,

layout and gathering together of books – what Malcolm Parkes called the *ordinatio* and *compilatio* of the medieval book.[62] Parkes opened his study of this by saying: 'It is a truism of palaeography that most works copied in and before the twelfth century were better organized in copies produced in the thirteenth century, and even better organized in those produced in the fourteenth.' During the twelfth century, the argument runs, monastic intellectual enquiry gave way to that of the schools. New kinds of books and a new kind of technical literature appeared: a scholastic *lectio*, a process of study, appeared that involved rational scrutiny and consultation of texts for ready reference purposes. This required a different text presentation, reflected in a different page layout. In the twelfth century the main ancillary apparatus was the gloss, carefully aligned with the text to be studied, whether of the Bible, Peter Lombard on the Psalms or the Pauline Epistles. Clarity was created by careful column and gloss layout and such things as red underlined *lemmata*. Gradually, and in line with scholastic enquiry into the authorities studied, these methods of clarification evolved further towards what came to be known as the *ordinatio* of the work: a rhetorical term. These new devices are found in the Sentences of Peter Lombard, and in manuscripts of Gratian on canon law.

But according to Parkes the 'turning point' for academic readers came in the thirteenth century, when the rediscovered Aristotelian logic entailed even more precise methods for dissecting and displaying knowledge. Knowledge had a hierarchy, starting with divine science and scripture and ending with human or worldly science: philosophy was secondary to theology. In keeping with the Aristotelian theory of causality (see Chapter Two), each branch had its own order appropriate to its material (its *forma tractatus*) and way of proceeding (*forma tractandi*) (see Chapter Three). Another word for this ostensible ordering by style and clear procedure was *ordinatio*. Parkes concluded: 'the structure of reasoning came to be reflected in the physical appearance of books'. What Parkes seems to be pointing to is a 'Panofskian' shift (a shift in the importance of *manifestatio* or clarity for clarity's sake) in the 'value rationality' of the thirteenth century. These values were above all those of the urban schools and universities and the preachers – those institutions and professions that placed a premium on rapid information retrieval assisted by standardized layouts, search formats and thematic or alphabetical indexes.[63]

This progressive standardization of the form of books can and should be placed in the context, indeed was part of the connective tissue, of developments specific to the middle

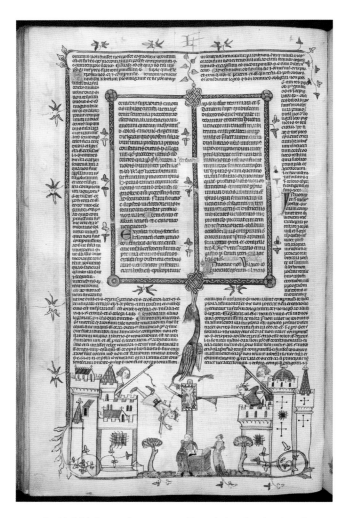

260 Smithfield Decretals, *circa* 1340, 'Batayles' in border (London, BL MS Royal 10.E.IV, fol. 90v)

decades of the thirteenth century. There is an historical coincidence between the rise of the new *ordinatio* in books, the 'thematic' sermon, and the encouragement of memory techniques amongst the mendicants no later than the mid-thirteenth century, the time of the veritable explosion of imagery into the margins of illuminated Latin in exactly the same spheres.[64] Mary Carruthers also saw a connection between the use of striking and salacious *bas-de-page* pictorial narratives of the sort that proliferate in the fourteenth-century Smithfield Decretals (British Library MS Royal 10.E.IV) (pl. 260) and the need to commit canon law to heart.[65] That such practices involved a witty self-reflexivity – rather than a specific sense of iconographical 'reference' – is also indicated by her further point that marginal *inventio* enjoyed a playful but committed relation to the act

of reading as a form of enquiry, seeking, finding and storing away: hence the imagery of treasure, wildlife, hunting – the acquisition and storage of knowledge is the civilized man's hunter-gatherer instinct.[66] In the Burney *Artes* just mentioned (fol. 293), Geometry and its proofs are accompanied by scenes of hunting with arrows and fighting. Kendrick has developed further thoughts about the role of wordplay in regard to the French words *bords* (borders) and *bourdes* (jests), which in turn give us *borden* (to joust), *bordel* (brothel), and so on.[67] Also telling is the *imagines verborum* approach that connects specific marginal motifs to words or phrases.[68] Presumably Latin and vernacular wordplay was ever more likely in the increasingly heterogeneous market for books emerging in the course of the thirteenth century, though since clerks and laypeople were capable of both, neither can be diagnostic of the origin and function of the idea. So a question arises as to *whose* ludic sensibility – for here the notion of *ludus* in invention seems especially powerful – was involved. When one points to memory, information retrieval and sheer verbal wit as important factors in the production and 'usefulness' of drolleries, whose intentions were involved: consumers, producers, or both?

Within the book illuminator's shop itself, the dynamic of invention in question is not in fact especially hard to understand, though it requires a harder look at small-group thinking. Here the functional aspect of the new *ordinatio* and its relation to textual use and enquiry was one factor. Another was aesthetic: the dynamic between order and standardization on the one hand, and their undoing on the other. Nordenfalk's observation is too easily overlooked: that it was not until after the middle of the thirteenth century that the Gothic system of marginal decoration, with bars or antennae framing the page with foliated branches that provided the staging ground for drolleries, asserted itself completely.[69] It is quite clear that Gothic marginalia were not necessarily *spontaneous* anarchic reactions to text, but were often carefully incorporated from the start within this new framework. This is proved by unfinished manuscripts that disclose the working methods of illuminators, such as the beautiful early fourteenth-century Metz Pontifical in the Fitzwilliam Museum in Cambridge (MS 298), determined at its drawing stage down to the smallest flourish, bunny and baboon (pl. 261).[70] The comparison with the fine fourteenth-century elevation drawings such as those for Freiburg and Prague, in which gargoyles or other 'marginal' devices form fundamental marker points in the setting out of the design, is clear.[71] Such 'gestures' were carefully thought through and perfected by the craft of illuminations itself. This point is

261 Metz Pontifical, 1303–16 (Cambridge, Fitzwilliam Museum MS 298, fol. 129)

reinforced by the (very few) instances where marginalia were edited, corrected or replaced.[72] Obvious calculation of this type forces one to set aside the idea that marginalia belonged to some utopian zone of artistic freedom, or daydreaming.[73] Theories of 'freedom' run the risk of overlooking the crucial dynamic of order and disorder in any inventive process: that order and disorder are symbiotic and confer significance upon one another in a way that renders theories of mutual subversion hazardous. The first thing any book maker did to an illuminated page was *rule* it with a *ruler*. Practical experience alone shows that drawing a baboon against such a framework becomes a pleasurable *unruling*, not least when the look of the page has stiffened into highly regularized column formats with running heads, framing ornamental bars and a clear hierarchy of text sizes,

and when the people executing such pages are making them by the thousand. Serial production for large markets and formal standardization were no doubt fundamental parts of the dynamic of the 'marginal', the wit of the book lying, as it were, in the self-conscious exploitation of page layout as an object of artistic comment in, and on, itself. The order of the book has conferred significance on the self-conscious (but artful) pushing of the boundaries of orderliness. So the page's internal relations are necessarily artificial, and in the creation of a zone of unruliness lay something ritualized. The new *ordinatio* and the new markets had brought together two countervailing processes: a change in book function and market, and a realization that the response to such functional and commercial changes could create a new zone of pleasurable creativity for book makers, which also helped to sell books. Function shaped the way books were 'displayed'. But only the small groups actually making them, groups endowed with their own special knowledge and practical wisdom, would understand this and be able to give it shape.

Central to this line of argument is the belief that manuscript marginalia are a specialized, but by no means isolated, instance of the larger phenomenon of the ludic in medieval invention — play that can be serious and high-minded and ritualized, but which fundamentally energizes the whole process of creation. The area of creative play is necessarily specialized, in the sense that it implies the priority of conventions or rules that must first be understood and assimilated in order to be cast aside: these rules or conventions might belong equally to the relatively enclosed order of a craft with its specific training and procedure, or to the literary or intellectual practices of certain professions, or to playing chess or making music. Jazz riffs are, after all, founded on virtually invariant formal progressions such as twelve-bar blues, but the freedom of the riff is not a subversion of the given matrix of harmonic narrative. To reiterate a distinction made earlier in this study, play might evolve from system and method (*téchnē*) or from within traditional know-how (*empeiría*). The dominance of modern literary criticism in generating theory about the marginal, and constantly devaluing the aesthetic, has led us to overlook the serio-ludic aspect of craft itself, in which persuasion, the power to bait and lure, lies in the witty manipulation of things based on artisanal experience and method, as much as in the signification of things themselves. These are not just production-line jokes. The claim is much larger: it is that in the witty manipulation of things lies their actual power to charm, move and convince. Marginalia are spread across all Gothic artworks not just because of some signifi-

catory project, but also because this is what the intended *experience* required, not least as a matter of style. Architectural gable ends morph as a matter of style into dragon heads or marmosets while line endings flow into fish or fowl (see pl. 87, main gable, pl. 259): the *opus* of Gothic is a matter of setting out something apparently always in *process*. By this reading many marginalia of the hybrid type occupy the same place in total design as Rayonnant architectural drawings, such as Cologne Cathedral's Plan F, which factor into elevations design a repertory of small-scale grotesque devices right from the start, much as in the Metz Pontifical already noted.[74] The same sense of seamless artifice, of creative fiction, might be shown in the work of a metalworker or a sculptor of the period. In all domains of Gothic this point holds true, but its role in architectural play seems to have been especially durable and deep, especially after the 1240s or so when 'canonical' Gothic — invested in the Rayonnant style — was becoming as internationally established a benchmark as the Parisian Vulgate Bible.

The text-bound arts, in other words, did not possess a monopoly of the powers that constitute a style. As Ethan Kavaler has shown in his remarkable account of playfulness and deconstruction in sixteenth-century German Gothic rib vaults, the ludic possibilities of the rib vault deliberately shown as broken, divergent or incomplete, or just botched, indicate a conscious and enjoyable display of the erratic, which, in its 'nurtured complexity,' indicates what it is to have a reflective or self-conscious grip on a style.[75] There is every reason to suppose that productive thinking in the crafts was possessed of a real appreciation of the hilarious misunderstanding as well as of that creative ambiguation that I have traced in this account of the Decorated Style. In this such crafts were analogous to, and probably in dialogue with, other small professional groups with their own 'in jokes' or insider humour, whose influence must also be considered, not least because they were often themselves patrons.

Small-Group Humour: Markets, Law, Bureaucracy

Implicit in this argument is a view that the craft of making and the craft of thinking were not as separate in the medieval mind as they were later to become — and for this view there is now wider support.[76] My intention here is to guard against an implicit if well-intentioned elitism embedded in modern and postmodern critical outlooks. By drawing together the activities of book makers and clerks it may be seen that the immediate social context for book art was that

of the initial producers, and only secondarily consumers: consumption nevertheless mattered, because book producers knew quite well that to sell a ware it is necessary to make it distinctive and attractive. A book maker was therefore not some marginalized, subservient figure incapable of self-inscription, but rather the shaper and proponent of a commodity possessing its own forms of persuasive power in the marketplace.[77] Recent, though not always coherently formulated, arguments about the margins as a collusive but also subversive force have in contrast been careful to distance marginalia from the forces of commodification that are held ultimately to have destroyed them: the market and the rise of 'rational' Renaissance aesthetics ended the utopian free play of signs.[78] But it is unwise to imagine the great illuminated Psalters made in fourteenth-century Norwich and London – and, I think, earlier in thirteenth-century Paris – as in some way floating above market conditions. In fact, commodification may have assisted rather than hindered the development of the borders. Norwich-related books such as the Ormesby, Gorleston and Macclesfield Psalters (pls 262–4) clearly participate in the same repertory of amusing marginal topics and commonplaces, such as the plethora of rabbits in the Gorleston and Macclesfield books, and the story of Reynard the Fox, which appears on folio 71v of the Ormesby Psalter. Sculptors shared these themes: thus the *Fall of Pride* on folio 235v of the Macclesfield Psalter remarkably resembles that carved in the south cloister walk of Norwich Cathedral (see pls 313, 314); Reynard appears pursued by a woman on the south porch boss of the church at Cley (see pl. 73), also probably built by the Norwich-based Ramseys, as well as in the Peterborough Psalter (see pl. 270, top border).[79] The long *bas-de-page* sequences in Latin liturgical and law books made in London – for instance, the Queen Mary Psalter, the Taymouth Hours (see pls 175, 176) and the Smithfield Decretals (see pl. 260) – also share something like a commercial look and, again, this type of work impacted on the sculptors and woodcarvers at Ely.[80] Such pattern-book groupings occur frequently. That image makers in various media were in conversation need not be surprising: the point is that one gains in seeing these motifs as a form of intelligent 'branding' – something that implies skilled commercial thinking which got these teams the work in the first place.[81]

This in turn points to a changing and growing market particularly after about 1300 in England, when marginalia ceased to be an innovative, and became a conventional aspect of illuminated art, particularly of lavish liturgical manuscripts. One reason for this 'normalization' is not hard

262 Gorleston Psalter, Psalm 80, *circa* 1320 (London, BL MS Add. 49622, fol. 107v)

to find. Even from Randall's necessarily incomplete survey it is apparent that, while out-and-out scatology is actually quite rare in marginalia (under 5 per cent of instances), the prevalence of marginalia generally in Latin liturgical books, particularly Psalters and Books of Hours, is overwhelming. This could mean that 'moral' books tended to attract this sort of thing. But it is after 1300 in particular that the theory about 'pious laypeople' enters into its own. From the late thirteenth century Books of Hours, and especially Psalters, became part of the economy of gift exchange associated with marriage alliance. An early instance is the delicately illuminated and bordered Psalter made for Edward I's eldest son, Prince Alphonso, in time for his marriage to Margaret, daughter of the count of Holland – but broken off at his untimely death in 1284.[82] Here, exquisite representation of

263 Macclesfield Psalter, rabbit outrider sounds horn, *circa* 1330–40 (Cambridge, Fitzwilliam Museum MS 1–2005, fol. 115v)

264 Macclesfield Psalter, rabbits run forth (Cambridge, Fitzwilliam Museum MS 1–2005, fol. 116)

flora and fauna accompanies heraldry – a feature of a significant number of such Psalters and Hours that manifestly celebrate matrimonial alliances and which were probably produced as wedding gifts: examples include the Foliot and Bardolph families (the Ormesby Psalter), the Warennes (the Gorleston Psalter) (see pl. 262) and the Greys and Fitzpayns or Clifford and Pabenhams (the former Grey-Fitzpayn Hours) (pl. 265).[83] In their showy heraldry and use of borders with fertility images these books catered directly to young wealthy consumers and their families preoccupied with land and dynasty.[84] To suggest that such images were not commodities, or that their histories did not reflect the vagueries and desires of the marriage market, would be unrealistic. Book producers doubtless thought hard about both the content and the visual impact of their work, and

in larger cities with numerous relatively small and evenly matched rival producers innovation would have been motivated by inter-workshop competition. Quite possibly marginalia were by then measured out and paid for, as it were, by the yard. Martine Mauwese draws attention to a striking instance in a Middle Dutch illuminated manuscript book with marginalia made towards 1300, the *Nederrijns Moraalboek*, of an obviously professional illuminator who presented the bill for doing the initials and fifty-seven beasts (*ymagines animalium*) on the front flyleaf – in Latin.[85]

To see border beasts as itemized commodities does help, from one point of view, to understand why marginalia of this type appear to have grown less common in books illuminated after about 1350 (but they did continue, as in the 'Bohun' manuscripts): while the impact of wage infla-

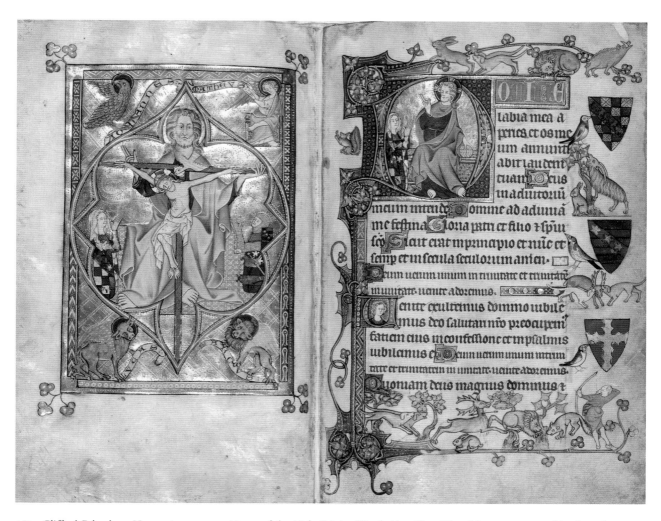

265 Clifford-Pabenham Hours, *circa* 1315–30, Hours of the Holy Trinity (Cambridge, Fitzwilliam Museum MS 242, fols 28v–29)

tion and the destruction of communities of skill in book art after the Black Death has not yet been studied, the possibility that marginalia simply became relatively too expensive has to be considered. But another point arises from the *Nederrijns Moraalboek*. The fact of a book painter entering his account in Latin into a vernacular manuscript should be a warning not to jump to conclusions about the lack of 'clergy', or Latin, in workshops of this type. Pointing this out does not entail a sniffy condescension to those without Latin; it is instead to avoid assuming that book craftsmen (and women) were simply manual operatives and innocent heroes of counterculture. On the contrary: those supplying complex decorated texts might just as well be understood as members of a para-academic culture enjoying the 'in-jokes' that are typical of small groups of people engaged in specialized knowledge or activity. Laura Kend-

rick is right to state that marginalia, far from being day-dreams, are the products of 'linguistic performances and games played in small groups, games like the troubadors', that involved the deliberate or chance discovery of equivocal senses of the text' – to which might be added the deliberate cultivation of nonsense.[86] Such play emerges within the slow repetitive process of fashioning things by teams: it is the jesting of *compagnonage*. But it is also the humour of educated or professional groups whose tasks are, in the first instance, to establish or perpetuate stable literary forms and to clarify meaning by eliminating error and contradiction – the work of the theologian, grammarian, lawmaker or maker of texts. The almost inevitable by-product of such tasks is the production of parody, satire or nonsense, which, far from being subversive, is, to quote Kendrick again, 'ultimately stabilizing rather than subver-

sive'.[87] Consider an example given by Lilian Randall, that of a manuscript produced around 1300 for an abbot of St Germain d'Auxerre which has a *bas-de-page* image of an ape dressed as an abbot holding up a skull in its raised hands: the abbot in question commissioned a seal with the same image and the legend *abbé de singe air main d'os serre* – the pun, or riddle, was his, but it stood for the slightly crass yet affectionate humour of his convent.[88]

This returns us to Noel Malcolm's account of English literary nonsense as, in its most developed instances, a type of conscious parody of literary form typical of educated elites, to which one might add those engaged in specialized technical activity. Parodic literary practices originated especially in 'enclosed groups of people – in colleges, churches, monasteries, etc. – where certain standard texts or formulae are in habitual use'.[89] English satire, so richly deployed from the twelfth century in the clerical writings of Walter Map or Nigel Longchamp and in its later guise developed by Chaucer, makes it abundantly obvious that *monde renversé* imagery, substitutions, wit and wordplay were especially characteristic of a certain style of male education.[90] Sexually explicit or even obscene material – even though a limited aspect of English Gothic marginalia – is as integral a part of high culture as of 'vernacular' or 'folk' culture, its presumed opposite.[91]

This needs to be stressed in the light of the assertion that marginal images are typically vernacularist or countercultural in their very nature. That many of the topics of marginalia derive from texts that were principally vernacular (the *fabliaux*, tales such as *Bevis of Hampton* and so on) is not worth disputing.[92] But there seems, first, to be a persistent – and perhaps insuperable – difficulty in deciding what is meant by 'vernacularity': was French not a language of culture, and how does a vernacular language translate into a 'vernacular' visual mode when the same styles and modes were used for Latin texts?[93] Here theories of origin are revealing. An instance is Michael Camille's discussion of a border image showing an ape riding backwards on an ass with a large owl on its arm, with an English caption, 'Pay me no lasse than an ape and an oule and an asse', in an English register of writs (New York, Pierpont Morgan Library MS M 812). This image and its text also appear in a fourteenth-century sermon and on a seal.[94] Camille states that this was 'an obviously popular rhyme' connected to what he later calls 'visual elements from an obviously popular tradition transmitted orally'.[95] The claim is one of origination: because by the fourteenth century the image of the ass, ape and owl was associated with English, its *origins*

too are therefore necessarily or 'obviously' popular or vernacular. But, as Camille himself noted in discussing this drollery, its first known occurrence is in the context of a manifestly proto-humanist series of images painted on the ceiling over the monastic choir and the nave at Peterborough Abbey *circa* 1240 (see pl. 275), where it is best classified as a latinate 'antic' – the word has a strong connotation of the mad or irrational – placed near the harp-playing ass on the same ceiling as a ludic comment on disorder in the nave or monastic choir beneath.[96] In short, an image whose first context is demonstrably within small or enclosed group humour of a clerical type has been conscripted by a modern writer to 'popular' art as part of an origination or authentication strategy derived from a notion of vernacular origins. The causal model underlying this interpretation is itself Bakhtinian, or carnivalesque. As Malcolm observes, 'When he talked of parody being generated by the "folk spirit", Bakhtin seemed to imply that carnivalesque comedy was somehow more vital and more valid because it came (in socio-political terms) from below, as a kind of cultural protest or revolution.'[97] The suggestion that the most powerful symbolic repertoires are found at borders, margins and edges should be recalled. Malcolm notes two major objections to this argument. The first (acknowledged by Camille) is that licensed disorder may be a safety valve that actually protects the established order – ultimately stabilizing rather than subversive. The second is that the Bakhtinian argument confuses the social nature of cultural events with the origins of the literary, aesthetic or ritual forms of which that cultural event makes use. The origin is in some way carried into the subsequent signification. Yet to elide the two in this way is rather like assuming that 'nursery rhymes must have arisen from the spontaneous creativity of small children'.[98] As has been seen in discussing the formal language of the period, the origin of something does not necessarily condition its future development; and the future development of something is not always a guide to its origin. What seems harder to dismiss is the evidence that book illuminations and borders evolved within the specific cultures of book manufacturers and teams of scribes and artists enjoying parodies and in-jokes, which played on sophisticated internal formulas and codes very like those of what is now sometimes still called high culture.

In the broadest terms, the developments that would particularly favour the growth of this kind of culture of educated rebellion or witty contumely would include the expansion of bureaucracy and the production of written record, the consolidation and codification of law, especially

Roman and canon law, the growth of urban schools and universities and a huge expansion in the market for quality books for lay people of rank.[99] This was precisely the situation in much of northern Europe in the thirteenth century. The cheeky border was a by-product of the emergence of a rationally minded professional culture of 'ordering' in which clarity, wit, artifice and memorability possessed special status or capital. Law is a particularly interesting instance. Earlier, I commented on the famous remark on the squandering of wealth by a student in acquiring glittering illuminated books in Paris. The observation was by a major jurist, Odofredus of Bologna, a student of Accursius, perhaps deliberately drawing a contrast between the sobriety of legal study in Bologna and the perils and delights of theological Paris. In fact, books of civil and canon law, a domain of the recollective, were rather prone to lively border decoration, if never to the extent of the Psalters and Hours of the period. An instance is the Smithfield Decretals, made for John Batayle, a canon of Smithfield, and very fully equipped with *bas-de-page* images often of a religious type, while being written in a form of Bolognese law script and completed with puns on the owner's name in the form of little *batayles* or battles in the lower borders (see pl. 260).[100] French, particularly Toulouse-made law books in the same type of script often have marginalia. A group of late thirteenth- or early fourteenth-century law books with an early Durham Cathedral provenance, written in a Bolognese script and partially illuminated by Italians as well as by artists of southern French origin (Durham Cathedral Library MSS C.I.3, C.I.6, C.I.9), contains Gothic-style and extraordinarily gaudy and wild marginalia of the type in the Luttrell Psalter, but earlier in date: Ms C.I.6, a copy of Justinian's *Codex*, is particularly remarkable (pl. 266).[101] Other eastern English-made marginalia of the sort in the Luttrell or Ormesby Psalter are found in a *Liber sextus*, a canon law compilation known as the Brewes-Norwich Commentaries, of the late 1330s or early 1340s (Cambridge, St John's College MS A.4[4]) (pl. 267).[102] Sir Geoffrey Luttrell, patron of the Luttrell Psalter, married his eldest son to the daughter of the king's sergeant-at-law and Chief Justice, Geoffrey le Scrope.[103] It is a striking fact that a significant proportion of the japes in the borders of this extraordinary Psalter consists of hybrids using forms derived from birds (see pl. 252), probably alluding to the Luttrell arms: some kind of family jest was involved, but it must also have been a parody of the bird borders found so commonly in liturgical books (see pls 250, 251). Doubtless Luttrell and his family also enjoyed jokes about 'outlawry' and the 'unruled' space

266 Justinian, *Codex*, and Accursius, *Glossa ordinaria*, Bologna and ?southern France, late thirteenth century (Durham Cathedral Library MS C.I.6, fol. 255)

of the border. When a puppeteer sports an Eleanor Cross 'hat' on folio 159v (pl. 268), the significance of such Crosses as public warnings, *cautelae* (p. 115), would not have been missed: the word *cautela* carries the connotation both of warning and of device, or trick. But in terms of taste and invention the immediate background of the grotesque work in the Luttrell Psalter could have been quite as much in

267 Brewes-Norwich commentaries, *circa* 1340 (Cambridge, St John's College MS A.4[4], fol. 46v)

professional law books as in devotional ones, since the Bolognese books already had the same sorts of florid and mad-looking monsters.

The potential, but perhaps underestimated, importance of law books as a source for ideas shows, once again, that the production of marginal meaning often occurred in books made for specific, often quite small, circles: these might have been enclosed monastic communities, professional groups, guilds, chantries, ultimately the Inns of Court,

the lawyers' professional associations – and the usual suspects, the universities, those communities of 'wit' whose urban centres oversaw the earliest proliferation of Gothic marginalia in books. It is this sort of context that might explain the apparent, but not real, incongruity of the cheek-by-jowl sanctity and profanity of many such books. Irony was not solely a product of educated elites sitting at their desks, but, as the clerical literature of England from the twelfth century onwards shows, it was a sort of specialism. In saying all this, I am of course indicating a social context for understanding marginalia, but it is not that of Bakhtin or Gurevich.[104] Closer to the mark are the observations on the practices of writing and doodling of bureaucracy itself, the great growth industry of the time. The occurrence of amongst the earliest Gothic drolleries in the papal registers (Vatican Archives, Reg. Vat. 4) around 1200 has already been noted, emanating from deep within the greatest universal bureaucracy of its day.[105] It may be necessary to take more account of the mindset of what Michael Clanchy called 'bored enrolling clerks' in the chanceries and exchequers of the period, which witnessed some of the earliest 'political' caricatures of the time; Elizabeth Sears has written of 'scribal wit' in Paris.[106] An emphasis on the games of clerks does not rely solely on the explanatory value of the culture they represented, valuable as that is: attention is also drawn to the cultural politics that have tended of late to demote it in the first place.

No one is born a Latinist, and each has a chattering wet-nurse; and whether or not one is part of some small select community, everyone participates in a wider world. By thinking of the humour of particular social and professional situations simply in terms of a dualistic and conflictual cultural politics, I repeat, one misses the crucial points of mediation, of outrageous mixture, of high and low that the written and illuminated page provided. This is not to shoot down context entirely. Providing it is recognized how dangerously ambivalent many of the 'social' readings of marginalia actually are, there is no obstacle to such reading. But contexts illuminate more often than they actually explain. The borders became a genre only slowly (if at all), especially when it became clear that they conferred an advantage in the market for books. That market was inherently geared to social elites. But without a sense of the delight – and the boredom – of writing and decorating anything, a true sense of the richness of the margins is lost in turn. Both, I suggest, arose from the possibility that Gothic drolleries were a form of ludic undoing or ambiguation of perfectly rational processes of ordering in the comparatively elite activity of book

268 Luttrell Psalter, juggler with puppet and Eleanor Cross, bull (London, BL MS Add. 42130, fol. 159v)

269 Poggio Bracciolini, various works, made for Humfrey, duke of Gloucester, mid-fifteenth century (Cambridge, CUL MS GG.I.34, fol. I)

making. Far from being the prized products of a delirious populist Middle Ages exterminated by a rationalist elitist modernity inaugurated by the Renaissance and its tyrannies, they themselves embody a kind of artisanal reasonableness and usefulness even at their most absurd, unruly and funny.[107] The word 'humour' has occurred surprisingly seldom in the earnest literature on borders of late. One might, perhaps, relax a little more and remind oneself that some of the latest occurrences of the nonsense marginalia found in works like the Ormesby Psalter are to be found in the 1440s or so, in a book decorated for Humfrey, duke of Gloucester: a copy of the works of the humanist Poggio Bracciolini, written in a script with humanist elements (Cambridge University Library MS GG.I.34 [I]) (pl. 269).[108] A centaur plays the bagpipes in the 'P' of *Poggius*, with beaked heads, masks and grylli in its 'Gothic' border nearby (fol. I). Humfrey had an eager eye for these things: he also owned a fine illuminated

Norwich-area book, the St Omer Psalter, worked on by artists found also in the Ormesby Psalter (see pl. 290).[109] Marginalia were, by fourteenth-century standards, a dying art form. Yet here they survive, charming naughtily in the lofty context of sophisticated discussion about the superiority of Scipio or Caesar. It was Poggio Bracciolini, collector of *facetiae*, who compiled what is in effect the earliest post-classical joke book.[110] His sense of humour was, doubtless, that dry Aristotelian laughter tinged by derision or contempt that had long characterized clerical humour. But that he, and Humfrey, saw something amusing in these drolleries seems certain; and whatever it was did nothing to undermine the authority of their words. Without *ludus*, no *seria*: Cicero reminds us in *De oratore* (III.30) that Crassus admired Caesar's rhetoric but saw no conflict between the weightiness of his ideas and his humour, for his jokes did not diminish his seriousness.[111]

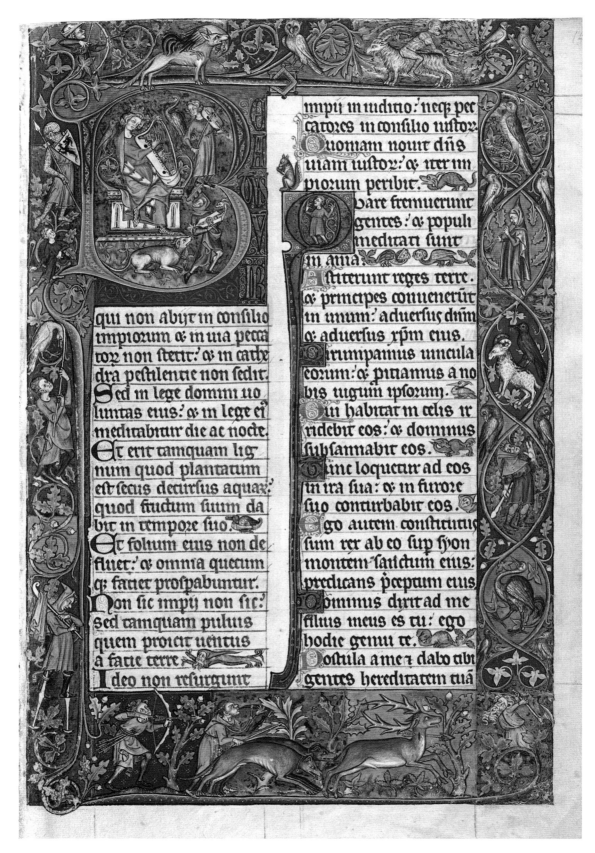

270 Peterborough Psalter, Psalm 1, *circa* 1310 (Brussels, Bibliothèque royale de Belgique MS 9961–2, fol. 14)

9

THE TRUE VINE

Novi libri non sunt ita veraces sicut antique
New books aren't as true as old ones

John Bromyard, *Summa predicantium* v.8.12

Typology and Pedigree

Where did authority lie in artworks of the period? There seem to have been some settled conclusions, the first of which lies in the world of fourteenth-century book art. The lavishly illuminated Peterborough Psalter now in Brussels (Bibliothèque royale de Belgique MSS 9961–2) has already been encountered.[1] Walter of Whittlesey, the Peterborough chronicler, states that it was given by Geoffrey of Crowland (abbot of Peterborough 1299–1321) to a papal nuncio, Gaucelm Duèse, who had travelled with another nuncio to England from Avignon in March 1317 and who returned there by 5 November 1318. Gaucelm immediately gave it to his uncle, Pope John XXII. Less than three weeks later, probably on 28 November, John in turn gave it to the dowager queen of France, Clémence of Hungary, widow of Louis X, who retreated with it to a nunnery at Aix. In 1328 it appears in the inventory of her goods after her death and was purchased from her estate by Philippe of France for his queen, Jeanne of Burgundy, whose arms it bears.[2]

According to local tradition, Geoffrey was a *vir magnificus*: he decorated various apartments at his abbey with murals, and employed a court wall painter, Thomas of Westminster, so attentively that Thomas was able to bargain hard with Edward II's officers for his expenses when they needed him again at Westminster in 1308 to redecorate the royal apartments for the coronation.[3] The Psalter certainly represents the most sparkling and erudite-seeming possibilities of book art of the day. Its finest hands, those responsible for the opening typological miniatures and the first Psalm (pl. 270), are indeed worthy of the English court. There is some question as to whether this book, full of seigneurial jollities, hunting, wildlife and japes, had not already been under way before 1299 for another patron.[4] One small but neglected piece of evidence suggests that it had been finished before or around 1308: according to later medieval French inventories, it had originally included the English royal coronation order, bound in at the end.[5] Since Abbot Geoffrey generally enjoyed royal favour, the addition of the coronation order, presumably that used at the coronation of Edward II in 1308, was a mark of loyalty and seniority, and it is around then that one might expect a memento of the ritual to be found. But whatever the initial plan, a Benedictine abbot with a crosier was depicted in prayer on folio 13v before the opening of the Psalms, and a monk kneels behind a priest at Psalm 101, *Domine exhaudi* (fol. 65), some-

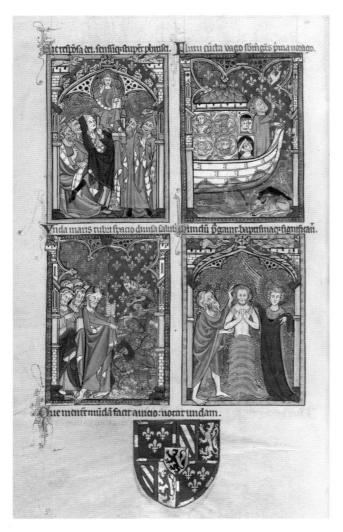

271 Peterborough Psalter, typological scenes, *circa* 1310 (Brussels, Bibliothèque royale de Belgique MS 9961–2, fol. 24v)

272 Citole, *circa* 1310 (London, British Museum)

times an appropriate place to invoke a book's patron or community. Prayers to St Guthlac of Crowland and St Pega were carefully added in a final section.[6] The manuscript's most significant illuminations include an entire sequence of 109 typological miniatures interspersed throughout the Psalter at the traditional liturgical divisions (pl. 271) – nothing like this had been seen since the twelfth century, yet the miniature scale speaks of less expansive times.

For all its courtliness, there is every reason to think that the Psalter's illuminations at least were planned locally, even if much about the book points to some link with the court. Its decoration reveals much about variety, pictorial authority and the relief of monastic tedium, but only when it is placed in its immediate context of intended use. Psalm 1

on folio 14 of the Psalter opens up a traditionally brilliant spectacle: nimble King David with his harp and musicians and birds, the frame showing at the top Reynard the Fox running away with juicy poultry in its mouth, an ape galloping backwards on a ram, with their pet owl a few inches away; and then *David and Goliath*, a man on stilts, hunting scenes and yet more wildlife, a paradise of ecology and blissful good cheer – *Beatus vir*, happy is the man, indeed. The setting, content and general texture of this border closely strike the same courtly jocular tone as the minute carvings with hunting scenes, a centaur and animals on the early fourteenth-century boxwood gittern or citole, framed with rows of quatrefoils, later owned by Elizabeth I and the earl of Leicester (pl. 272).[7] But one of these themes is also

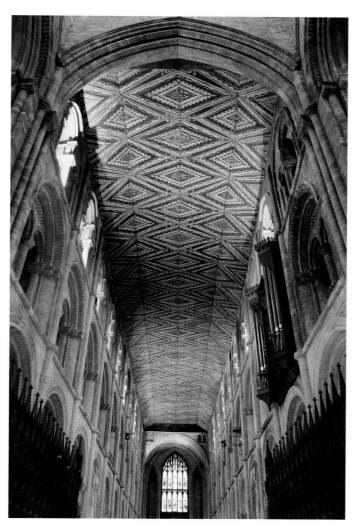

273 Peterborough Cathedral, nave ceiling, looking west

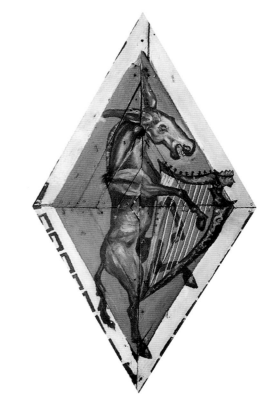

274 Peterborough Cathedral, nave ceiling, ass playing harp, *circa* 1240

275 Peterborough Cathedral, nave ceiling, ape, owl and goat, *circa* 1240

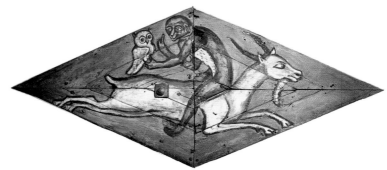

found nearer to hand, on the painted ceiling over the choir and nave of Peterborough Cathedral (pl. 273): the ape, riding backwards on a ram (or goat), holding and addressing an owl. The later progress of this particular image has already been noted in discussing borders. At the abbey it formed part, in fact the more riotous part towards the east and over the choir itself, of an entire sequence of paintings on the choir and nave vault begun most probably during the abbacy of Walter of Bury St Edmunds (1233–45) (the oak planking of the ceiling is dated by dendrochronology).[8] The decorous elements in the nave scheme further west consisted of images of kings, churchmen and (unusually) the Liberal Arts. Over the choir entrance, however, there gathered semi-naked fiddlers, the ass and the harp (pl. 274),

wyverns and grotesques mixed in with the *Agnus dei*, St Peter (the patron) and the ape, owl and goat (pl. 275); a fox, possibly Reynard, had also been intended for one of the decorative panels. Here was a pot-pourri of institutional, humanistic and satirical themes, *impossibilia*, 'antics', or what William of Malmesbury called 'Roman salt' – salacious, witty, mad or droll stuff which, through its variety, alleviates tedium.[9] Perhaps similar themes had once adorned the twelfth-century cloister capitals at Norwich.

What appeared on the pages of a great fourteenth-century Psalter had therefore been rehearsed even more ambitiously, but much earlier, in great church decoration. Some of the grotesque material might have been just as appropriate to the ceiling of some secular house (similar panels survive from a contemporary painted ceiling once in the Hotel du Voué in Metz, *circa* 1225; now Museés de Metz). But mixtures, puns and weird combinations of this type were no less part of the orthopraxis of monasticism itself, in which the outrageous or impossible served to set the reader or viewer 'straight' – a not inappropriate function for images prefacing the heart of the monastic office at Peterborough.[10] Such work, however jolly and vigorous, thinks about style itself. So the musical silly ass is a sign of vanity, of the usurpation of 'learned' music by the stupid. The leaping goat, monkey and owl are a conscious play on 'satire' and 'satyr', the goat that jumps about, for satire as a literary form jumps about in the fashion of a goat because it has no circumscribed theme, or flowing rhythm.[11] The ceiling as a whole has no theme or rhythm since it is a miscellany or medley, and in the medley lies a sort of pleasure. Near-nakedness is not just commonplace cheekiness, but emblematizes unadorned or unembellished style, as opposed to learned style, and so on. This is one reason for being cautious about assuming that jocularity, even linguistic mix, was not a feature of monastic and clerical culture before its traces in vernacular artefacts later on. The unusual treatise *Pictor in carmine*, written in England a generation or so before the ceiling at Peterborough was painted, refers specifically to painters (not carvers) introducing into churches such salacious themes as the 'fabled' story of the fox and cock, monkeys playing the pipes, Boethius's ass and lyre – topics that, the treatise says, make free 'as they say' with money, spending it on jokes (*jocosos*).[12] St Bernard's principal anxiety about such jokes – certainly invoked here – concerned pride and money. Were proverbial Latin comments about the emptiness of money spent nonsensically in fact the basis for later vernacular sayings such as 'Pay me no lasse than an ape and an oule and an asse'?[13]

Pictor in carmine, the Peterborough choir and its lavish Psalter also exhibit the same fundamental and mutual relation of satire to allegory, because they all use typology, the juxtaposition of events in the Old Testaments with those in the New that they prefigured. In *Pictor in carmine* the relation is both rhetorical and polemical: typology, revealing the gravid inner significance of God's plan, is the antidote to empty nonsense; yet nonsense paves the way rhetorically. At Peterborough the relation is in a sense more relaxed. The ceiling was probably painted at the same time as new painted choir stalls were made by Abbot Walter, showing long typological sequences whose captions indicate that their content is reproduced also, if physically awkwardly, in the Peterborough Psalter itself.[14] Walter simply (and not necessarily directly) reproduced something like the rhetorical plan of *Pictor in carmine* and so showed how the Benedictines saw not an opposition, but a fundamental continuity, a kind of useful tension, between allegory and satire, which was to revive in the fourteenth century as satire took over from the old way of reading.[15] The Peterborough typological scenes and captions (see pl. 271), copied from the choir or something very like it into the Psalter, certainly derived at least indirectly from the much older programme of typology in the stained glass at Canterbury Cathedral conceived as part of the high theological thinking of that and other monastic churches of the eleventh and twelfth centuries such as Bury and Worcester.[16] It occurred as a way of arranging things in the thirteenth century, though less frequently.[17]

So what is seen in the Peterborough Psalter is in effect a reiteration of an immense set of typological scenes of a type developed at Canterbury and perhaps transmitted via the choir-stall paintings at Peterborough or some common model. It would not be quite right, however, to see in the Psalter itself a 'revival' of a lost and now-distant way of allegorizing. The Psalter does what many books of the period did, namely compress into a world of *multum in parvo* a summary of something undeniably older and larger that possessed a kind of auratic greatness – for typology was the heroic mode of pictorial theological allegory, part of something present and continuing within western symbolism at large. The shift from great church concept to miniature format is, in one sense, symbolic of trends of the time, the slippage from Brobdingnag to Lilliput. And it was quite right that a great Psalter, perhaps for the abbot's stall in the choir, should be that choir's microcosm and at the same time the collation, the summoning, of an entire tradition; if the Psalter made play with the choir's own relationship of satire and allegory, all well and good.

This relation of church and book is treated eloquently by a friar, John Bromyard, in a passage in his *Summa predicantium* in which the beauty of a church – that macrocosm of the soul – is held to lie not only in its planning and wall paintings 'but also in plentifulness (*copia*) of books used in the divine liturgy'; it is as if the books were part of the moral order of the building.[18] Bromyard is here thinking tropologically (or morally) in a way that sustains an argument made throughout the present book, namely that one

can and should read across from one art form to another as well as from great to small, because that is what they did. Paul Olson, who first noted this passage, also concluded not unreasonably that the idea that books speak as eloquently as buildings may furnish one understanding of the use of micro-architecture in illuminations such as those in the Peterborough Psalter. The whole work of art 'spoke' of Peterborough. In gift exchange, such a book would carry the house's reputation for learnedness (however specious) and delicacy of sensibility far afield, in this case as far as Avignon. Its Bible allegories were one part of a gathering stream, ever present, occasionally strengthened, but not in need of 'revival'. Typology – as the ascent of the *Speculum humanae salvationis* was about to prove – was not in need of resurrection in the fourteenth century: typological thinking about number and symbol could inform (in the deepest sense) a building such as the Lady Chapel at Ely, as has been seen.

In fact, Peterborough Abbey, for all its imagery of the Liberal Arts and typology, had no special reputation for learning. Nobody at Peterborough Abbey drew up so spectacular a list of Marian miracles as that compiled in the same century at the smaller local house of Thorney, and the secular wall paintings in Longthorpe Tower near Peterborough are as well informed in encyclopedic terms as anything at the abbey church.[19] But learning of the allegorical sort had cachet in another sense – a sort of nobility. No later than Chaucer's time the literature of estates satire – the saucy version of tropological thinking – sets out a contrast between knowledge of proper form and lewdness, expressed most vividly in the even later sequel to the Canterbury Tales known as the *Tale of Beryn*.[20] In the tale, differences of social degree – supposedly ironed out by pilgrimage – are cruelly exposed at the very moment pilgrims arrive at Canterbury Cathedral, since it is at its door that 'curtesy gan to rise' (l. 135). The gentle knight, understanding protocol ('the guyse'), went straight up to the shrine; but those 'lewde sotes' the Pardoner and the Miller lurked around in the body of the church 'right as lewde gotes' feigning, as if they were gentlemen, to be able to work out the heraldic and other contents of its stained glass ('for the story mourned') (ll. 147–57). Goatish ogling is not the same thing as smooth, seigneurial comprehension: allegorical insight is noble, its lack a social embarrassment.

No one who has been completely thrown by the contents of some stained-glass window will fail to sympathize a little with the 'lewd gotes' visiting Canterbury. By the earlier fourteenth century, even the authorities at Canterbury felt it necessary to transcribe the various Latin inscriptions in the more difficult typological windows and themselves either made mistakes or recorded disordering already apparent in the glass even then.[21] Heraldry, like religious allegory, was beyond the ken of everyman. But of the sustained power of this stained-glass art there is no doubt. The Canterbury windows remained the most complex statement of the interlinking of typology, of which they contained a great deal, and genealogical and allegorical representation: the typological windows in the choir ran beneath a long biblical genealogy of Christ drawn from Luke and Matthew in the clearstory above, and the east corona chapel contained a *Tree of Jesse* and further typological subject matter of a priestly sort.[22] The sheer rooted authoritative power of Canterbury, its biblical genealogy especially, is witnessed by its successors in more than one medium: ensembles as diverse as the thirteenth-century west front and the stained glass of the fourteenth-century choir of Wells, the cocky line of armed males holding the lordship of Tewkesbury in the stained glass of the choir clearstory in the abbey there (pl. 276) and the founder imagery on the nave ceilings of the abbeys of Peterborough and Glastonbury (under Adam of Sodbury, 1322–34) all probably took Canterbury's glass or vault paintings into account and transformed them creatively.[23] Images of continuity, authority, lineage or blood line were, after all, astonishingly permeable and versatile, and translatable into new terms by visual grafting and cross-reference. The Tree of Jesse is found with the image of the Holy Kinship (addressing the issue of Christ's 'brothers') in the Queen Mary Psalter between folios 67v and 70; the Egerton Genesis, discussed later, depicts the descendants of Adam at folio 2.[24] Such images served new purposes, connecting allegorical thinking with a sort of intensification of interest in identity – particularly institutional consciousness typical of the historical traditions of fourteenth- and fifteenth-century English monasticism.[25] The Benedictines had themselves created a 'Tree' of St Benedict whose roots sprang not from Jesse, but rather from the saintly founder, as in the beautiful representation in the Sherborne Missal, to be understood as what Julian Luxford calls a 'demonstration of antiquity'.[26] The affinity between the less ascetic forms of monasticism and aristocratic ideals of blood line invested in the shield and the tree is apparent: a similar emphasis on continuity and with it an exclusive suspicion of the rootless upstart and outsider.[27] The imagery of the military order was related to this visual means of displaying social *taxis*.[28]

The Tree of Jesse and its derivatives, clearly of great antiquity yet still full of vitality, expressed something both

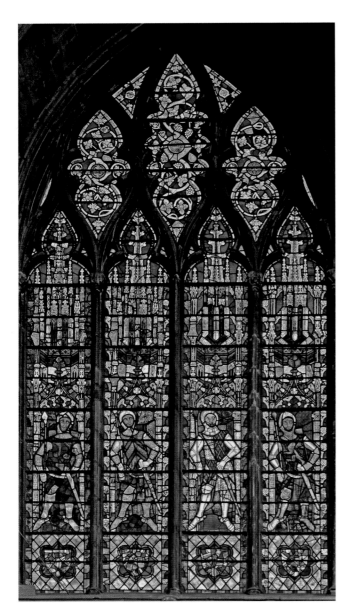

their late medieval history was also distinguished.[29] A ludic engagement of stone, tree and glass is made explicit in the Tree of Jesse window made for the Augustinians at Dorchester (see pl. 137), which, as has already been noted, 'switches' from one medium to another.[30] The inventive ambiguity this entailed proved both hugely enjoyable and productive in the fourteenth century. The powerful drawing of St John the Baptist of *circa* 1330 at the start of an academic book from St Augustine's Abbey in Canterbury (now British Library MS Royal 10.B.XIV) (pl. 277) places the saint beneath an extraordinary arch consisting of two flexed and conjoined skinny oak trees: the whole thing is magnificent in its thoughtful roughness.[31] The formal language of this isolated leaf brings to mind the fantastic over-scaled tree and plant life of the Holkham Bible Picture Book (British Library MS Add. 47682) of the same generation, as in its

277 John of Dumbleton, *Summa*, St John the Baptist, *circa* 1340 (London, BL MS Royal 10.B.XIV, fol. 3v)

276 Tewkesbury Abbey, choir clearstory, nobles holding the lordship of Tewkesbury, 1340s

imaginatively vivid and also aesthetically pleasing to four-teenth-century taste. There was a satisfying harmony between the motif and the contemporary preference for thick, lavish spreading foliage devices in almost all media, and the tendency even of window tracery to bend and sway as if pliant or organic. Transpositions of this type – as it were between stone and living wood, so creating interesting ambivalences – had already provided food for aesthetic and theological speculation in the thirteenth century and earlier;

278 *(left)* *God Creates the Animals*, Holkham Bible Picture Book, 1330s (London, BL MS Add. 47682, fol. 2v)

279 *(above)* Christchurch Priory (Dorset), reredos, *Tree of Jesse* with the *Adoration of the Magi*, mid-fourteenth century (for the context, see pl. 51)

robust page of God creating the animals (fol. 2v) (pl. 278) and the pair of genealogies on folio 10–10v, first the Tree of Jesse and then the genealogy of Joseph on the verso.[32] A mighty Jesse Tree opens the Psalms in the great Ormesby Psalter, discussed shortly (see pl. 291).

But the true fourteenth-century victory of genealogy (especially after 1325 or so) was on the grand scale, at the heart of sanctuary itself, as sanctioned by the ancient Jesse Trees at Saint-Denis and Canterbury, centres famous for connecting the imagery of the Old and New Law. The Augustinians at Bristol, Christchurch (Dorset) and Dorchester explicitly promoted the Tree of Jesse for main east windows or, as at Christchurch, the new large stone altar reredos compositions appearing in the middle of the fourteenth century (pl. 279); the Benedictines at Selby Abbey filled its flowing east window with the same image (see pl. 140); and perhaps the most harmonious of all was elected by the canons of Wells for the east window of their new choir (pl. 280): here, as previously at Dorchester, the tree supports the Virgin Mary and above her the Crucified

Christ.[33] Lucy Sandler has drawn attention to the coherence of the imagery of prophets and ancestors in the Dorchester Jesse window with other representations of the Augustinian community in works of art under their patronage.[34] In the image was found not merely a fecund and satisfying complement to the artistic fact of window tracery spreading and germinating across the surfaces of Gothic churches, but also a means of epitomizing devotion to Mary and Christ as a noble and ennobling activity continued in great religious houses. At the centre of a more mobile social and economic scene was established (not coincidentally) an image of extraordinary rootedness, deep and well nourished.

Copia

Nobility was vested in English allegorical and narrative picture making in regard both to the learnedness of such pictures and also their sheer extent. The typological pictures in the Peterborough Psalter belong to a substan-

313

280 Wells Cathedral, choir east window, *Tree of Jesse*, 1340s

tial and venerable English tradition, certainly inaugurated before the Conquest, of prefacing the Psalter with Bible pictures from the Fall to the Redemption, or interspersing them through the body of the Psalter at the liturgical divisions.[35] Some such picture cycles are epitomes, wonders of compression or *abbrevatio*; but others are manifest instances of thoroughness or *amplificatio*, and their often high, actually courtly, social context should be noted. The depth of thinking of English Bible illustration since Aelfric's Pentateuch and Book of Joshua was acknowledged by continental European book illuminators throughout this period. An instance would be the extraordinary Bible picture book in the Pierpont Morgan Library in New York (MS M638), made by northern French or Parisian illuminators around 1250, filled with lavish, dynamic and often deliberately paced pictures of the Old Testament down to the books of Kings, and in part informed by English formulas.[36] It is impossible to believe that such a book was made for someone without very considerable means, not least because unlike many extended picture cycles of this sort, this work, though now

281 London, Westminster Palace, Painted Chamber, story of Judas Maccabeus, originally probably 1292–7, engraved after watercolour copy by Charles Stothard, 1819 (*Vetusta Monumenta*, VI)

incomplete at the end, was finished technically in full colour to a very high level. There can be little doubt that the French court itself re-energized the production of Bible picture making in the wake of the heroic achievement of the Moralized Bibles of the first half of the thirteenth century: the prefatory pictures in the St Louis Psalter and its sister in Cambridge (see pl. 91) belong to an 'English' traditional format while breathing a particular choreographed elegance into the stories.[37]

The long-standing vigour of English Bible picture making and the new courtly French mode were both attested to in the oil-based wall paintings drawn from the Old Testament in the Painted Chamber or *camera depicta* at Westminster Palace executed at the end of the thirteenth century.[38] These pictures were remarked on by two Irish friars (p. 4) in 1323, the completeness of their painted inscriptions and the general splendour of the whole eliciting from the friars the stock, but still telling, phrase *maxima regali magnificentia* – 'the greatest royal magnificence'. Looking at the scale and content of the Westminster pictures as copied one can see why: 240 metres of continuous Bible narrative arranged in registers up to six deep, with French inscriptions, of which nearly 120 metres were drawn from the first book of Maccabees alone – the longest such sequence known in all art. Such ambition is almost imperial, but it could not have been easily realized without the already substantial, and specifically English, tradition of lengthy Maccabees illustration in the pre-Gothic period. Other pictures were drawn from the books of Judges and Kings. The Painted Chamber was in effect a vast homily on the nature of kingship,

including manifest tyrants and their dismal outcomes. The roll-call of the Good and the Bad depicted in the chamber, also the king's bedroom, deserves record: Alexander the Great, Antiochus Epiphanes, Judas Maccabeus (pl. 281), Nicanor, Ahaziah, Elijah, Elisha (see pl. 98), Gehazi, Naaman, Eliakim, Hezekiah, Isaiah, Sennacherib, Nebuchadnezzar and Nebuzaradan (see pl. 99), Zedekiah, Abimelech (pl. 282), Joab, Abner, and probably Saul, Holofernes and Pharaoh (much of the material had been lost by the early nineteenth century when the pictures were first revealed). The important point is that the thinking was not simply pictorial: many of these figures were part of a substantial and venerable tradition of English literary and expository Bible reading, whose roots lay first in clerical political commentary on the hazards of royal power, then in actual anti-

282 London, Westminster Palace, Painted Chamber, story of Abimelech, originally probably 1292–7, engraved after watercolour copy by Charles Stothard, 1819 (*Vetusta Monumenta*, VI)

315

royal discourse under Henry III, and finally, and subtly, within royal reading and storytelling itself: their late medieval fortune was to guide the heirs to the throne, the princes of Wales, in steering clear of the vices of tyrannical rule. With the exception of the Maccabees such biblical figures had not formed a major part of English or European Bible iconography. Yet the medium mattered, even if it was not the message. Genres – less tightly defined in the medieval period – change and evolve, but the rhetorical power of wall painting in impressing upon the courtly and the educable young the realities of power was not only being acknowledged in Italian fresco painting. It had been valued at northern European courts since the Carolingian emperors had decorated their palaces in the heroic mode of conquest and great deeds; it was an old but living form of public speech. To think of a 'revival' of past standards is misleading. Neck-cricking scale, dazzling and glittering colour, completeness and fullness were unchanging techniques for eliciting admiration and attention for that which was noble, and in their minds, true.

It is important to stress the charismatic and noble dimension of this extraordinary public display at Westminster – one exceptional I think even in its own time – because these features are lost sight of in the headlong intellectualist pursuit of iconographic sources by recensionists seeking out transmission and origins: this technique obscures vital issues of context, generic development, invention and artistic impact – in a sense occludes what made such works authoritative or powerful beyond their role in the handing on of subject matter. As I stated earlier (p. 77), to trace a 'source' is not to proffer an explanation for its use either in architecture or painting. The power of art objects is not understood by picking them apart, or by neglecting to see that long-standing traditions of image transmission also admitted significant scope for inventive departure.

Copia is a word related only partly to the idea of 'copying': its first sense, known from rhetoric and from Renaissance writing especially, is that of fullness, plentifulness, the visual virtue of largesse of effect.[39] Earlier it was seen that Bromyard used the term with reference to books. Books, small things, could attain to the great through sheer profusion, and it is from the early fourteenth century that a number of books survive, at least two of which were almost certainly of royal rank, with quite extraordinary copiousness of pictorial coverage of the Bible: the (monastic) Tickhill Psalter (New York Public Library MS Spencer 26), with more than 480 Old Testament pictures from the books of Genesis and Kings; the (royal) Isabella Psalter, covering the books of

Genesis to Kings; and the (also royal) Queen Mary Psalter, with more than 220 Old Testament scenes also from Genesis (see pl. 283) to Kings, to say nothing of New Testament material. Here is the same emphasis on *amplificatio* and, incidentally, the same eclecticism of sources as the Painted Chamber.[40] Michael Kauffmann saw these books as offering a thoroughness 'unrivalled since the eleventh century'.[41] The frequent, if not exclusive, use of the page bottoms for such little scenes, the *bas-de-page*, is notable. Even modest provincial artists in eastern England, such as the one who around 1300 drew episodes from Kings on the reverse of the early thirteenth-century Guthlac Roll from Crowland, knew and admired the thirteenth-century French court versions of these topics.[42] In fact 'provincialism' as an idea may not help here. In discussing the no less copious sculptures of the life and miracles of the Virgin Mary in the Lady Chapel at Ely, it was noted earlier (p. 212) that the immediate pictorial analogues are found (again) in the *bas-de-page* images in the Queen Mary Psalter, the Smithfield Decretals, the Carew-Poyntz Hours and the Taymouth Hours (see pls 175, 176), works whose orbit of production was London and eastern England. The cause-and-effect relationships of these fully developed sequences is obscure because it is clear that ideas moved quickly and fluently; but the conclusion that the authors of the Ely Lady Chapel sculptures, working under the impresarios of the Ramsey Company, had contacts with the illuminators seems inescapable. It is not obvious that a single centre alone preserved the core information: indeed, what form this information might have taken is itself an issue.

Authenticity: Mind Painting

Fullness of treatment, then, was one aspect of a book's or mural's claim to attention. A very fully illustrated book paid homage to traditionally extensive narrative by emulating or surpassing it in scope and magnificence, as well as taking its actual pictorial content into account. This was presumably what John Bromyard meant by painters 'who diligently ponder beautiful images in order to make similar ones: they gather together one excellent beauty and treatment from one picture, and one from another, in such a way that they place all these excellent features in one most beautiful picture' (p. 66). Another aspect of such treatment was subtler, more complex: it concerned the authenticity or authority of the images depicted. As a rule, authority and authenticity lay in long-established but continuing solutions: *Novi libri*

non sunt ita veraces sicut antiqui, 'New books aren't as true as old ones', as Bromyard also said in the *Summa predicantium*.[43] Richard of Bury, presumed author of the *Philobiblon*, agreed: he preferred the well-tested labours of the 'ancients'. As Alastair Minnis concluded of this general outlook, 'it would seem that the only good *auctor* was a dead one'.[44]

But there was a problem: what if the established *auctores* simply did not provide a large enough repertory of subject matter for modern needs? This issue was illuminated by Beryl Smalley's study of English friars and antiquity in the fourteenth century.[45] In order to understand one aspect of the pre-humanist approach to antiquity itself, Smalley addressed the use made by friars of sermon *exempla* drawn – or so they claimed – from classical literary or visual sources. The context for this was the increasing importance of mendicant Bible study and the public demand for sermons, which provoked the preachers into ransacking secular historical and classical sources in order to cater to a lay need for material, in a freshening up exercise of sermon content.[46] A product of this 'challenge to the preacher' was a veritable cult of storytelling that had to be at once racy and new, yet based in some claim to authority: the use of antique stories was demand-led.[47] Ideally, sermons would possess the vivid stamp of their authors' styles, including a suitably entertaining *varietas* in their choice of pleasure-giving anecdote. The analogy between virtuosic sermonizing and the use of showy pricksong in the liturgy was not lost on critics of the period such as Pierre de Baume.[48] Pierre stated: 'Similarly in the old days sermons were such as to profit the people. But now, they have rhymes and curious comparisons, and philosophical subtleties are mixed (*immiscentur*) with them.' Mixture was a means of making things pleasurable and hence it was also suspect to some.

To boost the imaginative life of sermons entailed enlarging their *imagines rerum*, their mental stock of material, in that process of mind painting known to rhetoricians as *enargeia*, the conjuration of pictures in the mind as if before the eyes.[49] Extraordinary light is shed on this conjuration in the mind by Smalley's discussion of the use by English friars from the late thirteenth century of imagined 'pictures' of topics, typically allegories or personifications. She had in mind aspects of the work of John of Wales and, later, John Ridevall's *Fulgentius metaforalis* and Robert Holcot's *Moralitates* and commentary on the Minor Prophets, probably work of the 1330s.[50] The technique – actually a formula taken from late antique mythography – is to cite some supposititious ancient literary source describing a figure as if it were a painting in order to bring it to mind verbally.[51]

Such images are common in Holcot's writings, and include Holy Scripture with the Liberal Arts, the Three Graces, Bacchus, *Fornicatio* and so on; they seem to be used both of the image of virtue and vice.[52] John Ridevall brings idolatry to mind by saying: 'It can be noted how the ancient poetic picture of this greatest of sins, idolatry, agrees with Fulgentius' procedure in his series of myths. This was the picture of Idolatry according to the poets.'[53] The notion of a Judaeo-Christian concept vested in antique painting is at one level incongruous, but it is also memorable in its strangeness. Holcot, following Ridevall and Fulgentius, summons up the image of Idolatry while preaching on the Minor Prophets, but in such a way as to imply that he placed an illumination in a book at the head of a chapter of the Bible:

> *In fine capituli, super illam literam Noli letari ubi loquitur de idolatria, pono picturam antiquorum de idolatria. Depingebatur enim quasi mulier notata, oculis orbata, aure mutilata, cornu ventilata, vultu deformata, morbo vexata.*

At the end of the chapter, above the text *Noli letari* [Hosea 9:1] where idolatry is spoken about, I put a picture of Idolatry as made by the ancients. She used to be painted as if she were a woman of infamy, with bulging eyes, ragged ears, dishevelled hair-do, distorted face and riddled with disease.[54]

Of such visions of loveliness, Smalley instructively uses the expression '"genuine" sham antique' to capture the authentication strategy at work.[55] No such pictures ever existed, of course, though much later actual illustrations were squeezed out of the Ridevall–Holcot tradition. They did not need to exist: it was enough that their catchy rhyming invocation and eclectic drawing together or collation of striking attributes could furnish a persuasive and memorable mental image, better, in fact, than an actual image in the same way that pictures are better on radio. To understand that this is intended to be mind- not brush-work, it might be as well to set next to them an instance of the period drawn from an actual set of instructions to an illuminator to make pictures, taken from an instance of one of the main pastoral texts of the time, the *Somme le roi* (Hanover, Hannover Niedersächsiche Landesbibliothek MS I. 82), of *circa* 1300.[56] One of a number of instructions in this book is intended to describe a scene of the Apostles composing their Creed:

> *Ci doivet estre le .xii. apostre ensenit et enmi eius doit avoer un libre sus un letrin vuert e chascun i doit mostrier a un doi*

por devisier le credo. e desus le livre doit auoer un colump descendent du ciel qui par le bec giete senblance de feu qui descent sus chascun des apostres [fol. 10]

Here should be the Twelve Apostles seated and amidst them should be an open book on a lectern, and each [Apostle] should point to it to compose the Creed; and above the book should be a dove coming down from heaven which spouts from its beak the likeness of fire which descends upon each Apostle.

Why a description of this length would be preferable to an actual picture is obscure, unless the text was itself thought to be a self-sufficient prompt to devotional contemplation. The differences with the rhyming Holcot passage are clear. The French text does not trip along so memorably or self-sufficiently, and nor does it press a claim to antiquity: this was apparently part of the game, albeit one handed down from antique mythography itself. It can be said that, in each text, picture making is a verbal activity that conveys how images could move as texts, as textual memory work, not as pictorial recensions. The *Somme le roi* texts – though based on a quite new set of pictures in 1300 – are in fact understandable within the older tradition of *hermeneia* writing (texts such as that of Dionysius of Forna) that set out quite full verbal prescriptions for images to be painted, which presumably could be committed to memory.[57]

The *hermeneia* tradition claimed (implicitly) to preserve the authority or authenticity of images. But thirteenth- and fourteenth-century image makers in northern Europe were radically extending the established pictorial repertory beyond what was obviously stable or authoritative. The contextual explanation offered by Smalley in regard to the 'challenge' to preachers to expand and freshen up their sermons by new mental images or *exempla* might be a guide to understand better the wider economy of image making of the period. What Smalley is really describing is something that goes beyond sermonizing to a more general demand-led crisis of inventive resource. Ransacking old books or pictorial resources and breathing new life into them was one option: after 1300 conventional Bible iconography was sustained at a level of thoroughness not always seen in the thirteenth century. But to conjure up images Holcot-fashion is to imagine something else: a vast realm of picture making without actual long-standing authority, yet in regard to which the claim to authenticity still carried weight. Indeed, one might say that the more fantastic the origins, the greater the need to authenticate them. The image that possessed authenticity, but not tradi-

tional authority, was a growth area of the period. Its realm was expanding hugely in the later Gothic era as developments in public liturgy and devotional practice produced altogether new types of images beyond the existing repertory, or radical adaptations of images developed elsewhere. Consider, for instance, the Apocryphal material of a 'controlled' sort that was used to flesh out the narratives of Christ's childhood and Passion, or Mary's life and miracles, apparent in the Holkham Bible Picture Book and the Lady Chapel at Ely.[58] The dual (and possibly related) drive to cater for the cult of storytelling and for new devotional practices placed artists in a position where they had to expand their inventive repertory either by *amplificatio* – filling out what they already had to hand – or by finding out altogether new stuff, as with the *Pietà* (see pl. 289) and the image of Christ with St John sleeping on his bosom: here German or Italian art proved of interest to them.[59] A pictorially curious culture would quickly become international. Images tended to become more developed, more interstitial (as it were, filling up the narrative gaps left by canonical textual tradition), or just longer in narrative content, not shorter: in contrast the recensional approach to narrative iconography, based on an idea of a lost Golden Age of thoroughness, often assumed the reverse, a decline into abbreviation and a sort of incompetence.

This is not the message conveyed by the luxurious fullness and lively originality of English religious art of the fourteenth century considered generally. Its eclecticism and relentless seeking out of the new, amplifying and representing that which was already known and regarded as authoritative but at the same time engaging in absolutely unexpected departures, was the inventive scenario of the visual arts and especially architecture.

Genesis

It is known from the career of authors such as the friar Holcot, and indeed from the history of book art generally, that comparatively new centres of learning such as Oxford, as well as courts, played a role in this culture of pictorial eclecticism and amplification, imagined or real. I have already pointed to the importance of this sphere in the development of border ornament in book illumination. Often an artist or centre important in one regard was also important in others. No satisfactory explanation has been offered, for instance, of how it was that the mid-thirteenth-century Oxford illuminator W. de Brailes, an important

figure in the history of marginalia as well as the development of the English Book of Hours, gained access to, and assimilated so intelligently, rather older stocks of English Bible iconography: but I think here the point about inventive hunger holds true.[60] De Brailes either saw, or had conveyed to him verbally, Bible pictures of a type found in earlier thirteenth-century devotional manuscripts possibly produced in the Oxford or St Albans area such as the Munich Psalter, Huntingfield Psalter and Lothian Bible; but he seems also to have encountered the yet older English traditions embodied now in the Aelfric Pentateuch and Caedmon manuscripts.[61] How this happened in Oxford is unknown; but that this body of knowledge mattered still in the fourteenth century is shown by two extraordinary illuminated manuscripts, the courtly Queen Mary Psalter of *circa* 1310–20, executed it is not known where, and the so-called Egerton Genesis (British Library MS Egerton 1894) of the 1350s or so.[62] Perhaps Oxford was a good place to compile pictures physical and mental, since W. de Brailes, John Ridevall (incepted at the Oxford Greyfriars *circa* 1331) and Robert Holcot (Oxford regent 1332–4) were 'university' men.

If the Queen Mary Psalter in its languid, somewhat stereotypical style and Old Testament imagery speaks the language of the French court, the Egerton Genesis (see pls 284–7) fits in almost nowhere, at least in any vision of English art of the period governed by artificial notions of genre and canon. Its frank depictions of sexual activity completely threw (and fascinated) its earliest commentator, M. R. James, for sex is to this manuscript what gratuitous violence is to the Morgan Bible Picture Book. As it survives, the manuscript consists only of twenty folios illustrating Genesis 1–44 in nearly 150 scenes, breaking off in the midst of the story of Benjamin. It may not be complete – it was certainly unfinished technically – and in its present state brings to mind the ninety-odd recorded *tituli* to a sequence of undated Genesis pictures painted 'in and around' the choir of the abbey at Bury St Edmunds, which also ended (probably coincidentally) with the story of Benjamin.[63] But, judged in themselves, it is uncertain whether these pictures would have formed an unusually thorough set of Psalter prefatory pictures – the size is not inconsistent with such a function – or a Bible picture book, in this case captioned in part with a French version of the *Historia scholastica*.[64] The whole concept of the 'Genesis' manuscript as a genre, as represented by the Anglo-Saxon Caedmon and Aelfric manuscripts, is problematical.[65] That the Egerton book is English is beyond dispute, partly because the same hand has

been recognized in other English books to be discussed shortly, and partly because only an English artist would conceive detailing like that of the little ciborium, still being carved with ogee arches, battlements and spires, shown over the altar at Hebron on folio 8 (see pl. 286, lower right).

But that something out of the ordinary was also at work in the Egerton manuscript was already spotted by James, and was given further intellectual standing by Otto Pächt, who placed the book in the internationalist context of the impact of *trecento* Italian art and also Early Christian Bible iconography, most notably the so-called Cotton Genesis tradition.[66] Pächt regarded the Egerton artist as a maverick, whose art was 'understandable . . . only on the assumption that [he] had been to Italy itself'.[67] Other commentators were more circumspect, seeing the artist as an eclectic compiler: Henderson remarked that he:

was gifted with a remarkably inquiring and acquisitive mind, who borrowed as he saw fit from pure Anglo-Saxon tradition, from English thirteenth- and fourteenth-century tradition, from Jewish and from mature Italo-Byzantine tradition, from the Cotton Genesis tradition as modified and interpreted by the thirteenth-century mosaicists at San Marco [in Venice], and from the authentic Cotton Genesis tradition itself as recorded, perhaps, in some manuscript preserved in England or Italy.[68]

In this activity of borrowing, works such as those by W. de Brailes and the Queen Mary Psalter may have figured: the Egerton book cites the same rendition of the story of Lot as is presented in W. de Brailes's Bible pictures, and its artist perhaps allowed the Queen Mary Psalter's picture of the embarkation of the Ark to mould that of his own image of the disembarkation (pls 283, 284).[69] Indeed, the length of the Queen Mary Psalter's prefatory pictures might have been a stimulus in itself. The Egerton book resulted from a kind of active reaction to different traditions rather than a passive obeisance to one great one; as books go it was a fox, not a hedgehog. One is inclined to think, if only in passing, of the eclecticism of Ridevall's and Holcot's various 'pictures'. More generally, the model of collation and rumination at work here is very like that posited for invention in architecture in regard to older authoritative buildings posed earlier in this book.

Perhaps the Italian 'look' was itself an aspect of the sense of authenticity that such pictures sought. The case for Egerton's knowledge, *inter alia*, of some Italian work, either monumental painting in Italy or some impressively finished book, is extremely strong. At folios 5v–6, the book includes

283 Queen Mary Psalter, Noah's embarkation, *circa* 1310–20
(London, BL MS Royal 2.B.VII, fol. 6v)

284 Egerton Genesis, Noah's disembarkation, *circa* 1350 (London,
BL MS Egerton 1894, fol. 4)

two sequential images of the Tower of Babel, one in build-
ing and the other in destruction (pl. 285), which look like
a citation of the same Cotton Genesis-derived pictures in
the mosaics of San Marco.[70] This suggestion is not especially
unrealistic: in 1323 the two Irish friars who passed comment
on the Painted Chamber at Westminster and the Sainte-
Chapelle on their way to the Holy Land eventually encoun-
tered the 'most sumptuous' church of San Marco (see pl.
123), with 'Bible stories adorned with exceedingly good
mosaic work' (*biblicis historiis opere mosaico excellenter ornata*).[71]
Mendicant connections would be one obvious route. What-
ever the study of Italian images entailed for this artist, it
was close and quite sensitive to idiom. The spare, austerely
vacant compositions of the Bible pictures, with figurative
scenes partitioned in the lower half of many of the images,
are reminiscent of the treatment of space in the legend of
St Francis painted before 1297 in the upper church at Assisi.
Only a very sharp-eyed artist and equally attractive object

of study could explain the nobly Giottesque figure of Hagar
in the wilderness on folio 9v, the sniggering Shem and Ham
on folio 4v, the archaic little vignette of shepherds on folio
8, as if in some Early Christian idyll (pl. 286), and the deli-
cately Italianate heads of Jacob and Rachel embracing on
folio 15v. The dry tautness of garments on some of the
figures (pl. 287) again looks Giottesque. So much is already
known: this artist gives away both himself and his stimulants
by means of detail and arrangement. He might have known
Italian paintings directly or – and I think more proba-
bly – he looked very closely at a large book or set of books
produced, to judge by his stylistic tricks, in the area between
Perugia, Bologna and perhaps the Veneto.[72] He must have
been doing this around 1350 since the armour and fashions
he depicts – including protruding cornette hairdos – were
at their height by the late 1340s.

The seamlessness of the Egerton Genesis's manoeuvring
between different pictorial traditions raises (actually unan-

320

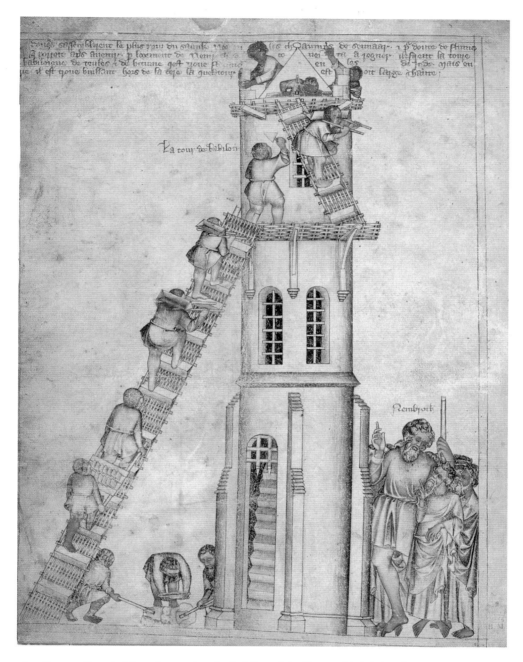

285 Egerton Genesis, Nimrod supervises the building of the Tower of Babel (London, BL MS Egerton 1894, fol. 5v)

swerable) questions about where and for whom such a strange book might have been painted. It has long been known that the same artist worked in a Psalter (British Library MS Add. 44949) donated, appropriately enough, in memory of M. R. James (pl. 288), and in another Psalter made for Stephen of Derby, a prior of Christ Church, Dublin (Oxford, Bodleian Library MS Rawlinson G.185),

after 1347–8.[73] The M. R. James Memorial Psalter was made for a female patron in the diocese of Durham, but both it and the Psalter of Stephen of Derby have entries in their calendars that could suggest production in a monastic context in Oxford, a state of affairs that might have arisen because Durham monks were sent to study at Oxford at Durham College, where book copying is known to

286 Egerton Genesis, top row: Parting of Lot and Abraham; God promises the land to Abraham and his seed. Bottom row: Abraham views the stars; Abraham and Sarah build the altar at Hebron (London, BL MS Egerton 1894, fol. 8)

have taken place.[74] Whatever sources were consulted – including the same as those used by W. de Brailes in Oxford – were presumably in existence no later than *circa* 1345, and if one of them was an Italian Bible picture book its history would have been unusual. An ideal patron in such circumstances, assuming the Oxford link to hold, would have had connections to Italy, Oxford and Durham. One figure who 'fits' is Richard of Bury, who earlier in this book

was encountered in Avignon in the circle of Pope John XXII and who became bishop of Durham in 1333 (see pl. 220), dying in 1345.[75] Richard's education had been at Oxford. While in Avignon, he would certainly have encountered illuminated Italian liturgical and legal books of the sort owned, for instance, by Cardinal Bertrand de Déaux (p. 262), who owned a Bolognese missal. Richard, supposed author of the *Philobiblon*, was the sort of man to acquire

287 Egerton Genesis, top row: Lamech with his wives and children, Jubal, Jabel, Tubalcain and Naamah. Bottom row: the building of the ark (London, BL MS Egerton 1894, fol. 2v)

cosmopolitan curiosities, and his study was reputedly so stuffed with books that people tripped over them.[76] At his death in 1345 his debts were such that his library was broken up and sold off in five cartloads: his plan to found a college at Oxford to house his library never materialized, and the fate of most of the books is unknown. But any unusual illustrated Italian book acquired by him by 1333 and kept at Durham could have made its way to Durham College between then and the late 1340s. Had the book, not generally known, been made available for copying for a particular commission, its general lack of influence would be understandable: in theory, the Egerton manuscript remained stranded because its visual hinterland was in a private episcopal library, as a rule un-consulted. And Bury raises one final connection: it is often stated that the *Philobiblon* itself was composed not by him at all, but by his

those aspiring to be so.[78] But not everything in the Egerton Genesis — not least its interest in sodomy, rape, fornication, genitalia and childbirth — is obviously for the fair of birth or delicate of mind, no matter how accurately it may present aspects of the text in hand; indeed, the extraordinary scene of the rape of Dinah taking place under the noses of a sublimely indifferent group of girls out shopping (fol. 17) smacks more of the marketplace than of landed decorum: the book is not chivalric in tone.[79] In particular, someone interested in the genesis of the arts might have been especially taken with certain aspects of the book's Bible imagery, which pick up the theme of genealogy. After depicting the descendants of Adam on folio 2, the genealogy continues on folio 2v with the progeny of Lamech and the construction of Noah's Ark (see pl. 287): the material here, starting at Genesis 4:20–22, is amplified by Petrus Comestor.[80] What is seen on this folio is a parade of the arts, anticipated in the Lamech sequences in the Aelfric and Caedmon manuscripts, but here developed to a degree.[81] Lamech's children of his bigamous marriages — the arts stem, as in the case of Daedalus, from the morally questionable — are Jubal, who was the first master of music on the harp and organ and who strums away to the beat provided by Tubalcain's striking of the anvil at the forge; Jabal, who is held to have invented the first mobile sheep pen, a wooden hut on wheels; and Tubalcain's sister, Naamah, who invented the art of weaving and who sits at her beautifully detailed loom. This lines up in a row the biblical equivalents of Orpheus, Vulcan and Arachne, followed by Noah the carpenter. Then Noah's progeny step forward. On folio 5 Noah's son Jonitus discovers astronomy and passes on this knowledge to the tyrannical Nimrod; on folio 5v Nimrod presides at the building of the Tower of Babel, again grandly and lovingly depicted with labourers and men with subtle measuring instruments at its top (see pl. 285); this monument to hubris is promptly struck down by God on folio 6 opposite: Nimrod has become Daedalus. Later, on folio 8 (see pl. 286), the manuscript depicts Abraham and Sarah raising an altar in Hebron, an ogival-arched and canopied ciborium with vault, crenellations and pinnacles being finished attentively by two youths wielding blades.

Could these concerns point to professional as much as landed patronage of the book, or to the forms of interest that might subsequently have been taken in pictures of this type by users other than the intended patrons? In the Egerton manuscript the captions are in French, slipping after folio 2 from a formal Gothic book hand into a cursive one, and given up from folio 7v. The use of French in the

associate Robert Holcot, whose 'antique' pictures might, for the more literal-minded, have whetted the appetite for real, rather than sham, old images coming from Italy.[77]

But this is at best a hypothetical sketch, since it is no easier to infer the circumstances of manufacture of such a unicum than its ownership and use. One tends to assume lordly ownership for anything so extended and manifestly in the tradition of the courtly looking pictures in the Morgan Bible Picture Book or the Queen Mary Psalter, with its French-captioned Bible pictures. The rougher-looking Holkham Bible Picture Book (see pl. 278) — a work that, idiom aside, may itself have been partially influenced by French court illuminations — was made by its own admission for 'riche gent', that is, well-to-do folk, or at least

various captions could point to more than one social level, since anyone involved in, for instance, estate management and administrative record keeping around 1350 would either have known French or seen it as the language of civility. Around 1400 this may have been less true. A search for professional lineage, the genesis of the architect so to speak, is found in the earliest English masonic manuscripts, most notably the so-called Cooke manuscript of *circa* 1400 (British Library MS Add. 23198).[82] The Cooke manuscript opens with an account of the origins of geometry and masoncraft based loosely on Genesis, but also, it claims (wrongly), upon such authorities as Higden, Petrus Comestor, Bede, Honorius Augustodunensis, Isidore and Methodius; Rykwert rightly calls it a 'mythical farrago', though Smalley's term 'sham' is not far off, for here is the same portentous claim to authority vested in an eclectic but unverifiable (and actually bogus) ransacking of sources old and new.[83] The story is that starting in Genesis 4 with the birth of geometry and masonry (and hence the quadrivial arts).[84] We meet again the progeny of Lamech, and are informed that they inscribed their erudite science into two pillars, eventually studied by Pythagoras. Nimrod's reputation is cleaned up.[85] Abraham emerges to teach geometry to the Egyptians; his clerk is Euclid – and so on.

The witty eclecticism of the Egerton Genesis, at first sight such an earnest and severe portrayal of the Bible, may reveal something about this world of the urban-based and professionally aspirant, and about the various techniques that preachers, illuminators and the manufacturers of social fictions of the sort in the Cooke manuscript deployed in addressing its members. The Cooke manuscript ends with extracts from Mirk's instructions for parish priests and the poem *Urbanitatis* on good manners – for this is a pseudo-learned courtesy book for the socially and professionally aspirant mason – medieval versions of Jude the Obscure seeking lineage, 'roots'.[86] Geometry is a counterpart to 'measured' social behaviour, courtly *mesure*; in the Cooke manuscript hierarchy of the arts, Geometry challenges Grammar as the 'lead' art.[87] So the art that Euclid, Abraham's clerk, offers to teach the Egyptians is such that 'they schylle lyve ther-by ientelmanly'.[88] Earlier I discussed architectural authorship in the context of the sociology of the professions. The claim to social standing conveyed by the scholastic notion of the superordinate sciences was that apparent on the tombstone of Pierre de Montreuil (d. 1267) in the chapel he built at St Germain des Prés in Paris, *Flos plenus morum vivens doctor lathomorum* (In life a flower of courtesy, teacher of masons).[89] As Lisa Cooper remarks of the Cooke

and its cousin the Regius manuscripts, small books can make big claims.[90] Architecture starts, and continues, with the patriarchs. In this, as Cooper notes, the inscription of masonic lore is important: Lamech's sons carve their knowledge in letters on stone pillars – craft is textualized and, once again, the barrier between craft and literacy is as open to challenge as it was in the discussion of the 'para-academic' character of book illumination. Jabal, son of Enoch, is thus 'a hero because he is both artisan and tutor, both mason and scribe'.[91] In this way readings of Genesis were enriched by social ambition: the 'land' of the ancestors of the un-landed medieval architects was the land of Abraham.

Norfolk, the Lombards and the Social Life of Books

A dispassionate view of the first half of the fourteenth century would have to concede that it was a time of significant innovation, not least in regard to the proliferation of the Book of Hours and the introduction of new images typically developed on the Continent. These included large-scale Calvary Crucifixions and the much more focused *Pietà* – features of the damaged murals (1320s?) in Prior Crauden's Chapel at Ely (see pls 167, 187) and of the Taymouth Hours, at folio 123v (pl. 289).[92] Yet this pictorial culture, dynamically informed in so many ways by changes in religious and devotional practice, was not entirely given over to straightforward innovation. The search for formal distinctiveness on the part of illuminators entailed recurrences, substitutions, echoes and atavisms no less typical of tradition and stability. Take something so simple as the use of interlace in book decoration. Earlier in this book a late twelfth-century response was noted to the fabulous minificence of early Insular book art, its 'intricacies, so delicate and subtle (*tam delicitas et subtiles*), so close together and well-knitted (*vinculatim colligatas*), so involved and bound together', that of Giraldus Cambrensis (above, p. 144). T. A. Heslop remarks how consistent Giraldus's form of attention was with trends in English book art from the late twelfth century onwards, as ultra-thin spiral interlace forms inhabited with tiny creatures again found favour in various types of book.[93] Many such books of the early thirteenth century were Psalters or Bibles.[94] One is therefore entitled to see in the renewed use of interlace in a work of *circa* 1330–40 such as the St Omer Psalter (British Library MS Yates Thompson 14 [Add. 39810]), made in the Norwich area (pl. 290), a process common to the arts in the fourteenth century whereby a traditional form yields fresh solutions: the usual

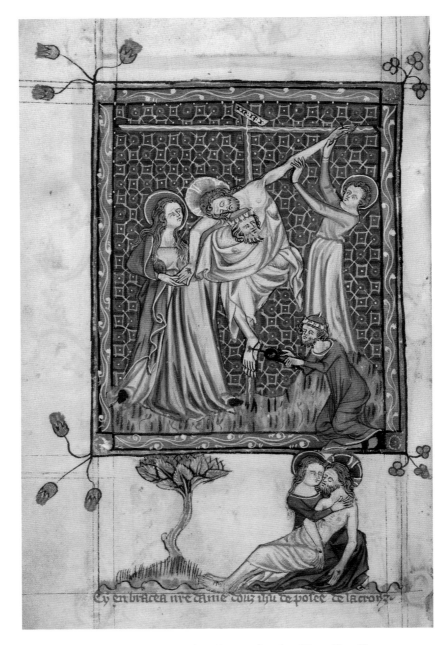

289 Taymouth Hours, *Deposition* and *Pietà*, 1330s (London, BL MS Yates Thompson 13, fol. 123v)

display points such as Psalm 1 exhibit delicate and subtle, soft and well-knitted interlaced vignettes for figurative scenes from the Bible or Last Judgement as if woven less from gold or thread than from spaghetti.[95] These latter-day Gothic carpet pages clearly engaged the *ingenium* of the illuminators, and the sense of homage to older standards paid by them is apparent also in such work as the grandiose thickets of foliage and figures of the *Beatus* page of the late thirteenth-century Windmill Psalter (New York, Pierpont Morgan Library MS M102), whose leaf forms include archaic Byzantine blossoms, flushed and alien-looking in their supernal anti-naturalism, yet here comfortably assimilated into the Gothic aesthetic of the 'natural'.[96] Other atavisms may simply have reflected the production context of books such as the possibly monastic M. R. James Memorial Psalter discussed earlier, whose decorative repertory of masks and

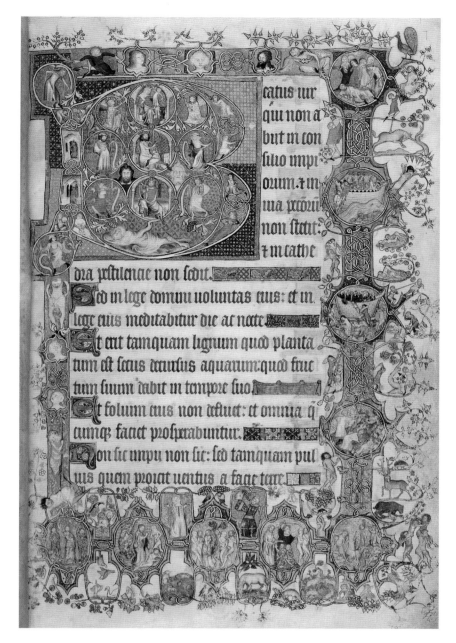

290 St Omer Psalter, Psalm 1 with scenes from Genesis, *circa* 1340 (London, BL MS 39810, fol. 7)

little figures caught and struggling in thickets of foliage looks Romanesque in inspiration, not Gothic.[97] And, as has been seen in considering the transcendent pictorial language of the Douce Apocalypse (p. 179), interest in striking and complex Romanesque solutions on the part of really talented artists seems probable.

This issue of continuity is exposed most dramatically in the case of violent disruption. Nothing was more important

yet vulnerable in this world of continuing reflection than a great library, little more challenging than its loss. It is evident that the riot and ensuing fire of 1272 that damaged or destroyed the church, conventual buildings and library of Norwich cathedral priory did almost more than anything else to speed up the circulation of fourteenth-century and older books in this region, as efforts were made in the next half century or more to recoup a library.[98] At this time the

Norwich library grew at a renewed rate, and it was a good time for the expansion of monastic collections, as at Canterbury under Prior Eastry (1285–1331).[99] Twelfth-century and later books, often very grand, such as a glowingly illuminated twelfth-century collection of the works of the Pseudo-Dionysius, which came to Norwich via Cambridge in the fifteenth century, presumably matched the lost or destroyed ones in the original collection.[100] The interesting point in regard to fourteenth-century East Anglian book manufacture – responsible for some of the greatest English books ever made – is how this circulation occurred. It entailed a chain of communication and patronage linking local lords, parish clergy and the cathedral priory and its bishops. What matters particularly is the extent to which the members of major monastic houses were linked by blood to the county lords and knights, second and third sons entering religion but retaining the means to act as sluices for precious objects to pass out of the county and into the monastery – from one lordly domain to another.

The relevant books, all of them almost certainly made in the region of Norwich, include the Ormesby Psalter (Oxford, Bodleian Library MS Douce 366), the Gorleston Psalter (British Library MS Add. 49622), the Douai Psalter (Douai, Bibliothèque municipale MS 171) and the St Omer Psalter.[101] According to an inscription in it, the Ormesby Psalter (pl. 291) was 'the Psalter of brother Robert of Ormesby, monk of Norwich, assigned by him to the choir of the church of the Holy Trinity in Norwich to lie before the subprior in perpetuity'.[102] Robert had been prior of Hoxne before 1336, his association with Norwich and donation probably occurring in the mid- or late 1330s; he may have been related to Sir William Ormesby (d. 1317), justice and local landowner in Norfolk.[103] His donation was adroit, since in shedding this magnificent example of private property and donating it to the subprior's stall, he was still retaining use of it, since he himself was probably subprior at this time.[104] But the book already had a history: it had been started in the late thirteenth century and had already evolved into a richly illuminated manuscript intended for a male member of the Foliot family and a female Bardolph: these two are shown with their arms within the *Beatus* initial on a magnificent tipped-in folio (fol. 7) showing a *Tree of Jesse* – exactly the place to emphasize lineage (pl. 291). It was below these earlier patrons that the images of a bishop and a monk of Norwich were eventually pasted in, presumably at the behest of Robert of Ormesby, as if to redirect the lineage of the book towards the priory of Norwich. The figure of David with his harp was added opposite, and this

later work was done by the same artist as that of the St Omer Psalter made for the Mulbarton family, based very near Norwich, presumably in the 1330s or towards 1340. At this time too the liturgical contents of the Psalter were revised by the addition of a Norwich cathedral priory calendar and litany, and the arms of the see and priory of Norwich were painted on the fore-edges; eventually the book gained a priory library pressmark 'A'.[105] So Robert had acquired the book perhaps some interval after the plan that it should belong to the Foliots had been set aside – no marriage alliance between the Foliots and Bardolphs actually occurred, suggesting just such altered circumstances. A relative of his, perhaps a younger brother, William, was rector of St Mary in the Marsh within the cathedral priory precinct; William too was donating books to the priory, since he provided a fine thirteenth-century glossed Bible.[106] There was evidently some tradition of the rector of St Mary's passing on books in this way, since it occurred again at the end of the fifteenth century in the case of a fine twelfth-century Peter Lombard.[107] The book need not in fact have strayed far from Norwich at any point in its manufacture since it is evident from two other illuminated manuscripts made by the same workshop, a copy of the *Moralia in Job* now in Emmanuel College, Cambridge, and the Bromholm Psalter from the priory of the name, that books in this idiom circulated within this region of Norfolk.[108]

It is very tempting to see in the Ormesby Psalter's subtle grandeur a conscious restoration to the priory's choir of past magnificence, lost in 1272. The no less splendid Gorleston and Douai Psalters – the latter severely damaged during the First World War – were both connected to another parish church, St Andrew in Gorleston, on the coast just to the south of Yarmouth, then a wealthy populous port district with a significant number of large churches and mendicant establishments.[109] Both Psalters have prominent entries for St Andrew's church (8 March) in their calendars, but quite why is one of the puzzles of English book study of the period. The Gorleston Psalter, probably largely complete by 1320 or so, has very reasonably been pressed into the circle of John de Warenne, earl of Surrey (d. 1347), not least because of its heraldry and canting use of rabbits (see pl. 262).[110] John, one of the region's great patrons, was busy divorcing his wife, the king's niece Joan of Bar, in the period 1313–16, and since the Gorleston Psalter contains his and his comrades' arms but not those of his wife, it does not fall into quite the same pattern as the numerous books of the period made for marriage alliances, rather the reverse: it might even bear signs of what was in the end a failed

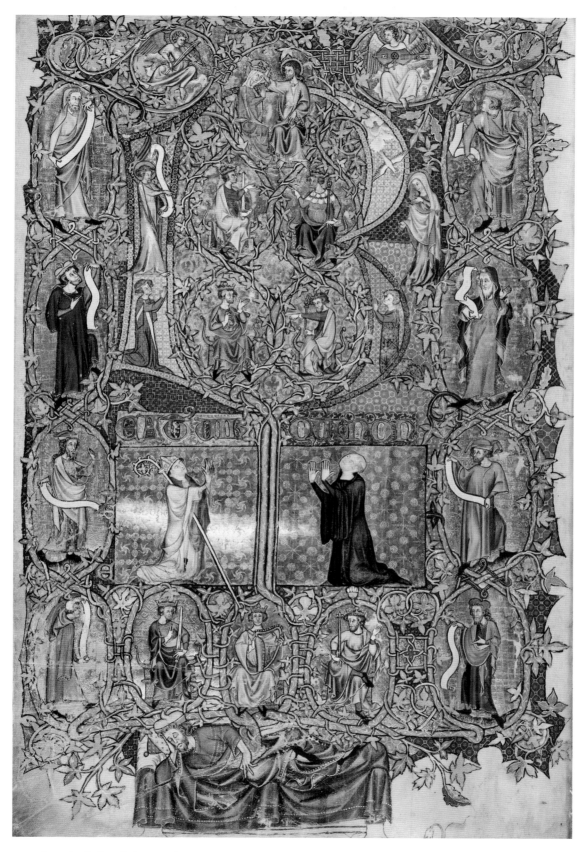

291 Ormesby Psalter, Psalm 1 with *Jesse Tree*, *circa* 1320 (Oxford, Bodleian Library MS Douce 366, fol. 9v)

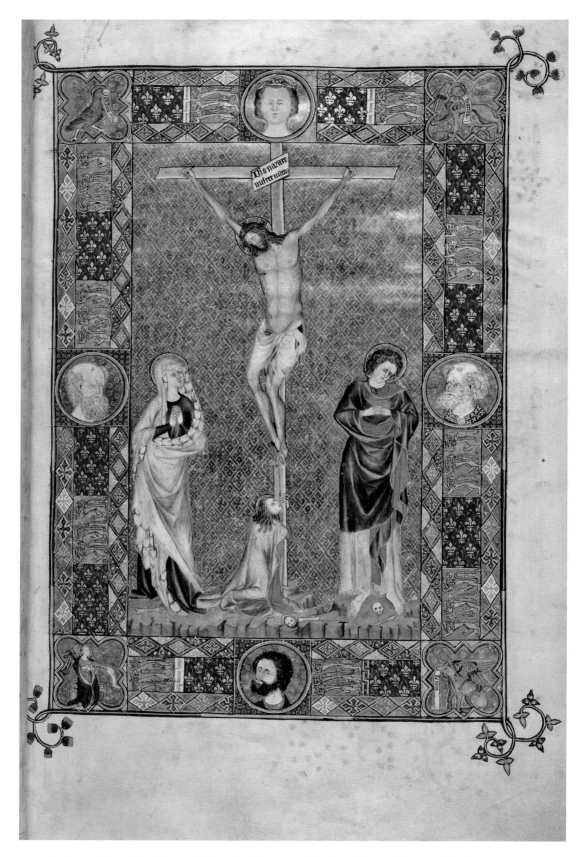

292 Gorleston Psalter, *Crucifixion with Mary Magdalene*, 1330s (London, BL MS Add. 49622, fol. 7)

divorce, and would place the book no earlier than 1313.[111] John was openly living with a mistress, Matilda of Nerford, and had two sons by her. An expiatory gift to a local parish church or priory would be understandable in view of this uncanonical situation.[112] Eventually the Psalter found its way into the hands of someone connected to Norwich cathedral priory, since at around the time Robert of Ormesby was adapting the Ormesby Psalter in the 1330s, a Norwich cathedral priory litany was added at folio 266v to the Gorleston manuscript and a very fine *Crucifixion* page, with the common Psalter prefatory prayer *Suscipere dignare* added on its verso, folio 7 (pl. 292).[113] Unlike Ormesby, however, the Gorleston manuscript never acquired a Norwich library shelf mark, which might mean that it remained for use in the church (though it contains no donor inscription to that effect) or that it passed via Norwich elsewhere. The Douai Psalter (pl. 293) appears to have been given by a later vicar of St Andrew's in Gorleston, Thomas of Popely, to John of Brinkley, abbot of Bury St Edmunds, after 1371.[114] Why such a fine book should not have gone to St Bartholomew's in Smithfield, which owned the living of Gorleston, or to the diocesan church at Norwich, is unclear, unless it is concluded that such books were now a significant element in regional gift exchange and the winning of favours of an entirely personal or circumstantial, and hence unpredictable, sort. What is evident from the social life of such books, again, is the growing role of parish churches in mediating in such transactions, because it seems that before it was given away the Douai Psalter must have been in the hands of St Andrew's since the time of its manufacture in the 1330s or so.

The link between the Gorleston and Douai Psalters extends to one important aspect of their decoration. The *Crucifixion* added at folio 7 of the Gorleston manuscript, not long after its initial manufacture, was painted in the style of a copy of Bede's historical works now in Cambridge (Trinity College MS R.7.3, fols 1, 34) (pl. 294).[115] This shows that both books were made in some significant centre, producing work in all probability only of interest to a major church establishment. Only such a centre would in turn explain the form of the Gorleston *Crucifixion*, which, as Pächt pointed out in the 1940s, is a free imitation of a small Tuscan, probably Sienese, panel painting from the circles of Duccio, Simone Martini or the Lorenzetti, or of some related Italian illumination.[116] This single page (pl. 292) is the most developed and explicit instance of the assimilation of Italian art in England in this period. It has a gilded ground; depicts an Italianate-style broken and bone-strewn

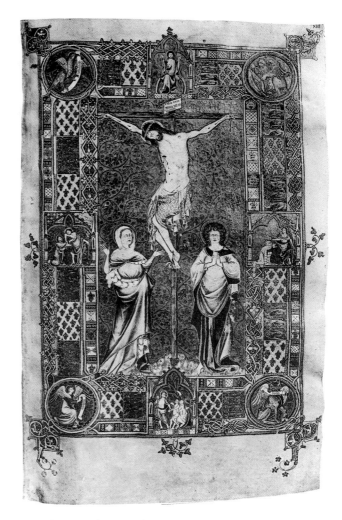

293 Douai Psalter, *Crucifixion* with *Harrowing of Hell, Noli me tangere* and *Doubting Thomas*, 1330s (Douai, Bibliothèque municipale MS 171, fol. 13, from Cockerell 1907)

landscape; shows Christ as a solid grey-hued cadaverous form; shows St John with a fingers-enmeshed gesture known in the works of Duccio and his circle; depicts St Mary Magdalene clutching the foot of the Cross in a fashion known in Sienese and Florentine *trecento* works; contains heads in border roundels in a fashion common in Tuscan panel painting; and in style looks like a reaction to Sienese facial types and hair.[117] No extant Italian work possesses all these features, so some lost exemplar must be presumed. It is doubtful that anywhere other than a significant urban centre, court or household could at this date have possessed a small Italian panel (or a polyptych) of this type, probably made no later than the 1330s. Apart from London, Norwich itself is by far the likeliest place for this

294　Bede, *Historia ecclesiastica*, initial with head of Bede, 1330s (Cambridge, Trinity College MS R.7.3, fol. 34)

Christ that may have been amplifications of the Magdalene image at the foot of the Cross in the Gorleston book. Douai is a sort of reissue of the Gorleston page. Very probably then, the new Gorleston arrangement was the model for that in Douai, still in manufacture. This implies that both manuscripts were at one point being worked on in close proximity, a scenario that might have arisen if the Douai Psalter was being executed for Gorleston church at the same time that the Gorleston Psalter was being adapted for its new destination, the crossover occurring in a single Norwich illuminator's shop in the 1330s, and presumably before 1340 given the nature of the royal arms.[120]

Can more be said about the Gorleston Psalter's later adaptation? As well as a showy display of royal heraldry, and so presumably allegiance, the Gorleston *Crucifixion* is framed by medallion heads including, at the top over the titulus of the Cross and in the position of God the Father, a young beardless king with eyes cast down to the Cross, reasonably if not provably identifiable as Edward III not long after his accession. It is tempting to see this added page as the product of the patronage of a bishop rather than a monk of Norwich, preferably one with royal experience and sensitivities to the new regime, and also with the right sort of connections.

William Ayermin, bishop of Norwich from 1325 to 1336 and a former Keeper of the Privy Seal, was one such, since having been pushed into the bishopric against Edward II's wishes, he had adroitly accommodated himself first to Queen Isabella's and then Edward III's regime, attending his coronation at Westminster in 1327.[121] At Ely, Prior Crauden and Bishop Hotham were no less intent on getting close to the new order, Hotham having the fleur-de-lis engraved on his seal, Crauden (or Alan of Walsingham) initiating mural paintings in the prior's chapel with a marked Italian tinge.[122] Ayermin is interesting here for the further reason that, like Richard of Bury, he had been to Avignon, one possible point of origin for portable Italian panel paintings.[123] No less feasible in this regard was his successor as bishop, Anthony Bek (1337–43), a former papal chaplain and bishop of Lincoln, consecrated as Ayermin's successor at Avignon in 1337.[124] In fact, Bishops Salmon, Ayermin, Bek and Bateman were all familiar with the curia at Avignon, though only the middle two seem to fit the likely time at which the Gorleston Psalter was adapted, between the late 1320s or *circa* 1330, and 1340 or so.

But Ayermin particularly is of interest for another reason. He had been an ally of Queen Isabella since 1321 and with her had shared the custody of the Great Seal. When John

to have happened, not least because the Douai Psalter is connected to another manuscript, the Macclesfield Psalter (Cambridge, Fitzwilliam Museum MS 1–2005) (see pls 256, 263–4, 313), whose art affiliations also point to that city.[118] From the start, the Douai Psalter included a similar *Crucifixion*, also of Italianate type, again placed before the Psalter (see pl. 293). Like that added to the Gorleston manuscript, the Douai version as recorded in photographs was framed by a show of French and English royal arms, though the sequence of the arms varies.[119] In Gorleston, this display seems to have been picked up from the existing decoration in the book, as on the Beatus page (fol. 8). Douai's *Crucifixion* is arranged differently, having no Italian-style broken ground, and does not include the Ducciesque Magdalene at the foot of the Cross: but it does include *Doubting Thomas* and the *Noli me tangere* in little tabernacles to either side, compositionally related recognitions of the resurrected

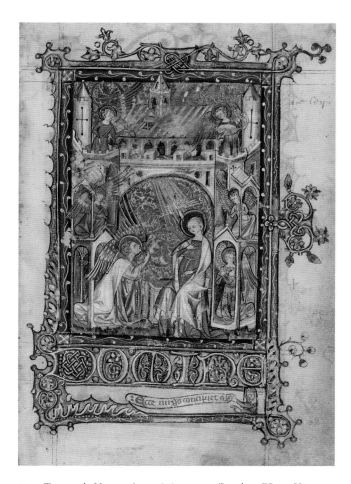

295 Taymouth Hours, *Annunciation*, 1330s (London, BL MS Yates Thompson 13, fol. 60)

296 London, Westminster Abbey, alabaster weeper on the tomb of John of Eltham (d. 1336)

Salmon died in 1325, Ayermin was Isabella's candidate for the see at Norwich, and was duly eased in with the assistance of Pope John XXII; by the end of 1326 he was Chancellor.[125] This matters because Isabella at her death in 1358 owned the largest-known collection of Italian panel paintings in England at the time: the inventory of her possessions at that date includes several liturgical manuscripts of Franciscan Use, four folding chapel panel paintings each of several leaves, three panels *de opere Lumbardorum* – a standard term for Italian, probably Tuscan, panel paintings – and a panel of the Veronica, one of which can now be shown to have come via the French royal family.[126] The Taymouth Hours with its *Annunciation* in the style of Jean Pucelle (fol. 60) (pl. 295) may point to the cosmopolitan taste of Edward III's court in the 1330s, as does the subtle Franco-Italianism of the alabaster figures on the tomb chest of Isabella's second son John of Eltham (d. 1336) at Westminster Abbey (pl. 296),

with which she was concerned.[127] Isabella's main London house was on Lombard Street, near the Italian banking houses whose chapels were probably equipped with panel paintings.[128] But from 1332 Isabella's principal residence, not least so far as her library was concerned, was Castle Rising in Norfolk, which she had gained in 1327.[129] It is likely that some, if not all, of her Italian panels were kept there: in which case there was a reserve of Italian art already within the diocese of Norwich quite possibly by the mid-1330s. If so, the added *Crucifixion* page in the Gorleston Psalter with its conspicuous bust of a young king, the arms of England and France, and obvious reference to Italian panel painting, a mobile art form, would make sense as a reflection of the loyalties and contacts of someone within Norfolk attached to the diocesan cathedral at this time – Ayermin himself.

The *Crucifixion* pages in the Gorleston and Douai Psalters are clearly thoughtful and closely related works. Yet it is not

297 York Minster, *Annunciation*, nave south aisle, westernmost bay, *circa* 1340

298 Ivory triptych with *Virgin and Child* and the *Crucifixion*, formerly possession of John Grandisson whose arms are visible in the spandrel over the Christ Child, 1340s (London, British Museum)

immediately obvious from them why an 'Italian' solution should have been thought attractive unless, as implied here, it was in some sense a sign of the tastes of a tiny political elite. Neither prompted a range of copies, which could suggest that the image from which the Gorleston artist was drawing was inaccessible, in an exclusive private chapel or household. What cannot be ruled out is that the Italian models proved attractive for their imagery as much as their mimetic powers. The Gorleston *Crucifixion* shows Mary Magdalene swathed in a brilliant violet mantle, vermilion-lined, clutching the foot of the Cross, an unprecedented image to my knowledge in England and, as the very epitome of the penitent woman and penance in general, a considered choice given that the Psalter may have come from the hands of John de Warenne, an adulterer. What is very striking about the new Italianisms is how often they carried with them Marian or other new devotional topics of specific interest to patrons or institutions. The model-book version of Duccio's *Annunciation*, developed by 1311 on the *Maestà*,

the high altarpiece of Siena Cathedral, found its way into the glass of York Minster by the 1330s (pl. 297) and as noted into the Taymouth Hours (fol. 60).[130] This Marian slant seems especially true of the single greatest 'collector' of Italianate objects in this period, John Grandisson, bishop of Exeter (1327–69). As is well known, Grandisson's little ivory triptych in the British Museum (pl. 298), though English-made, depicts a *Virgin and Child* of Sienese type, and it was probably at his behest that a very early English version of the *Madonna of Mercy*, again an Italian (Roman) innovation, was included in an initial added to an earlier medieval copy of Augustine's *De civitate dei* owned by the bishop (Oxford, Bodleian Library MS Bodley 691) (pl. 299).[131] Grandisson's will, drawn up on the feast of the Nativity of the Virgin (8 September), provided that he should be buried with tablets with an inscription describing him as 'Most miserable servant of the Mother of Mercy'.[132] His tiny intaglios had Franco-Italian imagery of the *Virgin and Child* and an inscription also referring to the *Madonna of Mercy*.[133] He

334

had clearly taken this sort of thing to heart. Grandisson's Avignon years and contacts with Paris again need emphasizing in regard to his acquisitions: he was consecrated bishop at Avignon in 1328 and, like Richard of Bury, had been close to John XXII. Grandisson is about as clear an instance as one could wish for of the elision of personal taste with a distinct and evidently personal devotional world shaped by Italian art. The *Crucifixion* in the Gorleston Psalter, I suggest, had a similar genesis, and it is to the international movements and connections of the episcopal class, as well as their private religious lives and penitential inclinations, that one might look first to account for it.

When, in a seminal paper published in 1943, Otto Pächt grouped together the Ormesby and Gorleston Psalters and the Egerton Genesis in an episodic narrative of the impact of the Italian *trecento* in England, he furnished evidence for an altogether grander narrative of the arts in late medieval Europe, the boldest statement of which was that of Erwin Panofsky in *Early Netherlandish Painting* (1953).[134] Pächt's term 'episode' was chosen judiciously, for the infiltration of Italian ideas into England in this period had much the same character as the infiltration of English ideas abroad at the same time, not forming a distinct pattern or movement but rather a scattering of novelties provoked by specific human agency, often courtly. For Panofsky, however, the role of the organization of space and the articulation of psychology in the new Italian arts was, in effect, to reorganize, to liberate aesthetically, the Gothic arts of northern Europe from their fundamentally symbolic mode of representation. 'From 1325', he said, 'the Northern painters and book illuminators felt compelled to absorb the Italian innovations until, towards the end of the fourteenth century, a state of equilibrium was reached' in the International Gothic Style and ultimately the Netherlandish masters. 'We are faced', he continued, 'with an infiltration too simultaneous and ubiquitous to be accounted for by an historical accident.'[135] It seems to me that it is not necessary to share, or even react seriously to, Panofsky's neo-Kantian dialectical matrix of thinking and the language of compulsion (and hence historical 'necessity') to see that from some point in the 1290s leading patrons had grown more curious about what was going on in Italy. In 1298 Philippe IV of France sent his painter, Etienne d'Auxerre, to Rome on royal business quite possibly arising from some project at the Capetian court to create picture cycles in Paris about Louis IX, canonized the previous year: the timing is of interest because it followed on the heels of the political collapse of the Colonna family, amongst the most important art patrons in Rome and especially Assisi,

299 Augustine, *City of God, Madonna of Mercy*, formerly possession of John Grandisson (Oxford, Bodleian Library MS Bodley 691, fol. 1v)

where the frescos about St Francis in the upper church of his basilica had been finished.[136] This 'Roman' wave manifested itself in the documented employment of Colonna artists (the Rusuti family) as Philippe IV's royal painters, so the existence of large-scale Italian-style work, either fresco or mosaic, in royal France can safely be assumed several years before the advent of Jean Pucelle in Paris. Within a generation or so the notion that Italian merchants or bankers in major cities had wall paintings in their houses is found even in Holcot, who conjures up a picture with inscriptions known from the Parisian houses of certain 'Lombards' (a common term for Italians), in this case the story of Aristotle and Phyllis.[137] A century earlier the idea that a picture might be 'vindicated' in English minds by tracing its ancestry to Italian patrons in Paris would have been peculiar. By 1330 it was not without some actual substance.

Such 'vindication' raises an issue slightly to one side of that identified by Panofsky. Panofsky's model was, at heart, a progressive one: something (historical compulsion) urged on the dialectic of the arts to produce new syntheses, in which the use of such Italian techniques as perspective played a fundamentally modernizing role: the liberation of northern symbolic art by advanced southern aesthetic sensibilities. But what this model does not address is what it was that gave such new images their power for specific audiences. There is no reception history of Italian images in England beyond what artists themselves did. In Holcot's conjuration of Italian paintings in Paris there is a gap, since

it is not clear what it was in these paintings that offered vindication: he wrote about a topic's contents and texts, not its aesthetic. Perhaps the sensibility in question was by now so well known that it did not need to be fleshed out – though this seems unlikely. Perhaps this gap or aperture itself enabled the spreading out of a canvas for mind painting, unconstrained by that which was too far away to be verifiable, yet also admirable, like the tradition of reporting far-off wonders considered at the start of this book. Hence the conjuration in Holcot's vague yet latent expression 'at Paris, in the house of certain Lombards'.

What is also evident is the risk of grand narrative of style itself: that it erases the subtly different, personal forms of reaction to these new arts that seem so evident in England at least. This is not the place for a full account of the narratives of Italian art in England before 1350 or so, but rather for a few final observations. The first concerns the arts in the public and private domains. It is clear from the inventorial evidence that Italian books and paintings in the new mode were circulating and collecting in important royal, noble and ecclesiastical households. The collections of such bishops as Richard of Bury at Durham and John Grandisson at Exeter, as well as of Queen Isabella, have already been cited. It is a matter of fairly secure presumption that the Italian banking firms based in London must have had households with chapels housing Italian devotional images. But it was the courts that had the best networks, and in this regard, limited as it was, the assimilation of Italian art in England was but the mirror image of the courtly dissemination of English innovations abroad traced in Chapter Seven.

These private worlds of sophisticated collecting stand in contrast to the rather weak penetration of Italian ideas into the English public domain of art before 1350 or so – indeed later. As already noted, only the nave glass of York Minster made no earlier than about 1340 points to the same sources in the circle of Duccio as those used by Jean Pucelle in Paris. What survives of the larger-scale arts in the diocese of Norwich, where it is believed that the private collections existed, does not argue for the grand transformational presence of Italian art. The west front of Exeter Cathedral (pl. 300), whose progress was probably interrupted by the Black Death, is perhaps an exception in England, in so far as the sculptures in the screen on the lower part of its façade begun in the 1340s bear comparison with Italian sculpture of the period.[138] Indeed, the narrative character of Pächt's aptly named 'Giottesque episode' in England should in general be laid at the feet of the assimilation into the private seigneurial domain of art forms whose effects were devel-

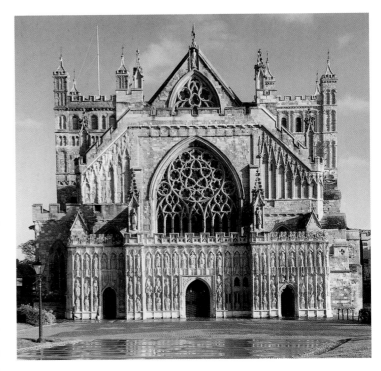

300 Exeter Cathedral, west front; the basic design is by Thomas of Witney completed in the early 1340s; the crenellated image screen was a mid-century afterthought probably inspired by Wells (pl. 165)

oped in Italy for public, not private, speech. It was the public domain of the cults of the saints, of the Virgin Mary – in those cases, cults of charismatic personality – as well as of the new image of politics of the city, that gave birth to the powerful public narrative and allegorical arts of central Italy: and it was within the public liturgies that new devotional images of an 'innovative' sort appeared.[139] France may have aspired to this new public art to emphasize to political ends – the promotion of the Capetian dynasty – the link between the 'mendicant' St Louis and the charismatic St Francis. But there is no evidence that anything like this took place in England, and even when Italian features appeared in court wall painting (as they did at St Stephen's Chapel, Westminster, after 1350) they did so on such an apologetic scale and in so specialized a context that the designation 'public' hardly seems useful.[140]

In stressing the transformational role of the public arts in Italy one is, of course, questioning the artificial paradigm of 'private' modernity and 'public' conservatism set out by Hans Belting, who supposed that it was the private images that, in his words, 'served up one modernism after another': this model is over-reliant on a public–private dichotomy

quite at odds with the shaping of devotional life and subjectivity precisely within the public sphere.[141] The point is that the nature and function of the arts in England in the public domain differed from Italy: what had been public, civic, even plebeian-directed images in Rome, Florence or Siena had become household images for the nobility of England. As I stated in the Introduction (p. 6), in France and Italy the arts in question were aspects of a wider hegemony in a way alien to the noble and literary classes of England: the English at this time seem never explicitly to have tied cultural achievement to political claims, and in this the relative weakness of their conception of public space, even of the heroic mode, was a factor. The Italian manner, I think, was attractive to the English as a choice in some way tied to specific subjective inclinations that had more to do with the perceived authority of a representation than its utility in the politics of imagery.

So the issue is deeper than the anyway difficult question of what is private or public. Such images as that copied in the Gorleston Psalter opened out a way of showing that carried depth and authenticity: they plumbed mysteriously a deeper well of knowing. The inclusion of a Veronica image, together with an Italian polyptych, in Queen Isabella's inventory in 1358 is important to this discussion since elective affinities and relations between images are more informative than isolated texts or artworks. The English, or at least a specific and perhaps rather exceptional Englishman – I mean of course Matthew Paris of St Albans, at work in the 1240s – had been relatively quick, by western European standards, to pick up the iconographies of the Italian public domain such as the Veronica itself, or the wonders occasioned by St Francis and his stigmatization.[142] Pope Innocent III's new conception of the indulgenced image – in so many ways congenial to the 'Anselmian' attitude to the religious image with which Matthew was undoubtedly familiar – proved popular in England, even if its exact mode of transmission is obscure. But it would be hard to argue that what interested Matthew was the Italian or Byzantine aesthetic of whatever images he saw, if images he did see: this aesthetic drew him and others towards something ulterior, a feeling of being in the presence of something exceptional. Matthew was interested in the miraculous, that which was extraordinary, and officially guaranteed to be so. It was exactly the issue of authority that later engaged the Italian Dominican Giordano da Rivalto when preaching in Florence in 1306 on the 'utmost authority' of old images, some of which were 'imported from Greece long ago' – for this authority lay in the recording of biblical persons 'as they really looked'.[143] It seems a paradox that this most conservative idea of true likeness should appear so nearly to resemble the progressive notion of mimetic truth implicit in such modern 'genres' of the fourteenth century as portraiture.[144] There is here a conflict in which, from the perspective of later Florentine art history, the (Byzantine) Greeks were simultaneously the conservative force to be overcome by the genius of the new luminaries of Italian art, yet at the same time the transmitters of a powerful and authentic way of knowing. The post-Renaissance, rationalistic historical standpoint that stresses the narrative of the triumphs of mimesis and psychological 'liberation' has perhaps prevented one from seeing that for many fourteenth-century patrons and viewers, as for Giordano da Rivalto and perhaps even Holcot, what mattered was not mimesis as something rationally progressive, but as that means by which traditional and authentic knowledge, and with it an apprehension of the miraculous, of the wondrous, was perpetuated by images 'imported' from distant lands, whether Greece or Italy with particular if elusive persuasive force. Only in regard to this very different type of dynamic does Panofsky's notion of compulsion survive scrutiny. Such knowledge was of very special people and situations: of Christ on the Cross, of Mary, of the two together at the *Pietà*, or of Francis or the Magdalene, suddenly revealed in unexpected and compelling new ways governed by a tremendous sense of authenticity but also of the unfamiliar. Italian art offered not a form of modernity but a means of defamiliarization.

This was the domain of the charismatic. Such images were chosen not because they were windows looking out to a new and soon-to-triumph world of representational possibility, but because they possessed charismatic force: they were the agents of changes of heart, and of behaviour, in humans, and to this end of transformation their strange authenticity, and their unaccustomed look, mattered.[145]

301 Egerton Genesis, top row: Abraham and the three angels; bottom row: Sodom, the angels encounter Lot (London, BL MS Egerton 1894, fol. 11)

IO

CONTAGION

Soft garments reveal a softness of the soul

St Bernard of Clairvaux, *Apologia*, 10

Moral Panic:

Men in Tights, a Malediction of Tabernacles

Anyone believing that there are not perennial moral issues will be partly, if not wholly, discouraged by reactions to the new fashions in clothing that had emerged across western Europe by the 1340s. The changes are very well known to medievalists and dress historians; the critiques of them seem oddly familiar. They were as international as the textile trade itself, and they involved a radical change to the profile of the human form, the loose-fitting gowns of the period (indeed centuries) up to about 1330 being cast aside in favour, for men, of close-fitting short tunics which revealed the legs, astonishingly long sleeves, voluminous hoods, absurdly pointed shoes, exaggerated beards and accessories that rendered the bodily profile jagged and asymmetrical. Analogous changes occurred in female fashion, not least in regard to much tighter-fitting and more revealing dresses. These figure-hugging trends 'transformed human beings from soft rounded creatures into harsh, spare, attenuated insect-like things'.[1] In English art the new profiles can be seen to emerge in the 1330s and early 1340s in such works as the Luttrell Psalter, the Taymouth Hours and the Smithfield Decretals; the Egerton Genesis is one of their finest showcases.[2] Because they featured tight smooth surfaces and clear profiles, the 'devil's shape' was easily identified in them.[3] To contemporary detractors they implicated youth, foreigners, slack attitudes to old and respectable values, and a weakened sense of social hierarchy – old enough commonplaces, but ones that seem to have bubbled up periodically in criticism of courtly culture especially. Sociologically, they provoked a medieval counterpart to modern 'moral panic', a conservative fear of cultural contagion from young beatniks threatening the established order, yet hedged about by taboos of various sorts.[4] As in the Egerton Genesis, sex was certainly one of the taboos. Since these fashions were common to both sexes, they raised the spectre of gender confusion and perversion. Such commentaries hint at nameless anxieties, uncertainties and resentments, and especially the great conservative fear that such signs were not, in fact, passing fashions at all, but harbingers of some appalling new established order of things.

Why these changes occurred is, as yet, unknown: what matters is that change happened within the supposedly monolithic Age of Faith. But while styles in dress can point to more universal shifts in value systems, to the *habitus* broadly construed, it is very unclear what light they might shed, for instance, on developments in the style of contem-

porary Gothic church building. In considering them in a larger sort of context, it is not a question of pursuing explanation, but rather more limited and specific quarry: evidence for the way changes in style (however explained) and commentary on them shed light on pressing moral and aesthetic issues which may, in turn, clarify our approach to the medieval arts. Fashion in dress was the only area of aesthetic activity at the time that elicited serious sustained comment. Because international responses differed, this chapter will look at England, France and Italy — Italy not least because the criticism of fashion there had, I think, wider relevance to Renaissance thought about Gothic art itself.

In 1327 regime change brought to the throne of England by far the youngest royal family in Europe: Edward III had been born in 1312, his queen Philippa of Hainault in 1314. Their youth may have been a factor in the encouragement of the new (possibly French) tight fashions, suited to teenage bodies, less flattering to the spreading middle-aged profile. Under the year 1344 a Westminster chronicle notes ruefully that the fad for following foreign styles had indeed arrived with the Hainaulters at court in the 1320s.[5] Such xenophobia would not have acknowledged that there was, in fact, some theoretical basis for the differentiation of courtly dress, which could have influenced both the materials used and their cut. It had been set out in the advice literature prepared by the clerk Walter de Milemete for Edward III just before he ascended the throne, namely the pseudo-Aristotelian text known as the *Secreta secretorum*. The *Secreta* tradition governing royal conduct observes that, in regard to royal vestiture, a king should wear beautiful and foreign clothes (in English renderings of the text 'dear, fair and strange') in order to set him apart from others as a subject of respect. This doctrine embodied the Aristotelian virtue of magnificence, largesse exhibited without regard to loss or gain. Decorum required a measure of 'strangeness', since foreignness was a measure of what power could command. By 1336 this thinking was given statutory substance in sumptuary legislation, which prohibited the use of foreign-made cloth by anyone other than the immediate royal family, and also restricted the use of fur and the export of wool.[6] The language of legislation in 1336 was less vivid than that issued in 1363, which alluded to the 'outrageous and excessive apparel' worn by diverse people 'contrary to their estate and degree'.[7] So the principle was clear: in the first instance, this was court prerogative. The problem was keeping it that way.

Things had manifestly got out of control by 1340. In 1337 the Scots (reputedly) pinned a rhyme to the door of a church in York which mocked English dress as a symptom of courtly decadence:

> longe berde herteles
> peyntede hood wytles
> Gay cote graceles
> maketh englond thriftles.[8]

The dominance of clerical opinion is notable. In 1342 Archbishop Stratford's constitutions for the clergy invoked the theory of decorum, which identifies the outer with the inner state of man, when condemning abuses in tonsure, clothing, horse trappings and other scandals already forbidden under canon 16 of the Fourth Lateran Council (1215): clerks should not wear over-long hair to their shoulders, tight paramilitary clothing, long sleeves, hoods with lappets of wonderful length, long beards, knives, horns hanging from their necks and fur, in disregard of the canons — all this on pain of suspension from office.[9] What worried commentators especially was not just uncanonical excess but also social and moral subversion. Under the year 1340 the *Chronicon anglie* describes a miraculous vision of the powerful, mean and avaricious former bishop of Lincoln and Chancellor, Henry Burgersh (d. 1340).[10] After his death, the bishop's ghost appeared to one of his men-at-arms with instructions that the parkland he had enclosed when bishop should be given back to the folk who had been ejected. The chronicler says that in the vision the bishop carried a quiver, a bow, arrows, and horn, and wore a short green tunic. Burgersh, once an exploiter, had become a postmortem social radical — an ecclesiastical Robin Hood.

The few but vivid English monastic chronicles that remark puritanically on these fads — specifically the Malmesbury-based *Eulogium historiarum* and its continuation in a *Brut*, and the Westminster *Chronica*, all of the 1340s to 1360s — take a noticeably strong line on their sheer wickedness, as opposed to their youthfulness or destabilization of the social order. Under the year 1362 the *Eulogium* (written, by his own admission, by a bored Malmesbury monk) excoriates the feminization of male garb, the wearing of tights or 'harlots' that contoured the genitals, and shoes with immense points called Crakowes resembling the claws of demons: the wearers look more like minstrels, or jesters, than real men, more like actors (*histriones*) than knights, comics (*mimi*) than soldiers.[11] The contrast of jesters, minstrels and actors with 'real men' and specifically soldiers is one born, one must assume, of the reinforced military ethic of the reign of Edward III and the conflict with France. The new dress was therefore unpatriotic and unpleasantly

sexual. At some point in the 1360s the Westminster monk John of Reading (d. 1368–9) set down a particularly grim *Chronicon anglie* entry for the year 1344 which placed the new style at the feet of the Hainaulters (his entry follows an account of the granting of the custody of Westminster Abbey's temporalities to Philippa late in 1344, and may therefore have been politically motivated). The long full dress of former decency (*antiqua honestate*) was cast aside, and the new weird fashions made people look like torturers or demons; women wore tight revealing dresses and fox fur hiding their arses (*ad anos celandos*).[12] The moral consequences of all this were explicit only by the time of his entry for 1365 in which the recent outbreak of plague or 'pokkes' was connected with the mad pursuit of foreign fashions, which among other things had led men to wear exceptionally long knives hanging suggestively between their legs.[13] Criticism was 'in the air'.

The Egerton Genesis, executed in the midst of this age of fashion anxiety in the 1340s to 1360s, sheds some light on what John meant. At folio 11–11v of this manuscript (pls 301, 302) there are particularly colourful images of Sodom and the Sodomites in the story of Lot and Abraham. As the inhabitants of Sodom roughly get down to it on folio 11, two Sodomites are shown in the latest fashions, one brazenly fondling the hilt and pommel of a sword positioned between his legs, the other, looking just like a jester with pointed hood and shoes, heartlessly battering some approaching beggars with a long paddle.[14] On folio 11v one of the Sodomites, also dressed like a jester but now struck blind, eerily gropes his way round Lot's house in an obscene mime, with a sword dangling down rudely between his legs. Abraham and Lot are, of course, in decent old-fashioned loose-fitting gowns. The visualization of moral types is so close to that of the *Eulogium* and the writing of John of Reading, just cited, as to remind one of the hypothesis that the Egerton manuscript was itself produced in a monastic milieu in the region of Oxford. It seems to flesh out just the same prejudices.

It is worth asking how these denunciations took the form they did, given that their content was not, in fact, original. At this point a recurrent theme of this book re-emerges: the sense in the fourteenth century of déjà vu, of a resurfacing of issues and styles that had first appeared well over two centuries earlier. The Malmesbury origin of the *Eulogium historiarum* is a reminder that a very similar critique of contemporary fashion and more had emerged across northern Europe in the late eleventh and early twelfth centuries. William of Malmesbury had been one of its exponents,

302 Egerton Genesis, top row: Lot offers his daughters to the Sodomites, who are struck blind; bottom row: Lot fornicates with his daughters (London, BL MS Egerton 1894, fol. 11v)

since, in his scathing attack in the *Gesta regum* on the vices of the court of William Rufus – and at this time the targeting of court culture was even more explicit – he explicitly attacked the wearing of pointed shoes, the loss of hardiness and military discipline, and the general effeminacy of young men, especially in their camp gait and softness of body (*mollitie corporis*).[15] William further developed this in writing of the court of Henry I, blaming the Normans for the importation of long hair.[16] It is inherently likely that the bored monk of Malmesbury who compiled the *Eulogium* had consulted Malmesbury's own copies of William's works, and in effect recycled and updated it. It was of course much more widespread. Eadmer had said much the same at Canterbury in the early twelfth century.[17] Within a few years Orderic Vitalis set down a particularly spectacular rant in his history of the Church. He targeted Fulk, count of Anjou, who, because he had deformed feet, invented shoes with pointed toes like scorpions' tails – whereupon all, rich

and poor alike, demanded this accessory. They spread to the court of William Rufus, where shoes with points likened to rams' horns indicated nothing other than sodomy and vice on the part of those who 'rejected the traditions of honest men', wore long hair, over-tight tunics, guzzled booze and gambled: 'our ancestors used to wear decent clothes'. And so God dealt out punishments with many scourges (*multiplici flagello*).[18] The theme of ancient modesty is found in John of Reading; but it may have been the French circulation of Orderic's works that account for the reuse of two ideas in the writings of fourteenth-century French commentaries: the notion that these fashions spread quickly to the lower orders and the imagery of flail-like punishment, which occur in the chronicle of Guillaume de Nangis and in the *Grandes chroniques*, to be considered shortly. Similar passages are to be found in the writings of Radbod of Tournai, who blamed long hair for the spread of epidemics, and of Siegfried, abbot of Gorze, and Ralph Glaber, the earliest of the critics who thought the French were being corrupted by southerners as early as the 1040s.[19]

This point about the recirculation of text is reinforced by a simple, visual truth: the fashions of the late eleventh and early twelfth centuries seem themselves to have anticipated those of the 1340s in their liking for fancy hair and beards, tight-fitting tunics, hose, long sleeves and pointed shoes.[20] As a result, by depicting them it was possible to shape the same sort of visual commentary that has already been found in the Egerton Genesis. In the copy of the Moralized Bible made in Paris for the French king Jean II around 1350, the new fashions are used to dress up demons or to illustrate the pitfalls of cross-dressing, as banned in Deuteronomy 22:5.[21] Exactly the same conceit appeared almost exactly two hundred years earlier in the English-made Winchester Psalter (British Library Cotton MS Nero C.IV): its prefatory Gospel cycle includes the *Temptations of Christ* (fol. 18), the third of which shows Satan tempting Christ with worldly goods while dressed in an ultra-tight dress-like tunic with laced sides through which his fur peeps fetchingly, flaunting super-chic knotted sleeves and train: the effect is deliberately feminized (pl. 303).[22] Jennifer Harris was right to point to this correspondence of outlook as evidence against some idea that self-consciousness in fashion was a product of the fourteenth century: plainly a sense of the parodic had appeared in the Romanesque period, and parody feeds self-awarely on established decorum.[23]

In fact, it is nearer to the truth to see the fashion problem as part of a cyclical but as yet unexplained (demographic?) tendency to crises of specifically youth culture at courts,

303 Winchester Psalter, *Temptations of Christ*, mid-twelfth century (London, BL Cotton MS Nero C.IV, fol. 18)

apparent in the eleventh and twelfth centuries and again in the course of the fourteenth, which was typified by the same general targets and by a recycling of the same rhetoric of anxiety. It is very unclear that fashion options around 1330–40 (the crucial period) were in some way informed by a self-conscious desire actually to revive the older, 'jongleuric' styles – the *Eulogium*'s attack on minstrels, jesters, actors and comics is interesting in this regard. One might ask how and where such old fashions could have been studied, unless, of course, certain groups in society at its more theatrical end had always tended to dress in this way, the fashion just intensifying and spreading at certain times rather than others. Notions of 'revival', as I have suggested elsewhere in this book (p. 68), are problematical. But circumstances do recur, and of these, periodic bouts of militarism – as occurred from the 1330s as Edward III's political

and military ambitions in France became clear – are much the most likely to have brought about stock responses to soft courtly *mores*, at least in seigneurial north-western Europe. Under Philippe III and Philippe IV of France, sumptuary legislation appears to have coincided with provisions for war.[24] It is likely that, so far as these fashions were concerned, the moral discourse of war pre-dated that of plague, and to judge by critiques of the court of Richard II (1377–99), it persisted long after.[25]

What is also obvious is that the critiques – actually rather few in number, and basically 'feudal' and conventional in content – made no difference at all to actual fashion choices. Moralizing attacks and sumptuary laws were issued repeatedly for the simple reason that they failed.[26] There is an important lesson here for 'fashion' in other media, and moral critique more generally, which tends to be oversold. As in the great era of pastoral reform of the twelfth and thirteenth centuries, basically stoic prescriptions about architectural decorum, as of 'habits' generally, had little or no general effect.[27] Ideally, the commentary ran, the way we conduct ourselves as moral agents should harmonize with the way we dress and build, for decorum should have coherence and universality as a proper correspondence of inner and outer form, as the 1342 constitution of Archbishop Stratford says. But for this to be true, architecture had to submit to the same ethical constraints as dress, enforceable only in the context of effective disciplinary frameworks such as those provided, in theory, by monasticism. Such controls were impractical in the world of building at large: architecture is dauntingly complex, slow moving and pragmatic, and not readily 'corrected'. Fashions in dress are by their nature volatile, capable of rapid change in a way that architecture is not. Dress fashion continued apace with sublime indifference to constraint, as the persistence of the tight style into the late fourteenth century proves. If anything, the moralists imply that standards dropped rather than rose after the great plague of 1349; vulgarity and sensualism remained in vogue well into the 1360s, and the repeated character of the bouts of plague seemed to inflame the problem yet further. The effect of the critique in England was subtler, more insidious, drawing certain forms of architectural patronage into a burgeoning literary discourse of satirical *vituperatio*, not *laudatio*, but not actually prescribing style as such. A 'moral' account of the end of the richer versions of the Decorated Style after the Black Death would be hard to establish. All that can be said is that there are instances where ambitious building projects were reined in as a result of financial imperatives whose guiding rhetoric, but not motive, was that of austerity. Money, not morals, was the issue.

The French and Italian positions on the new dress styles, in so far as they can be judged from a limited number of sources, are instructive in this general regard. The French were less inclined than the English to see the new styles as actually demonic, but more inclined to worry about war, youth and class. In what was long thought to have been a continuation of the *Chronique* of Guillaume de Nangis, the Parisian Carmelite Jean de Venette described the change of fashion in France after the military victories of Edward III at Sluys in 1340, his 'usurpation' of the arms of France and England conjoined, and the siege of Cambrai.[28] The *Chronique* witnessed it first amongst upper-class youth; but more worryingly, servants and townsfolk adopted it. Clothes had become deformed and short, beards over-long. The association with war is particularly direct: 'men thus tricked out were more likely to flee in the face of the enemy', as subsequent events were to prove. Similarly, the Saint-Denis *Grandes chroniques* mentioned the change after its account of the military disaster at Crécy in 1346.[29] It explicitly linked the defeat of the flower of French chivalry to the pride, greed and covetousness of the nobility and their lack of decency in clothing, such that the short tight tunics on men revealed their buttocks to those behind them when they bowed to their superiors, and that men attempting to shed such clothing looked as if they were being flayed alive.[30] Others wore girlishly pleated robes and particoloured cloth, so that they looked like jugglers (*jugleurs*). It was no surprise that (perhaps echoing Orderic Vitalis) God's punishment had been felt in the form of Edward III's flail. Foreigners were not responsible for importing the fashions (which were probably French), but rather for exposing their moral consequences.

On this point the Italians differed somewhat, at least to judge from the three often-quoted sources. Their concern was explicitly about the threat to Italy of invasive foreign cultural contagion. The Dominican Galvano della Fiamma (d. 1344), writing about Milan in 1340, stated that its youths had recently adopted the tight (*stricta*) style in the Spanish mode, French haircuts, wild beards and German gait; they spoke Italian like Tartars (i.e., roughly), and their women carried themselves like Amazons, tough and hard-hearted.[31] His discourse concerned barbarism, his interest in beardedness, behaviour *more barbarico*, and the geographical hemming in of Italy by Spanish, French, German, Tartar and Amazon customs, revealing a generalized fear of invasion. His authorities for this would have been far older, and their first

concern would have been the Latin language. Isidore in his *Etymologies* under 'barbarism' (I.xxxii) had defined it as ignorance of the purity of the Latin language by external groups who had themselves become Roman; Quintilian (*Institutio oratoria* I.5.5) thought of barbarism linguistically as consisting of ethnic words of African or Spanish derivation. Not surprisingly, Galvano's critique was followed by a text on the 'manners of the ancients' derived from Riccobaldo da Ferrara – a lament for the simplicity and rigour of the good old days of the preceding century. The contrast between the simplicity of the ancients and the luxury of the moderns alluded ultimately to the Senecan Stoic understanding of ancient virtue, a *locus communis* in the schools of declamation of imperial Rome. The Florentine chronicler Giovanni Villani (d. 1348) took a similar line on his city in the early 1340s, reporting that its youth were wearing tight clothing, elaborate belts, pouches in the German style (*alla tedesca*), hoods, beards and long sleeves. These fashions had been introduced by a foreigner, Walter de Brienne, duke of Athens but actually a Frenchman given to tyrannical action and lack of sympathy for the stoic dignity of the toga.[32] A dignified proto-humanist *romanitas* had entered the public iconography of the city states some years earlier.[33] It, and more ancient virtues, had to be defended. Even in Rome herself, foreign ways were prevailing: the *Anonimo Romano* chronicle for 1343, written by an author in the circle of Cola di Rienzo, reports on the adoption there of the tight Catalan style, hoods, daggers and great beards like those worn by Spanish soldiers.[34] What to northerners in France or England looked like a weakening of military strength seemed to their Italian neighbours a kind of over-militarization.

Italy's cultural xenophobia needs to be seen in the context of beliefs about the defence of the purity of the culture of Rome and its daughter Florence in the writing of Cola di Rienzo, Villani and, ultimately Petrarch: perhaps its greatest fourteenth-century text is the withering *Invective* against a (French) detractor of Italy composed by Petrarch in 1373, the ulterior aim of which was to move the papacy from Avignon back to Rome.[35] But there was a consequence too within the *quattrocento*. The underlying narrative of the destructive force of northern barbarism apparent in the Italian fashion commentary looks very much like a rehearsal of the opinion of the architectural theorist Filarete in his celebrated *Trattato* on architecture of the 1460s.[36] Filarete relates that he eventually felt disgust for the architecture of the Gothic *moderni*: connecting impurity of language to impurity of building style, he noted that architecture declined 'as letters declined in Italy'. The ruin of Italy had

been brought on 'by the wars of the barbarians (*questi barbari*) who desolated and subjected it many times. Then too, many customs and rites came from the other side of the Alps. Because no great buildings were built, since Italy had become poor', men lost experience in how to build and were forced to turn to goldsmiths, painters and ordinary masons. The goldsmiths fashioned buildings like tabernacles and thuribles, and they made real buildings in the same manner, though these had nothing to do with architecture. 'These modes and customs they have received, as I said, from across the mountains (*olatramontani* [*sic*]), from the Germans and the French. For this reasons ancient usage was lost.' So proper decorum based on tradition was pushed out as ultramontane barbarian invaders introduced art practices that derived from 'minor' arts, subverting the classical hierarchy of style and undermining one of its principal (Vitruvian) virtues, stability, that which makes architecture what it really is. 'Great' building was thrown aside by barbarians, along, so to speak, with the toga.

In saying this, Filarete was being neither especially original nor free of polemic. Still, it has not been noticed that he injected into serious discourse about architecture a stance about visual culture first explored in relation to fashions of dress a century earlier. Filarete was being shrewd. Much in the present book would lend substance to Filarete's insight, however prejudiced in itself, that Gothic architecture, certainly as developed in England in the early fourteenth century, consisted in the relation to that which it is not. The 'metalwork' agenda is easy to trace not only in the training of significant patrons or architects (Alan of Walsingham, Hanns Schmuttermayer), but also in the language of architecture as at once huge and microscopic, in such texts as the late thirteenth-century *Der jüngerer Titurel*.[37] Perhaps Filarete had in mind the extraordinary surfaces of the new cathedral at Milan, whose nave piers are topped by vast encircling tabernacles with sculpted figures, neither Gothic nor classical in proportion, which to one modern commentator invoked the decoration of gilded episcopal crosiers.[38] Even the French 'expert' called in to advise the Milan cathedral chapter at the time, Jean Mignot, found them monstrous: even he, the representative of canonical Gothic, was 'Vitruvian' by instinct.[39] But the final nail was hammered in by Vasari in the introduction to architecture in the 1550 edition of his *Lives*.[40] Not only were 'German' works very different from classical architecture, they also had portals with columns so 'subtle and twisted' as to be incapable of support; these architects 'made such a malediction of little tabernacles (*maledizzione di tab-*

ernacolini), put one above the other, that they cannot stand'. In their lack of Vitruvian *firmatas*, such buildings 'seem made more of paper than of stone or marble'.

Literary Imaginings: The Anxieties of Architecture

What to the Italians seemed like an unstable, and destabilizing, aesthetic vice was to their northern counterparts a fundamental aspect of invention, not least literary invention. A passage in the late fourteenth-century alliterative poem *Sir Gawain and the Green Knight* describes Bertilak's castle as a vision of glinting white towers, thick with battlements and pinnacles:

> So mony pynakle payntet watz poudred ayquere
> Among þe castel carnelez, clambred so þik,
> þat pared out of papure purely hit semed.[41]

'Semed' captures both a sense of uncertainty and a lack of solidity: things 'pared out of papure' and also 'poynted of golde' are found as table ornaments at Belshazzar's feast in the contemporary alliterative poem *Cleanness* in the same manuscript source as *Pearl* and *Sir Gawain and the Green Knight*.[42] *Cleanness* anticipates another theme of the Italian critics: the exchangeability of stone and metalwork, magnificence and minificence, in describing Solomonic liturgical vessels shaped 'as casteles arayed/ Enbaned under batelment with bantelles quoynt'.[43] But – it has to be said – these surface effects of tinsel and instability were built on solid literary foundations that positively celebrated the ludic, the mixed and impure, the hesitant, transient and the outlandish, as features of poetic invention that architecture, or the poet as master builder, seemed especially suited to expressing.[44] Literary considerations aside, it seems possible that this was so because of the peculiar freedoms of English architectural invention itself: it served poets well, because poetry, or a sort of poetic imagination, had already served it.

THE HOUSE OF FAME:
THE HEROIC MODE FALTERS

English literary practice now devoted its most concentrated and extended efforts to buildings of the literary imagination rather than to exercises of praise of actual buildings – an older practice. Such efforts were, as a rule, reveries, lingering accounts of buildings and architectural surfaces that drew on a much older and very substantial tradition of religious exegesis of architecture, often allegorical.[45] Architecture

insinuated the existence of something beyond, pleasant or otherwise. Satire could do the same. Indeed, by the second half of the fourteenth century the elaborate Christian-chivalric tradition of architectural exegesis, this allegorical mode, had begun to mutate into satire. The two longest passages of writing about architecture at the end of the century are found in Chaucer's early incomplete poem *The House of Fame* (probably under way in the late 1370s) and a slightly later critique of the mendicant orders, *Pierce the Plowman's Crede*, composed not long before 1400. One text is 'humanist', the other more emphatically religious–satirical. The high, or relatively high, literary context of such writers throws into relief the hesitant survival of the older, heroic, value system in passages such as the Walsingham memorandum (p. 224) being entered formally into monastic chronicle tradition at exactly the time (after *circa* 1366) that the satirical literary mode was starting to flourish. Before 1300 the major writings touching Gothic architecture in England had emerged in institutions associated with great saints, charismatic leaders such as St Thomas at Canterbury and St Hugh at Lincoln: but that age, the age of the personality cult, had faded. It is as well to recall that the description of Lincoln Cathedral in the Metrical Life of St Hugh occurred in the context of what was essentially canonization literature – Hugh was canonized in 1220. The significant reduction in the processes of canonization, especially episcopal canonization, typical of England from the late thirteenth century, marked the end of this tradition.[46] Praise, and blame, were now directed at different, more abstract, things – literary traditions, canons, social estates (Chaucer) or the betrayal by institutions that had served the old sacral personality cults (the Dominicans and Franciscans) of the values that those cults had at first instilled: the so-called anti-fraternal critique. In their earthiness, realism and tone of disappointment, the new writings set aside the old heroic values.

Chaucer's instance is exceptional because he is the one major writer in western Europe of the period who had practical dealings with buildings and architects, since he was Clerk of the King's Works between July 1389 and June 1391.[47] He was responsible for works at Westminster, Windsor and elsewhere, and paid salary arrears to the great court architect Henry Yevele, designer of the graceful new nave at Canterbury Cathedral.[48] But this does not mean that his literary awareness of architecture as style was 'Perpendicular', though it might have been more generally 'courtly'. There are dangers in locating Chaucer's extraordinary imaginative sensibility reductively in the historical realities of his professional station, not least because *The House of Fame* was

conceived and written a decade before his association with the royal works.[49] The fact that he wrote very intelligently about architecture (or at least, *with* architecture) is a measure of his poetic rather than his administrative capacities.

Book III of the unfinished, anarchic and highly influential *House of Fame* takes the poet, the Chaucer-persona, through the final two of three very odd buildings.[50] Book I opens with a dream-vision of a glass temple of Venus, furnished with many gold images in niches, rich tabernacles, stone pinnacles and 'curious portreytures/ and queynte maner of figures/Of olde werk': on a plaque on its wall are the opening lines of Virgil's epic *Aeneid* (ll. 119–27, 140–48). This is a crucial move, since it demonstrates the sense in which this edifice is a frame, an auratic setting, for an essentially literary ideal. The temple is a sort of para-architecture in the tradition of reckless combinations of glass and precious stones of the German epic *Titurel* and eventually Lydgate's *Temple of Glass* (also 'about' literature).[51] It possesses less 'style' than eloquent materiality, in which literary greatness is set as a gem *en cabochon*. The ascent to the palace of Fame herself occupies Book III. The *gradus ad parnassum* takes the poet-persona up a high rock, climbed with difficulty on the model of anagogic ascent: the rock is in fact made of ice, into which are carved the names of the famous, those exposed to the glare of the sun melting away, those in shaded obscurity on the north side lasting longer. 'Thoughte I, "By Seynt Thomas of Kent/This were a feble fundament/To bilden on a place hye"' (ll. 1131–3). Chaucer's oath is intelligent, aware of a mystery of English architectural poetics: Thomas Becket was commonly regarded in hagiography and liturgy as a mighty pillar of the Church, a cornerstone, the very model of what a foundation should be. The saint's 'stoniness' was a primal phenomenon, a thing in itself, not a sign.[52] But *Fame* on the contrary deals with the transient. Perched on this melting iceberg is the palace itself, formed throughout of beryl, translucent but not transparent: the English word 'brilliant' is derived from *berillus*, suggesting perhaps dazzling superficiality; not only that, beryl, like Fame, magnifies things so as to appear larger than they really are, 'And made wel more than hit was/To semen every thing, ywis/ As kynde thyng of Fames is' (ll. 1290–91).

There follows a substantial description of the House of Fame itself:

> Thoo gan I up the hil to goon, 1165
> And fond upon the cop a woon,
> That al the men that ben on lyve
> Ne han the kunnynge to descrive

> The beaute of that ylke place,
> Ne coude casten no compace 1170
> Swich another for to make,
> That myght of beaute be hys make
> Ne be so wonderlych ywrought;
> That hit astonyeth yit my thought,
> And maketh al my wyt to swynke 1175
> On this castel to bethynke.
> So that the grete craft, beaute,
> The cast, the curiosite
> Ne kan I not to yow devyse,
> My wit ne may me not suffise. 1180
> But natheles al the substance
> I have yit in my remembrance;
> For whi me thoughte, by Seynt Gyle!
> Al was of ston of beryle,
> Bothe castel and the tour, 1185
> And eke the halle, and every bour,
> Wythouten peces or joynynges,
> But many subtil compassinges,
> Babewynnes and pynacles,
> Ymageries and tabernacles, 1190
> I say; and ful eke of wyndowes,
> As flakes falle in grete snowes.
> And eke in ech of the pynacles
> Weren sondry habitacles,
> In which stoden, al withoute – 1195
> Ful the castel, al aboute –
> Of alle maner of mynstralles,
> And gestiours, that tellen tales
> Both of wepinge and of game,
> Of al that longeth unto Fame. 1200

The vocabulary will be familiar from much that has already been said in the present book: *kunnynge, wonderlych, astonyeth, wyt, curosite, devyse, subtil* and so on, often terms that mediate between verbal and visual craft. The poet Lydgate's language, when relating how Priam built Troy, is similar: *corious, wyt, merveilous, sotyle* and *crafty*.[53] Chaucer's passage moves, in effect, from wondering admiration to imitation, from standing back to peering. First is the commonplace of inexpressibility, usually a product of encounters with the great: the house is such as to defeat literary cunning in describing it, so wonderfully made that thought is astounded and wit put hard to work to capture it by literary devising. Far from being graspable as something literal and comprehensible, architecture occasions a literary perplexity characteristic of the wonder response: it triggers the labour

of investigation, aided by committing the entire thing to memory. The house is made of beryl but in such a way as to conceal the joints 'Wythouten peces or joynynges', the (rhetorical and Augustinian) notion – also encountered in the Metrical Life of St Hugh – of diverse materials forming one thing. Its 'subtil compassinges' (tracery?), baboons, pinnacles, tabernacles and habitacles – the last three rhyming diminutive forms, implying close working – indicate a Gothic building, as does the blizzard of windows, reminding one of the ice beneath. Only in this regard is there a sense of a repertory of style, of 'canonical' Gothic, captured by a pseudo-technical language: the clustering of topics is analogous to what is found on the *Judgement of Solomon* page in the Bodleian Psalter (MS Douce 131) discussed earlier (see pl. 166), but it is not clear that it could not paint a Perpendicular as much as a Decorated building, or indeed a house like that of Jacques Coeur in Bourges, where the same basic formal rules apply.[54] *Pinnacle, tabernacle* and *habitacle* are all found in English vernacular Bibles in the 1380s, which suggests either that the terms are in some sense also spiritual or that Chaucer, like Shakespeare, invented discourse in *Fame* itself. He may have elected to develop and use this vocabulary not because it was familiar, but because it was itself strange, the mysterious language of some inner secret circle of expert insiders.

Banal notions of art style – to say nothing of futile attempts to align late medieval poetry formally with the Perpendicular style – serve less well here in understanding this writing than getting to grips with the primal overlapping of the visual and textual whereby the visual seems to be the textual.[55] This is a question of understanding the building as poet-craft; and once this is seen, one may appreciate the extent to which Chaucer's 'portraits' of architecture are not to be understood in terms of some 'naturalistic' sensibility, style analogy or historicist contextualization, but precisely as the *undoing* of architecture by literary artifice, by style, to serious literary ends. This deconstruction of 'real' architecture of course addresses a question. Chaucer's problem is Fame, specifically literary fame; and this problem is objectified in his description of the main Hall of Fame, which, to Christiania Whitehead, 'is nothing other than an ambitious spatial representation of the entire literary canon', a structure that 'claims to comprehend the entirety of the written word'.[56] On entering it, the poet finds that every inch of the walls, floor and roof of the hall is plated half a foot thick in gold, a manifest reference to the gilded vulgarity of the houses and temples of the Romans, the Pantheon especially – for this is a literary pantheon of sorts (ll.

1345–6). The walls are crowded with niches filled with the various stones of the Lapidary (ll. 1350–53). Here Fame herself sits imperially, a figure now small, now touching heaven with her head in a wondrous Alice in Wonderland (or Boethian?) change of scale so typical of the aesthetics of the period, but here symbolic of the vicissitudes of fame and exemplifying rhetorical *amplificatio* (ll. 1368–75). Caliope, the Muse of epic poetry, sings her praises. The hall is arranged with a series of pillars of metal 'that shone not ful cler' because they were not of fine bronze or gold – the materials of the heroic mode – but base metals: on these columns stand the great of literature (ll. 1419–1512). Josephus stands on a pillar of lead and iron, lead for Saturn, iron for Mars; Statius on an iron pillar painted with tiger's blood; Homer on a pillar of iron; Virgil on a pillar of tinned iron (only slightly superior), and so on. The subtext here is clearly not dignified imperial triumph, but a form of idolatry, since medieval idols customarily stood upon columns, here ridiculed by the poet's semblance of this crowd of literary gods on sticks to trees stuffed with rooks' nests (ll. 1514–16).[57] Where the virtuous and great men of Christianity, the martyrs especially, were pillars sustaining the Church, here architecture props up empty and tarnished fame. The hall is a place of charisma; but the great illusion will soon be dispelled.

Radical inversion of great architectural ideas is exemplified too by *The House of Fame*'s final and most extraordinary structure, the *Domus Dedaly* down in the valley from the House of Fame itself (from l. 1916). This is no wondrous and stable construction of stone, but a vast 60-mile-wide multicoloured and brittle labyrinth, woven from twigs and reeds, spinning as rapidly as thought and emitting a terrible noise, with machinery, 'chirkynges' and 'werkynges', like some hellish fairground roundabout. Chaucer's labyrinth, like his pillars, is once again the undoing of an image of authorship, the cathedral labyrinth that positively celebrates the lofty intellectual and practical attainments of Gothic architects as found at Reims or Amiens.[58] Whitehead sees in Chaucer's version of the labyrinth a discourse of class, in which this building is the opposite of a palace, and instead a commonplace, restless and porous factory of Rumour, a satanic mill of whispering.[59] As in the great fantasy structures of the Christian imaginary such as the Grail temple in *Titurel* with its organ trees and vast acoustics, sound is as important as sight in capturing the strange horror of this structure. Something in this disorientating vision of *laborintus* exhausted even Chaucer, since his text ends imperfectly a few lines further on.[60]

Chaucer's sophisticated detachment and irony is not merely that of an intelligent informed observer of real architecture, but rather that of an essentially literary imagination that thinks 'with' architecture. *The House of Fame* may not have been without influence in England for all its ambivalence.[61] But its essentially literary objective, conjuring architecture or the architectural in order to construct a labyrinth of ideas about those most ancient of themes, invention and reputation, was different from latching onto architectural surfaces and details as signs of something subject to Christian moral critique.

PIERCE THE PLOWMAN'S CREDE: ERROR AND THE POETICS OF NAUSEA

This brings us to the long passage about buildings in *Pierce the Plowman's Crede*, composed probably in the 1390s.[62] *Pierce the Plowman's Crede* is a quest for knowledge of the tenets of the Faith, the intent of which is to expose the hypocrisy of the friars; the narrator has his primer or ABC, his *Pater noster* and *Ave Maria*, but not his Creed. The orders of friars to whom he turns for help, more intent as they are on mutual detraction than on pastoral guidance, fail to impart it: and so the narrator has to rely on the goodness of the ploughman who eventually teaches it to him. The poem is a variant of Langland's *Piers Plowman*, which, in keeping with the allegorical tradition, makes questing use of buildings to point up moments of significance, such as the Manor of Truth. Buildings, pathways, are the *ductus* of such poetry, its way 'through' the material.[63] But in *Pierce the Plowman's Crede* an exceptionally long conjuration of the appearance of a Dominican house acts not as a simple pathway steering us from *error*, wandering, but actually as an aesthetic exemplification of *error* itself. Indeed, the text thematizes the wandering of the friars as a negative sign or leitmotif, 'Wepyng, y warne yow of walkers aboute', a 'wandering' apparent in their art (ll. 87–90).[64] So in *Pierce*, which mentions John Wyclif and Walter Brut in a way consistent with a date in the 1390s, and is often described as being 'Lollard' in its sympathies, the old allegorical tradition as a basis of social, moral and religious stabilization is problematized to an extent that challenges it.[65] Though not a Lollard text doctrinally, *Pierce* is far more partisan than anything in Chaucer.[66] Architectural surfaces become not a way through, but a sort of fascinating dead end or at the very least a labyrinth; they are the subject of social and moral pessimism and denunciation, the expression not of the adherence to, but the betrayal of, values. Moral-aesthetic

reverie and criticism occupy some 70 of its 850 lines, directing us not upwards to enthusiasm or spiritual rapture, but downwards towards moral disgust and cynical knowledge. *Pierce the Plowman's Crede* is in part heir to a widespread critique of the mendicant orders, developing rapidly from the mid-thirteenth century, representative of anti-fraternalism, which entered English literary practice mostly after 1350 or so.[67] But as a discourse on error and *curiositas*, *Pierce*'s true ancestor is that master of close reading of variegated surfaces as signs of wealth, superfluity and pride, Bernard of Clairvaux.

The Franciscans, whom the narrator approaches first for his Creed, are let off comparatively lightly. Professing poverty, the minor friar eventually turns to the narrator for money:

> For we buldeth a burwgh – a brod and a large –
> A chirche and a chapaile with chambers-a-lofte,
> With wide windowes y-wrought and walles well
> heye, 120
> That mote bene portreid and paynt and pulched
> ful clene
> With gaie glittering glas glowing as the sonne.
> And myghtestou amenden us with money of thyn
> owne
> Thou chuldest cnely bifore Crist in compas of gold
> In the wide windowe westwarde wel nighe in the
> myddell 125
> And seynt Fraunces himself schall folden the in his
> cope,
> And presente the to the trynitie and praie for thy
> synnes,
> Thi name schall noblich ben wryten and wrought
> for the nones
> And, in remembrance of the y-rade ther for ever.

Their house is broad and large with chambers on upper floors, wide windows and high walls, painted and polished and full of (presumably) brilliant stained glass: it is in such a window that the friar offers the promise of an image of the narrator sheltered at its centre by St Francis and commemorated by inscriptions. Colour and dazzle ('gaie glittering glas glowing as the sonne') are means of allurement rooted out by St Bernard in his *Apologia* (p. 183), for the 'compas of gold' is a trap. John of Reading remarked wryly on the persuasiveness of the friars minor in winning the burial of Queen Isabella at Newgate.[68] The moral thinking is fairly conventional. As early as 1243 Matthew Paris, the Benedictine historian, had said of the friars that their

buildings rose to 'regal height' and that within their 'lofty' walls they spent untold treasures.[69] Even the future Franciscan archbishop of Canterbury, John Pecham (d. 1292), had to admit in 1270 that many of the order's churches were 'monstrosities', legislation issued in 1260 having attempted to rein in the tendency to height and 'superfluity', which St Bonaventure had blamed, in part, on property prices.[70]

But the narrator moves on. The real target of *Pierce* is the Dominican order, most closely associated with the condemnation of Wyclif in 1382.[71] In a passage of sixty lines the narrator leads us through a Dominican house, sometimes considered to be that at Blackfriars in London, itself massively sponsored by the crown under Edward I since it was here that Eleanor of Castile's heart was buried.[72] It is not in fact necessary to see what follows as a literal inventory: this is first and foremost a 'picturing', a moving kinaesthetic description enabling the spectator to wander in and around the friary. The impression of trespass without let or hindrance is important to this method: this landscape of excess is silent, unpeopled, for it self-sufficiently embodies the truths about it. And so the narrator sets off:

(Ich) highese to her house to herken of more 155
And whan y cam to that court y gaped aboute.
Swich a bild bold, y-buld upon erthe heighte
Say I noughte in certeine siththe a longe tyme.
Y remede upon that house and yerne theron loked,
Whough the pileres weren y-peynt and pulched
 ful clene, 160
And queynteli i-corven with curiouse knottes,
With wyndowes well y-wrought wide up o-lofte
And thanne y entrid in an even-forth went,
And all was walled that wone though it wid were,
With posternes in pryuytie to pasen when hem
 liste; 165
Orcheyardes and erberes evesed well clene,
And a curious cros craftly entayled,
With tabernacles y-tight to toten all abouten.
The pris of a plough-lond of penyes so rounde
To aparaile that pyler were pure lytel. 170

Thanne y munte me forth the mynstre to knowen,
And a-waytede a woon wonderlie well y-beld,
With arches on everiche half and belliche y-corven,
With crochetes on corners with knottes of golde,
Wyde wyndowes y-wrought y-written full thikke, 175
Schynen with schapen scheldes to schewen aboute,
With merkes of marchauntes y-medled bytwene,

Mo than twenty and two twyes y-noumbred.
There is none heraud that hath half swich a rolle,
Right as a rageman hath rekned hem newe. 180
Tombes upon tabernacles tyld opon lofte,
Housed in hirnes harde set abouten,
Of armede alabaustre (alfor) for the nones,
(Made upon marbel in many maner wyse,
Knyghtes in her conisantes clad for the nones,) 185
All it semed seyntes y-sacred upon erthe;
And lovely ladies y-wrought leyen by her sydes
In many gay garmentes that weren gold-beten
Though the tax of ten yer were trewly y-gadered,
Nolde it nought maken that hous half, as y trowe. 190

Thanne kam I to that cloister and gaped abouten
Whough it was pilered and peynt and portred well
 clene,
All y-hyled with leed lowe to the stones,
And y-paved with peynt til iche poynte after other;
With kundites of clene tyn closed all aboute, 195
With lavoures of latun lovelyche y-greithed.
I trowe the gaynage of the ground in a gret schire
Nolde aparaile that place oo poynt til other ende.

Thanne was the chaptire-hous wrought as a greet
 chirche,
Corven and covered and queyntliche entayled; 200
With semliche selure y-set on lofte;
As a Parlement-hous y-peynted aboute.
Thanne ferd y into fraytour and fond there an
 other,
An halle for an heygh kinge an housholde to
 holden,
With brode bordes aboute y-benched wel clene, 205
With windows of glas wrought as a chirche.

The poem continues for a few lines about the house's chambers and chapels 'gaie' and also quarters to house the queen (to l. 215).

Pierce the Plowman's Crede gives rise to two swift conventional points. First, from a realist perspective there are several suggestions of regality that might imply something about the character of this particular house. There is a carefully carved cross surrounded tightly on all sides by tabernacles looking out from it, which implies something like an Eleanor Cross (see pl. 102): the London Blackfriars had no Eleanor Cross nearby, with the exception of that at Cheapside, but it did retain the queen's heart, and heart burials could be ornate and polygonal.[73] The notion of

tabernacles that peer out or around – 'tabernacles y-tight to toten all abouten' – nevertheless expresses well the pan-optical character of the Eleanor Crosses. The reference to the chapter house 'As a Parlement-hous y-peynted aboute' may allude to the painted chambers of the Palace of West-minster, and not the chapter house of Westminster Abbey, fully painted only by the early fifteenth century and by then disused as a parliament chamber.[74] The frater – 'An halle for an heygh kinge an housholde to holden' – and the provision for housing the queen should also be noted. But, as Matthew Paris's sardonic reference to the 'regality' of the latest buildings of the Franciscans indicates, the dis-course of royalty here is quite as much a figure as a sign of some specific building or patronage. The implication here, as in the Benedictine John of Reading's comment that the Franciscans had 'seduced' Queen Isabella to be buried with them in London, is that the friars generally engaged in self-aggrandizing betrayals geared to increasing status and income. Art was one major weapon in this strat-egy of allurement.

Second, the passage fleshes out the anti-fraternal critique that had spread through Europe. Like the Franciscans, the thirteenth-century Dominican order legislated against excess in building, echoing the earlier art legislation of the Cistercian order; in its constitution of 1263, for instance, the order rejected anything 'notably enticing or superfluous' in sculpture, paintings, pavements or other such things; other decrees of the 1260s warned against ornate canopy work and clocks (*curiositates in tabernaculis et orologiis caveantur*) just when 'canonical' Gothic canopy work was establishing itself.[75] In a realist sense, *Pierce* simply lists all the infractions of this really quite specific statute, since it mentions carving, painting and ornate tiling. It is in the tradition of the most important early anti-fraternal document, William of Saint-Amour's *De periculis novissimorum temporum* of the 1250s.[76] *De periculis* describes a series of signs of what distinguishes a true from a false apostle. Thus true apostles do not preach for gain (no. 12), do not strive for eloquence in speech (no. 14), do not deceive men into giving them their temporal goods (no. 16), do not seek the world's favour or strive to a pleasing appearance, for a pleasing appearance is luxurious (no. 26); they eat modestly (no. 27) and do not seek lavish accommodation (no. 29).[77] This discourse found its way first into the French vernacular and then, increasingly after 1350, into English, to the point where Penn Szittya thinks (perhaps wrongly) of Chaucer and Langland as categorically anti-fraternal writers, concluding that 'anti-fraternalism was an English poetic tradition'.[78]

But realist considerations are surely secondary to the true purpose of these passages in *Pierce*, which is to demonstrate the nature of *error* and *curiositas*. The poet's vocabulary alone is an inventory of aesthetic and moral terms with particular resonances: 'gaped' (twice), 'height', 'polished', 'clean' (five times), 'quaint' (twice), 'curious' (twice), 'wide', and 'taber-nacles' (twice), to say nothing of 'crockets', 'knots', 'thick', 'shine' and 'gay'. The common use of 'clean' – a term that will be considered again shortly – must be ironic: here it carries the sense of narcissistic perfection bordering on the fastidious or luxurious. 'Quaint', here used of the sculpting of bosses or capitals (i.e., 'knottes') or other 'entails', is a rich but non-technical term derived from the Latin *cogitus* which implies something wise or learned or inventive (i.e., a 'mindful' hand, like the term *docta manus*: see p. 65), analo-gous to the literary 'cunning' that fails Chaucer in his efforts to describe the House of Fame (l. 1168). But significant as is the vocabulary, more telling still is the form of looking implicit in this account, and its presentation by alliteration. The narrator engages in a sort of telescopic viewing, a form of mental 'zooming'. So at first he wants to look at the Dominican house keenly, eagerly, with appetite – 'Y remede upon that house and *yerne* theron loked' (l. 159) – and finds an array of detail, expertly studied: columns 'y-peynt and pulched ful clene/ And queynteli i-corven with curiouse knottes' (ll. 160–61). Then he sees more broadly, taking in the whole, namely walls, orchards and herb gardens (ll. 164–6), before focusing again on the 'curious cros craftly entayled' at line 167. Alliteration, though used throughout *Pierce*, has a particular effect with regard to this shifting viewing and studying. The plosive hard 'c's in such 'art' terms as quaint, curious, knot, crockets and corner, connect in catenas whose effect is to create a kind of sequential over-load. This effect is quite different from the omission of conjunctions (asyndeton) in Latin architectural reveries such as that of Jean de Jandun on Paris and its buildings, where the resulting acceleration of effect ends in the term *raptus*, psychological 'take-off'.[79] Alliteration, together with a sense weakened by *error* of what order things should be taken in, provides in contrast a distinct sense of friction. Together with the wandering telescopic viewpoint, *Pierce* creates an archi-tectural and linguistic texture that is not strictly architectural (it has detail but no structure), but which consists primarily in directionless aesthetic overload, corresponding to the hyper-attention to detail in much late medieval allegorical writing about architecture.[80] The term 'thick', as in stained-glass windows 'y-written full thikke' (l. 175), catches the poem's affective intent or cast as a text about clouded appre-

hension and visual over-stuffing without true nourishment. What is intended to satisfy an eager eye and to divert pleasurably, itself becomes at once engorgement and empty satiation, even nausea: the greatest pleasure borders on disgust.[81]

Moral nausea is of course central to this, but the thinking involved is really no more than a speculation on *curiositas*: what Mary Carruthers calls 'polyfocal perspective', a sort of beneficial experience of manifold or complex things that could, like variety itself, go 'wrong'.[82] The crucial lines that prepare us for this intention come just before the visit begins, when at line 144 the Dominican friar (following Matthew 7:3 and Luke 6:41) hypocritically advises the narrator to 'clense clene thi syght and kepe well thyn eighe'. What follows is the Dominicans' own visual domain of *curiositas*, of the besmirched inner eye or *aspectus* clouded by aimless sensory stimulation.[83] In *Pierce* the term 'curious' is on two occasions connected with small-scale sculpture, and seems to retain the sense of *cura*, as in carefulness in the making of things.[84] It was used earlier in the century in the *Commendatio lamentabilis* of the delicate carvings on the memorials erected by Edward I (above, p. 185). *Curiositas* could have positive connotations as the means of alleviating tedium. But its more negative aspect was promulgated *circa* 1125 by St Bernard in his *Apologia* specifically to qualify carved representation: he writes of 'painstaking representations' (*curiosae depictiones*) in connection with 'sumptuous polishings' (*sumptuosae depolitiones*), and hence an idea of excessive expense and ultimately Pride.[85]

In its exposition of 'curious' looking as a response to great variety of surface, finish, medium and colour, *Pierce* uses, but subverts utterly, a noble ekphrastic tradition of architectural description that saw in great or indescribable variety something that urged the viewer to a sense of unity and transcendence. Even *The House of Fame* alludes to this unity in diversity in writing that 'Al was of ston of beryle/ ...Wythouten peces or joynynges' (ll. 1184–7). What I have in mind is the explicitly Christian rhetorical tradition of Procopius writing about Hagia Sophia (see pl. 3), or Abbot Suger about Saint-Denis, or Jean de Jandun about the Sainte-Chapelle (see pl. 24). In these texts, the encounter with pleasurable variety precedes and triggers rapture. Ways of looking are implicit in this tradition. In an important passage, Procopius says that the architectural details of Hagia Sophia produce on the one hand a

> ...single and most extraordinary harmony...and yet do not permit the spectator to linger much over the study of any one of them, but each detail attracts the eye and

draws it on irresistibly to itself. So the vision constantly shifts suddenly ...though they turn their attention to every side and look with contracted brows upon every detail, observers ...always depart from there overwhelmed by the bewildering sight.[86]

The crucial point is that here a shifting *ductus* may end in a certain perplexity, but in the case of Hagia Sophia triumphs in exaltation towards God. In *Pierce*, with studied cynicism, a wandering eye ends not in uplift, anagogy, but judgement, censure – in tropology, not *hypsos* but *bathos*. One might think of this as an aspect of the earthy 'realism' of the late Middle Ages: *Pierce's* mounting moral indignation is 'priced' banally by reference to the costs of a ploughland, ten years of tax and the income of an entire shire. Here is a conscious warping of an ancient and heroic Graeco-Latin tradition of ekphrastic *laudatio* whose ends were rapturous, for the sake of social commentary and *vituperatio*.

Colleges and 'Cleanness'

The cleansing of sight recommended by Pierce the Plowman's Dominican had a significant later life in Counter-Reformation writing: in Gabriele Paleotti's *Discorso* (1582), one of the main Counter-Reformation treatises on images, the highest level of perception of Christian art was open only to those *con occhio purgato*, with a cleansed eye, and was necessarily elitist, a matter for the educated and spiritually minded.[87] But the discourse of architectural curiosity also had an English afterlife, nearer to hand in the Catholic Middle Ages, in the fifteenth-century universities. Two separate pieces of evidence point to the possibility that high-minded caution about excess in architectural detailing was not a constant underlying issue, but something episodic or dependent upon specialized institutional or group consciousness; moreover, it may not have been free of common-sense attention to economic realities. Though 'late', these instances are relevant to the general discussion.

The first is provided by a change of heart about the finish of the new Divinity School at Oxford University under way in 1430 but evidently the subject of unfavourable comment by 1439. Early the following year the master in charge, Richard of Wynchecombe, was replaced by Thomas Elkyn, with whom a new indenture was drawn up by the university. It set out Thomas's wages, 4s. in the summer and 3s. 4d. in winter, and charged him with finding the best possible men for the work at the best possible

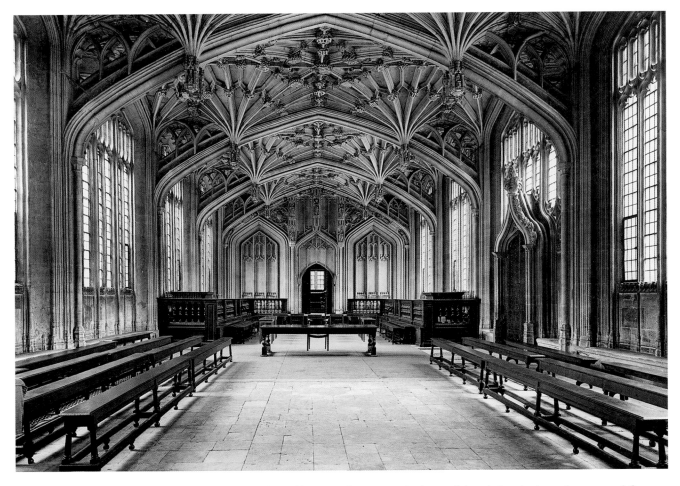

304 Oxford University, Divinity School. Discontinued mouldings may be seen on the bases of the window jambs at the extreme left

price (*et meliori precio quo poterit*).[88] The indenture is very firm on one point:

> And since several magnates of the kingdom and other wise men do not approve of, but have reproved, the excessive ornateness (*nimia curiositas*) of the said work as it has been begun, therefore the said University wishes that the said Thomas should refrain, as he has already started to do, from such pointless ornateness (*supervacuas curiositas*), namely images in tabernacles, battlements, casements, fillets and other frivolous elaborations (*frivolis curiositatibus*) quite irrelevant to the matter in hand, yet leading to excessive and wasteful expense (*nimia et sumptuosa expensae*) for the said University, and overly delaying the work.

It is unclear who the magnates of the realm and wise men might have been – possibly Humfrey, duke of Gloucester (d. 1447) and Archbishop Henry Chichele (d. 1443),

founder of All Souls College – but the need to cite authoritative opinion is striking. An examination of the school's interior window casements (pl. 304) shows that on one side subtle vertical mouldings were abandoned above the plinth, as if the brakes had been slammed on; the later vault is testimony to the futility of austerity measures. R. H. C. Davis, who first discussed this indenture in the post-war years of austerity in the 1940s, suggested that this (apparently) high-minded denial could have had its origins in contact with Italian early Renaissance architecture, and specifically mentioned Humfrey and his donation to the university of a copy of Vitruvius.[89] On this point it should be said swiftly that Humfrey's tastes could be perfectly jocular or curious when necessary (see pl. 269). Given how thoroughly the Christian language of denial was embedded in medieval writing, it is in fact hard to see why access to humanist thinking should be raised at all. For all his sense

of decorum, Vitruvius was not given to outright asceticism of thought, and Humfrey's acquisition and subsequent gift of a copy of Vitruvius anyway occurred in 1441–3, after the events in question.[90] The language used in the indenture is surely either Bernardine or mendicant. Thus the terms *curiositas*, *supervacuitas* and *sumptuositas* all occur at the start of Bernard's *Apologia*. In this sense, the subtext of the indenture might well be 'learned', a tone of neo-Cistercian reproof being stimulated by the new arrangements made for the Cistercians themselves at Oxford by the foundation there by Henry Chichele in 1437, two years earlier, of St Bernard's College.[91] Alternatively, the terms simply reflect their widespread infiltration into mendicant regulation.[92] Their Christian-moral basis is obvious.

Perhaps at that particular juncture reproofs were simply 'in the air', as they often are in comparatively enclosed, elite institutions. What is interesting is that such language could perfectly well register against the Perpendicular Style in its richer forms, a point made equally about the elaborations described in *The House of Fame* or *Pierce the Plowman's Crede*. This makes it hard to accept at face value John Harvey's suggestion that a 'clearly enunciated programme of aesthetic reform' was emerging in regard to Perpendicular in the 1430s and 1440s at the court and universities.[93] In claiming this, Harvey pointed to a second instance of the language of austerity provided by the plans for Henry VI's foundations at Eton and Cambridge. What are usually taken to be Henry's personal intentions for the chapels and collegiate buildings of these new foundations of 1440 and 1441 were set down in several documents, two of which, dated 1448, crystallize his 'will and intent'.[94] That concerning the chapel at Eton College was cited earlier in this book because it particularly mentions the height of St Stephen's Chapel at Westminster as something to be surpassed (p. 43).[95] The choice of tall corner turrets of the chapels at both Eton and Cambridge had been validated by the much more lavish Westminster exemplar. Aesthetically, however, the Eton chapel was to be relatively restrained, since the will and intent in question stated that it was to 'procede in large fourme, clene and substancial, wel replenysshed with goodely wyndowes and vautes leying a parte superfluite of to grete curious werkes of entaille and besy moldyng'.[96] The notion of being 'well replenished' or furnished with beautiful windows and vaults was not deemed inconsistent with a mandate about the aesthetic 'touch' the detailing was to show, the expression 'busy' moulding being particularly helpful as a comment on the risk of error or distraction in an educational institution. Wholesomeness and plentifulness

were signs of legitimate, manly and noble largesse; fussy ornament was an irrelevance. At Eton the position of this clause within the terms specifically of the chapel and not the collegiate buildings generally, as well as the allusion to fine windows and vaults, imply that these constraints were conceived initially for the chapel itself. The same general clause is reiterated in the intent for the college of the Virgin Mary and St Nicholas in Cambridge also in 1448, but moved later in the document in such a way as to indicate that it should apply to the entire college; the clause relating to chapel-specific features such as fine windows and vaults was therefore omitted.[97] Since the Cambridge chapel had almost certainly not been begun before 1448–9, the restraints apparent in the 1448 'will and intent' were either anticipatory or a reaction to something already in progress: the gatehouse to the main court must be a suspect.[98]

Of the terms 'large', 'clean' and 'substantial', 'clean' is the one with the greater resonances at the time. *Pierce the Plowman's Crede* sees the ironic side of cleanness: things can be a little too perfect for their own good. *Clene* had a wide range of positive senses and metaphorical associations: free of impurity, wholesome, reverent, morally righteous, proper, bright, elegant, complete; as a rule these opposed the no less important mixed, complex and curious aspects of *varietas*.[99] The poem *Cleanness* included in the Pearl manuscript finds such completeness and purity in the roundness and 'clene hwes' of the pearl itself, 'þat wynnes worschyp abof alle whyte stones' (ll. 999–1120).[100] The choice of a brilliant, as it were pearly white Yorkshire Magnesian limestone for the initial campaigns at the east end of the chapel and in its total setting out (pl. 305) makes absolute sense in regard to this aesthetic range, or lack of it.[101] It is not difficult to see why the will and intent for King's College, Cambridge, sets the expression 'clene and substancial' against 'superfluite of to grete curiouse werkes of entaille and besy moldyng'. Later English writing seems to take the ideas of wholeness, purity, elegance and completeness contained in the idea of cleanness a little further. In particular, John Leland writes in his *Itineraries* of buildings such as St Mary's church in Nottingham as being 'excellent [newe] and uniforme yn work, an [hath] so [many] fair wyndowes yn it that [no] artificer can imagine to set mo[re] there'.[102] To the period eye, a church of the thirteenth and fourteenth centuries could also warrant the term 'uniform': Leland's instance is Beverley Minster, undoubtedly impressively consistent in its retention of one general design for its interior, and according to Leland also 'of a fair uniforme making'.[103]

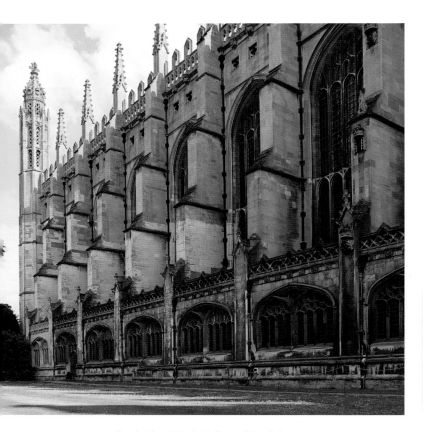

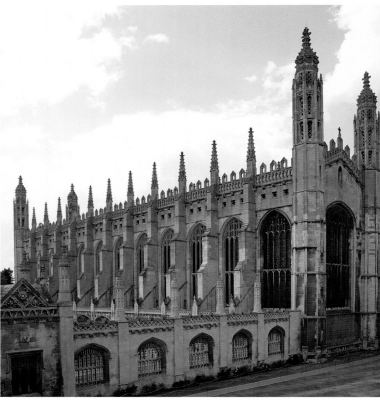

305 Cambridge, King's College Chapel, begun 1446, exterior looking south-east: the dwindling supply of white Yorkshire Magnesian stone is apparent as the buttresses progress westwards

306 Cambridge, King's College Chapel, exterior looking north-west

This approval of plentiful and well-worked uniformity might simply be a value of the Lancastrian and Tudor age (pl. 306). But – hypothetically – if it was in fact consistent with earlier positions, it implies that Perpendicular (and before it French Rayonnant) might always have been an idiom whose effects of unity and repetition operated visually as a totality, by their nature assimilated 'in one go', as if by the operation of a single glance (*conspectus*).[104] In contrast the Decorated Style, or richer forms of Perpendicular given to 'busyness', would have forced the eye to shift polyfocally and linger on specifics, not at first on the totality: *opsis*, not *synopsis*. Polyfocalism is naturally stimulated by those complex surfaces so central to the aesthetic and working of the Decorated Style: generally, surface is less relevant to Perpendicular. Both ways of looking, one fast and total, one slower and more partial, are, however, rooted deeply in medieval aesthetic experience.

But in pondering such possibilities, two more concrete historical points need stressing. The first is that these univer-sity postscripts indicate the inescapable realities of money. When, in 1439 and again in 1448, major patrons set down limits on costs either explicitly (Oxford) or implicitly (Cam-bridge), they were acting in an increasingly recessional climate in which building costs were themselves rising inexorably. It is generally thought that wage inflation in the building indus-try was picking up relentlessly by the 1420s and accelerating especially in the 1440s and 1450s, by which time wages were almost double what they had been a century earlier.[105] Such wage spikes, presumably painfully apparent by about 1440, are the single most likely explanation for the burst of the language of austerity in building-related documentation of the period, old words, as it were, addressing a no less peren-nial issue of costs. By the late 1440s Henry VI's government was 'living a hand-to-mouth existence in a fundamental state of bankruptcy', and the strict control of long-term expendi-ture, justified by traditional high-minded restraint and insti-tutional decorum, would have been inevitable.[106] The rhetoric of austerity might well be honed in such periods.

354

A second issue is the way in which such language points to the governing ethos of institutions such as universities, colleges and schools. By the fifteenth century the Perpendicular idiom had become the natural style for any major commission, as at the colleges of Oxford and Cambridge. At Oxford it was selected by William of Wykeham, bishop of Winchester (d. 1404), for his foundation of New College in 1379. The statutes drawn up by Wykeham follow the quasi-monastic constitutions for Merton College (1274) (p. 93).[107] In turn, they and their architectural context were taken as an exemplar at King's, since the dimensions of the chapel at Eton are explicitly related to that at New College in the documents of 1448.[108] Reading the King's statutes is to encounter a form of micro-management of conduct that will be practically familiar nowadays only to those who experienced the late Victorian style of education provided in some English public schools. The controls of conduct and dress descend directly from earlier monastic and clerical regulations. Thus in chapter 17 of the statutes concerning Bible readings in hall, students are admonished not to disturb the silence by nattering, gossip, shouting or sniggering.[109] Displays of greed are forbidden. Control of dress is especially evident: chapters 22–3 admonish members of the college to adhere to their 'uniform' (an interior as much as exterior state), and are forbidden from wearing parti-coloured red and green stockings, pointed shoes and long knives. Long hair is not to be nourished, or beards.[110] These various prohibitions are little different from those concerning clerical conduct and dress in canons 15–16 of the Fourth Lateran Council of 1215. The interesting point is the way that they persisted into the fifteenth century because of the sheer inertia of statute making. The statutes for King's College, Cambridge, dated 1443 are in many places simply lifted verbatim from those for New College.[111] These include the chapters (identically numbered) on hall and habit with few modifications.[112] By the 1440s concerns about out-of-date long hair, beards, daggers, stockings and pointed shoes were needless: such things were by then as fashionable as top hats were in the 1970s, but they survived textually as the ghost of old and faded worries. One addition of 1443 is interesting in the light of 'Italian' anxieties about the threat to the ancient virtue of the toga posed by modern fashion. The King's College statute no. 22 relating to dress expands that of Wykeham by stating that since the dress code of the college was to eschew 'the folly and impropriety of modern innovations' (*inventiones et ineptias modernorum insolentes*), scholars should dress in togas, gowns, 'of decent and plain cut' fitting the ancient gravity of schol-

arly and clerical dress. In a final affirmation of orthodoxy the heresies of Wyclif are abjured.[113]

In sum – and this perhaps goes without saying – aesthetic statements about architecture, not least their conventions of language, are often best considered in the light of the institutional character of the participating institution and of the values of the small groups that most influenced that character. A later report (by John Blacman) of Henry VI's personal austerity and avoidance of curious fashion belongs to a form of quasi-hagiographic pastoral writing in which the growth of humility and stoic virtue in life was a conventional element.[114] Henry's circle in the early 1440s included two major former Wykehamists, Henry Chichele himself and his close associate Thomas Bekynton (d. 1465), the king's secretary and later bishop of Bath and Wells. The Wykehamist character of Henry VI's statutes is therefore scarcely surprising. Chichele and Bekynton were both relatively conservative administrators, and both elected to have two-tier *transi* tombs erected for them at Canterbury (see pl. 311) and Wells respectively, Bekynton's probably done in imitation of his mentor's.[115] It is not wrong to see such men as members of a like-minded coterie resembling the small groups of mandarins and architects that constituted what I earlier called an 'oligopoly' in the formation of the Decorated Style well over a century earlier (p. 95). In the case of Henry VI the coterie was small, and the level of institutional specification very high, probably higher than in the period *circa* 1300. Only within enclosed contexts of authority could such value systems actually be enforced. Outside the walls of college or monastery the prospects for them were bleaker. Here new forms of unruliness and invention reigned, and with them this book ends.

Contagion: *The Black Death*

Art language cannot always sensibly be disaggregated from social and economic change; and far more of interest was ever said on matters aesthetic in regard to money, pride and excess than in regard to idolatry. Yet art language helps not at all in confronting the socio-economic upheaval of the Black Death in England in 1348–9.[116] Even so, the again-fashionable question of the impact of the Black Death – promoted most successfully in Millard Meiss's thoroughly post-war *Painting in Florence and Siena after the Black Death* (1951) – cannot be sidestepped.[117] Some ideas about it can be put forward based not on the critical language of the time – too scarce, too partial as it often is – but on intel-

ligent inference from art and architecture itself. By this I do not mean the most objective option: tracking those physical mismatches and ruptures in the walls and vaults of the slow-moving architectural projects begun before the summer of 1348 and restarted after 1350 which seem so vividly to bring the reality of crisis to the imagination. That some sort of social earthquake happened is evident in the fabrics of Lichfield, or Exeter, or (perhaps) Ely Cathedral. But whether this tells us much beyond the obvious – that plagues, like wars, are human emergencies that throw things out of kilter – is debatable. Two salient features are known about plague, which was possibly a lethal mixture of bubonic and pneumonic plague, in the three decades after 1348. The first is that having entered England in the Weymouth area via shipping from Gascony in the summer of 1348 – so reversing the path of 'influence' traced in an earlier chapter – it moved throughout England at the rate of about a kilometre a day (faster by water) and removed between 40 and 60 per cent of the population depending on station and lifestyle.[118] Second, the major outbreak was followed by further virulent strikes, in 1361–2, 1369 and 1374–9, whose importance in regard to cultural impact is increasingly recognized: the monk John of Reading's fashion invectives were connected by him to the second 'strike' of the 1360s, as morals just carried on slumping.[119] The cumulative effect of these outbreaks presumably brought to mind Noah's Flood, the plagues of Egypt or the opening of the seals in the Apocalypse. Xenophobia and scapegoating have already been noted in regard to the cultural contagion of fashions in dress; indecent clothing was blamed by some for the plague as accusation was also directed at Jews, Arabs, Portuguese pilgrims, lepers and (in Narbonne) the English.[120]

Meiss's account was the most ambitious attempt in cultural studies of the mid-twentieth century to get at the psychology of this sort of trauma. No one has ever thought of replicating Meiss's methods for the same period in England. There are two reasons why such an endeavour would be wrong-headed, even futile. I have already implied that there might be two paths to take, one practical and one interpretative. Meiss was more inclined to the latter. His intellectual position was formed by earlier formalists and empathy theorists – notably Heinrich Wölfflin – and can now be seen as representative of the new spiritualism and intellectualism of medieval writing (particularly in Germany) in the post-war years generally, as Henk Van Os astutely noted.[121] To my mind collective psychological theorizing is inherently questionable. Much that has already been said in the present book goes against the psycho-spiritual, intel-

lectualist and moralizing drift of this hugely influential phase of modern study, and I have already suggested in the present chapter that practical discussion of moral and aesthetic positions reveals how partial they are in helping one form clear ideas about why styles evolved as they did. It is for this reason that I am unable to agree, for instance, that Perpendicular architecture in some way embodied a different moral vision from the Decorated Style, as suggested, for instance (and tentatively), by one authority on medieval architecture: 'to people who felt themselves chastened by what was universally interpreted as a visitation of divine wrath . . . it is very likely that the sculptural luxuriance and rich colouring of Decorated came to appear ostentatious and worldly and that Perpendicular was welcomed as a soberer and more spiritual style'.[122] This 'Meissian' mode of explanation relies on an early to mid-twentieth-century moral, religious and psychological outlook, which, in turn, may have been influenced by the nineteenth-century popularity of Boccaccio's *Decameron*.[123] In fact, moral panics are not simply universals, but products of particular social groups and moments; notions of decorum and patterns of conduct vary from person to person, institution to institution; and there is no guarantee that, when literary satirists took on building as a sign of Pride, they did not have in mind the splendours of Perpendicular. Under the right circumstances almost any but the most austere architecture could provoke fears about excess and cost.

The futility of this first approach lies partly in its thinking, but also in the nature of the evidential base. Meiss's central Italy preserves a vastly greater archive of wall and panel painting, to say nothing of illumination, the plastic arts and testamentary and other documentary evidence, than does England around 1350, and from it generalization is inherently more feasible. Change and transition are norms, not occasional phases, and it must be said that from even a cursory examination of English manuscript illumination of the period 1330–60 or so, one could neither deduce the fact of 'plague' from its form and content, nor find a need to invent such a concept if no evidence for it already existed. Here instead is something remarkably subtle. In regard to it, the present writer finds much more of specific value in English empiricist writing of the sort represented by the architectural historians Francis Bond and Edward Prior in whose work a practical view is taken of the progress of style in a climate greatly altered by demographic disaster and increasing wages.[124] Not that this school was free of value judgement: central to its pragmatic narrative of rupture was a belief that within it were to be found the origins of

'decline', of that decadence or decrepitude that so many Victorian and post-Victorian commentators on English medieval art saw in the era of the Luttrell Psalter and the sober sterilities of Perpendicular. Nevertheless, and setting morality aside, it is by means of this second line of thinking on money and society – what Van Os called the 'productive conditions' of art – that one can begin to make sense of some of the developments in the period to 1380 or so in markets, production and idiom.[125]

Although pattern-book ornamental devices and figure styles certainly evolved in the figurative arts in the second half of the fourteenth century, and would have evolved anyway, the gradual shift from the Decorated Style to Perpendicular architecture remains the most conspicuous, high-status and permanent change in the English visual landscape at the time. In essence, it embedded in English building a set of visual practices derived, Maurice Hastings first argued, from French Rayonnant Gothic as mediated by important late thirteenth-century projects in England such as St Stephen's Chapel at Westminster and York Minster. The style that John Harvey promulgated as the quintessence of late medieval English national identity in fact signalled a rapprochement with France closer and in its way more rigorous than anything attained since late twelfth-century Canterbury. Perhaps, as suggested earlier, the Decorated Style and Perpendicular catered to different ways of actually apprehending architecture. But in saying this one must guard against a kind of fallacy of origin and essence that implies that because these architectures look different, were capable of different things and stemmed from different aesthetic thinking, they in some way represented separate, tribal, consciousnesses or were the products of fundamentally different moral revelations. It is better to see them historically and critically as representing two aspects of an extraordinarily mixed and diverse, but single, system, which, as the fourteenth century advanced, tended to become rather less diverse. The harbinger of this mixed system *circa* 1300 was St Stephen's Chapel, and in their more fully developed form both options existed side by side (at Ely) from the late 1320s, in the extreme curvilinearity of the Lady Chapel and the panelled timber work of the octagon's lantern: so a crude economic or demographic explanatory model for style per se is scarcely worth advancing. The plague was not a prime mover of innovation; the ignition key having been turned, it acted instead as a sort of accelerator pedal.

Nor in regard to style can Lent be said to have followed Carnival. Curvilinear and richly adorned Decorated work persisted well into the 1350s and later in regional parish

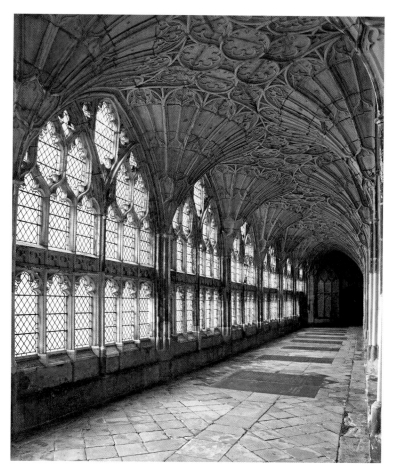

307 Gloucester Cathedral (formerly Abbey), cloister, west walk, completed early fifteenth century

church building in East Anglia (Sutton, Hingham, Attleborough) and Yorkshire.[126] Ideas developed in Bristol around 1300 were still being deployed in the port of King's Lynn (St Nicholas) almost exactly a century later, and Melrose Abbey in Scotland proceeded without obvious restraint. Though the actual production costs of substantial Perpendicular buildings have not as yet been systematically compared with those in the Decorated Style, early Perpendicular on the larger scale was in no sense an austere mode, like the 'reduced' Rayonnant or *Reduktionsgotik* favoured for many mid-size works in continental Europe from the late thirteenth century, typically under mendicant patronage.[127] Perpendicular's most elaborate vaulting systems, such as the fan vaults developed in the west of England in the cloister of Gloucester Abbey in the 1360s (pl. 307), surpassed anything in the Decorated Style of the preceding decades, even the assured net vaults of the West Country (Wells, see pl.

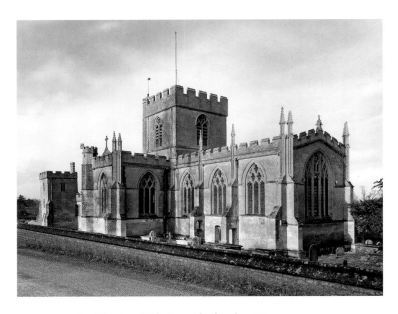

308 Edington (Wilts.), parish church, 1350s

39, Ottery St Mary) and the sparkling liernes of Ely (see pl. 156).[128] The same holds for the gigantic Perpendicular windows erected, for instance, in the transept and presbytery at Gloucester (see pl. 43, right). Though such schemes as those in the choir at Gloucester and the nave at Winchester were essentially brilliant refits, the building record after 1350 at Gloucester, Canterbury and Winchester stands as impressive testimony to underlying stability, even ambition, for the remainder of the fourteenth century.[129] Considering that the evidence tends to point to rising costs in the post-plague era, evidence for long-term recession is surprisingly thin, though the evidence for church building more generally in the recessional period 1350–75 is still being weighed up. In regard to monastic patronage Julian Luxford notes of the outbreaks of plague after 1348 that 'though they may have nipped nascent projects in the bud, and otherwise retarded patronage in the short term', they do not in general appear to have had a lasting influence on patronage at the larger houses.[130] And some projects continued to press on regardless, such as Bishop William Edington's priory church at Edington, Wiltshire, built between 1351 and 1361 (pl. 308), and the largest of all, Edward III's mighty scheme at Windsor Castle.[131]

At stake, however, was something subtler. In matters of stylistic change, quite small differences, differences of degree, can in the long run add up to what looks like a serious change of taste. Every historian will know that explaining why styles are gradually set aside is as hard as accounting

for how they arose in the first place. It is a simple matter of fact that no building in the Perpendicular style in the decades after 1350 produced anything like the arcading of the Lady Chapel at Ely or the so-called Percy tomb at Beverley. Such prodigies – certainly the extreme end of 'curvilinearity' – simply disappeared. For this, four principal reasons can be advanced, and all were consequences of the plague: loss of leading talent, loss of cooperative networks, reduced affordability of labour-intensive work and destruction of small local producers, all coinciding with a fragmented and more granular market.

If, in any community, between 40 and 60 per cent of the population is suddenly killed, as appears to have been the case in the late 1340s, it is a reasonable assumption that the kind of leading talent that initiates change and sustains useful artisanal tradition will be lost in equal measure. That this occurred in Italy in regard to the major painters' workshops in the cities has been reasonably well established: there occurred an almost immediate loss or grave weakening of specialized knowledge built up over at least two or three generations.[132] This knowledge was embedded in the personnel of workshops and their highly specialized working traditions, which relied in part on the charismatic, personal teaching relationship of master and apprentice. In or around 1349 at least three major architects in England disappeared from the record, John and William Ramsey and also William Joy of Wells, presumably because of plague. It is a measure of the devastation of the Ramsey Company, the most generally innovative of the first half of the fourteenth century as a whole, that almost a decade after the Black Death it was still governed by William Ramsey's daughter Agnes: male succession was a problem. Throughout this study I have referred to the Ramseys as a company: but in such cases kin and company were the same, and to lose the former was to lose the latter. The short-term consequences for government projects were simple: staff had to be obtained by impressment of labour.[133]

But some longer-term effects were probable, though they have yet to be systematically researched. Close study of the unfolding of architecture in specific regions after 1349 such as the diocese of Lichfield reveals a pattern of sudden rupture and then new stylistic incursions consistent with radical changes in the regional workforce, which in effect displaced everything by the newish Perpendicular mode.[134] Some projects, like the comparatively modest Decorated Style carved shrine base of St Werburgh at Chester (pl. 309), were pressed on up to the Black Death years, though it is unclear that they bear witness to the intervention of the

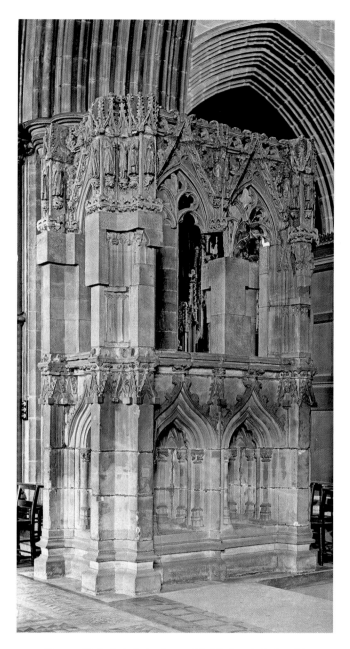

309 Chester Cathedral, shrine base of St Werburgh, in hand in 1348–9

plague itself.[135] The loss of talent extended downwards from the workshop heads, who offered *consilium*, to the 'learned hands' capable of the amazing feats of undercut micro-sculpture of the period, which imply lengthy training. Loss of specialized artisanal knowledge and expertise of this type can only be remedied slowly, partly because training is slow, but also because practical tradition is vested in memory, habits of mind and hand – the 'mindful hand', as it were

– governed by procedural memory. To lose personnel is to destroy the main memory banks of a system, unless that memory is incorporated in some archive – I have in mind the distinction (drawn by social theorists) between bodily or 'incorporated' memory and 'inscribed' memory.[136] It remains to be established whether idioms that had undoubtedly developed out of relatively centralized workshop drawing archives, such as the Perpendicular of London and Gloucester, had a better chance of survival than the curvilinear variants of the Decorated Style spread throughout the eastern half of England with no known central repository of designs to ensure continuity in the face of the dramatic loss of personnel and oral craft traditions with a strong basis in a ludic mindset, incapable of self-inscription in formal rules. Drawings were invulnerable to plague; and drawings tended, one may infer, to be based in large centres: such an archive of 'patrons' provably existed at Westminster by the late fifteenth century, but it is a matter of inference from court architecture itself that an archive must have been formed earlier.[137] Is it perhaps right to see the eventual success of Perpendicular as the success of a more impersonal, bureaucratic mode, a system in the true sense?

One likely factor, then, was a loss of talent and memory. But two further and related effects would have been felt that influenced the nature of workmanship itself. One concerned networks. Games are often played with competing teams. I have argued that the Decorated Style was a collection of practices governed by an extraordinary level of inter-media cooperation and porous exchange. Herein lay its inventiveness and capacity for surprise; herein too lay its vulnerability. When plague struck to the extent that it did in 1348–9 and again in 1361–2, what may have been broken or lost was not only leadership and the memory invested in it, but also that cobweb-like connectivity, even interdependency, among producers – sculptors, glaziers, metalworkers, carpenters, painters and so on – that had been such a fertile source of exchange and ideas, particularly so when the possibilities of such exchange were grandstanded on the giant scale, as at Ely. At some level this particular discussion simply broke down, at least for a while.

Second, the viability of consciously mixed projects that pursued a subtle *varietas*, as well as a high level of idiomatic invention, depended on pricing and hence on business margins: loss of inter-media cooperation was linked to a tendency to depress any commission whose effects relied on labour-intensive work. In Oxford in 1439 cost factors arising from over-elaboration were paramount in spending decisions when labour costs were rising steadily. It is reason-

able to infer from this that the earlier richly wrought curvilinear projects, many of which also continued to use costly marble detailing (Ely, Beverley), were also sensitive to fluctuations in the supply and hence cost of skilled labour. This raises a question about the sustainability of any super-complex idiom in the face of drastic long-term changes in the labour market of the type evident after the Black Death and on well into the middle of the fifteenth century. Wages of building craftsmen in the period 1340–80 inflated by a factor of some 40 per cent, requiring the issue of an Ordinance and Statutes of Labourers in 1349, 1351 and 1361 which attempted to hold down wage levels for master masons at 4d., and ordinary masons at 3d. per day – in essence the traditional top rates paid at centres such as Exeter throughout the first half of the century. Wage rates virtually doubled between 1350 and 1450, between the completion of the Lady Chapel at Ely and the founding of King's College, Cambridge.[138]

While it has justly been pointed out that increases in wages do not necessarily have implications for levels of prosperity or absolute levels of income amongst workers – wage rates and earnings differ – the consequences of plague and then a sustained rise in building costs for patrons would have been several.[139] In the short run any large, complex, ornate and so slow-moving project, such as the west façade of Exeter Cathedral (see pl. 300), would have been interrupted and then badly held up, if not actually terminated.[140] A preference would have asserted itself for building finishes and methods that, though they could produce dazzling overall effects, in effect prioritized speed and efficiency. It is possible that English Perpendicular took over and benefited expediently from the French legacy of sheer rational efficiency of production, quite as much as from its aesthetic character. By contrast, the favourable conditions that had once allowed the Decorated Style to flourish would have evaporated as Perpendicular, an idiom less inherently dependent on sculptural enrichment, gained the price advantage. Deterministically, then, it is not wholly surprising that the Decorated Style in its most highly wrought forms, especially those of the elaborately finished curvilinear Gothic of the West Country and much of the eastern side of England, became relatively less current as an idiom of choice between 1340 and 1380 as Perpendicular became relatively more so.[141] It is not so much that the Perpendicular Style began, as that the Decorated Style ground slowly to a halt. Also, though this is again beyond demonstration, the negative impact of labour costs on other arts such as illuminating, and so upon the price attractiveness of things such as plenti-

ful marginalia, may have been a factor in the relative decline of this feature of book decoration.

A final consideration was the changing texture and increased granularity of society following the outbreaks of plague in the 1340s and 1360s. The same mortality rate would have had radically different consequences for large and small producers. So, if the Ramsey Company was struck down by a factor of 40–60 per cent, the possibility of commercial survival remained because the clan and company had originally been large enough. Though damaged, the Ramsey Company did survive in the hands of Agnes Ramsey. But for a much smaller team, the effect would be devastating. It is unlikely that the many smaller projects in the Decorated Style in the period to 1348 were entirely governed by large companies. If so, the outcome of high mortality would have been the immediate termination of many small local companies and the subsequent medium-term consolidation of the remaining workforce in the larger remaining ones. Older patterns and associations were destabilized. Yet as art producers regrouped, the market also changed, though almost in the reverse direction: swift wealth redistribution empowered a growing number of socially more modest but ambitious patrons, who in turn inevitably would have favoured small but striking, if less sophisticated commissions.

All is Other Men's

The idea that the plague episodes created a more diverse market of upwardly mobile patrons of very modest origins is hard to demonstrate given that the kind of artefacts that might register such a shift, particularly small votive panel paintings, do not survive in England as they do in Italy; and it is from the denser Italian evidence that this idea first emerged.[142] Millard Meiss and his later commentators agreed that this period witnessed a grave loss of major talent, a weakening of large-scale commissioning, the decline of old urban patriciates and established wealth, and the rise of a nouveau riche: all this fragmented and displaced the patterns that had enabled the dazzling achievements of the central Italian artistic avant-garde of the early fourteenth century.[143] The nature of art commissioning in England, not least in the public domain, was different. Yet one or two signs suggest that a similar model of post-plague fragmentation might also hold there, not least in response to the pattern of recurrence in the 1360s and 1370s. As Rosemary Horrox has observed, while the effects of the Black Death

itself were negotiable, the demoralizing recurrences of epidemic produced and embedded uncontainable change.[144] The cult of remembrance, accelerating hugely in England to the point where 40 per cent of all chantry licences granted in the Middle Ages were issued by 1348, seems to have slowed slightly in the 1350s before growing again in the 1360s and 1370s, a pattern also found in Italian commissioning, which burgeoned in these decades.[145] And though the situation varied regionally, the 1360s and 1370s were the period most likely to witness spikes in donations to English cathedral and other shrines, which may also argue for shifts in disposable per capita wealth implying a wider than usual range of donors.[146]

Horrox and Samuel Cohn agree on a second point, which relates to commemoration. This is that the Black Death and subsequent outbreaks not only hit the socially disadvantaged harder, but also provoked a sort of horror at the depersonalization of the dead: chronicles frequently mention the shoddy treatment of the dead 'carted off by louts looking to earn some quick money'; 'contemporary sensibilities must have been bruised by conveyor-line burials'.[147] A reaction to this in the post-epidemic years, taking the form of small but individualistic and even unorthodox memorials to the dead, would be understandable.

Only one English memorial of the period enables one to follow the thinking of a specific person whose origins were undoubtedly modest but whose standing had grown rapidly during the plague years as a result of the frequent land-grabs that occurred with rapid depopulation. This is an earthy tomb inscription made for a documented peasant-turned-yeoman, John the Smith, in the parish church at Brightwell Baldwin not far from Oxford.[148] The inscription (pl. 310), measuring only 10.5 × 5.3 centimetres, is now separated from its Purbeck marble tomb slab in the north aisle of the church, but its *precissa* letter forms point to a date in the 1370s, subsequently confirmed by documentary work on John the Smith himself in Oxfordshire estate records; and the inscription was originally accompanied by a small image riveted over it. It is the oldest English-language epitaph of any length.

> *Man com & se how schal alle dede be:*
> *Wen þow comes bad and bare /*
> *Noth hab ven ve away fare:*
> *All ys ozermens þ^t ve for care: /*
> *Bot þ^t ve do for godys luf ve have nothyng þare:*
> *Hundyr / þis grave lys John þe smyth*
> *God yif his soule heven grit*

310　Brightwell Baldwin (Oxon.), brass of John the Smith, 1370s: the effigy's appearance is a hypothetical reconstruction by the author, but follows the lines of the existing indent

Man come and see how all dead shall be
When you come [to die], sinful and bare,
We've naught when away we fare,
All's other men's that was our care;
Except that we do for God's love, we've nothing there.
John the Smith lies under this grave,
May God his soul in heaven save.[149]

The address 'Man com & se' is strongly reminiscent of English religious lyrics and some tombs: witness the expressions *cerne tuum speculum* (perceive your mirror) and *ecce meum tumulum* (behold my tomb) on Archbishop Chichele's cadaver tomb at Canterbury (pl. 311).[150] In such cases the opening appeal is to the eyes. The text was certainly composed to accompany an image, in this case an image of death as everyman's future state ('how schal alle dede be'), and presumably some sort of cadaver, since the outline of the now-lost image over the inscription remaining in the marble slab in the aisle indicates a shroud's topknot. The features were presumably 'bad and bare', that is, nasty and naked, as we all are when we come to die. John Blair has shown that John the Smith is first documented in estate records for Chalgrove and Brightwell Baldwin in 1355. In that year he was fined for trespass with forty sheep into a villein's cornfields at Cuxham, between Chalgrove and Brightwell Baldwin; in 1356–7 he was admitted to one-third of a messuage and 4 acres of land at Chalgrove. He was a juror at Brightwell Baldwin in 1357 and had holdings in the area in 1371–2.[151] Blair calls him 'a typical figure in late fourteenth-century rural society; the luckier peasant who took advantage of depopulation following the Black Death to enlarge his holding'. John had amalgamated holdings to

311 Canterbury Cathedral, tomb of Archbishop Chichele (d. 1443), raised in the 1420s

brass extends a history of ideas and images. Its background lies squarely in pastoral text and image making of the previous century or so in England, admittedly of an educated sort. The imagery of the Three Living and the Three Dead was certainly circulating in England before 1300, and, as in the case of the famous picture in the Psalter of Robert de Lisle (fol. 127), could be accompanied by French verses and exclamatory inscriptions in English – 'Lo whet I see', 'Such scheltou be' and so on, in which death is a contagion of the eyes.[152] The image of Death personified appears in a fourteenth-century *Somme le Roi* made for English readers in the 1320s (Cambridge, St John's College MS S.30, fol. 64) in a pastoral tract on 'learning to die'.[153] In this case Death (pl. 312) is personified as a grinning cadaver in a bright red shroud striking a seated king in the breast with his dart. Shortly after this, in the Macclesfield Psalter of the 1330s (pl. 313), a grey greasy skeletal Death leaps up onto the bedspread of a dying man and spears him in the chest, as his widow looks on grieving: here the image is in the initial to the text for Vespers in the Office of the Dead (fol. 235v).[154] In both the *Somme le Roi* and the Psalter, the Death images are either linked to, or are closely followed by, the Wheel of Fortune or the Fall of Pride, pictures of social or moral reversal. That in the Macclesfield Psalter is related to the *Fall of Pride* carved in the south walk of the cloister at

312　*Somme le Roi*, Death, 1320s (Cambridge, St John's College, MS S.30, fol. 64)

become a substantial farmer, eventually accorded the privilege of burial in church. It is not known if John the Smith died in one of the recurrences of the plague in the mid-1370s, but he may have commissioned his macabre little tomb in his lifetime. The fact that a man of his status had a brass at all is itself remarkable.

In character this tomb is demonstrably personal: its psychology, as it were, is that of the guilty survivor, the man grown fat on the suffering and loss of others who is himself shortly to grow very thin indeed. His fate, his gains and losses, are set against the ulterior horror of the universality, the depersonalization, of death. Even so, behind this little

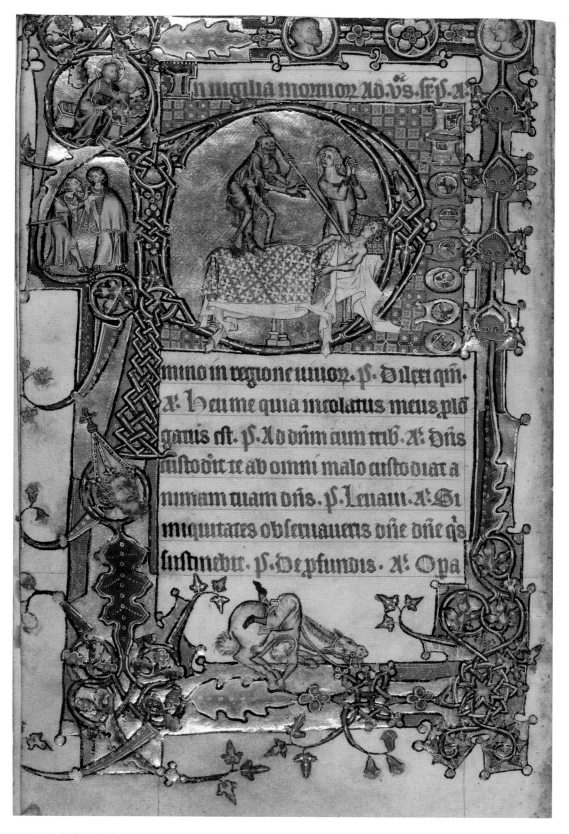

313 Macclesfield Psalter, *circa* 1330–40, Office of the Dead with a deathbed and the *Fall of Pride* (Cambridge, Fitzwilliam Museum MS 1–2005, fol. 235v)

314 Norwich Cathedral, cloister south walk, *Fall of Pride*

Norwich (pl. 314). In the Luttrell Psalter at folio 157v, a marginal image of a shrouded corpse with a topknot is revealed as the lid of a grave is slid away, in melancholy illustration of Psalm 87.[155]

The Brightwell Baldwin tomb is fully in this tradition. But it takes the fatal step, so to speak, of introducing standard pastoral *contemptus mundi* and death imagery to a tomb, a step not taken generally by English elites for some time to come. In the epitaph of the Black Prince (d. 1376) at Canterbury the penitential tone of the inscription is not matched by any of the radiantly beautiful imagery.[156] Nor is it in the case of the brass of Henry Chichele's brother William (d. 1425) at Higham Ferrers in Northamptonshire, where the inscription alone is again of the 'such shall ye be' type.[157] But this does point to some sort of family

interest since, though he died in 1443, Henry Chichele himself was raising his famous cadaver tomb at Canterbury around 1426, directly opposite the metropolitan throne that he was to occupy for many more years. His double-decker tomb belongs to a self-conscious era of macabre representation, self-examination and reproach, placed in a position analogous to that of the wall painting of the Wheel of Fortune in the choir at nearby Rochester.[158] Chichele's epitaph is itself a wheel of fortune, a tale of 'what goes round comes round', in saying in effect that he was a pauper born, then raised to primate, then cut down and now, finally, laid out as food for worms. Chichele's Wykehamist coterie, as noted, included Bishop Bekynton at Wells, who also had a double *transi* tomb set up before his death.[159] John the Smith's tomb is almost certainly the earliest-known cadaver memorial in England, long predating the examples of the next century, which may be attributed to socially secure elite clubs.

Any confidence that innovation was solely the preserve of elites is rattled by such hard evidence from the era of plague. For a while at least, the social register of innovation had provably slipped several notches downwards to an altogether new class of person. Perhaps in this case novelty could only go with a sort of certain bluntness, a rough overcoming of inhibitions. Once again, moral critique and material considerations of what belongs to other men seem linked. Critiques of fashion, new anxieties about the signification and expense of architecture, and worries about destabilizing social change, all testify to the linked material and cultural preoccupations of the time. Here the final funereal image of transformation, of human gain and loss, and of the reproach of the betrayals involved – by mankind of his like, by Death of everyone cheated of life – is of similar type. In this last case, however, it is difficult not to see surprising invention as a product of the Black Death and of its persistent, and no less gloomy, sequels.

NOTES

ABBREVIATIONS

BAACT	British Archaeological Association Conference Transactions
BL	British Library
BnF	Bibliothèque nationale de France
CP	*Calendar of Papal Letters*
CUL	Cambridge University Library
CVMA	Corpus Vitrearum Medii Aevi
ODNB	*Oxford Dictionary of National Biography*
PL	*Patrologia Latina*
RCHM	*Royal Commission on Historical Monuments (England)*
VCH	*Victoria County History*

INTRODUCTION

1 Rickman 1817, 5.

2 The English nationalist approach is represented by John Harvey; see J. H. Harvey 1944, 1946, 1947, 1950, 1961, 1978.

3 Harries 2011, 496; see Pevsner 1953, 1956/1976, 1959; also for differing views on Pevsner and related writers, Crossley 1981a and 1981b, Draper 1982, Crossley 2011.

4 Pevsner 1949/1978, 39.

5 Bony 1979; for resistance, see Bony 1957–8.

6 For 'modernity', the 'avant garde' and 'movements', see Bony 1979, 1–2, 4; Bony 1983, 43, 45.

7 Panofsky 1951, 8–9.

8 See the compilation in J. H. Harvey 1987.

9 Bock 1962a, 1962b; for Bock, see Crossley 2011, 208–9;

I except the very useful and accessible, though un-footnoted, survey in Coldstream 1994.

10 Throughout I cite the Riverside edition (Benson 2008); here, at 347–73, especially 362 for *The House of Fame*, ll. 1165–1200.

11 *Ballade*, no. 285: see Kendrick 1983, 3–4.

12 For 'rude speche', see the prologue to Chaucer's Franklin's Tale: Benson 2008, 178, l. 718. For an early assertion of the same idea, see William of Malmesbury, *Gesta regum anglorum*, in Mynors 1998–9, vol. 1, 15–16.

13 For estates satire, see Mann 1973.

14 Burrow 2008, 1–3.

15 I have given an account of this age of charisma and ethical greatness in Binski 2004.

16 Binski 2004, 53–62, using Garton 1986. For the Virgilian mode and monastic foundation myths *circa* 1200, see Henderson 1985b, 86–7.

17 I have found Mann 1994 and Whitehead 2003 especially useful.

18 Gransden 1982.

19 Binski 2004, 30 n. 12.

20 Burrow 2008.

21 Burrow 2008, 4, 101–49.

22 Burrow 2008, 114–15 (ll. 1573–82).

23 Muscatine 1972; Du Boulay 1991.

24 I cite the particular focus of interest apparent in Watkin 1977.

25 After Paris, BnF MS lat. 14884. See Le Roux de Lincy and Tisserand 1867, 3–79: part I describes Paris as a paradise, part II moves on to the university and the buildings; see also MacClintock 1956, 128–9; Inglis 2003. For city laudations, see Hyde 1965–6.

26 Le Roux de Lincy and Tisserand 1867, 44, 46, 48; Inglis 2003, 66–8, 78–9.

27 Le Roux de Lincy and Tisserand 1867, 38–9.

28 Le Roux de Lincy and Tisserand 1867, 58–61, at 60: see Schmugge 1966, 23–6, and MacClintock 1956, 97–8; for Greek self-confidence, see A. Murray 1978, 251–7.

29 Le Roux de Lincy and Tisserand 1867, 44, 46.

30 Esposito 1960, 30–31.

31 Le Roux de Lincy and Tisserand 1867, 538, 571–7 at 576 for what follows (cf. also Inglis 2003, 71):

> Hoc templum tantum magnum, tantumque venustum
> Altumque et clarum est, ac omni parte decorum
> Ut Galli in patria nullum formosius omni
> Esse ferant penitus, licet illi Virginis almae
> Templum Carnoti quidam praeponere tentent

32 Pannier and Meyer 1877, 39; Inglis 2003, 73.

33 S. Murray 1987, 149 no. 6, 150 no. 2.

34 Marsh 2003, 364–475.

35 Marsh 2003, 452–5 and notes.

36 Tatham 1925–6, vol. 1, 343–6 at 345–6; Ross 1970, 538.

37 Branner 1965, 7, 98; for the Narbonne document, see the next chapter, p. 38.

38 Southern 1970, 147.

39 For the *Commendatio lamentabilis*, see Stubbs 1882–3, vol. 2, 3–21; for the Westminster and Lichfield paintings, see Binski 1986, *passim* and 112.

40 Hedeman 1991; Phillips 2010, 7.

41 Bradley 1995, 401–2.

42 Kinney 2006, 215–16; for the *Gesta regum anglorum*, see Mynors 1998–9, vol. 1, 613–15; for Master Gregorius, Huygens 1970 and Osborne 1987.

43 Harvey 1969, 314–17, 332–3.

44 Harvey 1969, 59–61, 116–17, 290–91; for a set of late medieval verses on William Rufus and Westminster Hall, see Cambridge, Corpus Christi College MS 139, fol. 181v: M. R. James 1912, 232 (my thanks to Julian Luxford for this item).

45 Carley 2010, 181.

46 Leland 1745, vol. 1, 103–4, especially 47.

47 Leland 1745, vol. 8, 4; vol. 3, 81–2.

48 M. R. James 1895b, 125–6.

49 Aston 1973, 244 for Leland, 255 for quotation.

50 This is a theme in Burrow 2008, 3–5; for the 'school of suspicion' (i.e., Marx, Nietzsche and Freud), see Ricoeur 1970.

51 Goldie 2006, especially 3–11.

52 Jaeger 2010, at 1–16, especially 5–6.

53 For one distinction between the sublime and the wonderful, see Fisher 1998, 2; for another more mixed reading, Bynum 2001.

54 Carruthers 2006, 999 (after Aristotle, *De sensu et sensatu*); Carruthers 2013, 46–8; Knapp 2008, ix.

55 Bynum 2001; Binski 2010b; also Fisher 1998, 1–31, 138.

56 My argument on the relation of beauty and truth has points of contact with, but differs from, those of Scarry 1999.

I THE HEROIC HORIZONS OF PRE-DECORATED ART

1 Stubbs 1882–3, vol. 1, 276 (*Annales Londinienses*), in English in Salzman 1952, 389; for the 'new work' being consecrated, see R. K. Morris 1990, 75, for the date of the measuring as given in different sources; also Keene, Burns and Saint 2004, 127–39 (by C. Davidson Cragoe).

2 Nicolas and Tyrrell 1827, 174, 181.

3 Krautheimer 1942, 20.

4 Rudolph 1997.

5 For these and other examples, see Krautheimer 1942, 2–3, 4, 16; see also Gem 1983b, 3–4, and Binding 1996, 345–67.

6 Krautheimer 1953, 21–2; Binding 1996, 352; Malone 2000.

7 Krautheimer 1942, 4.

8 Carruthers 1998, 120–21.

9 Stubbs 1876, 91–4 at 92.

10 Anstruther 1851, 189–91 at 190: 'vici te, Salomon'.

11 Robertson and Sheppard 1875–85, vol. 1, 531; Salzman 1952, 16–17.

12 Carruthers 1998, 224–8, and 345 n. 10.

13 Otter 2004, 115–16.

14 Lehmann-Brockhaus 1955–60, nos. 4615–16; see also the account of the miracles of St Edmund by Hermann the Archdeacon, Lehmann-Brockhaus 1955–60, no. 475.

15 For a general survey, see Conant 1978; Bony 1983, 49; for the fifth-century cathedral of Paris, see also Erlande-Brandenburg 1994, 51; cf. Greenhalgh 2009, 484–5.

16 Derived from Fernie 1993, 138; Fernie 1998, 5.

17 Bony 1990.

18 Gem 1990, 51–2; Thomson and Winterbottom 2007, vol. 1, 145–6, vol. 2, 73.

19 C. R. Dodwell 1966.

20 Vincent 2011, 46.

21 Binski 2010b, 134.

22 Stubbs 1879–80, vol. 1, 7–8.

23 Heslop 2013, 60.

24 Fergusson 2011.

25 Quiney 2001, 169 and fig. 5; see also Gem 1986.

26 Lehmann-Brockhaus 1955–60, no. 6696.

27 Nederman 1990, 3, 5; for the arch image, see 43.

28 Brewer, Dimock and Warner 1861–91, vol. 4, 283–5.

29 At Cap. 21: Huygens 1970, 23–4; Osborne 1987, 29–30.

30 Quiney 2001, 169.

31 Fernie 1979, 1993, 1998; Gem 1983a, 1983b, 1990. On the theme more generally, see Warnke 2006.

32 Gem 1983b, 3–4.

33 Mynors 1998–9, vol. 1, 280.

34 Gem 1983b, 10.

35 Gem 1990, 57–8.

36 Fernie 1979, 4; Fernie 1993, 135–40; Fernie 1998, 4–5.

37 In general, Fernie 1993; B. Dodwell 1996, 38–9; Gilchrist 2005, 81–2, 251–3.

38 Halsey 1985; Kidson 1985; McAleer 1998.

39 Colvin 1963, vol. 1, 45–7.

40 Greenway 2002, 444–7.

41 Text E s.a. 1097: Irvine 2004, 108.

42 Mynors 1998–9, vol. 1, 564–7, vol. 2, 283.

43 Binski 2004, 75.

44 Book I, cap. viii: Jessopp and James 1896, 28–9.

45 On this tradition, see Hyde 1965–6; Scattergood 1996, 15–36.

46 Robertson and Sheppard 1875–85, vol. 3, 1–13; Scattergood 1996, 15–36.

47 Alexander and Binski 1987, no. 193; Wheatley 2004, 67–8 and fig. 3.

48 Robertson and Sheppard 1875–85, vol. 3, 2, 8; Scattergood 1996, 21, 28.

49 Robertson and Sheppard 1875–85, vol. 3, 2–3.

50 Wheatley 2008, 279.

51 Binski 2004, 21–3.

52 Scattergood 1996, 35–6.

53 Draper 2001; Binski 2004.

54 Cameron and Hall 1999, 133–7 (Book III, 29–40); Biddle 1999, 66–9; Kinney 2011, 193–4.

55 On which issue, see the essays in Binski and New 2012; Hourihane 2013.

56 For a useful account of this, see Coldstream 1994, 17–23.

57 Hoey 1986.

58 For the derivation of the original two-story elevation of the Exeter choir from St Urbain, Troyes, see C. Wilson 2007.

59 Bock 1962a, 74–82, 124–7, pl. 28; G. Russell 1991.

60 Kidson, in Kidson, Murray and Thompson 1965, 105.

61 Greenhalgh 2009; Kinney 2011, 191.

62 Krautheimer 1942, 4.

63 Biddle 1999, 87–8.

64 Deér 1959; Glass 1980; Kinney 2011, 196.

65 Robertson and Sheppard 1875–85, vol. 2, 81: *duas in utroque laterum habens fenestras*; Biddle 1999, 28–40; Binski 2004, 18 and fig. 17.

66 Binski 2004, 3–9.

67 O'Reilly 1981; Gage 1993, 25–6.

68 *PL*, 95, col. 257C: *Color autem ejusdem monumenti et sepulcri albo et rubicundo permixtus esse videtur*.

69 France 1989, 116–17 and 126–7 (III: 13, 14, 15, 19); Greenhalgh 2009, 483–522, 496–8. See also Hiscock 2003.

70 Kinney 2011, 197–8; for a larger discussion of the concepts of the enchanting, charismatic and auratic, see Jaeger 2012.

71 For what follows, see Garton 1986, 52–61, ll. 833–949; Binski 2004, 53–62; for the crazy vault, see Pevsner 1959, 333–5.

72 Binski 2002b, 119–23; in general, see Grant 2000 and Greenhalgh 2009.

73 Whitehead 2003, 143–60.

74 Greenhalgh 2009, 7.

75 Garton 1986, 54–5, ll. 872–88; for hesitation, see Binski 2004, 56–7; for wondering at marble, see Carruthers 2013, 189–92.

76 Wyckoff 1967, 44.

77 Carruthers 2013, 181–7.

78 Dewing 1971, 26–7, 1.i.58–65 (B179). For Paulus Silentarius, see Whitby 1985; for a sermon (no. 27) by Philagathos referring to the pavement of the Cappella Palatina in Palermo as having marble coloured like flowers, truly like a spring meadow, see Taibbi 1969; for Leo of Ostia, see Grant 2000, 55.

79 Binski 2004, 56.

80 See Thomson and Winterbottom 2007, 220–21: . . . *in vitrearum fenestraum luce, in marmorei pavimenti nitore, in diversicoloribus pictoris* . . . (cf. Statius, *Silvae*, IV.2, l. 27; and for him as 'the most influential master of marble panegyric', Kinney 2011, 193).

81 *Etym.* XIX.xi, see Lindsay 1911/1985: *Venustas est quidquid illud ornamenti et decoris causa aedificiis additur, ut tectorum auro distincta laquearia et pretiosi marmoris crustae et colorum picturae.*

82 Mynors 1937, 21.

83 Carruthers 2009; for *varietas* and the Psalms, see Minnis 1988, 151–3; see also Carruthers 2010, 199.

84 The most important writings by Aristotle on this issue are *On Generation and Corruption*, the *Physics*, *On Sense and Sensibilia* and *On the Soul* (see J. Barnes 1984); cf. the commentaries by Aquinas (see the *Corpus Thomisticum* website: www.corpusthomisticum.org) and Avicenna (e.g. Van Riet 1987, 4–5: Bk I, ll. 52–64); for an Aristotelian-rhetorical account of mixture and its pleasures, see especially Carruthers 2006 and Carruthers 2013, particularly 45–79. For St Bernard, wonder and mixture, see Bynum 2001, 43, 53, 69.

85 See Carruthers 2013, 135–64.

86 Carruthers 2009, 35.

87 Baxandall 1971, 94–5, 104, 136.

88 Binski 2004, 180; Carruthers 2009, 35.

89 Dewing 1971, 26–7, 1.i.58–65 (B179); Panofsky 1979, 62–5 (Carruthers 2013, 39–40, offers a different translation of Suger's words); Le Roux de Lincy and Tisserand 1867, 44, 46, 48; Inglis 2003, 66–8, 78–9.

90 Grant 2000, 50–53.

91 Panofsky 1979, 48–50: *tot arcuum et columnarum distinctione variatum . . .*; on columns, variety and magnificence, see Kinney 2011.

92 Brenk 1987; Kinney 2005, 29; Kinney 2006; Carruthers 2009, 49.

93 Carruthers 2009, 44–7.

94 Carruthers 2009, 40–41.

95 Rudolph 1990, 106 (*Apologia* 29). The appreciation of the fully aesthetic character of Bernard's writing here is owed first to Schapiro 1977, 6–10. For monsters and *venustas*, see Carruthers 2013, 146–9, 182–3.

96 Astell 1990, 92, after *Sermo* XL.1: *Vide autem ne carnaliter cogites coloratam carnis putredinem, et purulentiam flavi sanguineive humoris, vitreae cutis superficiem summatim atque aequaliter suffundentem; e quibus sibi invicem moderate permixtis, ad venustandam genarum effigiem rubor subpallidus in efficientiam corporeae pulchritudinis temperatur. Alioquin incorporea illa anima invisibilisque substantia . . .*

97 Huygens 1970, 20: . . . *faciem purpureo colore perfusam gerit. Videreturque comminus aspicientibus in niveo ore ymaginis sanguinem natare*; Osborne 1987, 12; Curta 2004, 46–7, and 51 for red–white preferences, and flesh. On Gregorius's *Venus*, see Carruthers 2013, 194–5.

98 Pine-Coffin 1961, 231–2 no. 27; Bell 1978, 207; Southern 1990, 154; on ingestive piety and English art of the period, see Binski 2004, 233–4; Carruthers 2006. On taste and aesthetics, see Carruthers 2013, 108–34.

99 Garton 1986, 56–7, ll. 910–18.

100 Bony 1983, 42; for wonder at that which we do not understand or cannot assimilate, see Bynum 2001, 39, 40–41, 43, 53.

101 Greenhalgh 2009, 13.

102 Greenhalgh 2009, 4–6, 12–14, 327.

103 Fernández Valverde 1987, 299–300; Nickson 2012.

104 Kidson 1987, 16–17.

105 Guidi 1878, from 179; B. Lewis 1957, 412; Greenhalgh 2009, 329.

106 Łanowski 1965, col. 1022; for Rhodes, see Greenhalgh 2009, 21.

107 Stubbs 1876, 91–4.

108 Luxford 2013b, 203–5.

109 Fisher 1998, 17.

110 Łanowski 1965; McDermott 1975; Clayton and Price 1988; Brodersen 1992 and 1996; Kunze 2003; Coleman 2006; Deliyannis 2010.

111 Deliyannis 2010, 377.

112 Lindsay 1911/1985: *Mausolea sunt sepulchra seu monumenta regum, a Mausoleo rege Aegyptiorum dicta. Nam eo defuncto uxor eius mirae*

magnitudinis et pulchritudinis extruxit sepulchrum in tantum ut usque hodie omnia monumenta pretiosa ex nomine eius Mausolea nuncupentur.

113 Leo the Great, *Sermo* xvi, cap. 1 (*PL*, 54, col. 511D); Rabanus Maurus, *De universo*, 14:28 (*PL*, 111, col. 408D), following Isidore; Anastasius Bibliothecarius, *Historia de Vitis Romanorum Pontificum*, xcviii.391 (*PL*, 128, cols 1225–6); Helinand, *Chronicon*, iv.807 (*PL*, 212, col. 850A), etc.

114 Łanowski 1965, cols 1022–3; Cahn 1979, 29–31; McDermott 1975.

115 Łanowski 1965, col. 1023; Greenhalgh 2009, 353.

116 E.g., Duchesne et al. 1886–92, vol. 2, 242–3 (Hilarus).

117 Lehmann-Brockhaus 1955–60, nos. 167, 170, 3863, 3924, 3967, 4180, 4315, 4590, 5578, 5906, 5939, 6676.

118 Huygens 1970, 23.

119 Doob 1990; Kern 2000.

120 I have found Williams 1993 useful.

121 E. M. Labande 1981, 392–3 (III.13). It is difficult not to see at Laon an echo of the Bestiary view of oxen as helpful and team-spirited creatures, as volunteers (hence *iuventus* from *iuvare*); oxen also look out carefully and stick their necks out from their stalls, all gazing at once in order to show themselves willing to go forth: T. H. White 1984, 76–8.

122 Binski 2012b; Rawski 1991, vol. 3, 1 (preface to Book II).

123 Doob 1990, 97–100, 332 and for *The House of Fortune*, see below, Chapter Ten.

124 Cameron and Hall 1999, 133–7 for the whole passage (Bk III, 29–40) at section 36: . . . *opus plane admirabile, in immensam altitudinem elatum, et longitudine ac latitudine maxima expansum.*

125 Esposito 1960, 28–9.

126 S. Murray 1989, 161 no. 11.

127 For an exploration of this 'truism', see Binski 2010b.

128 Bony 1983, 74–6.

129 Bony 1983, 21.

130 C. Wilson 2010, 61–2.

131 Dimensions derived from Kinney 2005, 18–19; Kinney 2011, 190.

132 Aubert 1929, 28 n. 1, after Delisle 1873, 68: *Mauricius episcopus Parisiensis jam diu est quod multum laborat et proficit in aedificatione ecclesiae praedictae civitatis cujus caput iam perfectum est excepto majori tectorio. Quod opus si perfectum fuerit, non erit opus citra montes, cui apte debeat comparari.*

133 Binski 2004, 43–6.

134 For Beauvais, see S. Murray 1989, 100–11.

135 Trachtenberg 2010, 116, 158–61.

136 Rankin 2010.

137 Ackerman 1949.

138 On medieval drawings for prodigy towers, see Bork 2011.

139 Mark and Çakmak 1992, 179–94; Hillenbrand 1999, 261–7.

140 Eichholz 1962, 58–9 (Book xxxvi.xvi.75).

141 Branner 1962; Kimpel and Suckale 1990, 350–51.

142 S. Murray 1989, 84–11, 100.

143 For Amiens, see S. Murray 1996.

144 Lillich 2011, 61–103; see also Frodl-Kraft 1972.

145 Rosenau 1931.

146 Kimpel and Suckale 1990, 454.

147 Brachmann 1998, 31–54; also Brachmann 2000, 27.

148 For the interpretative fortunes of this unusual document, see Sigal 1921–3, 51; Branner 1965, 98; Paul 1991, 27, 38 n. 8; the document is printed in Freigang 1992, 372 no. AII.

149 Boehmer 1896, 659–77, at 666; Freigang 2011, 303–5.

150 Mukerji 2009.

151 For Tournai, see Lopez 1952.

152 J. Gardner 2010b.

153 Colvin 1963, vol. 1, 130–57; Bony 1979, 3–4; for what follows, see Binski 1995a; for Henry III's involvement, see C. Wilson 2008; and for further comments on the church, see Coldstream 1994, 23–7.

154 Colvin 1963, vol. 1, 131–2; Binski 1995a, 11.

155 Bony 1979, 1; Webb 1949 should also be consulted.

156 For the contract for which, see Peringskiöld 1719, 18–19; for the Parisian elements at Westminster, see Binski 1995a, 28–9, and C. Wilson 2010.

157 R. K. Morris 1990, 88–9.

158 Bony 1979, 3.

159 Bony 1979, 3. My study Binski 1995a, as an exposition of the power of *varietas* in royal commissions, is devoted to a critique of this position.

160 See my forthcoming paper on the Cosmati pavement, Binski, in preparation (b).

161 Bony 1979, 9.

162 *Calendar of the Close Rolls*, 1247–51, 311: *imagines apostolorum in circuitu ejusdem capella et judicium in occidentali parte.*

163 Guerout 1950.

164 I derive these measurements *inter alia* from Topham 1795 and Mackenzie 1844, pp. 11–12 and pls 2 and 7; the latter's reconstruction of the clearstory's form is of course hypothetical. Calculating the original extended height of the roofline proved problematical.

165 The evidence is set out quite clearly in Mackenzie 1844, vii–x, also 7–8, 11–13. Hastings 1955, 87–94, is justified in taking it seriously; Webb 1956, 134; J. H. Harvey 1961, 141–50, does not comment; and Colvin 1963, vol. 1, 514–16 and 523, is not especially helpful on the point, but the progress by 1333 of the eastern great gable implies that any new decision about the absolute height of the chapel must have been taken earlier. The original plan with a single stage of windows and a horizontal cornice was not consistent with the inclusion of a rib vault with shafts, so a change of plan must be assumed.

166 Mackenzie 1844, p. x of intro., gives an interior height of 67 feet, but the parameters of this measurement (including the lower chapel but not the hypothetical clearstory?) are not defined. He suggests, p. 12, that the clearstory windows added at least 18 feet (5.4 m) to the interior height.

167 For homage, see Prestwich 1980, 166–7; for Edward and Isabella in Paris, see Phillips 2010, 209–13: of the illuminations in the text *Kalila and Dymna* presented by Edward II to Philippe, Phillips remarks (at 211): 'In order to emphasize his importance, Philip IV is depicted slightly larger than those around him, including Edward' (see Paris 1998, fig. at 17 and no. 179). For a full discussion of the Paris trip, see E. A. R. Brown and Regalado 1994, especially 60, also 58, 61.

168 Willis and Clark 1886/1988, 366–7.

169 For an overview of these themes, see Binski 2013.

170 Bony 1979, 3.

171 Bony 1979, 1, 3.

172 Panofsky 1963.

173 This is well brought out in Crossley 2011, 206–8.

174 Panofsky 1951, 8–20.

175 Bismanis 1989, 118.

176 See Gajewski and Opačić 2007.

177 Bony 1979, 19; for the importance of play, see Carruthers 2013, 16–44.

178 Bony 1990.

179 Mitchell 1994, 107.

180 Gage 1982, 42–4; see Leo of Ostia's chronicle of Montecassino, III.26–7.

181 Binski 2012a.

182 For 'holistic' readings generally, see Binski 1995a and 2004; Raguin, Brush and Draper 1995; Carruthers 2013. As Madeleine Caviness notes in her essay in Raguin, Brush and Draper 1995, at 254, the notion of 'integration' is anticipated in the *Gesamtkunstwerk* concept of Sedlmayr (and ultimately, of course, Wagner), against which modern critics argue for the separation of the arts; see also Recht 2008, 22–3. Holism in my view entails mixture, ambiguity and impurity, not spurious unity.

183 Among the more important studies are Dumoutet 1926, Jay 1993, Hamburger 1998 and Kessler 2000.

184 Carruthers 2009, 51.

185 Chenu 1968, 326–7.

186 A large literature; see, for instance, Merton 1965, Jeauneau 1967, Yalouris 1995, Leuker 1997, Marchiori 2007.

187 Cahn 1979, 41.

2 GOTHIC INVENTION

1 *PL*, 202, col. 614; Meyvaert 1991, 745–6, 749–50; H. M. Thomas 2003, 302–3.

2 Panofsky 1955, 156–71.

3 For medieval stereotyping of the English, see H. M. Thomas 2003, for instance, 297–306.

4 Bony 1979, 1, 19–20. C. Wilson 1990, 194, writes of the 'fantastic and anti-rational element in Decorated architecture'.

5 Bony 1979, 28.

6 The seminal study is Middleton 1962–3. Recht 2008, 10–18, is also useful.

7 Bony 1979, 2–3, after Panofsky 1951.

8 Bony 1979, 19.

9 On *seria* and *ludus*, see Carruthers 2013, 20, 141–2, 154, 170, 172.

10 Bony 1990.

11 D'Avray 2010, 2, and in general 1–30; A. Murray 1978, 6–14.

12 D'Avray 2010, 21.

13 D'Avray 2010, 21–3.

14 Panofsky 1951, 27–35; Trachtenberg 2010, 269.

15 Nims 1967, 16–17; Carruthers 1993, 889; Carruthers 2010, 190–91. For Chaucer, see *Troilus and Criseyde*, I, ll. 1065–71; Benson 2008, 488.

16 Hubbell 1949, 74–5; Carruthers 2010, 199–200, 205.

17 Butler 1921, 2–3.

18 For what follows, see Kimpel 1977, 1986; Kimpel and Suckale 1990, from 214; S. Murray 1996, 5–6.

19 Kimpel 1977, 221; for drawings, see Bork 2011.

20 Kimpel 1986; Kimpel and Suckale 1990, 225–9; also Warnke 1976, 128; Binding 1996.

21 Freigang 1992, 404.

22 C. Wilson 1990, 122–3 and fig. 81.

23 Parkes 1976; Rouse and Rouse 1982, 1990, 2000.

24 Branner 1965, 137; Bony 1983, 377, 461; C. Wilson 2007, 118.

25 Bony 1979, 21.

26 The literature on this topic is extensive, but for overviews, see Long 2001 and Christine 2005.

27 Fisher 1998, 2; for 'methodological atheism' and the expulsion of aestheticism from art as a form of theology, see Gell 1992, 40–42.

28 See, for example, Tachau 1998; and especially for God the 'architect', Tachau 2011, 29–34.

29 See especially Gilson 1921; De Bruyne 1946; Sedlmayr 1950; Panofsky 1979; Simson 1962; also McGinn 1995 for this trend; Recht 2008, 19–30; Hamburger 2006a for theology; Bork 2011, 414; the implications are discussed in Carruthers 2013, 8, 196–7 and throughout.

30 Camille 1989, 27–49, at 43; for *consilium*, see Carruthers 2010.

31 Carruthers 2013, 199–204, for a different reading of St Bonaventure.

32 I cite Camille 1989, at 40; for *consilium*, see Carruthers 2010.

33 Carruthers 1993, 1998, 2010; Long 2001; L. H. Cooper 2011, 146–87.

34 Belting 1990, 1994.

35 Redfield 1971.

36 Rancière 2006, 20–26, and for what follows.

37 Gell 1992, 40; see also Gell 1998.

38 For an exploration of this issue, see Garnett and Rosser 2013.

39 Belting 1994, from 409; see the discussions in Hamburger 2006a and 2006b.

40 Nagel and Wood 2005, 404; Trachtenberg 2010; I argue explicitly against this general position in Binski 2010a.

41 Knapp 2008, 4. I do not consider Benjamin's elusive phenomenal or transcendental concept of the 'aura' to be sensory-aesthetic, for instance, Hansen 2008.

42 Camille 1989, 78.

43 Freedberg 1989, 167, also 120.

44 As argued by Gell 1992, especially 43–6.

45 Belting 1994, 434.

46 Knapp 2008, 4–5.

47 For the presence of absence, see Kessler 2000; for magic, see Gell 1992, 44–56.

48 Carruthers 2013.

49 Hoeniger 1995 is an instance.

50 Binski 1997, 2004; Hamburger 2006a, 14.

51 J. James 1981, 1984, 1989.

52 Frankl 2000, as revised by Crossley, 26; Shelby 1981.

53 Salzman 1952, 54–8.

54 Trachtenberg 2010, 104–5.

55 Shelby 1981, 177.

56 Hutchins 1995; Mukerji 2009.

57 See the essays in Binski and New 2012; Hourihane 2013.

58 J. Barnes 1984, vol. 2, 1799–80.

59 J. Barnes 1984, vol. 2, 1552–3.

60 Reynolds 2007, 9–10.

61 J. Barnes 1984, vol. 1, 332–4, vol. 2, 1600–01.

62 Binski 1995a, 98–101; Binski 2002b, 129.

63 The phrase *duxit in actum* is unusual but terminates an inscription of 1316 on the façade of the Loggia degli Osii in Milan: . . . *hoc commisit opus qui rem duxit in actum*.

64 Minnis 1988, 15–33, 73–159; and Binski 2010a for what follows.

65 Minnis 1988, 76–9.

66 Marenbon 1987, 190.

67 Minnis 1988, 78–9.

68 Binski 2010a, 21–2; Minnis 1988, 81–2.

69 Binski 2010a, 27–8, for what follows; Pevsner 1942b is also useful.

70 Binski 2010a, 22–4.

71 Buc 1994, 176; Binski 2010a, 34–6.

72 L. H. Cooper 2011, 146–87.

73 Binski 2010a, 31–3.

74 Duru 1850, 474–5; Kimpel and Suckale 1990, 28, 311, 474 n. 37.

75 M. T. Davis and Neagley 2000, at 162 and text at 178–9 take *previis tractatibus studiosis* to mean 'former learned treatises', but have since agreed that there is some merit in my translation.

76 The classic study of rationality and social mobility is A. Murray 1978.

77 Paul 1991, 40 n. 37; for Narbonne, see Freigang 1991 and 1992; see also Kurmann 1989.

78 Salzman 1952, 53; J. H. Harvey 1961, 142, 155 n. 38; Colvin 1963, vol. 1, 175; Knoop and Jones 1967, 87.

79 Toker 1985.

80 Costantini 2003, 56–9.

81 J. H. Harvey 1987, 45–7 and 240–45; *ODNB*, vol. 45, 981–2, for William Ramsey (by C. Wilson); Whittingham 1980a.

82 Chapman 1907, vol. 2, 6.

83 Pevsner 1942a, 235, for what follows; see also C. Wilson 1980a, 223–40.

84 The term is also used in a bond with William Joy at Wells: J. H. Harvey 1987, 164–5; Pevsner 1942a notes design made *par conseil* of Henry Yevele; for legal *consilium*, see Brand 2012, 52–3.

85 Bony 1979, 19, 22; for an introduction to craftsmen and administrators, see Coldstream 1994, 163–85.

86 Woodman 2012, 179.

87 Ackerman 1949, 109–10; Binski 2010a, 40.

88 Reynolds 2007, 10.

89 M. Kemp 1977, 351–2.

90 Bork 2011.

91 Toker 1985, 88.

92 On charismatic and intellectual culture, see Jaeger 1994, 4–9; Jaeger 1997; Jaeger 2012, 148.

93 Carruthers 1998.

94 D. A. Russell 2001a, 348–51; D. A. Russell 2001b, 281–325.

95 L. H. Cooper 2011, 158.

96 Gell 1992, 46.

97 The expression is *opere francigeno basilicam ex sectis lapidibus construi jubet*: Boehmer 1896, 666; Branner 1965, 1; Freigang 2011, 303–5.

98 Carruthers 2013, 167–8.

99 Noted in Bork 2011, 419; this model informs Trachtenberg 2010.

100 Gell 1992.

101 Branner 1965, 57–8.

102 Bork 2011.

103 Claussen 1981, 30.

104 Baxandall 1971, 124.

105 Lehmann-Brockhaus 1955–60, nos. 1382, 3838, 3906, 5936, 6116.

106 J. H. Harvey 1987, 153.

107 Roberts, Schaffer and Dear 2007; Long 2001.

108 Carruthers 1990, 217; Carruthers 1998, 16, 64, 153–4.

109 Carruthers 1990, 36, 123, 174, 198, 217; Carruthers 1998, 33.

110 Binski 2010b; for geometry, see Bork 2011.

111 Carruthers 1990, 108; Carruthers 1998, 16.

112 Salzman 1952, 22, i.e., for 'stones to be worked (*tractandis*)'.

113 Salzman 1952, 17–22; Binski 1986, 21.

114 Girard 1936–7, at 644–9; Costantini 2003, 196–7 and n. 1.

115 Parkes 1976, 120; Rouse and Rouse 1982, 224; Minnis 1988, 17, 21–2, 29, 49, 54, 118–59; Carruthers 1990, 174, 202–3; Carruthers 1998, 240.

116 Binding 1996, 345–67.

117 *PL*, 187, col. 879 (Gratian, *Decretum*, Part II, causa XI, quest. III, c. 106); Baglow 2002.

118 M. T. Davis 2012, 176–7 and n. 21 for other uses, also 181.

119 Bruzelius 1991, 420.

120 Müntz 1884, 24.

121 Parkes 1976; Carruthers 1998, 198–203, 230.

122 Binski 1986, 21; Tristram 1955, 282.

123 Smalley 1960, 167.

124 Boyle 1973; Walls 2007, 189–96, for the date, and 27 n. 134, for the passage following.

125 Hubbell 1949, 166–71

126 Krautheimer 1942.

127 Carruthers 1990, 217.

128 I refer to Nagel and Wood 2005, 2010.

129 The literature is large, but see, for instance, Pevsner 1949/1978; Schapiro 1977; Bismanis 1989; Trachtenberg 2000; Dynes 2006; Fernie 2008; Nagel 2012.

130 Branner 1965, 12; Bismanis 1989, 118.

131 Trachtenberg 2000, 189.

132 Chenu 1928, 1968.

133 For the elision of *modernus* and modern, cf., however, Trachtenberg 2000, 184, and Reeve 2012, 235.

134 Nagel and Wood 2005, 410–12.

135 For improvement at Romanesque Lincoln, see Gem 1986, 11; for Canterbury and Lincoln and the exploration of poetic (often somatic) imagery, see Binski 2004; for affectation at Beverley, see Woodworth 2009.

136 For legislative aesthetics, see Binski 2004; see also Molland 1978.

137 Smalley 1975, 131; Binski 2004, 29–51, 53–77; Fernie 2008.

138 Duru 1850, 474–5.

139 Maddison 1993, 124, after *VCH, Stafford*, vol. 3, 158 n. 92. I have altered the translation.

140 Carruthers 1990, 216–17.

141 For instance, Draper 1982, 331; Binski 1995b, 320–21; Coldstream 1994, 17–35; Draper 2006, 247–8.

142 Pevsner 1956/1976, 74–5, 83–5.

143 Draper 2006, 125–45.

144 Binski 2004, 62–75; Draper 2006, 152–9. For the constraints of the existing building stock and the traditional nature of partial rebuilding in England, see C. Wilson in Alexander and Binski 1987, 78–9, and C. Wilson 1990, 191, 204.

145 Pevsner 1953; for a defence and amplification of Pevsner's views, see C. Wilson 2011b, cf. R. K. Morris 1997; and for Pevsner on Bristol in context, see Crossley 2011.

146 Pevsner 1953, 92; R. K. Morris 1997, 47–51; C. Wilson 2011b, 115–16, discusses the Bristol Master's 'archaizing' tendencies.

147 Noted in Willis 1845, 99; also C. Wilson 2011b, 98, 114. For Eastry's work, see Coldstream 2013.

148 Bony 1979, 45–6.

149 Alexander and Binski 1987, no. 490.

150 Focillon 1980, 148–9; Bony 1979, 45.

151 Draper 1979; Binski 2004, 81–101; Draper 2006, 171.

152 Draper 1979, 8.

153 Fernie 1993, 183–4; Woodman 1996, 179–82.

154 The relationship of Wells and Prague is discussed in C. Wilson 2011a.

155 For what follows, see Maddison 2003.

156 Maddison 2003, 117–27, figs 11–12 (following Stewart 1868, 141–2).

157 Branner 1963; Fergusson 2011.

158 Maddison 2003, 126–7, n. 52.

159 The seminal study is C. Wilson 1980a.

160 Maddison 2003, 126.

161 Baxandall 1985, 58–60 and 62.

3 MONEY AND MOTIVE

1 Lopez 1952; for late medieval catastrophes, see Pirenne 1936/1976, 192–209.

2 Patronage and the economy are discussed in the main exception to this, Coldstream 1994, 61–78, 115–61.

3 Lopez 1952; cf. Johnson 1967.

4 Following Lopez, see Kraus 1979 for case studies; Kimpel 1977; Abou-El-Haj 1988, 1995a and 1995b; and for a reply to Lopez, see S. Murray 1989, 47–8; Kimpel and Suckale 1990.

5 Gem 1975.

6 See Bautier, cited at Kimpel 1986, 153.

7 Kimpel and Suckale 1990, 224–5; also Kimpel 1986, 142.

8 J. James 1984, 33 n. 130; J. James 1989, 96–7 and notes.

9 For these critiques, see Binski 2004, 29–51; also Binding 1996, 215–35.

10 Kimpel 1977; Abou-El-Haj 1995a.

11 Kimpel and Suckale 1990, 222–5; for Westminster, see Colvin 1963, vol. 1, 130–57; Binski 1995a; for Séez, see Grant 2005, 213–14.

12 Cf., however, the model of time as a commodity and the long build proposed by Trachtenberg 2010, e.g., at 111–12, 122–3, which seems to assume sustained economic development.

13 As noted by Wilson in Alexander and Binski 1987, 75, and C. Wilson 1990, 166–7.

14 Branner 1961, 31–2.

15 Huffman 1998, 23–40.

16 Puente 1999.

17 I have in mind Kimpel and Suckale's account of the rise of the chapel as a preeminent type in the new richness of Gothic: Kimpel and Suckale 1990, 398–405; Bork 2011.

18 Bony 1979, 33–7; J. Gardner 2010b.

19 Draper 2006, 142–3, 147–73, 167–8, 212–13.

20 Reckoned from Willis 1845, 48–58, table at 48 and plan fig. 5.

21 R. K. Morris 1990, 75. These very approximate figures are derived simply by dividing the total documented build time in years by the numbers of bays. I am indebted at this point to the research by Gabriel Byng preparatory to his doctorate on the economics of medieval English church building.

22 Draper 1979, 26–7 appendix 1; *ODNB*, vol. 41, 153–5; the Ely chronicle gives the period as seventeen years and the cost as £5,400 (Lehmann-Brockhaus 1955–60, no. 1583). Branner 1961, 32, cites Ely and Reims as examples of a fourteenth-year 'rule' (actually thirteenth at Ely), at which point in the construction of such churches costs increased because of the loftiness of the work.

23 Cocke and Kidson 1993, 43.

24 Wharton 1691, vol. 1, 647.

25 Wharton 1691, vol. 1, 644.

26 Derived from Erskine 1981 and 1983.

27 Colvin 1963, vol. 1, 248–57.

28 Brentano 1968, 62–6.

29 See the map in Alexander and Binski 1987, at 227 fig. 127.

30 Erskine 1983, ix–xiii.

31 For the latter, see Buck 1983, 49–53.

32 Buck 1983, 53.

33 Miller 1951, 81–2; quotation from B. Thompson 2010, 103.

34 For Freiburg, see Bork 2011, 55.

35 See, for instance, Hilton 1973; Campbell 1991.

36 Postan 1966, 1972 and 1973, 186–213.

37 W. C. Jordan 1996.

38 The literature is very extensive. For Postan 1966, see B. F. Harvey 1966, but her position is revised in B. F. Harvey 1991, 7, and see also Kershaw 1973; for post-plague demography, Hatcher 1977 is central; see also Mate 1984, Bailey 1989, Campbell 1991, Farmer 1988, 1991, Mate 1991, Hatcher 1994, Bailey 1996, Bailey 1998, Hatcher and Bailey 2001.

39 Hatcher 1977 and 1994; Bailey 1996; also Benedictow 2004, 342–79; for a higher than usual estimate of mortality rates, see Arthur 2010.

40 Rogers 1866; also Phelps Brown and Hopkins 1955 and 1956; Farmer 1988, 769–71, and 1991, 474–8.

41 Hatcher 1994, 20.

42 Erskine 1981, 175–212; Erskine 1983, 293, 310; Salzman 1952, 70.

43 Farmer 1988, 718; for inflation and money supply, see Mate 1975.

44 Chapman 1907.

45 Willis 1845, 115–17.

46 Costantini 2003, 193.

47 Erskine 1981; for the throne, see Erskine 1981, 71, 85, 94, 119, 147; and Erskine 1983, preface, xxx, and see the 'altar' accounts at 196–7, 198–9, 200–02, 203–4, 205–6; for discussion, see Sekules 1991a and 1991b.

48 R. Morris 1979, 180 and fig. 8, 177–236.

49 Hatcher 1977, 71, followed by Hatcher and Bailey 2001, 29 figs 2–3.

50 Colvin 1963, vol. 1, 228–48, 293–404, vol. 2, 864–88; C. Wilson 2002.

51 Mate 1975, 14; cf. also Gem 1975, 40–45.

52 W. C. Jordan 1996.

53 For a European overview by 'genre', see Kroesen and Steensma 2012; also for England, Bond 1916.

54 Binski 2004, 149–77; and Binski 2009, for what follows.

55 Binski 2004, 153–6; Rubin 1991, 164–212; see the useful account in R. Morris 1989, 350–76.

56 Binski 2004, 174–7.

57 J. M. Wilson 1920, 21–3.

58 Sekules 1983, 1986, 1990 and 1995.

59 Sekules 1986, and see below.

60 C. Wilson 1980b; Binski 2009.

61 Le Goff 1981, 237–333.

62 Le Goff 1981, 284–8.

63 *Respondeo dicendum quod caritas, quae est vinculum Ecclesiae membra uniens, non solum ad vivos se extendit, sed etiam ad mortuos qui in*

caritate decedunt ('charity, which is the bond which unites the Church, is extended not only to the living but also to the dead that died in charity'), pseudo-Aquinas, *Summa Theologie, Supplementum* III, Quest. 71, art. II, discussed in Le Goff 1981, 266–78 at 274–5.

64 Wood-Legh 1965; Luxford 2011a; McNeill 2011.

65 Carruthers 2013, 54, 123, 139.

66 Hinnebusch 1951; Brooke 1975.

67 For Poissy, see Moreau-Rendu 1968; Schlicht 2005; for the London mendicant churches, see Colvin 1963, vol. 1, 205–6, 207, 479, 481, 482, 486; also Bony 1979, 20, 34, 82 n. 6.

68 R. Morris 1979, 197, fig. 10.

69 On canonization, see E. W. Kemp 1947, 117–27; on the factors inhibiting canonization after 1300 or so, see Vauchez 1997, 71–82, 219–24, 488–98; for general discussions, see Draper 1979 and 1981; Nilson 1998; Binski 2004; Draper 2006.

70 For varying opinions, see Krämer 2007, C. Wilson 2011b, Luxford 2011b.

71 Kreider 1979, table 3.1, fig. 1.

72 Kreider 1979, 71–9; Raban 1982.

73 Le Goff 1981, 289, 330–31.

74 Kreider 1979, 80, 86–7; cf. Raban 1982, 42–3, 99, 154. Krieder (at 40–41) does not elaborate his views on purgatory or the doctrine of suffrages as unfolded in 1274.

75 Raban 1982, 12, 99–100, 188, 191.

76 Erskine 1983, 317; Platt 1990, 136; McNeill 2011, 18–21.

77 See T. Ayers 2007 and 2013; for the college, see G. H. Martin and Highfield 1997.

78 Vincent 2010, 65–9 at 68.

79 C. Hall and Lovatt 1989.

80 *Documents* 1852, 6–42.

81 C. Hall and Lovatt 1989, 16, map 3, also 18, 20, showing the chancel of St Mary of Grace with St Peter's at its west end; for the chronology, see Willis and Clark 1886/1988, 50–61, especially 50–51; services were not taking place in old St Peter's at the building's west end in 1340, which indicates dereliction or work in progress: a licence for the dedication of St Peter's was granted in 1349, but work was still under way in 1352, the dedication to the Virgin Mary occurring at the end of 1352.

82 *RCHM, City of Cambridge*, 1959, vol. 2, 280–83.

83 Bony 1979, 12, 17, 34, 54, 58–9, 62–3 (date confirmed by C. Wilson 1980a, 31 n. 9); T. Ayers 2007.

84 Willis and Clark 1886/1988, 51 n. 3 for the restoration of 1857, fig. 17 at 55 for the tracery. The east, side and west windows at Ely all informed that of the Cambridge church; a variant form occurs in the blind tracery panels of the embrasures of the west door of St Margaret's, King's Lynn. For Holborn, see Bony 1979, 12 and pl. 63.

85 *Documents* 1852, 41.

86 It is a striking consideration that Colvin 1963 was unable to devote particular chapters to Edward, unlike Henry III; for the king, see Prestwich 1988; for the king's bedroom, see Binski 2011c.

87 Colvin 1963, vol. 1, 248–57 and 510–27.

88 Colvin 1963, vol. 1, 293–408; Prestwich 1988, 170–232. Bony makes no mention of Edward's castles.

89 Colvin 1963, vol. 1, 257–63.

90 Colvin 1963, vol. 1, 162; C. Wilson 2002.

91 J. H. Harvey 1987, 45–6; the earlier published literature on St Stephen's leaves much to be desired, see Hastings 1955 and J. H. Harvey 1946 and 1961; the building's centrality to the Decorated Style, though stressed by Hastings, is emphasized by C. Wilson 1980a, his

entries in Alexander and Binski 1987, nos. 324–5, and C. Wilson 1990, 192–4, 196, 203–6.

92 Kimpel and Suckale 1990, 393–8, 405, 428–31.

93 Bony 1979, 11–13; Prestwich 1988, 134–69, 233–66.

94 Colvin 1963, vol. 1, 479–85; see the essays in Parsons 1991; for Burnell and Kirkby, see *ODNB*, vol. 8, 898–901, and vol. 31, 783–4.

95 Lindley 1984.

96 Buck 1983; see also *ODNB*, vol. 52, 272–4.

97 *ODNB*, vol. 48, 729–30; vol. 28, 256–7.

98 *ODNB*, vol. 32, 523–5.

99 *ODNB*, vol. 37, 761–2.

100 *ODNB*, vol. 16, 939–40, vol. 37, 604–5; for Wells, see Draper 1981.

101 For Eastry, see Coldstream 2013; for the architects, see J. H. Harvey 1987, 45–7, 240–45, 338–41, and for Hurley, 154–5.

102 Sekules 1983, 152; Sekules 1986, 129–30 n. 46; Sekules 1990, from 69; Sekules 1995; also Phillips 2010, 554. For an alternative perspective on Easter sepulchers, see Sheingorn 1978.

103 Sekules 1983, 163; Sekules 1986, 130 n. 46.

104 Sekules 1986, 130 n. 46.

105 *Sixth Report* 1877, 295; *RCHM: City of Cambridge*, 1959, vol. 2, 284–5; the structure was incomplete in 1327 and the expenses to 1326 relate to the chancel, but the west window of the nave cannot be much earlier than *circa* 1340 since its unusual tracery is an inverted form of that in bay two of the north walk of the cloister at Norwich.

106 Lehmann-Brockhaus 1955–60, no. 392; *VCH*, Cambridgeshire, vol. 10, 215, 218–19; Binski 1987, 74–5, fig. 54; *ODNB*, vol. 4, 738 (by P. Brand).

107 Whittingham 1980a, 288; C. Wilson 1980a, 180–81.

108 Erskine 1983, xii, 259; for Bristol, see S. Brown 1997, Krämer 2007, C. Wilson 2011b, Luxford 2011b; for Tewkesbury, see S. Brown 2003b, R. K. Morris 2003.

109 Coales 1987; Saul 2009.

110 Two case studies: Martindale 1989; Marks 1993–4.

111 For whose patronage, see Sekules 1986, 126 n. 3; Marks 1993–4, 348 n. 24; Camille 1987 and 1998; Sandler 1996 and 2000; M. Brown 2006.

112 These approximate figures are based on provenances in Morgan 1982 and 1988; and Sandler 1986.

113 Kauffmann 2003, 228–31; Morgan 2004.

114 Britnell 1996; see also Bailey 1998 and Kaye 2000.

115 A. Murray 1978.

116 Binski 2004, 201–4, for what follows.

117 For a recent study, see Hoffmann et al. 2006.

118 A. H. Thomas 1926, 26 (1327); Keene, Burns and Saint 2004, 38.

119 Fernie and Whittingham 1972, 27–9; Fernie 1993, 163–6, 211–12, appendix 5; Binski 2010c.

120 For such relics in England, see Vincent 2001, especially 69–71 and 209–10 (appendix 4), also 151, 153, 166–7, 172–3.

121 Binski 2010c.

122 Aston 1994.

123 The fundamental study is Ker 1949.

124 Fernie and Whittingham 1972, 29–44, for accounts 49 (1282: *item in fraccione capituli*, i.e., for the demolition of the old chapter house), 81 (1301–2: payments *ad fenestras capituli*, i.e., for the windows); Fernie 1993, 167.

125 The principal accounts of the cloister discussed here are Fernie and Whittingham 1972, 29–44, and for masonic contribution,

34, 98; Fernie 1993, 166–79, with summary document (the First Register) relating to the duration of building at 166–7 and n. 30, cited also in Salzman 1952, 388–9; Woodman 1996, 163–78; Gilchrist 2005, 77–94; Sekules 2006.

126 Tatton-Brown 2008.

127 Fernie and Whittingham 1972, accounts at 96 (John [Ramsey?] 1323–4), 98, 100 (John Ramsey, 1324–5), 104 (William Ramsey, 1326–7), 115 (John [Jalke] and William, 1329–30); summary in roll 1042A for *x panellarum iuxta Refectorium*, or bays running along the refectory range (eleven in all), at 107; for the Ramseys, see J. H. Harvey 1987, 240–45, and Whittingham 1980a; for the diffusion of Norwich cloister tracery in the region, see Fawcett 1979, 82; Fawcett 1980; C. Wilson 1980a, 172–85.

128 The nearest reflection of the chapter house tracery may perhaps be found in the east window of the church at Trowse Newton just outside Norwich, founded according to an inscription by the prior of Norwich, William Kirkby (1272–88), and paid for in 1282–3, the stonework by Master Nicholas costing £2 15s. 6d. and the glass £3 3s. (the relative cost of the glass should again be noted); see Pevsner and Wilson 2002, 698. If Nicholas is the same as the Nicholas *le machun* recorded with robes at Norwich Cathedral in 1288–9 (Fernie and Whittingham 1972, 53), Trowse was quite possibly an offshoot of the chapter house project then in hand. Its window includes an unusual motif of Rayonnant derivation, a diagonally set quadrilobe, found, for instance, in the tracery of the north transept of Notre-Dame in Paris. I suggest that in this motif, perhaps a feature of the new chapter house tracery installed in the same years, the Ramseys found the origin of the very popular four-petalled motif they first applied in the south walk of the cloister and in the choir triforium at Ely, which is in essence a freer version of the quatrefoil resting on its sides. This would secure its origin from within Rayonnant but via local sourcing.

129 M. R. James 1911; Rose and Hedgecoe 1997.

130 Franklin 1983; Franklin 1996, 126–35; Gilchrist 2005, 77–82.

131 As well as M. R. James 1911 and Rose and Hedgecoe 1997, see, for instance, Gilchrist 2005, 86–90; Sekules 2006. According to an unpublished paper by N. J. Morgan, which he has kindly allowed me to cite, the Apocalypse bosses are based on the Anglo-Norman French prose recension found in Oxford, New College MS 65; Bodleian Library MS Selden Supra 38; and Lincoln College MS 16: Sandler 1986, nos. 7, 54, 72. Fernie and Whittingham 1972, 38, draw attention to the purchase in 1346–7 of a 'History of the Apocalypse' 'for use in carving the bosses' in the Communar Roll 1052, now Norfolk Record Office DCN 1/12/26, drawn up for William of Witton. The reference, in a paragraph of miscellaneous expenses, states simply '*solut' pro Libro historie Apocalypsis 4s.*', and no connection is made with the carving of bosses. Hence it cannot be evidence for the start of the vaulting of the south walk (see Sekules 2006, 289).

132 Cave 1948.

133 Brighton 1985; Sekules 2006, 288.

134 Tolhurst 1948, 87, 152.

135 As illustrated by Fernie 1993, pls 51–4.

136 Here I accord with Sekules 2006, 289.

137 Fernie 1993, 166–7 and n. 30.

138 Interpretations of the course of work within the span of 1299–1325 differ, however: (1) Fernie and Whittingham 1972, 31–3, argue (correctly in my view) that the southern bays of the east walk were vaulted next after the three central ones before the chapter house entrance, in (they think) 1316–19; the tracery of the chapter house entrance itself is dated after the Carnary Chapel; the vaulting in the north bays followed (they think) in 1325–7 and the prior's door in 1330; (2) Fernie 1993, 173–5, revises this chronology backwards, so the chapter house entrance and vaulting dates to 'later' in the period 1297–1314 (*sic*), as does the vault over the prior's door and the door itself, again shortly before 1314; (3) Woodman 1996, 166–8 and fig. 84, and 177, accords somewhat with Fernie and Whittingham 1972, pressing the vaulting of the northern bays of the east walk back towards the late 1320s and the portal to *circa* 1330; (4) Sekules 2006, 288–9, prefers a date of 1320–30 for the east walk vault and bosses, which also has implications for the prior's door connected to them (but contrast Sekules 1996, 199). The solution adopted in what follows by the present writer is to date the insertion of the chapter house tracery, prior's door and associated vaulting in the northern bays no earlier than *circa* 1315 and no later than *circa* 1320–55. The entry in the First Register to the effect that Salmon made at his own expense the vaults together with the door of the church (*residuum vero 5 versus ecclesiam cum hostio eiusdem. . . . factum est sumptibus domini Johannis*) (Fernie 1993, 167 n. 30) should date the prior's door before 1325, and is not obviously consistent with the arguments in Fernie and Whittingham 1972 and Woodman 1996 for a date *circa* 1330.

139 Fernie 1993, 173, 175.

140 Fernie and Whittingham 1972, 33–4, 89, 91 (roll 1039A), including materials for painting; Macnaughton-Jones 1966; Fernie 1993, 180–81; Woodman 1996, 161–3; Sekules 1996, 199–202.

141 For Repton's drawing of 1803 of the west face showing the original patterning of the flushwork, see Sekules 1996, 200 fig. 97.

142 Whittingham 1980b; Fernie 1993, 181–2; Woodman 1996, 178, incorrectly states that it was built after 1316.

143 Harper-Bill 1996, 110.

144 The dating evidence is not set out clearly in the secondary literature. Here it is: (1) provisions were made for chaplains in the chapel 'built' by John Salmon in August 1316: *Calendar of the Patent Rolls*, 1313–17, 525; (2) the foundation charter of 4 October 1316 entrusts to St John the chapel at the western end of the cathedral, which 'we have established' *(fundari fecimus)*, as a perpetual chantry with four priests celebrating for the souls of John Salmon, his father and mother Solomon and Amice, and his predecessors and successors at Norwich: Saunders 1932, 50–61; (3) the charter was confirmed by the pope in April 1317: *Calendar of Papal Letters*, 1305–42, 140; (4) in April 1317 an indulgence of 100 days was granted to those visiting the chapel on the feasts of St John: *Calendar of Papal Letters*, 1305–42, 142; (5) resources for ornaments were available in February 1319: *Calendar of the Patent Rolls*, 1317–21, 270–71; (6) a charter of June 1319 for the acquisition of lands to maintain the four priests for the chapel states it to be *de novo constructa* (newly built): Saunders 1932, 61–3; (7) by 1322 the number of priests had risen to six by a charter establishing regulations for the college including regular choral Masses at its high altar: Saunders 1932, 64–82. Cattermole 2011 should also be consulted, but lacks references.

145 Shown in this form in 1712: Fernie 1993, 178 pl. 59; cf. C. Wilson 2011b, ill. 4.44–5, for Bristol and Hardingstone.

146 *Calendar of the Patent Rolls*, 1317–21, 270–71; Gilchrist 2005, 28, 147–8, 152–4.

147 Fernie and Whittingham 1972, 33.

148 Whittingham 1980a, 285; for the Gorleston Psalter, fol. 149v, see Cockerell 1907.

149 Whittingham 1980a, 288.

150 Christie 1938, pl. cxxv.

151 Bony 1979, 67.

152 Liverpool, Walker Art Gallery, no. WAG 6135, presented by the Mayer Museum in Bebington in 1962. It was originally owned by the Liverpool antiquary Joseph Mayer and made substantially before 1878; it had had a Renaissance orphrey added to it: Christie 1938, 183 no. 96.

153 Watson 1969, 48 and fig. 3, attributing the form to Islamic influence (questionably).

154 Sandler 1974, 116–19, figs 74–5; Sandler 1986, no. 41; for dating, see also Binski 2000.

155 Whittingham 1980a, 287, tracing the Ramsey clan from the Curteis family of Outwell on the Ramsey estates

156 E.g., The National Archives E101/468/6, mem. 1 (April 1292), mem. 8 (June 1292), mem. 9 (June 1292), etc.

157 See the impressive instance published by Luxford 2010.

158 Norton, Park and Binski 1987; the arguments regarding the Warenne arms *checky or and azure* on the painted ground of the retable proposed by D. King 2010, after its true colours were revealed by cleaning, strengthen the association of the retable with Thetford, which John de Warenne founded in 1335.

159 Binski and Howard 2010, 192–3.

160 S. J. A. Evans 1940, 6–23.

161 CUL MS ii.4.35: Binski and Zutshi 2011, no. 132.

162 Carter 1935, 19–24.

163 Harper-Bill and Rawcliffe 2004, 101–8.

164 In general, see Ehrle 1892; Sundt 1987; Freigang 1992, 405; Volti 2003 and 2004; Schlicht 2005; J. Gardner 2010b.

165 Sutermeister 1977, 2–3, 21–9.

166 Lindley 1987a.

167 Olson 1963.

168 Sekules 2006, 288.

169 Harper-Bill and Rawcliffe 2004, 77–8, 87.

170 Fernie and Whittingham 1972, 29, 31, 56 (roll 1030, 1288–9).

171 Chapman 1907, vol. 2, 50; *Sixth Report* 1877, 289–300, at 292.

172 For the precinct enclosure, see also Gilchrist 2005, 44–60, and in general Coulson 1982, Morant 1995 and M. W. Thompson 2001, 105–25.

173 Borg et al. 1980, 30–35; Fernie 1993, 180–81; Sekules 1996, 199–202 and fig. 97; Woodman 1996, 161–3; Gilchrist 2005, 50–52.

174 Binski 2010c, 248.

175 Fernie 1993, 163 and n. 18; B. S. Ayers 1996, 65–6.

176 Branner 1963; Fergusson 2011.

177 Coulson 1982, 75–92.

178 Alexander and Binski 1987, no. 327; Luxford 2013a.

179 Luxford 2014, in preparation.

180 Coulson 1982, table at 93–4.

181 Coulson 1982, 69–70, cited at 92.

182 Coulson 1982, 96 n. 8.

183 Tracy 1987, 16–24, 77.

4 INVENTION ENERGIZED

1 Camille 1992, 77.

2 For Bordieu's notion of the *habitus* in regard to 'legislative aesthetics', see Binski 2004, 43–6.

3 Rickman 1817, 37–9.

4 The definitive text is Colvin 1963.

5 Hastings 1955, 3. An early recognition of the importance of St Stephen's for Perpendicular is found in Lethaby 1906, 220–21.

6 J. H. Harvey 1946, already responding to Hastings, whose full thesis appeared in Hastings 1955; J. H. Harvey 1961 and 1978, 44–5: it is not to Harvey's credit that he omitted reference to Hastings's work in the bibliography of the last work. For this 'vitriolic' exchange, see Crossley 2011, 204.

7 Bony 1979, 59–60.

8 C. Wilson 1980a, from 34; Alexander and Binski 1987, 82; C. Wilson 1990, 192–207.

9 Bony 1979, 5; Bock 1962b, 412; and see also Bucher 1976. The importance of such forms is recognized by C. Wilson 1980a; see also Coldstream 1994, 37–9.

10 Bony 1979, 22.

11 Paris, BnF Est. Oa 9, fol. 64, 'Vue du sanctuaire de la Sainte-Chapelle du Palais'. For arch and gable forms of this sort, see Branner 1963, 101; Branner 1971; also Bony 1983, 413; Bugslag 2008.

12 Bony 1983, 400–01 and n. 50, and fig. 380.

13 Frankl 2000, 65.

14 Vitruvius, *Ten Books on Architecture*, Book VII.v.4, see Rowland 1999, 91–2.

15 The date is given variously as 1301 and 1311: Bugslag 2008, 67–8, after Hocquet 1924, 25–6.

16 Donnay-Rocmans 1961, 201–2; Kurmann 1996a; Bugslag 2008, 64 and n. 20.

17 J. Gardner 2010a.

18 Lehmann-Brockhaus 1955–60, no. 351.

19 Now comprehensively discussed in the essays in Binski and Massing 2009, particularly Christopher Wilson's on architecture.

20 *Calendar of the Close Rolls*, 1247–51, 343.

21 Binski 1995a, 45–6.

22 As in the case of the shrine of St Chad at Lichfield ordered by Bishop Walter Langton to be made in Paris and complete by 1307; see Maddison 1993, 70 and n. 19.

23 Lillich 2007 and 2011, at 63–103.

24 Lillich 2011, 74.

25 Clark 2000; Lillich 2011, 73–5.

26 Lillich 2011, 69–75.

27 C. F. Barnes 2009, colour pl. 64.

28 C. Wilson 1980a, 82–3; Binski 1995a, 116.

29 P. Klein 1983; Morgan 1988, nos. 153–5; Morgan 2007.

30 Alexander and Binski 1987, no. 462.

31 For Strasbourg, see Becksmann 1967; for St Louis, see Stahl 2008; for the Fitzwilliam or Isabella Psalter, see Binski and Panayotova 2005, no. 72.

32 Gould 1978; Bony 1979, 15–16, and compare pls 93–4 and 173.

33 Binski and Massing 2009, 30–32.

34 Binski and Massing 2009, 31 and 90.

35 Cahn 1996, no. 117 and fig. 278.

36 Binski 1995a, fig. 15 for the 'Dickinson' drawing of the north transept.

37 Maillon 1964; Sauerländer 1972, 438–40.

38 Binski 1995a, fig. 36.

39 Grant 2005, pl. 188.

40 S. Brown 1999, fig. 157

41 Bony 1979, 22 and n. 10.

42 Bock 1962b, 414–15; see Binski 1986 and 2011c.

43 Sauerländer 1972, ill. 186, 272.

44 Whittingham 1980a, 286; cf. Binski 2011c, fig. 9.

45 Bony 1979, 22, 60.

46 Binski 2012a on such projects.

47 The literature is very extensive: Hunter 1842; J. Evans 1949a; Colvin 1963, vol. 1, 479–85; Stone 1972, 143–5; Zukowsky 1974; Bony 1979, 20–21; Alexander and Binski 1987, 361–6; Parsons 1991; P. Williamson 1995, 217–18; Dilba 2008; Coldstream 2011.

48 The queen's executor's accounts are in Turner 1841, 95–139, covering Charing, Lincoln, Northampton (i.e., Hardingstone), Cheapside, St Albans, Waltham, Dunstable, Stony Stratford, Woburn, omitting Geddington, Stamford and Grantham.

49 For a discussion of ciboria, see Binski 2009.

50 Bony 1979, 26, in fact, makes scant passing reference to the throne, solely in relation to 'Islamic' forms. For the throne and its context, see Bock 1962a, 124–7: much more attuned than Bony to the importance of this object in virtue of his prioritizing tabernacle architecture, as in Bock 1962b; Alexander and Binski 1987, no. 488; Tracy 1987, 12, 46–7; Sekules 1991a and 1991b, 175–6.

51 Bock 1962a, 125–6 and fig. 25.

52 Erskine 1981, 71; Erskine 1983, xxx.

53 J. H. Harvey 1987, 338–41; J. H. Harvey 1961, 157 n. 79; R. K. Morris 1991.

54 Erskine 1981, 85, 94, 119, 147.

55 Alexander and Binski 1987, no. 488; personal communication, Hugh Harrison, to whom I am grateful for advice about revisions to the second, now tower, stage.

56 Cocke and Kidson 1993, 10. The impact of the throne at Exeter on the interior, especially its visibility from the nave over the new pulpitum, is stressed in A. Budge, 'Episcopal Visibility: The Extant Fourteenth-century Bishops' Thrones at Exeter, Wells, Hereford, St David's and Durham', unpublished MA dissertation, Oxford University, 2011, 21–3. I am grateful to Mr Budge for making his work available to me.

57 Becksmann 1967; Bony 1979, 20–21.

58 Hastings 1955, 23, connects them; see Bugslag 1993, 73–5.

59 ONDB, vol. 52, 272–4; the standard biography is Buck 1983, at 124–5 for France.

60 Erskine 1981, 98.

61 T. Ayers 2004, vol. 1, 29, and fig. 1.19.

62 O'Connor and French 1987, 4, 15–23.

63 Buck 1983, 46.

64 Sekules 1991a; Sekules 1991b, 177–8.

65 Vauchez 1997, 169.

66 C. Wilson 1980b, 98; for the licence for the tomb, see Raine 1839, appendix cxxxvii–cxxxviii, also cxlviii–cli.

67 Buck 1983, 10, 220.

68 Sekules 1991a and 1991b; for the reredos, see P. Morris 1943; also R. K. Morris 1991; for the accounts, see Erskine 1981, 88, 110–12, 144–5, 163; Erskine 1983, xxx–xxxi.

69 In general, see Tracy 1987.

70 Remnant and Marks 1980; Kevin et al. 2008.

71 Dawton 1983; Dawton 2000; Lindley 2007, 167–98.

72 C. Wilson 2011b, 99–103 and ill. 4.28, and ill. 4.59 for St Mary Redcliffe; Coldstream 1994, 44 and fig. 29 for Stanton Harcourt;

73 Draper 2006, 246–7; S. Brown 1999, figs 139–41.

74 C. Wilson 1990, 192–4, 202; R. K. Morris 1991; C. Wilson 2011b, 95–114, for the regional impact of St Stephen's and related works.

75 J. M. Wilson 1920, 21–3.

76 Erskine 1981, 98, 118, 119, 153, 156, 157; Erskine 1983, xxx–xxxi.

77 For the pulpitum vault, see Bock 1962a, 60–61; R. K. Morris 1991, pl. xid.

78 Draper 1981, especially 24–7; R. K. Morris 1991.

79 For Winchelsea, see Bony 1979, 34, 59; for Thomas of Witney at Winchelsea, see R. K. Morris 1991, 61, 71, 72; for the tombs in question, see Gee 1979, 38–40, but compare C. Blair, Goodall and Lankester 2000, especially 18–25.

80 Binski 1995a, 115–18.

81 Panofsky 1951, 45–51.

82 C. Wilson 1990, 201–3; C. Wilson 2011a, 99, 103, 105.

83 C. Wilson 1990, 204–7.

84 Bucher 1976, 82.

85 Bucher 1976.

86 Bucher 1976, 74.

87 See Timmermann 2009 for a discussion that omits reference to English evidence; a comprehensive collection of short essays on related themes is collected in Kratzke and Albrecht 2008.

88 Kurmann 1996b is not free of this pitfall in using the non-medieval category of Kleinkunst as opposed to Grossbau.

89 Curtius 1990, 487–94; for magnificence and minificence, see Carruthers 2013, 172–5.

90 Gage 1973, 360; Heslop 1998, 132.

91 Bynum 2001, 37–75, at 42–3, 51–3.

92 A. S. Cohen 2010.

93 Bachelard 1994.

94 Bucher 1976, 72; Bony 1979, 54. For 'nook' aesthetics and theology, see Binski 2004, 109–12, 119–21.

95 Bachelard 1994, 155.

96 A point made forcefully by Carruthers 2013, 1–15. For an exploration of the notion of enchantment in medieval literature, see Olsan 2010.

97 Carruthers 2013, 14.

98 Mann 1994, 192–5.

99 Whitehead 2003, 18; see also Binski 2004, 3–77.

100 Bony 1979, 19–20.

101 For castles, see Coulson 1982 and 2003; J. Goodall 2011; and for their symbolism, Wheatley 2004.

102 For the rise and fall of this mode, see Smalley 1952.

103 Carruthers 2013, 22; Binski 2012b.

104 Gem 1986; Wheatley 2004, 91–2.

105 Gem 1986, 24–5.

106 A. Murray 1978, 333, 377; Binski 2004, 44–5.

107 Cocke and Kidson 1993; Binski 2004, 62–77.

108 For crenellations on the north faces of Westminster, see Binski 1995a, 36 and figs 15, 35, 48; for Reims, see Abou-El-Haj 1988, 1995a and 1995b.

109 Binski 1995a, 76–86

110 Bony 1979, 12 and pls 69–71; J. Goodall 2011, 231–2.

111 Bony 1979, 19–22.

112 Coulson 1982, 69; Coulson 2003.

113 Alexander and Binski 1987, no. 98.

114 Panofsky 1964, 62 and fig. 252.

115 Sauerländer 1972, 467 ill. 88; Binski 2004, 98.

116 For texts, see Whitehead 2003, 87–116; for art, see Binski 2004, 181–6; for what follows, see Binski 2011b.

117 A. Murray 1978, 355–62.

118 M. W. Evans 1982; Binski 2004, 227–30, fig. 184.

119 Arnould 1940; Whitehead 2003, 87–116.

120 Bony 1979, 19–20.

121 Carruthers 2013, 16–44, on artful play.

122 Binski 2011b for what follows. My arguments were first presented in a Slade Lecture delivered at Oxford in the Lent Term of 2007.

123 C. Wilson 2007.

124 Binski 2011b, 269–70.

125 Binski 2004, 181–6.

126 Binski 2011b, 270–73; for the text, see Sajavaara 1967; Wheatley 2004, 78–86, creates the impression that this exegesis originated with Ailred.

127 Gem 1986; Wheatley 2004, 98–103.

128 Mann 1994, 203.

129 Loomis 1919; Bony 1979, 19; Whitehead 2003, 88–90, 93–4; Wheatley 2004, 103–8; R. K. Morris 1998.

130 Wheatley 2004, 104–7. The analysis of this image in Camille 1998, 118–19, is in the default parodic mode critiqued below in Chapter Eight; he connects this image with the following Psalm 38.

131 Sandler 1974, fig. 57; Sandler 1986, no. 40.

132 . . . *fac nos famulos tuos sanctae domini genitricis virginis Mariae et omnium sanctorum tuorum ubique tueri persidiis necnon familaritate atque consanguinitate nobis coniunctis et omni populo christiano cunctis insidiis fallacis inimici depulsis concede ad caelestem pristinam redeundi aditum.* The suggestion in Caviness 2007, 150, that this image is ironic is not consistent with the evidence.

133 Lefèvre-Pontalis 1904; Frankl 2000, 167–8, 335 n. 102.

134 The debt, again, is owed to Pevsner 1953; Bony 1979, 10, 11, 46; Coldstream 1980, 92; Frankl 2000, 166–8, 169; C. Wilson 2007; Isnard 2010 for its French influence.

135 S. Brown 2003a, 51–5, for dendrochronological dating of the roof; C. Wilson 2007, 114–15.

136 Sekules 1986, 126 n. 3; Marks 1993–4, 348 n. 24; Camille 1998, 132–5. See also Lindley 2007, 184–9, for the suggestion that the Percy tomb at Beverley had a dual tomb-Easter sepulchre function. A ?female figure, perhaps a donor, has been struck off what is now the lower part of the north side.

137 Coulson 1982, 92.

138 Bony 1979, 21–2.

139 Binski 1986, 74–5.

140 Branner 1965, figs 23–5, 79, 104, 139; Binski and Panayotova 2005, no. 72.

141 An instance is the canopy work of the figures in the lost clearstory window in bay 129 of the nave of Reims Cathedral, *circa* 1270?; see Lillich 2011, 206 and fig. 202.

142 M. Wood 1981, 370 and pl. 31c.

143 Bock 1962b.

144 O'Reilly 2001; see also Whitehead 2003.

145 Hamburger 2006b, 376–7.

146 Dekkers and Fraipont 1956, 466–7; McGinn 1995.

147 Deshman 1995, 122.

148 Lehmann-Brockhaus 1955–60, no. 1584.

149 Binski and Howard 2010, 190.

150 Stahl 2008, 83–9, 86.

151 Paris 1998, nos. 188–9.

152 Branner 1965, pl. 60; Binski 1986, 142 n. 174; Binski and Panayotova 2005, no. 72; Stahl 2008, fig. 92.

153 Gillerman 1977.

154 Schmidt 1979–80; R. Quednau 1980.

155 See, however, Coldstream 2011.

156 Alexander and Binski 1987, 128.

157 E. Martin 1998, especially 159–60, and 160 for brick; J. Goodall 2011, 232 and pl. 173.

158 H. Howard 2003, 53, 54, 55, 56.

159 Sandler 1983.

160 Keene, Burns and Saint 2004, fig. 84, and compare also fig. 66.

161 C. Wilson 1980b, 91–5; Binski 1995a, 167–71; Binski 2009, 36–8; Kroesen and Steensma 2012, pl. 4.15.

162 M. Wood 1981, pl. L.A; J. Goodall 2011, 233, pl. 174.

5 ARTIFICE AND ALLURE

1 Bony 1979, 19–29.

2 Focillon 1948; Focillon 1980, especially 139–57.

3 For this and what follows, see Focillon 1980, 144–51; see also Bialostocki 1966, 87–91.

4 Focillon 1980, 149.

5 Gombrich 2002, 204–9; Recht 2008, 47–52.

6 Ruskin 1849/1925, III, 113 (chapter 2, XXIV–XXV).

7 Baltrušaitis 1955.

8 Baltrušaitis 1955, 263–80.

9 Baltrušaitis 1955, fig. 118, for instance.

10 Bony 1979, 22–5, at 23, also 25–9.

11 Demus 1960, 104–5, 147–8; D. Howard 2000, 142–6, cited at 142.

12 D. Howard 2000, 143–4; Ettinghausen, Grabar and Jenkins-Madina 2001, 254–5, fig. 422.

13 D. Howard 2000, 99–109, cited at 99. Useful arguments against this general style of exoticist interpretation are made by Michael Michael in Binski and Massing 2009, 97–102.

14 Ettinghausen, Grabar and Jenkins-Madina 2001, 162–4, figs 248–9.

15 Draghi et al. 2006.

16 Bony 1979, 24 and fig. 138.

17 J. Gardner 1975, 82 and pl. 10(i).

18 On which topic, see among others Grabar 1989.

19 For example, brasses of *circa* 1340 at Westley Waterless and Stoke d'Abernon, Binski 1987, figs 102–3.

20 Davies 2010. For a variant of the orientalist model, via the influence of Eleanor of Castile, see Tolley 1991.

21 See Prestwich 1988, 330–31; J. H. Harvey 1950, 77, 143; also Baltrušaitis 1955, 270–71; for the accounts, see Desimoni 1877–84, 594, 610, 612, 615, 616, 619, 623 and 624, where Robert is evidently paid for repairing two alabasters. Harvey neglects to note that Robert and his companion Richard were active in Trebizond, Constantinople and Apulia, not the Mongol empire. J. H. Harvey 1961, 153, nevertheless refers to Robert returning with an 'album of Oriental sketches' as if he were David Wilkie.

22 Gombrich 2002, 270–71.

23 Taralon 1966, 233, 299–300.

24 Oxford, Bodleian Library MS Gough Drawings Gaignières 2 (18,347), no. 22; the tracing in Paris, BnF Est. Rés. Pe 1a, fol. 122, is in Adhémar 1974, 38 no. 166; Erlande-Brandenburg 1975a, 162–3, no. 90 fig. 40; see also Nolan 2009, 117–19 and fig. 29; Bony 1979, 79 n. 26, queries its form; C. Wilson 1990, 193, accepts it. The fact that Hugo de Plailly worked on more than one commission in the 1230s (Nolan 2009, 117–19) also favours a date not long after 1236.

25 Oxford, Bodleian Library MS Gough Drawings Gaignières 1

(18,346), no. 98; also BnF Est. Rés. Pe 1, fol. 98; Adhémar 1974, 49 no. 230; Bony 1979, 24 and fig. 145, 25 and fig. 147; Teuscher 1990, 171–4.

26 Bony 1979, 25.

27 Oxford, Bodleian Library MS Auct. D.4.1,7, fol. 3; Paris, BnF MS fr. 403, fol. 6; and for Solomon's Temple with an onion dome, New York, Pierpont Morgan Library MS M 524, fol. 7v.

28 Binski 1986, pl. VII.

29 C. Wilson 1990, 193.

30 Deér 1959, 37–8, fig. 11; Ettinghausen, Grabar and Jenkins-Madina 2001, 254–5, fig. 422.

31 Weitzmann 1977, 21–2 and colour pl. 37; Lowden 1997, 92; for the reliquary, see Legner 1985, vol. 3, 88–9 no. H12; also Bony 1979, 24, fig. 141.

32 D. Howard 2000, figs 124, 171.

33 Paris 1992, no. 242; Lowden 1997, ill. 223.

34 Paris 1992, no. 233 and its fig. 1; Branner 1971.

35 In Binski and Massing 2009, 85–7 and fig. 10.

36 H. A. Klein 2010, especially 196–21 for what follows.

37 What is often regarded as the nearest French instance to Douce chronologically, the ogee found on a single western jamb of the south portal of St Urbain at Troyes, is in fact a fourteenth-century repair (personal communication C. Wilson; see Bond 1910, 390–91; cf. Crossley 2006, 328: 'It is now generally agreed that the ogee made its first concerted appearance in northern Europe in Paris and north eastern France in the 1280s and 1290s, in the context of Parisian and Parisian-inspired "court" art'). The interesting aspect of the Douce Apocalypse ogees is that they occur within a context of architectural depiction that is as a rule un-Parisian in character.

38 For the lectionary, see Branner 1977, 137, and Kauffmann 2004; for the picture book, see Stones 1997; for the shrine, see Donnay-Rocmans 1961 and Kurmann 1996a: fol. 104 of MS nouv. acq. Fr. 16251 is intimately related to the figure of St Gertrude on the shrine; see also Bony 1979, 26–7 and 80 n. 4; Crossley 2006, 328–30.

39 U. Quednau 1979: for split cusps, pls 34–5; for ogees, pls 85, 89, 91; for split cusps and ogees, pls 93–4.

40 C. Wilson 2011b, illus. 4.17.

41 Kurmann 1986, 12–13 and fig. 1; Crossley 2006, and see Coldstream 1994, 42–4.

42 Bony 1979, 26, pl. 152.

43 Bony 1979, fig. 318; cf. Watson 1969, which persists with Islamic sources.

44 For the glass of Merton College, see T. Ayers 2007; and for a comprehensive discussion, T. Ayers 2013, for the date 83–4, and documents at 10; see also Sandler 1986, nos. 26, 40 and 41; and for dating, see also Binski 2000.

45 Sandler 1983.

46 This point is lost by taking each image singly and not as a diptych; see Michael 2007.

47 Christie 1938, 149 no. 78, pl. CII; Sandler 1983, figs 35–7, for these instances.

48 Pevsner 1956/1976, 130–32.

49 Pickering 1970, 264, 276–9; Binski 2004, 209–30, for the affects of the Crucifixion.

50 Binski 2004, 218–23.

51 Rodwell 2009, 84–91; and Sandler 2012 for what follows.

52 Kavaler 2005, 2008 and 2012. It is of course implicit in the play of permanence and impermanence in foliage motifs in England since at least the twelfth century; see Binski 2004, 87–101.

53 Bond 1905, 479–90, 487 fig. 5, 489; C. Wilson et al. 1986, 82–3.

54 The literature on flowing tracery is extensive, but see, for instance, Sharpe 1849; Bock 1962a, 141–7; Etherton 1965; Coldstream 1973, for the fullest investigation of Yorkshire; Coldstream 1980, 96; O'Connor and French 1987; O'Connor and Reddish 1995. Bony 1979 does not give a full account of it.

55 Binski 1995a, 74–6; Binski 1997, 364–5; Binski 2004, 281–2.

56 Inglis 2003, 66.

57 Kerr 1985.

58 Vinken 1999, 33–50, 63.

59 Olson 1963, 92–3.

60 O'Connor and French 1987, 15–18 and pl. 13 (a–b); for Selby, see O'Connor and Reddish 1995.

61 Rodwell 2009, fig. 88; Sandler 2012, 339.

62 Jaeger 1994, 331–48; Binski 2004, 233–59.

63 For what follows, see S. Gardner 1927, especially 39–41; Pevsner 1945; Stone 1972, 138–41; Givens 1998 and 2005.

64 Sandler 1986, no. 4

65 For mimesis at Southwell, see Pevsner 1945; also Givens 1998 and 2005.

66 C. Wilson 2011b, fig. 4.27.

67 For which, see Kavaler 2008, 139.

68 Pevsner 1945, 67.

69 Pevsner 1945, 53; Panofsky 1951, 6–7.

70 Pevsner 1956/1976, 46–7; see also Binski 1997, 369–70.

71 Panofsky 1951, 8–20.

72 For smiling and flashing out, see Gage 1993, 77–8; see also Binski 2004, 233–59.

73 Bynum 1992, 255–8, at 256.

74 Binski 1997, 367–9; Binski 2004, 283–7; see also Hamburger 1990.

75 Binski 1997; Binski 2004, 368–82.

76 S. Brown 1999, 119–20 and fig. 12.

77 Muratova 1989.

78 *Magna nec ingeniis investigata priorum / quaeque diu latuere, canam; iuvat ire per alta / astra, iuvat terris et inerti sede relicta / nube vehi validique umeris insistere Atlantis.* See Yalouris 1995; Leuker 1997; Marchiori 2007.

79 Zarnecki 1958, pls 47–9.

80 Carruthers 2013, 168.

81 For a more fully developed version of this position, see Scarry 1999.

82 For 'charismatic effects', crucial to which is the overriding of judgement and personal conviction, see Jaeger 2012, 22–3.

83 Fisher 1998, 6–9, 9–17; Gell 1992, 46–9.

84 Jaeger 2010, introduction at 12–13, and Carruthers 2013, *passim*.

85 Carruthers 2013, especially 181–2 for allegory as a surface *color* of rhetoric.

86 L. H. Cooper 2011.

87 Gell 1992, extended in Gell 1998; for enchantment, see Jaeger 2012, for medieval romance especially 162–84, at 182.

88 I refer to the discussion of the term *dídón* in Baxandall 1979 at 457; see the discussion of Gell's concept of agency in Layton 2005.

89 See Bedos-Rezak 2006, especially 51–6.

90 Olson 1963, 92–3: 'Sicut etiam pulchritudo domus religiosorum consurgit ex bona ordinatione claustri & aliorum edificiorum . . . Iterum cordis pulchritudo, quod debet esse domus religiosa consurgit ex debita dispositione claustri'; Boyle 1973; Walls 2007, 189–96; also for *ordinatio*, see Pevsner 1942a, 233.

91 Barret 1965; for Canterbury, see Willis 1845, 97, after Wharton 1691, vol. I, 141.

92 Carruthers 2013, 188–9.

93 Lehmann-Brockhaus 1955–60, no. 816.

94 Carruthers 2013, 135–40, 181–7.

95 Freedberg 1989, 397–8.

96 Carruthers 2013, 188–9.

97 Cap. XII: Rudolph 1990, 278–85.

98 Gell 1992, 44–9.

99 Carruthers 2013, 181–2.

100 Minnis 1988, 140–41; Carruthers 1998, 124–30; Carruthers 2013, especially 181–2.

101 Mann 1994.

102 Andrew and Waldron 1978, 237–8.

103 Jaeger 2012, 171–2; for enchantment, see also Olsan 2010.

104 Deliyannis 2010; Carruthers 2013, 184.

105 Jaeger 2012, 162–3.

106 Constans 1907, 96–7, ll. 16,650–52.

107 Meyer 2003, 164.

108 Norton and Park 1986, 380, 382; for French royal tombs, see Erlande-Brandenburg 1975a.

109 Knapp 2008, 39, after Scarry 1999.

110 Stubbs 1882–3, vol. 2, 6.

6 SOLOMON'S HOUSE

1 Lindley 1985, chapter one and 127.

2 I have used principally London, Lambeth Palace Library MS 448, a copy of the Ely chronicle based on a compilation no earlier than the third quarter of the fourteenth century. MS 448 has two systems of foliation, in ink and pencil; the pencil one is cited here. I have collated it with BL MS Cotton Titus A. I (fols 57–140v) and Cotton Nero A. XVI (fols 1–80), and Wharton 1691, vol. 1, 639–62 (based on MS 448), especially 643–4 for the tower collapse, cf. MS 448, fols 52–3; the 'Walsingham memorandum' is discussed below; see also Owen 1976, 163 n. 24, 166; Lindley 1985, 1, 14 n. 4, 120.

3 Stewart 1868, 86.

4 Wharton 1691, vol. 1, 651.

5 Chapman 1907, vol. 1, 167–77.

6 CUL MS Add. 2957, fol. 65.

7 For the *lantern*, see the passage in Lambeth MS 448, fols 51v–52v, also fol. 119, as at Wharton 1691, vol. 1, 644: *Notandum quod capella beate Marie virginis incepit construi in Ely per fratrem Johannem Wysb[] A.D. m°cccxxi et consummata erat anno ejusdem m°cccxlix°. Item lanterna incepta construi per fratrem Alanus de Walsyngham tunc sacrista A.D. m°cccxxii° et in sex annis consummavit opus lapideum viii columpnas et in xiiij annis consummavit totum opus ligneum mirifico factum A.D. m°cccxlii° circa quod expendidit m¹ m¹ xxxvi l. vi s. xi d.* [etc.] (this corrects the version in Stewart 1868, 88); see also the summary at fol. 119; the expression *lanterna* is also used in the praise poem on the Lambeth MS 448 flyleaf iiiᵛ; see below.

8 Wharton 1691, vol. 1, 644; since the octagon vault was being painted in 1334, the reference in 1336–7 to the whitewashing of the new vault must apply to the choir vaults: Chapman 1907, vol. 1, 73, 83.

9 Chapman 1907, vol. 1, 86; vol. 2, 155.

10 Stewart 1868, 218.

11 Wharton 1691, vol. 1, 652. Reckoning with Cheney 1978, 126–7 and 140–41, tables 22 and 29, in 1321 and 1349 the feasts of the Annunciation (25 March) and Visitation in each case fell on a Wednesday and Thursday respectively, leaving thirteen clear weeks between.

12 CUL MS EDC I/F/13/7 (dorse); CUL MS 2957 (Bentham transcript), fols 65–6: Chapman 1907, vol. 1, 61–3; for Fressingfield being 'feeble in body and mind', see Wharton 1691, vol. 1, 643.

13 Owen 1976, 162–3, 169.

14 Lambeth MS 448, at fols 52–3, gives the sum for the octagon as £2,408 19s. 7d. for the *novum opus*, as per Wharton 1691, vol. 1, 644, but the memo on fol. 119 states that it cost £2,406 6s. 11d.; for the choir, see Wharton 1691, vol. 1, 647; for Prior Crauden's Chapel, CUL MS Add. 2957, fol. 65, transcribed from the treasurer's roll: *in nova constructione capelle et camere domini prioris*, 1324–5.

15 B. Thompson 2010, 75.

16 For what follows, see Lindley 1985, 9; *ODNB*, vol. 28, 256–7 (by Mark Buck); B. Thompson 2010, 70–79, 103, 114.

17 The link is made by Coldstream 1979, 36–7.

18 Wharton 1691, vol. 1, 649–50; CUL MS Add. 2957, fol. 68 (1332–3): *in aurifrigio et aliis apparatur pro capa domini prioris empt. £22 9s.*; for his patronage, see Binski and Park 1986, especially 37–8 for the copes; Meadows and Ramsay 2003, 395–6 and n. 22; for royal links at Ely under Hotham, see B. Thompson 2010, 114.

19 *Sixth Report* 1877, 289–300, at 295.

20 Binski and Park 1986, 37 and fig. 11.

21 *ODNB*, vol. 57, 128–9; Meadows and Ramsay 2003, 396–7 and n. 23.

22 Chapman 1907, vol. 1, 151–66, especially 159–66 and tree of descent at 159.

23 Riley 1863, 138–9.

24 Wharton 1691, vol. 1, 651.

25 CUL MS Add. 2957, fol. 50; Meadows and Ramsay 2003, 397 n. 23.

26 Chapman 1907, vol. 1, 148–9, and vol. 2, 52, 57; also for the *selda* and other chambers, Wharton 1691, vol. 1, 646.

27 Vaughan 1958, 198–204; an altar of St Alban with an image is noted in 1289: CUL MS Add. 2957, fol. 16.

28 Phillips 2010, 68–9.

29 B. Thompson 2010, 72.

30 Dickinson 1956.

31 Chapman 1907, vol. 1, 12–13.

32 Wharton 1691, vol. 1, 651.

33 Cressford and Dickens 2007, 166–71.

34 Chapman 1907, vol. 1, 28, 29, 219.

35 Dixon 2002.

36 S. J. A. Evans 1940, 13–14, no. 17, and 23, no. 39; see also the prior and chapter ordinance at 37, no. 5; Lindley 1985, 101; Dixon 2002, 72.

37 Draper 1990.

38 Gunton 1696/1990, 37 and 315–16, and figs opposite 1 and 225 for the site.

39 Binski 2003, 57 n. 61.

40 Gunton 1696/1990, 99–100.

41 *VCH: Cambridge*, vol. 4, 60; for Paris, see S. Murray 1996–7, 23.

42 M. R. James 1895b, 121–2.

43 Cf., however, Woodman 1984; the date of the vault is discussed below.

44 M. T. Davis and Neagley 2000, 179; for Solomon, see Haussherr 1968; Binding 1996, 337–44; Freigang 2011, 302–5; for the Sainte-Chapelle, see S. Murray 1996–7, following a width of 10.63 m to the rear wall of the dado, a width across to the faces of the buttresses of 15 m and a length of 30.5 m, so yielding an internal length–width ratio of 1:3 and an external ratio of 1:2.

45 Peter Kidson, cited in M. T. Davis and Neagley 2000, 161.

46 Carruthers 2013, 12.

47 Blomefield 1805–10, vol. 2, 117–18.

48 Janes and Singer 2010, 5–7, 28–9, 38–41.

49 Clapham 1949, 109–10.

50 Binski 2004, 9–10.

51 E.g., Jerome's commentary on Job, *PL*, 26, col. 739: *In his finibus posita regina Saba, quae typum gerebat Ecclesiae, veri Salomonis meruit audire sapientiam.*

52 Wormald 1988, 61–9 at 63; Forsyth 1972.

53 Guest 1995, 131.

54 Wormald 1988, 64–5 and fig. 52.

55 Wormald 1988, 65 and fig. 53.

56 Fairweather 2005, 158–9 (*Liber Eliensis*, II, 60).

57 Wharton 1691, vol. 1, 652; the great gable of St Stephen's Chapel, Westminster, provides an analogy: J. H. Harvey 1961, 145 and 156 n. 51; Colvin 1963, vol. 1, 514, 516.

58 This should be distinguished from a further payment of £20, presumably also for glass, made by Bishop Barnet in 1373 for another window near the high altar: CUL MS Add. 2956, fol. 159; Lindley 1985, 114.

59 Lindley 1985, 222.

60 Lindley 1985, 212; Lindley 1986a, 82–4, thinks these images filled the niches in the octagon's stone base. I am most grateful to John Maddison for showing me these fragments and discussing them with me.

61 Lambeth MS 448, fols 62v–63; Wharton 1691, vol. 1, 652.

62 Bony 1979, pl. 63.

63 Lehmann-Brockhaus 1955–60, no. 1656: . . . *cum volta optima absque base media nodis deauratis pulchre ornatum . . . quae . . . inter alias domos capitulorum huius regni una de principalibus tenetur.*

64 Binski 2004, 103–21; Malone 2004; and see also Lindley 1985, 213; for Exeter, see Allan and Blaylock 1991.

65 Binski 2004, 119–21.

66 Draper 2006, 246–7; S. Brown 1999, figs 139–41.

67 For the Solomonic aspect of *opus francigenum*, see Freigang 2011, 303–5; M. T. Davis 1996–7, at 27–30, provides a useful discussion of the Temple and House.

68 Sandler 1986, no. 106.

69 The fullest documented accounts of the fourteenth-century work are Coldstream 1979 and 1985; Lindley 1985, 1986a and 1986b.

70 Chapman 1907, vol. 2, 47.

71 Stewart 1868, 141–2; Maddison 2003, 124–7.

72 Coldstream 1979, 37, for what follows.

73 C. Wilson 2011b, 90–93.

74 Bock 1962a, pl. 28 no. 11; Coldstream 1979, 37.

75 C. Wilson 1990, 196–8; see also Bock 1962a, 148–50; Coldstream 1979, 37; Coldstream 1985; Maddison 2003, 124–7.

76 Bock 1962a, 51, 54–6. The presbytery of Pershore Abbey reputedly possesses an even earlier instance, setting aside the Iberian evidence.

77 Lindley 1984.

78 The succinct published account in Whittingham 1980a forms a basis; and see also C. Wilson 1980a, 185–97; Coldstream 1979, 41–2; Lindley 1985 and 1986b; Maddison 2000, 63–5, 72–4; for the Ely accounts, a John the mason, presumably John Ramsey, is recorded in 1322–5, at the crucial time for planning and arrangement, and was given a chamber in 1325, so was not ordinarily resident: Chapman 1907, vol. 2, 34, 48, 60–61; for William Ramsey present in 1336–7, see

Chapman 1907, vol. 2, 81; John Attegrene (d. 1349) is recorded between 1334 and 1346 as a precinct architect: Chapman 1907, vol. 2, 68, also 82, 84, 87, 110, 128; he was at Norwich in the 1330s: Fernie and Whittingham 1972, 36–7.

79 For Cley, see Whittingham 1980a, 285, 288; for Snettisham, see C. Wilson 2011b, 105–6.

80 See also Coldstream 1979, 35–6.

81 For the image of the Virgin Mary (1491) in the *capella beate Marie in portico ecclesie*, see Barrett 1789, 574; see Dallaway 1834, 159, from those parts of the Worcestre itinerary not printed by J. H. Harvey 1969 (*circa* 1470s–1480s): *quantitas rotunditatis principalis capellae sanctae Mariae cum ymaginibus regum operatis subtiliter in opere de frestone continet in circuitu cum hostio introitus subtiliter operato 44 virgas* (i.e., its circumference was 132 ft). See the discussion in Norris 1888, 21–1; for the porch, see C. Wilson 2011b, 138, and Alexander and Binski 1987, no. 490.

82 Pevsner 1943/1970, 139–41. For the concept of Gothic Baroque, in Germany at least, see Bialostocki 1966, 87–91. For this aspect of Pevsner's writing, see Crossley 2011, 196, 206.

83 Binski 2004, 222.

84 Doob 1990, 214, for difficulty in Vinsauf; Binski 2004, 218–23; for difficulty as an aspect of ludic pleasure, see Carruthers 2013, 61–70.

85 Carruthers 2010, 203.

86 Carruthers 2010, 199.

87 I owe the observation about Emilia to Noel Sugimura: see Branca 1976 at 70; for *vaghezza*, see Sohm 2001, 110–12, 193–200; Lingo 2008, 125–41.

88 Summers 1972 and 1977.

89 Binski 2010b, 145; Carruthers 2013, 54 and 169–70.

90 Carruthers 2013, 80–107, especially 101–2.

91 J. R. Spencer 1966, 81.

92 Sohm 2001, 110–12.

93 Hogarth 1753, chapter 9; Pevsner 1956/1976, 52–3.

94 For Glastonbury, see Draper 1995; Thurlby 1995.

95 Maddison 1993, 70–76.

96 Coldstream 2011.

97 Though which one is controversial: perhaps Eleanor Percy, d. 1328, provided by her daughter-in-law Idonea; Lindley 2007, 180, 182–3; but compare Dawton 1983 and Dawton 2000, 133–42.

98 Fisher 1998 for such experiences; also Jaeger 2012, 119.

99 Knapp 2008, 113–14.

100 Woodworth 2009, 9–17.

101 Fisher 1998, 7–17, 11.

102 Sohm 2001, 110–12, 193–200.

103 A point explored in regard to the suppression of errant Crucifixes in Binski 2004, 201–5. The fundamental text on the related attraction and repulsion of images (or people) is Freedberg 1989. See also Besançon 1994.

104 For polyfocalism, see Carruthers 2013, 151–5.

105 Demore, Nougaret and Poisson 1990; Le Pogam 2009, 229 no. 75.

106 M. R. James 1895a. For a brief survey of later medieval Marian miracles in England with bibliography, see Howe et al. 2012, 40–42.

107 CUL MS EDC 1/5/7/5: *ferramentis faciand' pro hostiis de le parclos 6. 8d.* (under UV light); cf. the Crosby transcript in CUL MS Add. 6383, fol. 7.

108 *Acta Sanctorum*, 15 January; K. A. Smith 2003, fig. 114.

109 Pfaff 2009, 205–6; Ward 1893, 604, 622.

110 Binski 2010c, 243.

111 CUL MS Add. 2957, fol. 54, payment to Roger of Norwich: *pro informatione juniorum 4/-*; and fol. 58 (1383–4): *dat pueris laborantibus in capella ad missam S. marie 2/-*; see Meadows and Ramsay 2003, 87.

112 Schapiro 1977, 102–13, 116–17; Sauerländer 1972, 472, figs 186–7; M. T. Davis 2002.

113 Warner 1912; Sandler 1986, no. 56; for the miracles, see Stanton 2001, 49–51.

114 Sandler 1986, nos. 101, 130 and 98, respectively; see also Bovey 2002; Binski and Panayotova 2005, no. 83; for the patronage of the Taymouth Hours, see K. A. Smith 2012; also Meale 1990, 126–7.

115 Sandler 1986, no. 115; for the Bohun manuscripts, see Sandler 1986, nos. 135, 138, 140.

116 For the Marian and related images in the Neville of Hornby Hours, see K. A. Smith 2003, 222–37; for the Taymouth Hours, see K. A. Smith 2012, 241–54. For the Bohun imagery, see Sandler 1986, no. 138, fols 182, 188v, and no. 140, fols 1, 6v.

117 Southern 1958.

118 Meale 1990, 124–5.

119 M. R. James 1895b, 143, 190, 192–3; cf. Heslop 2001, 300 (1a) and 306 (9) and (10); see also Heslop 2005.

120 M. R. James 1895b, 190.

121 M. R. James 1895c, 76–109.

122 Tracy 1987, 34–9.

123 Grössinger 1997, 60–61.

124 Woodman 1984.

125 For the bosses, see Cave 1932; for the joining of vault severies, see CUL MS Add. 2957, fol. 58: *In testis oistr' pro volta colligenda 6d.* (1383–4).

126 CUL MS Add. 2957, fol. 67: *in denariis dat' ad fabricam nove capelle Beate marie 80/-* (cf. same entry in CUL MS EDC 1/F/13/7); for Hotham, see *Sixth Report* 1877, 289–300, at 297 (fol. 78v); Lindley 1985, 111.

127 Wharton 1691, vol. 1, 647–8.

128 Lambeth MS 448, fol. 62–62v; Wharton 1691, vol. 1, 651.

129 Luxford 2005, 102.

130 Cessford and Dickens 2007, 166–71.

131 Rudolph 1997, 404–5.

132 *VCH*, Cambridge, vol. 4, 60, 61, 62.

133 *ODNB*, vol. 38, 767; B. Thompson 2010, 71.

134 Wharton 1691, vol. 1, 651.

135 Stewart 1868, 136–8; *VCH*, Cambridge, vol. 4, 62.

136 First noted in *VCH*, Cambridge, vol. 4, 60; implication for date discussed in Lindley 1985, 118, and Lindley 1986b, 127. The shields show three crowns for Ely and the arms of Montacute; the same charges appear on two shields on Alan of Walsingham's seal as prior, 1341; see CUL MS EDC 1/H 2–4.

137 Lambeth MS 448, fol. 61v; Wharton 1691, vol. 1, 651: *In vita sua suffulsit domum in diebus suis corroboravit templum.*

138 Wharton 1691, vol. 1, 652.

139 For what follows I refer to CUL MS Add. 2957, fols 51–3, which correspond to the extant roll CUL MS EDC 1/F/7/2, which is misdated in the Cambridge University Library's EDC notes as being of 1357–8. The top of the roll is missing, but is given in transcription in MS Add. 2957, fol. 51, as being the *rotulus integer transcriptus* with the regnal year 23 Edward III and the four following, i.e., 1349–53. The statement in Alexander and Binski 1987, no. 743, that these accounts pertain to the period 1356–9, is incorrect.

140 CUL MS Add. 2957, fol. 53 [= CUL MS EDC 1/F/7/1].

141 Lindley 1985, 114.

142 Arnould 1940.

143 The evidence for Thetford is discussed by Norton in Norton, Park and Binski 1987, 87–8 and n. 22; see also D. King 2010; for the Hastings brass, see Saul 2009, 216–17.

144 CUL MS Add. 3468, fols 53–76: *registrum taxe bonorum temporalium et spiritualium in diocesi Eliensis existencium*, at fol. 53v top, drawn to my attention by Julian Luxford.

145 Rosser 1989, 46–51.

146 CUL MS Add. 2957, fol. 50 (1318–19), fol. 53 (1359); Lindley 1985, appendix A.

147 Wharton 1691, vol. 1, 644. For the full text, see below.

148 Maddison 2000, 44–5 and 79; for Hugh's work, see Lehmann-Brockhaus 1955–60, nos. 1582–3.

149 Personal communication Philip Dixon, to whom I am grateful. His theory is alluded to with illustrations in M. White 2007, 43–6.

150 Potts and Potts 2002.

151 Chapman 1907, vol. 2, 73, 84.

152 Chapman 1907, vol. 2, 73, 83.

153 Chapman 1907, vol. 2, 65, 73 and 97–8.

154 Chapman 1907, vol. 2, 137, 138, 143, 156.

155 For the space of Ely, see Bony 1979, 40–42.

156 Freigang 1999.

157 Peers 1927a; Gem 1983a; Malone 2000. For space, see Bony 1979, 31–42.

158 Bony 1979, 41.

159 Kidson, in Kidson, Murray and Thompson 1965, 117; T. Ayers 2004, vol. 2, 448–55; also Lindley 1985, 36–9.

160 Maddison 2000, 68–9 and figs 56–7; Whittingham 1980a, 286.

161 For the sequence of work, see Draper 1981; C. Wilson 1990, 199–201.

162 C. Wilson 1990, 198.

163 Chapman 1907, vol. 2, 33–4, 48, 60–61.

164 Chapman 1907, vol. 2, 60.

165 Chapman 1907, vol. 2, 45; and for the template cost, see Fernie and Whittingham 1972, 36, where two were acquired for the Ramseys for 6s. 8d. I have simply averaged the cost but accept of course that the templates might have differed in cost. Cf. Coldstream 1979, 34; Lindley 1986b, 120–21, who both appear to assume that the payment is for a person, not a thing. Though the Ramsey family was split between Norwich and London, William Ramsey was employed at St Stephen's Chapel in 1323: J. H. Harvey 1987, 242.

166 For mensuration at Ely, see Fernie 1979 and Meadows and Ramsay 2003, 106–7; for the lantern, see Lindley 1987b; Bentham 1771, 288, gives its internal height as 142 ft; Lindley 1985, 30, gives it as 152 ft 6 in., apparently following Chapman 1907, vol. 1, 56–7: I suspect Chapman's measure to be a misprint for 142 ft.

167 Kidson, in Kidson, Murray and Thompson 1965, 117.

168 Trachtenberg 2001, 746–54, especially 749–53; Trachtenberg 2010, 159–62.

169 Trachtenberg 2010, 116.

170 Trachtenberg 1997, 263; Nagel and Wood 2005, 410.

171 Bock 1962a, 115–16; Bony 1979, 40; C. Wilson 1990, 261.

172 Bony 1979, 40, cf. Draper 1982, 331; Lindley 1986a, 91.

173 Nichols 1986, 21–3; cf. Osborne 1987, 29–30.

174 Stubbs 1874, 391–5, at 392: *ad sanctam Mariam rotundam.*

175 Lehmann-Brockhaus 1955–60, no. 1583: *Novo opere constructa, tota ecclesia Eliensis dedicata erat anno . . . 1252 . . . in honorem b. Marie, b. Petri et b. Etheldrede virginis.*

176 Draper 1979, 15; Binski 2004, 95 and fig. 75.

177 Garton 1986, 60–61:

Astant ecclesie capitolia qualia nunquam
Romanus possedit apex; spectabile quorum
Vix opus inciperet nummosa pecunia Croesi.
Scilicet introitus ipsorum sunt quasi quadra
Porticus; interius spatium patet orbiculare,
Materia tentans templum Salomonis et arte

178 Huygens 1970, 23–4; Osborne 1987, 29–30.

179 Osborne 1987, 1, 3; Gransden 1982, 43–57.

180 Another English reader of the *Mirabilia* was the Franciscan John Ridevall: Smalley 1960, 125–6, 170–71.

181 Krautheimer 1953, 21–2; Malone 2000, 306–7; Malone 2009, 61–73, 100–01.

182 Chapman 1907, vol. 1, 43.

183 Chapman 1907, vol. 2, 28, 29.

184 Chapman 1907, vol. 1, 75–6, vol. 2, 109, 122; also Stewart 1868, 116, 117, 119.

185 Lindley 1987b, 94.

186 Fuller 1662, 149.

187 Chapman 1907, vol. 2, 131, 137.

188 Chapman 1907, vol. 1, 81; vol. 2, 117, 137, 138, 139.

189 Greatrex, in Meadows and Ramsay 2003, 88–9; Atkinson 1933, vol. 1, 28.

190 Lindley 1986a for what follows; for the glass, see Chapman 1907, vol. 2, 136, 137, 138.

191 For Peterborough, see Binski 2003, 47–50; for the Ramsey Psalter, see Sandler 1986, no. 41.

192 Lowden 1997, ill. 153, 178, 186–7; for San Marco, see Demus 1960, fig. 124.

193 Luxford 2013b, 203–5.

194 Binski and Park 1986.

195 Keen 1979.

196 Hutton 1950, pl. 24A; Glass 1980, 30 and fig. 71.

197 Binski 1995a, figs 133, 144.

198 Bock 1962a, 115–16.

199 Chapman 1907, vol. 1, 54–5 and 55 n. 1; for Italian banking, see Hunt 1994.

200 Fryde 1951; Hunt 1994, 61, 150, 161; for Caerphilly, see J. H. Harvey 1987, 154–5; and for gifts, see Chapman 1907, vol. 1, 62.

201 See CUL MS class EDC 1/D, also the *Status Prioratus* EDC 1/F/13/7 for such men as Ricardo de Florencete.

202 Lambeth MS 448, fols 1–77v are in a single hand, breaking off at fol. 77v after the account of the election of Simon Langham as archbishop of Canterbury in 1366, as Wharton 1691, vol. 1, 663–4. BL MS Cotton Titus A. I, fols 57–140v run in one quite rough cursive hand of no earlier than the late fourteenth century to the middle of the episcopate of Thomas de Lisle, an imperfect continuation starting in another hand at fol. 141 ending at fol. 145 in the midst of the episcopate of Simon Langham. BL MS Cotton Titus A. XVI is a small neat volume written in one fifteenth-century cursive hand on fols 1–80 to the end of the episcopate of Thomas of Arundel (1388). It is difficult to be certain since the manuscripts all post-date the period, but a compilation in the period 1366–88 seems possible, shortly after the death of Alan of Walsingham.

203 Owen 1976, 162–3, 169.

204 For the theft and miraculous recovery, see Lambeth MS 448, fols 53–4, as Wharton 1691, vol. 1, 645–6; this accords with an entry in the sacrist's rolls in 1322–3 of a payment of 10s. to Brother Robert of Rickling for going to London to find gold and silver stolen from the feretory, Chapman 1907, vol. 2, 31: *Item Fratri Roberto de Rickelyngge eunti apud London pro argento et auro furato de feretro querend. 10s.*

205 Revised after Lambeth MS 448, fols 51v–52v, as Wharton 1691, vol. 1, 643–4, and collated with BL MS Cotton Titus A. I, fols 116–17, and BL MS Cotton Titus A. XVI, fols 7–10v. There is an English translation of the main passage in Salzman 1952, 390. Here is the Latin:

In cujus tempore multa et varia onera gravia valde officio sacristarie et maxime eodem anno sue prefectionis evenerunt. Nam in nocte ante diem festi S. Ermenilde post matutinas in capella S. Katerine decantatas eo quo in choro propter imminentem ruinam illas decantare conventus non audebat. Facta namque processione ad feretra in honore S. Ermenilde et conventu in dormitorium regrediente vix paucis fratribus in lectulis suis ingressis et ecce subito et repente ruit campanile super chorum cum tanto strepitu et fragore; veluti putabatur terre motus fieri; neminem tamen ledens nec opprimens in ruina. Aliud etiam contigit mirabile, miraculo potius ascribendum quam nature quod in illa horribili ruina et lapidum collisione maxima unde tota fere tremebat Elyensis villa illa tamen pulcra et magna fabrice eminens supra sanctarum virginum sepulcra, protegente Deo et meritis sue dilecte Virginis Etheldrede ut speratur ab omni lesione salvata est et fractura; unde Christo sit gloria. Ex quo eventu dampnoso nimis et lamentabili prefatus sacrista Alanus dolens vehementer et tristis effectus quo se verteret vel quid ageret ad tantam ruinam resarciendam, penitus ignorabat. Sed resumpto spiritu, in Dei adjutorio et sue piissime matris Marie necnon et in meritis S. Virginis Etheldrede plurimum confidens, manum misit ad forcia [Proverbs 31:19]; *et primo lapides et ligna que conciderant in illa ruina cum magno labore et expensis variis extra ecclesiam fecit apportare; et ipsam de pulvere nimio qui ibi erat celeritate qua potuit emundare; et locum in quo novum campanile fuisset constructurus per viii partes arte architectonica mensuratas in quibus viii⁰ columpne lapidee totum edificium supportantes erigerentur et infra quas chorus postea cum stallis esset construendus fodere fecit et scrutari; donec inveniret locum solidum, ubi firmamentum operis secure possit inchoare. Illis siquidem viii⁰ locis sic ut predicitur solicite scrutatis lapidibus et arena firmiter condensatis; tunc demum illas viii⁰ columpnas cum subsequenti opere lapideo inchoavit quod quidem usque ad superiorem tabulatum per vi annos consummatum anno Domini mcccxxviii⁰. Et statim illo anno illa artificiosa structura lignea novi campanilis summo ac mirabili mentis ingenio ymaginata super predictum opus lapideum edificanda fuit incepta et maximis et onerosis expensis presertim pro lignis grossis structure predicte necessario congruentibus longe lateque requirendis et difficultate maxima tandem inventis magno precio comparatis; ac per terram et per mare apud Ely adductis necnon et per ingeniosos artifices sculptis et fabricatis atque in ipso opere artificiose coadunatis; honorificam et optatam auxiliante Deo fortiter est consummationem.*

206 Salzman 1952, 377–8.

207 Lehmann-Brockhaus 1955–60, nos. 1932, 2704, for such instances.

208 Cicero, *Philippic* II.74; *In Verrem* II.2.74: *quid ageret, quo se verteret nesciebat.* The phrase is used *inter alia* by William of Malmesbury (*Gesta regum*), Simeon of Durham and Cesarius of Heisterbach.

209 Binski 2002b, 119–23.

210 Panofsky 1979, 90–91.

211 Carruthers 2013, 38–9.

212 Binski 2002b, 120.

213 For the Ely work, see Hewett 1985, 114–22; for Westminster, see Colvin 1963, vol. 1, 527–33.

214 Lambeth MS 448, flyleaf iii–iiiv and fol. 140 (Wharton 1691, vol. 1, 592):

Hec sunt Elye lanterna capella marie
Atque molendinum multum dans vinea vinum

Continet in fontes quos vallant undique pontes
Hos decant montes nec desunt flumina pontes
[*Nomen ab anguilla ducit insula nobilis illa* added by Wharton on the authority of a source also used in BL MS Cotton Titus A. I, fol. 57, where the verses also appear incomplete]. Compare Cambridge, Corpus Christi College MS 393, fol. 59. For Gregory, see McDermott 1975, 209–10.

7 THE ENGLISH ABROAD

1 Hourihane 2012.

2 For alabaster, see Ramsay 1991; K. Woods 2012.

3 The standard survey remains Christie 1938, 1–2, for sources.

4 Lehmann-Brockhaus 1955–60, no. 6517.

5 Brel-Bordaz 1982; Michael 2013, 278; for *opere francigeno* see Boehmer 1896, 666; Branner 1965, 1; Freigang 2011, 303–5; for the expression *ad modum franciae*, see Bruzelius 1991.

6 Archivo de la Catedral de Toledo, X.12.B.1.1, 1 April 1277: *Item, dos capas buenas blancas, la una con orofres laurada a las armas del rey de Aragon, con madroños de aliofar delant e en los pechos, e la otra con orofres de Londres.* See also the codicil of 1282 to the will of Alfonso X, recording 'el paño rico que nos dio la reina de Inglaterra', in González Jiménez 1991, doc. 518 (though misdated to 1283). I am grateful to Tom Nickson for these references.

7 Christie 1938, 2–3; Müntz and Frothingham 1883, 11, 12, especially 18.

8 Rymer 1816, 752; Christie 1938, 3; Paravicini Bagliani 1980, 306 no. 35: *capam nostram cum ymaginibus in qua describitur stirps Jesse quam rex Anglie misit nobis*; J. Gardner 2000, 87; J. Gardner 2006, 165.

9 In general, see Molinier 1888, 1552–3; also Müntz and Frothingham 1883, 11, 18; Christie 1938, 3; J. Gardner 2006, 166–9.

10 L. H. Labande 1893, 65–7: *. . . et accepit mantum seu pluviale valde pulchrum de opere anglicano*; see also Menache 1998, 200–03; J. Gardner 2000, 89.

11 Menache 1998, 247, 248; for the copes, see Christie 1938, 124 no. 66, 128 no. 67.

12 Christie 1938, 3; J. R. Wright 1980, 283, App. 2; J. Gardner 2006, 165.

13 Christie 1938, 183 no. 96. The seventeenth-century drawing, perhaps by Pietro Santi Bartoli (personal communication X. Brooke) is in the Walker Art Gallery, Liverpool (no. WAG 6135), formerly in the collection of Joseph Mayer: it is discussed by C. Borgioli in Sicca 2008, 258–61, fig. 91.

14 For musical angels, see the Bologna cope: Alexander and Binski 1987, no. 576; for manuscript birds, see Sandler 1986, nos. 1, 10; see also J. Gardner 2002, 605–6; and in general Yapp 1981.

15 Van Uytven 1983; Munro 1994.

16 Lehmann-Brockhaus 1955–60, nos. 531, 534, 1222, 1390, 1391, 1444, 2902, 2911, 3964, 4453, 4608, 5577, 6021, 6110, 6468, 6513, etc.; Carruthers 2013, 45, 188–9.

17 Christie 1938, no. 51, pl. XLVI; no. 54, pl. LI; nos. 66–7, pl. LXXX; no. 78, pl. CII; no. 90; pl. CXXV.

18 Christie 1938, no. 96, pls CXLII, CXLIV.

19 Christie 1938, pl. CXXV, also cf. pl. CXXXI; compare the Metropolitan Museum chasuble, Alexander and Binski 1987, no. 577.

20 Christie 1938, pl. LXXX; J. H. Harvey 1950, 106–7, fig. 161; Guillouët 2009 and 2011.

21 Christie 1938, 9 and pls XXXVIII, CIX, CXXV, CXLIV, CXXXIX.

22 *Miller's Tale*, l. 3318: Benson 2008, 69–70; Alexander and Binski 1987, 49 and no. 681; Newton 1980, fig. 10.

23 Leedy 1980.

24 Bony 1979, 22, 60.

25 Bony 1979, 55; Bony's date in the first decade, at 87 n. 28, omits to note that, according to an inscribed tomb in the chancel, it was the *novum opus* of the vicar Richard of Wichford, *fl.* 1309–44.

26 For a contemporary *Assumption* in a vesica with angels, see Sandler 1986, no. 59, fig. 147; for pilgrim badges, see B. Spencer 2010, nos. 56a and 60a.

27 Bony 1979, 62; Bony 1983, 462–3.

28 Pevsner 1956/1976, 104–5, 128–37; for Panofsky, see Panofsky 1951 and 1953.

29 Kidson, in Kidson, Murray and Thompson 1965, 108–9, 113–14; Bock 1961; Bock 1962a, 56–67.

30 Crossley 2003, 62–3.

31 Pevsner 1953 and 1959.

32 Bony 1979, 66–7; Crossley 1981a and 2003; C. Wilson 2011a; Crossley 2011; Bork 2011, 201–30.

33 Crossley 2003, 74–6; C. Wilson 2011a, 104–9.

34 For these successive 'waves', see Bony 1979, 57–69.

35 Bony 1979, 62–4.

36 For a critique, see Crossley 1981a and Crossley 1981b, 135–6; for Rayonnant, see Opačić and Timmermann 2011a.

37 Grant 2005, 225–9. The history of fourteenth-century art in Normandy may yet reveal anglicisms, of which one is the cornice with framed quatrefoils and miniature battlements on the tomb chest of Robert de Putot (d. 1326) at La Trinité, Fécamp: G. S. Wright 1984, fig. 4.

38 Bony 1979, 65–6.

39 Bony 1979, 1.

40 J. H. Harvey 1947, fig. 69 at 49.

41 Whittingham 1980a, 286; Tracy 2008, 42 (and fig. 3 for a stall end from St Nicholas showing a fine two-masted ship, *circa* 1400); C. Wilson 2011b, 144.

42 Whittingham 1980a.

43 Dawton 2000.

44 Coldstream 1979, 36–7.

45 For what follows, see Fischer 1965 and 1969; Imsen 2003; Ekroll 2004 and 2007; Binski 2004, 33–5; Binski 2007. Bony 1979, 79 n. 29, refers to Trondheim in such a way as to suggest that he was unfamiliar with the building.

46 Binski 2006c.

47 Ekroll 2004 and 2007; Peers 1927a; Gem 1983a; Kidson 1993, 988; Malone 2000; Binski 2007, 42–6.

48 For sculpture, see Alexander and Binski 1987, nos. 299–306.

49 Unger and Huitfeldt-Kaas 1869, 140–41 no. 126, dated 12 August 1328 (in Norse); gifts were sent in 1328 by Laurence of Hólar to the archbishop of Trondheim either in connection with the fire or in order to ensure the smooth pursuit of a law suit with Mödruvellir: see Elton 1890, 120.

50 Fischer 1969, 20–26 and nineteenth-century plates for its pre-restoration state. The history of the sequence of partial rebuilds of the octagon since 1328, including work in the sixteenth century, is complex, but is being elucidated by Øystein Ekroll in a full-length investigation following the conservation of 2011, and I am most grateful to him for his generous advice.

51 Ekroll 2007, 176.

52 Kimpel and Suckale 1990, 103–4; Imsen 2003, 189.

53 Ekroll 2004, 165–7; Andås 2004.

54 Binski 2004, 90–92.

55 Binski 2004, 34, fig. 31.

56 Coldstream 1994, fig. 24; Bony 1979, fig. 153.

57 For a cross-section, see Bock 1962a, 89 fig. 18, at A.

58 C. Wilson 1995, 465–7.

59 Binski 2004, 38 and fig. 36; the original location of these heads was drawn to my attention by Øystein Ekroll.

60 C. Wilson 1980a, 55; C. Wilson 2011b, 114.

61 Vallance 1936, 38, 39.

62 C. Wilson 1980a, 55–6; Reculver belongs to a series of early churches in Kent or the Thames estuary with similarly formed chancels: in Canterbury, St Pancras, St Peter and St Paul, St Martin; in Rochester, St Andrew; St Mary at Lyminge; and St Peter at Bradwell-on-Sea. For this form, see Peers 1927a and 1927b; E. Fletcher 1965; H. M. Taylor 1968; B. Cherry 1976; Fernie 1983, 35–42; Gem 1997, 101–3.

63 Krautheimer 1986, 50, fig. 16.

64 Lowden 1997, 123 fig. 73; Krautheimer 1986, 190–91 and figs 152–3; also Fernie 1983, 41.

65 Sargent 1918, and for Sir Oliver de Ingham and his English patronage, Richards 2006.

66 For Normandy, see Grant 2005.

67 Bony 1979, 65 and 90 n. 37, but cf. Rousseau 1965, which dates the screen in the fifteenth century in accordance with the style of its paintings. It was discovered in 1962.

68 For Navenby's links to Fécamp and Séez, see Sekules 1986, 130 n. 46.

69 C. Wilson 1980b.

70 Le Pogam 2009, 215 no. 43.

71 Bonnefoy 1954, 158 and pls 15–23; Mesuret 1967, 199–200 and pl. xxi. An incised inscription by the west door of nineteen lines bears the date AD MCCC:XXIX.

72 Sandler 1974, figs 30, 77.

73 Sandler 1974, fig. 39 (fol. 40).

74 Alexander and Binski 1987, no. 584.

75 Carolus-Barré 1950, 80–82; Sandler 1974; Sandler 1986, no. 40.

76 See, however, Walker 2007.

77 Oakeshott 1972.

78 Gutiérrez Baños 2005.

79 Rey 1929, 59.

80 Uranga Galdiano and Iñiguez Almech 1973, 105 and pl. 51; cf. Balbas 1952, 263; for the context of patronage, see Bango Torviso 2006.

81 Mullins 2001, 67–8; Vincent 2007, 118.

82 C. Wilson et al. 1986, 82–3.

83 Shaw 1992.

84 Sandler 1986, no. 157.

85 For which, see Durán Gudiol 1956; Aguadé 2008.

86 The inscription in my opinion reads *Anno domini mccc^oxxx^o [Ego] dominus iohannes petri de stella archidiaconus sancti petri de osun fuit operarius ecclesie beate marie pamp[ilinensis] fecit fieri istud refectorium et iohannes oliveri depinxit istud opus.* See Callahan 1953; Lacarra 1974, 155–89; Ducay 1996, 181–3; Ducay 2008, 141–7; for an alternative reading of the date as 1335, see Menéndez Pidal de Navascués and Martínez de Aguirre 1996. Juan Périz was a canon of Pamplona from 1291.

87 Merback 1999, colour pl. 38 for Spain; for English instances, see Sandler 1974, figs 46, 71, 117; also Stones 1997, at fol. 37v.

88 Following Callahan 1953.

89 Watson 1979; Sandler 1986, no. 78, fig. 199.

90 Sandler 1986, no. 43.

91 Ducay 1996, 182–3.

92 Luttrell and Blagg 1991.

93 Faucon 1882, 51–72; Faucon 1884, 89–90, 91, 92; Müntz 1884, 27, 28.

94 Faucon 1884, 91, 96, 98; Müntz 1884, 24; Schäfer 1911, 203, 385; for Sorgues, see Luttrell and Blagg 1991, 174.

95 Faucon 1882, 52–71; Mesuret 1967, 34–5; Müntz 1884, 24, 25, 26, 33.

96 Müntz 1884, 24, 25.

97 Müntz 1884, 27, 28.

98 Faucon 1884, 96, 98; Schäfer 1911, 292, 301; Reyne and Brehier 2002, 219–20.

99 For the latest assessment, see J. Gardner 1992, 138–41; the fullest recent account of the documentation is in Reyne and Brehier 2002, 215–35.

100 Christie 1938, 3; J. R. Wright 1980, App. 2, 283, after London, Society of Antiquaries MS 120, fols 53v–54.

101 Tatham 1925–6, vol. 1, 147–72; Simone 1969, 46; Ross 1970, 534; D. Wood 1989, 47–8; for Trivet, see Smalley 1960, 58–61.

102 Tatham 1925–6, vol. 1, 379–80.

103 Smalley 1960, 5–8, 280–307; for Simon, see Martindale 1988, 45–6.

104 Walsh 1981, 85–107.

105 Gallet 2007, 36–7 and 38 n. 14; also Smalley 1960, 42–3.

106 For Longpont, see Adhémar 1974, 65 no. 327, 108 no. 580; J. Gardner 1992, 139 and fig. 166; for Aix, see J. Gardner 1988, 50–53 and fig. 30; for Beauvais, see Adhémar 1974, 83 no. 436; Hastings 1955, 138–9; also J. Gardner 1992, fig. 78.

107 For which, see respectively Binski 1995a, 115–19; Lindley 1984; C. Blair, Goodall and Lankester 2000, especially 18–25.

108 C. Wilson 1995, 459–64.

109 Bond 1910 and J. H. Harvey 1947, 66 (dating it to 1345); J. H. Harvey 1950, 81; Hastings 1955, 119, 132–8; C. Wilson 1980a, 120; C. Wilson 1995, 468 and n. 77. For the restoration of chapel and tombs, see Reyne and Brehier 2002, 230–35.

110 Duhamel 1883, 7–8; Reyne and Brehier 2002, 221–2. The detailing of the tomb and its framing masonry are sufficiently restored to make it uncertain that this niche was inserted in the course of construction.

111 Reyne and Brehier 2002, 222.

112 Reyne and Brehier 2002, 215–17.

113 Reyne and Brehier 2002, 218–21, indicate the nature of the problem. John XXII indeed commissioned a chapel dedicated to the Apostles, which was vaulted by 1323: Reyne and Brehier 2002, 218–19 n. 8. The bosses are less consistent with the dedication of a chapel of St Michael and All Angels completed the previous year; see Schäfer 1911, 290.

114 Duhamel 1883, 17–25; J. Gardner 1992, 141, for his effigy. Reyne and Brehier 2002 accept a date under Benedict XII for its execution.

115 Bony 1979, 65.

116 Alexander and Binski 1987, no. 497; K. Woods 2012, 91–3; citing *inter alia* Morganstern 2000, 83 (for a date shortly after 1327 under Isabella's tutelage, following C. Wilson 1980a, 117–21); Luxford 2005, 157–62; for a fair summary of the state of knowledge, see also Phillips 2010, 554–60. The stages of manufacture of the tomb and a date in the period 1327–37 are set out in Heighway and Bryant 2007.

117 I refer to the work of my former student James Hillson, 'The Tomb of Pope John XXII: Politics, Nationality and the English Decorated Style in Avignon circa 1316–70', unpublished MA dissertation, University of York, 2012.

118 Binski 1995a, 101–4.

119 Willis 1845, 115–17.

120 J. Gardner 1992, figs 171–2.

121 This matters in so far as the surviving figures presumed to come from the tomb are variously identified as white marble (Paris 1981, no. 26) and alabaster (J. Gardner 1992, 139, but apparently in error). For the description, by Moszinsky, see Reyne and Brehier 2002, 227–8.

122 Fraser 2005, 159–61 and 169– 72, figs 8.1, 8.2.

123 For Thomas of Canterbury, see J. H. Harvey 1987, 46–7. The only mason working at Avignon in the early 1320s who might be relevant is mentioned in an account for 1322, in Schäfer 1911, 290: *pro edificio capelle S. Michaelis et omnium Angelorum et Archangelorum constructe in ecclesie b. Maria Avin. pro papa per mag. Hugonem Angelicum 80 fl.* J. H. Harvey 1987, 334, takes this name to be 'Anglicus'. The chapel was painted in 1322–3: Schäfer 1911, 291, 292. For further (minor) works by Joannes *Anglicus lapiscidus* in the palace in 1339–40, see Ehrle 1890, 610, 614.

124 For gift giving and favours secured under John XXII, see Plöger 2005, 213–17.

125 Denholm-Young 1937; *ODNB*, vol. 9, 67–9, for what follows. Richard is discussed further in Chapter Nine.

126 Weir 2005, 180–81.

127 J. R. Wright 1980, 134, 284.

128 Tatham 1925–6, vol. 1, 313–16, 360–61.

129 MacLagan 1960; Smalley 1960, 66–74. See also Chapter Nine.

130 Heslop 1980; see also Alexander and Binski 1987, no. 523, and Michael 1994a, 118–19.

131 Blackley 1983; Gee 2002, 119; Weir 2005, 162, 353.

132 Binski 1995a, 177–9.

133 C. Wilson 1995, 468–70; Lindley 2003.

134 J. Gardner 1992, 147–9, pl. 190.

135 J. Gardner 1992, 146–7, pl. 188.

136 J. Gardner 1992, fig. 41.

137 Sekules 1986 and 1990.

138 Girard 1936–7, 644–9; Costantini 2003, 196–7 and n. 1.

139 Cassee 1980.

140 J. H. Harvey 1987, 102–3.

141 *ODNB*, vol. 4, 309–11.

142 Lightbown 1978, 93; Taburet-Delahaye 1995, 15–16.

143 D. Wood 1989; Costantini 2003.

144 D. Wood 1989; Enaud et al. 1971.

145 Erlande-Brandenburg 1975b; Frankl 2000, 199–200; Costantini 2003, 13–29.

146 J. Gardner 1992, 143–51; Morganstern 2001; Costantini 2003, 19–25.

147 J. Gardner 1992, 151–2, accepts the identification as Montclar's tomb, but Frédérique Costantini has informed me that early sources indicate that Montclar's tomb was under a slab in the choir itself; Faucon 1904, 53, attributes it to a member of Clement VI's family, the Beauforts.

148 Mackenzie 1844, pl. 10(3).

149 Bony 1979, 65; Meadows and Ramsay 2003, 180, 396 n. 22.

150 See Sandler 1986 nos. 119, 130, 140 and 149.

151 S. Brown 2003b, 186 and colour pl. 22.

152 Binski 1995a, figs 96–7.

153 Cowan 2005, 115.

154 Costantini 2003, 27–8, 28 n. 76. I am most grateful to Frédérique Costantini for her advice on the cloister's starting date.

155 Maddison 2000, 80.

156 Draper 1979, 8–9 and n. 5, after Stewart 1868, 79–81.

157 Durliat 1962, 211; Monzó 1923, 36–7, for the document.

158 Durán Sanpere and de Lasarte 1956, 293; this is accepted by Bugslag 2008, 68; cf. Grässe 1972, vol. 1, 112–13.

159 Durán Gudiol 1956; Durán Sanpere and de Lasarte 1956, 276.

160 Puig i Cadafalch 1921–6, 129 n. 4, also 132–3: according to a source of 1367, the refectory was begun in 1303 and the cloister in 1313; the work was finished in 1341; for another view of the chronology and authorship, see Español i Bertran 1985.

161 Puig i Cadafalch 1921–6, 129–31 and figs 233–4; for the tombs, see Rosenmann 1984, Blattmacher 2008, Nickson 2009.

162 This is derived from a document cited by Puig i Cadafalch 1921–6, 131–2, 132 n. 1, to the effect that in 1331 'fuit benedictum claustrum et capitulum', which is taken here to mean the chapter house together with its adjoining walk.

163 Puig i Cadafalch 1921–6, 130–31; Rosenmann 1984; Nickson 2009.

164 For smaller-scale instances, see the use of decorative tracery on the Anglesola retable, now in Boston, in which the arrangement of the shafts and capitals of the miniature arcades strikingly resembles that of the cloister at Santes Creus: Vives i Miret 1969, 195–204.

165 Puig i Cadafalch 1921–6, 123–5; stonemasons were contracted for the task in 1332; cf. Vives i Miret 1969; J. H. Harvey 1987, 109–10; Bony 1979, 65 and 90 n. 35; Español i Bertran 1985.

166 Puig i Cadafalch 1921–6, 123, 125; Español i Bertran 1985, 124–6; for his work at Tarragona, see Liaño Martinez 1991; for a recent overview, see Buades 2012.

167 Puig i Cadafalch 1921–6, 132–3 and fig. 240, following Bond 1905, 479–90; Bony 1979, 65 and 90 n. 35, cf. Etherton 1965, 177 nos. 34a–b; for Norfolk, see Fawcett 1980; for Mileham and patronage, see Daunton 2010, 30–35.

168 For Bristol, see C. Wilson 2011b, 90–3, ill. 4.9, 4.17. The Great Walsingham glass somewhat resembles the Thornham Parva Retable: Norton, Park and Binski 1987.

169 For a relation of the sculpture to work in Oxfordshire (Hanwell, Adderbury, Alkerton), see Bony 1979, 90 n. 35; see also Stone 1972, 170, 195; J. Goodall 1995.

170 Millar 1932; Sandler 1986, no. 107; Camille 1987 and 1998; Backhouse 1989. CUL MS Ii.2.7, a copy of the *Oculus sacerdotis* and church constitutions dating to *circa* 1340 (see Binski and Zutshi 2011, no. 157), contains similar work.

171 Puig i Cadafalch 1921–6, 127.

172 Puig i Cadafalch 1948; cf. Stubbs 1879–80, vol. 1, 21.

173 As advanced by Español i Bertran 1985, 128–9. It is in my view more likely that French masons were summoned at this date because they were the only ones capable of repairing curvilinear masonry of this sort.

174 Pere ça Anglada appears with Michael Lochner and Frederick Kassel, in 1394–9: Tomas 1979; Tomas 1993–4; Block 2004, 17–22; in general, Grössinger 1997.

175 Binski 2006c, 229; see Liaño Martinez 1991, 382–3.

176 Liaño Martinez 1991, 389–400.

177 Liaño Martinez 1991, 393, 400.

178 Liaño Martinez 1991, figs 2, 3, 5.

179 Balbas 1952, fig. 191; Etherton 1965, 175 nos. 16–18 (type A2).

180 J. H. Harvey 1950, 106, ill. 154.

181 J. H. Harvey 1950, 106; see especially Guillouët 2011.

182 Bony 1979, 69.

183 Bony 1979, 65–6.

184 Bony 1979, 65 and fig. 371; Bruzelius 2004, 99 and pl. 100; Michalsky 2004.

185 M. B. Hall 1974, 334 and fig. 12.

186 Not explored in Bony 1979, 63, though he notes other forms of English style there; see Olympios, in preparation.

187 Binski 2002a.

188 Frankl 2000, 200 and 347 nn. 56–56A.

189 Work in progress by Dr J. Adamski, Warsaw University.

190 Fawcett 2011, 236–52.

191 Baron 1968, 58, 69–70 no. 167; Baron 1970, 108, no. 73; Baron 1975, 34, 54, 55 no. 62; Paris 1981, no. 10 (a), 430; Alexander and Binski 1987, no. 501.

192 Enlart 1906; for the Paris region, see Plagnieux 2004.

193 Classic studies are S. Murray 1987, 1989 and 1996.

194 Frankl 2000, 216–19.

195 Enlart 1906, 55–6; Bony 1979, 67.

196 Enlart 1906, 58; Bony 1979, 67 and pl. 395; J. Gardner 1992, 157–8, 164.

197 Enlart 1906, 60; Bony 1979, 67; Etherton 1965, 178 no. 436.

198 Bony 1979, 67, noted in Frankl 2000, 217, 353 n. 110; Meiss 1967, vol. 1, 36–40.

199 For reflections on this, see Kurmann 1986; Crossley 2006; and Gajewski and Opačić 2007.

200 For the cusped layers, see Fuchss 1999, 186–8, ill. 196; Kroesen and Steensma 2012, pl. 4.20.

201 Panofsky 1951, 8–9.

202 Bony 1979, 1.

8 THE PLEASURES OF UNRULING

1 Kendrick 2006, 290.

2 Geremek 1987; Stallybrass and White 1986.

3 Stallybrass and White 1986, 20.

4 Camille 1992, 160.

5 Camille 1992, 10.

6 For a serious view of play and invention, see Carruthers 2013, 16–44.

7 Randall 1966, 4–5.

8 Kendrick 1999, 221–2.

9 The literature on this topic is now equally prodigious, but apart from Randall 1966 and Camille 1992, see the following, at least for English-related material: Sandler 1997 and Kendrick 2006, for overviews; Hamburger 1993, for attention to non-English language studies; also Sandler 1981; Gehl 1983; Wentersdorf 1984; Patterson 1990; Alexander 1993, 4–5; Sandler 1996; Camille 1998; Nishimura 1999; Sandler 2000; Caviness 2007; Sandler 2007.

10 Rashdall 1936, 423 n. 2; Branner 1977, 2; Camille 1992, 152; Rouse and Rouse 1990, 103.

11 Owst 1961, 238; Sekules 1995, 45–58; for Holcot, see Smalley 1960, 167. For a warning about generalizing from sermons, see Carruthers 2013, 10, 11, 17.

12 Sekules 1995, 50–51, pl. 19.

13 Randall 1966, 3–4; Wentersdorf 1984, 5.

14 For morality, see Randall 1966, 3; cf. Carruthers 2013, as cited at 146–9.

15 Gage 1973.

16 Knapp 2008, 4–5.

17 May and Wisse 2001, 195, a reference owed to Andrew Chen.

18 Knapp 2008, 128.

19 A point owed to Carruthers 2013, 8–9, developed briefly in Binski 2013, 14–15, as here.

20 Schapiro 1977, 46.

21 I argue against this position, sustained as it is by the public–private dichotomy apparent in Belting's work, in Binski 2004, as at 174–7.

22 Camille 1987 and 1998.

23 Kendrick 1999, 217–18.

24 Pevsner 1956/1976, 41, 'if one tries to trace baboonery to its source, one finds that it originated in England'.

25 Pevsner 1956/1976, 39–47.

26 Hutchinson 1974, and in general Yapp 1981; Sandler 1986, no. 10; for Luttrell, see Millar 1932; Sandler 1986, no. 107; Camille 1987 and 1998; Backhouse 1989.

27 Pevsner 1956/1976, 46–7; Gransden 1972.

28 Camille 1998, 43.

29 I refer to Camille 1998 and M. Brown 2006, 3, 4–10, 11, 19: Brown, following Camille, draws attention to the desirability of reading marginalia (2006, 11), and states that 'A primary function may have been to symbolize the world turned upside down.' In my view such japes do not *symbolize* but actually *embody* the world turned upside down: 'symbolism' is a form of displacement from experience. This distinction is more important than late twentieth-century morality-driven logocentrism admitted.

30 *Troilus and Criseyde*, Book II, ll. 1041–3: Benson 2008, 503.

31 Sandler 1981, 54.

32 Knapp 2008, 41–2.

33 Binski 2004, 252.

34 For a discussion, see Patterson 1990.

35 Caviness 2007, 150.

36 Malcolm 1997.

37 Malcolm 1997, 78–124; Curtius 1990, 96–8.

38 See, for example, Oakeshott 1972, pl. 50; Binski 2003, 55, 62.

39 Malcolm 1997, 83.

40 Malcolm 1997, 84–5.

41 Binski and Zutshi 2011, no. 157.

42 For which, see Cockerell and James 1926; Sandler 1986, no. 43; Panayotova 2008.

43 For a discussion, see Kendrick 1999, 145–6.

44 Carruthers 1990, 245–8; Carruthers 1998, 161–5.

45 Malcolm 1997, 89–90.

46 Kendrick 1999, 111–46, for what follows.

47 Kendrick 1999, 137–9.

48 Kendrick 1999, 143–4.

49 Kendrick 1999, 136–9.

50 Randall 1966, 9–10.

51 Binski and Panayotova 2005, no. 26.

52 E.g., the *De universo* in CUL MS Dd.1.30, Binski and Zutshi 2011, no. 82; see also Morgan 1982, nos. 59 (a, b), 88.

53 Nordenfalk 1967 at 421 and figs 53 and 55 discussed here; for the text, see Hageneder and Haidacher 1964, 464–7, at 466.

54 Morgan 1982, no. 30; Sandler 1997, fig. 1; Morgan 2002, 27–8.

55 Morgan 1982, nos. 69, 70, 73, 74.

56 Morgan 1988, nos. 112, 158.

57 Morgan 1988, nos. 159, 161–2.

58 Branner 1972; Bennett 1972; Branner 1977, 83.

59 Camille 1985; Morgan 1988, no. 145.

60 Camille 2001.

61 Binski and Zutshi 2011, no. 315.

62 Parkes 1976; see also Rouse and Rouse 1982. Camille 1992, 20, places Parkes's insight in the context of a 'shift' from oral to written culture.

63 Parkes 1976, 121, 137–8.

64 Carruthers 1990, 245.

65 Carruthers 1990, 245–6; Sandler 1986, no. 101; Bovey 2002.

66 Carruthers 1990, 246–7.

67 Kendrick 1999, 217–25; cited in Carruthers 1998, 162.

68 Embodied throughout Camille 1992; also Sandler 1997, 37, 39–40.

69 Nordenfalk 1967, 421.

70 Binski and Panayotova 2005, no. 52.

71 Bork 2011, 148, 151, 158, 205 fig. 4.3, 214.

72 Caviness 2007.

73 For daydreams, see Kendrick 1988, 113–15; Camille 1992, 43: 'In saying that marginal imagery was conscious I am not suggesting that it was pre-planned, as were most miniatures . . . it was one area where artists could "do their own thing"'.

74 Freigang 2007, 73 and fig. 5.

75 Kavaler 2005.

76 Carruthers 1998 and 2010.

77 Cf., however, Camille 1992, 148–50.

78 For the association of commodification with the decline of marginalia, see Camille 1992, 151–7.

79 Sandler 1986, nos. 43, 50; For rabbits, see Nishimura 1999; Nishimura and Nishimura 2007; also Panayotova 2007, fig. 76, for the *Fall of Pride*. A similar figure is found on fol. 189v of the Taymouth Hours: K. A. Smith 2012, fig. 173, illustrating the fall of Napoleone Orsini.

80 Sandler 1986, nos. 56, 98, 101; K. A. Smith 2012.

81 Randall 1966, 9.

82 Sandler 1986, no. 1.

83 See note 78; in addition, Binski and Panayotova 2005, no. 81; also Kauffmann 2003, 228–31.

84 Caviness 2007.

85 Mauwese 2012, 196.

86 Kendrick 1988, 114–15.

87 Kendrick 1988, 114; Gehl 1983.

88 Kendrick 1988, 115, after Randall 1966, 5.

89 Malcolm 1997, 89–90, 119–20. Schmitt, Le Goff and others think of a clerical rather than a folkloric culture in this regard; see Schmitt 2010, 24–5.

90 Randall 1966, 11–12.

91 Shanzer 2006; see also Wentersdorf 1984; for low and high, see Van Engen 1986.

92 Brantley 2002.

93 Brantley 2002; Rothwell 1976.

94 Derived from Owst 1961, 238; Camille 1993, 9–10; Camille 1998, 171–2.

95 Camille 1993, 12.

96 Binski 2003, 55–6.

97 Malcolm 1997, 118–19, for what follows.

98 Malcolm 1997, 119.

99 Clanchy 1979.

100 Carruthers 1990, 245–6; Bovey 2002.

101 Alexander 1980, especially 151 for Luttrell; Gibbs and L'Engle 2001, 161–4 and nos. 11, 12, 13; also L'Engle 2006.

102 Sandler 1986, no. 113; Gibbs and L'Engle 2001, no. 19

103 Marks 1993–4, 350; Camille 1998, 53; Gibbs and L'Engle 2001, 164 n. 14.

104 See Kauffmann 1994.

105 Nordenfalk 1967, 421.

106 Clanchy 1979, 228–9; Sears 2007.

107 Cf., however, Camille 1992, 153–60.

108 Binski and Zutshi 2011, no. 247.

109 Sandler 1986, no. 104.

110 Hurwood 1968.

111 May and Wisse 2001, 233; Carruthers 2013, 142.

9 THE TRUE VINE

1 Sandler 1986, no. 40.

2 For the foregoing, see Gunton 1696/1990, 41; Carolus-Barré 1950, 80–82; Sandler 1974 and Sandler 1986, no. 40, do not fully trace the history of the manuscript.

3 Gunton 1696/1990, 39–42, 317–19; Binski 1986, 21–2.

4 Bennett 1982, 507–8.

5 Carolus-Barré 1950, 81–2, 'et y est le sacre des roys d'Angleterre'.

6 Bennett 1982, 508.

7 Remnant and Marks 1980; Alexander and Binski 1987, no. 521; Kevin et al. 2008, figs 6–10.

8 Binski 2003.

9 Mynors 1998–9, vol. 1, 15–16; Carruthers 2009, 37–8.

10 Carruthers 1998, 164–5.

11 Minnis 1988, 21–2.

12 M. R. James 1951, 141, 142.

13 Shaver 1943; cf. the vernacularist reading of Camille 1993, 9–10; Camille 1998, 171–2.

14 For the ceiling, see Binski 2003; for the stalls and typology, see Sandler 1970 and, for illustrations between figs 17 and 60, Sandler 1974; Bennett 1982, 506–7.

15 Smalley 1952, 245, 284–5.

16 Sandler 1970, following M. R. James 1897 and 1901; Caviness 1977, 120–22; also Heslop 2001.

17 Henry 1990.

18 Olson 1963, 93–4: . . . *pulchritudo enim ecclesiae non solum consistit in situatione, vel pictoris, de quibus praedictum est, sed etiam in copia verorum librorum qui ad cultum Dei pertinent.*

19 Yun 2007.

20 Furnivall and Stone 1909, 6, for what follows.

21 M. R. James 1901, 3, also 7–9 draws attention to errors in transcripts of inscriptions there; Caviness 1977, 4, 115–16.

22 Caviness 1977, 107–38.

23 Binski 2004, 106–21; T. Ayers 2004; S. Brown 2003b; Binski 2003, 47–50; Luxford 2005, 55.

24 Stanton 2001, 146–55.

25 In general, Gransden 1982; Luxford 2005.

26 Luxford 2005, 145–9.

27 On which themes, see A. Murray 1978; Crouch 1992; Michael 1994a and 1994b; Coss 2002.

28 As on the brass of Sir Hugh Hastings (d. 1347) at Elsing, Norfolk, see Alexander and Binski 1987, no. 678.

29 Binski 2004, 87–101, 212–23; for related conceits in vaulting, see Kavaler 2005 and 2008.

30 Rodwell 2009, 84–91.

31 Luxford 2010.

32 M. Brown 2007.

33 For which, see S. Brown 1997, 109–10; also Sabin 1957; the Christchurch reredos, an offshoot of the west façade works at Exeter, is scarcely published, but see Stone 1972, pl. 132(b), and P. Williamson 1991, 78, for its relationship to the west façade at Exeter; for Selby, see O'Connor and Reddish 1995; for a comprehensive discussion of Wells, see T. Ayers 2004, vol. 1, 283–414, for the clearstory glazing, also Draper 1981 for chronology. The glass in the east widow of St Mary's, Shrewsbury, though not made for this church, should also be mentioned. For an overview of stained-glass schemes of this period, see Marks 1993, 150–65.

34 Sandler 2012, 336–46.

35 For instances, see Morgan 1982; see also Henderson 1985a; Kauffmann 2003, 105–90.

36 Cockerell and Plummer 1969; Noel and Weiss 2002.

37 Lowden 2000; Stahl 2008.

38 Binski 1986; discussion of the Bible scenes is expanded in Binski 2011c, for what follows.

39 Carruthers 1998, 61, 63, 64; Baxandall 1972, 133–4.

40 Sandler 1986, nos. 26, 27, 56; Warner 1912; S. Lewis 1990; Stanton 2001; Kauffmann 2003, 211–28, table at 214.

41 Kauffmann 2003, 215.

42 Binski 1986, 89–90.

43 *Summa predicantium* v.8.12: Walls 2007, 273–4 and 276 n. 11.

44 Minnis 1988, 12.

45 Smalley 1960.

46 Smalley 1960, 9–27.

47 Smalley 1960, 26, 28–44.

48 Smalley 1960, 42–3, for what follows; see also Randall 1966, 7–8; for pricksong, see Gallet 2007.

49 Carruthers 1998, 118, 130–33.

50 Smalley 1960, 110–21, 133–202; also Saxl 1942, 99–103, 115–17; Palmer 1983, 178, 182–3; Carruthers 1990, 230–31.

51 Palmer 1983, 182–3.

52 Smalley 1960, 172–8.

53 Smalley 1960, 114–15.

54 Smalley 1960, 173–4 no. 7; Carruthers 1990, 230–31.

55 Smalley 1960, 115.

56 I am indebted to Alexa Sand for conveying this transcription to me and for pointing it out in the first place.

57 Hetherington 1974.

58 In general, Pickering 1970, 223–307; Kauffmann 1994; M. Brown 2007.

59 For such images in England, see Marks 2004.

60 For a Book of Hours, see Morgan 1982, no. 73.

61 Morgan 1982, nos. 23, 30, 32, and no. 71 for de Brailes; Henderson 1985a, 138–70 and 184–215; Noel 2004, 79–87.

62 Warner 1912; Sandler 1986, no. 56; Stanton 2001; for the Egerton Genesis, see M. R. James 1921b; Pächt 1943; Sandler 1986, no. 129; Dennison 2001; Joslin and Watson 2001 (to be used with care).

63 M. R. James 1895b, 200–02.

64 M. R. James 1921b, 6–7; Pächt 1943, 58; Dennison 2001, 97–8.

65 Lowden 1992, especially 44–5.

66 Pächt 1943, 57–70; Weitzmann and Kessler 1986; Lowden 1992.

67 Pächt 1943, 66.

68 Henderson 1985a, 109.

69 Henderson 1985a, 92–4, 96–8, 108; Morgan 1982, no. 71; Noel 2004.

70 Henderson 1985a, 86–7, 108.

71 Esposito 1960, 34–5.

72 Pächt 1943, 59–64, 65–69; Dennison 2001, 91–3; a range of analogies is discussed in Joslin and Watson 2001, but in the context of a misleading suggestion that the work derives from Flemish illumination.

73 Pächt 1943, 69–70; Sandler 1986, nos. 127–8; for a full discussion, see Dennison 2001.

74 Dennison 2001, 80–88.

75 Denholm-Young 1937, 162–3; Smalley 1960, 66–74; *ODNB*, vol. 9, 67–9 (by W. J. Courtenay), for what follows.

76 Raine 1839, 127–30.

77 Smalley 1960, 67.

78 Though not a 'rich gent', see M. Brown 2007, 31. For the view that the frontispieces of the Holkham book are based on the Moralized Bible passed (in his view) from Louis IX to Henry III, see Lowden 2010, 76 n. 8.

79 Keene 1990, 41 and fig. 4.

80 Joslin and Watson 2001, 264–5.

81 M. R. James 1921b, 5–6.

82 Knoop, Jones and Hamer 1938; Rykwert 1988, 41–2; for context, see Prescott 2005 and 2009.

83 Knoop, Jones and Hamer 1938, 8; Rykwert 1988, 41.

84 Knoop, Jones and Hamer 1938, 69–103, ll. 1–642.

85 L. H. Cooper 2011, 69; on Roriczer and quasi-mythical guarantors of fine art, see Rykwert 1988, 36 n. 27.

86 Knoop, Jones and Hamer 1938, 139–51.

87 Knoop, Jones and Hamer 1938, 71, ll. 45–7, and 73, ll. 85–6; on this, see L. H. Cooper 2011, 64–5; also see Lydgate, discussed by Reynolds 2007, 7–8.

88 Knoop, Jones and Hamer 1938, 490–95.

89 Binski 2010a, 30–31.

90 L. H. Cooper 2011, 56.

91 L. H. Cooper 2011, 66–82, at 68.

92 For Crucifixions and the *Pietà*, see the Taymouth Hours, fols 121v, 123v; and the Holkham Bible Picture Book, fol. 32v: Sandler 1986, nos. 97–8 and fig. 249; K. A. Smith 2012; M. Brown 2007; in addition, see Morgan 1993, 51–7; Marks 2004; K. A. Smith 2003, 221–2 and fig. 123.

93 Heslop 1998, 132–5,

94 Morgan 1982, nos. 2, 14, 15, 28, 29, 30, 50, etc.

95 Sandler 1986, no. 104.

96 Sandler 1986, no. 6, at fig. 7.

97 Dennison 2001, 89–91.

98 Cockerell and James 1926, 32; Ker 1949, 5–6.

99 For Eastry's bequest, see M. R. James 1903, 143–5; see also Coldstream 2013.

100 Binski and Zutshi 2011, no. 40.

101 Sandler 1986, nos. 43, 50, 104–5; see also Lasko and Morgan 1973, nos. 20, 21, 27, 28; for facsimiles, see Cockerell and James 1926; Cockerell 1907; Yates Thompson 1900, respectively.

102 Cockerell and James 1926, 2 and plate III(a); Ker 1949, 12 no. 1.

103 For the latter, see *ODNB*, vol. 41, 947–8 (by P. Brand).

104 Greatrex 1997, 546–8.

105 Cockerell and James 1926, 3 and pl. III(b).

106 Now CUL MS Kk.4.3, Binski and Zutshi 2011, no. 115 (and see also nos. 114, 124); Cockerell and James 1926, pl. 34(b); Ker 1949, 16 no. 36. For St Mary in the Marsh, see Gilchrist 2005, 31–3.

107 Binski and Zutshi 2011, no. 64.

108 Sandler 1986, nos. 44–5; for the Psalter, see Cockerell and James 1926.

109 Cockerell 1907, 5–8.

110 Nishimura 1999, 109–35; Nishimura and Nishimura 2007.

111 Nishimura 1999, 156–8; the discussion in J. A. Goodall 1997, 185–6, is less conclusive.

112 For further observations of John's marital situation and patronage, see D. King 2010, especially 296–7.

113 Nishimura 1999, 228.

114 Hull 1994 and 2001.

115 First placed in context by Binski and Park 1986, 36; and Dennison 1986, 50 n. 36.

116 Pächt 1943, 51–2; for subsequent examinations of this issue, see Binski and Park 1986 and Martindale 1994; further comments in relation to the Macclesfield Psalter are in Panayotova 2008, 17–28. In my view the Italian episode in the Gorleston Psalter should be dated later than the mid-1320s assigned to it by Sandler 1986, no. 50.

117 Bagnoli et al. 2003, nos. 29, 54 and p. 195; Martindale 1988, pl. 120.

118 Panayotova 2008.

119 For the English arms at this time, see Michael 1994a.

120 Cockerell 1907, 33, stated that they were worked on 'side by side'.

121 For Ayermin, see *ODNB*, vol. 1, 520 (by M. C. Buck); Phillips 2010, 480, 515, 539; for Isabella, see *ODNB*, vol. 29, 419–23 (by J. C. Parsons); Weir 2005, 255.

122 B. Thompson 2010, 114; For Ely, see Binski and Park 1986; the subsequent cleaning of the west wall *Annunciation* has not entirely detracted from its Italianate nature, such as the Virgin Mary's blue veiled mantle; the adjoining *Crucifixion* is of the Italian Calvary type, noted in Lindley 1986a, 92.

123 Wharton 1691, vol. 1, 413–14.

124 *ODNB*, vol. 4, 864.

125 Weir 2005, 166, 175–7, 179–80, 245.

126 J. Vale 1982, 170 and 52. One of these, namely *unam tabulam de iiij foliis*, is presumably the 'painting on four folios, a gift from the King of France' to Edward III, mentioned in *Calendar of the Patent Rolls*, 1330–34, 190, passed on by Edward to Isabella. My thanks to Julian Luxford for this last reference. The very fact that such evidence continues to come up throws into doubt Martindale's counsel of despair, at Martindale 1994, 102–3, that the search for specific circumstantial links for such movements is a 'fool's errand'.

127 K. A. Smith 2012, 39–40, 133–4, 136–7; for John of Eltham, see Binski 1995a, 178–9; Gee 2002, 49–54; Weir 2005, 312.

128 Weir 2005, 257.

129 Doherty 2003, 173; Weir 2005, 257, 357–8.

130 Aylmer and Cant 1977, 378–9 and pl. 128; Gee 2002, 51, pl. 12.

131 *ODNB*, vol. 23, 266–8; Alexander and Binski 1987, 463, nos. 589–98; Stratford 1991, 147–8 fig. 213, and 150, fig. 218. For the image's origins, see Belting-Ihm 1976; and for England, see Morgan 1993, 49–50.

132 Stratford 1991, 155.

133 Stratford 1991, 150 and figs 220–21; see also J. Cherry 1991, 207.

134 Pächt 1943; Panofsky 1953.

135 Panofsky 1953, vol. 1, cited at 20 and 24.

136 For a recent discussion of this episode, see Binski 2011a.

137 Smalley 1960, 167–8, 168 n. 2: *Unde sicut vidi scriptum Parisius in domo quorundam lombardorum ibi hec historia depicta erat* (after BL MS Royal 2 D. IV, fol. 158v).

138 Muratova 1989; P. Williamson 1991. For the archaeology and chronology of the west front and screen, see Allan and Blaylock 1991.

139 Belting 1985, 154–66.

140 Binski 1995a, 182–5.

141 Belting 1994, 409; for comments, see Binski 2004, 175; Hamburger 2006a, 12–13; and Hamburger 2006b.

142 Binski 2006b.

143 Davidsohn 1927, 214; Belting 1994, 305,

144 Perkinson 2009.

145 Jaeger 2012, 98–133. My thoughts are 'Freedbergian': Freedberg 1989, for example at 120 and 167.

10 CONTAGION

1 Newton 1980, 2.

2 Newton 1980, 10.

3 S. Cohen 1980, 193–4.

4 S. Cohen 1980; Scattergood 1996, 240–57.

5 Tait 1914, 88–9.

6 *Statutes* 1810, 280–81; Baldwin 1926 should be consulted with care.

7 *Statutes* 1810, 378–83, at 380; see Horrox 1994, no. 121.

8 Robbins 1959, xxxviii.

9 Shinners and Dohar 1998, 22–3 no. 11, cf. 21 no. 9; cf. also the Augustinian canons issued at Leicester in 1346: Boyle 1973, 535–6.

10 E. M. Thompson 1874, 14; for his ambitious palace at Lincoln, see Coulson 1982, 76–7.

11 Hayden 1863, 230–31; Gransden 1982, 103–5; Newton 1980, 54.

12 Tait 1914, 88–9; Newton 1980, 9, 53–4; Gransden 1982, 105–9; see also Brie 1908, 296–7, and Newton 1980, 9.

13 Tate 1914, 167–8; Newton 1980, 53–4; Horrox 1994, 97–8 and nos. 44–5.

14 Joslin and Watson 2001, 147–8 and fig. 39.

15 Mynors 1998–9, vol. 1, 558–61.

16 Jaeger 1985, 180–81.

17 Rule 1884, 48.

18 Chibnall 1969, 186–93.

19 Jaeger 1985, 178–81; Harris 1987, 7–8; Harris 1998.

20 Harris 1987; Lachaud 2002, for the earlier period.

21 Paris, BnF MS fr. 167, fol. 44: Lowden 2000, vol. 1, 221–50; Waugh 2000, fig. 37.

22 Harris 1987; Harris 1998, 89–90, 94–5 and fig. 57.

23 A large topic: see Harris 1998, 99. On this point contrast the materialist-determinist perspective in Sponsler 1997, 2–3, and for style consciousness, Waugh 2000; see Hodges 2000.

24 Lachaud 2002, 107.

25 Ormrod 2004.

26 Scattergood 1996, 248–9.

27 Binski 2004, 29–51.

28 Gérard 1843, vol. 2, 185, also 367; Birdsall and Newhall 1953, 31–4.

29 Viard 1937, 284–5.

30 Newton 1980, 9–10.

31 Muratori 1728, col. 1033; Newton 1980, 7–8.

32 Dragomanni 1845, cap. 8, 15–22; or Aquilecchia 1979, 231–2; Newton 1980, 6–8. Villani had created the myth that the Peruzzi had been bankrupted by Edward III's war finance: Hunt 1994, 1–2, 268–71.

33 Skinner 1986.

34 Porta 1981, 42–3.

35 Marsh 2003, x, 364–475; in general, see Panofsky 1960, 8–35.

36 J. R. Spencer 1965, 174–5, at 176 (100v, book XIII); Panofsky 1960, 19–20.

37 Timmermann 2000; Binski 2012a, 21.

38 C. Wilson 1990, 271.

39 Ackerman 1949, 98.

40 Bellosi and Rossi 1986, 38–9.

41 Andrew and Waldron 1978, 237–8, ll. 800–02.

42 BL Cotton MS Nero A.x; see Andrew and Waldron 1978, 168, l. 1408.

43 Andrew and Waldron 1978, 170–71, ll. 1458–9; Carruthers 2013, 173–4.

44 Carruthers 1993.

45 Whitehead 2003, 2.

46 Vauchez 1997, 71–3, 81–2.

47 Colvin 1963, vol. 2, 1045, also 1024–5, 883, and vol. 1, 194.

48 J. H. Harvey 1987, 358–66; J. H. Harvey 1944, 44–53.

49 I refer to Braswell 1981; also Doob 1990, 308.

50 Whitehead 2003, 174–200; also Doob 1990, 307–39; the edition used is Benson 2008, from 347. On The House of Fame and locational memory, see Carruthers 1987.

51 Timmermann 2000; Schick 1891, 1–2; Whitehead 2003, 250–55.

52 Binski 2004, 9–12.

53 Cited conveniently at Salzman 1952, 405–7; for Lydgate's aesthetic language, see Reynolds 2007.

54 Cf., however, Braswell 1981.

55 For empty analogism between poetry and Perpendicular, see Steinberg 1981.

56 Whitehead 2003, 178–9.

57 For an inventory of idols, see Camille 1989.

58 For this metaphor, see Doob 1990.

59 Whitehead 2003, 181–3.

60 Doob 1990, 97–100, 332.

61 Doob 1990, 323 and n. 32.

62 The edition used is Barr 1993, from 61.

63 Whitehead 2003, 105–10; Carruthers 2010.

64 On wandering, see Szittya 1986, 228–9.

65 Barr 1993, 8–14 and notes at 213–46; Whitehead 2003, 107.

66 Geltner 2004, 358–9.

67 Szittya 1986, especially 197–8, 207–11; cf. Geltner 2004 and 2008.

68 Tait 1914, 128–9; Gransden 1982, 106.

69 Luard 1872–83, vol. 4, 279–80.

70 Douie 1952, 45; J. Gardner 2010b, 307; Ehrle 1892, 94–5; Sundt 1987.

71 Barr 1993, 12.

72 Mooney 2000, 119–21.

73 E.g., the heart tomb of Thibaut V of Champagne: Sauerländer 1972, 492–3, pl. 274.

74 Binski and Howard 2010, 196.

75 Sundt 1987, at 401, 405 item IV, 406 appendix C (Périgueux).

76 Geltner 2008.

77 Geltner 2008, 113–39.

78 Szittya 1986, 183–4, 190–91, 195–8; cf. Geltner 2004 and Geltner 2008, 18–22.

79 E. Inglis 2003, 68.

80 Whitehead 2003, 59–60, 107.

81 Carruthers 2009, 36–7; Carruthers 2013, 86.

82 Carruthers 1998, 82–94; Carruthers 2009, 40–42; Carruthers 2013, 149–55.

83 Minnis 1988, 120–22; Carruthers 1998, 63, 259 for aspectus, and for curiositas 82–7; Carruthers 2009, 41.

84 Newhauser 1982, 563.

85 Apologia XII.28 and XII.29: Rudolph 1990, 104, 106; Carruthers 2009, 39–40; Carruthers 2013, 146–9.

86 Procopius, Buildings 1.i.47–8: Dewing 1971, 20–22; cited in Carruthers 2009, 33–4.

87 Paleotti 1582, Bk I, ch. 22.

88 Anstey 1898, 191–2; R. H. C. Davis 1946–7, 79–80.

89 R. H. C. Davis 1946–7, 79–80. The case is discussed and illustrated by Gombrich 2002, 212.

90 Borsa 1904, 524; Petrina 2004, 253. Vitruvius's Ten Books VII.5 is a standard point of reference, but its critique of wall paintings concerns mimesis and deviancy from truth, not excess: Rowland 1999, at 91–2.

91 Colvin 1959.

92 Sundt 1987.

93 J. H. Harvey 1978, 183.

94 Willis and Clark 1886/1988, 350–80; cf. Heywood and Wright 1850, 172–93; in general, Griffiths 1981, 242–8.

95 Willis and Clark 1886/1988, 366–7.

96 Willis and Clark 1886/1988, 354.

97 Willis and Clark 1886/1988, 370.

98 Willis and Clark 1886/1988, 465–6.

99 Andrew and Waldron 1978, 21–2.

100 Andrew and Waldron 1978, 158.

101 Willis and Clark 1886/1988, 466, 486–7; it was replaced by a grey-yellow Clipsham.

102 Leland 1745, vol. 1, 103–4.

103 Leland 1745, vol. 1, 47.

104 Carruthers 1998, 63.

105 Phelps Brown and Hopkins 1955.

106 Griffiths 1981, 376–401, at 377.

107 Parker 1853; Eavis 2011.

108 Willis and Clark 1886/1988, 367.

109 Parker 1853, 41.

110 Parker 1853, 44–6.

111 Heywood and Wright 1850.

112 Heywood and Wright 1850, 71–80.

113 Heywood and Wright 1850, 78 and 171.

114 M. R. James 1919; Freeman 2005.

115 P. M. King 1990.

116 A comprehensive statement of the literature is unfeasible, but see Hatcher 1977 and 1994; Bean 1982; Williman 1982; Horrox 1994 for a selection of documents and useful discussion at 229–47; Campbell 1991; Lindley and Ormrod 1996; Phillipotts 2000; Arthur 2010; Benedictow 2004; Gummer 2009; Arthur 2010.

117 Meiss 1951.

118 Benedictow 2004, 342–79; for a higher than usual estimate of mortality rates, see Arthur 2010.

119 The later strikes are given due emphasis in European plague studies by Cohn 1997.

120 Ziegler 1982, 98–111; Horrox 1994, documents at 207–26.

121 Van Os 1981; in a telling phrase, Meiss 1951, 65, describes the huge trenches dug for corpses as 'sights not unfamiliar to modern eyes'; see also Steinhoff 2006, 9–26.

122 C. Wilson 1990, 212.

123 E.g., the observation about 'a sobered England' in Bond 1905, 499; a point owed generally to Van Os 1981, 239.

124 Lindley 1996, 128–9, after Bond 1905, 136, and Prior 1905, 78, 82–8.

125 Van Os 1981, 242; for related critiques, see Steinhoff 2006, 9–26.

126 Here local studies are useful, e.g., Fawcett 1979.

127 See the essays in Gajewski and Opačić 2007.

128 Leedy 1980.

129 R. Morris 1979, fig. 7; Gummer 2009, 351–6.

130 Luxford 2005, 43–5, 202.

131 Phillipotts 2000, 121; for Windsor, see Colvin 1963, vol. 2, 864–88; C. Wilson 2002.

132 See, for instance, Van Os 1981; Lindley 1996, 137–8; Cohn 1997, 270.

133 Colvin 1963, vol. 1, 182–5.

134 Maddison 1988.

135 Maddison 1988, 109–13.

136 Connerton 1989. For the 'mindful' hand, see Roberts, Schaffer and Dear 2007.

137 Colvin 1963, vol. 1, 201.

138 For the foregoing, see Phelps Brown and Hopkins 1955, 296–314, especially table at 311 (after Rogers 1866); also Salzman 1952, 69–81; Knoop and Jones 1967, 98–115, 210–14; Hatcher 1977, 25, 50; Farmer 1988–91; *Statutes* 1810, 312; Horrox 1994, 240–41 and doc. 112.

139 For wages, earnings and prosperity, see Hatcher 2011.

140 Lindley 1996, 142–3; see also Allan and Blaylock 1991, 102–3; also P. Williamson 1991, 78.

141 J. H. Harvey 1978, table at 275–81.

142 Cohn 1997.

143 Meiss 1951; Van Os 1981; Steinhoff 2006, after Cohn 1997.

144 Horrox 1994, 236–7.

145 Cohn 1997, 217, 244–69, 252; Phillipotts 2000, 121.

146 Nilson 1998, 175–82 and graphs at 234–42; Raban 1982, 12, 99–100, 188, 191.

147 Horrox 1994, 245; Cohn 1997, 272.

148 Binski 2006a.

149 I am grateful to Richard Beadle for his opinion on orthography and dialect, which he considers to be east Midlands or Yorkshire. In my own doggerel I have taken 'thow' as a nominative and cannot find a rhyme for 'grit' (peace).

150 Binski 1996, 143–4.

151 J. Blair 1999.

152 Binski 1996, colour pl. VIII.

153 Berenbeim 2007; on this topic in England, see Palmer 1983.

154 Panayotova 2008, 71–3.

155 Backhouse 1989, fig. 6.

156 Tyson 1977.

157 Binski 2006a, 391.

158 Binski 1996, 42–7. The Brightwell Baldwin brass is early too in relation to European examples of the macabre, of which the earliest include the tomb of François I de La Sarra (d. 1362) at La Sarraz (Vaud), Panofsky 1964, fig. 257, and the incised slab showing a cadaver commemorating Thomas de Saulx, sire de Vantoux (d. 1391) formerly in the Sainte-Chapelle at Dijon, for knowledge of which I am indebted to Jean-Bertrand de Vaivre. Together with that of Cardinal de La Grange at Avignon (d. 1402), these instances are all aristocratic or curial.

159 P. M. King 1990.

BIBLIOGRAPHY

Abou-El-Haj 1988
B. Abou-El-Haj, 'The urban setting for late medieval church building: Reims and its cathedral between 1210 and 1240', *Art History*, 11/1 (1988), 17–41

Abou-El-Haj 1995a
—, 'Building and decorating at Reims and Amiens', in *Studien zur Geschichte der europäischen Skulptur im 12./13. Jahrhundert*, ed. H. Beck and K. Hengevoss-Dürkop, Frankfurt am Main, 1995, 763–75

Abou-El-Haj 1995b
—, 'Artistic integration inside the cathedral precinct: social consensus outside?', in Raguin, Brush and Draper 1995, 214–35

Ackerman 1949
J. S. Ackerman, '"Ars Sine Scientia Nihil Est": Gothic theory of architecture at the cathedral of Milan', *Art Bulletin*, 31/2 (1949), 84–111

Addington 1860
H. Addington, *Some Account of the Abbey Church of St Peter and St Paul, at Dorchester, Oxfordshire*, Oxford, 1860

Adhémar 1974
J. Adhémar, 'Les tombeaux de la collection Gaignières: dessins d'archéologie du xviie siècle', *Gazette des Beaux-Arts*, 6th ser., 84 (1974), 1–192

Aguadé 2008
C. F.-L. Aguadé, 'El gótico navarro en el contexto hispánico y europeo', in *Presencia e influencias exteriores en el arte navarro. Actas del Congreso Nacional: Pamplona, 5–7 de noviembre de 2008*, ed. M. C. García Gainza and R. Fernández Gracia, Pamplona, 2008, 87–125

Ailes 2002
A. Ailes, 'Heraldry in medieval England: symbols of politics and propaganda', in *Heraldry, Pageantry and Social Display in Medieval England*, ed. P. R. Coss and M. Keen, Woodbridge, 2002, 83–104

Alexander 1980
J. J. G. Alexander, 'An English illuminator's work in some fourteenth-century Italian law books at Durham', in *Medieval Art and Architecture at Durham Cathedral* (BAACT, 3), 1980, 149–53

Alexander 1993
—, 'Iconography and ideology: uncovering social meanings in western medieval Christian art', *Studies in Iconography*, 15 (1993), 1–44

Alexander and Binski 1987
— and P. Binski, eds, *Age of Chivalry: Art in Plantagenet England, 1200–1400* (exh. cat.), London, 1987

Allan and Blaylock 1991
J. P. Allan and S. R. Blaylock, 'The west front, i: The structural history of the west front', in *Medieval Art and Architecture at Exeter Cathedral* (BAACT, 11), 1991, 94–115

Allen Brown 1989
R. Allen Brown, 'William of Malmesbury as an architectural historian', in Allen Brown, *Castles, Conquest and Charters*, Woodbridge, 1989, 227–34

Altschul 1965
M. Altschul, *A Baronial Family in Medieval England: The Clares, 1217–1314*, Baltimore, 1965

Andås 2004
M. S. Andås, 'A royal chapel for a royal relic?', in *The Nidaros Office of the Holy Blood: Liturgical Music in Medieval Norway* (Senter for middelalderstudier, 16), ed. G. Attinger and A. Haug, Trondheim, 2004, 175–97

Andrew and Waldron 1978
M. Andrew and R. A. Waldron, eds, *The Poems of the 'Pearl' Manuscript*, London, 1978

Anstey 1898
H. Anstey, ed., *Epistolae Academicae Oxon.: Part I* (Oxford Historical Society), Oxford, 1898

Anstruther 1851
R. Anstruther, ed., *The Chronicles of Ralph Niger*, London, 1851

Aquilecchia 1979
G. Aquilecchia, *Giovanni Villani: Cronica con le continuazioni di Matteo e Filippo*, Turin, 1979

Arnould 1940
E. J. Arnould, ed., *Le Livre de Seyntz Medicines* (Anglo-Norman Text Society: Anglo-Norman Texts, 2), Oxford, 1940

Arthur 2010
P. Arthur, 'The Black Death and mortality: a reassessment', in *Fourteenth-century England*, vol. 6, ed. C. Given-Wilson, Woodbridge, 2010, 49–72

Aspin 1953
I. S. T. Aspin, *Anglo-Norman Political Songs* (Anglo-Norman Text Society: Anglo-Norman Texts, 11), Oxford, 1953

Astell 1990
A. W. Astell, *The Song of Songs in the Middle Ages*, Ithaca and London, 1990

Aston 1973
M. Aston, 'English ruins and English history: the Dissolution and the sense of the past', *Journal of the Warburg and Courtauld Institutes*, 36 (1973), 231–55

Aston 1994
—, 'Corpus Christi and Corpus Regni: heresy and the Peasants' Revolt', *Past and Present*, 143/1 (1994), 3–47

Atherton et al. 1996
I. Atherton et al., eds, *Norwich Cathedral: Church, City and Diocese, 1096–1996*, London and Rio Grande, 1996

Atkinson 1933
T. D. Atkinson, *An Architectural History of the Benedictine Monastery of Saint Etheldreda at Ely*, 2 vols, Cambridge, 1933

Aubert 1929
M. Aubert, *Notre-Dame de Paris*, 2nd edn, Paris, 1929

Auerbach 1953
E. Auerbach (trans. W. R. Trask), *Mimesis: The Representation of Reality in Western Literature*, Princeton, 1953

Auerbach 1965
— (trans. R. Mannheim), *Literary Language and its Public in Late Antiquity and in the Middle Ages*, London, 1965

B. S. Ayers 1996
B. S. Ayers, 'The cathedral site before 1096', in Atherton et al. 1996, 59–72

T. Ayers 2004
T. Ayers, *The Medieval Stained Glass of Wells Cathedral* (CVMA Great Britain, 4), 2 vols, Oxford, 2004

T. Ayers 2007
—, 'Remaking the Rayonnant interior: the choir of Merton College Chapel, Oxford', in Gajewski and Opačić 2007, 123–31

T. Ayers 2013
—, *The Medieval Stained Glass of Merton College, Oxford* (CVMA Great Britain, 6), London, 2013

Aylmer and Cant 1977
G. E. Aylmer and R. Cant, eds, *A History of York Minster*, Oxford, 1977

Bachelard 1994
G. Bachelard (trans. M. Jolas), *The Poetics of Space*, Boston, MA, 1994

Backhouse 1989
J. Backhouse, *The Luttrell Psalter*, London, 1989

Baglow 2002
C. T. Baglow, *'Modus et Forma': A New Approach to the Exegesis of Saint Thomas Aquinas* (Analecta biblica, 149), Rome, 2002

Bagnoli et al. 2003
A. Bagnoli et al., *Duccio alle origini della pittura senese*, Milan, 2003

Bailey 1989
M. Bailey, *A Marginal Economy? East Anglian Breckland in the Late Middle Ages*, Cambridge, 1989

Bailey 1996
—, 'Demographic decline in late medieval England: some thoughts on recent research', *Economic History Review*, 49/1 (1996), 1–19

Bailey 1998

—, 'Historiographic essay: the commercialization of the English economy, 1086–1500', *Journal of Medieval History*, 24 (1998), 297–311

Bailey 2007

—, *Medieval Suffolk: An Economic and Social History, 1200–1500*, Woodbridge, 2007

Balbas 1952

L. T. Balbas, *Arquitectura gótica* (Ars hispaniae, VII), Madrid, 1952

Baldwin 1926

F. E. Baldwin, *Sumptuary Legislation and Personal Regulation in England*, Baltimore, 1926

Baltrušaitis 1955

J. Baltrušaitis, *Le Moyen Age fantastique: antiquités et exotismes dans l'art gothique*, Paris, 1955

Bandmann 2005

G. Bandmann (trans. K. Wallis), *Early Medieval Architecture as Bearer of Meaning*, New York, 2005

Bango Torviso 2006

I. G. Bango Torviso, ed., *Sancho el Mayor y sus herederos: el linaje que europeizó los reinos hispanos*, 2 vols, Pamplona, 2006

Barker 1986

J. R. V. Barker, *The Tournament in England, 1100–1400*, Woodbridge, 1986

C. F. Barnes 1978

C. F. Barnes, 'Cross-media design motifs in XIIIth-century France: architectural motifs in the Psalter and Hours of Yolande of Soissons and in the cathedral of Notre-Dame at Amiens', *Gesta*, 17/2 (1978), 37–40

C. F. Barnes 2009

—, *The Portfolio of Villard de Honnecourt*, Farnham, 2009

J. Barnes 1984

J. Barnes, ed., *The Complete Works of Aristotle* (Bollingen Series, 2), 2 vols, Princeton, 1984

Baron 1968

F. Baron, 'Enlumineures, peintres et sculpteurs parisiens des XIIIe et XIVe siècles d'après les rôles de la taille', *Bulletin archéologique*, new ser., 4 (1968), 37–121

Baron 1970

—, 'Enlumineures, peintres et sculpteurs parisiens des XIVe et XVe siècles d'apres les archives de l'hôpital Saint-Jacques-aux-Pèlerins', *Bulletin archéologique*, new ser., 6 (1970), 77–115

Baron 1975

—, 'Le décor sculpté et peint de l'hôpital Saint-Jacques-aux-Pèlerins', *Bulletin monumental*, 133/1 (1975), 29–72

Barr 1993

H. Barr, ed., *The Piers Plowman Tradition*, London, 1993

Barret 1965

C. Barret, 'Medieval art criticism', *British Journal of Aesthetics*, 5 (1965), 25–36

Barrett 1789

W. Barrett, *The History and Antiquities of the City of Bristol*, Bristol, 1789

Barron 2004

C. M. Barron, *London in the Later Middle Ages: Government and People, 1200–1500*, Oxford, 2004

Baxandall 1971

M. Baxandall, *Giotto and the Orators: Humanist Observers of Painting in Italy and the Discovery of Pictorial Composition, 1350–1450*, Oxford, 1971

Baxandall 1972

—, *Painting and Experience in Fifteenth-century Italy: A Primer in the Social History of Pictorial Style*, Oxford, 1972

Baxandall 1979

—, 'The language of art history', *New Literary History*, 10/3 (1979), 453–65

Baxandall 1985

—, *Patterns of Intention: On the Historical Explanation of Pictures*, New Haven, 1985

Bean 1982

J. M. W. Bean, 'The Black Death: the crisis and its social and economic consequences', in Williman 1982, 23–38

Becksmann 1967

R. Becksmann, *Die architektonische Rahmung des hochgotischen Bildfensters: untersuchungen zur oberrheinischen Glasmalerei von 1250 bis 1350*, Berlin, 1967

Bedos-Rezak 2006

B. M. Bedos-Rezak, 'Replica: images of identity and the identity of images in prescholastic France', in *The Mind's Eye: Art and Theological Argument in the Middle Ages*, ed. J. F. Hamburger and A.-M. Bouché, Princeton, 2006, 46–64

Bell 1978

D. N. Bell, 'Contemplation and the vision of God in the Commentary on the Song of Songs of Thomas the Cistercian', *Cîteaux*, 29 (1978), 207–27

Bellosi and Rossi 1986

L. Bellosi and A. Rossi, eds, *Le vite de' più eccellenti architetti, pittori, et scultori italiani di Giorgio Vasari* [Florence, 1550], Turin, 1986

Belting 1985

H. Belting, 'The new role of narrative in public painting of the trecento: *historia* and allegory', in *Pictorial Narrative in Antiquity and the Middle Ages* (Studies in the History of Art, 16), ed. H. L. Kessler and M. S. Simpson, Washington, DC, 1985, 151–68

Belting 1990
— (trans. M. Bartusis and R. Meyer), *The Image and its Public in the Middle Ages: Form and Function of Early Paintings of the Passion*, New York, 1990

Belting 1994
— (trans. E. Jephcott), *Likeness and Presence: A History of the Image before the Era of Art*, Chicago and London, 1994

Belting-Ihm 1976
C. Belting-Ihm, *'Sub matris tutela': Untersuchungen zur Vorgeschichte der Schutzmantelmadonna*, Heidelberg, 1976

Benedictow 2004
O. J. Benedictow, *The Black Death, 1346–1353: The Complete History*, Woodbridge, 2004

Bennett 1972
A. L. Bennett, 'Additions to the "William of Devon" group', *Art Bulletin*, 54/1 (1972), 31–40

Bennett 1982
—, review of Sandler 1974, *Art Bulletin*, 64/3 (1982), 502–8

Bennett 2010
—, review of M. Brown 2007, *Speculum*, 85/1 (2010), 147–9

Benson 2008
L. D. Benson, ed., *The Riverside Chaucer*, 3rd edn, Oxford, 2008

Bent and Wathey 1998
M. Bent and A. Wathey, eds, *Fauvel Studies: Allegory, Chronicle, Music and Image in Paris Bibliothèque Nationale de France, MS français 146*, Oxford, 1998

Bentham 1771
J. Bentham, *The History and Antiquities of the Conventual and Cathedral Church of Ely*, Cambridge, 1771

Berenbeim 2007
J. Berenbeim, 'An English manuscript of the *Somme le Roi*: Cambridge, St John's College, MS S.30', in Panayotova 2007, 97–114

Besançon 1994
A. Besançon, *L'Image interdite: une histoire intellectuelle de l'iconoclasme*, Paris, 1994

Bialostocki 1966
J. Bialostocki, 'Late Gothic: disagreements about the concept', *Journal of the British Archaeological Association*, 3rd ser., 29 (1966), 76–105

Biddle 1999
M. Biddle, *The Tomb of Christ*, Stroud, 1999

Binding 1996
G. Binding, *Der früh- und hochmittelalterliche Bauherr als Sapiens architectus*, Cologne, 1996

Binski 1986
P. Binski, *The Painted Chamber at Westminster* (Society of Antiquaries Occasional Papers, new ser., 9), London, 1986

Binski 1987
—, 'The stylistic sequence of London figure brasses', in Coales 1987, 69–132

Binski 1995a
—, *Westminster Abbey and the Plantagenets: Kingship and the Representation of Power, 1200–1400*, New Haven and London, 1995

Binski 1995b
—, 'The English Decorated Style: problems and possibilities', in *Bilans et perspectives des études médiévales en Europe. Actes du premier congrès d'études médiévales: Spoleto, 1993*, ed. J. Hamesse, Louvain-la-Neuve, 1995, 313–28

Binski 1996
—, *Medieval Death: Ritual and Representation*, London and Ithaca, 1996

Binski 1997
—, 'The Angel Choir at Lincoln and the poetics of the Gothic smile', *Art History*, 20/3 (1997), 350–74

Binski 2000
—, 'A note on the Hutton Conyers charter and related Fenland manuscript illumination', *Antiquaries Journal*, 80 (2000), 296–302

Binski 2002a
—, 'How northern was the Northern Master at Assisi?', *Proceedings of the British Academy*, 117 (2002), 73–138

Binski 2002b
—, 'The Cosmati and *romanitas* at Westminster: an overview', in *Westminster Abbey: The Cosmati Pavements* (Courtauld Institute Research Papers, 3), ed. L. Grant and R. Mortimer, Aldershot, 2002, 116–34

Binski 2003
—, 'The painted nave ceiling of Peterborough Abbey', in *The Medieval English Cathedral: Papers in Honour of Pamela Tudor-Craig* (Harlaxton Medieval Studies, 10), ed. J. Backhouse, Donington, 2003, 41–62

Binski 2004
—, *Becket's Crown: Art and Imagination in Gothic England, 1170–1300*, New Haven and London, 2004

Binski 2006a
—, 'John the Smith's grave', in *Tributes to Jonathan J. G. Alexander: The Making and Meaning of Illuminated Medieval and Renaissance Manuscripts, Art and Architecture*, ed. S. L'Engle and G. B. Guest, Turnhout, 2006, 386–93

Binski 2006b

—, 'The faces of Christ in Matthew Paris's *Chronica Majora*', in *Tributes in Honour of James H. Marrow: Studies in Painting and Manuscript Illumination of the Late Middle Ages and Northern Renaissance*, ed. J. F. Hamburger and A. S. Korteweg, London and Turnhout, 2006, 85–92

Binski 2006c

— (with M. L. Sauerberg), 'Matthew Paris in Norway: the Faberg St Peter', in *Medieval Painting in Northern Europe: Techniques, Analysis, Art History. Studies in commemoration of the 70th Birthday of Unn Plahter*, ed. J. Nadolny et al., London, 2006, 230–47

Binski 2007

—, 'Liturgy and local knowledge: English perspectives on Trondheim Cathedral', in *The Medieval Cathedral of Trondheim: Architectural and Ritual Considerations in their European Context*, ed. M. S. Andås et al., Turnhout, 2007, 21–46

Binski 2009

—, 'Statues, retables and ciboria: the English Gothic altar in context, before 1350', in *The Altar and its Environment, 1150–1400* (Studies in the Visual Cultures of the Middle Ages, 4), ed. J. E. A. Kroesen and V. M. Schmidt, Turnhout, 2009, 31–46

Binski 2010a

—, '"Working by words alone": the architect, scholasticism and rhetoric in thirteenth-century France', in *Rhetoric Beyond Words: Delight and Persuasion in the Arts of the Middle Ages*, ed. M. Carruthers, Cambridge, 2010, 14–51

Binski 2010b

—, 'Reflections on the "Wonderful height and Size" of Gothic great churches and the medieval sublime', in Jaeger 2010, 129–56

Binski 2010c

—, 'The Ante-Reliquary Chapel paintings in Norwich Cathedral: the Holy Blood, St Richard and All Saints', in *Tributes to Nigel Morgan: Contexts of Medieval Art: Images, Objects and Ideas*, ed. J. M. Luxford and M. A. Michael, London and Turnhout, 2010, 241–61

Binski 2011a

—, 'Art-historical reflections on the fall of the Colonna, 1297', in *Rome across Time and Space: Cultural Transmission and the Exchange of Ideas, c.500–1400*, ed. C. Bolgia, R. McKitterick and J. Osborne, Cambridge, 2011, 278–90

Binski 2011b

—, 'The imagery of the high altar piscina of St-Urbain at Troyes', in Opačić and Timmermann 2011a, 263–73

Binski 2011c

—, 'The Painted Chamber at Westminster, the Fall of Tyrants and the English literary model of governance', *Journal of the Warburg and Courtauld Institutes*, 74 (2011), 121–54

Binski 2012a

—, 'London, Paris, Assisi, Rome around 1300: questioning art hierarchies', in *From Major to Minor: The Minor Arts in Medieval Art History* (Index of Christian Art Occasional Papers, 14), ed. C. Hourihane, Princeton, 2012, 3–21

Binski 2012b

—, 'Villard de Honnecourt and invention', in *Inventing a Path: Studies in Medieval Rhetoric in Honour of Mary Carruthers* (Nottingham Medieval Studies, 56), ed. L. Iseppi De Filippis, Turnhout, 2012, 63–79

Binski 2013

—, 'The heroic age of Gothic and the metaphors of modernism', *Gesta*, 52/1 (2013), 1–17

Binski, in preparation (a)

—, 'Notes on artistic invention in Gothic Europe', *Intellectual History Review* (2014)

Binski, in preparation (b)

—, 'The context, art and significance of the pavement', in a book on the Cosmati pavement edited by W. Rodwell, in preparation

Binski and Howard 2010

— and H. Howard, 'Wall paintings in the chapter house', in *Westminster Abbey Chapter House: The History, Art and Architecture of 'a chapter house beyond compare'*, ed. W. Rodwell and R. Mortimer, London, 2010, 184–208

Binski and Massing 2009

— and A. Massing, *The Westminster Retable: History, Technique, Conservation*, Turnhout, 2009

Binski and New 2012

— and E. New, eds, *Patrons and Professionals in the Middle Ages* (Harlaxton Medieval Studies, 22), Donington, 2012

Binski and Noel 2001

— and W. Noel, eds, *New Offerings, Ancient Treasures: Studies in Medieval Art for George Henderson*, Stroud, 2001

Binski and Panayotova 2005

— and S. Panayotova, eds, *The Cambridge Illuminations: Ten Centuries of Book Production in the Medieval West* (exh. cat.), London and Turnhout, 2005

Binski and Park 1986

— and D. Park, 'A Ducciesque episode at Ely: the mural decorations of Prior Crauden's Chapel', in Ormrod 1986, 28–41

Binski and Zutshi 2011

— and P. Zutshi, *Western Illuminated Manuscripts: A Catalogue of the Collection in Cambridge University Library*, Cambridge, 2011

Birdsall and Newhall 1953

J. Birdsall and R. A. Newhall, ed. and trans., *The Chronicle of Jean de Venette*, New York, 1953

Bismanis 1989
M. R. Bismanis, 'The necessity of discovery', *Gesta*, 28/2 (1989), 115–20

Blackley 1983
F. D. Blackley, 'The tomb of Isabella of France, wife of Edward II of England', *Bulletin, International Society for the Study of Church Monuments*, 8 (1983), 161–4

C. Blair, Goodall and Lankester 2000
C. Blair, J. A. Goodall and P. Lankester, 'The Winchelsea tombs reconsidered', *Church Monuments*, 15 (2000), 5–30

J. Blair 1987
J. Blair, 'English monumental brasses before 1350: types, patterns and workshops', in Coales 1987, 133–74

J. Blair 1999
—, 'John Smith of Brightwell Baldwin', *Bulletin of the Monumental Brass Society*, May 1999, 431

Blattmacher 2008
A. Blattmacher, 'Grabdenkmäler als mikroarchitektonische Gehäuse: die Königsgrabmäler im Zisterzienserkloster Santes Creus (Katalonien)', in Kratzke and Albrecht 2008, 135–60

Block 2004
E. C. Block, *Corpus of Medieval Misericords, Iberia (Portugal–Spain, XIII–XVI)*, Turnhout, 2004

Blomefield 1805–10
F. Blomefield, *An Essay towards a Topographical History of the County of Norfolk*, 11 vols, London, 1805–10.

Bock 1961
H. Bock, 'Exeter rood screen', *Architectural Review*, 130 (1961), 313–17

Bock 1962a
—, *Der Decorated Style: Untersuchungen zur Englischen Kathedralarchitektur der ersten hälfte des 14. Jahrhunderts*, Heidelberg, 1962.

Bock 1962b
—, 'Zum tabernakelmotiv des 14. Jahrhunderts in England', in *Der Mensch und die Künste: Festschrift für Heinrich Lützeler zum 60. Geburtstag*, ed. G. Bandmann, Düsseldorf, 1962, 412–17

Boehmer 1896
H. Boehmer, ed., *Cronica ecclesiae Wimpinensis auct: Burcardo de Hallis et Dythero de Helmestat* (Monumenta Germaniae Historia, 30, pt 1), Hanover, 1896

Böker 1984
H. J. Böker, *Englische Sakralarchitektur des Mittelalters*, Darmstadt, 1984

Bond 1905
F. Bond, *Gothic Architecture in England*, London, 1905

Bond 1908
—, *Screens and Galleries in English Churches*, London, 1908

Bond 1910
—, 'Le tombeau du pape Jean XXII', *Congrès archéologique de France, Avignon*, 76 (for 1909), vol. 2 (1910), 390–92

Bond 1916
—, *The Chancel of English Churches*, Oxford, 1916

Bonnefoy 1954
Y. Bonnefoy, *Peintures murales de la France gothique*, Paris, 1954

Bony 1957–8
J. Bony, 'The resistance to Chartres in early thirteenth-century architecture', *Journal of the British Archaeological Association*, 3rd ser., 20–21 (1957–8), 35–52

Bony 1979
—, *The English Decorated Style: Gothic Architecture Transformed, 1250–1350*, Oxford, 1979

Bony 1983
—, *French Gothic Architecture of the 12th and 13th Centuries*, Berkeley, CA, 1983

Bony 1990
—, 'The stonework planning of the first Durham master', in *Medieval Architecture and its Intellectual Context: Studies in Honour of Peter Kidson*, ed. E. Fernie and P. Crossley, London, 1990, 19–34

Borg et al. 1980
A. Borg et al., *Medieval Sculpture from Norwich Cathedral*, Norwich, 1980

Bork 2011
R. Bork, *The Geometry of Creation: Architectural Drawing and the Dynamics of Gothic Design*, Aldershot, 2011

Borsa 1904
M. Borsa, 'Correspondence of Humphrey, duke of Gloucester, and Pier Candido Decembrio', *English Historical Review*, 19 (1904), 509–26

Bovey 2002
A. Bovey, 'A pictorial *ex libris* in the Smithfield Decretals: John Batayle, canon of St Bartholomew's, and his illuminated Law Book', in *Decoration and Illustration in Medieval English Manuscripts* (English Manuscript Studies, 1100–1700, 10), ed. A. S. G. Edwards, London, 2002, 60–82

Boyle 1973
L. Boyle, 'The date of the *Summa Praedicantium* of John Bromyard', *Speculum*, 48/3 (1973), 533–37

Brachmann 1998
C. Brachmann, *Gotische architektur in Metz unter Bischof Jacques de Lorraine (1239–1260): der neubar des Kathedrale und seine folgen*, Berlin, 1998

Brachmann 2000
—, 'Tradition and innovation: Archbishop Chrodegang (742–66) and the thirteenth-century family of churches at Metz', *Journal of the Warburg and Courtauld Institutes*, 63 (2000), 24–58

Bradley 1995
S. A. J. Bradley, ed. and trans., *Anglo-Saxon Poetry*, London, 1995

Branca 1976
V. Branca, ed., *Giovanni Boccaccio, Decameron*, Florence, 1976

Brand 2012
P. Brand, 'The development of professional lawyers and a legal profession in the English lay courts: the relationship between the earliest professional lawyers and their clients', in Binski and New 2012, 41–60

Branner 1961
R. Branner, 'Historical aspects of the reconstruction of Reims Cathedral, 1210–1241', *Speculum*, 36/1 (1961), 23–37

Branner 1962
—, 'Le mâitre de la cathédrale de Beauvais', *Art de France*, 2 (1962), 77–92

Branner 1963
—, 'Gothic architecture, 1160–1180, and its Romanesque sources', in *Studies in Western Art. Acts of the Twentieth International Congress of the History of Art: New York, 1961*, Princeton, 1963, vol. 1, 92–104

Branner 1965
—, *St Louis and the Court Style in Gothic Architecture*, London, 1965

Branner 1971
—, 'The Grande Châsse of the Sainte-Chapelle', *Gazette des Beaux-Arts*, 6th ser., 77 (1971), 5–18

Branner 1972
—, 'The Johannes Grusch atelier and the Continental origins of the William of Devon Painter', *Art Bulletin*, 54/1 (1972), 24–30

Branner 1977
—, *Manuscript Painting in Paris during the Reign of Saint Louis: A Study of Styles*, Berkeley, CA, 1977

Brantley 2002
J. Brantley, 'Images of the vernacular in the Taymouth Hours', in *Decoration and Illustration in Medieval English Manuscripts* (English Manuscript Studies, 1100–1700, 10), ed. A. S. G. Edwards, London, 2002, 83–113

Braswell 1981
M. Braswell, 'Architectural portraiture in Chaucer's *House of Fame*', *Journal of Medieval and Renaissance Studies*, 11 (1981), 101–12

Brel-Bordaz 1982
O. Brel-Bordaz, *Broderies d'ornaments liturgiques XIIIe–XIVe siècles*, Paris, 1982

Brenk 1987
B. Brenk, 'Spolia from Constantine to Charlemagne: aesthetics versus ideology', *Dumbarton Oaks Papers*, 41 (1987), 103–9

Brentano 1968
R. Brentano, *Two Churches: England and Italy in the Thirteenth Century*, Berkeley, CA, and London, 1968

Brewer, Dimock and Warner 1861–91
J. S. Brewer, J. F. Dimock and G. F. Warner, eds, *Giraldus Cambrensis, Opera omnia* (Rolls Series, 21), 8 vols, London, 1861–91

Brie 1908
F. W. D. Brie, ed., *The Brut, Part II* (Early English Text Society, 136), London, 1908

Brieger 1968
P. Brieger, *English Art, 1216–1307*, Oxford, 1968

Brieger and Verdier 1972
— and P. Verdier, eds, *Art and the Courts: France and England from 1259 to 1328* (exh. cat.), 2 vols, Ottawa, 1972

Brighton 1985
C. R. Brighton, *Lincoln Cathedral Roof Bosses*, Lincoln, 1985

Britnell 1996
R. H. Britnell, *The Commercialisation of English Society, 1000–1500*, 2nd edn, Manchester, 1996.

Brodersen 1992
K. Brodersen, ed. and trans., *Reiseführer zu den Sieben Weltwundern: Philon von Byzanz und andere antike Texte*, Frankfurt and Leipzig, 1992

Brodersen 1996
—, *Die sieben Weltwunder: Legendäre Kunst- und Bauwerke der Antike*, Munich, 1996

Brooke 1975
R. B. Brooke, *The Coming of the Friars*, London, 1975

Brooks and Evans 1988
C. Brooks and D. Evans, *The Great East Window of Exeter Cathedral: A Glazing History*, Exeter, 1988

E. A. R. Brown and Regalado 1994
E. A. R. Brown and N. F. Regalado, '*La grant feste*: Philip the Fair's celebration of the knighting of his sons in Paris at Pentecost of 1313', in *City and Spectacle in Medieval Europe*, ed. B. A. Hanawalt and K. L. Reyerson, Minneapolis, 1994, 56–86

M. Brown 2006
M. Brown, *The Luttrell Psalter*, London, 2006

M. Brown 2007
—, *The Holkham Bible Picture Book*, London, 2007

S. Brown 1995
S. Brown, 'The fourteenth-century stained glass of Madley', in *Medieval Art and Architecture at Hereford* (BAACT, 15), 1995, 122–31

S. Brown 1997
—, 'The stained glass of the Lady Chapel of Bristol Cathedral: Charles Winston (1814–64) and stained glass restoration in the 19th century', in *'Almost the Richest City': Bristol in the Middle Ages* (BAACT, 19), 1997, 107–17

S. Brown 1999
—, *Sumptuous and Richly Adorned: The Decoration of Salisbury Cathedral*, London, 1999

S. Brown 2003a
—, *'Our Magnificent Fabrick': York Minster: An Architectural History, c.1220–1500*, Swindon, 2003

S. Brown 2003b
—, 'The medieval stained glass', in R. K. Morris and Shoesmith 2003, 183–96

Brownrigg 1990
L. L. Brownrigg, ed., *Medieval Book Production: Assessing the Evidence*, Los Altos Hills, 1990

Bruzelius 1991
C. Bruzelius, '*Ad modum franciae*: Charles of Anjou and Gothic architecture in the Kingdom of Sicily', *Journal of the Society of Architectural Historians*, 50 (1991), 402–20

Bruzelius 2004
—, *The Stones of Naples: Church Building in Angevin Italy, 1268–1343*, New Haven and London, 2004

Buades 2012
M. C. Buades, 'Consuetu y cambio en la arquitectura del principado de Cataluña en torno al 1400', in *Catalunya 1400: el gòtic internacional*, ed. R. Cornudella et al., Barcelona, 2012, 95–107

Buc 1994
P. Buc, *L'ambiguïté du livre: prince, pouvoir, et peuple dans les commentaires de la Bible au Moyen Age*, Paris, 1994

Bucher 1976
F. Bucher, 'Micro-architecture as the "Idea" of Gothic theory and style', *Gesta* 15/1 (1976), 71–89

Buck 1983
M. Buck, *Politics, Finance and the Church in the reign of Edward II: Walter Stapledon, Treasurer of England*, Cambridge, 1983

Buckton and Heslop 1994
D. Buckton and T. A. Heslop, eds, *Studies in Medieval Art and Architecture Presented to Peter Lasko*, Stroud, 1994

Bugslag 1993
J. Bugslag, 'Early fourteenth-century canopywork in Rouen stained glass', in *Medieval Art and Architecture at Rouen* (BAACT, 12), 1993, 73–80

Bugslag 2008
—, 'Architectural drafting and the "Gothicization" of the Gothic cathedral', in Reeve 2008, 57–74

Burrow 2008
J. A. Burrow, *The Poetry of Praise*, Cambridge, 2008

Butler 1921
H. E. Butler, trans., *Quintilian, Institutio oratoria, VII–IX*, Cambridge, MA, and London, 1921

Bynum 1992
C. W. Bynum, 'Material continuity, personal survival and the resurrection of the body: a scholastic discussion in its medieval and modern contexts', in Bynum, *Fragmentation and Redemption: Essays on Gender and the Human Body in Medieval Religion*, New York, 1992, 239–97

Bynum 2001
—, 'Wonder', in Bynum, *Metamorphosis and Identity*, New York, 2001, 37–75

Cahn 1979
W. Cahn, *Masterpieces: Chapters on the History of an Idea*, Princeton, 1979

Cahn 1996
—, *Romanesque Manuscripts: The Twelfth Century: A Survey of Manuscripts Illuminated in France*, 2 vols, London, 1996

Callahan 1953
G. G. Callahan, 'Revaluation of the refectory retable from the cathedral at Pamplona', *Art Bulletin*, 35/3 (1953), 181–93

Cameron and Hall 1999
A. Cameron and S. G. Hall, ed. and trans., *Eusebius, Life of Constantine*, Oxford, 1999

Camille 1985
M. Camille, 'Illustrations in Harley MS 3487 and the perception of Aristotle's *Libri naturales* in thirteenth-century England', in *England in the Thirteenth Century: Proceedings of the 1984 Harlaxton Symposium*, ed. W. M. Ormrod, Harlaxton, 1985, 31–43

Camille 1987
—, 'Labouring for the Lord: the ploughman and the social order in the Luttrell Psalter', *Art History*, 10/4 (1987), 423–54

Camille 1989
—, *The Gothic Idol: Ideology and Image-Making in Medieval Art*, Cambridge, 1989

Camille 1992
—, *Image on the Edge: The Margins of Medieval Art*, London, 1992

Camille 1993
—, 'At the edge of the law: an illustrated register of writs in the Pierpont Morgan Library', in *England in the Fourteenth Century* (Harlaxton Medieval Studies, 3), ed. N. Rogers, Stamford, 1993, 1–14

Camille 1998
—, *Mirror in Parchment: The Luttrell Psalter and the Making of Medieval England*, London, 1998

Camille 2001
—, 'Illuminating thought: the trivial arts in British Library, Burney MS 275', in Binski and Noel 2001, 343–66

Campbell 1991
B. M. S. Campbell, ed., *Before the Black Death: Studies in the 'Crisis' of the Early Fourteenth Century*, Manchester, 1991

Cannon and Williamson 2011
J. Cannon and B. Williamson, eds, *The Medieval Art, Architecture and History of Bristol Cathedral: An Enigma Explored*, Woodbridge, 2011

Carley 2010
J. P. Carley, ed. (with C. Brett), *John Leland, De viris illustribus*, Toronto, 2010

Carolus-Barré 1950
L. Carolus-Barré, 'Le psautier de Peterborough et ses miniatures profanes empruntées au Roman de Philippe de Beaumanoir *Jehan et Blonde*', *Romania*, 71 (1950), 79–98

Carruthers 1987
M. Carruthers, 'Italy, *Ars memorativa* and Fame's House', *Studies in the Age of Chaucer* (Proceedings series), 2 (1987), 179–88

Carruthers 1990
—, *The Book of Memory: A Study of Memory in Medieval Culture*, Cambridge, 1990

Carruthers 1993
—, 'The poet as master builder: composition and locational memory in the Middle Ages', *New Literary History*, 24 (1993), 881–904

Carruthers 1998
—, *The Craft of Thought: Meditation, Rhetoric and the Making of Images, 400–1200*, Cambridge, 1998

Carruthers 2006
—, 'Sweetness', *Speculum*, 81/4 (2006), 999–1013

Carruthers 2009
—, 'Varietas: a word of many colours', *Poetica: Zeitschrift für Sprach- und Literaturwissenschaft*, 41 (2009), 33–54

Carruthers 2010
—, 'The concept of *ductus*, or journeying through a work of art', in *Rhetoric Beyond Words: Delight and Persuasion in the Arts of the Middle Ages*, ed. M. Carruthers, Cambridge, 2010, 190–213

Carruthers 2013
—, *The Experience of Beauty in the Middle Ages*, Oxford, 2013

Carter 1935
E. H. Carter, ed., *Studies in Norwich Cathedral History*, Norwich, 1935

Cassee 1980
E. Cassee (trans. M. Hoyle), *The Missal of Cardinal Bertrand de Deux: A Study in 14th-century Bolognese Miniature Painting*, Florence, 1980

Cattermole 2011
P. Cattermole, *Norwich School Chapel and School House*, Norwich, 2011

Cave 1932
C. J. P. Cave, 'The roof bosses of Ely Cathedral', *Proceedings of the Cambridge Antiquarian Society*, 32 (1932), 33–50

Cave 1948
—, *Roof Bosses in Medieval Churches: An Aspect of Gothic Sculpture*, Cambridge, 1948

Caviness 1977
M. H. Caviness, *The Early Stained Glass of Canterbury Cathedral*, Princeton, 1977

Caviness 2007
—, 'Marginally correct', in K. A. Smith and Krinsky 2007, 141–56

Cessford and Dickens 2007
C. Cessford and A. Dickens, 'Ely Cathedral and environs: recent investigations', *Proceedings of the Cambridge Antiquarian Society*, 96 (2007), 161–74

Chapman 1907
F. R. Chapman, ed., *Sacrist Rolls of Ely*, 2 vols, Cambridge, 1907

Chenu 1928
M. D. Chenu, 'Notes de lexicographie philosophique médiévale: antiqui, moderni', *Revue des sciences philosophiques et théologiques*, 17 (1928), 82–94

Chenu 1968
— (ed. and trans. J. Taylor and L. K. Little), 'Tradition and progress', in Chenu, *Nature, Man and Society in the Twelfth Century*, Chicago, 1968, 310–30

Cheney 1978
C. Cheney, *Handbook of Dates for Students of English History*, London, 1978

B. Cherry 1976
B. Cherry, 'Ecclesiastical architecture', in *The Archaeology of Anglo-Saxon England*, ed. D. M. Wilson, Cambridge, 1976, 151–200

J. Cherry 1991
J. Cherry, 'The ring of Bishop Grandisson', in *Medieval Art and Architecture at Exeter Cathedral* (BAACT, 11), 1991, 205–9

Chibnall 1969, 1973
M. Chibnall, ed. and trans., *The Ecclesiastical History of Orderic Vitalis*, vols 2 and 4, Oxford, 1969 and 1973

Christie 1938
A. G. I. Christie, *English Medieval Embroidery*, Oxford, 1938

Christine 2005
H. Christine, 'Reassessing "genius" in studies of authorship: the state of the discipline', *Book History*, 8 (2005), 287–320

Ciggaar 1976
K. N. Ciggaar, 'Une description de Constantinople traduite par un pèlerin anglais', *Revue des études Byzantines*, 34 (1976), 211–68

Clanchy 1979
M. T. Clanchy, *From Memory to Written Record: England, 1066–1307*, London, 1979

Clapham 1949
A. Clapham, 'Walsingham Priory', *Archaeological Journal*, 106 (1949), 109–10

Clark 2000
W. W. Clark, 'Reading Reims, I: the sculptures on the chapel buttresses', *Gesta*, 39/2 (2000), 135–45

Claussen 1981
P. C. Claussen, 'Früher Künstlerstolz: mittelalterliche Signaturen als Quelle der Kunstsoziologie', in *Bauwerk und Bildwerk im Hochmittelalter*, ed. K. Clausberg et al., Giessen, 1981, 7–34

Clayton and Price 1988
P. A. Clayton and M. J. Price, *The Seven Wonders of the Ancient World*, London and New York, 1988

Coales 1987
J. Coales, ed., *The Earliest English Brasses: Patronage, Style and Workshops, 1270–1350*, London, 1987

Cocke and Kidson 1993
T. Cocke and P. Kidson, *Salisbury Cathedral: Perspectives on the Architectural History*, London, 1993

Cockerell 1907
S. C. Cockerell, *The Gorleston Psalter*, London, 1907

Cockerell and James 1926
— and M. R. James, *Two East Anglian Psalters at the Bodleian Library, Oxford*, Oxford, 1926

Cockerell and Plummer 1969
— and J. Plummer, *Old Testament Miniatures*, London, 1969

A. S. Cohen 2010
A. S. Cohen, 'Magnificence in miniature: the case of early medieval manuscripts', in Jaeger 2010, 79–101

S. Cohen 1980
S. Cohen, *Folk Devils and Moral Panics: The Creation of the Mods and Rockers*, Oxford, 1980

Cohn 1988
S. K. Cohn, *Death and Property in Siena, 1205–1800: Strategies for the Afterlife*, Baltimore and London, 1988

Cohn 1997
—, *The Cult of Remembrance and the Black Death: Six Renaissance Cities in Central Italy*, Baltimore and London, 1997

Coldstream 1972
N. Coldstream, 'York Chapter House', *Journal of the British Archaeological Association*, 3rd ser., 35 (1972), 15–23

Coldstream 1973
—, 'The Development of Flowing Tracery in Yorkshire, *c.*1300–1370', unpublished PhD thesis, University of London, 1973

Coldstream 1976
—, 'English Decorated Shrine Bases', *Journal of the British Archaeological Association*, 3rd ser., 39 (1976), 15–34

Coldstream 1979
—, 'Ely Cathedral: the fourteenth-century work', in *Medieval Art and Architecture at Ely Cathedral* (BAACT, 2), 1979, 28–46

Coldstream 1980
—, 'York Minster and the Decorated Style in Yorkshire: architectural reaction to York in the first half of the fourteenth century', *Yorkshire Archaeological Journal*, 52 (1980), 89–110

Coldstream 1985
—, 'The Lady Chapel at Ely: its place in the English Decorated Style', in *East Anglian and Other Studies Presented to Barbara Dodwell*, ed. M. Barber, P. McNulty and P. Noble, Reading, 1985, 1–17

Coldstream 1994
—, *The Decorated Style: Architecture and Ornament, 1240–1360*, London, 1994

Coldstream 2011
—, 'Eleanor of Castile and the New Jerusalem', in Opačić and Timmermann 2011b, 225–8

Coldstream 2013
—, 'The *Nova Opera* of Prior Henry of Eastry', in *Medieval Art, Architecture and Archaeology at Canterbury* (BAACT, 35), 2013, 139–55

Coleman 2006
K. M. Coleman, ed. and trans., *M. Valerii Martialis, Liber spectaculorum*, Oxford, 2006

Collinson, Ramsay and Sparks 1995
P. Collinson, N. Ramsay and M. Sparks, eds, *A History of Canterbury Cathedral*, Oxford, 1995

Colvin 1959
H. M. Colvin, 'The building of St Bernard's College', *Oxoniensia*, 24 (1959), 37–48

Colvin 1963
—, ed., *The History of the King's Works: The Middle Ages*, 2 vols, London, 1963

Conant 1978
K. J. Conant, *Carolingian and Romanesque Architecture, 800 to 1200*, 2nd edn, Harmondsworth, 1978

Connerton 1989
P. Connerton, *How Societies Remember*, Cambridge, 1989

Constans 1907
L. Constans, ed., *Benoît de Sainte-Maure, Le Roman de Troie*, vol. 3, Paris, 1907

L. H. Cooper 2011
L. H. Cooper, *Artisans and Narrative Craft in Late Medieval England*, Cambridge, 2011

W. D. Cooper 1850
W. D. Cooper, *The History of Winchelsea*, London, 1850

Coss 2002
P. Coss, 'Knighthood, heraldry and social exclusion in Edwardian England', in *Heraldry, Pageantry and Social Display in Medieval England*, ed. P. Coss and M. Keen, Woodbridge, 2002, 39–68

Costantini 2003
F.-A. Costantini, *L'abbatiale Saint-Robert de La Chaise-Die: un chantier de la papauté d'Avignon, 1344–1352*, Paris, 2003

Coulson 1982
C. Coulson, 'Hierarchism in conventual crenellation: an essay in the sociology and metaphysics of medieval fortification', *Medieval Archaeology*, 26 (1982), 69–100

Coulson 2003
—, *Castles in Medieval Society*, Oxford, 2003

Cowan 2005
P. Cowan, *The Rose Window: Splendour and Symbol*, London, 2005

Crane 2002
S. Crane, *Performance of Self: Ritual, Clothing and Identity during the Hundred Years War*, Philadelphia, 2002

Cressford and Dickens 2007
C. Cressford and A. Dickens, 'Ely Cathedral and environs: recent investigations', *Proceedings of the Cambridge Antiquarian Society*, 96 (2007), 161–74

Crossley 1981a
P. Crossley, 'Wells, the West Country and Central European Late Gothic', in *Medieval Art and Architecture at Wells and Glastonbury* (BAACT, 4), 1981, 81–109

Crossley 1981b
—, review of Bony 1979, *Journal of the British Archaeological Association*, 133 (1981), 132–7

Crossley 2003
—, 'Peter Parler and England: a problem revisited', *Wall-Richartz-Jahrbuch*, 64 (2003), 53–82

Crossley 2006
—, 'Salem and the ogee arch', in *Architektur und Monumentalskulptur des 12.–14. Jahrhunderts: Produktion und Rezeption. Festschrift für Peter Kurmann zum 65. Geburtstag*, ed. S. Gasser, C. Freigang and B. Boerner, Bern, 2006, 321–42

Crossley 2011
—, 'Bristol and Nikolaus Pevsner: *Sondergotik* and the West Country', in Cannon and Williamson 2011, 186–215

Crouch 1992
D. Crouch, *The Image of Aristocracy in Britain, 1000–1300*, London, 1992

Crouch 2005
—, *The Birth of Nobility: Constructing Aristocracy in England and France, 900–1300*, Harlow, 2005

Curta 2004
F. Curta, 'Colour perception, dyestuffs and colour terms in twelfth-century French literature', *Medium Aevum*, 73/1 (2004), 43–65

Curtius 1990
E. R. Curtius (trans. W. R. Trask), *European Literature and the Latin Middle Ages*, Princeton, 1990

Dallaway 1834
J. Dallaway, *Antiquities of Bristow in the Middle Centuries*, Bristol, 1834

Daunton 2010
C. Daunton, 'Contrasting patrons and their glass: the church of St John the Baptist, Mileham, Norfolk', in *Memory and Commemoration in Medieval England* (Harlaxton Medieval Studies, 20), ed. C. M. Barron, Donington, 2010, 24–39

D'Avray 2010
D. L. D'Avray, *Medieval Religious Rationalities: A Weberian Analysis*, Cambridge, 2010

Davidsohn 1927
H. Davidsohn, *Die Frühzeit der florentiner Kultur, Part 3* (Geschichte von Florenz, 4), Berlin, 1927

Davies 2010
G. Davies, 'New light on the luck of Edenhall', *Burlington Magazine*, 152 (2010), 4–7

M. T. Davis 1996–7
M. T. Davis, 'The literal, the symbolic and Gothic architecture', *Avista Forum*, 10/1 (1996–7), 25–30

M. T. Davis 1998
—, 'Desespoir, Esperance and Douce France: the new palace, Paris, and the royal state', in Bent and Wathey 1998, 187–213

M. T. Davis 2002
—, 'Canonical views: the Theophilus story and the choir reliefs at Notre-Dame, Paris', in *Reading Medieval Images: The Art Historian and the Object*, ed. E. S. Sears and T. K. Thomas, Ann Arbor, 2002, 103–16

M. T. Davis 2007
—, 'The visual logic of French Rayonnant architecture', in Gajewski and Opačić 2007, 17–28

M. T. Davis 2012
—, 'Guidelines: the bishop's garden, a mason's drawings and the construction of Notre-Dame, cathedral of Clermont', in Binski and New 2012, 167–81.

M. T. Davis and Neagley 2000
— and L. E. Neagley, 'Mechanics and meaning: plan design at Saint-Urbain, Troyes, and Saint-Ouen, Rouen', *Gesta*, 39/2 (2000), 161–82

R. H. C. Davis 1946–7
R. H. C. Davis, 'A chronology of Perpendicular architecture in Oxford', *Oxoniensia*, 11–12 (1946–7), 75–89

Dawton 1983
N. Dawton, 'The Percy tomb at Beverley Minster', in *Studies in Medieval Sculpture* (Society of Antiquaries Occasional Papers, new ser., 3), ed. F. H. Thompson, London, 1983, 122–50

Dawton 2000
—, 'Gothic sculpture' and 'The medieval monuments', in Horrox 2000, 107–55

Dayman and Rich Jones 1883
E. A. Dayman and W. H. Rich Jones, eds, *Statuta et consuetudines ecclesiae cathedralis sarisberiensis*, Bath, 1883

De Bruyne 1946
E. De Bruyne, *Etudes d'esthetique médiévale*, 3 vols, Bruges, 1946

De Lasarte 1992
J. A. De Lasarte, *Els vitralls del monestir de Santes Creus i la catedral de Tarragona* (CVMA Spain, 8, Catalonia, 3), Barcelona, 1992

Deér 1959
J. Deér, *The Dynastic Porphyry Tombs of the Norman Period in Sicily* (Dumbarton Oaks Studies, 5), Washington, DC, 1959

Dekkers and Fraipont 1956
E. Dekkers and J. Fraipont, *Sancti Aurelii Augustini Enarrationes in Psalmis* (Corpus Christianorum, Series Latina, 38), Turnhout, 1956

Delisle 1873
L. Delisle, ed., *Chronique de Robert de Torigni*, vol. 2, Rouen, 1873

Deliyannis 2010
D. M. Deliyannis, 'The mausoleum of Theoderic and the Seven Wonders of the World', *Journal of Late Antiquity*, 3/2 (2010), 365–85

Demore, Nougaret and Poisson 1990
M. Demore, J. Nougaret and O. Poisson, *Le grand rétable de Narbonne*, Narbonne, 1990

Demus 1960
O. Demus, *The Church of San Marco in Venice*, Washington, DC, 1960

Demus 1970
—, *Byzantine Art and the West*, London, 1970

Denholm-Young 1937
N. Denholm-Young, 'Richard de Bury (1287–1345)', *Transactions of the Royal Historical Society*, 4th ser., 20 (1937), 135–68

Dennison 1986
L. Dennison, 'The Fitzwarin Psalter and its allies: a reappraisal', in Ormrod 1986, 42–63

Dennison 1993
—, 'Some unlocated leaves from an English fourteenth-century Book of Hours now in Paris', in *England in the Fourteenth Century* (Harlaxton Medieval Studies, 3), ed. N. Rogers, Stamford, 1993, 15–33

Dennison 2001
—, 'The suggested origin and initial destination of London, British Library, Additional MS 44949, the M. R. James Memorial Psalter', in *The Legacy of M. R. James: Papers from the 1995 Cambridge Symposium*, ed. Dennison, Donington, 2001, 77–98

Deshman 1995
R. Deshman, *The Benedictional of St Aethelwold*, Princeton, 1995

Desimoni 1877–84
C. Desimoni, 'I conti dell'ambasciata al Chan di Persia nel MCCXCII', *Atti della società Ligure di storia patria*, 13 (1877–84), 537–698

Dewing 1971
H. B. Dewing, trans., *Procopius: Buildings*, London and Cambridge, MA, 1971

Dickinson 1956
J. C. Dickinson, *The Shrine of Our Lady of Walsingham*, Cambridge, 1956

Dilba 2008
C. Dilba, 'Die *Eleanor Crosses*: Applizierter Dekor oder sinnstiftende Form?', in Kratzke and Albrecht 2008, 279–96

Dixon 2002
P. Dixon, 'Gateways to heaven: the approaches to the Lady Chapel, Ely', *Proceedings of the Cambridge Antiquarian Society*, 91 (2002), 63–72

Documents 1852
Documents Relating to the University and Colleges of Cambridge, vol. 2, London, 1852

B. Dodwell 1996
B. Dodwell, 'Herbert de Losinga and the foundation' and 'The monastic community', in Atherton et al. 1996, 36–43, 231–54

C. R. Dodwell 1966
C. R. Dodwell, 'The Bayeux Tapestry and the French secular epic', *Burlington Magazine*, 108 (1966), 549–60

Dohar 1995
W. J. Dohar, *The Black Death and Pastoral Leadership: The Diocese of Hereford in the Fourteenth Century*, Philadelphia, 1995

Doherty 2003
P. C. Doherty, *Isabella and the Strange Death of Edward II*, London, 2003

Donnay-Rocmans 1961
C. Donnay-Rocmans, 'La Châsse de Sainte Gertrude à Nivelles', *Gazette des Beaux-Arts*, 6th ser., 58 (1961), 185–202

Doob 1990
P. Doob, *The Idea of the Labyrinth from Classical Antiquity through the Middle Ages*, Ithaca, 1990

Douie 1952
D. L. Douie, *Archbishop Pecham*, Oxford, 1952

Draghi et al. 2006
A. Draghi et al., *Gli affreschi dell'Aula gotica nel Monastero dei Santi Quattro Coronati*, Milan, 2006

Dragomanni 1845
F. G. Dragomanni, ed., *Cronica di Giovanni Villani*, vol. 4, Florence, 1845

Draper 1979
P. Draper, 'Bishop Northwold and the cult of St Etheldreda', in *Medieval Art and Architecture at Ely Cathedral* (BAACT, 2), 1979, 8–27

Draper 1981
—, 'The sequence and dating of the Decorated work at Wells', in *Medieval Art and Architecture at Wells and Glastonbury* (BAACT, 4), 1981, 18–29

Draper 1982
—, review of Bony 1979, *Art Bulletin*, 64/2 (1982), 330–32

Draper 1990
—, '"Seing that it was Done in all the Noble Churches in England"', in *Medieval Architecture and its Intellectual Context: Studies in Honour of Peter Kidson*, ed. E. Fernie and P. Crossley, London, 1990, 137–42

Draper 1995
—, 'Interpreting the architecture of Wells Cathedral', in Raguin, Brush and Draper 1995, 114–30

Draper 2001
—, 'Canterbury Cathedral: classical columns in the Trinity Chapel', *Architectural History*, 44 (2001), 172–8

Draper 2006
—, *The Formation of English Gothic: Architecture and Identity*, New Haven and London, 2006

Du Boulay 1991
F. R. H. Du Boulay, *The England of Piers Plowman: William Langland and his Vision of the Fourteenth Century*, Woodbridge, 1991

Ducay 1996
C. L. Ducay, 'Pintura mural gótica en Navarra y su ámbito de influencia', *Cuadernos de artes plásticas y monumentales*, 15 (1996), 169–93

Ducay 2008
—, 'Pintura mural gótica en Navarra y sus relaciones con las corrientes europas: siglos XIII y XIV', *Cuadernos de la cátedra de patrimonio y arte navarro*, 3 (2008), 127–71

Duchesne 1886–92
L. Duchesne et al., *Etude sur le Liber Pontificalis*, 2 vols, Paris, 1886–92

Dugdale 1817
W. Dugdale, ed., *Monasticon Anglicanum*, 8 vols, London, 1817

Duhamel 1883
L. Duhamel, *Un neveu de Jean XXII le Cardinal Arnaud de Via*, Tours, 1883

Dumoutet 1926
E. Dumoutet, *Le désire de voir l'hostie at les origines de la dévotion au saint-sacrement*, Paris, 1926

Durán Gudiol 1956
A. Durán Gudiol, 'Notas de archivo, 5: un arquitecto inédito del año 1338', *Argensola: Revista del Instituto de estudios oscenses*, 25/7 (1956), 98–9

Durán Sanpere and de Lasarte 1956
A. Durán Sanpere and J. A. de Lasarte, *Escultura gótica* (Ars Hispaniae, 9), Madrid, 1956

Durliat 1962
M. Durliat, 'Les attributions de l'architecte à Toulouse au début du XIVe siècle', *Pallas*, 11 (1962), 205–12

Duru 1850
L.-M. Duru, *Bibliothèque historique de l'Yonne*, vol. 1, Auxerre, 1850

Dyer 1989
C. Dyer, *Standards of Living in the Later Middle Ages: Social Change in England, c.1200–1520*, Cambridge, 1989

Dynes 2006
W. Dynes, 'Medievalism and Le Corbusier', *Gesta*, 45/2 (2006), 89–94

Eavis 2011
A. Eavis, 'The commemorative foundations of William of Wykeham', *Journal of the British Archaeological Association*, 164 (2011), 169–95

Ehrle 1890
F. Ehrle, *Historia Bibliothecae Romanorum Pontificum tum Bonifatianae tum Avenionensis*, vol. 1, Rome, 1890

Ehrle 1892
—, ed., 'Die ältesten Redactionen der Generalconstitutionen des Franziskanerordens', *Archiv für Literatur- und Kirchengeschichte des Mittelalters*, 6 (1892), 1–138

Eichholz 1962
D. E. Eichholz, *Pliny, Natural History*, vol. 10, Cambridge, MA, and London, 1962

Ekroll 2004
Ø. Ekroll, 'Nidaros Cathedral: the development of the building', in *The Nidaros Office of the Holy Blood: Liturgical Music in Medieval Norway* (Senter for middelalderstudier, 16), ed. G. Attinger and A. Haug, Trondheim, 2004, 157–73

Ekroll 2007

—, 'The shrine of St Olav in Nidaros Cathedral', in *The Medieval Cathedral of Trondheim: Architectural and Ritual Considerations in their European Context*, ed. M. S. Andås et al., Turnhout, 2007, 147–207

Elton 1890

O. Elton, trans., *The Life of Laurence Bishop of Hólar in Iceland (Laurentius saga)*, London, 1890

Enaud et al. 1971

F. Enaud et al., 'Les fresques du Palais des Papes à Avignon', *Les monuments historiques de la France*, new ser., 17/2–3 (1971), 1–139

Enlart 1906

C. Enlart, 'Origine anglaise du style flamboyant français', *Archaeological Journal*, 63 (1906), 51–96 [see also *Bulletin Monumental*, 70, 1906, 38–81]

Erlande-Brandenburg 1975a

A. Erlande-Brandenburg, *Le Roi est mort*, Geneva, 1975

Erlande-Brandenburg 1975b

—, 'L'abbatiale de la Chaise-Dieu', *Congrès archéologique de France*, 133 (1975), 720–55

Erlande-Brandenburg 1994

— (trans. A. Thom), *The Cathedral: The Social and Architectural Dynamics of Construction*, Cambridge, 1994

Erskine 1981

A. M. Erskine, *The Accounts of the Fabric of Exeter Cathedral, 1279–1353. Part I: 1279–1326* (Devon and Cornwall Record Society, new ser., 24), 1981

Erskine 1983

—, *The Accounts of the Fabric of Exeter Cathedral, 1279–1353. Part II: 1328–1353* (Devon and Cornwall Record Society, new ser., 26), 1983

Erskine 1991

—, 'The documentation of Exeter Cathedral: the archives and their application', in *Medieval Art and Architecture at Exeter Cathedral* (BAACT, 11), 1991, 1–9

Español i Bertran 1985

F. Español i Bertran, 'Remarques a l'activitat de mestre Fonoll i una revisió del "Flamíger" de Santes Creus', *D'art: revista del Departament d'historia de l'arte*, 11 (1985), 123–31

Español i Bertran 2009

—, 'Artistas y obras entre la Corona de Aragón y el reino de Francia', in *El intercambio artístico entre los reinos hispanos y las cortes europeas en la Baja Edad Media*, ed. María C. Cosmen, María Victoria Herráez Ortega and María Pellón Gómez-Calcerrada, León, 2009, 253–94

Esposito 1960

M. Esposito, ed., *Itinerarium Symonis Semeonis ab Hybernia ad Terram Sanctam* (Scriptores Latini Hiberniae, IV), Dublin, 1960

Etherton 1965

D. Etherton, 'The morphology of flowing tracery', *Architectural Review*, 138 (1965), 172–80

Ettinghausen, Grabar and Jenkins-Madina 2001

R. Ettinghausen, O. Grabar and M. Jenkins-Madina, *Islamic Art and Architecture, 650–1250*, New Haven and London, 2001

J. Evans 1949a

J. Evans, *English Art, 1307–1461*, Oxford, 1949

J. Evans 1949b

—, 'A prototype of the Eleanor Crosses', *Burlington Magazine*, 91 (1949), 96–9

M. W. Evans 1982

M. W. Evans, 'An illustrated fragment of Peraldus's *Summa* of Vice: Harleian MS 3244', *Journal of the Warburg and Courtauld Institutes*, 45 (1982), 14–46

S. J. A. Evans 1940

S. J. A. Evans, ed., *Ely Chapter Ordinances and Visitation Records, 1241–1515* (Camden Miscellany, 17/1; Camden 3rd ser., 64), London, 1940

Fairweather 2005

J. Fairweather, ed. and trans., *Liber Eliensis: A History of the Isle of Ely from the Seventh Century to the Twelfth*, Woodbridge, 2005

Farmer 1988

D. L. Farmer, 'Prices and wages', in *The Agrarian History of England and Wales*, vol. 2, ed. H. E. Hallam, Cambridge, 1988, 715–817

Farmer 1991

—, 'Prices and wages, 1350–1500', in *The Agrarian History of England and Wales*, vol. 3, ed. E. Miller, Cambridge, 1991, 431–525

Faucon 1882

M. Faucon, 'Les arts à la cour d'Avignon sous Clément V et Jean XXII, 1307–1334', *Mélanges d'archéologie et d'histoire*, 2 (1882), 36–83

Faucon 1884

—, 'Les arts à la cour d'Avignon sous Clément V et Jean XXII: deuxième partie, 1320–1334', *Mélanges d'archéologie et d'histoire*, 4 (1884), 57–130

Faucon 1904

—, *Notice sur la construction de l'église de la Chaise-Dieu (Haute-Loire): son fondateur, son architecte, ses décorateurs, 1344–1352*, Paris, 1904

Fawcett 1979

R. Fawcett, 'Sutton in the Isle of Ely and its architectural context', in *Medieval Art and Architecture at Ely Cathedral* (BAACT, 2), 1979, 78–96

Fawcett 1980

—, 'A group of churches by the architect of Great Walsingham', *Norfolk Archaeology*, 37 (1980), 277–94

Fawcett 2011
—, *The Architecture of the Scottish Medieval Church*, New Haven and London, 2011

Fayen 1908
A. Fayen, ed., *Lettres de Jean XXII, 1316–1334*, 2 vols, Brussels, 1908

Fergusson 2011
P. Fergusson, 'Abbot Anselm's gate tower at Bury St Edmunds', in Opačić and Timmermann 2011a, 25–33

Fernández Valverde 1987
J. Fernández Valverde, ed., *Roderici Ximenii de Rada, Historia de rebus Hispanie sive Historia Gothica*, Turnhout, 1987

Fernie 1979
E. C. Fernie, 'Observations on the Norman plan of Ely Cathedral', in *Medieval Art and Architecture at Ely Cathedral* (BAACT, 2), 1979, 1–7

Fernie 1983
—, *The Architecture of the Anglo-Saxons*, London, 1983

Fernie 1993
—, *An Architectural History of Norwich Cathedral*, Oxford, 1993

Fernie 1998
—, 'The Romanesque church of Bury St Edmunds', in *Bury St Edmunds: Medieval Art, Architecture, Archaeology and Economy* (BAACT, 20), 1998, 1–15

Fernie 2001
—, 'Technical terms and the understanding of English medieval architecture', *Architectural History*, 44 (2001), 13–21

Fernie 2008
—, 'Medieval modernism and the origins of Gothic', in Reeve 2008, 11–23

Fernie and Whittingham 1972
— and A. B. Whittingham, eds, *The Early Communar and Pittancer Rolls of Norwich Cathedral Priory with an Account of the Building of the Cloister* (Norfolk Record Society, 41), Norwich, 1972

Fischer 1965
G. Fischer, *Domkirken i Trondheim*, 2 vols, Oslo, 1965

Fischer 1969
—, *Nidaros Domkirke: Gjenreising i 100 År 1869–1969*, Trondheim, 1969

Fisher 1998
P. Fisher, *Wonder, the Rainbow and the Aesthetics of Rare Experiences*, Cambridge, MA, 1998

E. Fletcher 1965
E. Fletcher, 'Early Kentish churches', *Medieval Archaeology*, 9 (1965), 16–31

J. Fletcher 1979
J. Fletcher, 'Medieval timberwork at Ely', in *Medieval Art and Architecture at Ely Cathedral* (BAACT, 2), 1979, 58–70

Focillon 1948
H. Focillon (trans. C. B. Hogan and G. Kubler), *The Life of Forms in Art*, New York, 1948

Focillon 1980
— (ed. J. Bony, trans. D. King), *The Art of the West, II: Gothic Art*, Oxford, 1980

Forsyth 1972
I. H. Forsyth, *The Throne of Wisdom: Wood Sculptures of the Madonna in Romanesque France*, Princeton, 1972

France 1989
J. France, ed. and trans., *Rodulfus Glaber, The Five Books of the Histories*, Oxford, 1989

Frankl 2000
P. Frankl (revised P. Crossley), *Gothic Architecture*, New Haven and London, 2000

Franklin 1983
J. A. Franklin, 'The Romanesque cloister sculpture at Norwich cathedral priory', in *Studies in Medieval Sculpture* (Society of Antiquaries Occasional Papers, new ser., 3), ed. F. H. Thompson, London, 1983, 56–70

Franklin 1996
—, 'The Romanesque sculpture', in Atherton et al. 1996, 116–35

Fraser 2005
I. Fraser, 'The tomb of the hero king: the death and burial of Robert I and the discoveries of 1818–19', in *Royal Dunfermline*, ed. R. Fawcett, Edinburgh, 2005

Freedberg 1989
D. Freedberg, *The Power of Images: Studies in the History and Theory of Response*, Chicago and London, 1989

Freeman 2005
T. S. Freeman, '"Ut verus Christi sequester": John Blacman and the cult of Henry VI', in *Of Mice and Men: Image, Belief and Regulation in Late Medieval England* (The Fifteenth Century, 5), ed. L. Clark, Woodbridge, 2005, 127–42

Freigang 1991
C. Freigang, 'Jean Deschamps et le Midi', *Bulletin monumental*, 149/4 (1991), 267–98

Freigang 1992
—, *Imitare Ecclesias Nobiles: die Kathedralen von Narbonne, Toulouse und Rodez und die nordfranzösische Rayonnant Gotik im Languedoc*, Worms, 1992

Freigang 1999
—, 'Die Expertisen zum Kathedralbau in Girona (1386 und 1416/17): Ammerkungen zur mittelalterlichen Debatte um Architektur', in *Gotische architektur in Spanien*, ed. C. Freigang, Frankfurt am Main and Madrid, 1999, 203–26

Freigang 2007
—, 'Changes in vaulting, changes in drawing: On the visual appearance of Gothic architecture around the year 1300', in Gajewski and Opačić 2007, 67–77

Freigang 2011
—, 'Imitatio in Gothic architecture: forms versus procedures', in Opačić and Timmermann 2011a, 297–313

Friedländer 1912
P. Friedländer, Johannes von Gaza und Paulus Silentarius: kunstbeschreibungen Justinianischer Zeit, Leipzig and Berlin, 1912

Frodl-Kraft 1972
E. Frodl-Kraft, 'Zu den Kirchenschaubildern in den Hochchorfenstern von Reims: Abbildung und Abstraktion', Wiener Jahrbuch für Kunstgeschichte, 35 (1972), 53–86

Fryde 1951
E. B. Fryde, 'The deposits of Hugh Despencer the Younger with the Italian bankers', Economic History Review, 2nd ser., 3 (1951), 344–62

Fuchss 1999
V. Fuchss, Das Altarensemble: eine Analyse des Kompositcharakters früh- und hochmittelalterlicher Altarausstattung, Weimar, 1999

Fuller 1662
T. Fuller, The History of the Worthies of England, London, 1662

Furnivall and Stone 1909
F. J. Furnival, and W. B. Stone, eds, The Tale of Beryn (Early English Text Society, extra ser., 105), London, 1909

Fyler 2007
J. M. Fyler, Language and the Declining World in Chaucer, Dante and Jean de Meun, Cambridge, 2007

Gage 1973
J. Gage, 'Horatian reminiscences in two twelfth-century art critics', Journal of the Warburg and Courtauld Institutes, 36 (1973), 359–60

Gage 1982
—, 'Gothic glass: two aspects of a Dionysian aesthetic', Art History, 5/1 (1982), 36–58

Gage 1993
—, Colour and Culture: Practice and Meaning from Antiquity to Abstraction, London, 1993

Gajewski and Opačić 2007
A. Gajewski and Z. Opačić, eds, The Year 1300 and the Creation of a New European Architecture, Turnhout, 2007

Gallet 2007
Y. Gallet, 'French Gothic, 1250–1350, and the paradigm of the motet', in Gajewski and Opačić 2007, 29–38

J. Gardner 1975
J. Gardner, 'Some cardinals' seals of the thirteenth century', Journal of the Warburg and Courtauld Institutes, 38 (1975), 72–96

J. Gardner 1988
—, 'A princess among prelates: a fourteenth-century Neapolitan tomb and its northern relations', Römisches Jahrbuch für Kunstgeschichte, 23–4 (1988), 31–60

J. Gardner 1992
—, The Tomb and the Tiara: Curial Tomb Sculpture in Rome and Avignon in the Later Middle Ages, Oxford, 1992

J. Gardner 2000
—, 'Legates, cardinals and kings: England and Italy in the thirteenth century', in L'Europa e l'arte italiana (Collana del Kunsthistorisches Institut in Florenz, 3), ed. M. Seidel, Venice, 2000, 74–93

J. Gardner 2002
—, 'Torriti's birds', in Medioevo: i modelli. Atti del convegno internazionale di studi: Parma, 27 settembre–1 ottobre 1999, ed. A. C. Quintavalle, Milan, 2002, 605–14

J. Gardner 2006
—, 'Opus Anglicanum, goldsmithswork, manuscript illumination and ivories in the Rome of Boniface VIII', in Le culture di Bonifacio VIII. Atti del convegno organizzato nell'ambito delle celebrazioni per il VII centenario della morte, Rome, 2006, 163–79

J. Gardner 2010a
—, 'A thirteenth-century Franciscan building contract', in Medioevo: le officine (I convegni di Parma, 12), ed. A. C. Quintavalle, Milan, 2010, 457–67

J. Gardner 2010b
—, '"Aedificia iam in regales surgunt altitudines": the mendicant great church in the Trecento', in Communes and Despots in Medieval and Renaissance Italy, ed. J. E. Law and B. Paton, Aldershot, 2010, 307–27

S. Gardner 1927
S. Gardner, English Gothic Foliage Sculpture, Cambridge, 1927

Garnett and Rosser 2013
J. Garnett and G. Rosser, Spectacular Miracles: Transforming Images in Italy, from the Renaissance to the Present, London, 2013

Garton 1986
C. Garton, ed. and trans., The Metrical Life of St Hugh, Lincoln, 1986

Gee 1979
L. L. Gee, '"Ciborium" tombs in England, 1290–1330', Journal of the British Archaeological Association, 3rd ser., 132 (1979), 29–41

Gee 2002
—, Women, Art and Patronage from Henry III to Edward III, 1216–1377, Woodbridge, 2002

Gehl 1983
P. F. Gehl, 'Texts and textures: dirty pictures and other things in medieval manuscripts', Corona, 3 (1983), 68–77

Gell 1992
A. Gell, 'The technology of enchantment and the enchantment of technology', in *Anthropology, Art and Aesthetics*, ed. J. Coote and A. Shelton, Oxford, 1992, 40–63

Gell 1998
—, *Art and Agency: An Anthropological Theory*, Oxford, 1998

Geltner 2004
G. Geltner, '*Faux Semblants*: antifraternalism reconsidered in Jean de Meun and Chaucer', *Studies in Philology*, 101/4 (2004), 357–80

Geltner 2008
—, ed. and trans., *William of Saint-Amour, De periculis novissimorum temporum* (Dallas Medieval Texts and Translations, 8), Paris and Leuven, 2008

Gem 1975
R. Gem, 'A recession in English architecture during the early eleventh century and its effect on the development of the Romanesque style', *Journal of the British Archaeological Association*, 38 (1975), 28–49

Gem 1983a
—, 'Towards an iconography of Anglo-Saxon architecture', *Journal of the Warburg and Courtauld Institutes*, 46 (1983), 1–18

Gem 1983b
—, 'The Romanesque cathedral of Winchester: patron and design in the eleventh century', in *Medieval Art and Architecture at Winchester Cathedral* (BAACT, 6), 1983, 1–12

Gem 1986
—, 'Lincoln Minster: *Ecclesia pulchra, Ecclesia fortis*', in *Medieval Art and Architecture at Lincoln Cathedral* (BAACT, 8), 1986, 9–29

Gem 1990
—, 'The Romanesque architecture of Old St Paul's Cathedral and its late eleventh-century context', in *Medieval Art and Architecture in London* (BAACT, 10), 1990, 47–63

Gem 1997
—, 'The Anglo-Saxon and Norman churches', in *Book of St Augustine's Abbey, Canterbury*, ed. R. Gem, London, 1997, 90–122

Gérard 1843
H. Gérard, ed., *Chronique Latine de Guillaume de Nangis de 1113 à 1300* (Société de l'Histoire de France), 2 vols, Paris, 1843

Geremek 1987
B. Geremek (trans. J. Birrell), *The Margins of Society in Late Medieval Paris*, Cambridge, 1987

Gibbs and L'Engle 2001
R. Gibbs and S. L'Engle, *Illuminating the Law: Medieval Legal Manuscripts in Cambridge Collections*, London and Turnhout, 2001

Gilchrist 2005
R. Gilchrist, *Norwich Cathedral Close: The Evolution of the English Cathedral Landscape*, Woodbridge, 2005

Gillerman 1977
D. W. Gillerman, *The Clotûre of Notre-Dame and its Role in the Fourteenth Century Choir Program*, New York, 1977

Gilson 1921
E. Gilson, *Etudes de philosophie médiévale*, Strasbourg, 1921

Girard 1936–7
J. Girard, 'La construction de l'église Saint-Didier d'Avignon', *Bulletin archéologique*, 1936–7, 631–49

Givens 1998
J. A. Givens, 'The leaves of Southwell revisited', in *Southwell and Nottinghamshire: Medieval Art, Architecture and Industry* (BAACT, 21), 1998, 61–6

Givens 2005
—, *Observation and Image-Making in Gothic Art*, Cambridge, 2005

Glass 1980
D. F. Glass, *Studies on Cosmatesque Pavements*, Oxford, 1980

Goldie 2006
M. Goldie, 'The context of the *The Foundations*', in *Rethinking the Foundations of Modern Political Thought*, ed. A. Brett and J. Tully, with H. Hamilton-Bleakley, Cambridge, 2006, 3–19

Gombrich 2002
E. Gombrich, *The Sense of Order: A Study in the Psychology of Decorative Art*, 2nd edn, London, 2002

González Jiménez 1991
M. González Jiménez, ed., *Diplomatario andaluz de Alfonso X*, Seville, 1991

J. Goodall 1995
J. Goodall, 'A study of the grotesque 14th-century sculpture at Adderbury, Bloxham and Hanwell in its architectural context', *Oxoniensia*, 60 (1995), 271–332

J. Goodall 2011
—, *The English Castle, 1066–1650*, New Haven and London, 2011

J. A. Goodall 1997
J. A. Goodall, 'Heraldry in the decoration of English medieval manuscripts', *Antiquaries Journal*, 77 (1997), 179–220

Gould 1978
K. Gould, *The Psalter and Hours of Yolande of Soissons*, Cambridge, MA, 1978

Grabar 1989
O. Grabar, *The Mediation of Ornament* (Bollingen Series, 35), Princeton, 1989

Gransden 1972
A. Gransden, 'Realistic observation in twelfth-century England', *Speculum*, 47/1 (1972), 29–51

Gransden 1982

—, *Historical Writing in England, II: c.1307 to the early sixteenth century*, London, 1982

Grant 2000

L. Grant, 'Naming of parts: describing architecture in the High Middle Ages', in *Architecture and Language: Constructing Identity in European Architecture, c.1000–c.1650*, ed. G. Clarke and P. Crossley, Cambridge, 2000, 46–57

Grant 2005

—, *Architecture and Society in Normandy, 1120–1270*, New Haven and London, 2005

Grässe 1972

J. G. T. Grässe, *Orbis Latinus: lexikon lateinischer geographischer Namen des Mittelalters und der Neuzeit*, 3 vols, Brunswick, 1972

Greatrex 1997

J. Greatrex, *Biographical Register of the English Cathedral Priories of the Province of Canterbury, c.1066 to 1540*, Oxford, 1997

Greenhalgh 2009

M. Greenhalgh, *Marble Past, Monumental Present: Building with Antiquities in the Mediaeval Mediterranean*, Leiden and Boston, MA, 2009

Greenway 2002

D. E. Greenway, ed. and trans., *Henry, Archdeacon of Huntingdon, Historia Anglorum/The History of the English People*, Oxford, 2002

Greenway, Holdsworth and Sayer 1985

—, C. J. Holdsworth and J. E. Sayer, eds, *Tradition and Change: Essays in Honour of Marjorie Chibnall Presented by her Friends on the Occasion of her Seventieth Birthday*, Cambridge, 1985

Griffiths 1981

R. A. Griffiths, *The Reign of King Henry VI: The Exercise of Royal Authority, 1422–1461*, London, 1981

Grössinger 1997

C. Grössinger, *The World Turned Upside-Down: English Misericords*, London, 1997

Guerout 1950

J. Guerout, 'Le palais de la Cité à Paris des origines à 1417: essai topographique et archéologique', *Mémoires: Fédération des Sociétés historiques et archéologiques, Paris et de l'Ile-de-France*, 2 (1950), 21–204

Guest 1995

G. B. Guest, *Bible moralisée: Codex Vindobonensis 2554, Vienna Österreichische Nationalbibliothek*, London, 1995

Guidi 1878

I. Guidi, 'La descrizione di Roma nei geografi arabi', *Archivio della Società Romana di storia patria*, 1 (1878), 173–218

Guillouët 2009

J.-M. Guillouët, 'Les transferts artistiques: un outil opératoire pour l'histoire de l'art médiévale', *Histoire de l'art*, 64 (2009), 17–25

Guillouët 2011

—, *Le portail de Santa Maria da Vitória de Batalha et l'art européen de son temps* (Portugalia sacra, 1), Leiria, 2011

Gummer 2009

B. Gummer, *The Scourging Angel: The Black Death in the British Isles*, London, 2009

Gunton 1696/1990

S. Gunton, *The History of the Church of Peterburgh* [1696], facsimile edn, Peterborough, 1990

Gutiérrez Baños 2005

F. Gutiérrez Baños, 'Un castellano en la corte de Enrique III de Inglaterra: relaciones entre la escuela de Salamanca y el círculo cortesano de Westminster', *Bolétin del seminario de estudios de arte y arquologia-arte*, 71 (2005), 13–64

Hageneder and Haidacher 1964

O. Hageneder and A. Haidacher, eds, *Die Register Innocenz III, 1: Pontifikatsjahr, 1198/99*, Graz and Cologne, 1964

C. Hall and Lovatt 1989

C. Hall and R. Lovatt, 'The site and foundation of Peterhouse', *Proceedings of the Cambridge Antiquarian Society*, 78 (1989), 5–46

M. B. Hall 1974

M. B. Hall, 'The *Tramezzo* in Santa Croce, reconstructed', *Art Bulletin*, 56/3 (1974), 325–41

Halsey 1985

R. Halsey, 'Tewkesbury Abbey: some recent observations', in *Medieval Art and Architecture at Gloucester and Tewkesbury* (BAACT, 7), 1985, 16–35

Hamburger 1990

J. F. Hamburger, *The Rothschild Canticles: Art and Mysticism in Flanders and the Rhineland circa 1300*, New Haven and London, 1990

Hamburger 1993

—, review of Camille 1992, *Art Bulletin*, 75/2 (1993), 319–27

Hamburger 1998

—, *The Visual and the Visionary: Art and Female Spirituality in Late Medieval Germany*, New York, 1998

Hamburger 2006a

—, 'The place of theology in medieval art history: problems, positions, possibilities', in *The Mind's Eye: Art and Theological Argument in the Middle Ages*, ed. Hamburger and A.-M. Bouché, Princeton, 2006, 11–31

Hamburger 2006b

—, 'The medieval work of art: wherein the "Work", wherein the "Art"?', in *The Mind's Eye: Art and Theological Argument in the Middle Ages*, ed. Hamburger and A.-M. Bouché, Princeton, 2006, 374–412

Hanna 2005

R. Hanna, *London Literature, 1300–1380*, Cambridge, 2005

Hansen 2008
M. B. Hansen, 'Benjamin's aura', *Critical Enquiry*, 34 (2008), 336–75

Harper-Bill 1996
C. Harper-Bill, 'The English Church and English religion after the Black Death', in Lindley and Ormrod 1996, 79–123

Harper-Bill and Rawcliffe 2004
— and C. Rawcliffe, 'The religious houses', in Rawcliffe and Wilson 2004, 73–119

Harries 2011
S. Harries, *Nikolaus Pevsner: The Life*, London, 2011

Harris 1987
J. Harris, '"Thieves, Harlots and Stinking Goats": fashionable dress and aesthetic attitudes in Romanesque art', *Costume*, 21 (1987), 4–15

Harris 1998
—, '"Estroit vestu et menu cosu": evidence for the construction of twelfth-century dress', in *Medieval Art: Recent Perspectives. A Memorial Tribute to C. R. Dodwell*, ed. G. R. Owen-Crocker and T. Graham, Manchester, 1998, 89–103

Harriss 2005
G. L. Harriss, *Shaping the Nation: England, 1360–1461*, Oxford, 2005

B. F. Harvey 1966
B. F. Harvey, 'The population trend in England between 1300 and 1348', *Transactions of the Royal Historical Society*, 5th ser., 16 (1966), 23–42

B. F. Harvey 1991
—, 'Introduction: the "crisis" of the early fourteenth century', in Campbell 1991, 1–24

B. F. Harvey 1993
—, *Living and Dying in England, 1100–1540: The Monastic Experience*, Oxford, 1993

J. H. Harvey 1944
—, *Henry Yevele, c.1320 to 1400: The Life of an English Architect*, London, 1944

J. H. Harvey 1946
—, 'St Stephen's Chapel and the origin of the Perpendicular Style', *Burlington Magazine*, 88 (1946), 192–9

J. H. Harvey 1947
—, *Gothic England: A Survey of National Culture, 1300–1550*, London, 1947

J. H. Harvey 1950
—, *The Gothic World, 1100–1600*, London, 1950

J. H. Harvey 1961
—, 'The origin of the Perpendicular Style', in *Studies in Building History*, ed. E. M. Jope, London, 1961, 134–65

J. H. Harvey 1969
—, ed., *William Worcestre, Itineraries*, Oxford, 1969

J. H. Harvey 1978
—, *The Perpendicular Style, 1330–1485*, London, 1978

J. H. Harvey 1987
—, *English Mediaeval Architects: A Biographical Dictionary down to 1550*, 2nd edn, Hulverston, 1987

M. M. Harvey 1999
M. M. Harvey, *The English in Rome, 1362–1420: Portrait of an Expatriate Community*, Cambridge, 1999

Hassall 1954
W. O. Hassall, *The Holkham Bible Picture Book*, London, 1954

Hastings 1949
J. M. Hastings, 'The Court Style', *Architectural Review*, 105 (1949), 3–9

Hastings 1955
—, *St Stephen's Chapel and its Place in the Development of Perpendicular Style in England*, Cambridge, 1955

Hatcher 1977
J. Hatcher, *Plague, Population and the English Economy, 1348–1530*, London, 1977

Hatcher 1994
—, 'England in the aftermath of the Black Death', *Past and Present*, 144 (1994), 3–35

Hatcher 2011
—, 'Unreal wages: long-run living standards and the "Golden Age" of the fifteenth century', in *Commerical Activity, Markets and Entrepreneurs in the Middle Ages: Essays in Honour of Richard Britnell*, ed. B. Dodd and C. D. Liddy, Woodbridge, 2011, 1–24

Hatcher and Bailey 2001
— and M. Bailey, *Modelling the Middle Ages: The History and Theory of England's Economic Development*, Oxford, 2001

Haussherr 1968
R. Haussherr, '*Templum Salamonis* und *Ecclesia Christi*: zu einem Bildvergleich der Bible Moralisée', *Zeitschrift für Kunstgeschichte*, 31/2 (1968), 101–21

Hayden 1863
E. S. Hayden, ed., *Eulogium Historiarum* (Rolls Series, 9), vol. 3, London, 1863

Hedeman 1991
A. Hedeman, *The Royal Image: Illustrations of the Grandes Chroniques de France, 1274–1422*, Berkeley, CA, 1991

Heighway and Bryant 2007
C. Heighway and R. Bryant, *The Tomb of Edward II: A Royal Monument in Gloucester Cathedral*, Stonehouse, 2007

Henderson 1985a
G. Henderson, *Studies in English Bible Illustration*, 2 vols, London, 1985

Henderson 1985b
—, 'The imagery of St Guthlac of Crowland', in *England in the Thirteenth Century: Proceedings of the 1984 Harlaxton Symposium*, ed. W. M. Ormrod, Harlaxton, 1985, 76–94

Henry 1990
A. Henry, *The Eton Roundels: Eton College MS 177*, Aldershot, 1990

Heslop 1980
T. A. Heslop, 'The episcopal seals of Richard of Bury', in *Medieval Art and Architecture at Durham Cathedral* (BAACT, 3), 1980, 154–62

Heslop 1998
—, 'Late twelfth-century writing about art, and aesthetic relativity', in *Medieval art: Recent Perspectives. A Memorial Tribute to C. R. Dodwell*, ed. G. R. Owen-Crocker and T. Graham, Manchester, 1998, 129–41

Heslop 2001
—, 'Worcester Cathedral chapterhouse and the harmony of the Testaments', in Binski and Noel 2001, 280–311

Heslop 2005
—, 'The English origins of the *Coronation of the Virgin*', *Burlington Magazine*, 147 (2005), 790–97

Heslop 2013
—, 'St Anselm and the visual arts at Canterbury Cathedral, 1093–1109', in *Medieval Art, Architecture and Archaeology at Canterbury* (BAACT, 35), 2013, 59–81

Hetherington 1974
P. Hetherington, trans., *The 'Painter's Manual' of Dionysius of Forna*, London, 1974

Hewett 1985
C. A. Hewett, *English Cathedral and Monastic Carpentry*, Oxford, 1985

Heywood and Wright 1850
J. Heywood and T. Wright, *The Ancient Laws of the Fifteenth Century for King's College, Cambridge, and for the Public School of Eton College*, London, 1850

Hillenbrand 1999
R. Hillenbrand, *Islamic Art and Architecture*, London, 1999

Hilton 1973
R. H. Hilton, *Bond Men Made Free: Medieval Peasant Movements and the English Rising of 1381*, London, 1973

Hinnebusch 1951
W. Hinnebusch, *The Early English Friar Preachers*, Rome, 1951

Hiscock 2000
N. Hiscock, *The Wise Master Builder*, Aldershot, 2000

Hiscock 2003
—, ed., *The White Mantle of Churches: Architecture, Liturgy and Art around the Millennium*, Turnhout, 2003

Hocquet 1924
A. Hocquet, *Le rayonnement de l'art tournaisien aux XIIIe et XIVe siècles*, Tournai, 1924

Hodges 2000
L. F. Hodges, *Chaucer and Costume*, Woodbridge, 2000

Hoeniger 1995
C. Hoeniger, *The Renovation of Paintings in Tuscany, 1250–1500*, Cambridge, 1995

Hoey 1986
L. Hoey, 'Pier alternation in Early English Gothic architecture', *Journal of the British Archaeological Association*, 139 (1986), 45–67

Hoffmann et al. 2006
G. Hoffmann et al., *Das Gabelkreuz in St. Maria im Kapitol zu Köln und das Phänomen der Crucifixi dolorosi in Europa*, Worms, 2006

Hogarth 1753
W. Hogarth, *The Analysis of Beauty*, London, 1753

Horrox 1994
R. Horrox, ed. and trans., *The Black Death*, Manchester, 1994

Horrox 2000
—, ed., *Beverley Minster: An Illustrated History*, Beverley, 2000

Horrox and Ormrod 2006
— and W. M. Ormrod, eds, *A Social History of England, 1200–1500*, Cambridge, 2006

Hourihane 2012
C. Hourihane, ed., *From Major to Minor: The Minor Arts in Medieval Art History* (Index of Christian Art Occasional Papers, 14), Princeton, 2012

Hourihane 2013
—, ed., *Patronage: Power and Agency in Medieval Art* (Index of Christian Art Occasional Papers, 15), Princeton, 2013

D. Howard 2000
D. Howard, *Venice and the East: The Impact of the Islamic World on Venetian Architecture, 1100–1500*, New Haven and London, 2000

H. Howard 2003
H. Howard, *Pigments of English Medieval Wall Paintings*, London, 2003

Howe et al. 2012
E. Howe et al, *Wall Paintings of Eton*, London, 2012

Hubbell 1949
H. M. Hubbell, trans., *Cicero, De inventione*, Cambridge, MA, and London, 1949

Huffman 1998
J. P. Huffman, *Family, Commerce and Religion in London and Cologne: Anglo-German Emigrants, c.1000–c.1300*, Cambridge, 1998

Hull 1994
C. Hull, 'The Douai Psalter and Related Manuscripts',
unpublished PhD dissertation, Yale University, 1994

Hull 2001
—, 'Abbot John, Vicar Thomas and M. R. James: the early
history of the Douai Psalter', in *The Legacy of M. R. James:
Papers from the 1995 Cambridge Symposium*, ed. L. Dennison,
Donington, 2001, 118–27

Hunt 1994
E. S. Hunt, *The Medieval Super-Companies: A Study of the Peruzzi
Company of Florence*, Cambridge, 1994

Hunter 1842
J. Hunter, 'On the death of Eleanor of Castile, consort of King
Edward the First, and the honours paid to her memory',
Archaeologia, 29 (1842), 167–91

Hurwood 1968
B. J. Hurwood, trans., *The Facetiae*, New York, 1968

Hutchins 1995
E. Hutchins, *Cognition in the Wild*, Cambridge, MA, 1995

Hutchinson 1974
G. E. Hutchinson, 'Attitudes towards nature in medieval England:
the Alphonso and Bird Psalters', *Isis*, 65/1 (1974), 5–37

Hutton 1950
E. Hutton, *The Cosmati: The Roman Marble Workers of the XIIth
and XIIIth Centuries*, London, 1950

Huygens 1970
R. B. C. Huygens, ed., *Magister Gregorius (12e ou 13e siècle),
Narracio de mirabilibus urbis Romae*, Leiden, 1970

Hyde 1965–6
J. K. Hyde, 'Medieval descriptions of cities', *Bulletin of the John
Rylands Library*, 48 (1965–6), 308–40

Imsen 2003
S. Imsen, ed., *Ecclesia Nidrosiensis, 1153–1537: Søkelys på
Nidaroskirkens og Nidarosprovinsens historie* (Senter for
middelalderstudier, 15), Trondheim, 2003

Inglis 2003
E. Inglis, 'Gothic architecture and a scholastic: Jean de Jandun's
Tractatus de laudibus Parisius (1323)', *Gesta*, 42/1 (2003), 63–85

Irvine 2004
S. Irvine, ed., *The Anglo-Saxon Chronicle: A Collaborative Edition*,
Woodbridge, 2004

Isnard 2010
I. Isnard, 'Un cas d'utilisation de modèle architectural vers 1300
en Champagne: l'exemple des collégiales Saint-Urbain de
Troyes et Saint-Pierre-aux-Liens de Mussy-sur-Seine',
Zeitschrift für Kunstgeschichte, 73 (2010), 19–40

Jaeger 1985
C. S. Jaeger, *The Origins of Courtliness: Civilizing Trends and the
Formation of Courtly Ideals, 939–1210*, Philadelphia, 1985

Jaeger 1994
—, *The Envy of Angels: Cathedral Schools and Social Ideals in
Medieval Europe, 950–1200*, Philadelphia, 1994

Jaeger 1997
—, 'Charismatic body–charismatic text', *Exemplaria*, 9/1 (1997),
117–37

Jaeger 2010
—, ed., *Magnificence and the Sublime in Medieval Aesthetics: Art,
Architecture, Literature, Music*, New, York 2010

Jaeger 2012
—, *Enchantment: On Charisma and the Sublime in the Arts of the
West*, Philadelphia, 2012

J. James 1981
J. James, *The Contractors of Chartres*, London, 1981

J. James 1984
—, 'An investigation into the uneven distribution of Early
Gothic churches in the Paris Basin, 1140–1240', *Art Bulletin*,
66/1 (1984), 15–46

J. James 1989
—, *The Template-Makers of the Paris Basin*, West Grinstead, 1989

M. R. James 1895a
M. R. James, *The Sculptures in the Lady Chapel at Ely*, London,
1895

M. R. James 1895b
—, *On the Abbey of St Edmund at Bury* (Cambridge Antiquarian
Society, 28), Cambridge, 1895

M. R. James 1895c
—, *A Descriptive Catalogue of the Manuscripts in the Library of
Sidney Sussex College, Cambridge*, Cambridge, 1895

M. R. James 1897
—, 'On the paintings formerly in the choir at Peterborough',
Proceedings of the Cambridge Antiquarian Society, 9 (1897), 178–94

M. R. James 1901
—, *The Verses Formerly Inscribed on Twelve Windows in the Choir of
Canterbury Cathedral*, Cambridge, 1901

M. R. James 1903
—, *The Ancient Libraries of Canterbury and Dover*, Cambridge, 1903

M. R. James 1911
—, *The Sculptured Bosses in the Cloisters of Norwich Cathedral*,
Norwich, 1911

M. R. James 1912
—, *A Descriptive Catalogue of the Manuscripts in the Library of
Corpus Christi College, Cambridge*, vol. 1, Cambridge, 1912

M. R. James 1913
—, *De nobilitatibus, sapientiis, et prudentiis regum: Reproduced in Facsimile from the MS Preserved at Christ Church, Oxford*, Oxford, 1913

M. R. James 1919
—, ed. and trans., *Henry the Sixth: A Reprint of John Blacman's Memoir*, Cambridge, 1919

M. R. James 1921a
—, *A Peterborough Psalter and Bestiary of the Fourteenth Century*, Oxford, 1921

M. R. James 1921b
—, *Illustrations of the Book of Genesis*, Oxford, 1921

M. R. James 1951
—, 'Pictor in Carmine', *Archaeologia*, 94 (1951), 141–66

Janes and Singer 2010
D. Janes and S. A. Singer, eds, *Walsingham in Literature and Culture from the Middle Ages to Modernity*, Farnham, 2010

Jay 1993
M. Jay, *Downcast Eyes: The Denigration of Vision in Twentieth-century French Thought*, Berkeley, CA, and London, 1993

Jeauneau 1967
E. Jeauneau, '"Nani gigantum humeris insidentes": essai d'interprétation de Bernard de Chartres', *Vivarium*, 5 (1967), 79–99

Jennings 1968
J. C. Jennings, 'The origins of the "Elements Series" of the Miracles of the Virgin', *Mediaeval and Renaissance Studies*, 6 (1968), 84–93

Jessopp and James 1896
A. Jessopp and M. R. James, *The Life and Miracles of St William of Norwich*, Cambridge, 1896

Johnson 1967
H. T. Johnson, 'Cathedral building and the medieval economy', in *Explorations in Entrepreneurial History*, 2nd ser., 4/3 (1967), 191–210

A. A. Jordan 2002
A. A. Jordan, *Visualizing Kingship in the Windows of the Sainte-Chapelle*, Turnhout, 2002

W. C. Jordan 1996
W. C. Jordan, *The Great Famine: Northern Europe in the Early Fourteenth Century*, Princeton, 1996

Joslin and Watson 2001
M. C. Joslin and C. C. Watson, *The Egerton Genesis*, London, 2001

Kamerick 2002
K. Kamerick, *Popular Piety and Art in the Late Middle Ages: Image Worship and Idolatry in England, 1350–1500*, New York, 2002

Kantorowicz 1965
E. H. Kantorowicz, 'The sovereignty of the artist: a note on legal maxims and Renaissance theories of art', in Kantorowicz, *Selected Studies*, New York, 1965, 352–65

Kauffmann 1994
C. M. Kauffmann, 'Art and popular culture: new themes in the Holkham Bible Picture Book', in Buckton and Heslop 1994, 46–69

Kauffmann 2003
—, *Biblical Imagery in Medieval England, 700–1500*, London and Turnhout, 2003

Kauffmann 2004
—, 'The Sainte-Chapelle lectionaries and the illustration of the parables in the Middle Ages', *Journal of the Warburg and Courtauld Institutes*, 67 (2004), 1–22

Kavaler 2005
E. M. Kavaler, 'Nature and the chapel vaults at Ingolstadt: structuralist and other perspectives', *Art Bulletin*, 87/2 (2005), 230–48

Kavaler 2008
—, 'Architectural wit: playfulness and deconstruction in the Gothic of the sixteenth century', in Reeve 2008, 139–50

Kavaler 2012
—, *Renaissance Gothic: Architecture and the Arts in Gothic Europe, 1470–1540*, New Haven and London, 2012

Kaye 2000
J. Kaye, *Economy and Nature in the Fourteenth Century: Money, Market Exchange and the Emergence of Scientific Thought*, Cambridge, 2000

Keen 1979
L. Keen, 'The fourteenth-century tile pavements in Prior Crauden's Chapel and in the south transept', in *Medieval Art and Architecture at Ely Cathedral* (BAACT, 2), 1979, 47–57

Keene 1990
D. Keene, 'Shops and shopping in medieval London', in *Medieval Art and Architecture in London* (BAACT, 10), 1990, 29–46

Keene, Burns and Saint 2004
—, A. Burns and A. Saint, eds, *St Paul's: The Cathedral Church of London, 604–2004*, New Haven and London, 2004

Kelly 1966
D. Kelly, 'The scope of the treatment of composition in the twelfth- and thirteenth-century arts of poetry', *Speculum* 41/2 (1966), 261–78

Kelly 1978
—, 'Topical invention in medieval French literature', in *Medieval Eloquence: Studies in the Theory and Practice of Medieval Rhetoric*, ed. J. J. Murphy, Berkeley, CA, 1978, 231–51

E. W. Kemp 1947
E. W. Kemp, *Canonization and Authority in the Western Church*, Oxford, 1947

M. Kemp 1977
M. Kemp, 'From "Mimesis" to "Fantasia": the Quattrocento vocabulary of creation, inspiration and genius in the visual arts', *Viator*, 8 (1977), 347–98

M. Kemp 2012
—, *Christ to Coke: How Image Becomes Icon*, Oxford, 2012

Kendrick 1983
L. Kendrick, 'Rhetoric and the rise of public poetry: the career of Eustache Deschamps', *Studies in Philology*, 80/1 (1983), 1–13

Kendrick 1988
—, *The Game of Love: Troubadour Wordplay*, Berkeley, CA, 1988

Kendrick 1999
—, *Animating the Letter: The Figurative Embodiment of Writing from Late Antiquity to the Renaissance*, Columbus, 1999

Kendrick 2006
—, 'Making sense of marginalized images in manuscripts and religious architecture', in Rudolph 2006, 274–94

Ker 1949
N. R. Ker, 'Medieval manuscripts from Norwich cathedral priory', *Transactions of the Cambridge Bibliographical Society*, 1/1 (1949), 1–28

Kern 2000
H. Kern, *Through the Labyrinth: Designs and Meanings over 5,000 Years*, Munich, 2000

Kerr 1985
J. Kerr, 'The east window of Gloucester Cathedral', in *Medieval Art and Architecture at Gloucester and Tewkesbury* (BAACT, 7), 1985, 116–29

Kershaw 1973
I. Kershaw, 'The Great Famine and agrarian crisis in England, 1315–1322', *Past and Present*, 59 (1973), 3–50

Kessler 2000
H. L. Kessler, *Spiritual Seeing: Picturing God's Invisibility in Medieval Art*, Philadelphia, 2000

Kevin et al. 2008
P. Kevin et al., 'A musical instrument fit for a queen: the metamorphosis of a medieval citole', *British Museum Technical Research Bulletin*, 2 (2008), 13–28

Kidson 1985
P. Kidson, 'The abbey church of St Mary at Tewkesbury in the eleventh and twelfth centuries', in *Medieval Art and Architecture at Gloucester and Tewkesbury* (BAACT, 7), 1985, 6–15

Kidson 1987
—, 'Panofsky, Suger and St-Denis', *Journal of the Warburg and Courtauld Institutes*, 50 (1987), 1–17

Kidson 1993
—, 'Gervase, Becket and William of Sens', *Speculum*, 68 (1993), 969–91

Kidson, Murray and Thompson 1965
—, P. Murray and P. Thompson, *A History of English Architecture*, Harmondsworth, 1965

Kimpel 1977
D. Kimpel, 'Le développement de la taille en série dans l'architecture médiévale et son rôle dans l'histoire économique', *Bulletin Monumental*, 135/3 (1977), 195–222

Kimpel 1986
—, 'La sociogenèse de l'architecte moderne', in *Artistes, artisans et production artistique au moyen âge, I: les hommes*, ed. X. Barral i Altet, Paris, 1986, 135–61

Kimpel and Suckale 1990
— and R. Suckale (trans. F. Neu), *L'architecture gothique en France, 1130–1270*, Paris, 1990

D. King 2010
D. King, 'John de Warenne, Edmund Gonville and the Thetford Dominican altar paintings', in *Tributes to Nigel Morgan: Contexts of Medieval Art: Images, Objects and Ideas*, ed. J. M. Luxford and M. A. Michael, London and Turnhout, 2010, 293–306

P. M. King 1990
P. M. King, 'The cadaver tomb in England: novel manifestations of an old idea', *Journal of the Church Monuments Society*, 5 (1990), 26–38

Kinney 2005
D. Kinney, 'Spolia', in *St Peter's in the Vatican*, ed. W. Tronzo, Cambridge, 2005, 16–47

Kinney 2006
—, 'Rome in the twelfth century: *urbs fracta* and *renovatio*', *Gesta*, 45/2 (2006), 199–220

Kinney 2007
—, 'Bearers of meaning', *Jahrbuch für Antike und Christentum*, 50 (2007), 139–53

Kinney 2011
—, 'The discourse of columns', in *Rome across Time and Space: Cultural Transmission and the Exchange of Ideas, c.500–1400*, ed. C. Bolgia, R. McKitterick and J. Osborne, Cambridge, 2011, 182–99

H. A. Klein 2010
H. A. Klein, 'Refashioning Byzantium in Venice, ca.1200–1400', in *San Marco, Byzantium and the Myths of Venice*, ed. H. Maguire and R. S. Nelson, Washington, DC, 2010, 193–225

P. Klein 1983
P. Klein, *Vollständige Faksimile-Ausgabe im Originalformat der Handschrift Ms. Douce 180*, 2 vols, Graz, 1983

Knapp 2008
P. A. Knapp, *Chaucerian Aesthetics*, Basingstoke, 2008

Kneale 1955
W. C. Kneale, 'The idea of invention', *Proceedings of the British Academy*, 41 (1955), 85–108

Knoop and Jones 1967
D. Knoop and G. P. Jones, *The Mediaeval Mason*, Manchester, 1967

Knoop, Jones and Hamer 1938
—, — and D. Hamer, eds, *The Two Earliest Masonic MSS*, Manchester, 1938

Kowa 1990
G. Kowa, *Architektur der englischen Gotik*, Cologne, 1990

Krämer 2007
S. Krämer, *Herrschaftliche Grablege und lokaler Heiligenkult: Architektur des englischen Decorated Style*, Munich, 2007

Kratzke and Albrecht 2008
C. Kratzke and U. Albrecht, eds, *Mikroarchitektur im Mittelalter: ein gattungsübergreifendes Phänomen zwischen Realität und Imagination*, Leipzig, 2008

Kraus 1979
H. Kraus, *Gold was the Mortar: The Economics of Cathedral Building*, New York, 1979

Krautheimer 1942
R. Krautheimer, 'Introduction to an "Iconography of Mediaeval Architecture"', *Journal of the Warburg and Courtauld Institutes*, 5 (1942), 1–33

Krautheimer 1953
—, 'Sancta Maria Rotunda', in *Arte del primo millennio. Atti del IIo convegno per lo studio dell'arte dell'alto medioevo*, ed. E. Arslan, Turin, 1953, 21–7

Krautheimer 1986
—, *Early Christian and Byzantine Architecture*, Harmondsworth, 1986

Kreider 1979
A. Kreider, *English Chantries: The Road to Dissolution*, Cambridge, MA, and London, 1979

Krinsky 1970
C. H. Krinsky, 'Representations of the Temple of Jerusalem before 1500', *Journal of the Warburg and Courtauld Institutes*, 133 (1970), 1–19

Kroesen and Steensma 2012
J. Kroesen and R. Steensma, *The Interior of the Medieval Village Church*, 2nd edn, Leuven, 2012

Kuczynski 1995
M. P. Kuczynski, *Prophetic Song: The Psalms as Moral Discourse in Late Medieval England*, Philadelphia, 1995

Kumler 2011
A. Kumler, *Translating Truth: Ambitious Images and Religious Knowledge in Late Medieval France and England*, New Haven and London, 2011

Kunze 2003
M. Kunze, ed., *Die sieben Weltwunder der Antike*, Mainz, 2003

Kurmann 1986
P. Kurmann, 'Spätgotische Tendenzen in der europäischen Architeektur um 1300', in *Europäische Kunst um 1300. Akten des XXV internationalen Kongresses für Kunstgechichte, 1983*, ed. G. Schmidt, vol. 6, Vienna, 1986, 11–18

Kurmann 1989
—, 'Gauthier de Varinfroy et le problème du style personnel d'un architecte au XIIIe siècle', in Recht 1989, 187–94

Kurmann 1996a
—, 'Cathédrale miniature ou reliquaire monumental? L'architecture de la châsse de sainte Gertrude', in *Un trésor gothique: la châsse de Nivelles*, Paris, 1996, 135–53

Kurmann 1996b
—, 'Gigantomanie und Miniatur: Möglichkeiten gotischer Architektur zwischen Grossbau und Kleinkunst', *Kölner Domblatt*, 61 (1996), 123–46

E. M. Labande 1981
E. M. Labande, ed., *Guibert de Nogent, Autobiographie* (Les classiques de l'histoire de France au Moyen Age, 34), Paris, 1981

L. H. Labande 1893
L. H. Labande, 'Le cérémonial romain de Jacques Cajétan: les donées historiques qu'il renferme', *Bibliothèque de l'école des Chartes*, 44 (1893), 45–74

Lacarra 1974
I. M. C. Lacarra, *Aportación al estudio de la pintura gótica en Navarra*, Pamplona, 1974

Lachaud 2002
F. Lachaud, 'Dress and social status in England before the Sumptuary Laws', in *Heraldry, Pageantry and Social Display in Medieval England*, ed. P. Coss and M. Keen, Woodbridge, 2002, 105–23

Łanowski 1965
J. Łanowski, 'Weltwunder', in A. Pauly et al., *Realencyclopädie der classischen Altertumswissenschaft*, supp. vol. 10, Stuttgart, 1965, cols 1020–30

Lasko and Morgan 1973
P. Lasko and N. J. Morgan, eds, *Medieval Art in East Anglia, 1300–1520*, Norwich, 1973

Layton 2005
R. Layton, 'Structure and agency in art', in *Les cultures à l'oeuvre: rencontres en art*, ed. M. Coquet, B. Derlon and M. Jeudy-Ballini, Paris, 2005, 29–47

Leech-Wilkinson 1993
D. Leech-Wilkinson, 'Le Voir Dit and La Messe de Nostre Dame: aspects of genre and style in late works of Machaut', *Plainsong and Medieval Music*, 2/1 (1993), 43–73

Leedy 1980
W. C. Leedy, *Fan Vaulting: A Study of Form, Technology and Meaning*, London, 1980

Lefèvre-Pontalis 1904
E. Lefèvre-Pontalis, 'Jean Langlois, architecte de Saint-Urbain de Troyes', *Bulletin monumental*, 68 (1904), 93–108

Legner 1985
A. Legner, *Ornamenta ecclesiae: Kunst und Künstler der Romanik*, 3 vols, Cologne, 1985

Le Goff 1981
J. Le Goff (trans. A. Goldhammer), *The Birth of Purgatory*, Aldershot, 1981

Lehmann-Brockhaus 1955–60
O. Lehmann-Brockhaus, ed., *Lateinische Schriftquellen zur Kunst in England, Wales und Schottland vom Jahre 901 bis zum Jahre 1307*, 5 vols, Munich, 1955–60

Leland 1745
J. Leland, *The Itinerary*, 9 vols, London, 1745

L'Engle 2006
S. L'Engle, 'Outside the canon: graphic and pictorial digressions by artists and scribes', in *Tributes to Jonathan J. G. Alexander: The Making and Meaning of Illuminated Medieval and Renaissance Manuscripts, Art and Architecture*, ed. S. L'Engle and G. Guest, Turnhout, 2006, 69–77

Le Pogam 2009
P.-Y. Le Pogam, with C. Vivet-Peclet, eds, *Les premiéres retables (XIIe–début du XVe siècle)*, Paris, 2009

Le Roux de Lincy and Tisserand 1867
A. Le Roux de Lincy and L. M. Tisserand, *Paris et ses historiens aux XIVe at XVe siècles*, Paris, 1867

Lethaby 1906
W. R. Lethaby, *Westminster Abbey and the King's Craftsmen*, London, 1906

Lethaby 1925
—, *Westminster Abbey Re-examined*, London, 1925

Lethaby 1930
—, 'Old Saint Paul's', *The Builder*, 139 (1930), 193–4, 234–6, 393–5, 791–3

Leuker 1997
T. Leuker, '"Zwerge aus den Schultere von Riesen": zur Enstehung des berühmten vergleichs', *Millellateinisches Jahrbuch: Internationale Zeitschrift für Mediävistik*, 32/1 (1997), 71–6

B. Lewis 1957
B. Lewis, 'The Muslim discovery of Europe', *Bulletin of the School of Oriental and African Studies*, 20 (1957), 409–16

S. Lewis 1986
S. Lewis, '*Tractatus Adversus Judaeos* in the Gulbenkian Apocalypse', *Art Bulletin*, 68/4 (1986), 543–66

S. Lewis 1990
—, 'The Apocalypse of Isabella of France: Paris, Bibl. Nat. Ms FR. 13096', *Art Bulletin*, 72/2 (1990), 224–60

Liaño Martinez 1991
E. Liaño Martinez, 'Reinard de Fonoll maestro de obras de la seo de Tarragona: una hipótesis sobre su obra', in *Miscellania en homenatge al P. Agustí Altisent*, Tarragona, 1991, 379–402

Lightbown 1978
R. W. Lightbown, *Secular Goldsmiths' Work in Medieval France: A History*, London, 1978

Lillich 2007
M. P. Lillich, 'The stained-glass spolia in the south transept of Reims Cathedral and Rémois ecclesiastical seals', *Gesta*, 64/1 (2007), 1–18

Lillich 2011
—, *The Gothic Stained Glass of Reims Cathedral*, University Park, PA, 2011

Lindley 1984
P. G. Lindley, 'The tomb of Bishop William de Luda: an architectural model at Ely Cathedral', *Proceedings of the Cambridge Antiquarian Society*, 73 (1984), 75–87

Lindley 1985
—, 'The Monastic Cathedral at Ely, circa 1320 to circa 1350: Art and Patronage in Medieval East Anglia', unpublished PhD thesis, Cambridge University, 1985

Lindley 1986a
—, 'The imagery of the octagon at Ely', *Journal of the British Archaeological Association*, 139 (1986), 75–99

Lindley 1986b
—, 'The fourteenth-century architectural programme at Ely Cathedral', in Ormrod 1986, 119–29

Lindley 1987a
—, 'The "Arminghall Arch" and contemporary sculpture in Norwich', *Norfolk Archaeology*, 40/1 (1987), 19–43

Lindley 1987b
—, '"Carpenter's Gothic" and Gothic carpentry: contrasting attitudes to the restoration of the octagon and removals of the choir at Ely Cathedral', *Architectural History*, 30 (1987), 83–112

Lindley 1996
—, 'The Black Death and English art: a debate and some assumptions', in Lindley and Ormrod 1996, 125–46

Lindley 2003
—, 'The later medieval monuments and chantry chapels', in R. K. Morris and Shoesmith 2003, 161–96

Lindley 2007
—, *Tomb Destruction and Scholarship: Medieval Monuments in Early Modern England*, Donington, 2007

Lindley and Ormrod 1996
— and M. W. Ormrod, eds, *The Black Death in England*, Stamford, 1996

Lindsay 1911/1985
W. M. Lindsay, ed., *Isidori Hispalensis Episcopi: Etymologiarum sive Originum* [1911], vol. 2, Oxford, 1985

Lingo 2008
S. Lingo, *Federico Barocci: Allure and Devotion in Later Renaissance Painting*, New Haven and London, 2008

Long 2001
P. Long, *Openness, Secrecy, Authorship: Technical Arts and the Culture of Knowledge from Antiquity to the Renaissance*, Baltimore, 2001

Loomis 1919
R. S. Loomis, 'The allegorical siege in the art of the Middle Ages', *American Journal of Archaeology*, 23/3 (1919), 255–69

Lopez 1952
R. Lopez, 'Economie et architecture médiévales, cela avait-il tué ceci?', *Annales: Economies, sociétés, civilisations*, 7 (1952), 433–8

Lowden 1992
J. Lowden, 'Concerning the Cotton Genesis and other illustrated manuscripts of Genesis', *Gesta*, 31/1 (1992), 40–53

Lowden 1997
—, *Early Christian and Byzantine Art*, London, 1997

Lowden 2000
—, *The Making of the Bibles moralisées*, 2 vols, University Park, PA, 2000

Lowden 2010
—, 'The Holkham Bible Picture Book and the *Bible Moralisée*', in *The Medieval Book: Glosses from Friends and Colleagues of Christopher de Hamel*, ed. J. H. Marrow, R. A. Linenthal and W. Noel, Houten, 2010, 75–83

Luard 1864–9
H. R. Luard, ed., *Annales Monastici* (Rolls Series, 36), 5 vols, London, 1864–9

Luard 1872–83
—, ed., *Matthew Paris, Chronica majora* (Rolls Series, 57), 7 vols, London, 1872–83

Luttrell and Blagg 1991
A. T. Luttrell and T. F. C. Blagg, 'The Papal Palace and other fourteenth-century buildings at Sorgues near Avignon', *Archaeologia*, 109 (1991), 161–92

Luxford 2005
J. M. Luxford, *The Art and Architecture of the English Benedictine Monasteries, 1300–1540: A Patronage History*, Woodbridge, 2005

Luxford 2010
—, 'Out of the wilderness: a fourteenth-century English drawing of John the Baptist', *Gesta*, 49/2 (2010), 137–50

Luxford 2011a
—, 'The origins and development of the English "stone-cage" chantry chapel', *Journal of the British Archaeological Association*, 164 (2011), 39–73

Luxford 2011b
—, 'The late medieval abbey: patronage, buildings and images', in Cannon and Williamson 2011, 216–46

Luxford 2013a
—, 'The Great Gate of St Augustine's Abbey: architecture and context', in *Medieval Art, Architecture and Archaeology at Canterbury* (BAACT, 35), 2013, 261–75

Luxford 2013b
—, 'Manuscripts, history and aesthetic interests at Tynmouth Priory', in *Newcastle and Northumberland: Roman and Medieval Architecture and Art* (BAACT, 36), 2013, 193–213

Luxford 2014
—, 'Architecture and environment: St Benet's Holm (Norfolk) and the fashioning of the English monastic gatehouse', *Architectural History*, 57 (2014), 31–72

McAleer 1983
J. P. McAleer, 'The Romanesque choir of Tewkesbury Abbey and the problem of a "Colossal Order"', *Art Bulletin*, 65/4 (1983), 535–58

McAleer 1998
—, 'The west front of the abbey church', in *Bury St Edmunds: Medieval Art, Architecture, Archaeology and Economy* (BAACT, 20), 1998, 22–33

MacClintock 1956
S. MacClintock, *Perversity and Error: Studies in the 'Averroist' John of Jandun*, Bloomington, 1956

McDermott 1975
W. C. McDermott, 'The Seven Wonders of the World', in *Monks, Bishops and Pagans: Christian Culture in Gaul and Italy, 500–700*, ed. E. Peters, Philadelphia, 1975, 207–18

McDonald 2006
N. McDonald, ed., *Medieval Obscenities*, York, 2006

McGinn 1995
B. McGinn, 'From admirable tabernacle to the house of God: some theological reflections on medieval architectural integration', in Raguin, Brush and Draper 1995, 41–56

Mackenzie 1844
F. Mackenzie, *The Architectural Antiquities of the Collegiate Chapel of St Stephen, Westminster*, London, 1844

McKeon 1942
R. McKeon, 'Rhetoric in the Middle Ages', *Speculum*, 17/1 (1942), 1–32

McKinnon 1984
J. McKinnon, 'The late medieval Psalter: liturgical or gift book?', *Musica Disciplina*, 38 (1984), 133–57

MacLagan 1960
M. MacLagan, ed., *Richard de Bury, Philobiblon*, Oxford, 1960

Macnaughton-Jones 1966
J. T. Macnaughton-Jones, 'Saint Ethelbert's Gate, Norwich', *Norfolk Archaeology*, 34 (1966), 74–81

McNeill 2011
J. McNeill, 'A prehistory of the chantry', *Journal of the British Archaeological Association*, 164 (2011), 1–38

Maddison 1988
J. Maddison, 'Master masons of the diocese of Lichfield: a study in 14th-century architecture at the time of the Black Death', *Transactions of the Lancashire and Cheshire Antiquarian Society*, 85 (1988), 107–72

Maddison 1993
—, 'Building at Lichfield Cathedral during the episcopate of Walter Langton (1296–1321)', in *Medieval Art and Architecture at Lichfield* (BAACT, 13), 1993, 65–84

Maddison 2000
—, *Ely Cathedral: Design and Meaning*, Ely, 2000

Maddison 2003
—, 'The Gothic cathedral', in Meadows and Ramsay 2003, 113–41

Madero 2004
M. Madero, *Tabula picta: la peinture et l'écriture dans le droit médiéval*, Paris, 2004

Maillon 1964
J. Maillon, *Le jubé de la cathédrale de Chartres*, Luisant and Chartres, 1964

Mainstone 1997
R. J. Mainstone, *Hagia Sophia: Architecture, Structure and Liturgy of Justinian's Great Church*, London, 1997

Malcolm 1997
N. Malcolm, *The Origins of English Nonsense*, London, 1997

Mallion 1964
J. Mallion, *Le jubé de la cathédrale de Chartres*, Chartres 1964

Malone 2000
C. M. Malone, 'The rotunda of Sancta Maria in Dijon as "Ostwerk"', *Speculum*, 75/2 (2000), 285–317

Malone 2004
—, *Façade as Spectacle: Ritual and Ideology at Wells Cathedral*, Boston, MA, 2004

Malone 2009
—, *Saint-Bénigne de Dijon en l'an mil, Totius Galliae basilicis mirabilior: interprétation politique, liturgique et théologique* (Disciplina Monastica, 5), Turnhout, 2009

Mann 1973
J. Mann, *Chaucer and Medieval Estates Satire: The Literature of Social Classes and the General Prologue to the Canterbury Tales*, Cambridge, 1973

Mann 1994
—, 'Allegorical buildings in medieval literature', *Medium Aevum*, 63/2 (1994), 191–210

Manzalaoui 1977
M. A. Manzalaoui, ed., *Secretum Secretorum: Nine English Versions* (Early English Text Society, 276), vol. 1, Oxford, 1977

Marchiori 2007
M. L. Marchiori, 'Art and Reform in Tenth-century Rome: The Paintings of S. Maria in Pallara', unpublished PhD thesis, Queen's University, Ontario, 2007

Marenbon 1987
J. Marenbon, *Later Medieval Philosophy (1150–1350): An Introduction*, London, 1987

Mark and Çakmak 1992
R. Mark and A. S. Çakmak, *Hagia Sophia from the Age of Justinian to the Present*, Cambridge, 1992

Marks 1993
R. Marks, *Stained Glass in England during the Middle Ages*, Toronto and London, 1993

Marks 1993–4
—, 'Sir Geoffrey Luttrell and some companions: images of chivalry, c.1320–50', *Wiener Jahrbuch für Kunstgeschichte*, 46–7 (1993–4), 343–55

Marks 2004
—, *Image and Devotion in Late Medieval England*, Stroud, 2004

Marks and Williamson 2003
— and P. Williamson, eds, *Gothic: Art for England, 1400–1547* (exh. cat.), London, 2003

Marsh 2003
D. Marsh, ed. and trans., *Francesco Petrarca, Invectives*, Cambridge, MA, and London, 2003

E. Martin 1998
E. Martin, 'Little Wenham Hall: a reinterpretation', *Proceedings of the Suffolk Institute of Archaeology*, 39/2 (1998), 151–64

G. H. Martin and Highfield 1997
G. H. Martin and J. R. L. Highfield, *A History of Merton College, Oxford*, Oxford, 1997

Martindale 1988
A. Martindale, *Simone Martini*, Oxford, 1988

Martindale 1989
—, 'The knights and the bed of stones: a learned confusion of the fourteenth century', *Journal of the British Archaeological Association*, 142 (1989), 66–74

Martindale 1992
—, 'Patrons and minders: the intrusion of the secular into sacred spaces in the late Middle Ages', in *The Church and the Arts* (Studies in Church History, 28), ed. D. Wood, Oxford, 1992, 143–78

Martindale 1994
—, 'St Stephen's Chapel, Westminster, and the Italian experience', in Buckton and Heslop 1994, 102–12

Mate 1973
M. Mate, 'The indebtedness of Canterbury Cathedral priory, 1215–95', *Economic History Review*, 26/2 (1973), 183–97

Mate 1975
—, 'High prices in early fourteenth-century England: causes and consequences', *Economic History Review*, 28/1 (1975), 1–16

Mate 1982
—, 'The impact of war on the economy of Canterbury Cathedral priory, 1294–1340', *Speculum*, 57/4 (1982), 761–78

Mate 1984
—, 'Agrarian economy after the Black Death: the manors of Canterbury cathedral priory, 1348–91', *Economic History Review*, 37/3 (1984), 341–54

Mate 1991
—, 'The agrarian economy of south-east England before the Black Death: depressed or buoyant?', in Campbell 1991, 79–109

Mauwese 2012
M. Mauwese 'The count and the codes: morals and miniatures in a Middle Dutch manuscript', in Binski and New 2012, 182–9

May and Wisse 2001
J. M. May and J. Wisse, trans., *Cicero, On the ideal orator (De oratore)*, New York and Oxford, 2001

Meadows 2010
P. Meadows, ed., *Ely: Bishops and Diocese, 1109–2009*, Woodbridge, 2010

Meadows and Ramsay 2003
— and N. Ramsay, eds, *A History of Ely Cathedral*, Woodbridge, 2003

Meale 1990
C. M. Meale, 'The miracles of Our Lady: context and interpretation', in *Studies in the Vernon Manuscript*, ed. D. Pearsall, Woodbridge, 1990, 115–36

Meiss 1951
M. Meiss, *Painting in Florence and Siena after the Black Death: The Arts, Religion and Society in the Mid-Fourteenth Century*, Princeton, 1951

Meiss 1967
—, *French Painting in the Time of Jean de Berry: The Late Fourteenth Century and the Patronage of the Duke*, 2 vols, London, 1967

Menache 1998
S. Menache, *Clement V*, Cambridge, 1998

Menéndez Pidal de Navascués and Martínez de Aguirre 1996
F. Menéndez Pidal de Navascués and J. Martínez de Aguirre, 'Precisiones cronológicas y heráldicas sobre el mural del refectorio de la catedral de Pamplona', *Príncipe de Viana*, 57/207 (1996), 5–17

Merback 1999
M. B. Merback, *The Thief, the Cross and the Wheel: Pain and the Spectacle of Punishment in Medieval and Renaissance Europe*, London, 1999

Merton 1965
R. K. Merton, *On the Shoulders of Giants: A Shandean postscript*, New York, 1965

Mesuret 1967
R. Mesuret, *Les peintures murals du sud-ouest de la France du XIe au XVIe siècle*, Paris, 1967

Meyer 2003
A. R. Meyer, *Medieval Allegory and the Building of the New Jerusalem*, Woodbridge, 2003

Meyvaert 1991
P. Meyvaert, '"Rainaldus est malus scriptor Francigenus": voicing national antipathy in the Middle Ages', *Speculum*, 66/4 (1991), 743–63

Michael 1994a
M. A. Michael, 'The Little Land of England is Preferred before the Great Kingdom of France': quartering of the royal arms by Edward III', in Buckton and Heslop 1994, 113–26

Michael 1994b
—, 'The iconography of kingship in the Walter of Milemete treatise', *Journal of the Warburg and Courtauld Institutes*, 57 (1994), 35–47

Michael 2007
—, 'Planning for style: a preliminary reading of the De Lisle Psalter *Virgin and Child*', in K. A. Smith and Krinsky 2007, 173–86

Michael 2013
—, '*Vere hortus noster deliciarum est Anglia*: John of Thanet, the Madonna Master and a fragment of English medieval embroidery', in *Medieval Art, Architecture and Archaeology at Canterbury* (BAACT, 35), 2013, 276–95

Michalsky 2004
T. Michalsky, '*Mater serenissimi principis*: the tomb of Maria of Hungary', in *The Church of Santa Maria Donna Regina: Art, Iconography and Patronage in Fourteenth-century Italy*, ed. J. Elliott and C. Warr, Aldershot, 2004, 61–77

Middleton 1962–3
R. D. Middleton, 'The abbé de Cordemoy and the Graeco-Gothic ideal', *Journal of the Warburg and Courtauld Institutes*, 25 (1962), 278–320; 26 (1963), 90–123

Millar 1932
E. G. Millar, *The Luttrell Psalter*, London, 1932

Miller 1951
E. Miller, *The Abbey and Bishopric of Ely: The Social History of an Ecclesiastical Estate from the Tenth Century to the Early Fourteenth Century*, Cambridge, 1951

Minnis 1988
A. J. Minnis, *Medieval Theory of Authorship*, 2nd edn, Aldershot, 1988

Mitchell 1994
W. J. T. Mitchell, *Picture Theory: Essays on Visual and Verbal Representation*, Chicago and London, 1994

Molinier 1888
E. Molinier, *Inventaire du trésor du Saint-Siège sous Boniface VIII*, Paris, 1888

Molland 1978
A. G. Molland, 'Medieval ideas of scientific progress', *Journal of the History of Ideas*, 39/4 (1978), 561–77

Mommsen 1942
T. E. Mommsen, 'Petrarch's conception of the "Dark Ages"', *Speculum*, 17/2 (1942), 226–42

Monzó 1923
E. T. Y. Monzó, *La catedral gótica de Valencia*, Valencia, 1923

Mooney 2000
L. Mooney, 'A new manuscript by the Hammond scribe discovered by Jeremy Griffiths', in *The English Medieval Book: Essays in Memory of Jeremy Griffiths*, ed. A. S. G. Edwards, R. Hanna and V. Gillespie, London, 2000, 113–23

Morant 1995
R. W. Morant, *The Monastic Gatehouse*, Lewes, 1995

Moreau-Rendu 1968
S. Moreau-Rendu, *Le prieuré royal de Saint-Louis de Poissy*, Colmar, 1968

Morgan 1982
N. J. Morgan, *Early Gothic Manuscripts, I: 1190–1250* (A Survey of Manuscripts Illuminated in the British Isles, 4/1), London, 1982

Morgan 1988
—, *Early Gothic Manuscripts, II: 1250–1285* (A Survey of Manuscripts Illuminated in the British Isles, 4/2), London, 1988

Morgan 1993
—, 'Texts and images of Marian devotion in fourteenth-century England', in *England in the Fourteenth Century* (Harlaxton Medieval Studies, 3), ed. N. Rogers, Stamford, 1993, 34–57

Morgan 2002
—, 'The decorative ornament of the text and page in thirteenth-century England: initials, borders extensions, and line fillers', in *Decoration and Illustration in Medieval English Manuscripts* (English Manuscript Studies, 1100–1700, 10), ed. A. S. G. Edwards, London, 2002, 1–33

Morgan 2004
—, 'Patrons and their devotions in the historiated initials and full-page miniatures of 13th-century Psalters', in *The Illuminated Psalter: Studies in the Content, Purpose and Placement of its Images*, ed. F. O. Büttner, Turnhout, 2004, 309–19

Morgan 2007
—, *The Douce Apocalypse: Picturing the End of the World in the Middle Ages*, Oxford, 2006

Morganstern 2000
A. M. Morganstern, *Gothic Tombs of Kinship in France, the Low Countries and England*, University Park, PA, 2000

Morganstern 2001
—, 'Art and ceremony in papal Avignon: a prescription for the tomb of Clement VI', *Gesta*, 40/1 (2001), 61–77

P. Morris 1943
P. Morris, 'Exeter Cathedral: a conjectural restoration of the fourteenth-century altar-screen', *Antiquaries Journal*, 23 (1943), 122–47

R. Morris 1979
R. Morris, *Cathedrals and Abbeys of England and Wales: The Building Church, 600–1540*, London, 1979

R. Morris 1989
—, *Churches in the Landscape*, London, 1989

R. K. Morris 1974
R. K. Morris, 'Tewkesbury Abbey: the Despenser Mausoleum', *Transactions of the Bristol and Gloucester Archaeologicial Society*, 93 (1974), 142–55

R. K. Morris 1985
—, 'Ballflower work in Gloucester and its vicinity', in *Medieval Art and Architecture at Gloucester and Tewkesbury* (BAACT, 7), 1985, 99–115

R. K. Morris 1990
—, 'The New Work at Old St Paul's Cathedral and its place in English thirteenth-century architecture', in *Medieval Art and Architecture in London* (BAACT, 10), 1990, 74–100

R. K. Morris 1991
—, 'Thomas of Witney at Exeter, Winchester and Wells', in *Medieval Art and Architecture at Exeter Cathedral* (BAACT, 11), 1991, 57–84

R. K. Morris 1997
—, 'European prodigy or regional eccentric? The rebuilding of St Augustine's abbey church, Bristol', in *'Almost the Richest City': Bristol in the Middle Ages* (BAACT, 19), 1997, 41–56

R. K. Morris 1998
—, 'The architecture of Arthurian enthusiasm: castle symbolism in the reign of Edward I and his successors', in *Armies, Chivalry and Warfare in Medieval Britain and France* (Harlaxton Medieval Studies, 7), ed. M. Strickland, Stamford, 1998, 63–81

R. K. Morris 2003
—, 'The Gothic church: architectural history', in R. K. Morris and Shoesmith 2003, 109–30

R. K. Morris and Shoesmith 2003
— and R. Shoesmith, ed., *Tewkesbury Abbey: History, Art and Architecture*, Logaston, 2003

Mukerji 2009
C. Mukerji, *Impossible Engineering: Technology and Territoriality on the Canal du Midi*, Princeton, 2009

Mullins 2001
E. Mullins, *The Pilgrimage to Santiago*, Oxford, 2001

Munro 1994
J. H. A. Munro, *Textiles, Towns and Trade: Essays in the Economic History of Late-Medieval England and the Low Countries*, Aldershot, 1994

Müntz 1884
E. Müntz, 'Le palais pontifical de Sorgues (1319–1395)', *Mémoires de la société Nationale des Antiquaires de France*, 45 [5th ser., 5] (1884), 17–36

Müntz and Frothingham 1883
— and A. L. Frothingham, *Il tesoro della basilica di S. Pietro in Vaticano del XIII al XV secolo*, Rome, 1883

Muratori 1728
L. A. Muratori, ed., *Rerum Italicarum Scriptores*, vol. 12, Milan, 1728

Muratova 1989
X. Muratova, 'Exeter and Italy: assimilation and adaptation of a style: the question of Italian trecento sources in the sculptured front of Exeter Cathedral (fourteenth century)', in *World Art: Themes of Unity in Diversity. 26th International Congress of the History of Art, 1986*, ed I. Lavin, vol. 1, University Park, 1989, 117–24

A. Murray 1978
A. Murray, *Reason and Society in the Middle Ages*, Oxford, 1978

S. Murray 1978
S. Murray, 'The Gothic façade drawings in the "Reims Palimpsest"', *Gesta*, 17/2 (1978), 51–5

S. Murray 1987
—, *Building Troyes Cathedral: The Late Gothic Campaigns*, Bloomington, 1987

S. Murray 1989
—, *Beauvais Cathedral: Architecture of Transcendence*, Princeton, 1989

S. Murray 1996
—, *Notre-Dame, Cathedral of Amiens: The Power of Change in Gothic*, Cambridge, 1996

S. Murray 1996–7
—, 'The architectural envelope of the Sainte-Chapelle: form and meaning', *Avista Forum*, 10/1 (1996–7), 21–5

Muscatine 1972
C. Muscatine, *Poetry and Crisis in the Age of Chaucer*, Notre Dame, 1972

Mynors 1937
R. A. B. Mynors, ed., *Cassiodori Senatoris Institutiones*, Oxford, 1937

Mynors 1998–9
—, ed. and trans., with R. M. Thomson and M. Winterbottom, *William of Malmesbury, Gesta regum anglorum*, 2 vols, Oxford, 1998–9

Nagel 2012
A. Nagel, *Medieval Modern: Art out of Time*, London, 2012

Nagel and Wood 2005
— and C. Wood, 'Interventions: toward a new model of Renaissance anachronism', *Art Bulletin*, 87/3 (2005), 403–15

Nagel and Wood 2010
— and —, *Anachronic Renaissance*, New York, 2010

Nederman 1990
C. J. Nederman, ed. and trans., *John of Salisbury, Policraticus*, Cambridge, 1990

Newhauser 1982
R. Newhauser, 'Towards a history of human curiosity: a prolegomenon to its medieval phase', *Deutsche Vierteljahrsschrift für Literaturwissenschaft und Geistesgeschichte*, 56/4 (1982), 559–75

Newton 1980
M. S. Newton, *Fashion in the Age of the Black Prince: A Study of the Years 1340–1365*, Woodbridge, 1980

Nichols 1986
F. M. Nichols, ed. and trans., *The Marvels of Rome / Mirabilia urbis Romae*, New York, 1986

Nickson 2009
T. Nickson, 'The royal tombs of Santes Creus: negotiating the royal image in medieval Iberia', *Zeitschrift für Kunstgeschichte*, 72 (2009), 1–14

Nickson 2012
—, 'Copying Córdoba? Toledo and beyond', *Medieval History Journal*, 15/2 (2012), 319–54

Nicolas and Tyrrell 1827
N. H. Nicolas and E. Tyrrell, eds, *A Chronicle of London, from 1089 to 1483*, London, 1827

Nilson 1998
B. Nilson, *Cathedral Shrines of Medieval England*, Woodbridge, 1998

Nims 1967
M. F. Nims, trans., *Poetria Nova of Geoffrey of Vinsauf*, Toronto, 1967

Nishimura 1999
M. M. Nishimura, 'The Gorleston Psalter: A Study of the Marginal in the Visual Culture of Fourteenth-century England', unpublished PhD thesis, Institute of Fine Arts, New York University, 1999

Nishimura and Nishimura 2007
— and D. Nishimura, 'Rabbits, warrens and Warenne: the patronage of the Gorleston Psalter', in K. A. Smith and Krinsky 2007, 205–18

Noel 2004
W. Noel, *The Oxford Bible: Pictures from the Walters Art Museum*, Lucerne and Baltimore, 2004

Noel and Weiss 2002
— and D. Weiss, *The Book of Kings: Art War and the Morgan Library's Medieval Picture Bible*, Lingfield, 2002

Nolan 2009
K. D. Nolan, *Queens in Stone and Silver: The Creation of a Visual Imagery of Queenship in Capetian France*, New York, 2009

Nordenfalk 1967
C. Nordenfalk, 'Drolleries', *Burlington Magazine*, 109 (1967), 418–21

Norris 1888
J. P. Norris, *Some Account of the Church of St Mary Redcliffe*, Bristol, 1888

Norton and Park 1986
E. C. Norton and D. Park, eds, *Cistercian Art and Architecture in the British Isles*, Cambridge, 1986

Norton, Park and Binski 1987
—, — and P. Binski, *Dominican Painting in East Anglia: The Thornham Parva Retable and the Musée de Cluny Frontal*, Woodbridge, 1987

Oakeshott 1972
W. Oakeshott, *Sigena: Romanesque Paintings in Spain and the Winchester Bible Artists*, London, 1972

O'Connor and French 1987
D. O'Connor and T. French, *York Minster: A Catalogue of Medieval Stained Glass* (CVMA Great Britain, 3/1), Oxford, 1987

O'Connor and Reddish 1995
— and H. Reddish, 'The east window of Selby Abbey, Yorkshire', in *Yorkshire Monasticism: Medieval Art and Architecture from the 7th to 16th Centuries* (BAACT, 16), 1995, 117–44

Olsan 2010
L. T. Olsan, 'Enchantment in medieval literature', in *The Unorthodox Imagination in Late Medieval Britain*, ed. S. Page, Manchester, 2010, 166–92

Olson 1963
P. A. Olson, 'John Bromyard's response to the Gothic', *Medievalia et Humanistica*, 15 (1963), 91–4

Olympios, in preparation
M. Olympios, 'Looking anew at the curvilinear tracery of the Ballapais Abbey cloister', in *France de Chypre*, ed. G. Grivaud, in preparation

Opačić and Timmermann 2011a
Z. Opačić and A. Timmermann, eds, *Architecture, Liturgy and Identity: Liber amicorum Paul Crossley*, Turnhout, 2011

Opačić and Timmermann 2011b
— and —, eds, *Image Memory and Devotion: Liber amicorum Paul Crossley*, Turnhout, 2011

O'Reilly 1981
J. O'Reilly, '"Candidus et Rubicundus": an image of martyrdom in the "Lives" of Thomas Becket', *Analecta Bollandiana*, 99 (1981), 303–14

O'Reilly 2001
—, 'The library of scripture: views from Vivarium and Wearmouth-Jarrow', in Binski and Noel 2001, 3–39

Ormrod 1986
W. M. Ormrod, ed., *England in the Fourteenth Century: Proceedings of the 1985 Harlaxton Symposium*, Woodbridge, 1986

Ormrod 2004
—, 'Knights of Venus', *Medium Aevum*, 73/2 (2004), 290–305

Osborne 1987
J. Osborne, trans., *Master Gregorius, The Marvels of Rome* (Mediaeval Sources in Translation, 31), Toronto, 1987

Otter 2004
M. Otter, trans., *Goscelin of St Bertin, The Book of Encouragement and Consolation*, Woodbridge, 2004

Owen 1976
D. Owen, 'The muniments of Ely cathedral priory', in *Church and Government in the Middle Ages: Essays Presented to C. R. Cheney on his 70th Birthday*, ed. C. N. L. Brooke et al., Cambridge, 1976, 157–76

Owst 1961
G. R. Owst, *Literature and Pulpit in Medieval England*, Oxford, 1961

Pächt 1943
O. Pächt, 'A Giottesque episode in English mediaeval art', *Journal of the Warburg and Courtauld Institutes*, 6 (1943), 51–70

Paleotti 1582
G. Paleotti, *Discorso intorno all immagini sacre e profane*, Bologna, 1582

Palmer 1983
N. F. Palmer, '"Antiquitus depingebatur": the Roman pictures of death and misfortune in the *Ackermann aus Böhmen* and *Tkadleček*, and in the writings of the English classicizing friars', *Deutsche Vierteljahrsschrift für Literaturwissenschaft und Geistesgeschichte*, 57/2 (1983), 171–239

Panayotova 2007
S. Panayotova, ed., *The Cambridge Illuminations: The Conference Papers*, London and Turnhout, 2007

Panayotova 2008
—, *The Macclesfield Psalter*, London, 2008

Pannier and Meyer 1877
L. Pannier and P. Meyer, eds, *Le Débat des Hérauts d'armes de France et Angleterre*, Paris, 1877

Panofsky 1951
E. Panofsky, *Gothic Architecture and Scholasticism*, Latrobe, 1951

Panofsky 1953
—, *Early Netherlandish Painting: Its Origins and Character*, 2 vols, Princeton, 1953

Panofsky 1955
—, *The Life and Art of Albrecht Dürer*, Princeton, 1955

Panofsky 1960
—, *Renaissance and Renascences in Western Art*, Stockholm, 1960

Panofsky 1963
—, 'The ideological antecedents of the Rolls-Royce radiator', *Proceedings of the American Philosophical Society*, 107/4 (1963), 273–88

Panofsky 1964
—, *Tomb Sculpture: Its Changing Aspects from Ancient Egypt to Bernini*, New York, 1964

Panofsky 1979
—, ed. and trans., *Abbot Suger on the Abbey Church of St Denis and its Art Treasures*, 2nd edn, Princeton, 1979

Pantin 1955
W. A. Pantin, *The English Church in the Fourteenth Century: Based on the Birkbeck Lectures, 1948*, Cambridge, 1955

Paravicini Bagliani 1980
A. Paravicini Bagliani, *I testamenti dei cardinali del Duecento*, Rome, 1980

Paris 1981
Les fastes du Gothique: le siècle de Charles V (exh. cat.), Paris, 1981

Paris 1992
Byzance: l'art Byzantin dans les collections publiques françaises, Paris, 1992

Paris 1998
L'art au temps des rois maudits: Philippe le Bel et ses fils, 1285–1328 (exh. cat.), Paris, 1998

Parker 1853
J. H. Parker, ed., *Statutes of the Colleges of Oxford*, Oxford, 1853

Parkes 1976
M. B. Parkes, 'The influence of the concepts of *Ordinatio* and *Compilatio* on the development of the book', in *Medieval Learning and Literature: Essays Presented to Richard William Hunt*, ed. J. J. G. Alexander and M. T. Gibson, Oxford, 1976, 115–41

Parkes 2008
—, 'Layout and presentation of the text', in *The Cambridge History of the Book in Britain, vol. II: 1100–1400*, ed. N. Morgan and R. M. Thomson, Cambridge, 2008, 55–74

Parsons 1991
D. Parsons, ed., *Eleanor of Castile, 1290–1990: Essays to Commemorate the 700th Anniversary of her Death, 28 November 1290*, Stamford, 1991

Patterson 1990
L. Patterson, 'On the margin: postmodernism, ironic history and medieval studies', *Speculum*, 65/1 (1990), 87–108

Paul 1991
V. Paul, 'The projecting triforium at Narbonne Cathedral: meaning, structure or form?', *Gesta*, 30/1 (1991), 27–40

Peers 1927a
C. R. Peers, 'St Augustine's abbey church, Canterbury, before the Norman Conquest', *Archaeologia*, 77 (1927), 201–18

Peers 1927b
—, 'Reculver: its Saxon church and cross', *Archaeologia*, 77 (1927), 241–56

Peringskiöld 1719
J. Peringskiöld, *Monumenta Ullerakerensia, cum Upsalia nova illustrata*, Stockholm, 1719

Perkinson 2009
S. Perkinson, *The Likeness of the King: A Prehistory of Portraiture in Late Medieval France*, Chicago, 2009

Petrina 2004
A. Petrina, *Cultural Politics in Fifteenth-century England: The Case of Humphrey, Duke of Gloucester*, Leiden, 2004

Pevsner 1942a
N. Pevsner, 'Terms of architectural planning in the Middle Ages', *Journal of the Warburg and Courtauld Institutes*, 5 (1942), 232–7

Pevsner 1942b
—, 'The term "architect" in the Middle Ages', *Speculum*, 17/4 (1942), 549–62

Pevsner 1943/1970
—, *An Outline of European Architecture* [1943], Harmondsworth, 1970

Pevsner 1945
—, *The Leaves of Southwell*, London, 1945

Pevsner 1949/1978
—, *Pioneers of Modern Design: From William Morris to Walter Gropius* [1949], Harmondsworth, 1978

Pevsner 1953
—, 'Bristol, Troyes, Gloucester: the character of the early fourteenth century in architecture', *Architectural Review*, 113 (1953), 89–98

Pevsner 1956/1976
—, *The Englishness of English Art* [1956], Harmondsworth, 1976

Pevsner 1959
—, review of K. H. Clasen, *Deutsche Gewölbe der Spätgotik* (Berlin, 1958), in *Art Bulletin*, 41/4 (1959), 333–6

Pevsner and Wilson 2002
— and B. Wilson, *Norfolk, 1: Norwich and North-East*, 2nd edn, London, 2002

Pfaff 2009
R. W. Pfaff, *The Liturgy in Medieval England: A History*, Cambridge, 2009

Phelps Brown and Hopkins 1955
E. H. Phelps Brown and S. V. Hopkins, 'Seven centuries of building wages', *Economica*, new ser., 22 (1955), 195–206

Phelps Brown and Hopkins 1956
— and —, 'Seven centuries of the prices of consumables, compared with builders' wage-rates', *Economica*, new ser., 23 (1956), 296–314

Phillipotts 2000
C. Phillipotts, 'Plague and reconstruction: Bishops Edington and Wykeham at Highclere, 1346–1404', in *Fourteenth-Century England*, ed. N Saul, vol. 1, Woodbridge, 2000, 115–29

Phillips 1972
J. R. S. Phillips, *Aymer De Valence, Earl of Pembroke, 1307–1324: Baronial Politics in the Reign of Edward II*, Oxford, 1972

Phillips 2010
—, *Edward II*, New Haven and London, 2010

Pickering 1970
F. P. Pickering, *Literature and Art in the Middle Ages*, London, 1970

Pine-Coffin 1961
R. S. Pine-Coffin, *Saint Augustine, Confessions*, Harmondsworth, 1961

Pirenne 1936/1976
H. Pirenne, *Economic and Social History of Medieval Europe* [1936], London, 1976

Plagnieux 2004
P. Plagnieux, 'Les débuts de l'architecture flamboyante dans le milieu parisien', in *La France et les arts en 1400: les princes des fleurs de lys*, ed. F. Autrand et al., Paris, 2004, 83–95

Platt 1990
C. Platt, *The Architecture of Medieval Britain: A Social History*, New Haven and London, 1990

Plöger 2005
K. Plöger, *England and the Avignon Popes: The Practice of Diplomacy in Late Medieval Europe*, London, 2005

Polzer 1982
J. Polzer, 'Aspects of the fourteenth-century iconography of death and the plague', in Williman 1982, 107–30

Poncelet 1902
A. Poncelet, 'Miraculorum B. V. Mariae quae saec. VI–XV latine conscripta sunt: Index postea perficiendus', *Analecta Bollandiana*, 22 (1902), 241–360

Porta 1981
G. Porta, ed., *Anonimo Romano* (Piccolo Biblioteca, 125), Milan, 1981

Postan 1966
M. M. Postan, 'Medieval agrarian society in its prime, 7: England', in *The Cambridge Economic History of Europe*, ed. Postan, vol. 1, Cambridge, 1966, 556–9

Postan 1972
—, *The Medieval Economy and Society: An Economic History of Britain in the Middle Ages*, Harmondsworth, 1972

Postan 1973
—, *Essays on Medieval Agriculture and General Problems of the Medieval Economy*, Cambridge, 1973

Potts and Potts 2002
W. T. W. Potts and D. M. Potts, 'The architectural background of the Ely octagon', *Journal of the British Archaeological Association*, 155 (2002), 195–202

Prescott 2005
A. Prescott, 'Some literary contexts of the Cooke and Regius manuscripts', in *Freemasonry in Music and Literature: The Canonbury Papers, 2*, ed. T. Stewart, London, 2005, 1–36

Prescott 2009
—, 'Inventing symbols and traditions: the case of the stonemasons', in *Signs and Symbols* (Harlaxton Medieval Studies, 18), ed. J. Cherry and A. Payne, Donington, 2009, 110–18

Prestwich 1980
M. Prestwich, *The Three Edwards: War and State in England, 1272–1377*, London, 1980

Prestwich 1985
—, 'The piety of Edward I', in *England in the Thirteenth Century: Proceedings of the 1984 Harlaxton Symposium*, ed. W. M. Ormrod, Harlaxton, 1985, 120–28

Prestwich 1988
—, *Edward I*, London, 1988

Prestwich 2005
—, *Plantagenet England, 1225–1360*, Oxford, 2005

Prior 1905
E. S. Prior, *The Cathedral Builders of England*, London, 1905

Puente 1999
J. A. Puente, 'La frustrada cathedral gótica de Santiago de Compostela: ¿eslabón perdido en las relaciones artísticas entre Francia y españia durante el siglo XIII?', in *Gotische Architektur in Spanien*, ed. C. Freigang, Madrid, 1999, 41–57

Puig i Cadafalch 1921–6
J. Puig i Cadafalch, 'Un mestre anglès contracta l'obra del claustre de Santes Creus', *Anuari: Institut d'estudis catalans, secció històrico-arquelògica*, 7 (1921–6), 123–38

Puig i Cadafalch 1948
—, 'La introducció del gòtic flamigér a Espanya', in *Ensayos hispano-ingleses: homenaje a Walter Starkie*, ed. J. Janés, Barcelona, 1948, 313–14

R. Quednau 1980
R. Quednau, 'Zum programm der Chorschrankenmalereien im Kölner Dom', *Zeitschrift für Kunstgeschichte*, 43 (1980), 244–79

U. Quednau 1979
U. Quednau, *Die Westportale der Kathedrale von Auxerre*, Wiesbaden, 1979

Quiney 2001
A. Quiney, '*In Hoc Signo*: the west front of Lincoln Cathedral', *Architectural History*, 44 (2001), 162–71

Raban 1982
S. Raban, *Mortmain Legislation and the English Church, 1279–1500*, Cambridge, 1982

Raguin, Brush and Draper 1995
V. C. Raguin, K. Brush and P. Draper, eds, *Artistic Integration in Gothic Buildings*, Toronto and London, 1995

Raine 1839
J. Raine, ed., *Historia Dunelmensis Scriptores Tres* (Surtees Society, 19), London, 1839

Ramsay 1991
N. Ramsay, 'Alabaster', in *English Medieval Industries, Craftsmen, Techniques, Products*, ed. J. Blair and Ramsay, London, 1991, 29–40

Rancière 2006
J. Rancière (trans. G. Rockhill), *The Politics of Aesthetics*, London and New York, 2006

Randall 1966
L. M. C. Randall, *Images in the Margins of Gothic Manuscripts*, Berkeley, CA, 1966

Rankin 2010
S. Rankin, '*Terribilis est locus iste*: the Pantheon in 609', in *Rhetoric Beyond Words: Delight and Persuasion in the Arts of the Middle Ages*, ed. M. Carruthers, Cambridge, 2010, 281–310

Rashdall 1936
H. Rashdall, *The Universities of Europe in the Middle Ages*, vol. 1, Oxford, 1936

Rawcliffe and Wilson 2004
C. Rawcliffe and R. Wilson, eds, *Medieval Norwich*, London and New York, 2004

Rawski 1991
C. H. Rawski, ed. and trans., *Petrarch's Remedies for Fortune Fair and Foul*, 5 vols, Bloomington, 1991

Recht 1989
R. Recht, ed., *Les bâtisseurs de cathédrales gothiques*, Strasbourg, 1989

Recht 2008
— (trans. M. Whittall), *Believing and Seeing: The Art of Gothic Cathedrals*, Chicago and London, 2008

Redfield 1971
R. Redfield, 'Art and icon', in *Anthropology and Art: Readings in Cross-Cultural Aesthetics*, ed. C. M. Otten, New York, 1971, 39–65

Reeve 2008
M. M. Reeve, ed., *Reading Gothic Architecture*, Turnhout, 2008

Reeve 2012
—, 'Gothic', *Studies in Iconography*, 33 (2012), 233–46

Remnant and Marks 1980
M. Remnant and R. Marks, 'A medieval "gittern"', in *Music and Civilization* (British Museum Yearbook, 4), ed. T. C. Mitchell, London, 1980, 83–134

Rey 1929
R. Rey, *La cathédrale de Toulouse: petites monographies des grands édifices de la France*, Paris, 1929

Reyne and Brehier 2002
A. Reyne and D. Brehier, *La Métropole Notre Dame des Doms: haut lieu de spiritualité, d'art et d'histoire*, Avignon, 2002

Reynolds 2007
C. Reynolds, '"In ryche colours delytethe the peyntour": painting and the visual arts in the poems of John Lydate', in *Late Gothic England: Art and Display*, ed. R. Marks, Donington, 2007, 1–15

Richards 2006
J. Richards, 'Sir Oliver de Ingham (d. 1344) and the foundation of the Trinitarian priory at Ingham, Norfolk', *Church Monuments*, 21 (2006), 34–57

Rickman 1817
T. Rickman, *An Attempt to Discriminate the Styles of English Architecture from the Conquest to the Reformation*, London, 1817

Ricoeur 1970
P. Ricoeur (trans. D. Savage), *Freud and Philosophy*, New Haven, 1970

Riley 1863
H. T. Riley, ed., *Historia anglicana* (Rolls Series, 28), vol. 1, London, 1863

Robbins 1959
R. H. Robbins, ed., *Historical Poems of the XIVth and XVth Centuries*, New York, 1959

Roberts, Schaffer and Dear 2007
L. Roberts, S. Schaffer and P. Dear, eds, *The Mindful Hand: Inquiry and Invention from the Late Renaissance to Early Industrialisation*, Amsterdam, 2007

Robertson and Sheppard 1875–85
J. C. Robertson and J. B. Sheppard, eds, *Materials for the History of Thomas Becket, Archbishop of Canterbury* (Rolls Series, 67), 7 vols, London, 1875–85

Rodwell 2009
W. Rodwell, *Dorchester Abbey, Oxfordshire: The Archaeology and Architecture of a Cathedral, Monastery and Parish Church*, Oxford, 2009

Rogan 2000
J. Rogan, ed., *Bristol Cathedral: History and Architecture*, Stroud, 2000

Rogers 1866
J. E. T. Rogers, *A History of Agriculture and Prices in England*, vol. 1, Oxford, 1866

Rose and Hedgecoe 1997
M. Rose and J. Hedgecoe, *Stories in Stone: The Medieval Roof Carvings of Norwich Cathedral*, London, 1997

Rosenau 1931
H. Rosenau, *Der Kölner Dom: seine Baugeschichte und historische Stellung*, Cologne, 1931

Rosenmann 1984
B. Rosenmann, 'The tomb canopies and the cloister at Santes Creus', in *Studies in Cistercian Art and Architecture, II* (Cistercian Studies Series, 69), ed. M. P. Lillich, Kalamazoo, 1984, 229–40

Ross 1970
W. B. Ross, 'Giovanni Colonna, historian at Avignon', *Speculum*, 45/4 (1970), 533–63

Rosser 1989
G. Rosser, *Medieval Westminster, 1200–1540*, Oxford, 1989

Rothwell 1976
W. Rothwell, 'The role of French in thirteenth-century England', *Bulletin of the John Rylands Library*, 58/2 (1976), 445–66

Rouse and Rouse 1982
R. Rouse and M. Rouse, '*Statim invenire*: schools, preachers and new attitudes to the page', in *Renaissance and Renewal in the Twelfth Century*, ed. R. L. Benson and G. Constable, Oxford, 1982, 201–25

Rouse and Rouse 1990
— and —, 'The commercial production of manuscript books in late-thirteenth-century and early-fourteenth-century Paris', in Brownrigg 1990, 103–15

Rouse and Rouse 2000
— and —, *Manuscripts and their Makers: Commercial Book Producers in Medieval Paris, 1200–1500*, 2 vols, Turnhout, 2000

Rousseau 1965
F. Rousseau, 'Les retables de Notre-Dame en Audignon', *Bulletin de la société de Borda*, 89 (1965), 367–84

Rowland 1999
I. D. Rowland, trans., *Vitruvius, Ten Books on Architecture*, Cambridge, 1999

Rubin 1991
M. Rubin, *Corpus Christi: The Eucharist in Late Medieval Culture*, Cambridge, 1991

Rudolph 1990
C. Rudolph, *The 'Things of Greater Importance': Bernard of Clairvaux's* Apologia *and the Medieval Attitude toward Art*, Philadelphia, 1990

Rudolph 1997
—, 'Building-miracles as artistic justification in the early and mid-twelfth century', in *Radical Art History: Internationale Anthologie. Subject: O. K. Werckmeister*, ed. W. Kersten, Zurich, 1997, 398–410

Rudolph 2006
—, ed., *A Companion to Medieval Art*, Oxford, 2006

Rule 1884
M. Rule, *Eadmer, Historia Novorum in Anglia* (Rolls Series, 81), London, 1884

Ruskin 1849/1925
J. Ruskin, *The Seven Lamps of Architecture* [1849], London, 1925

D. A. Russell 2001a
D. A. Russell, ed. and trans., *Quintilian, The Orator's Education, Books 1–2*, Cambridge, MA, and London, 2001

D. A. Russell 2001b
—, ed. and trans., *Quintilian, The Orator's Education, Books 11–12*, Cambridge, MA, and London, 2001

G. Russell 1991
G. Russell, 'Some aspects of the Decorated tracery of Exeter Cathedral', in *Medieval Art and Architecture at Exeter Cathedral* (BAACT, 11), 1991, 85–93

Rykwert 1988
J. Rykwert, 'On the oral transmission of architectural theory', in *Les traités d'architecture de la Renaissance. Actes du colloque tenu à Tours, 1981*, ed. J. Guillaume, Paris, 1988, 31–48

Rymer 1816
T. Rymer, ed., *Foedera*, vol. 1, part II, London, 1816

Sabin 1957
A. Sabin, 'The 14th-century heraldic glass in the eastern Lady Chapel of Bristol Cathedral', *Antiquaries Journal*, 37 (1957), 54–70

Sajavaara 1967
K. Sajavaara, ed., *The Middle English Translations of Robert Grosseteste's Château d'Amour* (Mémoires de la Société Néophilologique de Helsinki, 32), Helsinki, 1967

Salter 1966–7
E. Salter, 'The alliterative revival, II', *Modern Philology*, 64 (1966–7), 233–7

Salzman 1952
L. F. Salzman, *Building in England down to 1540: A Documentary History*, Oxford, 1952

Sandler 1970
L. F. Sandler, 'Peterborough Abbey and the Peterborough Psalter in Brussels', *Journal of the British Archaeological Association*, 3rd ser., 33 (1970), 36–49

Sandler 1974
—, *The Peterborough Psalter in Brussels and Other Fenland Manuscripts*, London, 1974

Sandler 1981
—, 'Reflections on the construction of hybrids in English Gothic marginal illustration', in *Art the Ape of Nature: Studies in Honor of H. W. Janson*, ed. M. Barasch and L. F. Sandler, New York, 1981, 51–65

Sandler 1983
—, *The Psalter of Robert de Lisle*, Oxford, 1983

Sandler 1986
—, *Gothic Manuscripts, 1285–1385* (A Survey of Manuscripts Illuminated in the British Isles, 5), 2 vols, Oxford, 1986

Sandler 1990
—, '*Omne bonum: compilatio* and *ordinatio* in an English illustrated encyclopedia of the fourteenth century', in Brownrigg 1990, 183–200

Sandler 1996
—, 'The word in the text and the image in the margin: the case of the Luttrell Psalter', *Journal of the Walters Art Gallery*, 54 (1996), 87–99

Sandler 1997
—, 'The study of marginal imagery: past, present and future', *Studies in Iconography*, 18 (1997), 1–49

Sandler 2000
—, review of Camille 1998, *Studies in Iconography*, 21 (2000), 285–96

Sandler 2003
—, *Der Ramsey-Psalter*, Graz, 2003

Sandler 2007
—, 'In and around the text: the question of marginality in the Macclesfield Psalter', in Panayotova 2007, 105–14

Sandler 2012
—, 'In living memory: portraits of the fourteenth-century canons of Dorchester Abbey', in *Inventing a Path: Studies in Medieval Rhetoric in Honour of Mary Carruthers* (Nottingham Medieval Studies, 56), ed. L. Iseppi De Filippis, Turnhout, 2012, 327–49

Sargent 1918
F. Sargent, 'The wine trade with Gascony', in *Finance and Trade under Edward III*, ed. G. Unwin, Manchester, 1918, 256–311

Sauerländer 1972
W. Sauerländer (trans. J. Sondheimer), *Gothic Sculpture in France, 1140–1270*, London, 1972

Saul 2009
N. Saul, *English Church Monuments in the Middle Ages: History and Representation*, Oxford, 2009

Saunders 1932
H. W. Saunders, *A History of the Norwich Grammar School*, Norwich, 1932

Saxl 1942
F. Saxl, 'A spiritual encyclopedia of the late Middle Ages', *Journal of the Warburg and Courtauld Institutes*, 5 (1942), 82–134

Scarry 1999
E. Scarry, *On Beauty and Being Just*, Princeton, 1999

Scattergood 1996
J. Scattergood, *Reading the Past: Essays on Medieval and Renaissance Literature*, Blackrock, 1996

Schäfer 1911
K. H. Schäfer, ed., *Die Ausgaben der apostolischen Kammer unter Johann XXII nebst den Jahresbilanzen von 1316–1375* (Vatikanischen Quellen zur Geschichte der päpstlichen hof- und finanzverweltung, 1316–1378), vol. 2, Paderborn, 1911

Schapiro 1977
M. Schapiro, *Romanesque Art*, London, 1977

Schenkluhn 2011
W. Schenkluhn, 'The drawings in the lodge book of Villard de Honnecourt', in Opačić and Timmermann 2011a, 283–95

Schick 1891
J. Schick, ed., *Lydgate's Temple of Glas* (Early English Text Society, extra ser., 60), London, 1891

Schlicht 2005
M. Schlicht, 'Un "scandale" architectural vers 1300: l'intervention de Philippe le Bel dans les choix formels de l'architecture de Saint-Louis de Poissy', in *Hofkultur in Frankreich und Europa in spätmittelalter*, ed. C. Freigang and J.-C. Schmitt, Berlin, 2005, 289–325

Schmidt 1979–80

G. Schmidt, 'Die Chorschrankenmalereien des Kölner Domes und die europäische Malerei', *Kölner Domblatt*, 44–5 (1979–80), 293–40

Schmitt 2010

J.-C. Schmitt, "Unorthodox' images? The 2006 Neale Lecture', in *The Unorthodox Imagination in Late Medieval Britain*, ed. S. Page, Manchester, 2010, 9–38

Schmugge 1966

L. Schmugge, *Johannes von Jandun (1285/89–1328)*, Stuttgart, 1966

Sears 2007

E. S. Sears, 'Scribal wit in a manuscript from the Châtelet: images in the margins of Boileau's *Livre des Métiers*, BnF, MS fr. 24069', in K. A. Smith and Krinsky 2007, 157–72

Sedlmayr 1950

H. Sedlmayr, *Die Entstehung der Kathedrale*, Zurich, 1950

Sekules 1983

V. Sekules, 'A group of masons in early fourteenth-century Lincolnshire: research in progress', in *Studies in Medieval Sculpture* (Society of Antiquaries Occasional Papers, new ser., 3), ed. F. H. Thompson, London, 1983, 151–64

Sekules 1986

—, 'The Tomb of Christ at Lincoln and the development of the Sacrament shrine: Easter sepulchres reconsidered', in *Medieval Art and Architecture at Lincoln Cathedral* (BAACT, 8), 1986, 118–31

Sekules 1990

—, 'The Sculpture and Liturgical Furnishings of Heckington Church and Related Monuments: Masons and Benefactors in Early Fourteenth-century Lincolnshire', unpublished PhD thesis, Courtauld Institute of Art, London, 1990

Sekules 1991a

—, 'Early 14th-century liturgical furnishings', in *Exeter Cathedral: A Celebration*, ed. M. Swanton, Exeter, 1991, 111–44

Sekules 1991b

—, 'The liturgical furnishings of the choir of Exeter Cathedral', in *Medieval Art and Architecture at Exeter Cathedral* (BAACT, 11), 1991, 172–9

Sekules 1995

—, 'Beauty and the Beast: ridicule and orthodoxy in architectural marginalia in early fourteenth-century Lincolnshire', *Art History*, 18/1 (1995), 37–62

Sekules 1996

—, 'The Gothic sculpture', in Atherton et al. 1996, 197–209

Sekules 2001

—, 'Dynasty and patrimony in the self-construction of an English queen: Philippa of Hainault and her images', in *England and the Continent in the Middle Ages: Studies in Memory of Andrew Martindale* (Harlaxton Medieval Studies, 8), ed. J. Mitchell, Stamford, 2001, 157–74

Sekules 2006

—, 'Religious politics and the cloister bosses of Norwich Cathedral', *Journal of the British Archaeological Association*, 159 (2006), 284–306

Shanzer 2006

D. Shanzer, 'Latin literature, Christianity and obscenity in the later Roman West', in McDonald 2006, 179–202

Sharpe 1849

E. Sharpe, *A Treatise on the Rise and Progress of Decorated Window Tracery in England*, London, 1849

Shaver 1943

C. L. Shaver, 'Chaucer's "Owles and Apes"', *Modern Language Notes*, 58/2 (1943), 105–7

Shaw 1992

P. Shaw, 'The presence of Spain in Middle English literature', *Archiv für das Studium der neuren Sprachen und Literaturen*, 229/1 (1992), 41–54

Sheingorn 1978

P. Sheingorn, 'The *Sepulchrum domini*: a study in art and liturgy', *Studies in Iconography*, 4 (1978), 37–60

Shelby 1970

L. R. Shelby, 'The education of medieval English master masons', *Mediaeval Studies*, 32 (1970), 1–26

Shelby 1972

—, 'The geometrical knowledge of mediaeval master masons', *Speculum*, 47/3 (1972), 395–421

Shelby 1981

—, review of J. James 1981, *Gesta*, 20 (1981), 173–8

Sherman 1995

C. Sherman, *Imagining Aristotle: Verbal and Visual Representation in Fourteenth-century France*, Berkeley, CA, 1995

Shinners and Dohar 1998

J. Shinners and W. J. Dohar, eds, *Pastors and the Care of Souls in Medieval England*, Notre Dame, 1998

Sicca 2008

C. Sicca, ed., *John Talman: An Early Eighteenth-century Connoisseur*, New Haven and London, 2008

Sigal 1921–3

L. Sigal, 'Contribution à l'histoire de la cathédrale Saint-Just de Narbonne', *Bulletin de la Commission Archéologique de Narbonne*, 15 (1921–3), 11–153

Simone 1969

F. Simone (trans. H. G. Hall), *The French Renaissance: Medieval Tradition and Italian Influence in Shaping the Renaissance in France*, London, 1969

Simson 1962
O. G. von Simson, *The Gothic Cathedral: Origins of Gothic Architecture and the Medieval Concept of Order*, 2nd edn, New York, 1962

Sixth Report 1877
Sixth Report of the Royal Commission on Historical Manuscripts, vol. 1, London, 1877

Skinner 1986
Q. Skinner, 'Ambrogio Lorenzetti: the artist as political philosopher', *Proceedings of the British Academy*, 72 (1986), 1–56

Smalley 1952
B. Smalley, *The Study of the Bible in the Middle Ages*, Oxford, 1952

Smalley 1960
—, *English Friars and Antiquity in the Fourteenth Century*, Oxford, 1960

Smalley 1975
—, 'Ecclesiastical attitudes to novelty, *c*.1100–*c*.1250', in *Church, Society and Politics* (Studies in Church History, 12), ed. D. Baker, Oxford, 1975, 113–31

K. A. Smith 2003
K. A. Smith, *Art, Identity and Devotion in Fourteenth-century England: Three Women and their Books of Hours*, London and Toronto, 2003

K. A. Smith 2012
—, *The Taymouth Hours: Stories and the Construction of the Self in Late Medieval England*, London, 2012

K. A. Smith and Krinsky 2007
— and K. H. Krinsky, eds, *Tributes to Lucy Freeman Sandler: Studies in Illuminated Manuscripts*, Turnhout, 2007

R. M. Smith 1991
R. M. Smith, 'Demographic developments in rural England, 1300–48: a survey', in Campbell 1991, 25–77

Sohm 2001
P. Sohm, *Style in the Art Theory of Early Modern Italy*, Cambridge, 2001

Southern 1958
R. W. Southern, 'The English origin of the "Miracles of the Virgin"', *Mediaeval and Renaissance Studies*, 4 (1958), 176–216

Southern 1970
—, 'England's first entry into Europe', in Southern, *Medieval Humanism*, New York, 1970, 135–57

Southern 1990
—, *Saint Anselm: A Portrait in a Landscape*, Cambridge, 1990

B. Spencer 2010
B. Spencer, *Pilgrim Souvenirs and Secular Badges*, London, 2010

J. R. Spencer 1965
J. R. Spencer (introduction), *Treatise on Architecture: Being the Treatise by Antonio di Piero Averlino, Known as Filarete*, New Haven, 1965

J. R. Spencer 1966
—, ed. and trans., *Leon Battista Alberti, On Painting*, New Haven and London, 1966

Sponsler 1997
C. Sponsler, *Drama and Resistance: Bodies, Goods and Theatricality in Late Medieval England*, Minneapolis and London, 1997

Stahl 2008
H. Stahl, *Picturing Kingship: History and Painting in the Psalter of Saint Louis*, University Park, PA, 2008

Stallybrass and White 1986
P. Stallybrass and A. White, *The Politics and Poetics of Transgression*, Ithaca, 1986

Stanton 2001
A. R. Stanton, *The Queen Mary Psalter: A Study of Affect and Audience*, Philadelphia, 2001

Statutes 1810
Statutes of the Realm, vol. 1, London, 1810

Steele 1898
R. Steele, *Three Prose Versions of the Secreta Secretorum* (Early English Text Society, extra ser., 74), London, 1898

Steinberg 1981
T. L. Steinberg, 'Poetry and the Perpendicular Style', *Journal of Aesthetics and Art Criticism*, 40/1 (1981), 71–9

Steinhoff 2006
J. B. Steinhoff, *Sienese Painting after the Black Death: Artistic Pluralism, Politics and the New Art Market*, Cambridge, 2006

Stewart 1868
D. J. Stewart, *On the Architectural History of Ely Cathedral*, London, 1868

Stone 1972
L. Stone, *Sculpture in Britain: The Middle Ages*, 2nd edn, Harmondsworth, 1972

Stones 1997
A. Stones, *Le livre d'images de Madame Marie*, Paris, 1997

Stratford 1991
N. Stratford, 'Bishop Grandisson and the visual arts', in *Exeter Cathedral: A Celebration*, ed. M. Swanton, Exeter, 1991, 145–55

Strohm 1992
P. Strohm, *Hochon's Arrow: The Social Imagination of Fourteenth-century Texts*, Princeton, 1992

Stubbs 1874
W. Stubbs, ed., *Memorials of Saint Dunstan, Archbishop of Canterbury* (Rolls Series, 63), London, 1874

Stubbs 1876

—, ed., *The Historical Works of Master Ralph de Diceto* (Rolls Series, 68), vol. 1, London, 1876

Stubbs 1879–80

—, ed., *The Historical Works of Gervase of Canterbury* (Rolls Series, 73), 2 vols, London, 1879–80

Stubbs 1882–3

—, ed., *Chronicles of the Reigns of Edward I and Edward II* (Rolls Series, 76), 2 vols, London, 1882–3

Summers 1972

D. Summers, '*Maniera* and movement: the "Figura serpentinata"', *Art Quarterly*, 35 (1972), 269–301

Summers 1977

—, 'Contrapposto: style and meaning in Renaissance art', *Art Bulletin*, 59/3 (1977), 336–61

Summerson 1949

J. Summerson, *Heavenly Mansions and Other Essays on Architecture*, London, 1949

Sundt 1987

R. A. Sundt, '*Mediocres domos et humiles habeant fratres nostri*: Dominican legislation on architecture and architectural decoration in the 13th century', *Journal of the Society of Architectural Historians*, 46/4 (1987), 394–407

Sutermeister 1977

H. Sutermeister, *The Norwich Blackfriars*, Norwich, 1977

Swanson 1989

R. N. Swanson, *Church and Society in Late Medieval England*, Oxford, 1989

Symes 2007

C. Symes, *A Common Stage: Theater and Public Life in Medieval Arras*, Ithaca, 2007

Szittya 1986

P. R. Szittya, *The Anti-Fraternal Tradition in Medieval Literature*, Princeton, 1986

Taburet-Delahaye 1995

E. Taburet-Delahaye, 'L'orfèvrie au poinçon d'Avignon au XIVe siècle', *Revue de l'art*, 108 (1995), 11–22

Tachau 1998

K. H. Tachau, 'God's compass and *vana curiositas*: scientific study in the Old French *Bible moralisée*', *Art Bulletin*, 80/1 (1998), 7–33

Tachau 2011

—, 'What has Gothic to do with scholasticism?', in *Gothic Art and Thought in The Later Medieval Period: Essays in Honour of Willibald Sauerländer* (Index of Christian Art, Occasional Papers, 12), ed. C. Hourihane, Princeton, 2011, 14–34

Taibbi 1969

G. Taibbi, ed., *Philagathos of Cerami, Omelie per i vangeli domenicali*, vol. 1, Palermo, 1969

Tait 1914

J. Tait, ed., *Chronica Johannis de Reading et Anonymi Cantuariensis, 1346–1367*, Manchester, 1914

Taralon 1966

J. Taralon, *Treasures of the Churches of France*, New York, 1966

Tatham 1925–6

E. H. R. Tatham, *Francesco Petrarca*, 2 vols, London, 1925–6

Tatton-Brown 2008

T. Tatton-Brown, 'The date of the cloister of Salisbury Cathedral', *Journal of the British Archaeological Association*, 161 (2008), 94–103

H. M. Taylor 1968

H. M. Taylor, 'Reculver reconsidered', *Archaeological Journal*, 125 (1968), 291–6

J. Taylor 1966

J. Taylor, *The 'Universal Chronicle' of Ranulph Higden*, Oxford, 1966

Teuscher 1990

A. Teuscher, *Das Prämonstratenserkloster Saint-Yved in Braine als Grablege der Grafen von Dreux zu Stifterverhalten und Grabmalgestaltung im Frankreich des 13. Jahrhunderts*, Bamberg, 1990

A. H. Thomas 1926

A. H. Thomas, *Calendar of Plea and Memoranda Rolls Preserved among the Archives of the Corporation of the City of London at the Guildhall, 1323–1364*, Cambridge, 1926

H. M. Thomas 2003

H. M. Thomas, *The English and the Normans: Ethnic Hostility, Assimilation and Identity, 1066–c.1220*, Oxford, 2003

B. Thompson 2010

B. Thompson, 'The fourteenth century', in Meadows 2010, 70–121

E. M. Thompson 1874

E. M. Thompson, ed., *Chronicon Angliae* (Rolls Series, 64), London, 1874

M. W. Thompson 2001

M. W. Thompson, *Cloister, Abbot and Precinct in Medieval Monasteries*, Stroud, 2001

Thomson and Winterbottom 2007

R. M. Thomson and M. Winterbottom, ed. and trans., *William of Malmesbury, Gesta pontificum anglorum*, 2 vols, Oxford, 2007

Thurlby 1995

M. Thurlby, 'The Lady Chapel of Glastonbury Abbey', *Antiquaries Journal*, 75 (1995), 107–70

Tiller 2005
K. Tiller, ed., *Dorchester Abbey: Church and People, 635–2005*,
Witney, 2005

Tilley 2007
C. Tilley, 'Materiality in materials', *Archaeological Dialogues*, 14/1
(2007), 16–20

Timmermann 2000
A. Timmermann, 'Architectural vision in Albrecht von
Scharfenberg's Jüngerer Titurel: a vision of architecture?', in
*Architecture and Language: Constructing Identity in European
Architecture, c.1000–c.1650*, ed. G. Clarke and P. Crossley,
Cambridge, 2000, 58–71

Timmermann 2007
—, 'Microarchitecture and mystical death: the font ciborium of
St Mary's in Luton (*circa* 1330–40)', in Gajewski and Opačić
2007, 133–42

Timmermann 2009
—, *Real Presence: Sacrament Houses and the Body of Christ, c.1270–
1600*, Turnhout, 2009

Toker 1985
F. Toker, 'Gothic architecture by remote control: An illustrated
building contract of 1340', *Art Bulletin*, 67/1 (1985), 67–95

Tolhurst 1948
J. B. L. Tolhurst, *The Customary of the Cathedral Priory Church of
Norwich* (Henry Bradshaw Society, 82), London, 1948

Tolley 1991
T. Tolley, 'Eleanor of Castile and the "Spanish" Style in England',
in *England in the Thirteenth Century: Proceedings of the 1989
Harlaxton Symposium*, ed. W. M. Ormrod, Stamford, 1991,
167–92

Tomas 1979
T. Tomas, 'Pere ça Anglada maestro del coro de la catedral de
Barcelona: aspectos documentales y formales', *D'art*, 5 (1979),
51–64

Tomas 1993–4
—, 'Els cadiras de cor: una crònica d'època: el coro de la
catedral de Barcelona', *Lambard: estudis d'art medieval*, 7 (1993–
4), 129–38

Topham 1795
J. Topham, *Some Account of the Collegiate Chapel of Saint Stephen*,
London, 1795

Trachtenberg 1997
M. Trachtenberg, *Dominion of the Eye: Urbanism, Art and Power in
Early Modern Florence*, Cambridge, 1997

Trachtenberg 2000
—, 'Suger's miracles, Branner's Bourges: reflections on "Gothic
architecture" as medieval modernism', *Gesta*, 39/2 (2000),
183–205

Trachtenberg 2001
—, 'Architecture and music reunited: a new reading of Dufay's
Nuper Rosarum Flores and the cathedral of Florence',
Renaissance Quarterly, 54 (2001), 740–75

Trachtenberg 2010
—, *Building-in-Time: From Giotto to Alberti and Modern Oblivion*,
New Haven and London, 2010

Tracy 1987
C. Tracy, *English Gothic Choir-stalls, 1200–1400*, Woodbridge, 1987

Tracy 1988
—, 'The St David's Cathedral bishop's throne and its relationship
to contemporary fourteenth-century ecclesiastical furniture in
England', *Archaeologia Cambrensis*, 137 (1988), 113–18

Tracy 2008
—, 'The former nave and choir oak furnishings, and the west
end and south porch doors, at the Chapel of St Nicholas,
King's Lynn', in *King's Lynn and the Fens: Medieval Art,
Architecture and Archaeology* (BAACT, 31), 2008, 28–52

Tristram 1955
E. W. Tristram, *English Wall Painting of the Fourteenth Century*,
London, 1955

Turner 1841
T. H. Turner, ed., *Manners and Household Expenses of England in
the Thirteenth and Fifteenth Centuries*, London, 1841

Tyson 1977
D. B. Tyson, 'The epitaph of Edward the Black Prince', *Medium
Aevum*, 46 (1977), 98–104

Unger and Huitfeldt-Kaas 1869
C. R. Unger and H. J. Huitfeldt-Kaas, eds, *Diplomatarium
Norvegicum*, vol. 7, Christiania, 1869

Uranga Galdiano and Iñiguez Almech 1973
J. E. Uranga Galdiano and F. Iñiguez Almech, *Arte gotico* (Arte
Medieval Navarro, 4), Pamplona, 1973

J. Vale 1982
J. Vale, *Edward III and Chivalry: Chivalric Society and its Context,
1270–1350*, Woodbridge, 1982

M. Vale 2001
M. Vale, *The Princely Court: Medieval Courts and Culture in North-
West Europe, 1270–1380*, Oxford, 2001

Vallance 1936
A. Vallance, *English Church Screens*, London, 1936

Van Buren 2011
A. Van Buren, *Illuminating Fashion: Dress in the Art of Medieval
France and the Netherlands, 1325–1515*, New York, 2011

Van Engen 1986
J. Van Engen, 'The Christian Middle Ages as an historiographical
problem', *American History Review*, 91 (1986), 519–52

Van Os 1981
H. Van Os, 'The Black Death and Sienese painting: a problem of interpretation', *Art History*, 4/3 (1981), 237–49

Van Riet 1987
S. Van Riet, ed., *Avicenna latinus*, Leiden, 1987

Van Uytven 1983
R. Van Uytven, 'Cloth in medieval literature of western Europe', in *Cloth and Clothing in Medieval Europe: Essays in Memory of Professor E. M. Carus-Wilson*, ed. N. Harte and K. Ponting, London, 1983, 151–83

Vargas 2011
M. Vargas, 'How a "brood of vipers" survived the Black Death: recovery and dysfunction in the fourteenth-century Dominican Order', *Speculum*, 86/3 (2011), 688–714

Vauchez 1997
A. Vauchez (trans. J. Birrell), *Sainthood in the Later Middle Ages*, Cambridge, 1997

Vaughan 1958
R. Vaughan, *Matthew Paris*, Cambridge, 1958

Verlaque 1883
V. Verlaque, *Jean XXII: sa vie et ses oeuvres*, Paris, 1883

Viard 1937
J. Viard, ed., *Les Grandes Chroniques de France* (Société de l'Histoire de France, 9), Paris, 1937

Vincent 2001
N. Vincent, *The Holy Blood: King Henry III and the Westminster Blood Relic*, Cambridge, 2001

Vincent 2007
—, 'A forgotten war: England and Navarre, 1243–4', in *Proceedings of the Gregynog Conference* (*Thirteenth Century England*, 11), ed. B. Weiler et al., Woodbridge, 2007, 109–46

Vincent 2010
—, 'The thirteenth century', in Meadows 2010, 26–69

Vincent 2011
—, *A Brief History of Britain, 1066–1485*, London, 2011

Vinken 1999
P. Vinken, *The Shape of the Heart*, Amsterdam, 1999

Vives i Miret 1969
J. Vives i Miret, *Reinard des Fonoll, escultor i arquitecte anglès, renovador de l'art gòtic a Catalunya (1321–1362)*, Barcelona and Madrid, 1969

Volti 2003
P. Volti, *Les couvents des ordres mendiantes et leur environment à la fin du Moyen Age: le nord de la France et les anciens Pays-Bas méridionaux*, Paris, 2003

Volti 2004
—, 'L'explicite et l'implicite dans les sources normatives de l'architecture mendiante', *Bibliothèque de l'Ecole des Chartes*, 162/1 (2004), 51–73

Vroom 2010
W. Vroom, *Financing Cathedral Building in the Middle Ages: The Generosity of the Faithful*, Amsterdam, 2010

Walker 2007
R. Walker, 'Leonor of England and Eleanor of Castile: Anglo-Castilian marriage and cultural exchange in the twelfth and thirteenth centuries', in *England and Iberia in the Middle Ages, 12th–15th Century: Cultural, Literary and Political Exchanges*, ed. María Bullón-Fernández, Basingstoke, 2007, 67–88

Waller 1864/1975
J. G. Waller, *A series of monumental brasses from the thirteenth to the sixteenth century, drawn and engraved by J. G. and L. A. B. Waller* [1864], London, 1975

Walls 2007
K. Walls, *John Bromyard on Church and State: The* Summa Predicantium *and Early Fourteenth-century England*, Market Weighton, 2007

Walsh 1981
K. A. Walsh, *A Fourteenth-century Scholar and Primate: Richard Fitzralph in Oxford, Avignon and Armagh*, Oxford, 1981

Wander 1978
S. H. Wander, 'The York chapter house', *Gesta*, 17/2 (1978), 41–9

Ward 1893
H. L. D. Ward, *Catalogue of Romances in the Department of Manuscripts in the British Museum*, vol. 2, London, 1893

Warner 1912
G. Warner, *Queen Mary's Psalter*, London, 1912

Warnke 1976
M. Warnke, *Bau und Überbau: Soziologie der mittelalterlichen Architektur nach den Schriftquellen*, Frankfurt, 1976

Warnke 2006
—, 'Warum sind mittelalterliche Kirchen so gross?', in *Die gebrauchte Kirche: Symposium und Vortragsreihe anlässlich des Jubiläums der Hochaltarweihe der Stadtkirche Unserer Lieben Frau in Friedberg (Hessen), 1306–2006*, ed. N. Nussbaum, Stuttgart, 2006, 162–8

Watkin 1977
D. Watkin, *Morality and Architecture*, Oxford, 1977

Watson 1969
B. Watson, 'Islamic sources of the Ormesby Psalter', *Gesta*, 8/1 (1969), 47–52

Watson 1979
—, 'The artists of the Tiptoft Missal and the court style', *Scriptorium*, 33/1 (1979), 25–39

Waugh 2000
C. F. Waugh, 'Style Consciousness in Fourteenth-century Society and Visual Communication in the Moralized Bible of John The Good', unpublished PhD thesis, University of Michigan, 2000

Webb 1949
G. Webb, 'The decorative character of Westminster Abbey', *Journal of the Warburg and Courtauld Institutes*, 12 (1949), 16–20

Webb 1956
—, *Architecture in Britain: The Middle Ages*, Harmondsworth, 1956

Weir 2005
A. Weir, *Isabella, She-Wolf of France, Queen of England*, London, 2005

Weitzmann 1977
K. Weitzmann, *Late Antique and Early Christian Book Illumination*, London, 1977

Weitzmann and Kessler 1986
— and H. L. Kessler, *The Cotton Genesis*, Princeton, 1986

Wentersdorf 1984
K. P. Wentersdorf, 'The symbolic significance of *Figurae Scatalogicae* in Gothic manuscripts', in *Word, Picture and Spectacle*, ed. C. Davidson, Kalamazoo, 1984, 1–19

Wenzel 1982
S. Wenzel, 'Pestilence and Middle English literature: Friar John Grimestone's poems on death', in Williman 1982, 131–59

Wharton 1691
H. Wharton, *Anglia Sacra*, 2 vols, London, 1691

Wheatley 2004
A. Wheatley, *The Idea of the Castle in Medieval England*, York, 2004

Wheatley 2008
—, 'The White Tower in medieval myth and legend', in *The White Tower*, ed. E. Impey, New Haven and London, 2008, 277–88

Whitby 1985
M. Whitby, 'The occasion of Paul the Silentiary's Ekphrasis of S. Sophia', *Classical Quarterly*, new ser., 35/1 (1985), 215–28

M. White 2007
M. White, *A Promise of Beauty: The Octagon Tower and Lantern at Ely Cathedral*, Ely, 2007

T. H. White 1984
T. H. White, ed. and trans., *The Book of Beasts*, New York, 1984

Whitehead 2003
C. Whitehead, *Castles of the Mind: A Study of Medieval Architectural Allegory*, Cardiff, 2003

Whittingham 1980a
A. B. Whittingham, 'The Ramsey family of Norwich', *Archaeological Journal*, 137 (1980), 285–9

Whittingham 1980b
—, 'The Carnary College, Norwich', *Archaeological Journal*, 137 (1980), 361–8

Williams 1993
P. Williams, *The Organ in Western Culture, 750–1250*, Cambridge, 1993

B. Williamson 2007
B. Williamson, 'Site, seeing and salvation in fourteenth-century Avignon', *Art History*, 30/1 (2007), 1–25

P. Williamson 1991
P. Williamson, 'Sculptures of the west front', in *Exeter Cathedral: A Celebration*, ed. M. Swanton, Exeter, 1991, 75–81

P. Williamson 1995
—, *Gothic Sculpture, 1140–1300*, New Haven and London, 1995

Williman 1982
D. Williman, ed., *The Black Death: The Impact of the Fourteenth-century Plague*, New York, 1982

Willis 1845
R. Willis, *The Architectural History of Canterbury Cathedral*, London, 1845

Willis and Clark 1886/1988
— and J. W. Clark, *The Architectural History of the University of Cambridge* [1886], vol. 1, reprinted Cambridge, 1988

C. Wilson 1980a
C. Wilson, 'The Origins of the Perpendicular Style and its Development to *circa* 1360', unpublished PhD thesis, University of London, 1980

C. Wilson 1980b
—, 'The Neville Screen', in *Medieval Art and Architecture at Durham Cathedral* (BAACT, 3), 1980, 90–104

C. Wilson 1990
—, *The Gothic Cathedral: The Architecture of the Great Church, 1130–1530*, London, 1990

C. Wilson 1995
—, 'The medieval monuments', in Collinson, Ramsay and Sparks 1995, 451–510

C. Wilson 2002
—, 'The royal lodgings of Edward III at Windsor Castle: form, function, representation', in *Windsor: Medieval Archaeology, Art and Architecture of the Thames Valley* (BAACT, 25), 2002, 15–94

C. Wilson 2007
—, 'Not without honour save in its own country? Saint-Urbain at Troyes and its contrasting French and English posterities', in Gajewski and Opačić 2007, 107–21

C. Wilson 2008
—, 'Calling the tune? The involvement of King Henry III in the design of the abbey church at Westminster', *Journal of the British Archaeological Association*, 161 (2008), 59–93

C. Wilson 2010
—, 'The chapter house of Westminster Abbey: harbinger of a new dispensation in English architecture?', in *Westminster*

Abbey Chapter House: The History, Art and Architecture of 'a chapter house beyond compare', ed. W. Rodwell and R. Mortimer, London, 2010, 40–65

C. Wilson 2011a
—, 'Why did Peter Parler come to England?', in Opačić and Timmermann 2011a, 89–109

C. Wilson 2011b
—, 'Gothic metamorphosed: the choir of St Augustine's Abbey in Bristol and the renewal of European architecture around 1300', in Cannon and Williamson 2011, 69–147

C. Wilson et al. 1986
— et al., *Westminster Abbey*, London, 1986

J. M. Wilson 1920
J. M. Wilson, trans., *The Worcester Liber Albus*, London, 1920

Wittkower 1942
R. Wittkower, 'Marvels of the East: a study in the history of monsters', *Journal of the Warburg and Courtauld Institutes*, 5 (1942), 159–97

D. Wood 1989
D. Wood, *Clement VI: The Pontificate and Ideas of an Avignon Pope*, Cambridge, 1989

M. Wood 1981
M. Wood, *The English Mediaeval House*, London, 1981

Wood-Legh 1965
K. L. Wood-Legh, *Perpetual Chantries in Britain*, Cambridge, 1965

Woodman 1984
F. Woodman, 'The vault of the Ely Lady Chapel: fourteenth or fifteenth century?', *Gesta*, 23/2 (1984), 137–44

Woodman 1996
—, 'The Gothic campaigns', in Atherton et al. 1996, 158–96

Woodman 2012
—, '"For their monuments, look about you": medieval masons and their tombs', in *Architecture and Interpretation: Essays for Eric Fernie*, ed. J. A. Franklin, T. A. Heslop and C. Stevenson, Woodbridge, 2012, 176–91

K. Woods 2012
K. Woods, 'The fortunes of art in alabaster: a historiographical analysis', in *From Major to Minor: The Minor Arts in Medieval Art History* (Index of Christian Art Occasional Papers, 14), ed. C. Hourihane, Princeton, 2012, 82–102

M. C. Woods and Copeland 1999
M. C. Woods and R. Copeland, 'Classroom and confession', in *The Cambridge History of Medieval English Literature*, ed. D. Wallace, Cambridge, 1999, 376–406

Woodworth 2009
M. Woodworth, 'Unnatural ornament: Beverley Minster, historical consciousness and the Early English Style', *Immediations*, 2/2 (2009), 7–18

Woolgar 2006
C. M. Woolgar, *The Senses in Late Medieval England*, New Haven and London, 2006

Wormald 1988
F. Wormald, *Collected Writings, II: Studies in English and Continental Art on the Later Middle Ages*, ed. J. J. G. Alexander, T. J. Brown and J. Gibbs, London, 1988

G. S. Wright 1984
G. S. Wright, 'A tomb program at Fécamp', *Zeitschrift für Kunstgeschichte*, 47/2 (1984), 186–209

J. R. Wright 1980
J. R. Wright, *The Church and the English Crown, 1305–1334*, Toronto, 1980

Wyckoff 1967
D. Wyckoff, trans., *Albertus Magnus, Book of Miracles*, Oxford, 1967

Yamamoto 2000
D. Yamamoto, *The Boundaries of the Human in Medieval English Literature*, Oxford, 2000

Yalouris 1995
N. Yalouris, 'Eine ungewölniche Propheten-Apostel-Darstellung', in *Byzantine East, Latin West: Art Historical Studies in Honour of Kurt Weitzmann*, ed. D. Mouriki, S. Ćurčić and G. Galvaris, Princeton, 1995, 203–12

Yapp 1981
W. B. Yapp, *Birds in Medieval Manuscripts*, London, 1981

Yates Thompson 1900
H. Yates Thompson, *Facsimiles in Photogravure of Six Pages from a Psalter, Written and Illuminated about 1325 AD for a Member of the St Omer Family in Norfolk*, London, 1900

Yun 2007
B. Yun, 'A visual mirror of princes: the wheel on the mural of Longthorpe Tower', *Journal of the Warburg and Courtauld Institutes*, 70 (2007), 1–32

Zarnecki 1958
G. Zarnecki, *The Early Sculpture of Ely Cathedral*, London, 1958

Ziegler 1982
P. Ziegler, *The Black Death*, Harmondsworth, 1982

Zijlstra-Zweens 1988
H. M. Zijlstra-Zweens, *Of his array telle I no longer: Aspects of Costume, Arms and Armour in Western Europe, 1200–1400*, Amsterdam, 1988

Ziolkowski 1998
J. M. Ziolkowski, ed., *Obscenity: Social Control and Artistic Creation in the European Middle Ages*, Leiden, 1998

Zukowsky 1974
J. Zukowsky, 'Montjoies and Eleanor Crosses reconsidered', *Gesta*, 13/1 (1974), 39–44

INDEX

Note: Persons known primarily by Christian name appear under that name. Illustrations are shown as page numbers in *italics*. The letter n following a page number indicates an endnote.

Aachen: Carolingian palace chapel 14
Aachen Cathedral: reliquary 166, *166*
Abou-el-Haj, Barbara 82
Accursius: *Glossa ordinaria 303*
Adam and Eve imagery 214
Adam of Walsingham 193
adaptive building 37, 87
adiaphora 90
admiratio 144, 183
Adorno, Theodor 55–6
Adrian, St 245
'aesthetic engineering' 33
aesthetics
 'anti-aesthetic' 55–6
 architectural 20, 121, 355
 critiques of 54–7
 English viii, 50
 legislative 30, 68, 83, 122, 184, 349, 350
 medieval 7–9, 13, 46–7
 and perception 182
 and symbolism 14
 'technological' 51
 theory of 55
 and tradition 77
affect 7, 53, 56, 144, 157, 170, 171, 173, 174, 175, 180, 181, 183, 185, 207–8, 223, 351–2

aggrandizement 52, 350
Agricole, St, of Avignon: tomb 257
Ailred of Rievaulx 150
Aix-en-Provence: St Jean de Malte, tomb of
 Beatrice de Provence 254
alabaster 185, 231, 257, 260, 333
Alan of Walsingham, sacrist and prior of Ely 96, 188,
 189, 192–3, 215, 217, 218, 225, 226, 227, 228, 229
Alard family 98, 142
 tombs *99*
Alard, Stephen 141
 tomb *142*, 255
Alban, St 193
Alberti, Leon Battista 28, 63
 Della pittura 208
Albertus Magnus: book of miracles 27
Albrecht von Scharfenberg: *Der jüngerer Titurel* 344,
 347
Alfonso X, king of Spain 382n6
allegory 145–6, 148, 153
 and beauty 183
 Biblical 311
 Dorchester Abbey: Jesse window 172
 frescoes 150
 Grosseteste: *Château d'amour* 182
 Italian art 336
 Lincoln Cathedral 174
 Peterborough Psalter 311
 and satire 310
 and tradition 3, 345
 and wonder 209
alliteration 350

allure 29, 144, 159, 181, 182, 207, 208, 209, 348, 350
Alphonso, Prince (son of Edward I) 299
altar art 127, 157, 158, 246; *see also* retables
Amiens Cathedral 5, 33, 50, 51, 52, 82, 246
 building of 83
 chapels 277
 episcopal tomb 147
 height 35, 36, 37, 38
 interior *52*
 labyrinth 32
 stained glass representation of 128
 west portal façade 124, *124*, 125
amplificatio 143, 316, 318, 347
ancient and modern 45–6, 344
Ancona: Santa Maria della Piazza 225
Ancrene Wisse 147, 148, 150
angelic imagery 177, 178–9, *178*, 194, 199, *200*, 210,
 233, 264, *338*
Angevins 20, 21, 252, 254, 266, 274
Angles (Langlois), Jean 252, 253
Anglo-Saxon Chronicle 20
Anglo-Saxon tradition 6
 embroidery 231
 manuscripts 319
animal imagery 288, 290, *291*, 293–4, *294–5*, 297,
 299, 300, 302, *305*, *306*, *308*, 309, 328; *see also*
 Reynard the Fox imagery
Annunciation imagery 109, 166, 194, 197, 210, 224,
 225, 264, 334, *334*
Anselm of Bury 213
Anselm of Canterbury, St 18, 22
anthropology 54, 55

anti-fraternalism 93, 345, 348, 350
anti-reflection theory 287–8
antiquaries 6
antiquity 317, 337
Anzy-le-Duc 179
Apocalypses 164–5
 Douce 115, 128–9, 130–1, *130*, *131*, *132*, 164, 165,
 165, 166, 168, 177, 178, *178*, *179*, 327
 Liber Floridus 130
Apostle imagery 42, 318
apparators (*apparitors*) 52, 61–2
Aquinas, St Thomas 5, 44, 60, 65, 81, 185
 Summa contra gentiles 61
arcade screens 244–5
archetypes 14, 32, 45, 58, 222
architects
 authority of 60, 61, 63
 and authorship 53, 60, 62
 and 'Christian' classical aesthetic 30
 and Christian imagination 32
 and chronology 45, 46, 87
 communitarian model of 57
 and contracts 62–3
 and Decorated Style: nineteenth-century revival
 of 1
 Exeter Cathedral 24
 families of *see* Canterbury, Curteis, Ramsey
 families of architects
 God as 54
 Hagia Sophia 24
 and height of buildings 32, 33, 36
 identity of 265–6, 268–9, 270, 276
 influence of 78
 influences on 5
 and invention 77
 and mixture 187
 at papal court, Avignon 259
 profession of 52, 60, 61, 78, 265
 at Reims Cathedral 37
 and rhetoric 51
 and St Hugh's Metrical Life 26
 social status of 63, 325
 styles of 219
 at Uppsala Cathedral 40
 at Westminster Abbey 45
architecture
 aesthetics of 121
 as an art form 90
 decorum in 343
 effect of economic conditions on 53, 81–90
 fantasy 183–4
 Filarete: *Trattato di architettura* 344
 'future' 68
 Islamic 162, 163
 in literature 345–51
 Chaucer, Geoffrey: *House of Fame* 345–8, 351
 Langland, William: *Pierce the Ploughman's Crede*
 348–51
 micro- 143, 145, 156, 169, 178, 184, 205, 209, 235,
 254, 256, 311
 and narrative 129
 and professionalism 62
 writing on 3
 see also design

Aristotle
 Ethics 57–8
 and form 55, 182
 on hands 65
 and laughter 289
 Libri naturales 294
 and logic 296
 Metaphysics 57, 58, 59, 183
 natural science 177
 Physics 28, 58, 59
 Politics 4
 Rhetoric 183
armour 163, 320
Arnaud de Via, Cardinal 257
Arnesson Korte, Eilif, archbishop of Trondheim 241
Arnolfo di Cambio 36
arrangement 6, 51, 53, 63, 66, 114, 142, 156, 158–9,
 169, 171, 181, 196, 199, 202, 204–5, 222, 227, 241,
 243, 246, 286, 293, 320; *see also dispositio*; *ordinatio*
Arras Cathedral 36, 37
ars sacra 164, 165, 166; *see also* Christian art
art history 1, 4, 6, 29, 54, 56, 67, 134, 287, 288, 337
art-nature nexus 27–8
artes minores 45, 231
Arthurianism 145, 151
artifice viii, 9, 64, 159, 170–1, 176–7
artists
 as authors 55
 cult of 64
 initiative 53–4
 see also painters
aspiration 37
assimilation 162–3, 164, 331, 336
Assisi: San Francesco 150, 274, 320, 335
Astesano, Antonio: *Heroic Epistles* 5
Aston, Margaret 7, 101
astonishment viii, 32, 34, 276
Attegrene, John 192, 205
Aubert, Etienne (Pope Innocent VI) 262
Audignon: Notre-Dame: high altar reredos screen
 246, *247*
Auerbach, E. 29
Augustine, St 54, 58, 155
 authority of 67
 Confessions 29
 De civitate dei (*City of God*) 334, *335*
Augustinian friars 93, 113, 313
aula 6, 155, 156, 157, 159
austerity 83, 114, 218, 293, 320, 343, 353, 354
authenticity 316–17, 318, 319–20, 337
authority
 of architects 60, 61, 63
 of artworks 307
 and authenticity 316–17, 318, 337
 of manuscripts 325
 and traditions 67
authors/authorship 317
 agency of 55–7
 and artistic initiative 57–63
 'author function' 57, 63
 and invention 44
Auxerre Cathedral
 embrasures 168, *168*
 rebuilding of 61, 68

Auxerre: St Germain 218, 240, 302
avant-garde 2, 77, 157, 360
Avicenna 28
Avignon 83
 artists in 252–3
 importance of 232, 263
 Musée du Petit Palais 257
 Palais des Papes 263, 265, 270
 papal library 254
 St Didier 65
 tomb of Cardinal Bertrand de Déaux 261, *261*,
 262
Avignon Cathedral
 tombs 260
 Agricole, St 257
 Jean de Lagrange, Cardinal 277
 John XXII, Pope 154, 232, 244, 253–5, *253*, *255*,
 256, 257, 259, 264
 Magnus, St 257
Aycelin, Hugues, Cardinal 232
Ayermin, William, bishop of Norwich 262, 332, 333
Aymer de Valence 256

baboons 284, *285*, 287, 297
Bachelard, Gaston: *La poétique de l'espace* 144
Baghdad: Green Dome 32, 35
Bailey, M. 89
Bakhtin, Mikhail 284, 302
Baldock, Ralph 100
Bale, John 216
Baltrušaitis, Jurgis 291
 *Le Moyen Age fantastique: antiquités et exotismes
 dans l'art gothique* 162
bankers, Italian 192, 226, 389n32
barbarism 343–4
Barcelona 39
 Santa Maria del Mar 36, 39
Barcelona Cathedral 272
Bardolpf family 300, 328
Bårdsson, Pål, archbishop of Trondheim 241
Barkby (Leicestershire) 277
Barnet, John, bishop of Ely 210, 216, 379n58
Baroque style 55, 161
Barton-upon-Humber: St Peter 175
basilicas 16, 20, 22, 33, 36, 86, 150, 167, 196, 245,
 335
 Cluny Abbey 16–17
 St Paul's (Rome) 31
 St Peter's (Rome) 14, 17, 18, 19, 31, 34–5, 36, 259
Batalha Abbey 235, 273
Batayle, John 303
Batayle family 211
Bateman, William, bishop of Norwich 262, 332
Battle Hall (Kent) 154
battlements 116, 117, 132, 133, 135, 145, 146, 154,
 235, 244, 319; *see also* crenellations
Baudrillard, Jean 283
Bauhaus 2
Baxandall, Michael 65, 77
Bayeux Cathedral 18, 131
Bayonne Cathedral 246
Beatrice de Provence: tomb 254
beauty 27–8

and allegory 183
of churches 217
and design 66
Ely Cathedral: Lady Chapel 205
feminine 208
human 56
painters and 316
and the senses 56
in the Song of Songs 29
and surface 181–2
of tombs 184
and usefulness 185
of Westminster Abbey 39
and Wonders of the World 31, 32
Beauvais
St Lucien 33
tomb of Cardinal Jean Cholet 254
Beauvais Cathedral
chevet 82
choir 33, *34*, 37
collapse of 143
height of 35, 36, 37
stained glass representation of 128
Beche family 98
Becket, Thomas (St Thomas of Canterbury),
archbishop of Canterbury 19, 21, 97, 244, 346
circle of 293
miracles 16
shrine of 22, 25, *25*
Bede 145
De tabernaculo 155
De templo 155
Historia ecclesiastica 25–6, 222, 331, *332*
tradition of 150, 155
Beeston (Norfolk) 268, 273
Bek, Anthony, bishop of Norwich 332
Bekynton, Thomas, bishop of Bath and Wells 355,
364
bell towers 32; *see also* campaniles
Bellapais Abbey 274
Belleperche Abbey 164
bells: Ely Cathedral 188, 217, 223
Belting, Hans 56, 336
Bild-Anthropologie 55
Benedict, St: Rule of 146
Benedictine friars 27, 93, 217
Benevento: Santa Sofia 14
Benjamin, Walter 55–6
Benoît de Sainte-Maure: *Roman de Troie* 184
Berkeley family 93, 98
Bernard de Clairvaux, St 3, 28, 55, 122, 146, 177
Apologia 29, 183, 214, 285, 288, 339, 348, 351
sermons on the Song of Songs 29
Bernard de Rousergue, archbishop of Toulouse 251
Bernard of Chartres 46
Bertrand de Déaux, Cardinal 262, 322
tomb 261, *261*, 262, 265
Beverley Minster 6, 24, 25, 239
feretory 125–6
nave 78, 131, 218
Percy tomb 140, 176, *176*, 208, *208*, 209
rebuilding of 86
tower 227
uniformity of 353

Bible
Aelfric Pentateuch 319
architectural terms in 314
English vernacular 347
Genesis
Cotton 319
Egerton 319, *321*, *322*, 323, *323*, 335, *338*, 341, *341*
St Omer Psalter *327*
glossed 328
Gospels of Kildare 144
Holkham Bible Picture Book 312, *313*, 318, 324
iconography of 318
illustrations from 315–16, *315*, 319
interlace forms in 325
Isaiah 59
Lothian 319
marginalia in 294
and metaphor 145
Moralized 54, 198, 315, 342, 387n78
Morgan Bible Picture Book 319
murals 132
Parisian Vulgate 53, 54, 144, 295
Pauline epistles 146
Psalms 28, 67, 146, 147, 151, 155, 170, 175, 216,
288, 293, 299, 307–8, *313*, 326, 327, 364; *see also*
Psalters
Sainte-Chapelle Lectionary 168
Song of Songs 29, 149, 170, 201
stories from 5, 317
of William of Devon 294, *294*
bird imagery 26, 28, 232, *288*, *289*, 294, 295, 303, *306*,
308, 309, *309*
bishops 86, 96, 139, 146, 190; *see also* names of
individual bishops
Bitton, Thomas, bishop of Exeter 86, 93
Black Death 88, 95, 355–6, 358, 360–2, 364; *see also*
plague
Black Prince: tomb 364
Blacman, John 355
Blair, John 361
Blanche of Naples, Queen 266
Bleuet of Troyes 5, 38
Boccaccio, Giovanni 3
Decameron 207
Bock, Henning 2, 123, 132, 155, 225, 236
Bologna: San Petronio 35, 39, 83
Bonaventure, St 55, 113, 122, 349
Bond, Francis 172, 356
Boniface IV, Pope 36
Boniface VIII, Pope 93, 169, 222, 232
Bonitus, St (Bonet)
images of 209, *211*
miracle of 210–11, 214
Bony, Jean 2, 30, 33, 40, 41, 50, 53, 54, 63, 81, 83, 96,
110, 123, 132, 133, 134, 137, 145, 146, 148, 154, 161,
162, 164, 246, 257, 264, 265, 273, 276, 279, 283
*The English Decorated Style: Gothic Architecture
Transformed, 1250–1350* ix, 43, 44, 231, 235, 236,
237–8
books
academic 294
consumers of 299
and *copia* 316
eloquence of 311

Ely Cathedral: register of diocesan revenues
293–4
illuminated *100*, 101, 129, 131–2, 144, 175, 232,
254, 262, 284, 292–3, 295; *see also* Books of
Hours; marginalia; missals; Psalters
Artes (compilation) 294, *295*, 297
Black Death, impact of 360
branding 299
as gifts 299–300
interlace forms in 325–6
Italian 331
market for 293, 297, 298, 304
Moralia in Job 328
para-academic character of 325
Rabbula Gospels 166
La Sainte Abbaye 156
illustrated 233, 316
law 303–4
Brewes-Norwich Commentaries 303, *304*
liturgical 292
manufacture of 328
'moral' 299
Nederrijns Moraalboek 300, *301*
Norwich Cathedral: First Register 104, 109, 115
papal registers 293–4, 304
prayer 292
production 53, 99
register of writs 302
scholastic 296
see also Bible
Books of Hours 99, 211–12, 214, 293, 319, 325
of Alice de Reydon *100*
animal imagery in 294
Carew-Poyntz Hours 211, 316
Clifford-Pabenham Hours, Hours of the Holy
Trinity *301*
Egerton Hours 294
Grey-Fitzpayn Hours 300
market for 294
Neville of Hornby Hours 212
Salvin Hours 294
Taymouth Hours 211, *213*, 214, 299, 316, 325, *326*,
333, 334, 386n79
Tynmouth Hours *333*
Yolande of Soissons: Psalter and Hours of 129, 293
Bordeaux Cathedral 39, 246
bosses
Avignon Cathedral 254, *255*, 256, 257
Bayonne Cathedral 246
Cley parish church 108, *108*, 299
Ely Cathedral 115, 218, 221, 222, 223, *224*, 225
Evesham Abbey 201
Norwich Cathedral 102, *102*, 104, *104*, 105, 109,
109, 110, *110*, 111–12, *112*, *362*, 364, *364*
Bottisham parish church (Cambridgeshire) 98, *98*,
244
Bourges 5
house of Jacques Coeur 277
Bourges Cathedral 82
height of 35, 36, 38
sculpture *179*
vault 37
west front, central portal *180*
Boyton (Wiltshire): chantry 93

Bracciolini, Poggio: works 305, *305*
Bradfield, John, bishop of Rochester 141
 tomb 168
Branner, Robert 37, 43, 53, 67, 294
brass lettering 184
brasses 147, *147*, 163, 216, 361, *361*, 362, 364
Brenk, Beat 29
brick buildings 27, 83, 157
Bridport, Giles, bishop of Salisbury: tomb 152, 201
Brightwell Baldwin (Oxfordshire)
 brass of John the Smith 361, *361*, 364
Bristol
 as a centre of production 100
 Decorated style in 7, 357
 Mayor's Chapel 169
 Perpendicular church doors 6
 St Augustine's 69–70, 93, 194, 235, 236
 Berkeley chapel 140, 176, *176*
 Eleanor cross 108
 Jesse window 313
 Lady Chapel 204, 208, 268
 rebuilding of 86
 reredos 168
 St Mary Redcliffe: north porch 70, *70*, 140,
 205–6, *206*, 208, 218, 248
Bristol Cathedral 70, 97
 choir *70*
 Lady Chapel 168, *169*
 patronage 98
Bromyard, John 284
 Summa predicantium 66, 114, 174–5, 181, 217, 307,
 316–17
Bronescombe, Walter, bishop of Exeter 93, 96
bronze
 effigies 184–5
 tombs 165
Brunelleschi, Filippo 229, 231
Buc, Philippe 61
Bucher, François 143, 144
builders 51, 57; *see also* masons
building booms 26, 39, 82–4
building materials 195; *see also* stone; wood
building process 57
Burchard von Hall 38
Burgersh, Henry
Burgos Cathedral 83
burlesque 292
Burnell, Robert, bishop of Bath and Wells 96, 146
Burrow, John 3–4
Bury St Edmunds 82
Bury St Edmunds Abbey 18, 20, 75
 charnel chapel 106
 choir 319
 gatehouse 116, *116*
 Gothic additions to 187
 Lady Chapel 193, 194, 213
 Leland on 7
 length of 17
Butley Priory (Suffolk): gatehouse 115, *116*
buttresses 52, 262
 Audignon 246
 Avignon: St Didier 261
 Ely Cathedral 75, 197, *200*, 201, 218
 flying 67

Paris: Notre Dame 132, 133, 156
 Reims Cathedral 128
 Tarragona Cathedral 272
Bynum, Caroline 144, 177
Byzantine art 166, 175, 225, 326
Byzantium 162

Caedmon 319
Caen
 St Etienne 17
 stone quarries 65
Cahn, Walter 46
calvaries 251–2
Cambrai Cathedral 36, 37
Cambridge
 Little St Mary's parish church 94, *94*, 215
 Psalters 129, 295
 St John's Hospital 94
 St Michael's church 98
Cambridge University
 Corpus Christi College 216
 King's College 63, 353, 355
 Chapel 353, *354*
 Peterhouse College 94, 215
 Trinity Hall: Founder's Cup 262, *263*
Camille, Michael ix, 56, 287, 302
 The Gothic Idol 55
 Image on the Edge 284
 Mirror in Parchment 287
campaniles 36, 188; *see also* Ely Cathedral: octagon
canonical Gothic style 127, 143, 166, 298, 347
canonization 93, 345; *see also* sainthood
canopied niches 123, 125, 155
canopies 74, 75, 91, 98, 110, *119*, 124, 125, 126, 128,
 129, 130, 132, 133, 135, 138, 139, 140, 141, 142,
 143, *143*, *149*, 150, 152, 153, 155, 157, *158*, 159, 163,
 166, 176, *176*, *178*, 184, 197, 199, 204, 246, 254,
 255, 256, *263*, 350
Canterbury
 archbishops' hall 159
 archdiocese of 37
 Christ Church 97
 St Augustine's Abbey 17, 18, 115, 218, 312
 St Pancras 245
Canterbury Cathedral 18, 21
 architects 57
 choir 28
 choir screens 70, 155, 182, *182*
 crenellated cornices 154
 Jesse Tree 313
 length of 17
 library 328
 use of marble 25, *25*, 26, 27
 nave 87, 358
 prior's throne 141
 rationality of 50
 rebuilding of 22, 84
 shrine of St Thomas Becket 25, *25*
 St Anselm's Chapel window 88, *89*, 257
 stained-glass windows 310, 311
 tombs
 Archbishop Henry Chichele 355, 361, *362*, 364
 Archbishop Hubert Walter 244

 Archbishop John Pecham 157, 168
 Archbishop Simon Meopham 244, *244*, 259
 Archbishop John Stratford 261
 Black Prince 364
 Trinity Chapel *25*, *48*
Canterbury family of architects (Canterbury
 Company) 62, 97, 123; *see also* Michael of
 Canterbury; Thomas of Canterbury
Capel-le-Ferne 244
Capetian Gothic 237
Capetians 6
captatio benevolentiae 92
Carcassonne: St Nazaire 252
caricatures 304
Carlisle Cathedral 86, 172
Carmelites 113
carpentry 235
Carruthers, Mary 27, 45, 67, 182, 183, 296, 351
carving 152
Cassiodorus 32
 Institutiones 28
castles 84
 building of 52, 89, 96
 Castle Rising (Norfolk) 333
 in literature 184, 345
 metaphor of 150, 153
 Sherborne 147
 Stokesay 159
 symbolism of 115, 148
 toy 154
 Wales 5, 89, 96
 Windsor 358
 see also fortresses
Catherine, St: imagery 157, *158*, 248, *248*
causes: in authorship and art 57–63
cautelae 115, 303
Caviness, Madeleine 369n182
Celestine V, Pope 232
centralization 61, 62
Chalgrove (Oxfordshire) 361
Châlons Cathedral 128, 235
Chanac, André Ayraud de, Abbot 264
chantries 91, 92, 93, 95, 106, 141
chapels
 bankers' 336
 charnel 106; *see also* Norwich Cathedral: Canary
 (charnel) Chapel
 palatine 42
 Saintes chapelles 42; *see also under* Paris
 see also chantries
Chapman, F. R. 193
chapter houses 200–1, 218, 219
 Evesham Abbey 201
 Lincoln Cathedral 222
 Norwich Cathedral 101, 109–10, 114
 Pamplona Cathedral 249
 Roncesvalles collegiate church *249*
 Southwell Minster 175, *175*, 176
 Wells Cathedral 168
 Westminster Abbey 156, 350
 York Minster 152, *152*, 154
charisma viii, 3, 21, 25, 26, 27, 32, 64, 67, 69, 177,
 316, 335, 336, 337
charity 21, 180, 183, 185, 207, 216–17

Charlemagne 251
Charles I of Sicily, count of Anjou 66
Charles IV, Emperor 237, 275
Charles V, king of France 263
Chartham parish church (Kent) 141
 chancel window *243*
Chartres Cathedral 5
 building of 57, 82–3
 height of 35, 36, 38, 127
 jubé parapet *132*
 labyrinth 32
 military aesthetic of 153
 stained glass 46, *46*, 178
 vaults 37
Chaucer, Geoffrey 2–3, 33, 51, 64, 207, 251, 285, 289, 302
 The House of Fame 3, 4, 161, 183, 209, 284, 345–8, 351
 The Miller's Tale 235
 subtil compassinges 174
 Tale of Beryn 311
 Troilus and Criseyde 208
Chester Abbey 86, 96
Chester Cathedral: shrine base of St Werburgh 358–9, *359*
chevets 35, 82, 84, 126, 128, 131, 158, 251
Cheylard, Château du *see* Saint-Geniès
Chichele, Henry, archbishop of Canterbury 352, 353, 364
 tomb 355, 361, *362*
Chichele, William (brother of Archbishop Chichele): brass of 364
Chichester Cathedral 86, 87
Cholet, Jean, Cardinal: tomb 254
Chrétien de Troyes 233
 Lancelot 184
Christ
 Crown of Thorns relics 5, 111, 166, *200*
 Holy Blood relics 101, 241, 245
 imagery of 111, 115, *115*, 127, *127*, 164, 166, 174, 179, *179*, 223, 225, *250*, 251, *251*, 313, 318, *324*, 331, *342*; *see also* Crucifixion imagery; *Pietà* imagery; Virgin and Child imagery
 Incarnation of 149, 150
 narratives of 214, 318
 Passion of 40, 104, 110, 111, 112, 199
 and shield imagery 147
 tombs of 22, 26, 97, 99; *see also* Jerusalem: Holy Sepulchre
Christchurch Priory, Dorset
 choir and reredos *92*
 reredos 313, *313*
Christchurch Priory, Hampshire: reredos 178
Christian art 181; *see also* ars sacra
Christine de Pisan 58
Chronicon anglie 340, 340–1
Cicero 227
 commentaries on 207
 De inventione 51, 66
 De oratore 29, 286, 305
Cistercian friars 68, 93, 184, 353
Clanchy, Michael 304
Clasen, Karl-Heinz: *Deutsche Gewölbe der Spätgotik* 236

classical orders 122
classification 122
cleanness 345, 351, 353
Clémence of Hungary 307
Clement IV, Pope 37–8, 39, 41, 113, 262, 265
 mausoleum 263
Clement V, Pope 232, 235
 Clementines 90
Clement VI, Pope 88
clerical dress 340
Clermont-Ferrand Cathedral 65
Cley parish church (Norfolk) 205, 238, *239*, 268
 south porch boss 108, *108*, 299
Clifford family 300
clocks 350
cloisonné 166, 167
cloisters 29; *see also under* individual cathedrals
clothing 183; *see also* dress history
Cluny Abbey
 as a basilica 16–17
 dimensions 14, 33, 36, 196
 as a miracle 32
 nave portal *14*
 as a prodigy building 30
 workshops 45
Cobham family 98
Coeur, Jacques: house of 277
Cohn, Samuel 361
Coldstream, Nicola 69
Coleridge, Samuel Taylor: *Biographia literaria* 49
collatio 66, 67, 75, 87
Cologne 37, 83
 St Gereon 218
Cologne Cathedral 42
 chevet 82
 choir-stall paintings 156
 grotesque devices 298
 height of 35, 36, 37
 incompletion 38
 problems 83
 spires 87
 tomb of Philip von Heinsberg, archbishop of Cologne 147
Colonna family 335
colour
 in aesthetic experience 25–6, 27, 28, 29, 182–3, 184–5, 207
 in Bible illustration 314–15
 in Langland, William: *Pierce the Ploughman's Crede* 348
 symbolism of 150
 see also polychromy
columnar churches 17, 30–1
columns 20, 22, 25, 27, 29, 31, 32, 34–5, 36, 38, 102, 126, 228, 344, 350
Colvin, H. M. 96
Commendatio lamentabilis 6, 185, 351
commissioning
 artworks 125, 126, 157, 163, 225, 252, 302, 360–1
 books 99, 169, 192, 293
 buildings 19, 26, 40, 65–6, 83, 92–3, 96, 97, 98, 170, 201, 202, 208, 224, 254, 257, 260, 261–3, 268, 270, 277, 362; *see also* patronage
communitarian model 56, 57

competition 19, 27–8, 30, 43
 book production 300
 cathedrals 217
 and height of buildings 36, 37
 and innovation 81
 and labour costs 89
 masons 204
compulsion 335, 337
confidence 4, 5, 6, 36, 41, 78, 113, 121, 145, 163, 185, 193, 217, 227, 364
Conques 33
conservation 87
consilium 51–4, 55, 62, 227; *see also* logistics
Constantine, Emperor 22
Constantinople *see* Istanbul
Constantinopolitan decorative arts 167
Conti family 163
contracts 125
Cooper, Lisa 325
copes 169, *171*, 230, 232–5, *233*
Copford (Essex): chancel wall paintings 157
copia/fullness 310, 313, 316
corbels 105, 109, 132, 154, 200, 202, 204, 205, 215, 217, 223, *224*, 270
Córdoba: Great Mosque 30, *31*
Corneilla-de-Conflent (Pyrénées-Orientales) 246
cornices: crenellated 42, 120, 132, 133, 152, 154, 204, 244, *256*, 261
Corpus Christi 90, 98, 100, 101, 148, 153
Costantini, Frédérique 384n147
costliness 39, 52, 78, 83, 84–5, 86, 87–9, 90, 100, 138, 183, 192, 203, 220, 227, 237, 354, 356, 357, 358, 359–60
Coulson, Charles 146–7
Counter-Reformation 351
court artists 131
'Court Style' 67, 286
courtliness 132
courts
 and Decorated Style 185
 employment 89
 fashion 340, 341–2
 and innovation 157
 rivalries 40
 storytelling 134
 temporary installation art 133
 variety 41
 wall paintings 336
 youth culture 340, 342
craft 55, 61, 181, 298, 325
craftsmen 58, 61, 140, 301
creativity 132, 278
crenellations 116–17, 146, 147, 151, 152, 153, 154, 156, 194, 202, 204, 244, 255, 256, 262, 336
crises 81, 82, 88
crosses 115, 215, 226, 245; *see also* Eleanor Crosses
Crossley, Paul 236
Crowland, Geoffrey, abbot of Peterborough 248
crucifixes 100, 175
Crucifixion imagery 104, 110, 148, 157, 169–70, *170*, 172, 175, 199, 206, 207, 225, *250*, 251, 325, *326*, 331, *331*, 332, 333, *334*, 335
Crusades 162

cults
 artists 64
 bishops 139
 Corpus Christi 90, 98, 100, 101, 148, 153
 memory 90
 personalities 69, 345
 relics 69
 remembrance 361
 St Bonitus 210–11
 Virgin Mary 149–50, 206, 208, 336
curiositas 29, 31, 178, 209, 269, 348, 350, 351, 352, 353
Curteis family of architects 102, 111
curvilinear aesthetic 208, 267, 357, 359; *see also under*
 tracery; windows

Daedalus 32, 324
Damascus 30
Damian, Peter 197
Dante Alighieri 3
 Purgatorio 207
Daphni 225
Daristot, Thomas 252
Daussures, Jean 252, 253
David, King: imagery of 197, *198, 250, 251,* 308, *308,*
 328
Davis, R. H. C. 352
de Brailes, W. 294, 318–19, 322
De Bruyne, E. 54, 286
De Lisle Psalter *see under* Psalters
Death personified 362, *362, 363, 364*
decentralization 278
Decorated Style 231
 achievements of 64, 78, 179–85
 adaptability of 71
 aesthetics of 178
 and austerity 343
 battlements 117
 Bayonne Cathedral 246
 critiques of 81
 curvilinear phase 138
 development of 6
 and economic change 88
 Ely Cathedral 202
 and embroidery 236
 English and European reactions to 4
 Exeter Cathedral 24, 78
 fragmentation of 237
 French 277–8
 impact of 2, 7
 inauguration and development of 85
 innovation in 97, 98, 109
 intensive character of 90
 and Internationalism 2, 238
 Islamic influence in 123
 La Chaise-Dieu Abbey 265
 minificence of 167
 after Modernism 43–7
 national consequences of 77
 Norwich: Blackfriars 113, *113*
 Norwich Cathedral 101
 origins of 1, 69
 and Perpendicular Style compared 356, 357, 359,
 360

and persuasion 145
Pevsner on 1–2
prestige of 90
use of Purbeck marble 25
rational artifice of viii
reactionary nature of 43, 152, 161
responsiveness of 72, 78, 152, 180, 187
as a 'revitalizing' moment 273
risk in 209
and scale 176
and space 218
for tombs 98
and tradition 77
 Trondheim Cathedral 241
and uniformity 354
 Westminster Abbey 40
 Westminster Palace: St Stephen's Chapel 42
windows 174
wit in 171
see also Kentish style
decorum 292, 340, 342, 343, 344, 352–3
Deliyannis, D. M. 32
Delhi: Qutb Mosque 163
Demus, Otto 162
Derrida, Jacques 283
Deschamps, Eustache 3
Deschamps, Jean 61
Desiderius of Montecassino 27, 45
design 14, 50, 52, 56–7, 61, 63, 64, 65, 66, 77, 78,
 121, 150, 152, 175–6, 184, 187, 196, 231, 237, 238,
 253, 257, 276; *see also* architecture; drawings;
 ordinatio
Despencer family 98, 226, 261; *see also* Hugh le
 Despencer
Devizes 16, 196
diaperwork 90, 131, 135, 141, *182,* 255, 256
Dijon: St Bénigne 218
diminutio 142, 143
Dionysius of Forna 318
dispositio 50, 66
Dissolution of the Monasteries 7
diversitas 29, 30
Dixon, Philip 194, 217
doctus 64–5
domes
 Baghdad: Green Dome 32, 35
 in courtly literature 166
 Ely Cathedral 221
 Florence Cathedral 221–2, 229
 Islamic 163
 mosaics 225
 Rome: Pantheon 221, 222
Dominic of Evesham 213
Dominican friars 92–3, 96, 113, 349, 350, 351
Dorchester Abbey (Oxfordshire): Jesse window
 171–2, *171,* 312, 313
Draper, Peter 69
drawings
 architectural 63, 64, 69, 125, 298
 archives 219, 359
 components 65
 elevation 297
 Ely Cathedral 193, 197
 Exeter Cathedral 138

importance of 61, 63, 68
Lichfield Cathedral 63
masons and 204
movement of 192
ruling/rulers 297
scale 52
and standardization 64
see also design
dress history 163, 320, 339–43, 355; *see also* clothing;
 fashion
Drokensford, John, bishop of Wells 96
Duccio 336
 Annunciation 334
Duèse, Gaucelm 307
Dunfermline Abbey: tomb of Robert the Bruce
 259
Durán Sanpere, A. 265
Durham 146
Durham Cathedral
 aesthetic values 228
 design 52–3
 law books 303
 length 17
 nave *18,* 87
 spiral piers 50
 spiral pillars 17
 tomb-throne of Bishop Hatfield 139
 wealth 86
Durliat, Marcel 265
dwarfs: and giants 2, 5, 46, 178
dystopian: and utopian 290, 292

Eadmer 18, 341
early Gothic 35, 70, 179
Eastry, Henry, prior of Canterbury 70, 182, 328
Eberard, Guillaume 262
economics 53, 57, 81–2, 83, 84, 87–90, 114, 123, 163,
 184, 246, 276, 355
Edburga, St: shrine 140
Edgar, king of England 215, 226
Edington priory church (Wiltshire) 358, *358*
Edmund, St: miracles 366n14
Edmund Crouchback, earl of Lancaster
 marriage 150
 tomb 141, *142,* 154, 255
education 303; *see also* schools; universities
Edward I, king of England 5, 6, 42, 62, 85, 93, 95–6,
 115, 145, 154, 185, 232, 349, 351
Edward II, king of England 6, 42–3, 96, 97, 193,
 246, 254, 259, 307
 tomb 25, 185, 257, *258,* 260
Edward III, king of England 5, 101, 216, 246, 259,
 260, 332, 340, 342–3
Edward of Woodstock, Prince of Wales *see* Black
 Prince
Edward the Confessor, St, king of England 17
 shrine 58–9, *59*
 tomb 41
effect 181
effigies 125, 164, 184–5, *185,* 255, 260, *260*
Ekroll, Øystein 382n50
Eleanor Crosses 5, 97, 108, 115, 134, 138, 141, 146,
 154, 157, 159, 185, 208, 254, 303, *305,* 349–50

Geddington (Northamptonshire) 135, *135*, *256*
Hardingstone (Northampton) 108, 135, *136*, 158–9, *158*, *160*, 161, 168, 172, 265
London 115, 139
Eleanor of Castile, Queen 93, 96, 101, 129, 232, 349
Elias of Bekingham 98
Elias of Dereham 131
elites 287, 302, 304, 351
Elizabeth I, queen of England 140, 308
Elkyn, Thomas 351–2
Elsing (Norfolk): brass 216
Ely Cathedral 20, 45, 74–5, *188*
 adaptability 35
 administration 190, 192
 architects 62
 architectural diversity 187
 bells 188, 217, 223
 building work 86
 campanile 226–7
 choir 71–2, 154, 188, 239
 cloister 114, 373n128
 costs 84, 88
 cunning 64
 Decorated Style 77
 founders 223
 Galilee porch *74*, 75
 iconoclasm 209
 influence of Norwich Cathedral 205
 invention 87, 204
 Italian banking connections 226
 Lady Chapel 86, *95*, 114, 140, *189*, 195–200
 arcading 74, 75, *75*, *182*, 183, *198*, 208
 art 209, 210, 211, 318
 bosses 115, 195
 building 189, 190, 193, 194, 201–2
 colour 207, 216
 component manufacture 204, 211, 214
 curvilinearity 357
 Decorated Style 64
 dimensions 196
 dispositio 171
 eclecticism 196
 foundations 204
 funding 214–17
 imagery 196–7, 205, 206, 207
 insinuation 207
 mixture of forms 206
 plan *194*
 reredos 200
 screens 210, 211
 sculpture 178, 199–200, 219, 316
 south wall *197*, *198*, *206*
 stalls 205
 subtilitas 207
 tabernacles *198*
 vaulting 215, 216, 217
 wall arcade 205
 west end *216*
 windows 199, 205, 210, 216, 264
 wit 77
 lantern 42, 357
 length 17
 marble 25
 misericords 214, *214*
 mosaics 225
 nave 87, 188
 octagon 3, 42, 74, 97, 114, 154, *186*, 189, 193, 217–20, *219*, *220*
 architects 219
 artworks 225
 bells 223
 building 190
 choric nature 223
 corbel *224*
 cost 86, 192
 height of 35, 36
 heroic mode 220–1
 imagery 223, 225
 lantern 218, 219, 223, 229
 as a pantheon 223–4
 as a performative space 223
 rebuilding 227–8
 subcontractors 219–20
 symbolism of 222
 template 220
 painted surfaces 24
 presbytery *85*, 86, 188, 190, *191*, 192, 193, 204, 222, 265
 Prior Crauden's Chapel *190*, *203*, 204, 225
 arcading *64*, 75, 189
 building 74
 cost 192
 design 202
 guilloche *226*
 murals 325, 332
 windows 205, 264
 prior's door 102, 179, *179*
 reconstruction 87
 relics 223
 retrochoir *71*, 84
 shrines 188, 217, 223, 265
 spire 217
 stone seraph 199, *200*
 stone store 199
 tomb of William of Louth 96, 147, 204–5, 255, 274, *275*
 tower 188, 189
 tripartite niche forms 133
 vaulting 105
 wall arcading 175
 Walsingham memorandum 27
 wealth 86
 workforces 202, 204
Ely *Chronicon* 188, 190, 192, 193, 199, 200, 215, 218, 226, 228
embroidery 169, 231, 232, 273; *see also Opus anglicanum*
empiricism vii, 7
emulation 19–20, 26, 36, 37, 43
 books 316
 Eleanor Crosses 135
 heroic 140
 St Paul's Cathedral 40
 St Stephen's Chapel 41–2
 Westminster Abbey 40, 41
enamels 167, 248
encastellation 146
enchantment 181, 367n70, 375n96
endowments 93
English art 30, 44
English culture 3, 5–6
English idiom 64
English textual tradition 150
Enguerrand de Coucy: tomb 254
Enlart, Camille 276
epics 18
Erkenwald, St: *Saint Erkenwald* poem 184
Ernulf, Prior 70
eroticism 140
error 3, 183, 209, 301, 348, 350, 353
Erskine, Audrey 86
essentialism 14
Etheldreda, St 155, 156, 187, 215, 222, 223, 227
 shrine 217, 265
Ethelwold, St 155–6
Etienne d'Auxerre 335
Etienne de Bonneuil 40, 241
Eton College chapel 43, 353, 355
Eucharistic symbols 101, 174
Euclid 325
Eulogium historiarum 340, 341, 342
Eusebius 22, 27, 28, 33
Eustace, St 214
Evans, Michael 147–8
Evesham Abbey: chapter house 201
Evrard, Robert 262
Evrard, William *see* Eberard, Guillaume
Evrard family 262
Evreux Cathedral: shrine of St Taurin 125
exegesis 145
exemplars 16, 37, 163, 317, 318, 331, 353, 355
Exeter Cathedral 24, *24*, 78
 bishop's throne 70, 89, 135, *137*, 138, 140, 154, 175, 204, 254
 canopy work 129
 chantry 93
 choir 97, *137*, 218
 cost 85
 crenellations 146
 cult of bishops 139
 cunning 64
 Decorated Style 78
 glass 138
 launching of 96
 liturgies 139
 marble 25
 nave 24
 patronage 98
 portals 87
 pulpitum 140, *141*, 204
 Rayonnant Gothic 146
 rebuilding 86
 reredos 140, 256
 sedilia 91, *91*, 256
 tabernacle forms 254
 tomb of Sir Richard Stapledon 179, *180*
 vault 6, 236
 wages 88–9
 wealth of 86
 west front 178, 201, 336, *336*, 360
expressionism 170

fables *294*, 302, 310
Faith, St *134*
fantasy 183
 Christian 347
 Late Gothic 71
 in marginalia 290
 and miniature 144
 in ogee arches 162
fashion 235, 340, 343–4; *see also* dress history
Fécamp: La Trinité: tomb of Robert de Putot 382n37
Fernie, Eric 19, 20, 373n138
Ferrières-en-Gâtinais Abbey 241
fertility images 300
Fett, Harry 272
figura serpentinata 207
figurative arts 77, 81, 169, 240, 357
Filarete: *Trattato di architettura* 344
Finedon parish church (Northamptonshire) 154
Firenzuola, Agnolo 207
fireplaces *277*
Fisher, Paul viii
Fitzalan family 268
Fitzpayn family 300
Flamboyant art 276
Flavigny 218
Fleury 228
flint 115
Florence: Santa Croce 274
Florence Cathedral 39, 83
 Baptistery *221*, 222
 Campanile 36
 dome 229
 height 35, 36
 west front *221*
Florentine Renaissance 55
Focillon, Henri ix, 71, 161–2
 Art d'Occident (*The Art of the West*) 161
 La vie des formes 161
 L'art bouddhique 162
foliage forms 140, 174, 239, 246, 312
 Bayeux Cathedral 131
 Bristol: St Mary Redcliffe 70
 Dorchester Abbey 172
 Ely Cathedral 205
 Glastonbury Abbey 208
 Hardingstone: Eleanor Cross 168
 illuminated books 326, 327
 Little Wenham church 159
 Naples: Santa Maria Donna Regina 274
 Norwich Cathedral 108, 109, *109*, 112
 Pevsner on 177
 'stiff leaf' 175
 Wells Cathedral 135
 Westminster Abbey 140, 141
Foliot family 300, 328
forma et modus 65–6, 252, 253
forma tractandi 65, 296
formalist tradition 2
fortification 115, 146–7; *see also* battlements;
 crenellations
fortresses 151; *see also* castles
Foucault, Michel 57, 283
Foulques, Guy, archbishop of Narbonne *see*
 Clement IV, Pope

founder imagery 223, 311
Frampton (Lincolnshire) 285
France
 architectural 'nationalism' 5
 cultural influence 4
 economic and demographic expansion 82
 Gothic tradition 2, 30, 50
 height of buildings 33
 national sentiment 6
 opere francigeno 64, 232
 political tradition 6
 scholastic system 44
 self-confidence 4, 5
 superiority 37–9
 technologies 51–2
Francesco di Giorgio: *Trattato* 63
Francis, St 335, 336, 337
Franciscan friars 92, 113, 350; *see also* Friars Minor
François I de La Sarra: tomb slab 390n158
Frankfurt School 55–6
Frankl, Paul 64, 125
fraternalism *see* anti-fraternalism
Freedberg, David 56
freedom 297
Freiburg Cathedral 87, 297
Freigang, C. 53
frescoes 150, 225, 277, 335
friars 92–3, 317; *see also* Augustinian friars;
 Benedictine friars; Cistercian friars; Dominican
 friars; Friars Minor; mendicant orders
Friars Minor: tomb 260
Fry, Roger 236
Fulgentius 222
Fulk, count of Anjou 341

Gage, John 285
Galvano della Fiamma 343–4
gargoyles *282*, 297
gates 114–17, *116*, 129, 145
Gauthier de Coincy: *Miracles of the Virgin* 199
Gautier L'Engles 276
Gauzelin of Fleury 27
Gdansk: Marienkirche 83
Geddington (Northamptonshire): Eleanor Cross 135,
 135, *256*
Gell, Alfred 55, 64, 181, 183
Gem, Richard 19
genealogy 311, 313, 324
Genesis manuscripts *see under* Bible
Geoffrey of Crowland, abbot of Peterborough 232,
 307
Geoffrey of Vinsauf 51, 143
 Poetria nova 206
geometry 30–1, 49, 65, 67, 173, 176, 266, 297, 325
George, St: imagery 248, *248*
George of Trebizond 28
Geremek, Bronislaw: *The Margins of Society in Late*
 Medieval Paris 284
Gervase of Canterbury 3, 68, 84, 226
Gervase of Mont-Saint-Eloi 60
Ghent 17
Giffard, Godfrey, bishop of Worcester 93
 tomb 91, 140

gigantism 39, 83, 144, 218, 224–5
Giles of Rome 5
 De regimine principum 64
Gilson, E. 54, 286
Giordano da Rivalto 337
Giotto 36, 320
Giraldus Cambrensis 6, 68, 233, 293, 325
 Life of St Remigius 227
 Speculum ecclesie 19
 Topography of Ireland 144
Girona Cathedral 36, 195, 218
Glaber, Ralph 26, 68, 342
glass 163, 173; *see also* windows
Glastonbury Abbey 70
 Lady Chapel 208
 north portal 71, *71*
glosses 293, 296
Gloucester Cathedral (formerly Abbey)
 choir 74, *76*, 77, 87, 133, 143, 174, 358
 cloister *8*, 357, *357*
 nave 87
 rebuilding of 86
 south transept 122, 143, 219
 tomb of Edward II 25, 257, *258*, 260
 tower 227
gold 197, 216, 231, 254, 347
goldsmiths 127, 193, 229, 231
Gorleston (Norfolk): Saint Andrew's parish church
 328, 331
Gorleston Psalter *see under* Psalters
Goscelin of Saint-Bertin 17
 Liber confortatorius 16
 Life of St Edith 16
Gothic Baroque 161
Gothic 'movement' 2; *see also* canonical Gothic;
 Capetian Gothic; early Gothic; Gothic baroque;
 High Gothic; International Gothic; Late Gothic;
 Manueline Gothic; 'port' Gothic; Rayonnant
 Gothic; Spanish cathedral Gothic
Grandes chroniques 343
Grandisson, John, bishop of Exeter 86, 259, 334–5,
 336
 tomb 178
Grantham parish church (Lincolnshire) 108, 172
Gratian 296
 Decretum 65
Great Bardfield parish church (Essex) 244
Great Walsingham parish church (Norfolk): window
 tracery 266, *269*
greatness of mind (*magnanimitas*) 296
Greek art 178
green men *104*, 109, *109*
Gregorius, Master 6, 19
 Narracio de mirabilibus urbis Romae 29, 32, 222
Gregory of Tours 31, 32, 229
Gregory the Great, Pope 18
Grey family 300
Gropius, Walter 2
Grosseteste, Robert, bishop of Lincoln 93, 147, 175
 Château d'amour 150, 182
Grössinger, C. 214
grotesque imagery 110, 293, 298, 303–4, 309, 310;
 see also gargoyles
Grusch atelier 294

Guerric of Saint-Quentin 59, 60
Guibert de Nogent 33
Guillaume de Lorris 3
Guillaume de Machaut 3
Guillaume de Nangis 342
 Chronique 343
Guillaume de Nourriche 276
Guillermo Inglés 266
guilloches 225, *226*
Gunton, S. 194
Gunzo of Cluny 16, 196
Gurk (Carinthia) 199
Guthlac, St 308
Guthlac Roll 316

Håkon IV, king of Norway 240
Halicarnassus: tomb of King Mausolus 32, 184
Hamburger, Jeffrey 155
Hanseatic League 83
Hanwell (Oxfordshire) 270
hard power 22
Hardingstone (Northampton): Eleanor Cross 108,
 135, *136*, 158–9, *158*, *160*, 161, 168, 172, 265
Harris, Jennifer 342
Harvey, John 122–3, 265, 353, 357
Hastings, Sir Hugh 216
Hastings, Maurice 122, 357
Hastings family tombs 98
Hatcher, J. 89
Hatfield, Thomas, bishop of Durham 139
Hawton parish church (Nottinghamshire) 97
 sepulchre 91, *92*, 261, *262*, *262*
head imagery 152, 179, 241, *243*, 244, 320; *see also*
 baboons
heart imagery 174, *175*
Heckington parish church (Lincolnshire) 97, *98*,
 261–2
 chantry 97
 gargoyles *282*, 285
 sedilia 97, 152, *153*
 sepulchre 91, 246, *261*
 windows 174, *282*, 285
height of buildings 13, 14, 17, 19, 22, 32, 33–7, 38,
 41, 43, 50–1, 83, 113, 127, 220–1, 349, 353
Helena, Empress 245
Hélinand de Froidment 82
Henderson, G. 319
Henry II, king of England 179
Henry III, king of England 6, 39, 40, 58–9, 84,
 95–6, 101, 127, 146, 228, 240, 259, 316
 tomb 41, 257
Henry VI, king of England 43, 353, 355
Henry de Courtenay, earl of Devon 98
Henry de Lacy, earl of Lincoln 98
Henry of Avranches 222
Henry of Eastry, Prior 97, 141, 182
Henry of Ghent 60, 63
Henry of Grosmont, duke of Lancaster: *Livre de
 Seyntz Medicines* 148, 216
Henry of Huntingdon: *Historia anglorum* 20, 32
Henry of Reyns 40
heraldry 99, 145, 300, 328
 Avignon Cathedral 257

Bayeux Cathedral 246
Cambridge: Trinity Hall Founder's Cup 262, *263*
Douce manuscript 129
Ely Cathedral 215, 223
Gorleston Psalter 332
La Chaise-Dieu Abbey 264
Pamplona Cathedral *250*, 251
Peterborough Psalter *308*
Santes Creus Abbey 266
Westminster Abbey 146
Herbert de Losinga 20, 115, 210–11
Herbert of Bosham 293
Hereford Cathedral 14, 86, 87
Herland, Hugh 63
Hermann the Archdeacon 366n14
hermeneia tradition 318
heroic mode 3–4, 14, 21–2, 27, 32, 33, 43, 69, 75, 87,
 201, 337
 criticism of 7, 82
 Douce Apocal;ypse 178
 'dynamic tradition' and 46
 Ely Cathedral 188, 217, 229
 illuminated books 293
 influence of 9
 military building 89
 Westminster Abbey 40
Herrad of Hohenbourg 231–2
Hervey of Stanton 98
Heslop, T. A. 325
Higden, Ranulph 222
high culture 292, 302
High Gothic 36, 37, 40, 54, 82, 126
high style 4, 292
Higham Ferrers (Northamptonshire): brass of
 William Chichele 364
Hildebert of Lavardin 21
 Par tibi, Roma 6
Hiram of Tyre 201, 231
historicism 30, 46–7, 78
Hogarth, William: *The Analysis of Beauty* 208
Holcot, Robert 66, 222, 259, 284, 318, 319, 323–4,
 335–6
 Moralitates 317
holism 45
Hollar, Wenceslaus: London, St Paul's Cathedral 7,
 12, *80*
Holy Roman Empire 64, 83
Homer 3, 347
Honorius Augustodunensis 145
 Gemma animae 150
 Sigillum 150
Horace 3
 Ars poetica 58, 285
Horrox, Rosemary 360–1
Hotham, John, bishop of Ely 84–5, 96, 98, 114, 154,
 189, 192, *193*, 215, 217, 225, 232, 239, 259, 332
Houghton St Giles (Norfolk) 268
Howard, Deborah 162
Hrabanus Maurus: *De universo* 293
Huesca Cathedral 251, 266
Hugh, St, of Lincoln 69, 222
 Metrical Life of 3, 26, 27, 29, 68, 145, 176, 222,
 345, 347
Hugh de Chatillon, Bishop 235

Hugh le Despencer 226
Hugh of Balsham, bishop of Ely 94
Hugh of Northwold, bishop of Ely 71, 72, 84, 156,
 188, 215, 217, 222
Hugh of Saint-Cher 59, 60
Hugh of St Victor 55
 Didascalicon 65
Hugo de Folieto 114
Hugo de Plailly 164
Hugues de Fouilly 146
Huizinga, Johann: *Waning of the Middle Ages* 162
Hulme, T. E. viii
human body imagery 177, 178, *200*, 206; *see also*
 head imagery
Humfrey, duke of Gloucester 305, 352, 353
humour 289, 290, 301–2, 305; *see also* japes; jokes;
 laughter
Hundred Years War 82
Hunt, William 65
Hurley, William 42, 96, 97, 192, 202, 214, 218, 220,
 226
Hutchinson, G. Evelyn 287
hyperbole 290–1, *292*

iconoclasm 199, 205, 207, 209, 210
iconography 288, 319, 337
icons 55, 56, 166
idealization of art 55
ideology vii, viii, 9, 29, 38, 55–6, 285, 286
idolatry 317, 347
illuminated art 166, 192; *see also* manuscript art
illuminated books *see under* books
illuminated letters 292–3
illuminated manuscripts *see under* manuscripts
illuminators 276, 294
illusion 179
images 56, 318
imaginary
 Christian 66, 347
 crafting 181
 Decorated Style 132
 English 44
 literary 184
 militarized aesthetic 146
 Romantic 144
imagination 50, 144
 Ely Cathedral: octagon 227
 'historicist' 30
 'imaginative luxuriance' 286
 sermons 317
 and variety 134
 and windows 174
 and wonder 31, 32
imitation 144, 179, 331
Immaculate Conception 49, 213
impossibilia 38, 57, 290, *292*, 309
impurity 293
indulgences 93
information retrieval 296
Ingeborg of France, Queen: tomb plate (lost) 164, *164*
Ingham, Sir Oliver de 246
Innocent III, Pope 337
 registers of 293–4

Innocent IV, Pope 39, 231
 tomb 261
innovation 62, 69, 235
 and competition 81
 courtly 157
 Decorated Style 97, 98, 109
 French 44
 gatehouses 116
 inventive 184
 oligopoly and 97
 ornamenta 91
 'shift to the margins' theory 83
insinuation 207
Insular art 233, 325
integration 369n182
interlace forms 144, 169, 233, 325–6
International Gothic Style 335
internationalism 2, 67, 236, 237, 238, 275–6, 319, 335, 339, 340
invention 45, 87, 283
 and artistic initiative 53–4, 77
 and authorship 44
 and behaviour 206–7
 bipolarity of 279
 Ely Cathedral 193, 204
 excogitative 65
 formal 156
 Francesco di Giorgio on 63
 and freedom 297
 gatehouses 117
 hierarchies of 45
 literary 345–51
 measurement and 14, 16
 painters 66
 and playfulness 284, 298
 prodigies of 42
 'progressivist' nature of 77, 78
 and rationality 53
 and scale 20
 struggle for 33
 theory and practice of 66
 and tradition 68–78
 variety/*varietas* and 28
 visual 65
 see also *Opus anglicanum*
inventiveness 65, 123, 140–1, 176, 179, 184
inventories 6, 65, 66, 232, 233, 307, 333, 336, 337, 349, 350
Irnham parish church (Lincolnshire): Luttrell monument 99, 152–3, *153*
ironwork 83, 199, 210
irony 289–90, 304, 350
Isabella of France, queen of England 232, 254, 259, 260, 332–3, 336, 337, 348, 350
Isidore of Seville 181
 Etymologies 27, 28, 32, 344
Islamic art 30, 123, 162, 163, 166, 372n153, 375n50
Istanbul
 Hagia Sophia 14, *15*, 16, 27–8, 30, 32, 35, 36–7, 167, 225, 351
 Kariye Camii 225
 Suleymaniye mosque 37
Italy
 architecture 229, 344–5

art 4, 252, 254, 263, 331, 333–7, 356, 358, 360
 banking companies 192, 226, 333, 336
 beauty 207–8
 book production 294, 303, 322, 336
 Cosmati mosaics 41, 274
 culture 4, 5
 fashion 340, 343–4, 355
 visual arts 63, 64–5, 274, 334
 xenophobia 344
ivories 125, 144

Jacques de Lorraine, Bishop 37
Jacques de Via, Cardinal, later bishop of Avignon 257
Jaeger, C. Stephen 7, 181
Jaime II, king of Aragon: tomb 257, 266
Jakenez d'Anchin 125
James, John 56–7, 82
James, M. R. 210, 211, 319
 M. R. James Memorial Psalter 321, *324*, 326–7
James of Kokkinobaphos: Homilies 166
japes 102, *102*, 140, 270, 289, 290, *291*, 303, 307; *see also* jokes
Jarrow-Monkwearmouth ruins 6
Jean II, king of France 342
Jean, count of Angoulême 5
Jean, duc de Berry: palace fireplace 277, *277*
Jean de Jandun 4, 5, 21, 173–4, 351
 éloges of Paris 28
Jean de Joinville 6
Jean de Lagrange, Cardinal 277
Jean de Venette 343
Jeanne of Burgundy, queen of France 307
Jedburgh Abbey 20
Jerusalem
 Aqsa Mosque, minbar (destroyed) 163, *163*, 165
 Church of the Holy Sepulchre 14, 22, *22*, 25, 27, 33
 Temple 215 *see also under* Solomon, King
Jews 21
Joan II, king of Navarre 251
Joan of Bar 328
'Johannes Anglicus' 152
John, St 155
 imagery *130*, 165, 178, *179*, 318, 331
John XXII, Pope 66, 248, 252, 254, 307, 333
 tomb 154, 232, 244, 253–5, *253*, *255*, 256, 257, 260, 264, 265
John de Chelles 156
John of Banbury 88–9
John of Beverley, St: feretory 125–6
John of Brinkley, abbot of Bury St Edmunds 331
John of Brockhampton, Abbot 201
John of Crauden, prior of Ely 189, 192, 215, 226, 264, 332
 Chapel *see under* Ely Cathedral
John of Dumbleton: *Summa*, St John the Baptist 312, *312*
John of Eltham: tomb 260, *260*, 333, *333*
John of Fressingfield 190
John of Garland 143
John of Northampton 112
John of Reading 341, 342, 348, 350, 356

John of Salisbury
 Metalogicon 46
 Policraticus 19
John of Wales 317
John of Wisbech 190, 193, 215, 216
John the Baptist, St.: imagery 112, 214, *214*, 312, *312*
John the Frenchman (*Francigena*) 127
John the Smith 361–2
 tomb 361, *361*, 362, 364
joiners/joinery 134, 140
jokes *289*, 294, 298, 301, 302, 303, 305, 310; *see also* japes
Josephus 347
Joy, William 73, 140, 143, 154, 236, 237, 358, 370n84
Julian the Apostate 214
Julius Caesar 18
Jumièges 33
Justinian 16
 Codex 303, *303*

Kairouan 30
Kauffmann, Michael 316
Kavaler, Ethan 298
Kendrick, Laura 283, 292, 293, 297, 301–2
Kentish style 88, 106, 116, 123, 141, 154, 168, 238, 254
Ketton, John 193
Kidson, Peter 24, 218, 236
Kilwardby, Robert, archbishop of Canterbury 63
Kimpel, Dieter 51, 52, 54, 61, 82, 371n17
King's Langley (Hertfordshire) 96
King's Lynn (Norfolk)
 St Margaret's church 210
 St Nicholas 238, *238*, 357
Kirkby, John, bishop of Ely 96
Kirkby, William 373n128
Kirkham Priory (Yorkshire) 115
Knapp, Peggy 56, 285
knowledge 58, 60, 64, 296, 297
Konrad von Hochstaden, archbishop of Cologne 37
Krautheimer, Richard 13–14, 25, 45, 66, 196, 222, 245
Kreider, Alan 93

La Chaise-Dieu Abbey 262–4
 choir 264
 cloister 264, *264*, 276
 labour costs 88
 tombs 263–4, *263*, 265
La Charité-sur-Loire 17
labour costs 87, 88, 140, 354, 360
labour mobility 89, 253
labyrinths 32, 33, 347
Lanfranc, archbishop of Canterbury 18
Langham, Simon, archbishop of Canterbury 381n202
Langland, William
 chivalric association 251
 Pierce the Ploughman's Crede 3, 4, 150, 345, 348–51, 353
Langley, Sir Geoffrey de 164
Langlois, Jean *see* Angles (Langlois), Jean
Langton, Walter, bishop of Lichfield 96, 193

Languedoc 38
Laodicea 131
Laon 5
Laon Cathedral 33, 50, 87, 124, 128
Lasarte, J. A. de 265
Late Gothic 1, 71, 236, 237, 265, 274
Lateran Council, First (1123) 146
Lateran Council, Fourth (1215) 90, 340, 355
Latin 33, 63
Latin texts 2, 3, 4, 18, 21, 32, 59, 228, 240, 287, 297, 299, 301, 302
laudatio 3–4, 5, 6, 7, 17, 18, 21, 351
laughter 289, 305
law
 canon 90, 296, 303
 codification of 302–3
 Roman 303
 see also legislation
Le Débat des hérauts d'armes de France et d'Angleterre 5
le Goff, Jacques 91, 93
Le Mans Cathedral 36, 131, 132
legends 21, 132, 210–12, 251, 302, 320
legislation: sumptuary 340, 343; *see also* law
legislative aesthetics 30, 68, 83, 122, 184, 349, 350
Leland, John
 De viris illustribus 6
 Itineraries 6–7, 353
Leo of Ostia 28
León Cathedral 83
levitas 49, 50
libraries
 Canterbury Cathedral 328
 Castle Rising (Norfolk) 333
 Norwich Cathedral 327–8
licences 93
Lichfield: diocese of 358
Lichfield Cathedral
 architect 62, 63
 choir *62*, 154
 Lady Chapel *62*, 193, 208
 nave 218
 portals 87
 presbytery 62
 restoration 68, 86
 shaft effects 75
 tower 87
limestone 353
Lincoln 17, 146
Lincoln Cathedral
 chapter house 222
 choir *26*, 69, 73, 84, *84*, 174, 177
 cloister 104
 cost 84
 marble 7, 26
 nave *72*
 painted surfaces 24
 presbytery 87
 rebuilding 68, 84, 86
 south transept rose window *172*, 174
 spire 87, 138
 vault *26*, 236
 west facade 18, *19*
 windows 172, 173

Lindley, P. G. 379n60
Little Wenham Hall (Suffolk) 157, 159
Little Wenham parish church (Suffolk): wall paintings 157–8, *157*, 159
liturgical art 287, 318
Lleida Cathedral 266
 cloister *268*
localism
 Bristol: St Mary Redcliffe 70
 and decorated work 357
 Ely Cathedral 72
 and invention 77, 78–9, 276
logistics 57, 60
Lombard, Peter 5, 293, 296, 328
London
 architectural invention 62
 Blackfriars 349
 church building 87
 Cologne Guildhall 100
 Eleanor Crosses 115, 139, 349
 Ely Place chapel 95, *95*, 97, 200
 friaries 93
 influences on 130
 laudation of 21
 Lloyd's building 121
 Lombard Street 333
 Newgate: Friars Minor 260
 parish churches 87
 St Mildred's, Poultry 100
 as a power centre 20
 praise for 5
 St Paul's Cathedral 7, *12*, 13, 17–18, 98
 cloister 25, 259
 cost 84
 crucifix 100
 emulation 20
 measurements 36, 195
 nave 33, 34, 36, 87
 presbytery *80*
 rebuilding 84
 spire 13, 87, 138, 157
 and Tower of London compared 21
 windows 4, 40, *80*, 174
 Seal of the Barons of London 21, *21*
 Tower of London 21
 Westminster Abbey 5, 39–42, 43–7
 altarpieces 127
 altars 158, 216
 architects 57
 art-nature nexus 27
 artists 163
 building 83
 chapter house 112, 156, 350
 cloister 172
 Cosmati pavement 41, *41*, 259
 cost 96
 crenellations 146
 emulation 19–20, 38, 40, 128
 figurative carving 152
 foliage forms 175
 height of 33, 34, 36, 37, 41
 heraldry 146
 length 17
 marble 41

 mosaics 225
 nave 40, 87
 portals 87
 presbytery *39*
 rebuilding 84
 relics 215
 retable 127, *127*, 129, 130, *130*, 134, 145, 167, *167*
 St Faith wall painting 133, *134*
 sanctuary 228
 shrine of St Edward the Confessor 58–9, *59*
 tombs
 Edmund Crouchback, earl of Lancaster 141, *142*, 154, 168, 255
 Henry III, King 257
 John of Eltham *260*, 333, *333*
 windows 4, 6, 25, *40*, 41, *131*, 173, *174*, 264
 Westminster Hall 5, 20, 42, *228*
 Westminster Palace
 Painted Chamber 132, *133*, 165, 315, *315*, 350
 painters 111, 307
 paintings 66
 scale 20
 St Stephen's Chapel 41–2, *42*, 61–2, 65, 75, *75*, 96, 97, *103*, 120, 122–3, 140, 154, 168, 200, 204, 235, 243–4, 264, 336, 353, 357
Longchamp, Nigel, bishop of Ely 302
Longinus 252
Longpont 254
Longthorpe Tower (Peterborough) 311
Loomis, R. S. 151
Lopez, Robert 81, 82
Louis, St 6
Louis IX, king of France (St Louis) 37, 40, 132–3, 134, 157, 166, 336
Louis XII, king of France 2
low culture 5, 9, 21–2, 286, 292
Lübeck 237
 Marienkirche 35, 83
Lucan 3
Lucian: 'True Story' 290–1
Luck of Edenhall 163
ludic *see* playfulness
Luttrell, Sir Geoffrey 99, 151, 303
Luttrell family 99, 153
Luttrell Psalter *see under* Psalters
Luxford, Julian 358
luxury goods 163–4
Lydgate, John 58
 Temple of Glass 346
Lynwode, William 117
Lyons, Second Council of (1274) 91–2, 93
Lyons cope 235

macabre 362, 364
machismo 22, 114
Maddison, John 75, 77, 218
magnificentia 25, 64, 144, 197, 200, 209, 340
magnifying mode 3, 9
magnitude (*magnitudo*) 13, 30, 32, 43, 68, 373n89
Magnus of Avignon, St: tomb 257
Malcolm, Noel 290, 302
Malmesbury Abbey 69, 70, 87
mandators 268

manifestatio 51, 296
Mann, J. 183
mansions 133, 155, 157, 159
Manueline Gothic 235
manuscript art 169; *see also* illuminated art
manuscripts
 Bohun 212, 300
 Cotton Titus 381n202
 devotional 319
 Lambeth Palace 229
 masonic 325
 Metz Pontifical 297, *297*
 Pearl 353
 Rothschild Canticles 177
 Smithfield Decretals 210, 211–12, 214, 296, *296*,
 299, 303, 316
 Somme le roi 317–18, 362
 Verger de Soulas 199
 Westminster coronation order 251
 see also books; Psalters
Map, Walter 302
marble 6, 25–7
 Avignon Cathedral 257
 Canterbury Cathedral 25
 coloured 25–6, 27
 Dunfermline Abbey 259
 effigies 184–5
 Exeter Cathedral 24
 haulage 32
 Jerusalem: Church of the Holy Sepulchre 22, *22*
 Lincoln Cathedral 26
 Muslim buildings 30
 Purbeck 25, 27, 41, 204, 205, 361
 Rome: Arch of Titus 19
 Venice: San Marco 167
 white 26, 27, 29
Marcia, William, bishop of Wells 93, 96
Marenbon, John 60
Margaret, St: imagery 157, *158*
marginalia 44, 284, 318–19
 development 292–8
 scatology 299
 subversiveness 287, 288, 299, 302
marginality 55, 81, 84, 283–6
Marie de Montmirel: tomb 254
Marienburg 237
Marshal, William II 251
Martin IV, Pope 113
Martindale, A. 388n126
Martini, Simone 254
Mary Magdalen, St: imagery 157, *158*, 331, 334, 335
Mary of Hungary, Queen: tomb 274, *274*
masons 57, 204, 205
 Avignon: papal court, 259
 dispersal 276
 identity 265–6
 imagery 270, *321*, *322*
 wages 88, 220, 360
 see also builders
mathematics 58
Matilda of Nerford 331
Matthew of Arras 236, 275
maturitas 49, 50
Maufe family tomb 141

Maurice, bishop of London 17–18, 20
Maurice de Sully, bishop of Paris 34
mausoleums 263
Mauwese, Martine 300
measurement of buildings 6, 13–14, 16–17, 18, 138,
 195–6; *see also* height of buildings; width of
 buildings
medieval–modern nexus 67
Meiss, Millard 360
 Painting in Florence and Siena after the Black Death
 355, 356
Melrose Abbey 276, 357
Melton, William, archbishop of York 96
memorials 361; *see also* Eleanor Crosses; shrines;
 tombs
memory 90, 91, 359
mendicant building 39, 83, 87, 113, 114, 236, 241,
 328
mendicant orders 92, 222, 232, 296, 345, 348, 353;
 see also friars
Meopham, Simon, archbishop of Canterbury: tomb
 244, *244*, 259
Merimée, Prosper 162
metalwork 127, 165, 166, 167, 233, 344; *see also*
 brasses; bronze; goldsmiths; ironwork
metaphors 145
 of castles 150, 153
 and creativity 278
 of fortresses 151
 of hauling 32–3
 heart imagery as 174
 illumination as 292, 293
 of the marginal 283–6, 288
 military 148
 of textiles 183
Metz: Hotel du Voué 310
Metz Cathedral 37, 38, 83
Metz Pontifical 297, *297*
Mexico: Huejotzingo church 273
Michael, St: imagery 115
Michael of Canterbury 62, 75, 88, 96, 97, 98, 122,
 154, 204, 244, 255; *see also* Canterbury family
Mignot, Jean 63, 344
Milan 5, 21
Milan Cathedral 32, 35, 36, 39, 63, 83, 344
Mildenhall (Suffolk): St Mary's parish church 199,
 235, *235*, 264
Mileham (Norfolk) 268
Miles de Nanteuil, Bishop 37
militarism 342–3, 344
military aesthetic 146, 148, 153–4
mimesis 174, 176, 177, 179, 183, 337
miniature arts 144, 169, 217, 308
minificence 7, 144, 167, 209
Minnis, Alistair 59, 317
mirabilia 31
Mirabilia urbis Romae 21, 222
miracles 337
 Bonitus, St 210–11, 214
 buildings as 32, 196, 215, 229
 carts and oxen 33
 St Edmund 366n14
 St Thomas of Canterbury 16
 and similitude 14, 16

Virgin Mary 209–14, 311, 318
 visions 340
 Wonders of the World 31
misericords 214, *214*, 272
missals 262, 322–3
 Sherborne 311
 Tiptoft *251*, 252
Mitchell, W. J. T. 45
mixture in aesthetic experience 7, 9, 25, 27, 29, 30,
 40–1, 42, 43, 44, 47, 132, 134, 135, 156–7, 187,
 206, 257, 259, 292, 304, 357
mnemonic theory 150, 182
modernism 4, 67–8, 121, 336
 aesthetics of 45, 46, 344
 craft-based 2
 hyperrationalist properties of 51
 metaphors of 77
modernity 2, 44, 54
modesty 342
modus 65–6
Moissac: Romanesque portals 211
monastic buildings 115
Mongol empire 163
Monkwearmouth *see* Jarrow-Monkwearmouth
Monreale Cathedral (Sicily): throne 165, *166*
Montclar, Renaud de: tomb 263–4, *263*, 265
Montecassino 28, 228
moral panics 339, 356
morality/moralism 4, 211, 343, 356–7
 and courtly culture 339
 in courtly literature 184
 and fashion 341
 and illuminated books 293
 in Langland's *Pierce the Ploughman's Crede* 350
 St Bernard and 183, 285
Moreau, Jean *see* Morow (Moreau?), Jean
Moret, Guillem 272
Morgan, N. J. 373n131
Morris, Richard 89
Morris, William 2, 4
Mortimer, Roger de 259
Mortival, Roger, bishop of Salisbury: tomb 177–8,
 178
Mortmain, Statute of 93
mosaics 225, 245, 320
 Cosmati 41, *41*, 58, 225, 228, 259
mouchettes 108, 243
movement 206–8, 209
Mulbarton family 328
munificence 373n89
murals 133
 Bury St Edmunds Abbey 213–14
 Ely Cathedral 225, 325, 332
 Norwich Cathedral 74
 Pamplona Cathedral *250*, 251
 Peterborough Abbey 307
 Saint-Geniès: Château du Cheylard 246, 248,
 248
 Sigena (Aragon) 249
 Westminster Abbey 133, *158*
 Westminster Palace 132, 165
Murray, Alexander 4
Murray, Stephen 37, 196
music: Pope John XXII and 254

musical imagery 233, 239, 264, 287, 308, *308*, 309, *309*
Muslim buildings 30
myths 2, 9, 20, 21, 31

Naples: Santa Maria Donna Regina, tomb of Mary
 of Hungary 274, *274*
Narbonne: mendicant churches 113
Narbonne Cathedral
 centralization of management 61
 chevet 82
 choir 38, *38*
 controversy of 38
 crossing and nave *39*
 height of 35
 Rayonnant production methods 53
 retable 210
narrative art 178, 336
national sentiment 6
naturalism 175–9, 326
Naumberg 175
Navenby parish church (Lincolnshire): Tomb of
 Christ 97, 246
Neoplatonism 28, 54, 174, 286
Nequam, Alexander 82
Nicholas III, Pope 163, 232
Nicholas IV, Pope 232
Nicholas, Master (mason) 373n128
Nicholas de Biard 60
Nicholas of Clairvaux 197
Nicolas de Antona 265
Nivelles: shrine of St Gertrude 125, *125*, 168
nonsense 288, 290, 292, 301, 302
Nordenfalk, Carl 292–3, 297
Normans 17, 20, 23, 78, 146
Northburgh, Roger, bishop of Lichfield 96
Norwich
 architectural landscape of 146
 Arminghall Arch 113
 bishop's palace 108
 chapel 268
 gatehouse 116
 hall porch 108, *108*
 Blackfriars (now St Andrew's Hall) 39, 113, *113*
 castle 17
 civil unrest 82, 101
 Decorated Style in 7
 friars 93
 Holy Trinity church 328
 and Italian art 331–2
 'land of St Michael' 115
 parish churches 87
 patronage 100
 St Andrew's Hall *see* Blackfriars
 St Ethelbert's church 115
 St Mary in the Marsh 328
 St Michael's church 115
 Tombland 115
Norwich Cathedral 20, 72–3, *73*–4, 172
 adaptability of 71, 87
 Ante-Reliquary Chapel platform with wall
 paintings *101*
 Carnary (charnel) Chapel 105, 106, *107*, 108, 109,
 112, 114, 168, 205, 268

chapter house 101, 109–10, 114, 205
choir 87
clearstory windows 72, 73, *73*
cloister 104–6, *106*, 114, 205, 309
 bosses 102, 104, *104*, 105, 109, *109*, 110, *110*,
 111–12, *112*, 362, 364, *364*
 chronology 104, 109
 cusping 248
 east walk 102, *102*, *103*, 104, 105
 baboon *285*
 prior's door 102, *103*, 105, 110, 168, 235
 prior's portal 105, 111, *111*, 112
 public access 114
 south walk 197, *197*, 299
 tracery 102, *103*, 104, 105, *105*
 vaulting 104
corbels 105
cost 84–5
cult of St Bonitus 210–11
Decorated Style 77
Ethelbert Gate 105–6, *107*, 115, *116*, 205, 265
Gothic additions 187
invention 87
Lady Chapel 72, 193, 205
length 17
library 327–8
nave 73, 87
presbytery 74
priory 328, 331
relics 101, 115
slype doorway 278
spire 262
transepts 73
wall paintings 101, *101*
wealth 86
nostalgia 7
Nottingham: St Mary's church 6, 353
Noves: papal residence 252
Noyon 5
Noyon Cathedral 50, 128

oak 135
obscenity 302
Oculus sacerdotis 290–1, *291*
Odofredus of Bologna 284, 303
ogee arches 97, 161–9, 256, 278
 assimilation of 162–3, 164
 Audignon 246
 Avignon: St Didier 261
 barbed foil 168
 Bony on 50
 Bristol: St Mary Redcliffe 70, 208
 Bucher on 143
 derivation from Byzantium 166, 167
 doorways 167
 Egerton Genesis 319
 Ely Cathedral 197, 201, 204, 205
 English 168
 Exeter Cathedral 135
 fantastic 162
 in figurative arts 169
 in illustrations 164, 165, *165*, 166, 168, 169, 170,
 171, *202*, 206–7

Irnham parish church (Lincolnshire) 153, *153*
Islamic 163, 164
Lichfield Cathedral *62*
Norwich Cathedral: Canary Chapel 108
quatrefoil 166
trefoil 164
Westminster Hall, St Stephen's Chapel 75, *75*, 123
ogee lights 277
ogival canopies 163, 197, 204, 244
Olaf, king of Norway 240
Old Sarum 146
oligopoly 95–7
Oliveri, Johannes 252, 253
 Pamplona Cathedral: *Passion of Christ* mural, *250*,
 251
Olson, Paul 311
opere francigeno 64, 232
opsis 354
opus 64, 181–2
Opus anglicanum 64, 110, 231–3, 235, 237, 254, 273,
 274, *275*, 276, 277
Orderic Vitalis 341–2
ordinatio 51, 63, 66, 217, 227, 237, 253, 265, 268, 296,
 297, 298
ordo (forma) tractatus 65, 296
organs 32, 223, 324
Orientalism 162, 163, 164, 274
Orléans 5, 17
Ormesby, Sir William 328
Ormesby Psalter *see under* Psalters
ornamenta 90, 91
Orsini, Giangaetano *see* Nicholas III, Pope
Orsini, Napoleone 386n79
Osbert of Clare 19
Oswald, St: shrine 91
Ottery St Mary (Devon) 138
 collegiate church 86, 236
Ovid 3, 27
 House of Fame 183
 Metamorphoses 64, 178
Owen, Dorothy 226
Oxford 318–19
 Black Death 359
 Egerton Genesis 341
 Greyfriars 319
Oxford Abbey 20
Oxford University
 Divinity School 351, *352*
 Durham College 321–2, 323
 Gaignières collection 124, 164
 Merton College 93, *94*, 169, 355, 377n44
 New College 63, 355
 St Bernard's College 353
Øystein, archbishop of Trondheim 240

Pabenham family 300
Pächt, Otto 319, 331, 335
Paderborn: Bishop Meinwerk's church 14, 25
Painter, John 216
painters 66, 111, 134, 252–3, 310, 316
paintings 66
 Cologne Cathedral 156
 curiositas of 178

Ely Cathedral 216
English influence 274
panel 56, 331, 333
wall 101, *101*, 132, 133, *133*, *134*, 157, *158*, 165, 263, 264, 311, 316, 336; *see also* murals
Westminster Abbey 112
palaces 155, 202
churches as 156
Norwich: bishop's palace, Norwich 108, *108*, 116
papal *see* Avignon: Palais des Papes
Poitiers: palace of Jean, duc de Berry 277
see also Paris: palace of the Cité; Westminster Palace
Paleotti, Gabriele: *Discorso* 351
Palermo
Cappella Palatina 28, 225
Martorana 225
Palma Cathedral 35, 39, 83
Pamplona Cathedral
chapter house 249
cloister 251
Passion of Christ mural *250*, 251
refectory 251
Panofsky, Erwin 2, 53, 54, 61, 177, 179, 236, 283, 286, 337
Early Netherlandish Painting 335
Gothic Architecture and Scholasticism 44, 50, 142, 278
'The ideological antecedents of the Rolls-Royce radiator' 43–4
Pantaléon, Ancher, Cardinal 148, 149
Pantaléon, Jacques *see* Urban IV, Pope
Parigoritissa, Church of 225
Paris
Aristotelian 'scheme' 60
and artistic initiative 53
Bibles 53, 54, 144, 295, 342
book production 53
court-style buildings 67
doctores 61
Hôtel Saint-Pol 263
illuminated books 303
Italian painters 335–6
Jean de Janduns' *éloges* of 4
Notre Dame 5, 34, 373n128
buttresses 132, *133*
canopy of Louis of France 132–3
clôture 156, *156*
height 36, 38
Jean de Janduns' *éloges* of 4
nave *35*
north transept portal 211
quatrefoil frieze 132, 154
rationality of 50
rose window 174
tracery 82
palace of the Cité 42
praise for 4–5
Psalters 295
Rayonnant Gothic 2, 6, 123, 237
St Germain-des-Prés 61, 158, 325
St Jacques-aux-Pèlerins hospital 276
Sainte-Chapelle 4, 5, 40, 41, *41*
canopies 135
dimensions 378n44

Jean de Jandun's *éloges* of 28, 351
Lectionary 168
metalwork 126
mixture of media 134
proportions 196
reliquary platform 124, *124*
rose window 174
St Stephen's chapel, Westminster compared with 42–3
shrine 166
university 5
Paris, Matthew 95–6, 156, 193, 227, 231, 272, 293, 337, 348–9, 350
Chronica majora 72
Paris, William 194
Parkes, Malcolm 296
Parler, Heinrich 36
Parler, Peter 73, 236, 237, 275
parody 292, 301, 302, 342
pastoral mode 3, 26, 317–18
pastoralia 207
Patmos 178
Patrington parish church (Yorkshire) 97, 158
patronage 3, 98, 360
architectural 343
archives 359
and authorship 57
bishops 109
books 293
Books of Hours 211
church building 216
clerks 97
and commissions 95
eastern art 164
Ely Cathedral: Lady Chapel 215
Fitzalan family 268
friars 93, 113, 228, 313
Gorleston Psalter 328
Henry III, King 40
illuminated books 99
Isabella, Queen 260
Jean, duc de Berry 277
Justinian as 3, 6, 16
and *machismo* 22
mendicants 357
and mixture 187
murals 249
Normans 17
Norwich Cathedral 112
Ormesby Psalter 328
parish churches 97
Peterborough Psalter 248
popes 32, 86
religiously motivated 100
Rome 19
shrines 361
supernatural influences 196
universities 354
Visconti family 32
Westminster Abbey 59, 112
Paul, St 16, *21*, 196
Paulinus Silentarius 28
Payne, Robert 88–9
Peasants' Revolt (1381) 101

Pecham, John, archbishop of Canterbury 113, 349
tomb 128, 157, 168
Pega, St 308
Peraldus: *Summa* of Vices 147–8
Percy family: tomb 140, 176, *176*, 208, *208*, 209
Pere III, king of Aragon: tomb 266
Pere ça Anglada 272
perfection 1, 82
Pergamos 164, 165, 168
Périz de Stella, Iohannes 251
Perpendicular Style 1
Bristol 6
and Decorated Style compared 356, 357, 359, 360
educational institutions 355
Gloucester Cathedral (formerly Abbey) 77, 122, 133, 174, 219, 357, 358
parish churches 87
as a radical idiom 77
and Rayonnant Style 122, 123
rectilinearity of 161
reform of 353
and uniformity 354
windows 174
Perrot Lenorman 252, 253
Pershore Abbey 87, 379n76
persuasion 5, 9, 29, 43, 45, 46, 56, 60, 92, 145, 179–80, 183, 185, 206, 207–8, 211, 217
Perugia 39
Peruzzi family of bankers 192, 226, 389n32
Peter, St 16, 196
imagery 127, *127*, *130*, 248, 257
Peter Lombard 54
Peter of Blois 46
Peter the Chanter 28, 35, 82
Peter the Roman 58, 59
Peterborough Cathedral (formerly Abbey) 75
choir 309
founder images 223
gatehouse 116
Gothic additions to 187
Lady Chapel 193, 194, *195*, 214
Marian miracle texts 213
murals 307
nave ceiling 302, *309*
Petrarch 3, 4, 207, 254, 259
Gallia superbia 5
Invective 5, 344
on invention 33
and Rome 5, 6
Petrus Comestor 324
Petrus Massonerius (Pierre Masonnier) 252
Pevsner, Nikolaus 26, 206, 208, 236
and Decorated Style 1–2, 44
The Englishness of English Art 49, 177, 287
and historicism 78
The Leaves of Southwell 177
and morality 4
and ogees 170
Pioneers of Modern Design 2
on St Augustine's, Bristol 70
Phaedrus: fables 290
Philagathos 28
Philip von Heinsberg, archbishop of Cologne: tomb 147

Philippa of Hainault, queen of England 192, 211, 340, 341
Philippe III, king of France 343
Philippe IV, king of France 6, 42, 43, 93, 335, 343
Philippe VI, king of France 307
Philippe Auguste, king of France 51
Pictor in carmine 290, 310
Pierce the Ploughman's Crede see Langland, William
Pierre de Baume 317
Pierre de Celle, bishop of Chartres 49, 187
Pierre de Dreux: tomb 164
Pierre de Montreuil 61
 tombstone 325
Pierre du Puy 66, 252, 253
Pierre Masonnier *see* Petrus Massonerius
Pietà imagery 318, 325, 335
piety 68
pilgrim badges 235
pilgrims/pilgrimages 193, 251, 311
Pindar 3
Pisa 64
Pisano, Nicola 64
piscinas 148–9, *148, 149,* 150–1, 152, 154
plague 68, 82, 88, 90; *see also* Black Death
planning 51, 87, 196
Plantagenet–Capetian rivalry 40
Plato: *Republic* 218, 287
Platonism 55
playfulness (*ludus*) viii, ix
 Bourges: house of Jacques Coeur 277
 Dorchester Abbey: Jesse window 172, 312
 English architecture 44, 50, 148, 232, 276
 and invention 284, 298
 militarized architecture 154
 palace aesthetic 202
 Villard de Honnecourt and 65
 and wordplay 297
Pliny the Elder 32, 37, 58, 231
Plotinus 55
pluralism 286
Poblet Abbey
 cloisters 266
 royal apartments 273, *273*
poetic mode 183
Poissy: Dominican church 92–3, 154
Poitiers: palace of Jean, duc de Berry, great hall fireplace 277, *277*
Poitiers Cathedral: Crucifixion window 179
polarity of style 2, 14, 64, 236, 279
polychromy 24, 27
polyfocalism 209, 351, 354
Poore, Richard, bishop of Salisbury 193
popes
 burials 259
 patronage 32, 86
 residences/palaces 252, 259, 263, 265, 270
'popular' art 302
populations 88, 99
porphyry 25
'port' Gothic 238
portraiture 337, 347
post-Renaissance 55, 56
post-Romantics 56
Postan, Michael 88

postmodernism 286–7
Potterne prebendal church (Wiltshire) 131
Prague: St Peter and St Paul 14, 167
Prague Cathedral 83, 87, 236, 237, 274–5
 choir 73, *236*
 height 36
presidiums 21
prestige 5, 25, 30, 31
Prior, Edward 356
Procopius 27–8, 351
prodigy building 83, 87, 195, 358
professionalism 53, 61, 62, 193, 214, 253–4, 262, 265, 300, 301, 303, 325, 345–6
Prophets: imagery *250, 252*
proportionality 174
Psalters
 Bird 287, *288*
 Bodleian 202, *202,* 347
 Bromholm 328
 Cambridge 129, 295
 Cuerdon 294
 De Lisle 157, 169, 170–1, *170,* 175, 207, 362
 Douai 328, 331, *331,* 332, 333
 Fitzwarin 148, 154
 Gorleston 108, 262, 299, *299,* 300, 328, *330,* 331, 332, 333, 334, 335, 337
 Huntingfield 294, 319
 interlace forms in 325
 Isabella *129,* 154, 156, 316
 Luttrell 99, 151, *151,* 153, 270, *271,* 287, 288, *289,* 290, 303, *305,* 364
 M. R. James Memorial 321, *324,* 326–7
 Macclesfield 291, *291,* 299, *300,* 332, 362, *363,* 388n116
 marginalia 294
 markets 294
 Munich 319
 Ormesby 108, 110, 168–9, 252, 291, 299, 300, 305, 313, 328, *329,* 331, 335
 Paris 295
 Peterborough 140, 151, *151,* 169, 232, 248, 290, 299, *306,* 307–8, 310, 311, 313–14
 Queen Mary 211, 299, 316, 319, *320,* 324
 Ramsey 110–11, *110,* 169, 223, 248
 Rutland 294
 St Albans 293
 St Louis 129, 156, 315
 St Omer 305, 325–6, *327,* 328
 Stephen of Derby 321
 Tickhill 169, 316
 and tradition 314
 Winchester 342, *342*
 Windmill 175, 326
 Yolande of Soissons 129, 293
Psellos, Michael 208
Pseudo-Dionysius 328
pseudo-Platonists 55
public arts 336–7
Pucelle, Jean 333, 335, 336
Pugin, Augustus 4
Puig i Cadafalch, J. 267
pulpitum screens 223, 246
Purgatory 91, 93
Pynson's Ballad 196

pyramids (Egypt) 32, 37
Pyroun, William 216

quaintness 350
quatrefoils 98, *98, 105,* 131, 132, 152, 169, 235, 241, 244, 255, 261, 264
 balustrades 135, 154
 friezes 115, 154
Quiney, Anthony 19
Quintilian: *Institutio oratoria* 51, 63, 64, 206, 344

rabbit imagery 299, *300,* 328; *see also* animal imagery
Radbod of Tournai 342
Ralph d'Escures, archbishop of Canterbury 150
Ralph Diceto 16, 31
Ralph Niger 16
Ramsey, Agnes 260, 358, 360
Ramsey, John 62, 97, 154, 192, 202, 218, 358
Ramsey, William 62–3, 96, 97, 154, 192, 202, 205, 261, 358
Ramsey Abbey 110–11
Ramsey family of architects (Ramsey Company) 62, 74, 75, 78, 96, 97, 102, 108, 109, 111, 114, 133, 187, 192, 197, 202, 205, *214,* 218, 219, 238, 239, 248, 260, 264, 268, 276, 316, 358, 360
Rancière, Jacques 55
Randall, Lilian 285, 293, 294, 299, 302
rationalism ix, 43
rationality 44
 and aesthetic activity viii, 78
 and irrationality 2, 144
 rise of 49–51, 277
 'value rationality' 51, 52, 53, 61, 67, 296
Ravenna
 Mausoleum of Theoderic 14
 Sant'Apollinare Nuovo mosaic 245
Raynard de Fonoyll 267–9, 270, 273, 275
Rayonnant Gothic
 artistic supremacy of 279
 Avignon: tomb of Pope John XXII 254
 Bordeaux Cathedral 246
 Cambridge: Peterhouse College 94
 and curvilinear tracery 276
 development of 2
 English redaction of 6, 25, 40, 43, 135, 172, 175, 204, 205, 220, 357
 Exeter Cathedral 24, 146
 Iberia 266
 influence of 275
 ludic aspects of ix
 Norwich Cathedral 74
 ordinatio of 237
 Parisian 62, 123–4
 and rationality 44, 53, 54, 277
 reduced (*Reduktionsgotik*) 357
 Santes Creus Abbey 266, 267
 shaft effects 75
 streamlining 70
 Troyes: St Urbain 146, 152
 and uniformity 354
 Wimpfen im Thal 64

windows 123, 174, 235
York Minster 146, 218
realism 4, 287, 351
Reculver (Kent) 244–5
Redfield, Robert 55
Reformation 7, 55, 209
Regensburg Cathedral 87
Reims 5
archdiocese of 37
St Nicaise 254
Reims Cathedral 82
buttresses 128
chevet hemicycle 127–8, *128*
clearstory glass 131
crenellations 146
gablets 156
height 35, 36, 37, 38
influence of 128
labyrinth 32
naturalism 175
nave 376n141
rose window 235, 264
rejuvenation 68
religious art 185; *see also ars sacra*; Christian art
reliquaries 164, 166, *166*, 193, 235
reliquary chapels 245
reliquary platforms 124
Remigius, bishop of Lincoln 18–19, 69
remote management 52, 61–2, 192, 220
Renaissance 28, 54, 55, 57, 60, 63, 64, 68, 179, 229, 297, 305, 316, 340, 352
renewal 56, 68
renovation 30, 69
reredoses 91
Audignon: Notre Dame 246, *247*
Bristol: St Augustine's 168
Christchurch Priory (Dorset) *92*, 313, *313*
Christchurch Priory (Hampshire) 178
Ely Cathedral 200, 256
Exeter Cathedral 140
Patrington parish church 158
retables
Anglesola 384n164
Narbonne Cathedral 210
Prague: St Peter and St Paul 167
St Thibault-en-Auxois 278
Westminster Abbey 127, *127*, 129, 130, *130*, 145, *167*, *167*
Reynard the Fox imagery 214, 299, *308*
Reynolds, Walter, archbishop of Canterbury 232
rhetorical tradition 58, 206, 207
Rhodes: Colossus of 31
Richard II, king of England 5, 101, 343
Richard of Bury, bishop of Durham 254, 322–4, 336
Philobiblon 259–60, 317, 323–4
seal 260, *260*
Richard of Chichester 101
Richard of Potesgrave 97
Richard of Ware, abbot of Westminster 228
Richard of Wichford 382n25
Richard of Wynchecombe 351
Richeldis de Faverches 196
Rickman, Thomas 1, 6, 122
Ricoeur, Paul 7

Ridel, Geoffrey, bishop of Ely 74
Ridevall, John 319
Fulgentius metaforalis 317
Riom: Sainte-Chapelle, south side window 277, *278*
Ripoll 17
Ripon Cathedral 50
Robert de Lannoy 276
Robert de Thorigny 36
Robert of Beverley 131
Robert of Galmpton 89, 138
Robert of Ormesby 328, 331
Robert of Rickling 226–7
Robert the Bruce: tomb 259
Rochester Cathedral
tomb of Bishop Bradfield 141, 168
wealth of 86
Wheel of Fortune 364
Roger de Holebrok 157
Roger of Farringdon 125–6
Rogers, Richard 121
Rogers, Thorold 88
Roland, legend of 251
Roman art art 178, 225, 261
romance literature 184
Romanesque architecture 211
Romanesque art 71, 161, 251–2, 327
Romanesque Style 3, 33, 50, 87, 102, 202
romanitas 344
the romantic 145
Romanticism viii, 57, 121
Rome 18–19
Arch of Constantine 18–19, *19*
Arch of Titus 19
fashion 344
foundation legends 27
Hildebert of Lavardin and 6
imperial mode 23
imperial values 18
Lateran 31
embroidered cope 169, *171*
laudation of 21
materials from 27
Pantheon 14, *16*, 32, 35, 36, 222
Petrarch and 5, 6
St Criogono *23*
St Paul's Basilica 31
St Peter's Basilica 14, 17, 18, 19, 31, 34–5, 36, 259
San Paolo fuori le Mura 17, 19
Santa Costanza 163
Santa Croce in Gerusalemme 245
Santa Maria in Aracoeli 261
Santi Quattro Coronati 163
Santo Stefano 31
Vatican 232
as a Wonder of the World 31
Romsey Abbey 20
Roncesvalles collegiate church 249, 250
chapter house *249*
Rouen 5
St Ouen abbey church *53*, 61, 65, 196
Rouen Cathedral
cult of bishops 139
stained glass 138, *139*
west façade 277

Royaumont: royal Cistercian church 83, 184
Rudolph, Conrad 215
Ruskin, John 2, 4, 57
Seven Lamps of Architecture 162
Rusuti family 335
Rykwert, J. 325

sacral arts 126, 162, 175, 277
sacraments 9, 90, 91, 97, 101, 113, 148, 150, 151, 184
St Albans 82
St Albans Abbey 17, 86, 116, 193
Gesta abbatum 3
St Benet Holme monastery (Norfolk) 115
St-Bertin 218
Saint-Bertrand-de-Comminges Cathedral 232, 235
St David's Cathedral 135
Saint-Denis Abbey Church 28
battlements 146
colour 30
Grandes chroniques 343
Jesse Tree 313
patronage 228
standardization of components 53
variety 351
Saint-Geniès: mural 246, 248, *248*
St Germain-en-Laye: royal residence 156
St Germer-de-Fly: Lady Chapel 154
Saint Germigny-des-Prés 14
Saint-Quentin collegiate church 36, 37
Saint-Savin-sur-Gartempe 33
St Thibault-en-Auxois priory church 150
retable 278
Saintes chapelles 42
sainthood 20–1, 27; *see also* canonization
Salamanca Cathedral: murals 249
Salisbury: Chace of Bere 147; *see also* Old Sarum
Salisbury Cathedral 69
brass of Bishop Robert Wyvill 147, *147*
canons' flight to 146
cloister 102
cost 84
Lady Chapel 193
Leland on 7
portals 87
pulpitum 140, 201
rebuilding 86
St Martin's Chapel 131
spire 86, 87, 138
tombs 152, 177–8, *178*, 201
Salmon, John, prior of Ely, later bishop of Norwich 96, 101, 102, 104–5, 106, 108, 109, 111, 112–13, 114, 172, 192–3, 202, 205, 259, 332, 333
Salmon family 106
Saloman family 192
Sanchia, queen of Aragon 249
Sancho II, archbishop of Toledo 232
Sancho VII, king of Navarre 249, 251
Sandler, Lucy 289, 313
Sanpere, A. *see* Durán Sanpere, A.
Santa Maria di Realvalle 66
Santes Creus Abbey 266–7, 290
cloister 266, *267*, 269–70, *270*, *271*, 272, *272*, 288, *291*
tombs 257, 266, *266*

Santiago de Compostela Cathedral 19, 33, 83
 Pórtico de la Gloria 102, *103*
Sardis church 131, *132*
satire 3–4, 217, 290, 301, 310, 311, 345
scale 176
 of buildings 6, 17, 19–20, 143, 196
 of forms 142–3
Scarry, Elaine 9
scatology 285, 299
Scattergood, J. 21
Schapiro, Meyer 287
scholasticism 44, 50, 61, 283, 296
schools 296, 355
science 63
 'onward march of' 175–9, 287
sculpture
 curiositas of 178
 and effect 181
 Ely Cathedral: Lady Chapel 199–200, *211*, 214,
 219, 316
 Exeter Cathedral 336, *336*
 and mimesis 177
 Quintilian and 206
 Santes Creus Abbey 269–70, *270*, *271*
 Tarragona Cathedral 272
 tombs 179
 and vice 209
 see also statuary
seals 129, 144, 163, 181, 260, *260*, 302, 332
Sears, Elizabeth 304
secularity 18, 45, 54, 55, 68, 93, 102, 104, 145–6, 151,
 155, 159, 162, 177, 183, 311
sedilia
 Dorchester Abbey 171
 Exeter Cathedral 91, *91*, 256
 Heckington parish church 97, 152, *153*
Sedlmayr, H. 54
Séez Cathedral 75, 83
Sekules, Veronica 91, 115, 139, 373n138
Selby Abbey
 choir 239
 choir and presbytery *173*
 rebuilding 86
 windows 172, 174, 313
Senlis 5
Sens 37
senses: hierarchy of 45
sepulchres 91, 261–2, *261*, *262*; *see also* tombs
sermons
 culture of 60
 as *exempla* 317, 318
 on idolatry 222, 284
 on painters 66
 St Bernard on the Song of Songs 29
sex
 in Egerton Genesis 319, 324–5
 and fashion 339, 340–1
 and moralizing 211
 sexual vice 183
Sheba, queen of 197, 201, 213, 214, 216–17
Sherborne castle 147
shield imagery 147, 153, 154, 215, *216*, 239
shrines 83
 Canterbury Cathedral 25, *25*, *48*

Chester Cathedral 358–9, *359*
Ely Cathedral 217, 223, 265
Evreux Cathedral 125
 extensions for 84, 87
 Nivelles 125, *125*, 168
 patronage of 361
 Westminster Abbey 58–9, *59*
 Worcester Cathedral 91
Siagrus, archbishop of Toledo 210
Siegfried, abbot of Gorze 342
Siena 62
Sigena (Aragon) 249
Sigeric, archbishop of Canterbury 222
similitude 14, 147
Simon de Montacute, bishop of Ely 94, 95, 192,
 193, 215, 216
Sir Gawain and the Green Knight 184, 345
Smalley, Beryl 317, 325
Smyrna church 130
Snettisham parish church (Norfolk) 199, 205
social mobility 61, 99–101, 253, 325, 360
sodomy/sodomites 324, 341
'soft' power viii, 22
Soissons 5
Soissons Cathedral 36, 37, 38, 82, 127, *128*
Solomon, King 214
 House of 195–6, 197, 200, 201, 216
 imagery 197, *198*, 201, 202, *202*, *250*, 251
 Temple of 22, 38, 200, 201–2, 231
 throne of 197, *198*–9
Sorgues 252
Souillac 211
Southern, R. W. 6
Southwell Minster 177
 chapter house 175, *175*, 176
 pulpitum 246, *247*
Southwick Priory 129
Souvigny 17, 277
space 144, 218
Spanish cathedral Gothic 30; *see also* Manueline
 Gothic
Speyer Cathedral 17, 19, 30, 33, 36
spires 83, 87, 157
 Avignon Cathedral: tomb of Pope John XXII
 254, *255*, 265
 Egerton Genesis 319, *320*
 Ely Cathedral 217
 Exeter Cathedral: bishop's throne 254
 Norwich Cathedral 262
 St Paul's Cathedral 13
 Salisbury Cathedral 86
 Santes Creus Abbey: tomb of Jaime II 266
 symbolism of 138
 see also steeples
spolia 29, 30
Stallybrass, Peter and Allon White: *The Politics and
 Poetics of Transgression* 284
standardization
 Bibles 295–6
 books 296, 297, 298
 building logistics 52
Stanton Harcourt (Oxfordshire): shrine of St
 Edburga 140
Stapledon, Sir Richard: tomb 179

Stapledon, Walter, bishop of Exeter 86, 93, 96, 135,
 138, 139, 140
 tomb *180*
Statius 3, 347
statuary 29, 200, 201, 208; *see also* sculpture
Stebbing parish church (Essex): chancel screen 244,
 245
steeples 4, 38; *see also* spires
Stephen of Derby Psalter *see under* Psalters
stereotyping 49–50, 54
Stokesay Castle 159
stone
 adaptation of 87
 advantage of 90
 Cambridge: King's College 353
 churches 17
 cost 83, 88
 Ely Cathedral 195
 movement of 228
 standardization of components 52, 53
stone carvers 140
stone quarries 65
stonecutting 17, 50, 65
Stonehenge 32
Strasbourg Cathedral 129
Stratford, John, archbishop of Canterbury 261, 340,
 343
structural deficiencies 83
studiosus 65
sublimitas 9, 13, 30, 174
subtilitas 174, 182, 183, 207, 254
Suckale, Robert 51, 52, 54, 61, 82, 371n17
Suetonius 27
Suffield, Walter, bishop of Norwich 193
Suger of Saint-Denis, Abbot 27, 351
 De administratione 28, 29
 De consecratione 228
 lux continua 174
Sully family 36
Summers, David 207
sun imagery 174
superfluity 350
supernatural 14, 196
surfaces 56, 181, 293, 354
Sutton, Oliver, bishop of Lincoln 104
Sutton family 153
symbolism
 and the aesthetic 14
 crucifixes 100
 and design process 196
 Ely Cathedral: octagon 222
 marginalia 385n29
 monarchy 115
 religious building 145
 spires 138
Symon of Lenn (Lynn) 216
synopsis 354
Szittya, Penn 350

Tabarka (Tunisia) 245
tabernacles 155, 254–5
 Avignon Cathedral: tomb of Pope John XXII
 254, 256

Bristol: Mayor's Chapel 169
canopied 123
Cologne Cathedral 156
Douai Psalter 332
Ely Cathedral 197, 204
Florence: Santa Croce 274
image 135
in Langland's *Pierce the Ploughman's Crede* 349–50
London: St Paul's Cathedral 157
Pamplona: *Passion of Christ* mural 250, 251
Vasari's disapproval of 344–5
Tarragona Cathedral 268
chapel of Santa Maria de los Sastres 272, *272*
taste 29, 41
technologies 17, 32, 51
of enchantment 64, 181
and standardization 54
telescopy of forms 142, 143, 176, 350
temples
Jerusalem 215; *see also under* Solomon, King
in literature 346, 347
Tertullian 183
Tewkesbury Abbey
choir 69
Despencer tombs 261
elevations 20
nave 87
patronage 98
rebuilding of 86
windows *vi*, 263, *312*
textiles 233, 340; *see also* embroidery
Theodore, St. 248
theologians 3, 60
Theophilus
imagery of 211, *212*, 213, *213*
legend of 132, 211
treatise of 45
Thetford Priory 196
Lady Chapel 194, 216
Thidemann (German sculptor) 100
Thomas, St, the Apostle 16, 196
Thomas Aquinas, St *see* Aquinas, St Thomas
Thomas de Lisle 192
Thomas de Saulx, sire de Vantoux: tomb slab
390n158
Thomas of Canterbury *see* Becket, Thomas
Thomas of Hereford, St, bishop of Hereford 93
Thomas of Popely 331
Thomas of Westminster, Master (painter) 65, 307
Thomas of Witney 78, 88, 97, 138, 139, 140, 141,
205, 219, 336
Thomism 28, 92
Thorney Abbey 214, 311
Thornham Parva Retable 111
thrones
Canterbury Cathedral 141
Durham Cathedral 139
Exeter Cathedral 89, 135, *137*, 140, 154, 204, 254
imagery of 197, 198–9
of King Solomon 197, 198–9
Monreale Cathedral *166*
Wells Cathedral *73*
Thyatira: Church of 131, 164
Tino da Camaino 274

Tintern Abbey 6
Toker, Franklin 63
Toledo Cathedral 83
embroideries 232, 235
presbytery 249, 273
tomb plates *164*
tomb slabs 125, 184, 361, 390n158
tombs 97
Amiens Cathedral 277
Avignon Cathedral 154, 232, 253–5, *253*, *255*, *256*,
257, 259, 260, 264, 265
Avignon: St Didier 261, *261*, 262
Beauvais Cathedral 254
Beverley Minster 140, 176, *176*, *208*
Bridport 201
Canterbury Cathedral 128, 168, 259, 261, 355, *362*,
364
of Christ 22, 26, 97
Cologne Cathedral 147
copying of style 98–9
Corbeil 164, *164*
Dunfermline Abbey 259
Durham Cathedral 139
Ely Cathedral 204–5, 274, *275*, 382n25
Exeter Cathedral 178, *180*
Fécamp 382n37
Gloucester Cathedral (formerly Abbey) 25, 185,
257, *258*
Halicarnassus 184
incorporation into sepulchres 91
Jerusalem: Church of the Holy Sepulchre 22, 25
La Chaise-Dieu Abbey 263–4, *263*, 265
in literature 184
Longpont 254
Naples: Santa Maria Donna Regina 274
painted 184–5
of Pierre de Dreux 164
Roman 261
Salisbury Cathedral 177–8, *178*
Santes Creus Abbey 266
Tewkesbury Abbey 261
Villeneuve-lès-Avignon, 261
Wells Cathedral 355
Westminster Abbey 154, 168, *255*, *257*, *260*
Winchelsea parish church *99*, 142, *142*, 154, 175,
176
see also tabernacles
tombstones 325
Toulouse: St Sernin 17, 33, 86
Toulouse Cathedral
choir 251
nave 39
Tournai Cathedral 38, 82
choir 83
height 35, 37
stained glass representation of 128
tomb slab 125
Tours 5
St Martin 17
towers 38, 87, 116, 218
bell 32; *see also* campaniles
Beverley Minster 227
Ely Cathedral *see* Ely Cathedral: octagon
Gloucester Cathedral (formerly Abbey) 227

prodigy 83, 368n138
symbolism of 150
Tower of Babel imagery *321*, 324
Wilton: Edith's Tower 16
town-planning 5
tracery
Avignon Cathedral: tomb of Pope John XXII
256
blind 243
curvilinear 169–75, 235, 264, 265, 266, 272, 273,
274, 276, 277
evolution of 175
flowing 90, 97, 105, 108, 135, 171–2, 175, 239, 246,
276, 277
Kentish 154, 168, 238, 241, *243*
micro-architectural 201
ogival 98, 168, 241, 266, 268, 276
quatrefoil 106
reticulated 97, 172, 249, *249*, *250*, 266, 269, 272,
277
sub-cusped 244, 278
see also under windows
Trachtenberg, Marvin 51, 57, 67
tractare 65
trade 99
traditions
aesthetic 20
and authority 67
and barbarism 344
Black Death, impact of 359
Christian 351
'dynamic' 46
Egerton Genesis 319–21
Graeco-Roman 351
influence of 78
and invention 68–78
marginalia and 287, 288
notion of 77
oral 302
Psalters 314
Tree of Jesse imagery 171–2, *171*, 232, 311–12, 313, *313*,
328
trefoil arches 126, 131, 132, 146
trefoil canopies 140
trefoil motifs 74, 135, 141, 142, 154, 243, 246, 256, 264
Trier 37
Trivet, Nicholas 254
Trondheim Cathedral 238
octagon 143, 239–41, 243, 244
reliquary chapel 245
screen 239–40, *240*, 241, *242*, 243, 244, 245
Trowse Newton church (Norfolk) 373n128
Troyes 5
St Urbain 75, 151–2
piscina 148–9, *148*, *149*, 150–1, 154
sculpture 201
Tynmouth Abbey 31, 225
typology 16, 32, 45, 46, 66, 213, 217, 310, 311

uniformity 353–4
universities 351–5
and books 304
chantries 93

growth of 303
and knowledge 296
Paris 5
statutes 355
see also Cambridge University; Oxford University
Uphall, Richard 114
Uppsala Cathedral 4, 40, 241
Urban IV, Pope 148, 149
utopia 290, 292, 297

vaghezza 207, 208, 209
Vale Royal Abbey 85, 96
Valencia Cathedral 265
values 50, 121–2, 144
Van Os, Henk 356, 357
variety/*varietas* 28–9, 43, 45, 68, 129
 church portals 117
 and cleanness 353
 courtly 41
 and dignity 28
 and *diversitas* 29
 Ely Cathedral 202
 of form 123
 and impurity 123
 Jean de Jandun on 22
 Lleida Cathedral 266
 narrative 133
 painters and 134
 Peterborough Psalter 169
 Quintilian and 206
 and sensory experience 181
 stained glass 128
 windows 176
 working of 64
Vasari, Giorgio 229, 231
 Lives 344
Vauchez, André 139
vaults/vaulting 22, 24, 196
 adaptation of 87
 admiration for 276
 Amiens Cathedral 37
 Avignon Cathedral 256, 257
 bosses 104
 cost 83
 Ely Cathedral 215, 217
 Exeter Cathedral 6
 fan 235
 Irnham parish church 153
 lierne 236, 237, 273, 358
 Lincoln Cathedral 26, *26*
 net 236
 Norwich Cathedral 72, 104, 105, *109*
 Oxford University: Divinity School 352
 rib 33, 51, *52*, 277, 298
 St Paul's Cathedral 13
 sophistication of 44
 tierceron 237, 246
 triradial 237
 wooden 42, 73, 104, 152, 190, 192, 194, 196, 205, 217, 218
Venice
 economic power 163
 gigantism 39

San Marco
 cupola 225
 doorways 162, 163, 167
 marble 167
 mosaics 320
 west façade 162, *162*
vernacular
 Bibles 347
 culture 3–4, 213, 286, 297, 302, 310, 350
 manuscripts 301
Verona 21
Veronica image 110, 333, 337
Verstehen 122
Vic: cloister 266
vice 209
Victorians: and moralizing tradition 4
Victorines 58, 145
Villani, Giovanni 222, 344
Villard de Honnecourt 65, 127, 128
 Wrestlers 33, *33*
Villeneuve-lès-Avignon
 St Marie 257
 tomb of Pope Innocent IV 261
Vincent, Nicholas 18, 94
Viollet-le-Duc, E. E. 50, 54
Virgil 347
 Aeneid 3, 178
Virgin and Child imagery 109, 152, 153, 157, *157*, 169, *170*, 199, 201, 254, *255*, 264, *334*
Virgin Mary
 buildings dedicated to 95, 222
 cult of 149–50, 206, 208, 336
 devotion to 196, 216
 imagery 56, *127*, 149–50, 163, *170*, 178, 194, 197, 199, 208, 211, *211*, *212*, 213, 257, 313, 335;
 see also Annunciation
 invocations of 151
 miracles of 209–14, *215*, 311, 318
 narratives of 214
 visions of 196
 see also Immaculate Conception
Visconti family 32, 36
visual arts
 and human motivation 229
 and natural science 177
 and the textual 347
Vitruvius 51, 58, 125, 352–3
Vives i Miret, Josep 272
von Simson, O. G. 52, 54, 286

Walpole, Ralph, bishop of Ely 104, 112, 194
Walsingham Abbey 193, 196
Walsingham memorandum 3, 27, 188–9, 190, 217, 224–9
Walter, Hubert, archbishop of Canterbury 159
 tomb 244
Walter de Brienne, duke of Athens 344
Walter de Milemete: *Secreta secretorum* 340
Walter of Bury St Edmunds, Abbot 309
Walter of Merton, bishop of Rochester 93, 94, 96
Walter of Whittlesey 307
Warenne, John de, earl of Surrey 328, 331, 334, 374n158

Warenne family 300
Wastell, John 63
wealth 85–6, 183, 222, 284
Wells Cathedral 7
 architect's bond 370n84
 chapter house 168, 218, *220*
 choir *x*, *73*, 143, 154, 218, 236
 crenellations 146
 Decorated Style 77
 façade 200
 Lady Chapel 135, 139, 219, *221*
 nave 70
 painted surfaces 24
 portals 87
 presbytery 73, 140, 143
 rebuilding of 86
 tomb of Thomas Bekynton, bishop 355
 tower 87
 wealth of 86
 west front 140, 201, *201*
 windows 313, *314*
Wentersdorf, Karl 285
'West Country' Romanesque 70
Westminster *see under* London
Westwell parish church (Kent) 244
 triple arcade *245*
Wheel of Fortune imagery 362, 364
White, Allon *see* Stallybrass, Peter and Allon White
Whitehead, Christiania 347
Whittingham, A. B. 373n138
width of buildings 18, 19, 32, 73, 195, 218
William I, king of England (William the Conqueror) 17, 18, 20, 199
William II, king of England (William Rufus) 20, 165, 341, 342
William de Grez, bishop of Reims 37
William fitz Stephen 5
 Descriptio nobilissimae civitatis Londoniae 21
William of Conches 55
William of Devon 294
 Bible *294*
William of Herlaston 97
William of Louth, bishop of Ely: tomb 96, 147, 204–5, 255, 274, *275*
William of Malmesbury 17–18, 19–20, 28, 213, 309
 Gesta regum anglorum 6, 341
William of Norwich 21, 101
William of Occam 177, 257
William of Poitiers 18, 20
William of Saint-Amour: *De periculis novissimorum temporum* 350
William of Sens 182
William of Witton 373n131
William of Worcestre 206
 Itineraries 6, 7
William of Wykeham, bishop of Winchester 355
William Rufus *see* William II, king of England
William the Conqueror *see* William I, king of England
William the Englishman 251
Wilson, Christopher 53–4, 123, 166–7, 219, 369n4
Wilton: Edith's Tower 16
Wimpfen im Thal: Gothic church 38, 64

Winchelsea parish church (Sussex): tombs *99*, 140, 141, *142*, 154, 175, 176, 255
Winchelsea, Robert, archbishop of Canterbury 91, 93
Winchester 20
Winchester Cathedral 19
 adaptative building 87
 length 17
 nave 87, 358
 rebuilding 86
 stalls 117, 140
 wealth 86
Winchester College 65
windows
 admiration for 276
 clearstory 42, 72, 73–4, *73*, 83, 88, 131, *312*, 376n141
 cost of 83
 Crucifixion 179
 curvilinear 98, 171–5, 266
 Ely Cathedral: Lady Chapel 216
 hemicycle glazing 37
 'Kentish' style 88
 Marian miracles in 213–14
 mullioned 75
 multiform 199
 Perpendicular 358
 rose 4, *40*, *80*, *172*, 174, 235, 264
 stained-glass 28, 46, *46*, 83, 93, *94*, 127–8, *128*, 129, 138, 139, *172*, 178, *243*, 268, 310, 311, 336, 374n44
 tall/wide 33
 traceried 6, 24–5, 40, 41, 85, 94, 108, *109*, 123, 125, 142, 149, 156, 159, 162, 168, 169, 171–2, 174, 190, 194, *197*, 199, 204, 205, 215, 218, 238, 249, 251, 265, 268, *269*, 272, 276, 277, *278*, 313, 373n128
 Tree of Jesse 172, 171–2, *171*, *312*, 313
 variety/*varietas* in 176

of vaults 236
 Westminster Abbey *131*
Windsor Castle 5, 89, 96, 358
Wölfflin, Heinrich 64, 356
Wolfram von Eschenbach: *Parzival* 184
wonders/the wonderful
 buildings as 30, 38
 Chaucer and 209
 Douce manuscript 179
 experience of 33, 181
 London 4–5
 pre-Gothic 30–3
 Wonders of the World 30, 31–2, 229
wood
 Avignon: tomb of Pope John XXII 254–5
 bishops' thrones 70, 89, 135, 138, 140
 canopies 175
 carved objects 140
 Ely Cathedral 215, 223, 227, 228, 229, 357
 and heroic mode 276
 Islamic objects 166
 as a medium 78, 126, 133, 134
 Peterborough Abbey ceiling 309, *309*
 roofs 17, 22, 42, 154
 stalls 154
 templates 220
 temporary ceremonial devices 184
 vaulting 42, 73, 104, 152, 190, 192, 194, 196, 205, 217, 218
 York Minster 195
Woodlock, Henry, bishop of Winchester 117
Wookey Hole 6
Worcester Cathedral
 figurative carving 152
 rebuilding of 86
 sculpture 201
 shrine of St Oswald 91
 tomb of Bishop Godfrey Giffard 91, 140

wordplay 293–4, 297
workforces 57, 270, 276, 358–9
workmanship 51, 64, 233, 238, 257, 273, 359
Worringer, Wilhelm 236
Wren, Christopher 42
Wynard, William 63
Wyvill, Robert, bishop of Salisbury: brass 147, *147*

xenophobia 340, 344, 356
Ximénez, Rodrigo, archbishop of Toledo 30

Yevele, Henry 63, 345, 370n84
Ymagour, William 216
Yolande of Soissons: Psalter and Hours of 129, 293
York: parish churches 87
York Minster 5
 canopy work 129
 chapter house 152, *152*, 154, 205, 218
 choir 77
 foliage forms 175
 nave 34, 154, 218
 height of 36
 west window 172, *172*, 174
 portals 87
 Rayonnant Gothic in 146
 rebuilding 86
 shaft effects 75
 vaults 195
 west front 277, *278*
 windows 139, 236, 334, *334*
 workforce 57
Young, Edward: *Conjectures on Original Composition* 13
youth culture 340, 342, 343